ARCHITECTURAL INVENTION IN RENAISSANCE ROME

Villa Madama, Raphael's late masterwork of architecture, landscape, and decoration for the Medici popes, is a paradigm of the Renaissance villa. The coming-into-being of this important, unfinished complex provides a remarkable case study for the nature of architectural invention. Drawing on little-known poetry describing the villa while it was on the drawing board, as well as ground plans, letters, and antiquities once installed there, Yvonne Elet reveals the design process to have been a dynamic, collaborative effort involving humanists as well as architects. She explores design as a self-reflexive process, and the dialectic of text and architectural form, illuminating the relation of word and image in Renaissance architectural practice. Her revisionist account of architectural design as a process engaging different systems of knowledge, visual and verbal, has important implications for the relation of architecture and language, meaning in architecture, and the translation of idea into form.

YVONNE ELET is Associate Professor of Art History at Vassar College. She is a specialist in Italian early modern art and architecture, and her research focuses on Renaissance villa culture; integrated designs for art, architecture, and landscape; early modern stucco; and intersections among art, literature, science, and natural philosophy. Her articles appear in the *Journal of the Society of Architectural Historians* and *I Tatti Studies in the Italian Renaissance*. She has received grants from the Center for Advanced Studies in the Visual Arts, the Getty Research Institute, and the American Council of Learned Societies. She has been a Fellow at the Metropolitan Museum of Art and at the Frick Collection, and a visiting scholar at the Max-Planck-Institut für Wissenschaftsgeschichte in Berlin.

ARCHITECTURAL INVENTION IN RENAISSANCE ROME

ARTISTS, HUMANISTS, AND THE PLANNING OF RAPHAEL'S VILLA MADAMA

YVONNE ELET

CAMBRIDGE
UNIVERSITY PRESS

CAMBRIDGE
UNIVERSITY PRESS

University Printing House, Cambridge CB2 8BS, United Kingdom

One Liberty Plaza, 20th Floor, New York, NY 10006, USA

477 Williamstown Road, Port Melbourne, VIC 3207, Australia

314–321, 3rd Floor, Plot 3, Splendor Forum, Jasola District Centre, New Delhi – 110025, India

79 Anson Road, #06–04/06, Singapore 079906

Cambridge University Press is part of the University of Cambridge.

It furthers the University's mission by disseminating knowledge in the pursuit of education, learning, and research at the highest international levels of excellence.

www.cambridge.org
Information on this title: www.cambridge.org/9781107130524
DOI: 10.1017/9781316418161

First published 2017
Reprinted 2018

Printed in the United Kingdom by TJ International Ltd. Padstow Cornwall

A catalogue record for this publication is available from the British Library.

Library of Congress Cataloging-in-Publication Data
NAMES: Elet, Yvonne, author. | Sperulo, Francesco, active 15th–16th century.
TITLE: Architectural Invention in Renaissance Rome: Artists, Humanists, and the Planning of Raphael's Villa Madama / Yvonne Elet, Vassar College.
DESCRIPTION: New York: Cambridge University Press, 2017. | Includes bibliographical references and index.
IDENTIFIERS: LCCN 2017012390 | ISBN 9781107130524 (hardback)
SUBJECTS: LCSH: Architecture, Renaissance – Italy – Rome. | Humanism in architecture – Italy – Rome. | Architectural practice – Italy – Rome – History – 16th century. | Group work in architecture – Italy – Rome – History – 16th century. | Sperulo, Francesco, active 15th–16th century – Influence. | Raphael, 1483–1520 – Criticism and interpretation. | Raphael, 1483–1520 – Friends and associates. | Villa Madama (Rome, Italy) | Rome (Italy) – Buildings, structures, etc. | BISAC: HISTORY / Renaissance.
CLASSIFICATION: LCC NA1120 .E45 2017 | DDC 720.945/09031–dc23
LC record available at https://lccn.loc.gov/2017012390

ISBN 978-1-107-13052-4 Hardback

Illustrations in this book were funded by a Society of Architectural Historians/Mellon Author Award. Production was supported by a subvention from the Lucy Maynard Salmon Research Fund at Vassar College.

To the memory of Bernadette and Chloe
and for Katja, my mother, and Eric

CONTENTS

Color plates are to be found between pp. 6 and 7

PLATES

FIGURES

PREFACE AND ACKNOWLEDGMENTS

This book is not the one I set out to write. After finishing a dissertation about Villa Madama, Raphael's paradigmatic Roman villa for the Medici popes, and in the course of writing a monograph, my analysis of proleptic poetry about the villa began expanding and leading me in new directions. The resulting book is only partly about the villa itself; it became a prismatic topic reflecting several aspects of Italian Renaissance culture, especially the nature of invention in architectural design, and shifting tensions in the relation of word and image. The resulting book focuses on the collaboration of architects and humanists in the design of architecture. The coming-into-being of Villa Madama is the case study that anchors the book, although its implications are broader. Thus, this multidisciplinary work operates at the intersection of several topics: Raphael as architect, villa culture, literary studies, and the history of humanism.

Although even students of the Renaissance might question the need for another book on Raphael, in fact studies of Raphael as architect have been quiet in the last thirty years, following the intense focus on the subject during the series of international exhibitions, conferences, and publications held in 1983–4 celebrating the quincentenary of Raphael's birth. The centerpiece of these projects was the *Raffaello architetto* exhibition in Rome's Palazzo dei Conservatori, the eponymous catalogue of which remains the only modern monograph on Raphael's architecture.[1] Caroline Elam assessed the state of Raphael scholarship following those events, noting:

> The pioneering days of Raphael studies are perhaps nearly over ... What came out of the conference was that while the biographical facts and the limits of the oeuvre are more securely established, the need for more subtle modes of historical interpretation remains. While attempts to distinguish hands in the later works may be sterile, one looks forward to a more convincing model for characterizing the collaboration between Raphael and his assistants. Equally, perhaps our notions of the evolution of a project can be refined to include concurrent or overlapping ideas, and to entertain a creative interchange between artist and patron.[2]

Her call has certainly been answered in subsequent studies, as detailed herein. This book extends the roster of collaborators to include humanists, and their role in the design of architecture. It thereby opens a new view of architectural invention, in word and image, in Renaissance Rome.

The subject of this book began as a joint project in 2000–1 with James Hankins for an article that was to publish for the first time Francesco Sperulo's long poem describing Villa Madama: *Villa Iulia Medica versibus fabricata*, BAV, Vat. Lat. 5812, with Hankins' translation and my analysis. The project was delayed, and in the meantime the poem was published in the late John Shearman's corpus of Raphael documents in 2003 (although the transcription contained errors, and Shearman roundly dismissed the poem's importance).[3] Subsequently, my analysis from that unpublished article and my transcription of the poem appeared in my dissertation of 2007.[4] My thanks to James Hankins for his early translation of part of the poem, his clarification of points of Sperulo's language, and his comments on the early text that was the core of this book. I am also deeply indebted to Caroline Elam for guidance on this project in its early stages, especially for analyzing problematic parts of the poem with me, for discussing Sperulo's use of architectural and spatial vocabulary, and for comments on my analysis.

For this study of Renaissance collaborative practice, I have enjoyed a fruitful collaboration with Nicoletta Marcelli, who edited my transcription of Sperulo's villa poem and provided the critical edition and translation that appear in Appendix 1 of this book. Her deep knowledge of neo-Latin and vernacular literature, especially in Medicean circles, and her shared enthusiasm for iterative working sessions over issues of language and content have greatly enriched my understanding of the poem. She also contributed many good ideas to the gloss, read parts of the book manuscript, and offered important suggestions about key points and bibliography; I am deeply grateful for her contributions.

After centuries of obscurity, Sperulo is enjoying his moment. Just as this book was going into production, a complete edition of his oeuvre appeared by Paul Gwynne;[5] thus, while I cite Gwynne's conclusions at a handful of important places, I have been unable to incorporate his findings substantively into my text and notes. He and I worked independently without knowledge of each other's projects, and reached some similar basic conclusions about the function of Sperulo's villa poem, although I interpret the poet as offering more fundamental contributions to the villa's design development, involving functional and spatial constructs as well as proposed decorations. Fundamentally, we use some of the same evidence for different purposes. Gwynne's monograph presents Sperulo's villa poem in the context of his complete oeuvre, and it significantly expands our knowledge of his colorful *vita*, revealing the diverse roles this humanist played in different contexts. This book instead considers Sperulo's Medici villa poem within the context of villa literature, and delves deeply into the planning of the Medici villa. Additionally, my study focuses on the important implications of this poem for our understanding of Renaissance architectural invention, and the relation of word and image in Renaissance architectural design.

Various aspects of the material in this book were presented in talks at the conferences of the College Art Association, 2001; the Renaissance Society of America, 2006, 2008, 2009, and 2012; the Society for Textual Scholarship International Conference, 2007; the Wesleyan Renaissance Colloquium, 2008; the *WritingPlace* conference at the TU Delft, 2013; the Clark Art Institute, 2014; the conference "Cultural Encounters and Shared Spaces in the Renaissance City, 1300–1700" at the University of Manitoba, Winnipeg, organized by Roisin Cossar, Christina Neilson, and Filippo de Vivo, 2014; and the symposium "Raphael's Collaborations" at the Worcester Art Museum, organized by Linda Wolk-Simon and Jon Seydl, 2015. I am indebted to the organizers and participants in all these events for fruitful discussions. Especially important for this book was the 2006 RSA conference for which Nadja Aksamija and I co-organized a day of talks on the subject of villa literature, assembling a group of speakers and respondents to discuss the state of the field and new directions. My talk for this event, "The villa constructed in verse: panegyrics of Raphael's Villa Madama in Rome," proposed Sperulo's poem as a brilliant example of a little-known genre I identified as hortatory *ekphrasis*. I am grateful to everyone who participated in this event, and especially to Nadja Aksamija, whose insights and deep knowledge of villas and their literature have contributed significantly to this book at several stages.

The section in Chapter 5 on the "Topography of Christian Triumph" presents a short summary of my article, "Raphael and the Roads to Rome: Designing for Diplomatic Encounters at Villa Madama," in *I Tatti Studies in the Renaissance* 19.1 (2016); this material is © 2016 by The Villa I Tatti – The Harvard University Center for Italian Renaissance Studies, and appears herein by permission of the Center. Some of the general conclusions of this volume appeared in Elet, "Writing the Renaissance Villa," in *WritingPlace: Investigations in Architecture and Literature*, ed. Klaske Havik, Susana Oliveira, and Mark Proosten (Rotterdam, 2016).

This topic has taken me into unexpected places, and I am pleased to acknowledge the additional benefactors, guides, companions, and sanctuaries that have contributed so much to the result. I am grateful for a Society of Architectural Historians/Mellon Author's Award that supported the acquisition of images and image rights for this book, as well as a subvention from the Lucy Maynard Salmon Research Fund at Vassar College that enabled the publication in its current form. A leave from Vassar in the fall of 2011 provided an important period of writing. During that time, I was a visiting professor at the University of Bologna at the invitation of Prof. Francesco Ceccarelli, to whom I am indebted for many rewarding discussions of villas and villa culture. A Getty postdoctoral research fellowship in 2008–9 provided a crucial year of writing the monograph on the villa, when the ideas for this book first crystallized.

This book would not have been possible without the generous permission of Italy's Ministero degli Affari Esteri to visit, study, and photograph the villa on many occasions, and I wish to thank the Ufficio Cerimoniale, and especially Fabrizio Finazzi, Cav. Fernando Regaldo, and Dott.ssa Doriana Torselli for accommodating my visits. I am also indebted to Prof. Dr. Christoph L. Frommel and to the Bibliotheca Hertziana for an initial introduction to the Ministry. My study of sculptures formerly in the villa was enabled by the kind assistance of Dott.ssa Mariarosaria Borriello and Dott.ssa Rubino at the Museo Archeologico Nazionale di Napoli. For my study of illuminated manuscripts, I am fortunate to have had the expert help of Prof. Jonathan J. G. Alexander, who kindly looked at images of Sperulo's villa poem, and Dott. Paolo Vian in Vatican Library, who examined the manuscript itself with me; I thank them both very much.

Many libraries have provided a research base for this project. In Rome, the libraries of the Bibliotheca Hertziana, the American Academy in Rome, and the École française de Rome were a second home, and the holdings of the Biblioteca Apostolica Vaticana and the Biblioteca Nazionale Centrale di Roma were crucial to this study. I also benefited from the rich resources and expert help in the photo archives of the Bibliotheca Hertziana and the Musei Vaticani; and I am grateful for the many visual reproductions from the Musei Vaticani and the Biblioteca Apostolica Vaticana. In New York, my work has profited immeasurably from the holdings of the Avery Architectural Library and Butler Library at Columbia; the Bobst and Chan libraries at NYU; the Watson Library at the Metropolitan Museum; the Frick Art Reference Library; and the New York Public Library, where I was grateful to David Smith and Jay Barksdale for the privilege of working in the Wertheim study. At Vassar College, I am indebted to our polymathic art librarian Thomas Hill for a wide range of support, and to the interlibrary loan staff – Martha Conners, Lydia Smith, and Jessica Cartelli – without whose assistance the book would be much impoverished.

For this book that addresses the tensions between the ongoing processing of ideas and finished project, and between individual and collective efforts, I am particularly glad to record my gratitude to those who contributed so much to my thinking, especially those who generously read the manuscript. My warmest thanks to Sheryl Reiss, whose close reading and encyclopedic knowledge of all things related to Giulio de' Medici saved me from many errors and bibliographic omissions and enriched the manuscript in countless ways; I am further grateful for our working relationship and friendship forged over shared research interests and many conferences, trips to Rome, and to Villa Madama itself. I am very fortunate to have as a close colleague at Vassar Nicholas Adams, who brought to bear his wide-ranging architectural knowledge and expertise on Sangallo as well as his formidable editorial skills, greatly enhancing this

book in content and expression, and leaving me with food for thought that will resonate far beyond this project. Rachel Kousser has been a long-term reader, sounding board, and source of invaluable knowledge about classical sculpture and literary sources, who has contributed immeasurably to the process as well as the final result of this volume. I wish I could thank by name the two anonymous reviewers for Cambridge University Press, whose suggestions strengthened the book's organization and focus. My thanks to all these readers for the many ways they enhanced the content of this book and its bibliography, and sharpened its messages; and my apologies for any suggestions that did not make their way into final form due to my limits of space, time, or imagination. Of course, the conclusions and any errors in this book are my own.

I am also indebted to several other colleagues who read portions of this material at various stages: James Ackerman, Sarah Brooks, Curtis Dozier, Anne Leader, Julie Park, Lisa Rafanelli, Jean Sorabella, and Andrew Tallon. My editors at Cambridge, Beatrice Rehl and Asya Graf, both played vital roles in realizing this book, for which I give them warmest thanks. And I am very grateful to Adam Hooper, who adeptly guided the book through production.

For fruitful conversations about many aspects of this material, it is a great pleasure to thank Carmen Bambach, Mirka Beneš, Ann Blair, Amy Bloch, Anthony Corbeill, Joseph Dyer, Tracy Ehrlich, Patricia Emison, Juliet Fleming, Meredith Fluke, the late Oleg Grabar, Katja Grillner, Nicole Hegener, Tom Henry, Christopher Heuer, Berthold Hub, the late Julian Kliemann, Ann Kuttner, Amanda Lillie, Derek Moore, Arnold Nesselrath, Charlotte Nichols, Jens Niebaum, Laurie Nussdorfer, Pierluigi Panza, Linda Pellecchia, Alberto Pérez-Gómez, Maria Teresa Sambin de Norcen, Regine Schallert, Georg Schelbert, Richard Schofield, Christine Smith, Femke Speelberg, Fay Davis Taylor, the late Richard Tuttle, Patricia Waddy, Robert Williams, Kim Butler Wingfield, Linda Wolk-Simon, and Bahadir Yildirim. I am fortunate to have the support of many generous colleagues at Vassar, especially Eve D'Ambra, Giovanna Borrodori, Nancy Bisaha, Andrew Bush, Peter Charlap, Jon Chenette, Lisa Collins, Susan Donahue Kuretsky, Brian Lukacher, James Mundy, Molly Nesbit, Ron Patkus, Harry Roseman, and Amanda Thornton. My special thanks to Roberta Antognini, Olga Bush, and Karen Hwang for leavening my work with their friendship as well as their expertise. Students in my seminars on Raphael and on villas have posed stimulating questions and offered helpful insights. I am grateful to several student research assistants who will see the fruits of their labor in this volume: Moorea Hall-Aquitania, Ryder O'Dell, Sara Sadeghi, and especially Virginia Duncan.

I owe a particular debt to the professors who advised my Ph.D. studies at NYU's Institute of Fine Arts, and also at Columbia: Hilary Ballon, Leonard Barkan, Joseph Connors, Marvin Trachtenberg, Katherine Welch, and above all Kathleen Weil-Garris Brandt. Katja is present throughout the book; from her

advising of my dissertation to the thought-provoking conversations we have had about this material over many years since its inception, she has contributed more to this study and to my thinking than anyone else. She has been the keenest critic, and the most supportive friend I could imagine – a powerful combination, for which I am very fortunate, and profoundly appreciative.

I am indebted to many friends and family members, human and feline, who have supported this project in untold ways. I have been especially thankful for two very dear, late friends, Bernadette and above all Chloe, who understood better than anyone the special energy of the writing zone. I am deeply grateful to my mother, Norma Miller Elet; in addition to the helpful characteristics she has modeled for me all my life – intense curiosity, zeal for all-consuming projects, attention to detail, and the close scrutiny of buildings, interiors, and landscapes – she has provided a fundamental source of encouragement throughout this endeavor. My deepest debt is to my husband Eric Spitzer, who has embraced the study of Villa Madama himself, contributing to this book in myriad ways, directly and indirectly. I am grateful to him for dedicating his analytical and technical skills to this project, and especially for his support and deep well of patience throughout it.

The dedicatees of this book are more numerous than the Graces and fewer than the Muses, to paraphrase Varro's recipe for a successful convivium. They have each graced my life and inspired my work in countless ways for which I am infinitely grateful, and for which a book is inadequate thanks.

NOTE ON TRANSLATIONS AND ABBREVIATIONS

TRANSLATIONS

All references to Francesco Sperulo, *Villa Iulia Medica versibus fabricata* (*The Villa Giulia Medicea Constructed in Verse*), BAV, Vat. Lat. 5812, are to the critical edition and translation by Nicoletta Marcelli in Appendix 1; references to the dedicatory letter preceding the poem are identified by section (§) and to the poem itself by line numbers. Citations of classical sources are from the Loeb editions unless otherwise specified. All other translations are the author's unless otherwise noted.

ABBREVIATIONS

ASF	Archivio di Stato di Firenze
ASR	Archivio di Stato di Roma
BAV	Biblioteca Apostolica Vaticana
BNCR	Biblioteca Nazionale Centrale di Roma
Crusca	*Vocabolario degli Accademici della Crusca* (Venice, 1612)
LTUR	*Lexicon topographicum urbis Romae* (Oxford)
MANN	Museo Archeological Nazionale di Napoli
OCD	*Oxford Classical Dictionary*, ed. Simon Hornblower and Antony Spawforth (Oxford, 1996)
OLD	*Oxford Latin Dictionary*, ed. P. G. W. Glare (Oxford, 2003)
Raphael/Dewez	Raphael, "Letter Describing Villa Madama": transcription, translation, and commentary, in Guy Dewez, *Villa Madama: A Memoir Relating to Raphael's Project* (London, 1993), 21–31
Ruesch	Adolf Ruesch, *Guida illustrata del Museo Nazionale di Napoli* (Naples, 1908)

INTRODUCTION: THE NATURE OF INVENTION, IN WORD AND IMAGE

What extraordinary new mansion is this, rising so swiftly? To what end is there so much labor and sweat all around? Everywhere crowds of febrile workers, iron tools in hand, fall upon the stones. Vast foundations are laid in the open ground, from which an enormous mountain-peak of roofline climbs toward the stars. The clangor from the arduous work wanders through the seven hills of marveling Rome, the winding valleys echoing with the sound.

> Francesco Sperulo, *The Villa Giulia Medicea Constructed in Verse*
> *(Villa Iulia Medica versibus fabricata)*, 1–7.[1]

In early 1519, the humanist and papal courtier Francesco Sperulo went for a walk on the Monte Mario, a wooded hill on the northwest edge of Rome with a breathtaking view of the city (Plate 1). There, he tells us, he was inspired to write a poem, which he did as soon as he returned home. The object of his visit and his verse was the construction of the magnificent new villa overlooking the Tiber that we now know as Villa Madama, then being built by Pope Leo X Medici and his cousin and vice chancellor of the church, Cardinal Giulio de' Medici. Not only a pleasurable villa *suburbana* for the Medici, this complex would also be a papal *hospitium* to welcome foreign dignitaries about to make a ceremonial entry into Rome. It was to be one of the first grand villas of the Roman Renaissance, conceived on a colossal scale unprecedented in modern Rome. The complex was also intended to rival and surpass its ancient prototypes, known from archeological remains as well as evocative literary descriptions of Roman villa life. The new villa, designed and decorated by Raphael and his associates, would present a Rome of revived ancient

splendor and power to its important visitors. For Raphael, at the height of his powers, the Medici villa commission was a rare opportunity to conceive architecture and decoration together from the ground up, and a unique chance to design an entirely new, freestanding building and its landscape. As it turned out, it was also his last testament, incomplete at the artist's death in 1520.[2] Although the utopian complex was only partially realized, one wing and some of the gardens were largely completed and lavishly ornamented, creating a novel and extraordinary decorative ensemble integrating landscape, architecture, ancient sculpture, painted and stucco decoration, gardens, and waterworks (Plates II–VIII).[3] Moreover, the villa has long attracted legions of visiting architects, artists, and writers, from Raphael's own day through Grand Tourists and twentieth-century Rome Prize winners. The responses of these pilgrims to Raphael's complex can be seen in many forms, in word and image, from Renaissance Europe to Beaux-Arts New York.

At the time of the poet Sperulo's visit, however, the villa was nothing but a muddy construction site, begun only half a year earlier, its plans still in flux. Sperulo wrote to Cardinal Giulio de' Medici saying that he was so struck by this *locus amoenus* – the pleasant place of classical legend[4] – that he, too, wanted to engage in building the villa, which he had just done with ink and the help of the Muses. The poet chronicled the state of the villa's construction and foretold its planned decorations in a long neo-Latin poem titled *Villa Iulia Medica versibus fabricata* (*The Villa Julia Medicea Constructed in Verse*), which he recorded in a pocket-sized, leather-bound illuminated manuscript that survives in the Vatican Library (Plates IX–XII). Other, more celebrated poets described the villa at this early stage, too, if not at such length, notably Antonio Tebaldeo and Marco Girolamo Vida. Discounting Sperulo's declaration of poetic inspiration, what actually prompted these humanists to compose poems about a villa that was still on the drawing board? And what did Sperulo mean by his claim to construct in verse – a common metaphorical trope – in this context of an actual construction project?[5] Examining the poets' descriptions of what they saw – or foresaw – at the Medici villa reveals the significant role of humanists in conceiving the complex, and it opens a window into the collaborative working processes by which this important villa came into being.

This book considers the making of Renaissance architecture through language and design. Or rather, the making of architecture through a design process that encompassed verbal modes, as well as visual and spatial ones: language *was* a tool of design. The coming into being of Raphael's paradigmatic Roman Renaissance villa turns out to have been a collective enterprise engaging architects, artists, patrons, agents, and also humanists, who played a surprisingly active and important role in the design, from the earliest stages. Examining their visual–verbal dialectic in its intellectual and social context yields a new understanding of their collaboration: a

sometimes congenial, sometimes adversarial endeavor to design the Medici papal *hospitium*. Their struggles throw into sharp relief the often agonistic relationship of word and image in this period. The book presents a revisionist view of the architectural design process, shining a light on the relation of architecture and language, the nature of invention, and the ways that idea could become form in Renaissance Rome.

∽

This narrative unfolds in the historically tumultuous years when the Leonine pontificate was confronting serious challenges from Martin Luther and the Ottoman Turks, as well as dealing with wars across the Italian peninsula. The Vatican was focused on proclaiming the *renovatio imperii*, and betting its strategy on the international power of Latinity, in contrast to other voices in Italy and northern Europe who saw the future in the vernacular. The papal neo-Latin communications campaign was crafted by humanists – scholars, poets, and *letterati* of Greek and Latin – many of whom held posts in the Curia and further participated in the intellectual and social circles of the Roman sodalities. Drawn from all over the Italian peninsula and beyond, this cosmopolitan cohort encompassed rising luminaries such as Pietro Bembo, Baldassare Castiglione, and Ludovico Ariosto – all friends of Raphael – as well as functionaries less well known to us today, such as Sperulo. Leo X, following his father Lorenzo the Magnificent, placed an important value on multimedia communications involving word and image, reflected especially in his extravagant patronage of humanists. These wordsmiths flocked to Rome, creating an intellectual hothouse with intense competition for jobs and favors, and fostering a climate of symbiotic alliances, bitter rivalries, and tensions for control in collaborative projects. The intersection of cultural, social, and professional agendas was manifest in working environments that variously included elements of constructive collaboration but more often cutthroat competition. These circles of erudite, sharp-tongued scholars worked and socialized in fluid groupings that also included artists and patrons. Intensive philological, archeological, and topographical studies were the focus of their activity, spurred by the physical as well as textual remains of ancient Rome. They mixed business and pleasure in outings as well as convivia held in their villa gardens, the sites of legendary feasts. These influential humanists were shaping contemporary politico-linguistic discourse; formulating ideas about creative imitation, selection, and composition; promoting the use of neo-Latin after the model of Cicero as the highest form of communication; and quarreling over the valorization of the vernacular as an emblem of nascent *Italianità*. Their ideas on these issues were propagated in writings from papal briefs to literature and treatises. In Latin and in the vernacular, words functioned as tools to proclaim a new Golden Age under the patronage of Pope Leo X Medici, and to convey papal messages about a new Christian *res publica* that transumed the peak of ancient empire.[6]

Raphael, who rocketed to prominence as the leading artist and architect in Leonine Rome, was engaged in the same enterprise.[7] He created a new system of design and a new visual language – a visual rhetoric – that would parallel humanist verbal and philological attempts to proclaim the *renovatio imperii*.[8] He deployed his brilliant formulation of this new rhetoric in the service of the papacy as chief architect of St. Peters, painter of the Vatican Stanze frescoes, Prefect of Marbles, and designer of the Vatican Logge and Villa Madama. Raphael's role in the visual–verbal enterprise to create a new Christian *res publica* of revived ancient splendor has yet to be fully appreciated – especially in his architectural projects. Although he is most widely remembered today as a painter, in part thanks to Vasari's unjustified pigeonholing,[9] Raphael was equally famous in his own day as an architect, as recorded on his tomb in the Roman Pantheon in a Latin epitaph composed by his friend and colleague, the humanist Pietro Bembo. He was also highly admired for his abilities as a designer in many media, from architecture and landscape to tapestries and prints. The modern separation of art- and architectural-historical studies, an unfortunate turn for the early modern period in general,[10] especially limits and distorts our understanding of a polymath such as Raphael, and hinders our understanding of his multimedia, multidisciplinary projects.[11] Of course, painter-architects were not exceptional in Renaissance Italy; the practice was well known from the time of Giotto, and was familiar in early sixteenth-century Rome in the persons of Donato Bramante and Baldassare Peruzzi.[12] Yet few designed for as many different media as Raphael, or created such synthetic multimedia ensembles. He was also unusually engaged in projects involving extra-artistic knowledge: active as an archeologist, a topographer of ancient Rome, and supervisor of antiquities for Leo X, as well as collaborating on scenographic, philological, and literary projects.

In addition to his own inventive powers, an important aspect of Raphael's success lay in his aptitude for collaboration, which is now widely recognized, although little evidence has surfaced to explain how group efforts actually worked.[13] He is legendary for his remarkable ability to assemble and direct a large and dynamic workshop encompassing talented specialists in diverse media, who were deployed on a staggering array of simultaneous grand projects. Somehow, he ensured brilliant conceptions, productive collaboration, and (almost always) high-quality execution. His was a model that later artists strove to emulate, but few ever equaled. Little is understood, however, about how, exactly, Raphael accomplished these feats. Certainly the post-Romantic valorization of individual artistic genius has been overtaken in recent years by notions of the "nontriumphant Renaissance," and a broader view of the talents and skills that enable artistic success in any period.[14] This has been accompanied by an interest in workshop practice, although here again the evidence for Raphael's working methods is frustratingly thin.[15] Additionally, deep-seated ideas about individual creativity

and agency have fostered long-standing practices of studying attribution at the expense of collaboration, which is just now beginning to change.[16]

What did it mean to collaborate? The practice certainly entailed working with fellow artists, architects, masons, and builders in the workshop and beyond. It also involved working with patrons and their representatives, many of whom were deeply engaged and contributed significantly to their projects.[17] Some patrons claimed the mantle of architectural *auctor* for themselves, rather than the architect, such as Raffaelle Riario (1460–1521) or Giovanni Pontano (1426–1503), who was a poet as well as a building patron.[18] Most members of the Medici family were thoroughly steeped in methods of close collaboration with artists, architects, and humanists, and notable among them was Cardinal Giulio de' Medici, who directed the planning of Villa Madama. He had been raised alongside Michelangelo and the Sangallo family of architects, and became a remarkably shrewd and "hands-on patron" of art and architecture.[19] Many patrons delegated substantial authority to architectural agents, from the "courtier architect" in quattrocento Ferrara, to humanist-builders in early cinquecento Rome such as Mario Maffei, who, significantly for this story, actively worked on his own villas while managing the building of Villa Madama.[20]

Humanist collaborators also contributed to the development of visual projects in many ways. That they served as advisors and propagandists is well known, but we have scant knowledge of exactly how they worked with artists, and especially with architects. How did their ideas make their way into form? The role of the humanist advisor has been studied primarily in respect to the representational media of painting and sculpture, focusing on so-called iconographic programs or inventions; but their role in architectural projects is much less understood.[21] Of course, distinguishing individual ideas and agency in the creative process is a problematic endeavor for any medium in the early modern period. We lack evidence for most aspects of Raphael's design process other than the spotty record of surviving drawings and documents, discussed more specifically below. Thus, we know little about how conceptual ideas were proposed, developed, and translated into visual and spatial forms, or how ideas were negotiated or approved by this cohort of artists, humanists, and patrons in Renaissance Rome. This issue is the root problem that motivates my study.

This book examines Raphael's multimedia visual rhetoric and the collaborative processes by which it was generated in designing Villa Madama. Like a pastoral Vatican, this complex was to embody papal and Medicean messages in many media. Raphael's brief for this ambitious project necessitated the design of all elements from roads, landscape, and architecture to ornament and decoration – a task well suited to his fertile, wide-ranging inventiveness and his adroit navigation of Rome's professional culture encompassing architects, artists, humanists, and patrons. Therefore, it is fruitful to situate architectural design in broad cultural

and social contexts. My enterprise considers the agency of a group of planners, many of whom were not artists or architects. I consider the conceptualization, design, and very partial realization of the villa by this cohort, showing how they contributed ideas that could be transformed into visual and spatial forms. This study looks at the relation between conceptual ideas (ideological, literary, and archeological) and visual forms (architectural ground plans, figural decoration, sculptures, and ancient spoils). Additionally, it reconsiders the relation between architects and wordsmiths.

Examining several types of evidence in tandem allows new insights into the planning of the Medici villa by these professionals: architectural ground plans, poetry and prose descriptions of the villa, and ancient sculpture and spoils chosen to be installed in the fabric of the building. In particular, this book makes a serious study of poetry about the villa, evidence that has received scant attention on its own, and has been virtually unstudied in broader literary context or in relation to architectural design. The poets Tebaldeo, Vida, and Sperulo all made their way to the Medici construction site and praised the villa, although Sperulo's poem is unusually revealing. It has been known since the 1907 edition of Ludwig von Pastor's *Geschichte der Päpste*, but was published only recently in Shearman's anthology of documents related to Raphael, and the poem has either been mined for factual nuggets or dismissed as a pedestrian work by a sycophantic courtier.[22] But Sperulo's work cannot be disdained as empty flattery, as this analysis reveals, and as Paul Gwynne also concluded in his new monograph.[23] As this book demonstrates, Sperulo's poem turns out to be one of the most extensive of all Renaissance villa descriptions, and it is strikingly more detailed and specific to the actual building than is typical of this tradition. Moreover, it lies outside traditional forms of architectural *ekphrasis* or literary or rhetorical genres.

This study proposes that Sperulo's poem cloaked in the high diction of Virgilian hexameters was used for the nuts-and-bolts purpose of designing the building. Sperulo's claim to build the villa in verse was not just metaphor, but also a coded proposal, readily accessible to its Renaissance audiences. I trace how Sperulo distilled Medici ideology, literary metaphor, and information about available ancient spoils into poetic proposals for the villa, exhorting Raphael and their Medici patrons to follow the poet's ideas. Thus, taking Sperulo seriously opens fascinating new forms of evidence about the villa and its genesis. Considering the purpose of Sperulo's poem, as well as his claim to construct Raphael's villa in verse, sheds new light on the role of humanists, and the dialectic of verbal ideas and visual forms.

Raphael also undertook a written description of the Medici villa project in a well-known letter, which is part pastiche of the famous villa descriptions of Pliny, part declaration of the architect as author, and part walk-through of the plans. Although the letter has been the subject of extensive analysis,[24]

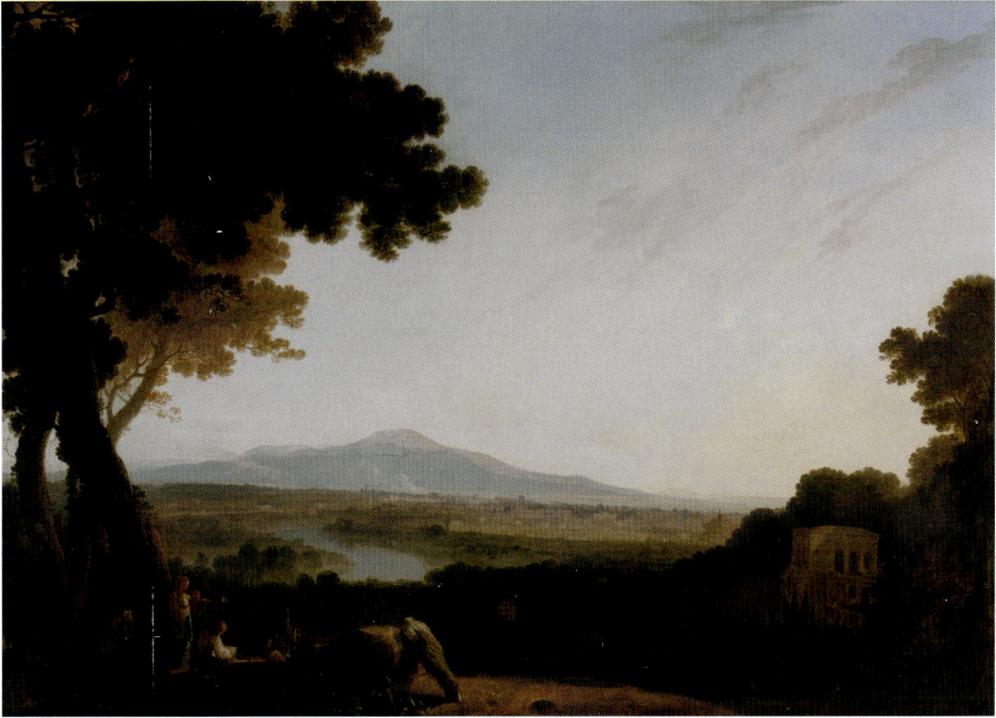

I Richard Wilson, *Rome from the Villa Madama*, detail, 1753. Yale Center for British Art.

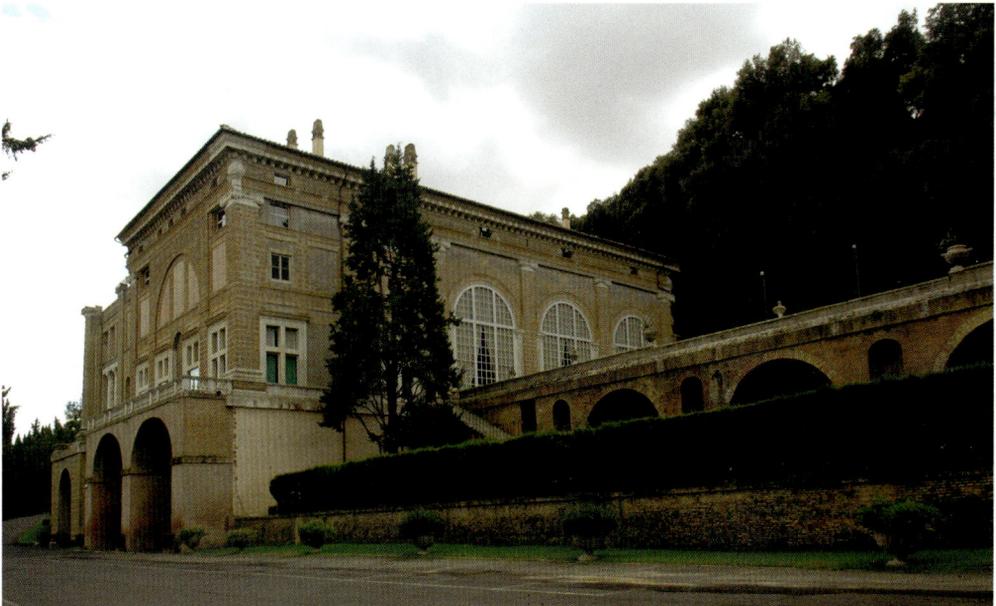

II Villa Madama, view of the complex looking southwest.

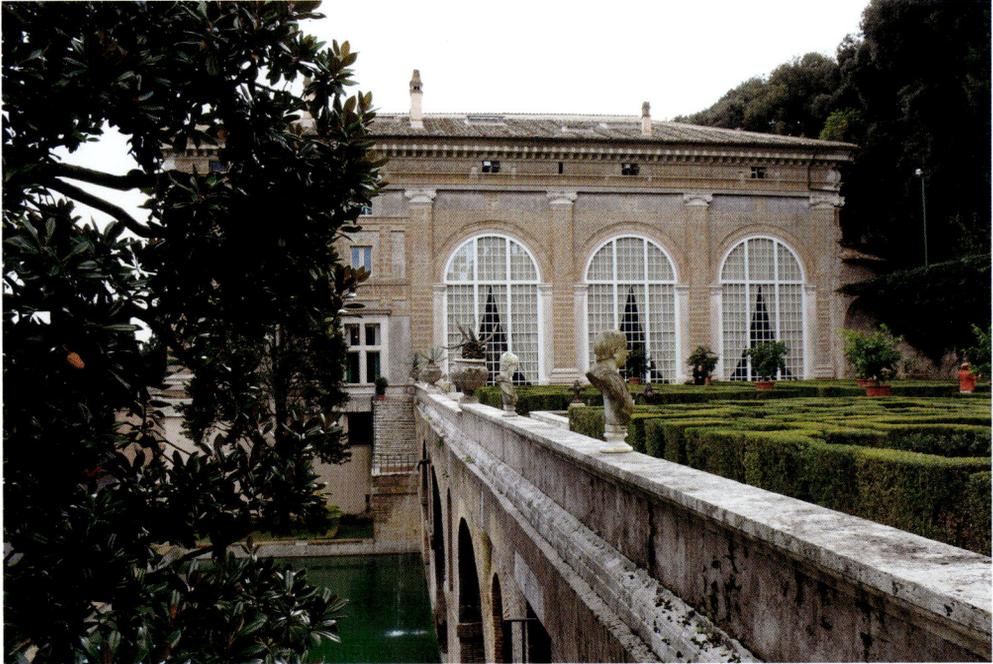

III Villa Madama, view of the rear façade of the garden loggia, adjoining the inner garden overlooking the fishpond.

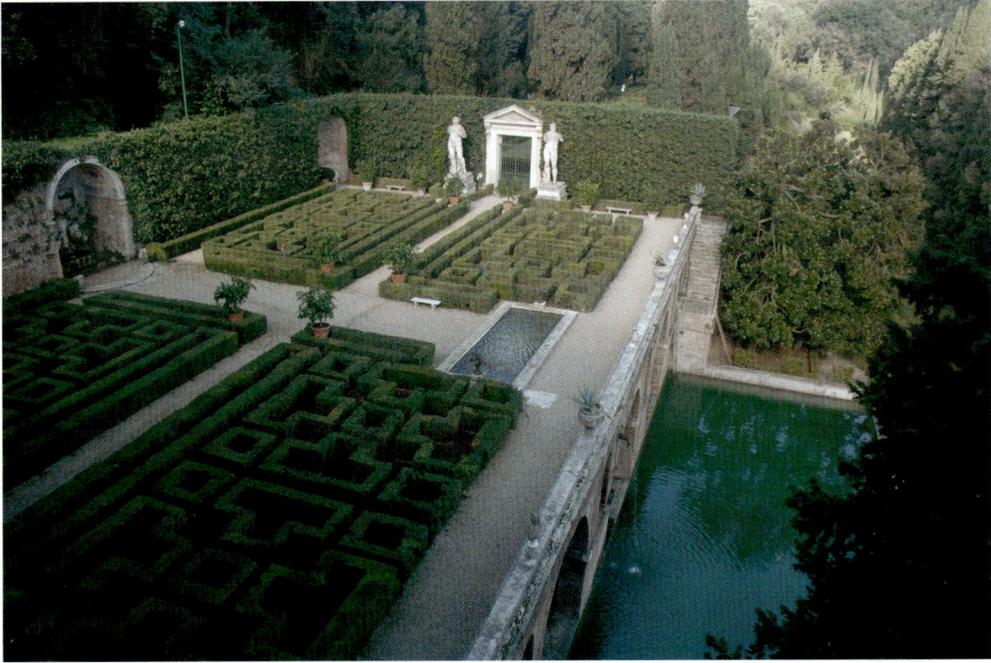

IV Villa Madama, view of the inner garden and fishpond from the building.

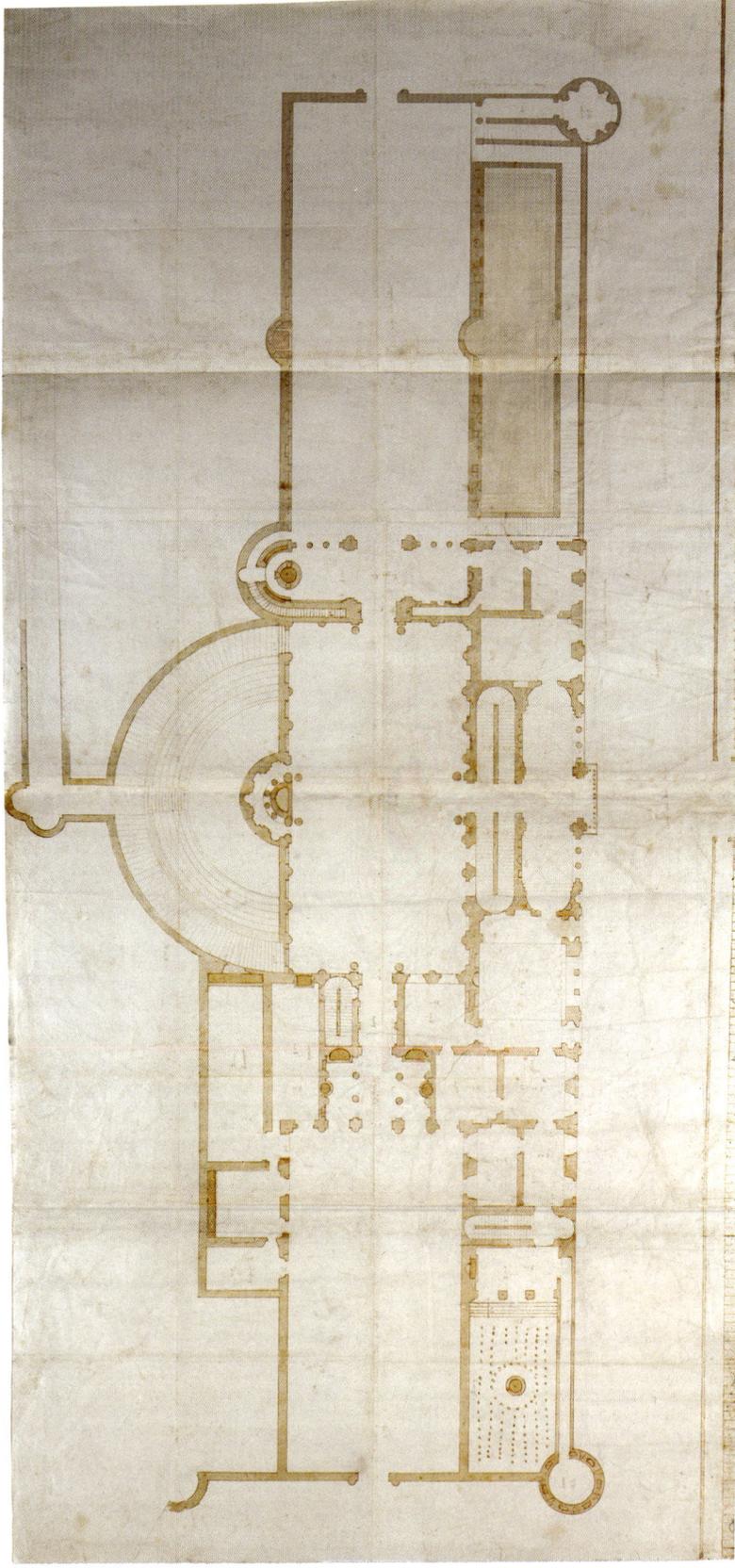

V Giovan Francesco da Sangallo, Plan for Villa Madama. Florence, Uffizi, Gabinetto Disegni e Stampe, 273A.

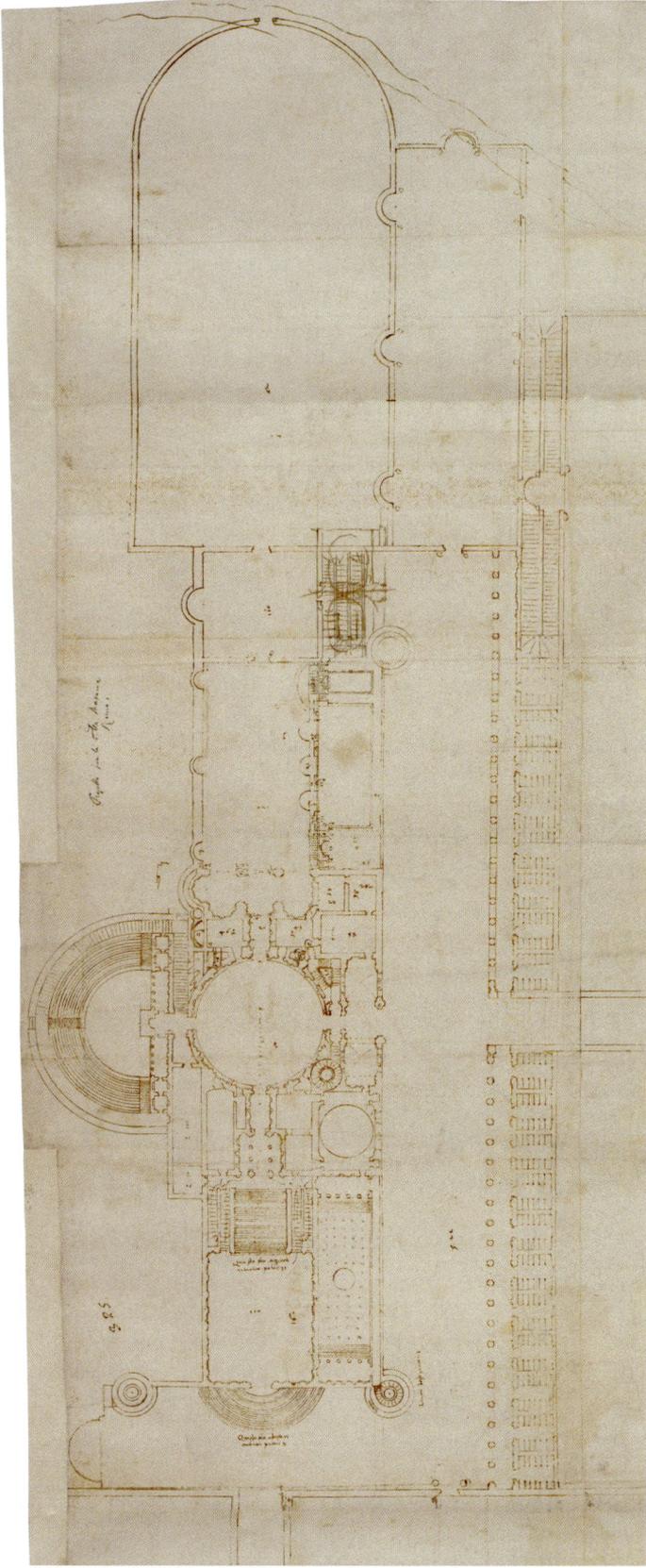

VI Antonio da Sangallo the Younger, plan for Villa Madama. Florence, Uffizi, Gabinetto Disegni e Stampe, 314A.

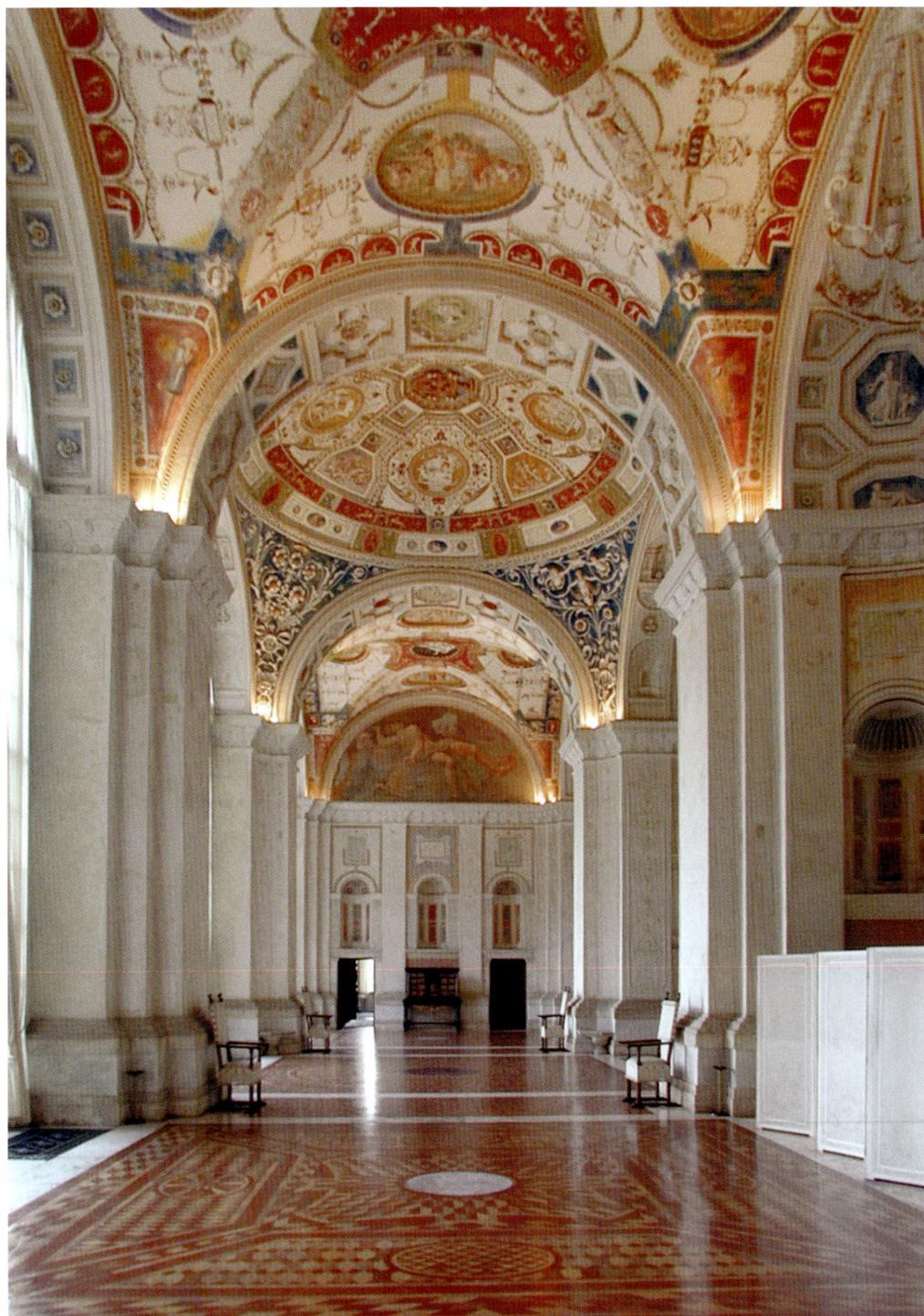

VII Villa Madama, garden loggia, looking northeast.

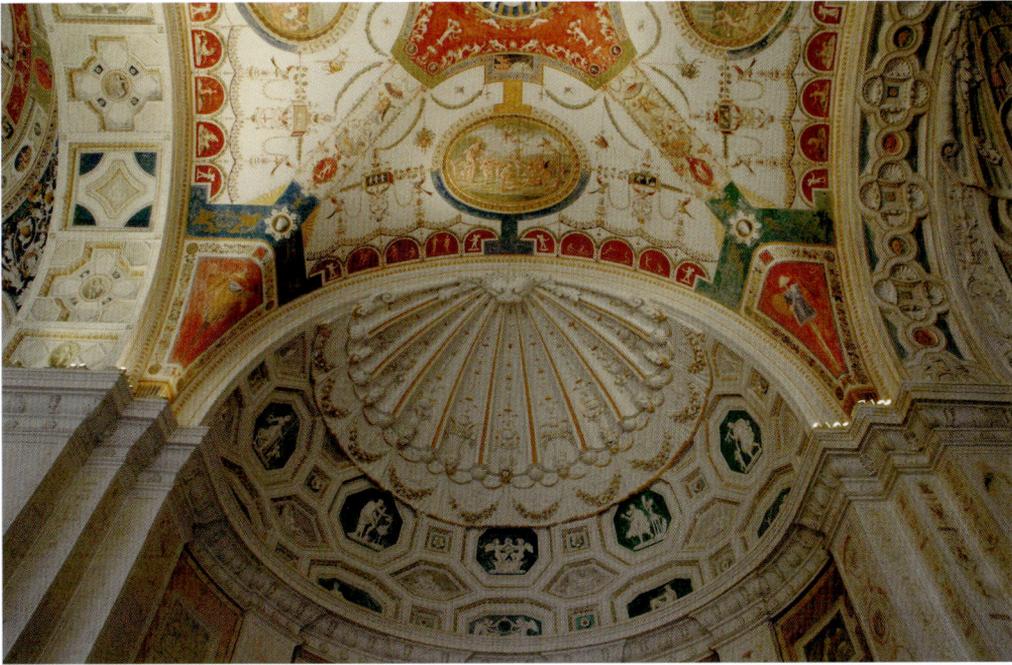

VIII Villa Madama, garden loggia, exedra with painted and stucco decorations depicting Venus.

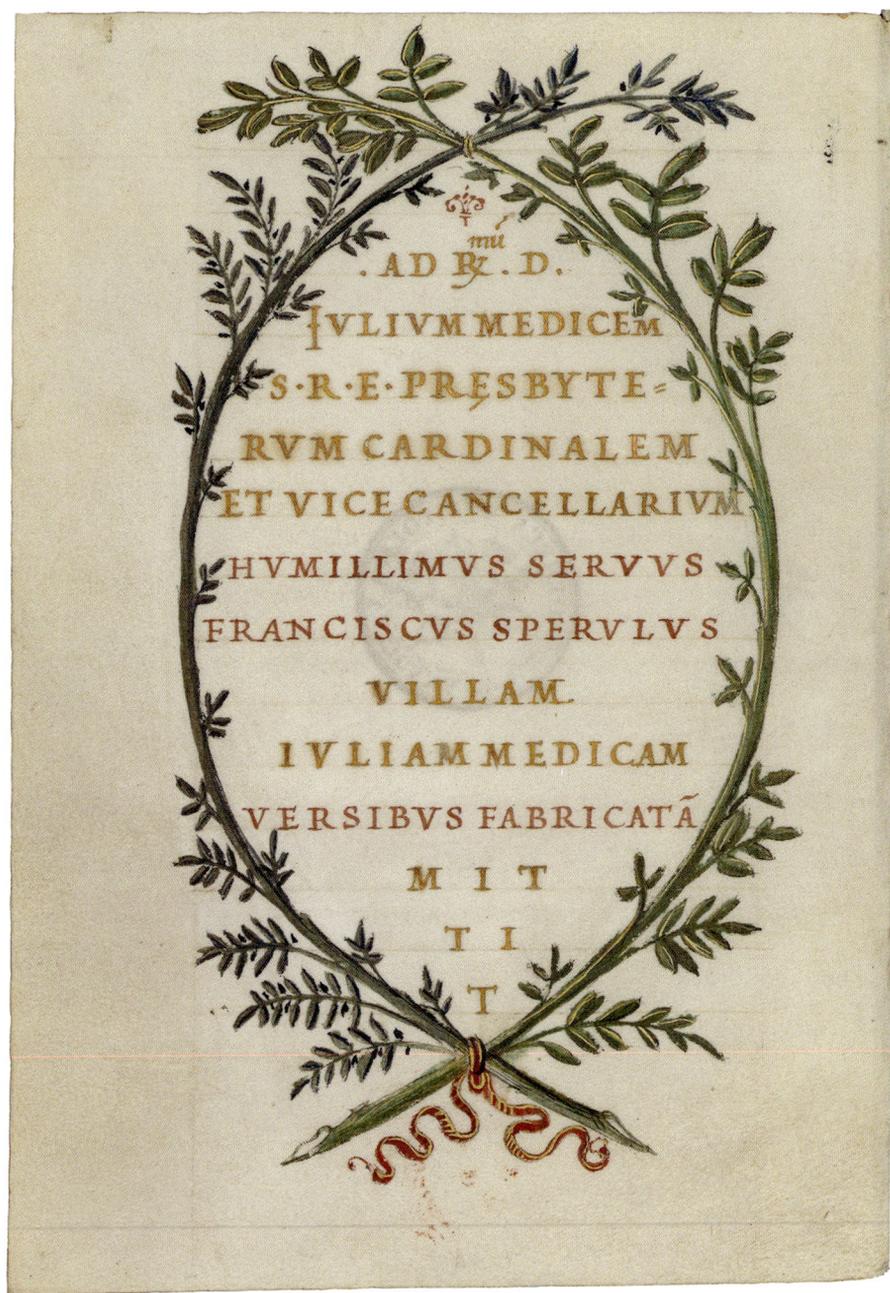

. AD R̃ . D .

IVLIVM MEDICEM

S·R·E· PRESBYTE-

RVM CARDINALEM

ET VICE CANCELLARIVM

HVMILLIMVS SERVVS

FRANCISCVS SPERVLVS

VILLAM.

IVLIAM MEDICAM

VERSIBVS FABRICATĀ

M I T

T I

T

IX Francesco Sperulo, *Villa Iulia Medica versibus fabricata*, 1519. BAV, Vat. Lat. 5812, fol. 1v; actual size.

Ndiustertius, obseruantia mea,
quae erga Te cum multis certat,
superiorem esse adhuc illi uideo nemi
nem, fecit, ut tempus deambulationi
designatum, conuerterem ad uisendam
uillam, quae ad primum fere lapidem
mira tibi impensa extruitur: Vix primo
lustrata obtuitu, ita me situs et amoe
nitas loci, magnitudo ac uarietas aediu
antiquitatis non aemula modo, sed lon
ge uictrix, affecit, ut alio mox om
ni, ex officina mea reiecto, hoc unum
opus ipse quoq fabricandum suscepe
rim, sperans, si feliciter cederet, quod
quidem sume est aleae, dignosci demu

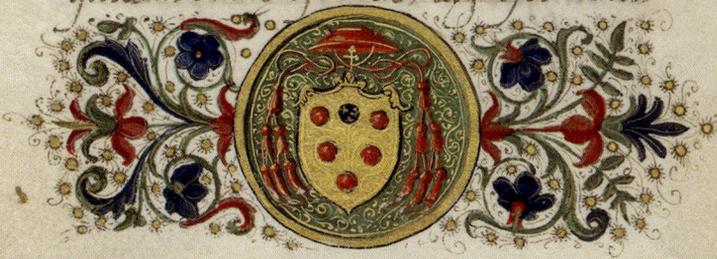

X Francesco Sperulo, *Villa Iulia Medica versibus fabricata*, 1519. BAV, Vat. Lat. 5812, fol. 2r; actual size.

praeconijs tuis . dum pro uiribus cer-
tasse' iudicari possim : vale' (spes et
pre'sidiu' omniu' bono⸝ : Roma' Cale⸝
Martijs : a' seruatoris nostri Nata
libus anno M . D . XViiij : ~

Q Væ' noua tam celeri surgut' præ'
toria duc'tu ?
Cui tantus circum' sudat labor ? undiq̅ ferro
Crebræ' instant in saxa manus : descendit aperto
Vasta solo moles : unde' ingens scandit in astra
Tecto⸝ uertex : operum certamine' multo
Per septena nagus mirantis culmina Roma'
It fragor : et curris resonat de' uallibus echo' :
Ipse' pater Thybris thusco festinus in amne'

XI Francesco Sperulo, *Villa Iulia Medica versibus fabricata*, 1519. BAV, Vat. Lat. 5812, fol. 3r;
actual size.

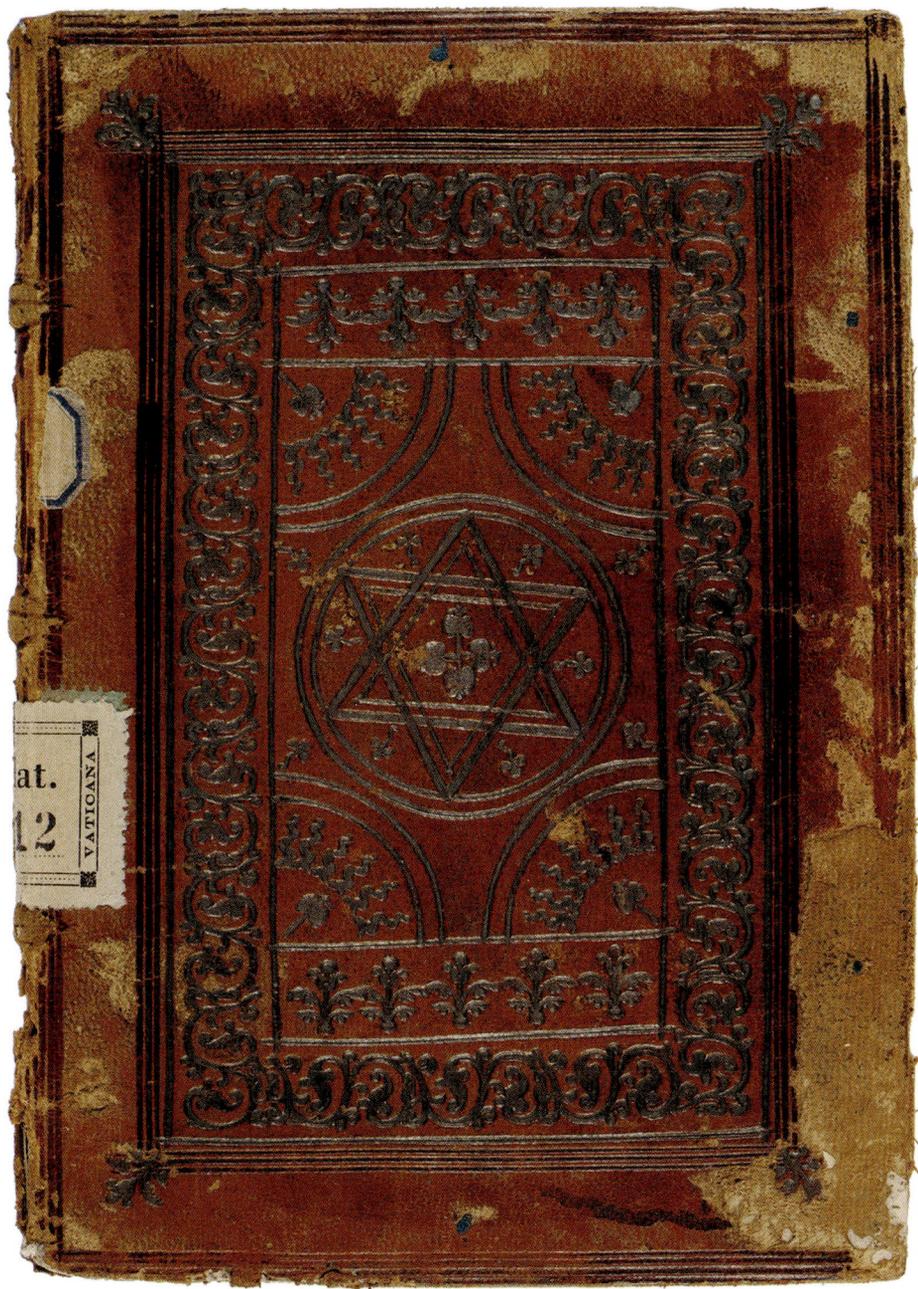

XII Francesco Sperulo, *Villa Iulia Medica versibus fabricata*, 1519. BAV, Vat. Lat. 5812, binding; actual size.

LVCIANI · DIALOGI MARITIMI INTERPRETE LIVIO GVIDOLOCTO VRBINATE AD AMPLISSIMVM ET ILLVSTRISS IVLIVM MEDICEM · S · R · E · CAR · ROMANDIOLAE LEGATVM ET VICECANCELLARIVM · B · M ·

DORIS ET GALATEA INTERLOC

DORIS

VNC SI culum pastorē scilicet formosū Galatea rumor est tuum esse amatorem, teꝗ usque ad insaniam amare. GALA Ne'me dictis lacessas Dori, ille enim (qualiscunꝗ sit) Neptuni est filius. o DOR Quid igitur? quid? An ne pu-

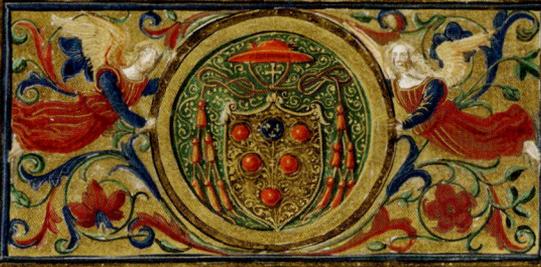

XIII Lucian, *Dialoghi maritimi*, 1519. BAV, Vat. Lat. 5802, fol. 17r.

quidem pulcherrimos Deos excipe. Vos
uero Tritones Latonam in eam trans-
fretate, et tranquilla sint omnia. Por-
ro draconem qui nunc ipsam instigat,
et perterrefacit, filij simulatq̃ in lucẽ
prodierint, punient matremq̃ ulciscent.
Cæterum heus tu nunciato q̃ primũ Io-
ui omniã esse parata. Stat eniz Delos
ueniat iam Latona et pariat.

+ D I A L + X I +

XANTHVS ET AMPHITRITE INTERL.

XANTHVS

V S C I P E
me' quæso Amphi-
trite qui grauia su-

Homerus ἐν τα̃ π.
τῦσ ιλδ̃.

XIV Lucian, *Dialoghi maritimi*, 1519. BAV, Vat. Lat. 5802, fol. 36r.

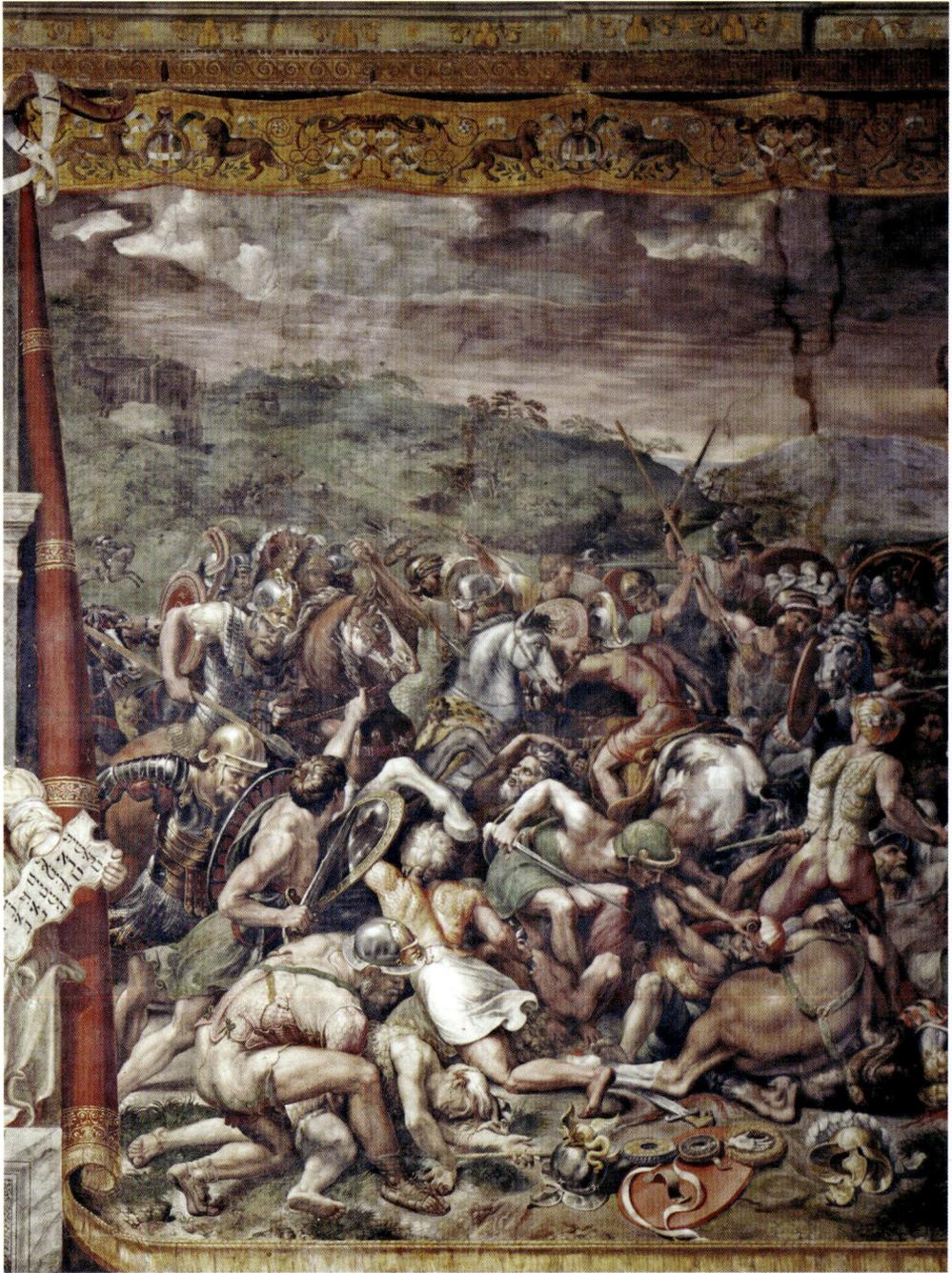

XV Raphael and associates, *Battle of the Milvian Bridge*, detail, Sala di Costantino, Vatican Palace. Villa Madama is seen at top left, on the hillside of Monte Mario overlooking the bridge.

XVI Raphael and associates, *Battle of the Milvian Bridge*, detail of the Villa Madama under construction on the hillside, Sala di Costantino, Vatican Palace.

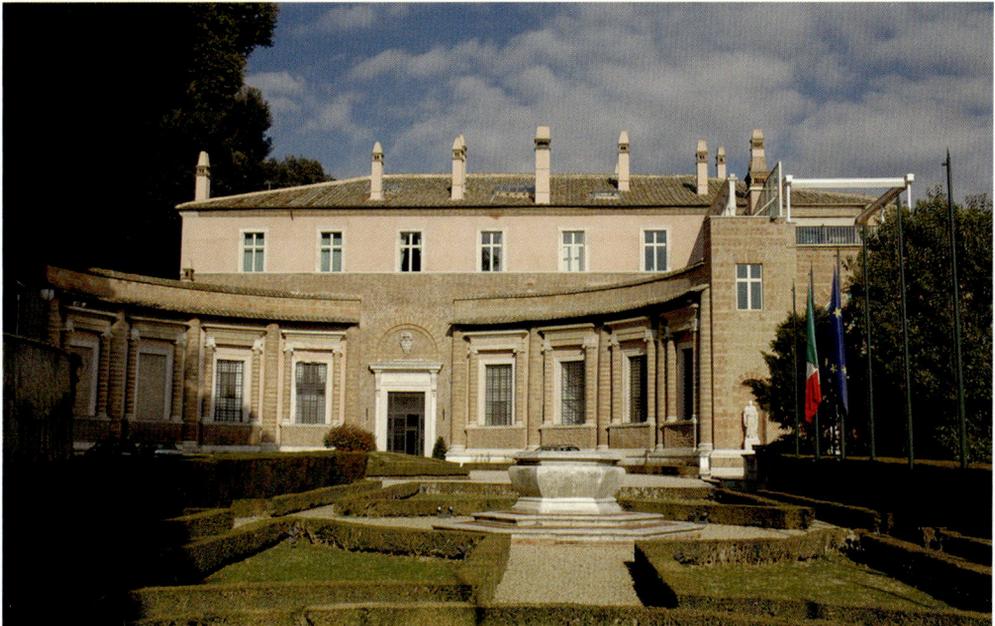

XVII Villa Madama, present day façade, which is half of the planned circular courtyard.

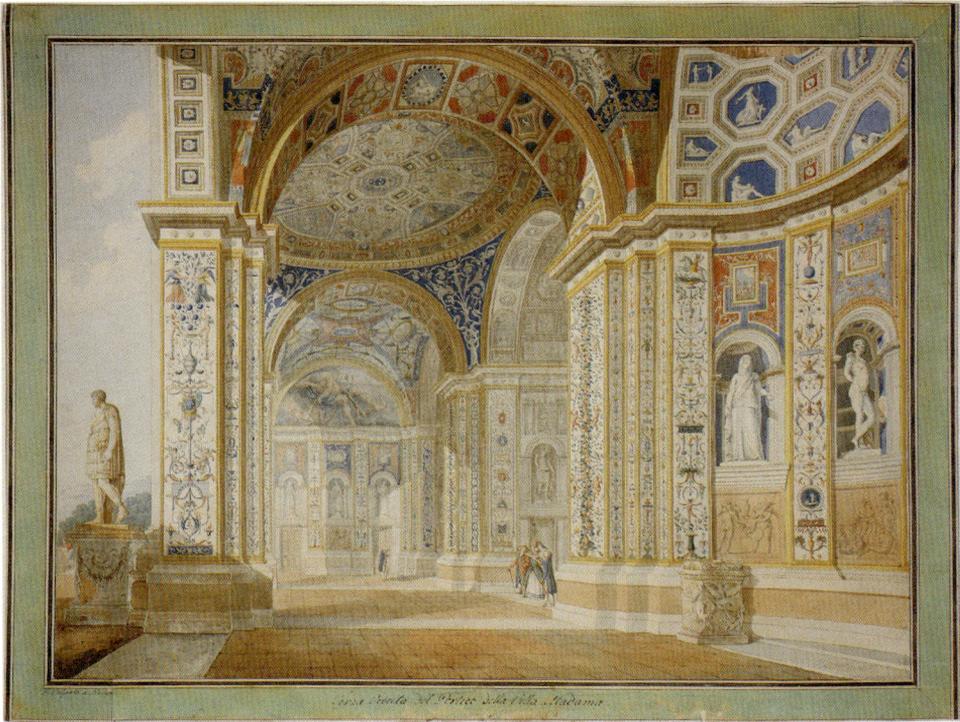

XVIII Giovanni Volpato (1738–1803), Villa Madama, garden loggia looking northeast; engraving with watercolor, Kunstsammlungen der Veste Coburg, Inv. XII.358.97.

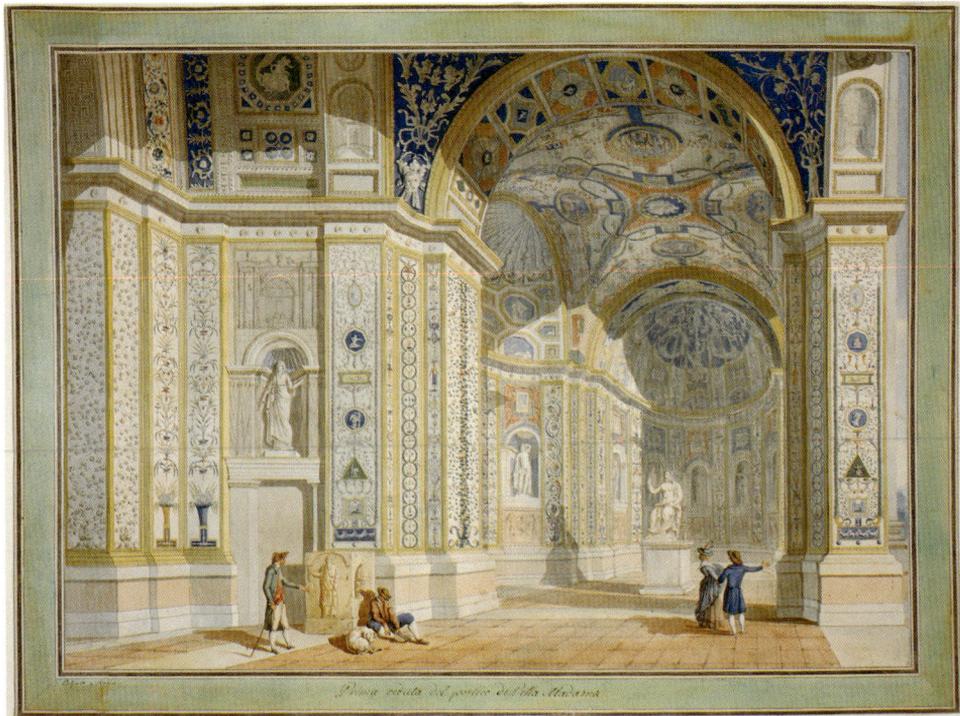

XIX Giovanni Volpato (1738–1803), Villa Madama, garden loggia looking southwest; engraving with watercolor, Kunstsammlungen der Veste Coburg, Inv. XII.358.99.

considering the architect's writing in relation to contemporary poetry, and within the context of social and professional conventions of textual communication among elite humanists and patrons, enables a new understanding of this famous document, and of architectural and literary agency.

Tracing the sculpture and antiquities once in the villa is also revealing for this story. It emerges that humanists were occupied not only with conceptual and literary issues, but also with physical aspects of design, especially the placement and meaning of ancient sculpture and spoils to be installed in the villa complex. Their poetry reveals that the disposition of significant antiquities was an important factor early in the planning process, and details the generative role of ancient sculpture and spoils for the architectural and decorative ensemble. The Renaissance appetite for antiquities is legendary, but the study of Villa Madama yields unusually specific examples of how papal patrons could appropriate ancient spoils, and employ them for rhetorical and ideological purposes. I trace how artists and humanists working together, in a milieu that emphasized intense visual and verbal archeological study, assembled ancient sculptures and repaired, re-membered, and recontextualized them, thereby reincarnating antiquity in surprisingly literal terms.

This analysis of literature, sculpture, and spoils invites and informs a new look at the ground plans and construction history of the villa. Traditional architectural methodologies provide an invaluable source of information and a springboard for this study, but leave unanswered fundamental questions about processes of ideation and authorship. Architectural historians have long studied plans and documents to trace the morphology of ideas for a project, considering the attribution of drawings to distinguish the contributions of different collaborators. Significantly, the great quantity of surviving preliminary-stage architectural drawings beginning in exactly this period, notably at St. Peter's, suggests their increasing importance.[25] Of course, the limitations of these methodologies are well known. Recent studies have acknowledged the perils of imposing a linear chronology on a fragmentary set of surviving drawings, some of which could have represented alternatives or variants in play at the same moment.[26] Also, determining the extent to which the draftsman was the ideator remains problematic for drawings more finished than "brainstorm sketches."[27] The standard practice of delegating the preparation of drawings to associates makes attribution difficult if not impossible, an issue especially relevant to the overextended Raphael. Our understanding of Raphael as architect and of the plans for the unfinished Villa Madama is indebted to studies by several generations of distinguished architectural historians, from Baron Heinrich von Geymüller to Christoph L. Frommel.[28] The surviving architectural plans for Villa Madama are by the hands of Antonio da Sangallo the Younger (1484–1546), Francesco da Sangallo (1494–1576), and Giovan Francesco da Sangallo (1482–1530), with just one by Raphael himself;[29] as

Frommel notes, the villa project exemplifies the complexity of determining individual contributions.[30] The numerous preparatory drawings by Antonio reflect that he was not simply an amanuensis for Raphael's ideas, but played an important design role himself, which included planning the building as well as addressing the difficulties of the steeply sloping villa site (which was plagued by argillaceous soil, frequent landslides, and erosion), and laying out the hydraulic systems for the villa's waterworks.[31] Thus, the major plans reflect the ideas of both Raphael and Antonio, as well as those contributed by its patrons,[32] and also by humanists, as this book will show. In a discussion of autograph plans as "snapshots of the design process" (*Momentaufnahmen aus dem Entwurfsprozeß*), Christof Thoenes has analyzed the perils of assessing authorial intent from the fragmentary corpus of surviving drawings for a large complex, many of which do not show the entire building.[33] The survival of drawings for partially built or unbuilt elements further complicates the task of interpretation. Frommel has discussed the limitations of architectural reconstruction, and Guy Dewez specifically posed similar questions with respect to Villa Madama.[34] Stefano Ray observed that the spotty survival of drawings and documents for all Raphael's architectural projects is one factor responsible for obscuring his reputation as an architect.[35] Indeed, the surviving record for the planning of Villa Madama is sparse: about a dozen architectural plans and the letter by Raphael, plus two letters from Cardinal Giulio de' Medici to the project manager, Mario Maffei, and a meager selection of payment documents.[36] Of these, few shed any light directly on the ideation of concepts and forms, or the roles of individual artists and advisors in the process. Considering poetry and sculpture together with architectural plans opens a new view of the design process, revealing how ideas could be generated, developed, disseminated, and actualized.

The intersection of humanism and architecture takes on special relevance for the villa, the building type perhaps most closely associated with literary culture since antiquity. Amanda Lillie has examined Renaissance notions of the "humanist villa," calling for further study of the relation between literary framework and Renaissance villa architecture.[37] This idea has reverberated among several historians of architecture. Nadja Aksamija has drawn attention to "textual villas," or poems as literary simulacra of actual villas in Counter-Reformation Bologna;[38] and other scholars have mined rich literary veins in recent studies of quattrocento villas in Ferrara and Naples.[39] The present book explores the dialectic between villa architecture and literature in Raphael's circle, revealing how the written word and architectural forms could inform each other; the reciprocal agency of architecture and text emerges in unexpected ways.

This study of poetry, spoils, and ground plans requires a cross-disciplinary approach: one that looks across the media (i.e. architecture, sculpture, and painting) and also beyond the history of art and architecture. My study complements conventional morphological analyses of architectural ground plans

by making a detailed consideration of literary and archeological evidence; and it builds on traditional literary analysis by taking into account the function and agency of poetry. My curiosity about why Sperulo devoted over 400 lines of verse to a construction site, and further recorded it in a luxurious illuminated manuscript booklet, demanded a consideration of the context in which this poetry – and the architectural designs themselves – were produced. An appreciation of the common social environment and shared discursive field of Roman Renaissance humanists and artists allows for a deeper understanding of the forms, function, and meaning of their interrelated works, in word and image.[40] Historians of knowledge in many fields have increasingly studied how ideas are communicated, orally and by material media; architectural historians analyze the communicative function of drawings,[41] and historians of the book consider the function and circulation of manuscripts and printed books. The parallel traditions of oral, scribal, and print publication in early sixteenth-century Italy complicate traditional notions of "publication," and challenge our understanding of why literature was produced, consumed, and circulated.[42] Sociological and anthropological approaches have recently been applied to the work of Renaissance humanists, considering the function of literary works in social context.[43] Lauro Martines marveled at what he considered historians' astonishing neglect of poetry's social function, calling for "social literary analysis," and recognizing that poems were "a form of practical action" in the world;[44] and recent studies have indeed emphasized the agency of poetry in Italian humanist culture, and in Raphael's own circle.[45] Applying these methodologies and working across traditional disciplinary boundaries of art and architectural history, literary and manuscript studies, and cultural history allows a new and holistic perspective on Raphael's work, and a rare glimpse of intellectual culture and creative processes in his circle.

The emphasis of this study on design reflects the increasing attention to artistic process as well as product in recent art and architectural studies focused on making and building.[46] The rich history of architectural design and construction in early cinquecento Rome provides a fundamental knowledge base about planning and practice, notably at the Fabbrica of St. Peter's, the epicenter of Italian architectural practice and discourse.[47] But most discussions of architectural process focus on spatial, structural, or technical issues of how an architect gave form to a building, as well as the use of materials and construction; here instead, we see the process of transforming conceptual ideas into architectural forms – a discourse more familiar to scholars of painting and studies of iconographic programs.[48]

This analysis of the coming-into-being of Villa Madama prompts an ontological reconception of architectural design. This book considers design in the sense of the temporal process, from conceptual ideas to their transformation into spatial and visual forms through writings, drawings, plans, construction, and

decoration. I propose that for Raphael and a variety of associates, design was a dynamic process that incorporated different systems of knowledge. I consider design to encompass not only the creative contributions of architects designing spatial and visual forms but those of wordsmiths contributing conceptual ideas, as well as the collective processes of collaboration and negotiation among many constituents to transform ideas into reality. By *design*, I mean this process of generating, developing, and presenting mental ideas, whether in visual, spatial, or verbal modes. I also refer to *ideation* to stress the generative aspect of this practice, or *invention*, a term used by sixteenth-century writers. (I leave aside notions of genius, human or divine inspiration, and theological and philosophical notions of creation and conception and their analogue in the visual arts.[49])

This study takes the notions of humanism and design off their sometimes lofty literary and artistic pedestals and into the everyday working world of humanists, artists, and architects. Sperulo, the foremost humanist in my study, was indeed brilliantly educated in Greek and Latin, with an extensive command of ancient literature, philosophy, and rhetoric, and a sophisticated ability to generate neo-Latin poetry in many meters; yet he deployed these skills in his day job in the service of the papal Curia generating efficacious poetry.[50] Similarly, the architectural design process, then as now, encompassed creative invention and execution, but also responded to external demands, shifting needs, and accommodation of the different parties involved. Architecture is frequently described as a social art: one that cannot be made single-handedly, and which must be presented to an outside audience to have meaning.[51] For Raphael's late masterwork, the design process itself was a social art; it emerges that this social interaction encompassed a broad range of players, including humanists, who were involved from the earliest stages of design, and who contributed significantly to the outcome.

For both wordsmiths and artists, however, the outcome of a project did not necessarily reflect a unified vision, originally or at any other point along the way; rather, it involved a series of compromises, based on negotiation among different constituencies. The transformational agency of time was a crucial factor in this diachronic, iterative, collaborative design process that extended over long periods. Adopting methodologies applied to texts by editorial theorists, I problematize notions of "original" or fixed-stage plans, as well as ideas of authorial intention.[52]

Broadening the view of the architectural design process to encompass professionals from different disciplines reveals thought patterns and working practices shared by architects, artists, and humanists. Tools of literature, rhetoric, and the *ars memoriae* could be applied to tasks from restoring a fragmentary ancient statue to designing a building, harnessing the imaginary to shape the real. Moreover, there was a striking epistemological similarity between early sixteenth-century visual and verbal traditions of appropriating ancient models to forge a new language. Notions of composition and *citazionismo*

were common to architects and humanists, who selected fragments of ancient buildings and texts, respectively, and recomposed them into new discourses.[53] Scholars have fruitfully analyzed Renaissance theoretical issues of architecture and language, exploring conceptions of *ut lingua architectura*, and specifically *ut architectura poesis*,[54] and showing how linguistic approaches helped shape new architectural vocabularies by architects in the early sixteenth century, notably Raphael and Michelangelo.[55] Raphael adapted literary methodologies, applying to architecture issues of creative imitation and selection articulated by Bembo and Castiglione, as Hans Aurenhammer and David Hemsoll have shown;[56] while their studies focus on the linguistic and theoretical foundation of formal architectural design, this book looks instead at Raphael's working processes, tracing the intersections of literary practices with architectural design. Likewise, mid-century architectural theorists would focus on parallels between rhetoric and design, equating the *maniere del dire* and the *maniere del edificare*, such as Daniele Barbaro who expounded on the similarities between crafting a speech and designing a building.[57] But once again, these discussions focus on formal and stylistic issues, especially the use of ornament and the language of the orders, or on linguistic analogies or metaphors of architecture.[58] The present study, by contrast, examines literature in relation not to architectural style or form, but to function; it shows how discursive or literary working methods were employed as tools in the conceptualization and design of an actual building, focusing on process rather than formal analysis of the product.

Strikingly, this could be an agonistic process, engaging visual and verbal means of representing ideas as rival modes, as scholars including W. J. T. Mitchell have treated them.[59] My story comes to a head at the moment of a major design change for the villa, corresponding to the two major surviving ground plans (Plates V, VI); planning for this change was under way early in 1519, when Sperulo composed his poem. I believe that Sperulo made a bid to control important conceptual *invenzioni* for the project at this juncture, which raises interesting questions about the contemporary understanding of architectural invention, and its expression in text or plans. The poet's challenge, although unsuccessful, presents a revealing instance of the long-running polemic over the relative powers of word and image, set in the context of Renaissance architectural practice.

The process of designing Raphael's grand papal villa engaged a large ensemble of people on a highly visible stage. The villa was one of the most closely watched projects in Renaissance Europe; what Raphael and the Medici did, and how they did it, was of keen interest to architects, artists, patrons, and humanists, who kept abreast by letter and visits to the unfinished site. Further, many of the artists who worked with Raphael dispersed throughout Europe after the master's untimely death and the Sack of Rome, spreading his ideas about process and product to a far-flung audience. Indeed, although the master plan for the Medici villa was not fully realized, it quickly became surprisingly widely known, and emerged as a

paradigm of the Renaissance villa *all'antica*; echoes of Raphael's ideas and plans – even the unexecuted aspects – appear in later projects and writings, from his own day to the present. Studying this important villa as imagined and as built, and the design processes by which it came to be, has significant implications for our understanding of Renaissance architectural practice, in Raphael's circle and beyond.

ɔ

The processes and protagonists I am discussing do not fit neatly into traditional vocabulary of architectural design, so a brief clarification of terminology is helpful. As noted, I refer to *design* in the sense of the temporal process, from artistic and conceptual ideas through drawings, plans, and descriptions used to realize the villa and its multimedia decorations. I use the terms *design, ideation,* and *invention* to designate the process of generating, developing, and presenting ideas using visual and verbal modes. I use the term *multimedia* in its literal sense to describe Raphael's novel ensembles, which could integrate the many media of landscape, architecture, painted and stucco decorations, antiquities, modern sculpture, and waterworks, as Villa Madama did. By *planners* I mean the large and varied group of patrons and professionals engaged in various activities necessary to conceptualize this project and bring it into existence, including architects, artists, humanists, agents, and project managers. In particular, I use the terms *artist* and *architect* primarily in the traditional sense to designate, respectively, a designer of the figurative arts of painting and sculpture, or of the built environment, including buildings, landscape, and urban space. But as the title of the book reflects and this study demonstrates, this distinction breaks down for Raphael and his projects. Throughout the book, I use the term *humanist* with the understanding that it refers to training or intellectual outlook, rather than a specific job;[60] humanists held various professional roles – physician, lawyer, notary, secretary, priest, to name a few. And I use *wordsmith* as a generic term to designate those professional roles that engaged the manipulation of words, especially via literary or philological sources. In particular, I use the umbrella terms *wordsmith* or *artist* to distinguish those whose powers of invention were expressed primarily via verbal or visual means, respectively. Together, they generated conceptual ideas that could be "embodied" or transformed into the body of the architecture.

ɔ

This book tracing the coming-into-being of the Medici villa begins with the context for villa building and description in Renaissance Rome. The first chapter places Raphael's conception of the Medici villa within the broader context of his interdisciplinary projects to revive the "corpse" of ancient Rome. It introduces the protagonists in this narrative, situating them in cultural context at the intersection of Curial humanism and the Roman humanist sodalities. The chapter further orients the reader to the villa itself, tracing its history and

appearance, as envisioned and as built. The following chapter introduces Sperulo and other poets who wrote proleptic verse about the Medici construction site, and positions their descriptions of the villa within broader literary traditions and practices. It traces classical and earlier Renaissance villa literature, from Pliny and Statius, through works of late quattrocento humanists in Laurentian Florence and Aragonese Naples, to early cinquecento humanists extolling the villas of Agostino Chigi as well as the Medici in Rome. Other literary and also rhetorical traditions served as models for these poets, notably mnemonic composition techniques; the *ekphrasis* of architecture and sculpture, such as the *Laocoön*; and descriptions of the non-existent, from Homer to the *Hypnerotomachia Polifili*. This chapter reveals the remarkably rich array of sources to which Renaissance poets were indebted, as they creatively selected elements and recomposed them into new villa discourses.

The third chapter analyzes Sperulo's claim to build the villa and his vision for it, from overarching conceptual ideas to more specific plans. This section reveals the poet's sophisticated use of authorial personae to reify his prophetic plans for the villa and present his proposals for frescoes and the installation of specific antiquities. Considering Sperulo's plans in light of the little-known antiquities collection once actually installed at the villa reveals that he was not just spinning poetic fictions but, in some cases, planning for actual marbles. (This and subsequent chapters are complemented by the appendices. Appendix I provides a new critical edition and translation of Sperulo's villa poem by Nicoletta Marcelli, with a gloss by the author. Appendix II analyzes the presentation manuscript of the poem as a material object, considering its format and its binding, illumination, and scribal hand. These findings round out the discussion of the poem's function in oral and manuscript culture, contributing an interesting case study in the history of the early modern book, and in verbal performance practice. Appendix III contains an additional elegy by the poet on the subject of Pope Leo's clemency, which informed the poet's ideas for the villa.)

The proleptic character of specific villa descriptions is the focus of the fourth chapter. It emerges that Sperulo's poem represents a little-known Renaissance mode, which I call hortatory *ekphrasis*. I explore the sources of this genre, showing how Renaissance humanists creatively adapted elements of classical literature and rhetoric to forge an authoritative and persuasive tool, exhorting patrons and artists to follow their ideas. The chapter also considers the relation between Sperulo's poem and Raphael's letter describing the unbuilt villa, analyzing these two texts to propose ideas about their function, the relation of poet and architect, and the relation of literature to the concrete villa project.

The fifth chapter raises the question of what exactly a *letterato* like Sperulo was involved in designing. I problematize the notion of "program" or invention, and instead find that he was proposing what I call "conceptual structures" or "metastructures" for architecture and decoration, which could involve spatial, functional, philological, archeological, or ideological notions. Case studies of this imagery show it to be at once familiar – it was supposed to be understood

by its target audience – and also more densely layered than we might think. This matrix of evidence reveals a pattern of dynamic collaboration by a highly sophisticated group of patrons, artists, and wordsmiths: the subject of the sixth chapter. I characterize their design process as an iterative, collaborative effort, which engaged ideas and working methods from different fields. I show how this cohort generated concepts, ideology, and imagery that were fundamentally important for the Medici villa from its earliest stages. This chapter also considers the effect of long-term construction for such an extensive project, with attendant changes in vision along the way; and it raises questions about the nature of authorship, intentionality, and the building as an autonomous work of art.

Given the focus of this study on the process of coming into being, this book purposefully does not analyze the villa as it was actually constructed.[61] Therefore, it is intentional that the villa as built and decorated does not fully come into focus here. I introduce select information about the villa's plans, appearance, and decoration necessary to illuminate specific aspects of the planning process for which evidence has emerged, without attempting a complete treatment of the villa. Nor is it a detailed study of the construction history or financing, for which we lack sufficient data.

The Conclusion draws together the discussion of visual and verbal modes of ideation at Villa Madama, presenting a new view of architectural design as a dynamic, collective process involving different epistemes. The instrumental role of word and image as tools for shaping the villa argues for a more holistic conception of Renaissance architectural thinking. The relation of architecture and literature in this context was not theoretical, but a practical working discourse, in which form and meaning evolved dialectically. Literary practices were mobilized for the practical goal of designing a building, and conceptual ideas could be manifested in architectural practice, and in spatial and decorative forms.

Furthermore, the interactive invention of ideas, words, and visual forms was a valued cultural matrix in itself. That is, the design process was not simply a means to an end, but part of larger cultural discourses. Visions of the villa as an architectural and literary edifice were recorded in proleptic villa descriptions thematizing ideation, which reflects that this process was considered a narrative worth recording. In part, this is an instance of the long-standing practice of harnessing the visionary to shape the real. The emphasis on process also reflects medieval notions of experiencing a work of art not as a static object, but as an ongoing, dynamic journey.[62] This practice also reflects the fundamental importance in Renaissance thought of the Aristotelian notion of the arts, especially architecture, as a process of bringing-into-existence, or *poiesis* (ποίησις). The notion is consonant with the Italian sixteenth-century metamorphic mindset, indebted to theological as well as natural historical beliefs about the world continually in the process of formation.[63] This book develops a conception of architectural design as a dynamic process that is also self-reflexive, opening a new view of the relation of discursive thought, language, and architecture in Raphael's Rome.

CHAPTER ONE

REVIVING THE CORPSE

You, too, Raphael, while with your wondrous talent you construct Rome, mutilated throughout her body and recall to life and to its ancient beauty the city's body, mangled by the sword, fire, and the years … you can return the breath of life to things long dead.

Baldassare Castiglione, *Carmen on the Death of Raphael, c.* 1520.[1]

In Raphael's Rome, artists, humanists, and patrons were engaged in what they understood as a collective enterprise to revive the corpse of Rome. Drawing on Petrarch's notion of *rimembrare* – to reassemble the limbs of a body as a form of memory[2] – the corpse metaphor served as an organizational system for reviving ancient sculpture, buildings, and the city of Rome itself. Figural sculptures emerged from the ground like mutilated bodies,[3] awaiting the healing powers of sculptors and poets to restore their limbs, in marble and in words. The ruins of ancient buildings, too, were understood as bodies, following the anthropological metaphor common to Renaissance architectural thinking. This image of Rome as a corpse had been a popular conceit from the time of Poggio Bracciolini (1380–1459).[4] Artists and humanists alike proclaimed themselves to be the healers of these mangled bodies, a project they undertook in various modes. In his own lifetime as well as after his death, Raphael would be particularly associated with this imagery, fashioned as the Christ-like healer of Rome's broken body, whose *restauratio* of Rome would become a metaphor for the divine, life-giving power of the artist.[5] In his famous letter to Leo X about the antiquities of Rome, Raphael laments that Rome is almost a

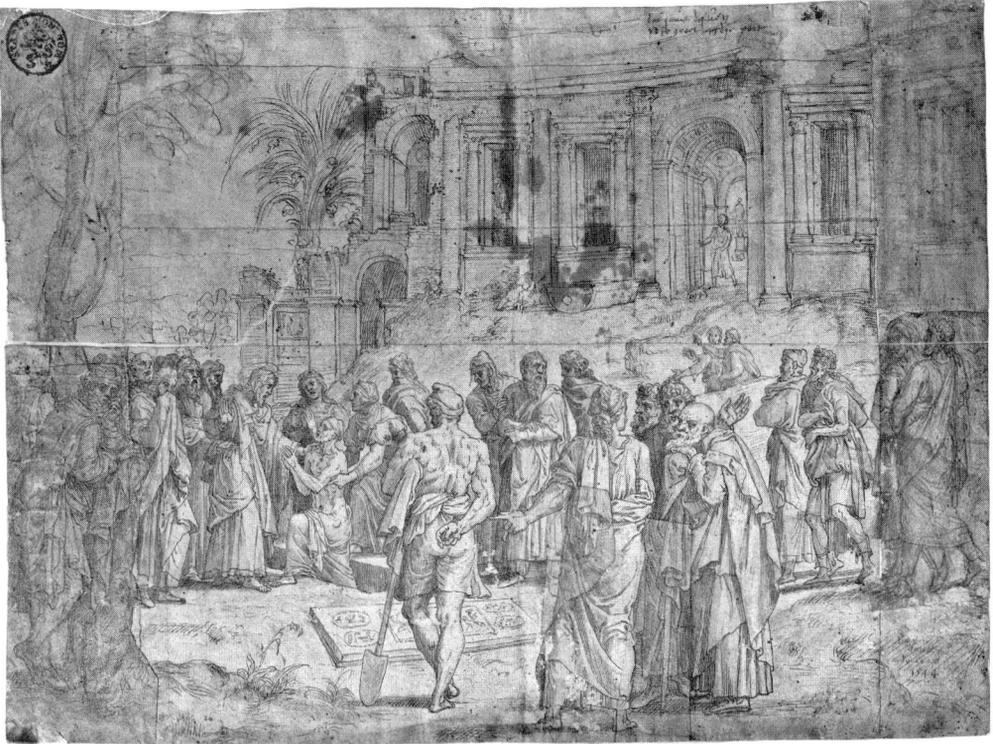

1. Lambert Lombard, *The Raising of Lazarus with Villa Madama in the Background*, 1544. Düsseldorf, Kunstmuseum, Graphische Sammlung, FP4748.

corpse, its monuments like the bones of the body without the flesh – a body that he, implicitly, is renewing.[6] During Raphael's lifetime, he was praised as god-like for these powers to reconstruct Rome; and the outpouring of poetry at his unexpected death describing his work as reviving the corpse reflects the currency of this metaphor.[7] Most famous among the many examples is Castiglione's carmen for his friend, quoted above.

In addition to the renovation of Rome's ancient remains, new construction after the antique was also understood as a tool for reviving the city; the parallel sight of crumbling ruins and scaffolded construction sites – "new ruins" – encouraged a conceptual equation of restoration and building activities.[8] So, the revival of the city, via old and new structures, was a collective venture of architects, artists, and poets. Thus, it would not have seemed a paradox that the Medici papal *hospitium* – a work of ex-novo construction outside the central city – gave Raphael the fullest opportunity to restore the glory of ancient Rome. In part, this reflects the revival of the villa *all'antica* as a locus of Renaissance cultural values.[9] More specifically, this villa, the late masterwork that the "divine" Raphael did not live to see completed, took on an important symbolic value. Lambert Lombard, who was among the northern artists in Rome in the 1530s, made a particular study of Raphael's works, and took him

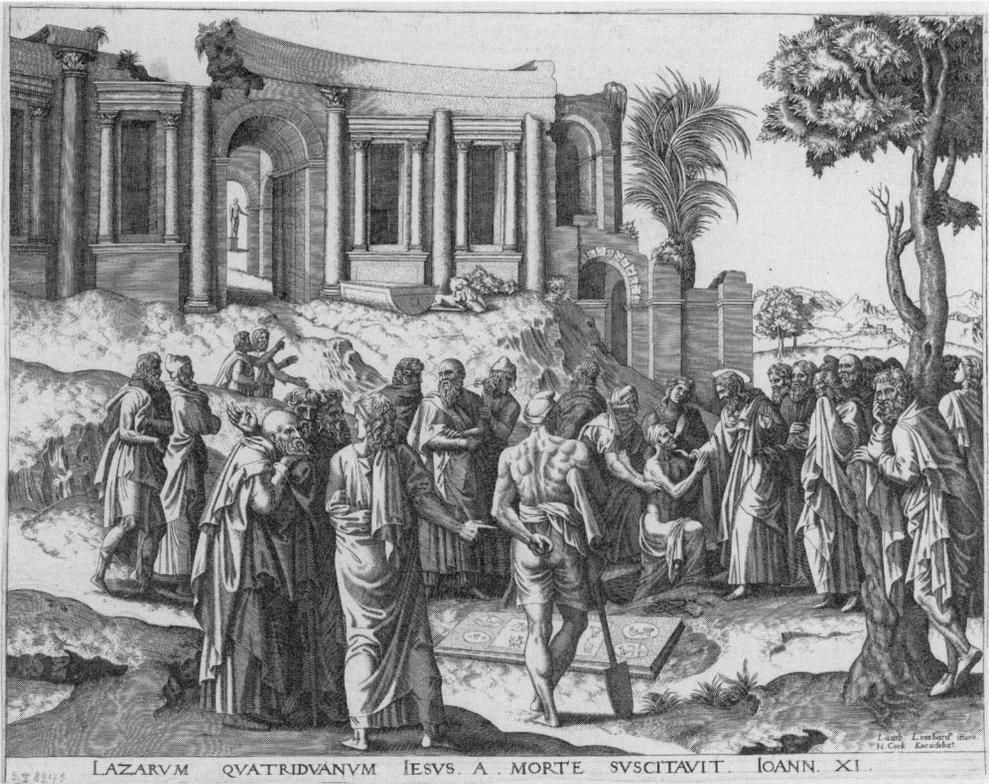

2. Hieronymus Cock after Lambert Lombard, *The Raising of Lazarus with Villa Madama in the Background*, Bibliothèque royale de Belgique, Cabinet des Estampes, x.v. 89185.

as a personal model; on returning to Liège, Lombard composed a Raphaelesque scene of Christ raising Lazarus set in front of the Medici villa, ambiguously rendered as ruin or half-built structure, a capriccio that was engraved by Hieronymous Cock (Figures 1, 2.)[10] Given Lombard's close identification with Raphael, his choice to set the Lazarus miracle in front of a prominent and meticulously rendered portrait of Raphael's unfinished villa surely reflected contemporary ideas about the late Raphael's Christ-like powers, and his villa as a resurrection of antiquity.[11] Thus, his papal villa *all'antica* represented not only a formal and cultural *rinascità*, but also a triumphal Christian resurrection.

This chapter presents the Medici villa project as Raphael's Lazarus, first introducing the patrons, humanists, and artists engaged in this visual–verbal enterprise to revive the corpse, and then presenting the villa complex itself.

PATRONS, HUMANISTS, AND ARTISTS IN LEONINE ROME

For its patrons – Pope Leo X Medici (r. 1513–21) and Cardinal Giulio de' Medici (later Pope Clement VII, r. 1523–34) – the villa Raphael designed on Monte Mario was a stage for the family's dynastic ambitions, as well as

for papal ceremonial. The complex was conceived and constructed during a turbulent period in Leo's pontificate: a time of acute political, religious, and economic threat to the Papal States, when its territory was being assaulted in wars with the French and the Emperor Charles V, and through incursions by the Ottoman Turks. Papal authority was being challenged by the rising Lutheran threat, European rulers, and the national churches, and papal coffers were scant.[12] The Vatican struggled to project an image of papal authority and magnificence with limited funds. The Medici family had been exiled from Florence for two decades, and they were restored to power there just a year before Leo X was elected in 1513 as the first Medici pope. A conspiracy of cardinals to assassinate Leo allegedly occurred in 1517, and although most scholars now believe that Leo feigned these events for his own ends, the fallout occupied the Curia for several years to come.[13] The Medici were therefore faced with a crisis of authority in both cities at once: in Rome they were viewed by the clannish Roman nobility and the Vatican bureaucracy as interlopers from Florence, and in Florence they had to combat perceptions that they were tyrants and usurpers of Republican power. Accordingly, a primary goal of much Medici patronage and rhetoric in the second decade of the sixteenth century was to convince powerful groups in both cities of the legitimacy and benevolence of Medicean rule.[14] The family's hopes for broader Medici dynastic control were dashed, however, by the premature deaths of the two legitimate family heirs, Giuliano, Duke of Nemours, in 1516 and Lorenzo, Duke of Urbino, in 1519. Cardinal Giulio de' Medici shared with his cousin Leo the burdens of these political, religious, and dynastic efforts; beginning in March 1517, Giulio served as vice chancellor of the church, a powerful role akin to Secretary of State, to which Raphael gives visual form in their portrait by placing Giulio at Leo's proper right (Figure 3).[15]

This precarious political moment was nonetheless characterized by utopian thinking; humanists declared that theirs was a new Leonine Golden Age, confident in the power of the papacy to unite Christian Europe in an empire that would outshine the cultural achievements of the ancient Romans.[16] This papal public relations machine focused on the persuasive power of word and image to proclaim the peaceful, new Christian *res publica*.[17] Curial humanists declared a syncretic union between classical learning and Roman Christianity, formulating an ideology of the Christian fulfillment of all earlier history – Greek, Roman, Egyptian, and Jewish – centered in Rome, the *caput mundi*. Using neo-Latin, they proclaimed the glory of this Rome reborn, declaring that the Christian papal empire had inherited the mantle of temporal power from the Roman empire. During the reign of Leo X, this rhetoric of persuasion was deployed with special skill to promote the notion of a new Christian era of peace under the Medici.[18] Drawing on Augustan and earlier Medici imagery, Leo fostered the personal imagery of a peace-bringer, the *Rex pacificus*, in marked contrast to his predecessor Julius II, known as the warrior-pope.

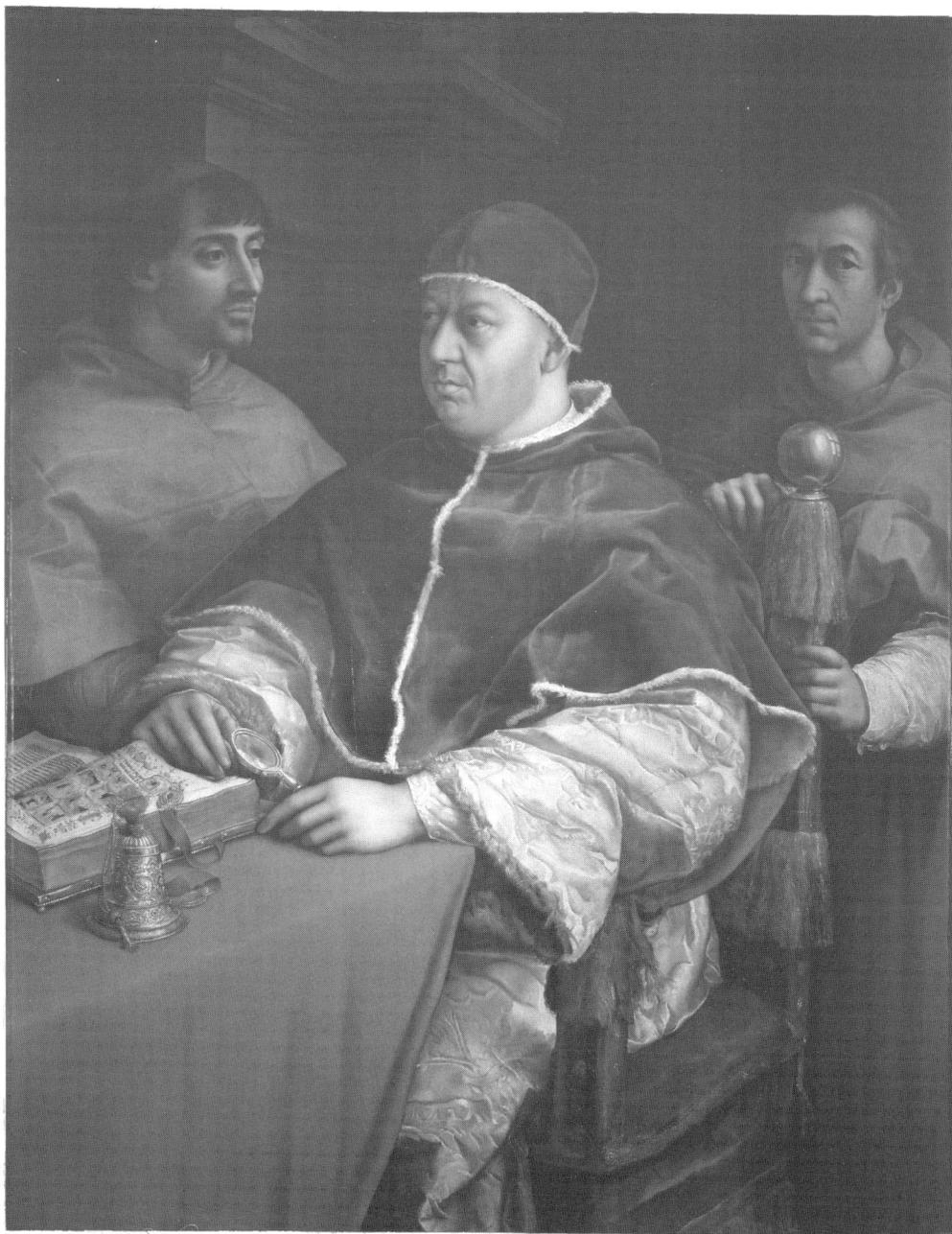

3. Raphael, *Portrait of Pope Leo X with Two Cardinals* (Giulio de' Medici at Leo's proper right, and Luigi de' Rossi behind him), 1518, Florence, Uffizi.

Leo's and Giulio's formation in Laurentian Florence was fundamental to their style of patronage. The cousins absorbed the patronage culture of Lorenzo and Piero il Gottoso in Florence, including patterns of Medici family collaboration, as well as close collaboration with and fostering of humanists, architects, and artists. Leo's boyhood tutor had been the humanist-poet Angelo

Poliziano (1454–94), who served as a kind of "Medicean house-philologist" under Lorenzo.[19] Thus, from boyhood Leo had absorbed Poliziano's brilliant formulations of Medici imagery, which were embodied in media from poetry and parade floats to music and paintings, notably by Botticelli. Giulio may have lived as a young boy in the household of Antonio da Sangallo the Elder; and both cousins grew up with the young Michelangelo, who was taken into the Medici household and sculpture garden. Once in Rome, these two Medici cousins worked at the nexus of very different patronage cultures: the Florentine culture of Lorenzo de' Medici, in which they were raised, and the Roman papal culture that sought to surpass the grandeur of imperial Rome.[20]

They took to Rome the rich repertoire of Medici family imagery formulated in Florence, which would be translated to a Roman setting, and inflected for the papacy.[21] The Medici had long fostered their family mythology as clement peace-bringers, who could tame Mars and draw the generative Venus to inhabit their realm. Their traditional messages of eternal return – as in Lorenzo's motto *Le tems revient* – echoed the cycle of time and the seasons, and were transposed into the imagery of Leo as a new Augustus: the *Rex pacificus* restoring the Golden Age to Rome.[22] Leo's horoscope was interpreted to have predicted his elevation to the papacy, as was his escape from his captors during the Battle of Ravenna. He was variously identified with Apollo, like his father Lorenzo, and in particular with Apollo *Musagetes* and Sol-Apollo, as well as with Jupiter. The Medici sought to "Romanize" the family history and even Florence, and stressed the union of Rome and Florence, in part by emphasizing the ancient Etruscan roots of Tuscany and the Medici themselves. They used the catalogue of family devices and *imprese*: laurel, the *broncone*, the yoke with the motto *iugum suave*, the falcon holding a diamond ring, or a diamond ring with feathers.[23] The family allied themselves with the strength and power of the lion and Hercules, symbols of Florence, as well as the regenerative power of Nature, Pomona, or Venus Genetrix; the balls (*palle*) of the family device were associated with the sour orange (*mala medica*), the golden apples of the Hesperides (*mala aula*), and also the globe, the sun, and the stars.[24] This repertoire of imagery is familiar to students of the Medici family; what is interesting is how creatively and flexibly it was deployed, translated from one place and project to another, and transformed for new environments – as indeed, we shall see was the case for their papal villa.

Drawn by the promise of Leonine largesse, humanists from all over Italy and beyond flocked to Rome, contributing to the city's character as a cosmopolitan cultural capital.[25] They held "day jobs" – sometimes many small ones at once – working in the papal Curia or for cardinals and other high-ranking patrons, but, like modern scholars, they also produced their own work.[26] Poetry was their most important mode of expression, deployed for a remarkable range of purposes: professional, social, and creative. Humanists in early cinquecento

Rome convened in two major literary groups: the circle of Johannes Goritz (c. 1455–1527), the Luxembourgian prelate and legendary patron of artists and *letterati*, who used the name Corycius,[27] and the loosely configured Roman Academy, then headed by Angelo Colocci (1474–1549).[28] Unlike later, organized academies, these open societies and other overlapping circles of humanists interacted in fluid groupings, meeting for occasions from informal walks and dinners to more elaborate, choreographed contests and banquets. Best known are the convivial gatherings hosted in the villa gardens of Goritz, Colocci, and later Blosio Palladio (1475–1550), where humanists dined, recited their newest works, and engaged in erudite, barbed Latin banter.[29] At Goritz's feasts, poets literally decked the halls with their verse, which they posted not only on the walls of the villa, but on its wells, statues, and trees.[30] Thus, written and oral modes of communication were intertwined.[31] Central to their fellowship was the notion of sodality. As Pierio Valeriano noted:

> No form of association produces a greater bond of friendship than dining together, than being nourished and fed together – whence the terms 'close friends' (*sodales*) and 'fellowship' (*sodalitium*) for a gathering of those friends who often dine together. You know this sort of fellowship at Rome, the sodalities of Sadoleto and of Giberti, Goritz, Colocci, Mellini, Corsi, Blosio, and the rest.[32]

Friendship and competition were both essential elements of this performative environment, in which humanists variously engaged in collective emendation of their drafts, traded manuscripts, and recited their works to each other.[33] At the same time, humanists needed sharp elbows to survive in Rome's intellectual labor market, as they competed for commissions in the zero-sum patronage game, as Julia Haig Gaisser has characterized it, and sharpened their skills through these interactions.[34]

Roman humanists in the service of the Curia and beyond were instrumental as papal image-makers, formulating and conveying Vatican messages. *Coryciana* poets explicitly paralleled the Rome of Leo X to Augustan Rome, proclaiming Leo as the *Rex pacificus* and themselves as new Virgils in the new Christian era that was truly the Golden Age.[35] These *letterati* no doubt ranged from reluctant to genuine advocates of the encomiastic and ideological messages they promoted; as Ernst Gombrich noted apropos of Medici Golden Age imagery, "propaganda need not be cynical. Those who propound it may be its first victims."[36] But there were tensions inherent in their roles as dependent scholar-courtiers jostling for work and payment. John D'Amico analyzed the Curia's exploitation of humanists who served as the mouthpiece for political and religious ideas, noting the "moral ambiguities" inherent in humanist careerism in Rome; and Gaisser has traced the frustration of often disaffected scholars who were valued not for their literary products, but for their roles as Curial

administrators and propagandists.[37] The *Dialogo contra i poeti* of Francesco Berni (1497–1535), a satirical exposé of contemporary literary mores written by 1525, provides a gimlet-eyed account of the careerist jockeying in this milieu.[38] But despite these drawbacks, Leo's extravagant patronage of humanists offered unrivaled opportunity. After the Sack of Rome in 1527, many *letterati* indeed looked back wistfully at the Leonine pontificate as a golden age for sponsorship and fraternity.[39]

The discourse of this intellectual elite in Leonine Rome was dominated by debates over language, which came to a head during the years when the Medici villa was being designed. Foremost among the players was Pietro Bembo (1470–1547), the leading advocate of Ciceronian Latin as the most perfect model of prose, rather than the imitation of many authors. As author of Leo's papal briefs (along with Jacopo Sadoleto, 1477–1547) Bembo thus set the linguistic tone for the papal court. When he turned his attention to the vernacular, he connected linguistic questions to political issues including the Italian wars, advocating a sort of cultural and linguistic Italian unification. His *Prose della volgar lingua*, which he worked on throughout his time in Leonine Rome, was more than a grammar; it was a political statement valorizing the Italian linguistic and literary tradition.[40] Pierio Valeriano (1477–1560) expanded on these issues about the vernacular in the form of a dialogue describing the discussion at a dinner party supposedly held at the Medici villa: his *Dialogo della volgar lingua*.[41] Baldassare Castiglione (1478–1529), drafting his *Cortegiano c.* 1513–18, took issue with Bembo's Ciceronianism in his discussion of the *questione della lingua*. These debates reached a dramatic climax early in 1519, with the affair of the Belgian humanist Christophe de Longueil, who, despite his mastery of Ciceronian Latin that had just earned him Roman citizenship, was run out of Rome for treason for having delivered a Francophile, anti-Italian panegyric many years earlier. This tempest that pitted northern humanists against the papal court was evidently a trumped-up academic tiff that veiled deeper xenophobic anxieties about the threats of Lutheranism and northern political powers, reflecting the intersection of literary and political concerns;[42] as Gaisser put it, "they transposed the real schism into the key of humanism."[43] Indeed, humanism was the mode for effecting action in this milieu.

This culture was the setting for the humanists engaged in the Medici villa project. Among them was Mario Maffei (1463–1537), the Curial humanist with a practical bent for project management, who became an overseer of Villa Madama's construction.[44] Paolo Giovio (1483–1552), who was awarded several benefices by Leo and served as a physician and member of Cardinal Giulio's household, was also engaged in the Roman academies as a historian and poet, and taught natural and moral philosophy in the Studio Romano (as the Università di Roma was then known.)[45] This cohort is well known for

their works in the *Coryciana* anthology of Latin poems by humanists in Goritz's circle, published in 1524. Francesco Arsilli's *De poetis urbanis*, a catalogue of Roman poets dedicated to Giovio in the *Coryciana* anthology, included Maffei, along with fellow humanists Colocci, Castiglione, and Valeriano, and praised each for his specialties and talents.[46]

Several of these humanists owned villas and were personally interested in the ideology and literature of *villeggiatura*, as well as enjoying actual villa life. Maffei actively managed his villas in Volterra and Rome, where he occasionally hosted academy members, and made his villas the subject of his poetry; Arsilli mentions Maffei's verses, noting his love of nature and his *vigna* (presumably one of his two Roman villas on the Aventine) to which he often summoned the Muses.[47] Pietro Bembo was devoted to a family villa near Padua; Giovio wrote about his family Villa Lissago near Lake Como;[48] and Tommaso Inghirami (1470–1516), the humanist-impresario, had a Roman villa on the Palatine, probably built into ruins with ancient frescoes, to name just a few.[49]

Perhaps the least-known humanist in this circle was our poet Sperulo (aka Sperulus, Spherulus, Speroli, Sferolo, 1463–1531), who had a successful career as a poet, orator, priest, and diplomat, much of it in the service of the papal Curia.[50] Born in Camerino in the Marchigian Apennines, he studied rhetoric in Bologna and canon and civil law in Perugia before coming to Rome. He was first active at the papal court under Cesare Borgia, whom he accompanied on traveling campaigns and honored in a panegyric.[51] Sperulo also had fruitful associations with both Medici cousins, an important point for this narrative. For Leo X, and later Adrian VI, he served as a chamberlain (*cubicularius*), a post that entailed rendering some kind of personal service to the pope, and thus typically carried the privilege of proximity and influence, as well as dignity and legal benefits.[52] In a 1515 brief, Leo made Sperulo the prior of San Salvatore di Aquapagana, a Camaldolese monastery near his home town of Camerino.[53] In April 1518, Sperulo was recorded as a *diacono* responsible for Greek readings in the papal chapel (at a salary of five gold ducats monthly),[54] and thus he must have been instrumental in the revival of Greek scholarship in Leonine Rome.[55] He also had some diplomatic responsibilities for Leo X following the Villa Madama poem.[56] His ordination to the priesthood came under the auspices of Cardinal Giulio;[57] and under Clement, he became the bishop of San Leone in Calabria,[58] and delivered several sermons, including one urging European peace.[59] His dedication of a book of his writings to Cardinal Ercole Rangone in 1520 reflects his connection to that cardinal,[60] and he became a nuncio to the Gonzaga under Pope Adrian in 1522. Thus, this educated humanist earned a living from various Curial posts and benefices, as well as his writings, as was common practice for the many humanists competing in the intellectual labor market in Rome. On his death in 1531, Sperulo was interred in Sant'Onofrio in Rome. Until recently, only a handful of his short poems and letters had been

published, notably a poem on the finding of the *Laocoön*,[61] several poems in the *Coryciana* anthology,[62] an encomium of Cardinal Ercole Rangone,[63] and an elegy about Pope Leo's clemency, included here as Appendix III.[64] Many more of Sperulo's works survive in manuscript form,[65] and are now published in a monograph.[66] Arsilli noted that Sperulo was celebrated for writing all types of poetry – elegiac, epic, and lyric[67] – a point also noted by Lilio Gregorio Giraldi in his *De poetis suorum temporum*.[68] Despite this range, it seems that much of Sperulo's oeuvre consisted of efficacious poetry, such as the Medici villa poem, rather than work valued principally for its literary merit (by his contemporaries or later critics), as were those of his contemporaries Bembo, Castiglione, and Ariosto.[69] Sperulo was perhaps most valued as a Leonine papal courtier for applying his philological expertise, as well as other skills, to a variety of practical tasks at hand, such as contributing ideas for the rising Medici villa.

Raphael's close associations with the most influential humanists and *letterati* of the era fostered a verbal as well as visual approach to art and architecture. In fact, he may have been raised on a diet of poetry and painting; although evidence for his early education remains elusive, his childhood as the son of Giovanni Santi (*c.* 1440–94), court painter and also poet in the sophisticated court of Urbino, suggests that Raphael absorbed many powers of expression expected of a courtier, which were later articulated by his friend Castiglione.[70] Santi's epic *Cronaca rimata* in terza rima had thematized notions of *ut pictura poesis*, comparing the powers of painting and sculpture to poetry and history, presumably a powerful lesson for the young Raphael. Bramante may also have been a mentor in this regard; the elder artist's intellectual formation in Urbino was then sharpened by immersion in the Florentine and Milanese visual–verbal culture at the Sforza court, where he was esteemed for his own learning and poetry; and he would later be described as an "architecto doctissimo" for these traits in Julian Rome.[71] Raphael's own accomplishments as a poet were modest, judging from his surviving sonnets, which he jotted on the drawings for the frescoes of the *Disputa* and *Parnassus* while working on the Stanza della Segnatura.[72] Nor did he master reading or writing in Latin. But the very fact of his composing vernacular literature – poetry and, later, literary epistles, notably one to Leo X about Roman antiquities and another describing plans for Villa Madama – was a significant marker of his ambition to be valued as an intellectual and visionary creative power.[73] Even if his primary education and genius lay in the visual and spatial realms, and he was busy with a crushing load of design work during his Roman years, he nonetheless felt the necessity to record important ideas in words, reflecting the verbal engagement fundamental to elite culture. His works in many media reflected this engagement with literary and rhetorical sources.[74]

Without mastery of Latin, Raphael could not participate fully in humanist sodalities, but he nonetheless expanded his range and elevated his role

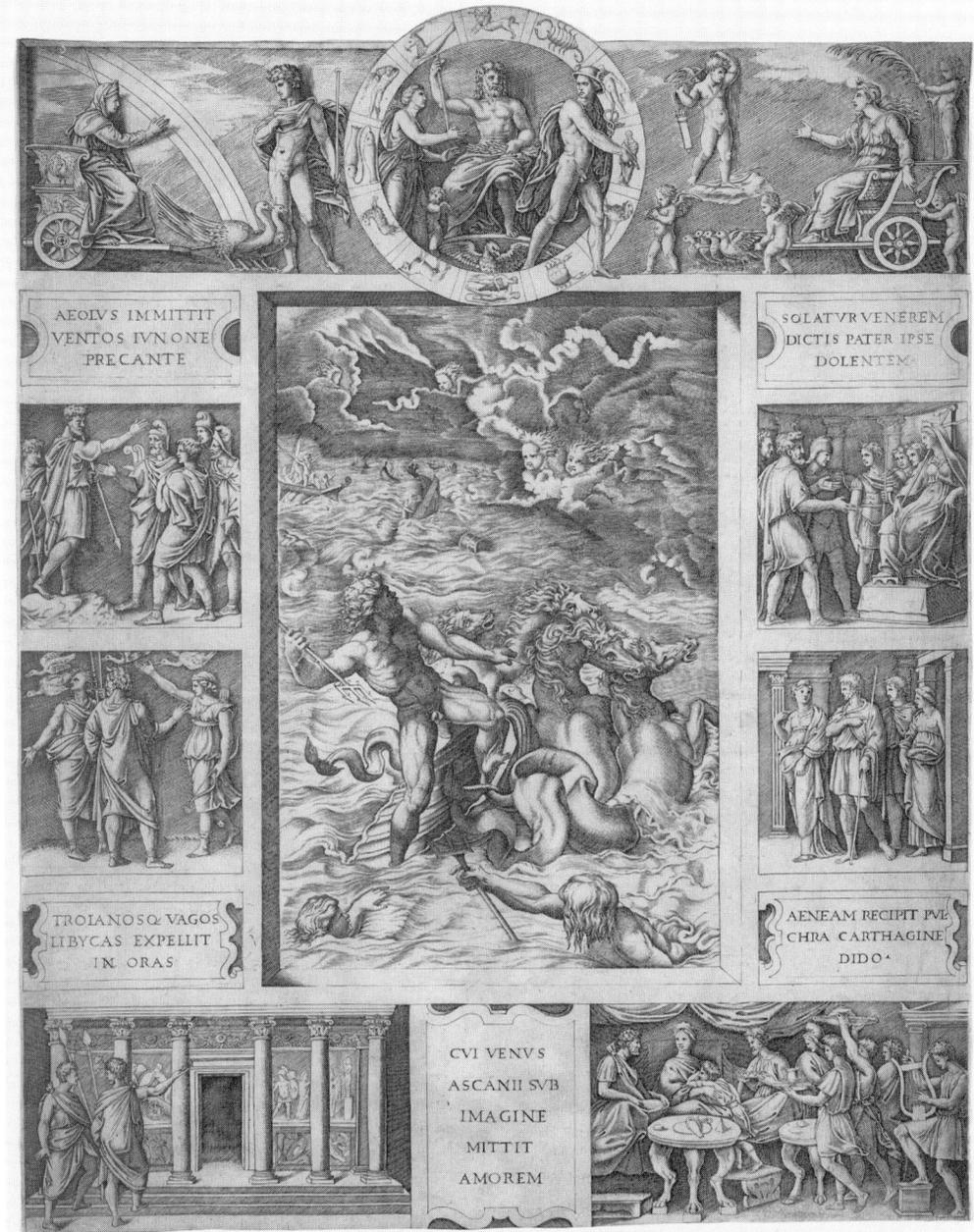

4. Marcantonio Raimondi after Raphael, *Quos Ego* (Neptune calming the tempest which Aeolus raised against Aeneas' fleet, surrounded by other scenes from book 1 of the *Aeneid*), engraving.

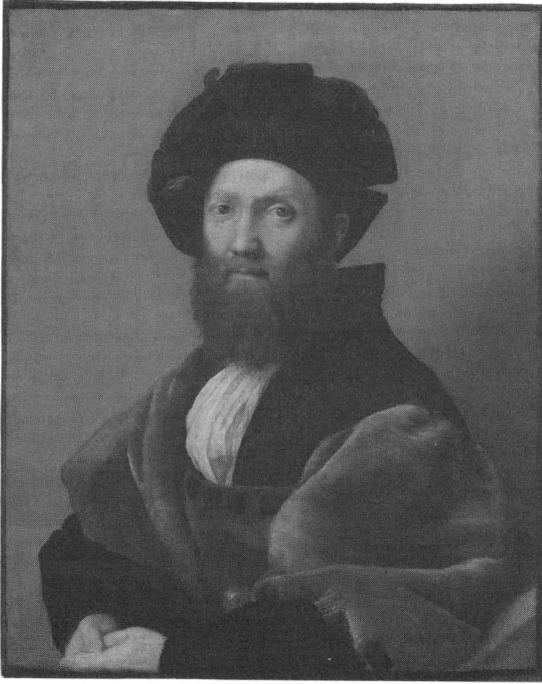

5. Raphael, *Portrait of Baldassare Castiglione*, 1514–16 (debated), Paris, Louvre.

through his collaboration with *letterati* on projects related to the study of ancient architecture, sculpture, and texts.[75] Among these ventures was an annotated translation of Vitruvius on which he collaborated with Colocci, probably with the participation of antiquarian Andrea Fulvio (*c.* 1470–1527) and other artists in Raphael's equipe.[76] He may also have been involved in preparing an illustrated edition of Virgil's *Aeneid*; his brilliant design for the *Quos Ego* engraving (Figure 4) gave visual form to scenes from book I and displayed an extensive knowledge of philological and archeological prototypes, distilled into a sophisticated representation of fictive media. It has been debated whether this print was a standalone invention and calling-card for the artist, or intended for a new edition of the *Aeneid* he would illustrate, but, in either case, it exemplifies Raphael's talent for working at the nexus of literary, artistic, and archeological interests.[77] He also worked closely with Pierio Valeriano to puzzle out the identification and meaning of ancient sculptures.[78]

Beyond professional working relationships, Raphael's close friendships with humanists with whom he shared intellectual interests afforded informal opportunities for the exchange of ideas. His famous 1516 field trip to explore the sights of Tivoli in the company of his humanist friends Pietro Bembo, Baldassare Castiglione, Andrea Navagero (1483–1529), and Agostino Beazzano (d. 1549) was one such example. The so-called buddy portraits

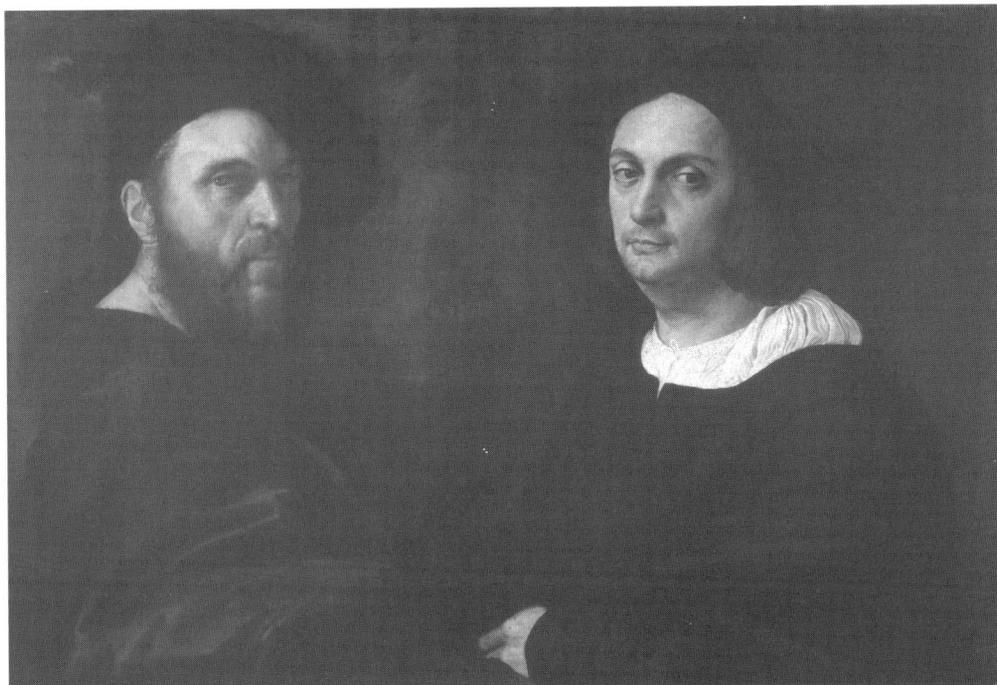

6. Raphael, *Andrea Navagero and Agostino Beazzano*, 1516, Rome, Galleria Doria Pamphilj.

Raphael painted of and for this group – a portrait of Castiglione and the one of Navagero and Beazzano that Pietro Bembo owned – attest to Raphael's affection for these friends, and to their swapping of favors (Figures 5, 6).[79] Bembo, in fact, expressed his jealousy that Raphael had not yet painted his portrait.[80] Raphael and Bembo had met in Urbino, and when both were at the Vatican, they worked together on projects including the decorations of the Vatican *stufetta* for Cardinal Bibbiena (1470–1520).[81] Raphael paid tribute to Tommaso Inghirami, with whom he had worked closely on the program of the Stanza della Segnatura, in a number of portraits, most importantly in the remarkably vivid image of Inghirami at the moment of receiving inspiration (Figure 7).[82] Another friend who merited such treatment was Antonio Tebaldeo (1463–1537), famous for his improvisation and performance of verse, whom Raphael represented in a famous portrait, now lost, but known through old photos (Figure 8), and whom he may have included among the poets in the *Parnassus* fresco.[83] Raphael's collaboration with Ludovico Ariosto (1474–1533) on the *apparato* for staging *I suppositi* in the Vatican was the talk of the Curia in early 1519 (Figures 9, 10).[84] During this period, Ariosto was also working on revisions to the first edition of his *Orlando furioso*, parts of which were read aloud, so ideas from this epic were topical among this cohort, too. But Raphael's most significant literary friendship was with Baldassare Castiglione, with whom he engaged in mutual self-fashioning in

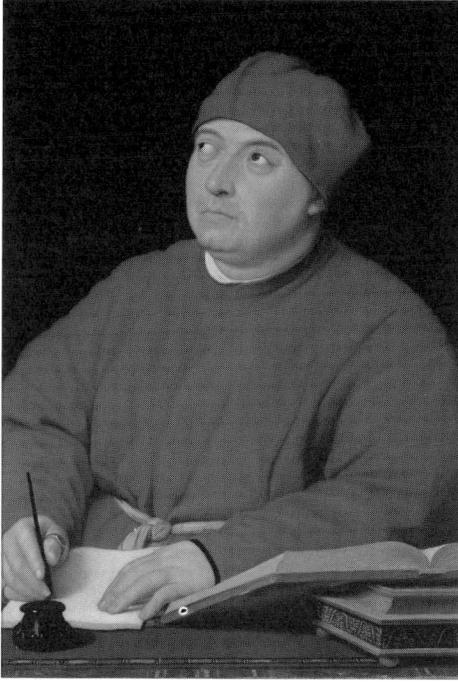

7. Raphael, *Portrait of Tommaso Inghirami, c.* 1510–11 (debated), Florence, Pitti Gallery.

word and image; if Raphael's portrait of Castiglione created the visual image of his friend as the ideal courtier, Castiglione crafted a verbal portrait of his friend in writings, some of them joint projects, as well as through his poems at Raphael's death.[85] The pair collaborated on the famous letter to Leo X about the antiquities of Rome (with input from Pietro Bembo and perhaps other humanists),[86] and Raphael's letter describing Villa Madama was also probably intended for Castiglione's editorial treatment.[87] The elements of visual–verbal collaboration, social interchange, and competition among artists and humanists were fundamentally important in this cultural milieu, significantly for my story.

These humanists and artists operated in an intellectual environment characterized by intensive literary, archeological, and topographical studies. Roman topography was fundamental to much of the imagery these humanists formulated for the papal *renovatio*, and under Pope Leo and Raphael a new archeological approach was also reflected in visual forms.[88] Raphael, working as an antiquarian and also an archeologist, was preparing a map of the ancient ruins of Rome, a project for which he was as renowned at his death as he was for his work as painter and architect – if not more so.[89] (The letter to Leo X was perhaps intended as a dedicatory letter to this project.[90]) In 1515, he was appointed Leo's Prefect of Marbles (*Praefectus marmorum et lapidum omnium*), a responsibility that has sometimes been misunderstood either reductively to apply only

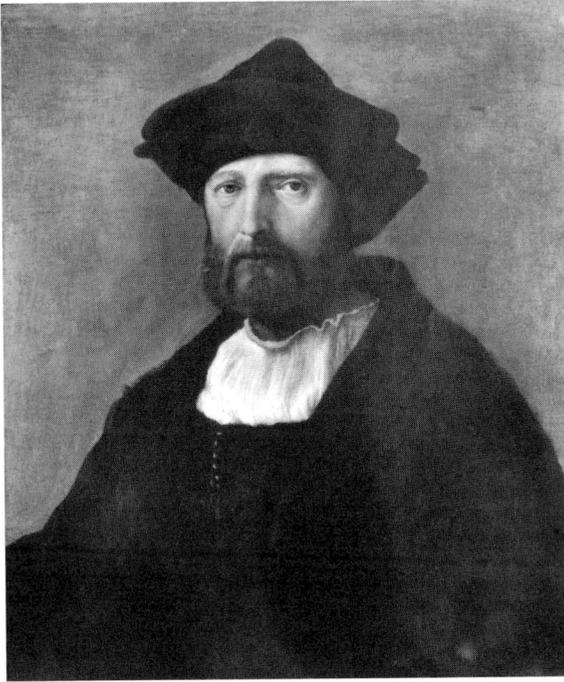

8. Raphael (or copy after), *Portrait of Antonio Tebaldeo, c.* 1515, location unknown.

to inscriptions, or anachronistically to make Raphael a superintendent with wide-ranging powers.[91] Leo's brief, reproduced here in full, clearly states that Raphael's primary task in this regard was acquiring marbles and stones for the construction of St. Peter's:

> To Raphael of Urbino: Since it is greatly in the interest of the construction of the Roman temple of the Prince of the Apostles that the supply of stones and marble, of which we need an abundance, should be had at home, rather than brought from afar; and [since] I have determined that the City's ruins suffice as an ample source for this material, and that stones of every kind are dug up here and there by practically everyone who in Rome, or near Rome, undertakes to build, or simply to turn the earth. *You, whom I employ as master of this building project, and whose skill in your craft and trustworthiness I have inspected and tested in many affairs, I appoint as overseer of all marbles and stones which henceforth shall be dug up in Rome, or within ten miles of Rome, so that you purchase for me what is suitable for the building of that temple.* Accordingly, I order all men, of middle, high or low rank, with regard to those pieces of marble, and stones of every kind, which they shall dig up within the area I have mentioned, that they should, as soon as possible, inform you as overseer of these things of each piece dug up. Whoever does not do so within three days shall be fined as you see fit, from a hundred to a thousand gold coins. Furthermore, since I have been informed that much of the ancient marble and stone, being

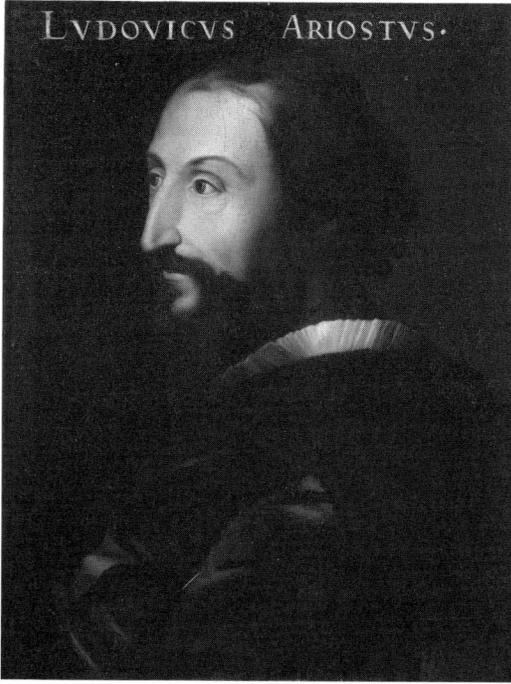

9. Cristofano dell'Altissimo, *Portrait of Ludovico Ariosto, c.* 1552–68, Florence, Uffizi.

inscribed with written records which often display some outstanding
information, the preservation of which would be worthwhile for the
cultivation of literature and for improving the elegance of the Roman
language, is randomly cut up by stone-masons using it as raw material,
with the result that the inscriptions are destroyed, I order all those who
exercise the craft of stone-cutting in Rome that they should not dare to
destroy or cut any inscribed stone without your command or permission,
the same fine being imposed on anyone who acts contrary to my order.
Issued on 27 August, the third year, at Rome.[92] [author's emphasis]

That confiscated ancient Roman marbles would be used for St. Peter's sup-
plied an unassailable justification for seizing them, for reasons both practical
and symbolic. But Leo surely extended this mandate to collect works for other
papal projects, including the Medici papal *hospitium* once begun, even if the
mostly private nature of the villa project would have precluded announcing
that fact.[93] Indeed the Medici were collecting ancient sculpture and spoils
while the villa was on the drawing board, and Sperulo's poem reveals that
ancient sculpture and spoils were essential components of the villa's design, as
the following chapters will demonstrate.

10. Raphael, *Project for a Stage Design*, probably Ariosto's *I suppositi*, staged in the Vatican on 6 March 1519. Florence, Uffizi, Gabinetto Disegni e Stampe, U 560Ar.

Of course, the nostalgia for the past glory of Rome and advocacy for its preservation and reconstruction were at once idealistic, pragmatic, and paradoxical, as Raphael himself continued to pillage ancient sites for the building supply of new Rome.[94] His

11. Raphael, *A Landscape with Figures and the Ruins of a Column*, c. 1512–13, Windsor, Royal Library Inv. RCIN 990117.

dual mandates to preserve and build anew necessarily came into conflict. But what has been called his "proto-archeological" approach signaled a new attitude, articulating a grand-scale, programmatic approach to Rome's ruins, and also embracing their study for study's sake; and his letter advocates using the tools of architectural design – plans, sections, and elevations – to study ruins, part of the ongoing dialogue among antiquarian studies, Vitruvian studies, and contemporary practice.[95]

RAPHAEL'S LAZARUS: THE MEDICI VILLA PROJECT

Just as Curial humanists revived Ciceronian Latin as a fundamental tool of verbal communication, Raphael forged a new visual language for the building of St. Peter's and the decorations in the Vatican Stanze and Logge.[96] Villa Madama was a manifestation of the same enterprise. At the villa, the Medici papacy would perform its power and authority in a microcosm of Leo's earthly kingdom. It was, in effect, a pastoral Vatican, whose architecture and decorations would be freighted with Medicean dynastic messages, modulated for a Roman papal environment. The villa complex was a utopian conception, and an environment for living *all'antica*, designed on an ambitious scale that was unprecedented in modern Rome, and intended to rival and surpass the villas of antiquity.[97]

Two surviving ground plans, U 273A and U 314A (Plates V, VI), provide the basis for reconstructing the grandiose scheme for the uncompleted Medici villa, along with additional plans detailing the gardens and outlying areas of the complex. U 314A is much closer to the design that was constructed, and is generally understood to have been a reworking of the earlier U 273A. These plans have been thoroughly analyzed, from early studies of Geymüller to the work of Frommel and David Coffin, among other scholars, who have used them to conceptualize elevations as well.[98] From these plans, we may imagine the grand complex envisioned by Raphael and Antonio da Sangallo: a long rectangular *corps de logis* set against the steep rise of the hillside, surrounded on three sides by an extensive network of gardens terraced down the gentler slope to the Tiber below. Geymüller's somewhat fanciful reconstruction in Figure 12 gives a good sense of the planned scope of the complex, if not its exact configuration. The wooden scale model of the building designed by Dewez for the Capitoline exhibition of 1983 is helpful in visualizing details of plan and elevation, albeit with some necessarily speculative elements (Figures 13, 14).

Raphael drafted a letter describing his plans for the unbuilt villa, a literary effort modeled closely on Pliny the Younger's descriptions of his Tuscan and Laurentine villas. Raphael's epistle contains elements of both ground plans, and thus must have been written during the time that U 314A was being formulated. No finished copy of this letter has emerged; the surviving draft was

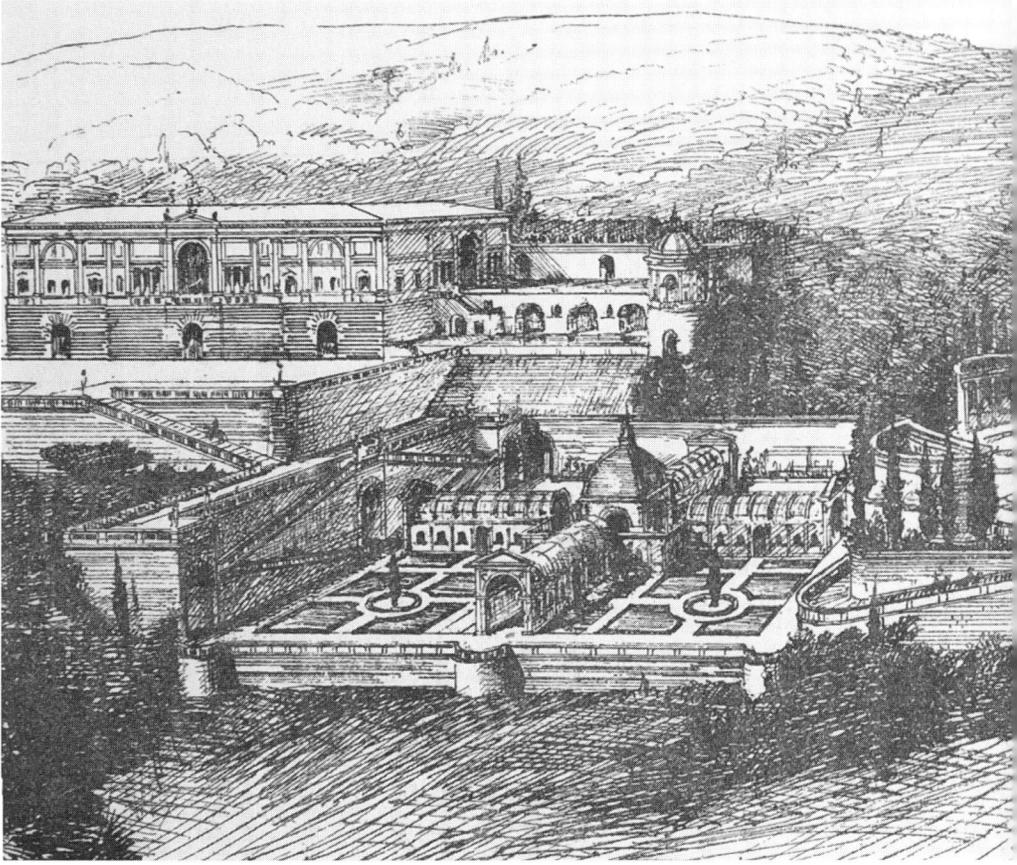

12. Heinrich von Geymüller, reconstruction of the Villa Madama complex, showing the northern half of the gardens.

probably intended to be polished by Castiglione,[99] and it was surely directed to Cardinal Giulio.[100] Raphael takes the patron/reader/listener on a virtual walk through the planned complex, giving a dynamic, bodily experience of the site and the space, and a vivid sense of the extraordinary amenities planned for the villa. He begins with the siting of the villa on the northeastern slope of Monte Mario, explaining the disposition of the building along a south-west-to-northeast axis as function of the winds (a literary formulation heavily indebted to Vitruvius and Pliny; in reality, the villa's siting was a function of the geography of the hillside, water sources, and symbolic topography as well).[101] Similarly, Raphael describes summer and winter quarters conceived for the comfort of visitors in all seasons; his letter entices the reader to imagine the pleasure of sitting on shaded benches next to a splashing fountain on a hot day, or in a southern-facing room with many glass windows on a cool one. These seasonal considerations were at once real, and also drew on long literary tradition, notably Pliny's villa descriptions.[102] Raphael details the three entrances to the villa (indicated on Figure 15): the main one from the Vatican

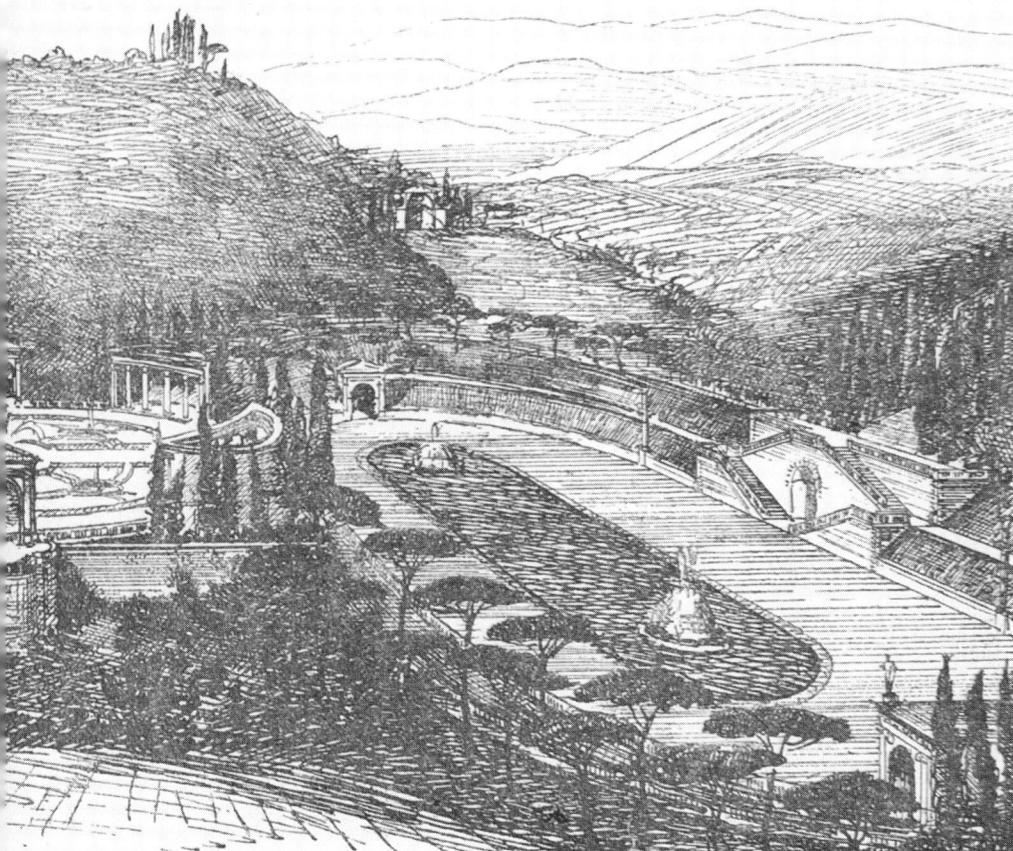

road, into a magnificent courtyard with ceremonial stairs; another proposed
road leading from the Rome–Viterbo road, which would bring visitors down
the steepest part of the hillside into the theater; and a proposed road lead-
ing straight from the Milvian Bridge to the villa's central Tiber loggia. This
emphasis on approaches was not a Plinian borrowing, and instead reflected
the importance Raphael and his patrons assigned to roads and sight lines in
determining the villa's siting.[103] Among the villa's highlights, he describes the
many grand halls; the round central courtyard (one of the major innovations
in U 314A); a semi-circular amphitheater terraced into the steep hillside; round
towers at the corners, one a winter *diaeta* (a pleasant place for conversation)
ringed with glass windows and another to house a chapel;[104] an enclosed gar-
den with bitter orange trees;[105] numerous fountains; a fishpond surrounded by
cool retreats for strolling and dining; a bath complex with hot, tepid, and cool
baths; stables for 400 horses with water running through the mangers; a hip-
podrome running the length of the villa for equine exercise and displays; and
gardens filled with trees. (Relevant locations are identified in the schematic
plan of the villa in Figure 15; the bath complex was to be on the floor below.)

13. Villa Madama, model of the reconstructed plan of the building, 1983; view as if looking downhill from the top of the site.

14. Villa Madama, model of the reconstructed plan of the building, 1983.

Construction of the villa probably began in 1518, and the work on the build-
ing and gardens continued intermittently for at least a decade, which also saw
the deaths of Raphael in 1520 and Pope Leo the following year, the elevation
of Cardinal Giulio to the papacy in 1523 as Pope Clement VII, and the Sack
of Rome in 1527.[106] Characteristic of construction practices for large projects,
the villa was to be built in phases, in this case beginning with the northeast
half of the *corps de logis* housing the summer quarters, which would constitute
a habitable nucleus of the grand plan. As it turned out, the first phase was
the only one executed, consisting of half the circular courtyard, half the long
building, the enclosed garden, the outer hippodrome-shaped garden, and the
fishpond, visible in an aerial photograph in Figure 16. Despite the deaths and
interruptions that plagued the project, this wing and the adjacent gardens were
mostly completed and abundantly ornamented. We do not know when hopes
of finishing the entire grand plan were abandoned, or when work ceased at the
villa; payments to two overseers at the villa site in 1528 and 1529 could be for
continuing work, or simply for maintenance,[107] but the *terminus ante quem* of
the initial Medicean phase was the death of Clement on 24 September 1534.[108]

The villa's rich post–Medici history includes its ownership by the Farnese
family and then the Bourbons, several private owners, and finally its acquisi-
tion by the Italian government in 1937 as the seat of the Ministry of Foreign
Affairs, thereby restoring the complex to its original function as a theater of
diplomacy to receive visiting heads of state, a function it still serves today.[109]

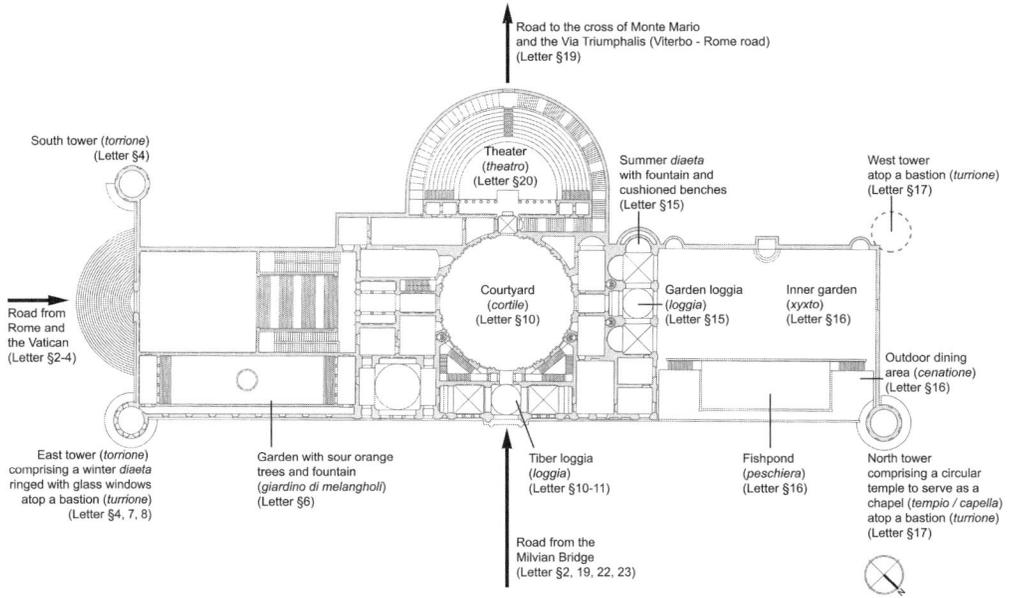

Road to the cross of Monte Mario
and the Via Triumphalis (Viterbo - Rome road)
(Letter §19)

South tower (*torrione*)
(Letter §4)

Theater
(*theatro*)
(Letter §20)

Summer *diaeta*
with fountain and
cushioned benches
(Letter §15)

West tower
atop a bastion (*turrione*)
(Letter §17)

Courtyard
(*cortile*)
(Letter §10)

Garden loggia
(*loggia*)
(Letter §15)

Inner garden
(*xyxto*)
(Letter §16)

Road from
Rome and
the Vatican
(Letter §2-4)

Outdoor dining
area (*cenatione*)
(Letter §16)

East tower (*torrione*)
comprising a winter *diaeta*
ringed with glass windows
atop a bastion (*turrione*)
(Letter §4, 7, 8)

Garden with sour orange
trees and fountain
(*giardino di melangholi*)
(Letter §6)

Tiber loggia
(*loggia*)
(Letter §10-11)

Fishpond
(*peschiera*)
(Letter §16)

North tower
comprising a circular
temple to serve as a
chapel (*tempio / capella*)
atop a bastion (*turrione*)
(Letter §17)

Road from the
Milvian Bridge
(Letter §2, 19, 22, 23)

15. Villa Madama, schematic plan based on U 314A identifying areas of the villa discussed, with Raphael's vocabulary for the spaces described in his letter, and a reference to the corresponding section of his letter in Raphael/Dewez.

It is known today as Villa Madama, after its owner later in the cinquecento: "Madama" Margarita d'Austria, natural daughter of Emperor Charles V. She married first Alessandro de' Medici and then, after his death, Ottavio Farnese, thereby transferring the villa into that family. But during the Medici pontificates, the villa was variously known as the *vigna del papa*, the *vigna sotto la croce di Monte Mario* (a toponymic reference discussed in Chapter 5), and the Villa Falcona, for the Medici falcon *impresa* as well as for the surrounding woods, the Prato di Falcone, as Sheryl Reiss discovered.[110]

The villa we see today, though just a kernel of the grandiose complex envisioned, is still an extraordinary place; the seeming remoteness of the verdant site, the grand scale of the rooms, the sparkle of the crystalline stucco revetments, the quality of light, and the views to the distant hills and Rome below are just a few elements that have prompted centuries of visitors to record the sense of wonder experienced during their visits. Although the focus of this book is not the villa as built, a brief overview of its major spaces will serve to orient the reader to the plans being formulated by our protagonists. Throughout the villa's history, the hemispherical half of the round courtyard that was built has served as an unlikely entry façade (Plates XVI, XVII). This entrance leads into an all-white vestibule; walls and vaults are articulated by low-relief stucco in a variety of forms, a tour de force of this new material recently revived after antiquity by the Raphael school (Figure 17).[111] The vestibule leads into the

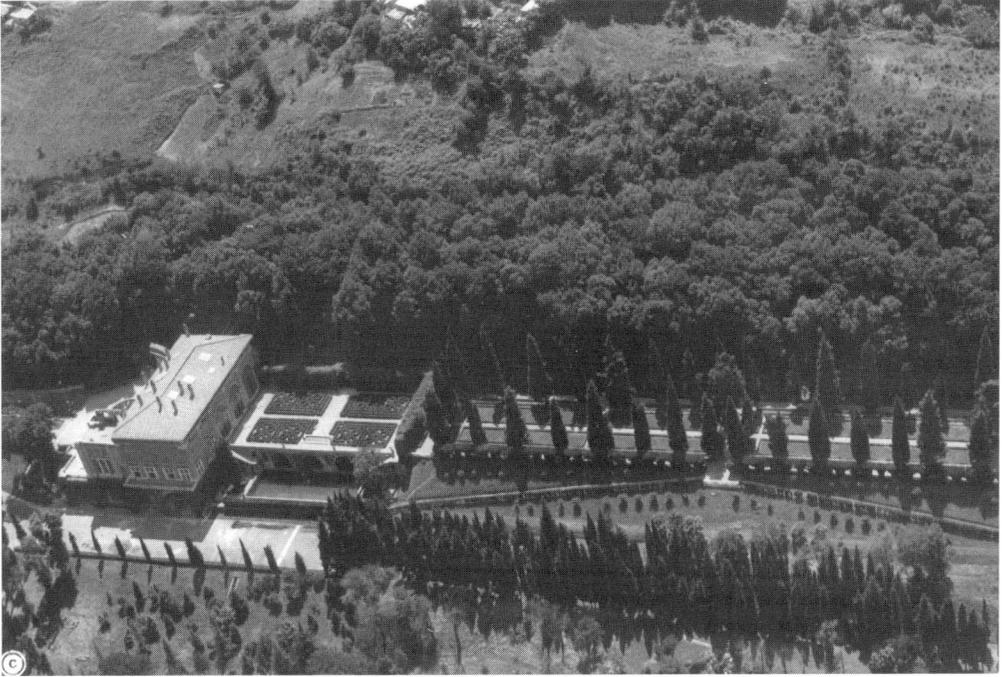

16. Villa Madama, aerial view showing the portion of the design that was built.

most important representational space constructed within the villa building: the garden loggia (Figures 18, 19), an extravagantly scaled room with soaring vaults that evoke an ancient bath complex or basilica. This tripartite loggia is capped by two groin vaults flanking a central dome vault. The long loggia is asymmetrical in plan; there is an exedra at the head of the loggia, while its tail end terminates in a flat wall (visible in plan in Figure 15 and in elevation in Plates XVIII, XIX). One long wall is punctuated with three arched openings to the garden, now glazed but originally open. On the opposite long wall, exedrae protrude from the two side bays, and the central bay leads back into the vestibule. The hall is decorated with richly interwoven frescoed and poly-chromed stucco decorations, which blanket the vaults, dome, pendentives, and walls. The loggia's walls and exedrae are also lined with niches for sculpture, and indeed the villa was once filled with antiquities, as we may see in eighteenth-century views (Plates XVIII, XIX), before the villa was stripped of its sculpture later in that century. The loggia was originally open to the rectangular inner garden, which Raphael labeled the *xystus* after Pliny (Figure 19). The sight line from the main entrance through the vestibule bisects the garden loggia, leading directly through the inner garden on axis (Figure 20). The interpen-etration of building and garden is striking; the architecture encloses the inner garden, which is an extension of the open loggia. This ensemble of loggia and garden exemplifies the Renaissance dialectic of art and nature.[112] The garden is

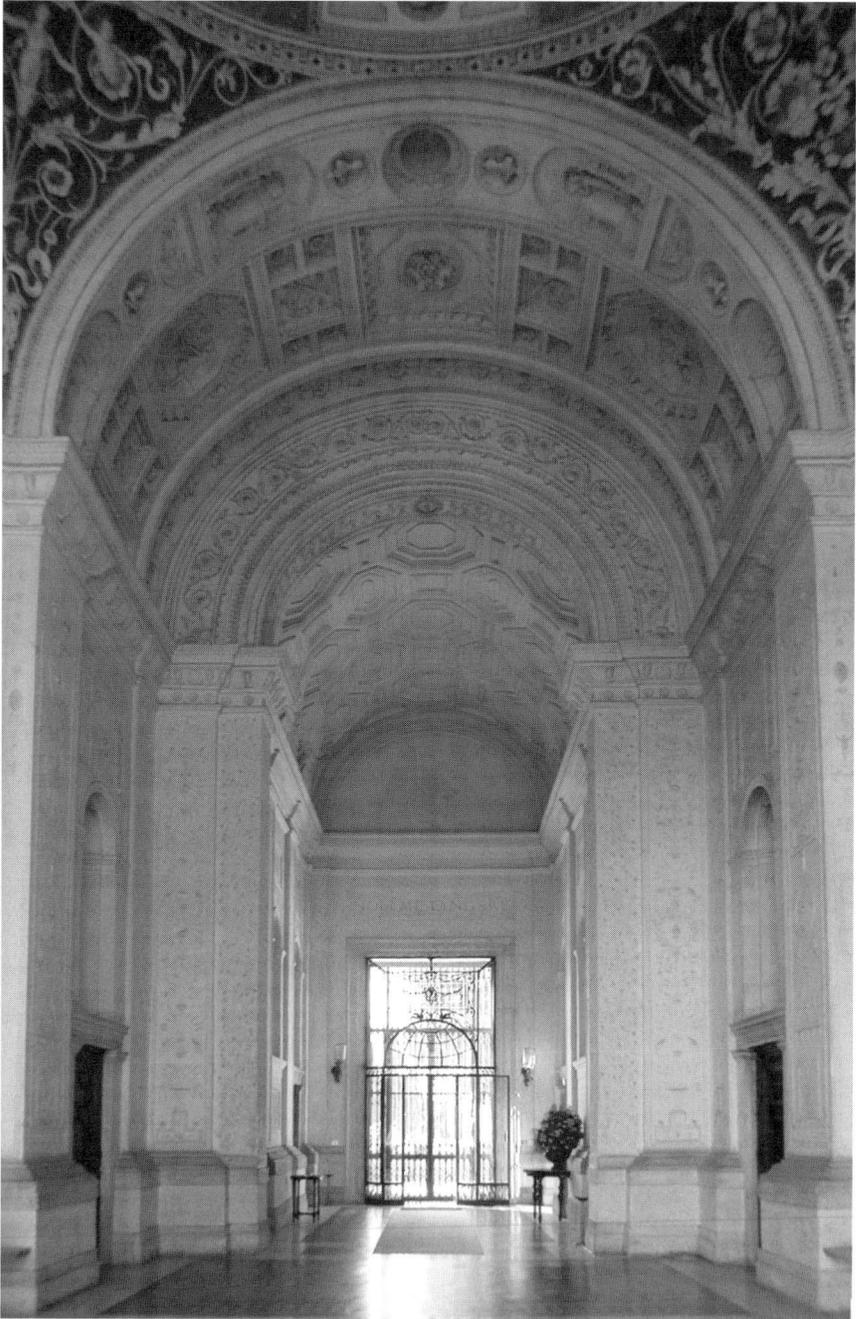

17. Villa Madama, vestibule.

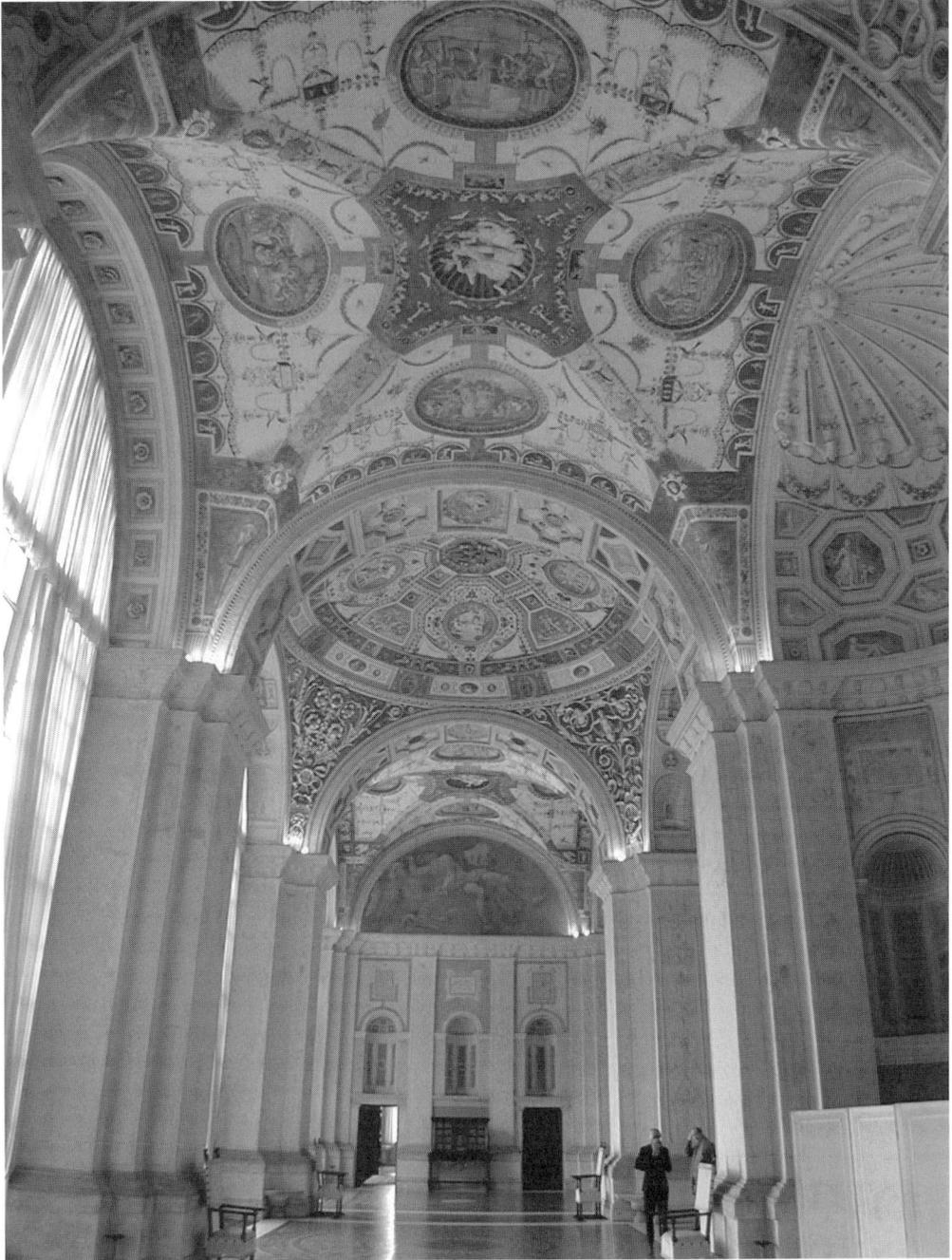

18. Villa Madama, garden loggia.

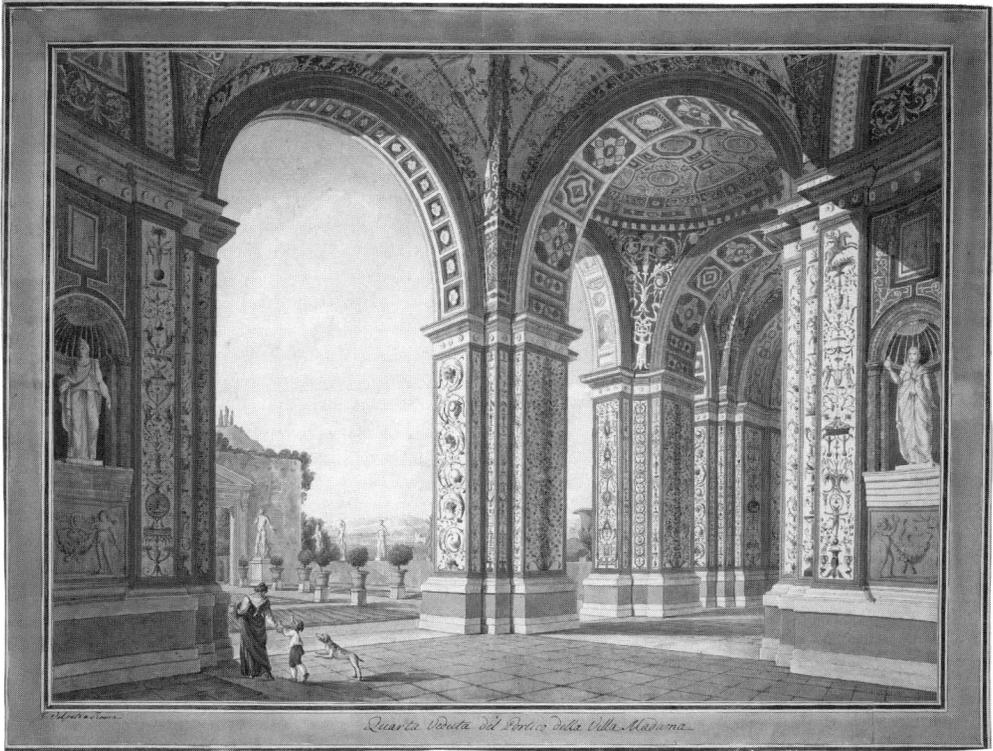

19. Giovanni Volpato (1738–1803), Villa Madama, garden loggia opening to the inner garden; view from the southwest end. Engraving with watercolor, Kunstsammlungen der Veste Coburg, Inv. XII. 252.1.

surrounded by architecture on three sides: the loggia and two enclosing walls. The long garden wall is punctuated by three niches; two were originally filled with colossal statues, and the central one still houses the well-known Elephant Fountain.[113] The short garden wall opposite the garden loggia has at its center a classical portal that separates this space from wilder nature in the hippodrome garden beyond. The door is flanked by two crumbling stucco colossi by Baccio Bandinelli (1493–1560) that remain from the era of Raphael and the Medici.[114] Stairs from either end of this garden lead down to the fishpond (*peschiera*), and to an ambulatory behind the pond with three grotto-like exedrae tucked beneath the hanging garden (Figure 21). These spots offer stunning views of the distant hills and the Tiber valley below.

The decorations were carried out after Raphael's death by his closest associates, notably Giulio Romano (*c.* 1499–1546), Giovanni da Udine (1487–1564), and Baldassare Peruzzi (1481–1536). Giulio and Giovanni battled each other for control of Raphael's workshop, and specifically for the villa project, as we know from a letter of Cardinal Giulio's referring to their squabbles in a tone of wry exasperation.[115] Nonetheless, they created an extraordinary decorative ensemble integrating painted and stucco decoration *all'antica* with figural and

relief sculpture, both ancient and modern. The decorative complex incorporated architecture, multimedia decorations, and garden elements into a network of meanings alluding to ancient literature, cosmology, Medici dynastic propaganda, papal foreign policy, and antiquarian interests. The villa's imagery would reflect its hybrid character, combining the pomp of a Vatican hall of state with the license of a private villa. The decorative ensemble was also remarkable for its union of classical pastoral imagery with Christian Golden Age material. In particular, imagery of Venus and related notions of peace, concord, and eternal spring under the Medici would appear throughout the villa in painting, stucco, and sculpture (Plate VIII). Such imagery translated Laurentian conceits to a Roman papal mode apposite for this villa. No evidence has yet emerged to show whether Raphael had a hand in conceiving the decorative scheme, even in broad outline; nor does his letter, perhaps following Pliny, devote much attention to decorations. However, the evidence laid out in the following chapters suggests that Raphael was indeed thinking ahead to certain aspects of the decorative complex.

Raphael and his associates drew on a rich list of formal sources for the design of the villa complex: the towers of the Ducal Palace in Urbino, the fishpond of Villa Poggioreale in Naples, the tripartite loggia of Bramante's Colonna nymphaeum at Genazzano, and the disposition of sculpture at Hadrian's Villa in Tivoli, to name just a few citations. The plentiful ruins of other suburban villas dotting the hillsides of Tivoli (including the Sanctuary of Hercules Victor, then understood to be a villa) offered powerful models for the siting of a terraced villa on a steep hillside with views – the so-called prospect villa – as well as ideas for the fishpond, water theater, grotto, and the use of calcareous materials. Earlier Medici villas served as especially important formal and conceptual models, from the form of a garden loggia open to an enclosed garden near the crest of a steeply terraced hillside, as in the Villa Medici at Fiesole,[116] to Laurentian ideas of *villeggiatura* embodied at Poggio a Caiano.[117] Pope Leo and Cardinal Giulio were involved in completing the decorations at Poggio a Caiano at the same time they were building their own villa in Rome, so they were closely attuned to parallels with Lorenzo's villa,[118] also conceived to serve the dual function of *hospitium* and private villa; and there was surely a crucial exchange of ideas among patrons, artists, and advisors for these contemporaneous projects for Florentine and Roman Medici villas. Medici patronage had long been characterized by an extensive interest in archeological and literary models, especially in connection with villas.[119] In her analysis of notions of the humanist villa, Amanda Lillie noted that the first Renaissance villas whose architectural form was in some way guided by humanist notions or ancient prototypes were the Medici villas at Fiesole and Poggio a Caiano,[120] so this Medicean emphasis on the relation between villa architecture and literary conception was long-familiar to

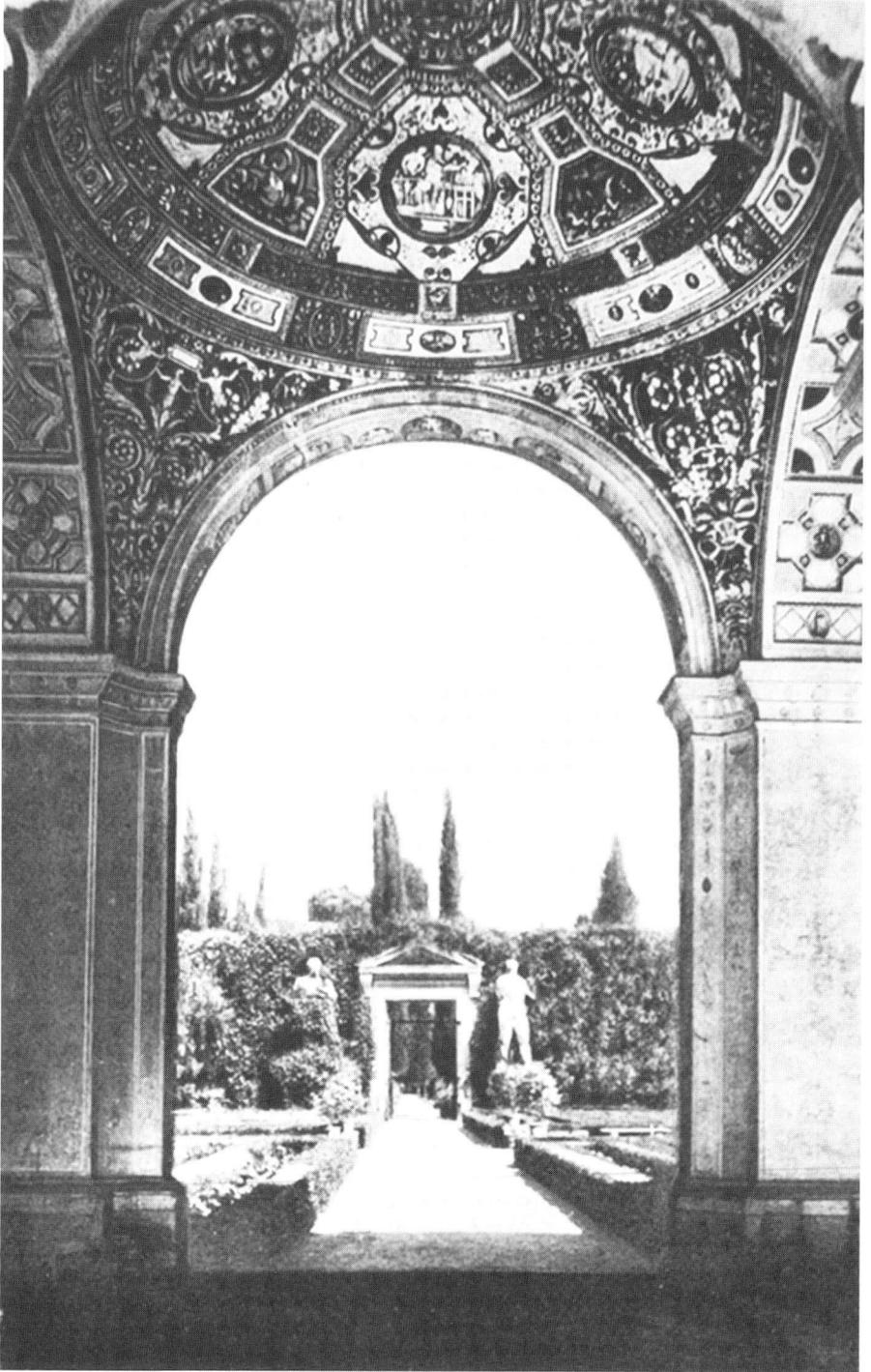

20. Photomontage reconstructing the view through the garden loggia when it was still unglazed; the vista from the entrance bisects the garden loggia, continuing through the inner garden on axis to the garden portal. From Mario Bafile, *Il giardino di Villa Madama,* Rome, 1942.

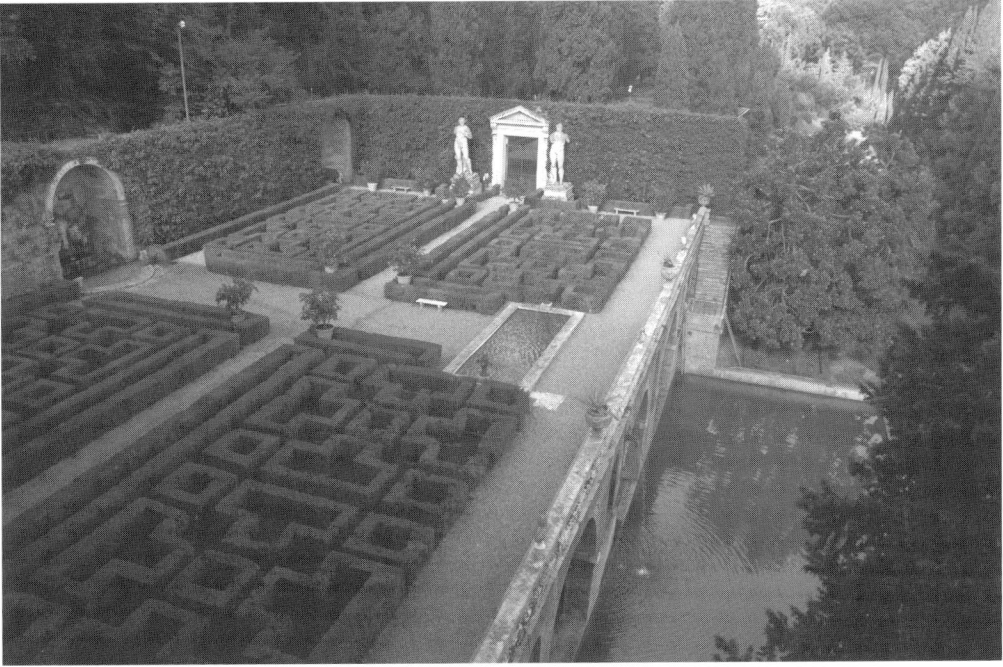

21. Villa Madama, view of the inner garden and fishpond from the building.

Pope Leo and Cardinal Giulio. Diplomatic and cultural exchange between Laurentian Florence and Aragonese Naples fostered another influential node of villa culture at the late quattrocento Aragonese villa of Poggioreale in Naples.[121] Lorenzo sent the Florentine architect Giuliano da Maiano to Naples with plans that were fundamental for Poggioreale, thus it featured the latest in Florentine as well as Aragonese/Neapolitan design. It also remained a beacon for the next generation; Raphael's close associates Fra Giocondo and Peruzzi visited and sketched the Neapolitan villa, so its architectural features were familiar to the Raphael school at first hand.[122] A thorough analysis of architectural sources is beyond the scope of the present study, but it is important simply to note this citation of significant models, ancient and modern.

This selection from many sources was, in fact, understood as a marker of the highest form of artistic creativity. The citation of many models at the Medici villa reflects the practice of creative selection of earlier prototypes and their transformation into an innovative assemblage, shared by artists and *letterati*. The Latin term *inventio* encompasses the meanings of the modern English words *invention* and *inventory* – the latter being necessary for the former.[123] The famous letter ostensibly written by Raphael about his "certain idea of beauty" presents the composite process of selection as his artistic

manifesto. Whether one accepts this letter as representing Raphael's own ideas polished by Castiglione, or as Castiglione's literary portrait of Raphael, it represents contemporary perceptions of Raphael's artistry.[124] Significantly, the letter stresses the importance of selecting elements from many models in architecture as well as in painting; as an architect, Raphael says he had to look beyond Vitruvius to consider other models in the ruins of Rome in order to find "le belle forme degli edifici antichi," while as painter of the *Galatea*, he needed many models of female beauty, an allusion to the topos of Zeuxis and the maidens of Crotona.[125] Of course, the point of the letter was that even more important than Raphael's models was his own "certa Idea." Eugenio Battisti first suggested that the *Idea* was not an internal image, but rather an instinctive criterion of *selection*, further noting that the "certa Idea" is a translation of Giovanfrancesco Pico della Mirandola's "Idea quaedam," which Pico connected with the Zeuxian topos as a model of eloquence.[126] Thus, the *Idea* itself evokes the selection method, and the letter suggests the importance of the creative practice of selection for various modes of Raphael's expression.[127] In addition, the letter's parallel between Raphael's composition from ruined buildings and from beautiful maidens reflects the architecture–body metaphor, appropriate for this collective enterprise to re-member the corpse of Rome and its buildings.[128]

At the same time Raphael and his Medici patrons were assembling plans for the extraordinary villa on Monte Mario, Roman humanists occupied themselves with the project, too; the following chapter turns to the poets who visited the construction site of the rising Medici *hospitium*, and their rich literary source-book on the theme of the villa.

CHAPTER TWO

WRITING ARCHITECTURE

SINCE ANTIQUITY, THE VILLA HAD BEEN THE BUILDING TYPE MOST closely associated with literary production, consonant with the ideology of the villa to foster *otium*, or the contemplative life.[1] A long tradition of literature celebrated villa life, design, and decoration in a variety of forms, notably poetry and prose panegyrics, *ekphrastic* set pieces, letters, dialogues set in villas, architectural treatises, agricultural and husbandry texts, and rhetorical exercises.[2] This chapter traces the rich sources of classical and earlier Renaissance villa literature, as well as other literary forms and practices that provided important models for early sixteenth-century humanists, before turning to the descriptions of Villa Madama itself. It considers the poets who visited the Medici construction site, their proleptic villa descriptions, and their practices for composing and disseminating these works.

THE TEXTUAL VILLA

Among the classical sources on villas, the letters of Pliny the Younger describing two of his estates provide the fullest descriptions, which served as touchstones for the literature, design, and conception of villas down to modernity.[3] Raphael was not the first to draw on these letters for literary and architectural inspiration; among his models were Paolo Giovio's description of his family's Villa Lissago at Como written in 1504, also a Plinian pastiche that borrowed terms such as *xystus, cryptoporticus*, and *coenatio*. Giovio additionally relied on

CAII PLINII SECVNDI NOVOCOMENSIS.ORATO
RIS FACVNDISSIMI EPISTOLARVM LIBER PRI,
MVS INCIPIT.
C.Plinius Secundus Septitio fuo.S.plu.dicit.

Requenter hortatus es:ut epiftolas fi q̄s pau
lo accuratius fcripfiffem:colligerem:publica
remq̃; collegi non feruato temporis ordine:
neq̃ enim hiftoriá cōponebam: fed ut quæq̃
in manus uenerat Supereft ut nec te confilii:
nec me pœniteat obfequii . Ita enim fiet : ut
eas quæ adhuc neglectæ iacent:requiram:& fi quas addide,
ro:non fupprimam. Vale.

C. Plinius Arrinio fuo Salutem.
Via tardiorem aduétum tuum profpicio:Li,
brum quem prioribus epiftolis promiferá :
exhibeo.Hunc rogo ex confuetudine tua &
legas & emendes : eo magis quod nihil ante
peræque eodem zelo fcripfiffe uideor . tenta
ui enim imitari Demofthenem femper tuum caluum nup
meum figuris duntaxat orationis.Nam uim tantorum uiro
rum/pauci quos æquus amauit Iupiter affequi poffunt.Nec
materia ipfa huie:(Vexeor ne improbe dicam) æmulationi
repugnauit:Erat enim prope tota in contentione dicendi:
quod me longæ defidiæ indormientem excitauit: Si modo
is fum ego;qui excitari poffim:non tamen omnino. M. no,
ftri ΛΗΚΥΘΟΝϹ · fugimus.quotiens paulum itinere decede
re non in tempeftiuis amœnitatibus admonebamur.Acres
enim nō triftes effe uolebamus.Nec eft quod putes me fub
hac exceptione ueniá poftulare.Immo quo magis incendá li
má tuam:confitebor & ipfum me & cōtubernales ab editio
ne nō abhorrere:fi modo tu fortaffe errori noftro albū cal
culum adieceris,Eft enim plane aliquid edédum; atq̃ utiná

a ii

22. Pliny the Younger, *Epistolarum libri IX*, Treviso: Ioannes Vercellius, 1483. First folio of Bernardo Bembo's copy of Pliny's Letters.

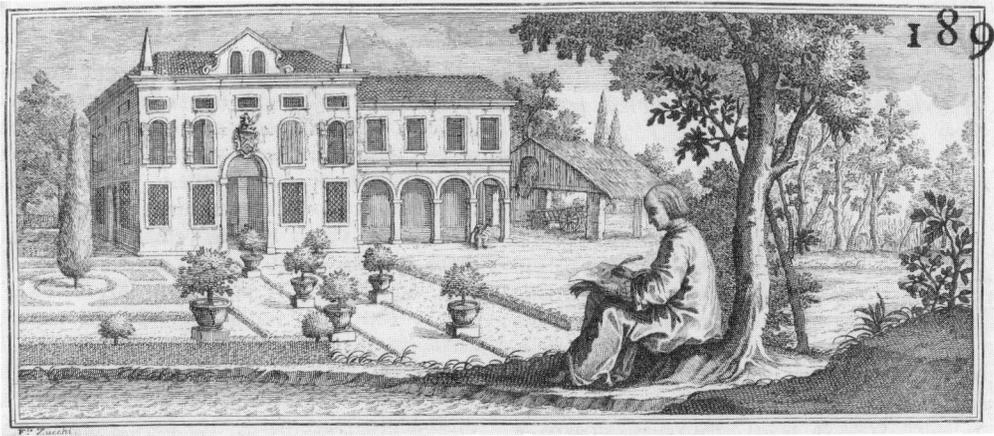

23. Francesco Zucchi, *Pietro Bembo in Villa Bozza*, in *Opere del cardinale Pietro Bembo*, Venice, 1729. The younger Bembo is visualized at Villa Bozza, the Bembo family villa in Santa Maria di Non outside Padua, at the meeting of the rivers Piovego and Brenta.

Grapaldo's *De partibus aedium*, a text of 1494 that interpreted such Plinian vocabulary.[4] Bernardo Bembo (1433–1519), the Venetian humanist/diplomat who spent time in the circle of Lorenzo de' Medici, owned a 1483 edition of Pliny's letters (Figure 22), as well as a villa outside Padua, and was deeply influenced by Pliny's notion of *villeggiatura*; these interests were shared by his son, Raphael's friend Pietro Bembo, as demonstrated in writings from his earliest work, *De Aetna*, to his autograph comments on the family copy of Pliny's letters, and his own letters describing the family villa, which he inherited at the death of his father in May 1519 (Figure 23).[5] Pliny's letters were already essential sources for the Renaissance villa in 1430s Ferrara, notably for the Este villa of Belriguardo, the first Renaissance seigneurial residence to attempt to rival the magnificence of the ancient villa; and the Plinian panegyrics produced by humanists in the Este circle must have been known to later humanists.[6]

But despite the fundamental importance of Pliny's letters for Renaissance readers and villa builders, their renown has overshadowed the abundant ancient villa literature read by Renaissance humanists such as Sperulo and his contemporaries, who looked to an extensive range of models for content, as well as language and form.[7] Renaissance humanists embraced the overlapping genres of poetry and rhetoric, and the associated forms of panegyric and encomium, all of which shared the technique of *ekphrasis* and an emphasis on praise and display.[8] In fact, the combination of genres and techniques to forge new literary modes is an important part of this story, a point that will become clear in Chapter 4. For form and diction, Virgil served as a fundamental model for cinquecento poetry, much as Ciceronian Latin provided the gold standard for Curial communiqués in prose.[9] Although the content of villa panegyrics differed markedly from Virgil's epic subjects in the *Aeneid* or his bucolic *Eclogues*

and *Georgics*, Renaissance poets adapted Virgilian epic and pastoral themes and language for their own uses.[10]

As we shall see, what has been disparagingly dismissed as the "shamelessly encomiastic" tone of Sperulo's poem is in fact a function of its most direct literary model: the *Silvae* of Statius, the first-century CE poet who heaped hyperbolic praise on the Emperor Domitian as well as private patrons by describing their accomplishments, from building palaces and imperial roads to erecting statues and hosting lavish banquets. Statius had raised the art of panegyric to a new level:[11] he was the first poet to describe a work of art as the subject of a full-length poem rather than a digression in a longer work, and two of his *Silvae* were devoted to the building of villas.[12] His *Silvae* became the model for late antique and Renaissance poets for the novel combination of an encomium to a patron, which included standard panegyrical tropes of praising his family and origins, with an extended description of one of his works, showing how it reflected the character and values of its builder. Along with Pliny's villa letters in prose, Statius' villa poems provided the first villa descriptions as the subject of a full-length text.[13] Furthermore, Statius' choice of the title *Silvae*, plural of the Latin *silva* – variously interpreted to mean wood, woodlands, forest, pasture, or metaphorically, the raw material of composition or construction – established a poetic tradition that would have rich associations for Renaissance pastoral poets.[14] His villa poems were a potent model for later villa writers, from Pliny himself to late-antique villa panegyrists.

Statius once again became popular at the time of Dante (for his ostensibly Christian-themed *Thebaid*), but his *Silvae* were not discovered until the early fifteenth century by Poggio Bracciolini, and the work was popularized in quattrocento Italy and beyond by Angelo Poliziano.[15] The first course Poliziano taught at the Studio Fiorentino in 1480–1 was on Statius' *Silvae* (as well as Quintilian's *Institutio oratoria*), and he prepared a commentary on the *Silvae* that was widely known in manuscript, although it remained unpublished.[16] The *Silvae* became important in Laurentian culture as sources for Poliziano's *Stanze*, Botticelli's *Primavera*, and Lorenzo's motto *Le tems revient*.[17] Statius' poems were also popular among Roman humanists in the late quattrocento and early cinquecento, including Niccolò Perotti, Domizio Calderini, who published an edition of the *Silvae* in 1475, and Parrhasius, who gave a course of lectures about the poems in Rome in 1514.[18] Angelo Colocci copied snippets of Statius' works in a manuscript collection interspersing the writings of ancient and Renaissance authors (BAV, Vat. Lat. 3353). Statius' popularity may even have landed him a privileged place in Raphael's collection of laurel-crowned ancient and modern poets in his *Parnassus* fresco; some scholars have proposed that Statius appears in the grouping of Homer, Dante, and Virgil – perhaps even as a self-portrait of Raphael (Figure 24).[19]

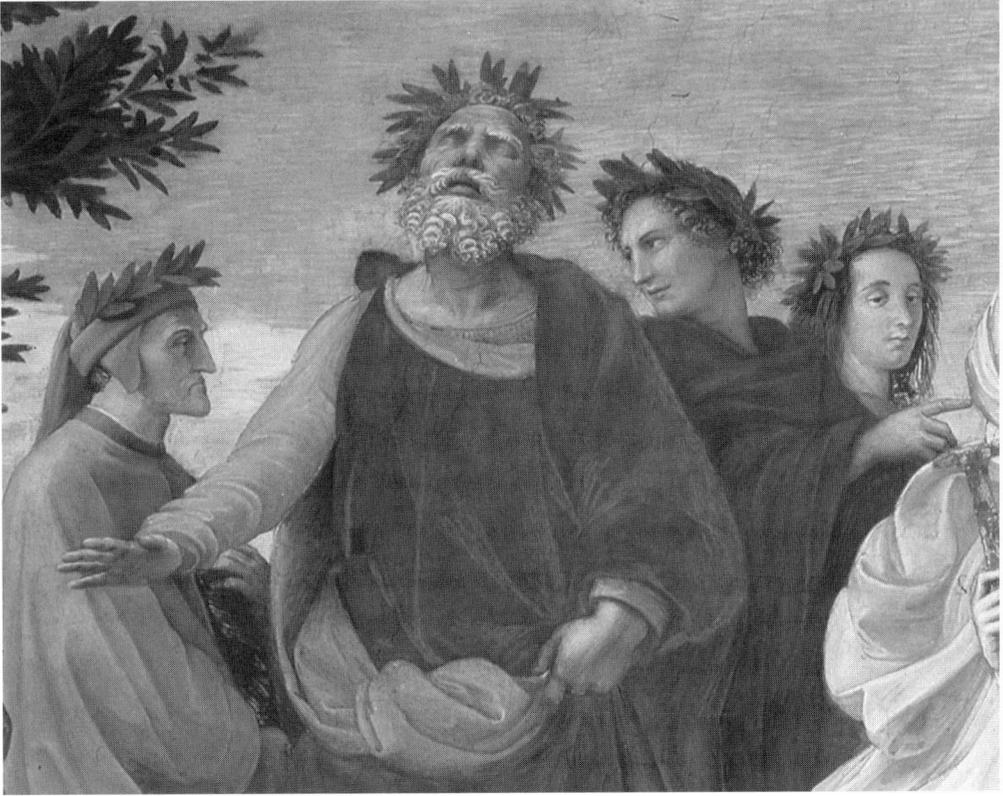

24. Raphael and associates, *Parnassus*, detail depicting (left to right) Dante, Homer, Virgil, and Statius(?), perhaps as a self-portrait of the artist; 1509–11, Stanza della Segnatura, Vatican Palace.

Another reason for the prominence of Statius' villa poetry in this circle may have been archeological. Raphael and his humanist friends who journeyed to Tivoli probably visited the ruins of one of the villas described by Statius: the Tiburtine villa of Manilius Vopiscus, or ruins they identified as such. Although no evidence for their itinerary has emerged, other cinquecento antiquarians specifically described the remains of Vopiscus' villa, and Antonio da Sangallo later described the fountains there, encrusted with sponge stones and stalactites. (This further suggests that Vopiscus' villa may have been a source of inspiration for the novel naturalistic grotto and fishpond at Villa Madama, discussed in Chapter 5.) The rare confluence of surviving physical and textual evidence surely made Vopiscus' villa a powerful model, in word and image.

Using Statius as a model, Poliziano and other quattrocento humanists had written *silvae* themselves, which popularized the *silva* throughout Europe.[20] The renaissance of the *silva* coincided with the development of the so-called humanist villa on the Italian peninsula;[21] this conjunction surely fostered the flowering of villa poems – many identified as *silvae* – throughout the Italian peninsula during the late quattrocento and early cinquecento.[22] Notable among

them for our story were many poems celebrating Medici villas, in addition to letters and prose panegyrics about villas.[23] These villa descriptions were part of a broader tradition of architectural panegyrics long favored by the Medici, especially Cosimo and Lorenzo.[24] The Medici villa poems included descriptions of Careggi by Alessandro Braccesi and Alberto Avogadro,[25] Poliziano's *silvae* celebrating the Fiesole villa,[26] and many poems about Lorenzo de' Medici's villa at Poggio a Caiano by poets including Poliziano and Lorenzo himself,[27] which hold special importance for this account of Sperulo and his Medici patrons. Non-Medicean examples abound, too. Poliziano's disciple Pietro Crinito wrote a *silva* about the Orti Oricellari, the Florentine garden villa of Bernardo Rucellai well known as the site of intellectual gatherings of eminent contemporary politicians and humanists, including Niccolò Machiavelli. This wooded garden itself became known as a *sylva* – a physical counterpart of the poetic *silva*.[28] Also in Florence, Sassetti's Villa di Montughi (now La Pietra) was the subject of poetry by Ugolino Verino and Bartolommeo Fonzio.[29] In the influential humanist center of Naples, Giovanni Pontano produced poems about Neapolitan villas including Poggioreale, the villas of Baia, and his own modest estates,[30] and Jacopo Sannazzaro later composed an epigram about his Villa Mergellina, where he wrote many of his *all'antica* eclogues.[31] In Bologna, the plague of 1478–9 dispersed humanists including Battista Spagnoli Mantuanus to the countryside, where he praised the virtues of his patron's villas.[32] In Rome, just a few years before the Medici villa was begun, Sperulo's colleagues Egidio Gallo and Blosio Palladio each wrote a long panegyric about Agostino Chigi's villa, now known as the Villa Farnesina. Both of these works were accompanied by a number of shorter poems by fellow Roman academicians praising either the villa itself or the main author's poem about it – an important precursor to the Villa Madama poetry.[33] Other poets drawn to Julian and Leonine Rome participated in this culture of the villa, including Neapolitan humanist Girolamo Borgia who wrote a panegyric eclogue about Angelo Colocci's popular villa garden near the Trevi fountain, which he dedicated to Colocci, Julius II, and his daughter Felice, who is cast as the nymph of the site.[34] Poems devoted to the Roman villa of Pietro Mellini include a Pindaric ode by the Cremonese poet Benedetto Lampridio (1478–1539), and others by Tebaldeo.[35]

There were close connections among these humanists and patrons from Rome, Florence, and Naples, as we know from their correspondence and diplomatic travels.[36] Since Lorenzo de' Medici and the rulers of Naples traded architects and villa ground plans at a time when Pontano was a diplomatic attaché, it would be surprising if villa poems were not exchanged as well.[37] Moreover, Bernardo Rucellai visited Pontano at one of his Neapolitan villas, and the Florentine Crinito addressed villa poems to Neapolitan patrons, a significant example of Florentine–Neapolitan cultural exchange on the

theme of *villeggiatura*.[38] Agostino Chigi also had property in Naples, and close ties to its rulers and humanists including Pontano and Sannazzaro, fostering exchange with Roman humanists and artists in his circle, from Blosio Palladio and Colocci to Raphael.[39] (We may also speculate that the poets in Aragonese Naples were aware of the tradition of the *rawdiyyāt*, the form of garden poetry that flourished in Spain as well as Sicily, and the Islamic tradition of poetic competitions held in gardens.[40]) So, Sperulo and his Roman colleagues were certainly familiar with villa poetry from all over the Italian peninsula. In fact, villa literature is notably intertextual, and Renaissance villa poets clearly responded to each other's works as well as those of their classical antecedents, inserting their poetry into this lineage, and competing with their predecessors and contemporaries.[41]

In addition to the rich tradition of villa literature itself, other literary models provided inspiration and context for poets describing specific architectural situations or locations. Virgil displayed a contrast between describing the abstract or utopian and the actual with his *Eclogues* and *Georgics*, the latter of which were a model for praising the specificity of a place.[42] Poetry about the ruins of Rome further contributed an instrumental model for the combination of literary, philological, and topographical tropes, from Petrarchan laments to Castiglione's early sonnet, *Superbi colli e voi, sacre ruine*. Other works provided models for describing the imaginary as well as the real. The *Hypnerotomachia Polifili*, with its rich archeological and philological sourcebook and fantastical conflation of a dreamscape with real-world places (which scholars are still trying to distinguish), must have been a crucial spur to creative descriptions melding the actual and imagined. If one accepts the interpretation that its author was Francesco Colonna, a Roman nobleman who was Lord of Palestrina and a member of the Roman Academy under Pomponio Leto, then this 1499 work takes on fundamental importance for the early cinquecento Roman intellectual milieu of Sperulo and the Medici.[43] But whatever the work's authorship and provenance, its allusions to actual Roman sites and antiquities surely contributed to its importance among Roman humanists, including Colocci.[44]

Poetry dedicated to specific works of sculpture was another popular element of Roman humanist-antiquarian culture that fostered ways of approaching the material world that would be important for poets at the Medici villa. Indeed, a significant amount of Renaissance poetry was devoted to sculpture, ancient and modern, which was composed for special occasions. Most famously, the copious poetry by humanists including Sperulo about the ancient *Laocoön* at its excavation in 1506 served to complete and recontextualize the sculpture. The *Ariadne*, then identified as a Sleeping Cleopatra, provided another impetus for poets including Castiglione to use text to recontextualize antiquities.[45] Goritz's 1510–12 commission for the St. Anne altar in the Roman church of Sant'Agostino, composed of a sculpture by Andrea Sansovino and a fresco by

Raphael, was praised by the foremost *letterati* in Rome, who produced several hundred poems annually about the work. These were physically affixed to the altar, becoming part of the display together with painting and sculpture, before they were later collected in the 1524 *Coryciana* anthology,[46] rendering the poets "makers" of the physical installation, along with the artists and patron.[47] This tradition of praising sculpture and making a new context for it through words will emerge as an important framework for the villa poetry I am discussing.

The power of the word to describe or invent places was based on long-standing habits of mind. Perhaps the most essential tool was *ekphrasis* (Latin *descriptio*), used since the ancient rhetorical exercises known as *Progymnasmata* to bring a variety of subject matter vividly before the eyes, including buildings and works of art, real or imagined.[48] Mnemonic practices also fostered these skills in the exercise of locational memory, which had been linked to invention from ancient oratory to medieval mnemonic methods. Aristotle, Cicero, St. Paul, and medieval monks all engaged in the practice of making fictive mental sites for remembering, and also for creative invention.[49] The trope of the poet as master builder in medieval literature reflected the inventional nature of mnemonic building as a technique of composition, used to construct everything from one's own education to a building.[50] Accordingly, the notion of verbal description to invent new places was understood as both metaphor and tool.

Thus, the poets praising the Medici villa drew on a rich array of literary sources and rhetorical techniques. But it is important to distinguish that their works did not treat the fantastical, the utopian, or the general, but rather the proleptic vision of an actual building coming into existence.

POETS AND MUSES AT THE CONSTRUCTION SITE

As we saw from the outset of this book, the humanist Francesco Sperulo claimed that he went for a walk at the site of the rising Medici villa and was spontaneously inspired to write a poem about it (dedicatory letter, §1). This conceit evokes the ancient notion of the *ambulatio*, or leisurely walk, for cultured thought or conversation, which was celebrated from Plato to Pliny and Cicero, and most appropriately done at a villa.[51] In particular, the site visit as the occasion for writing a poem was a device borrowed from Statius,[52] although it emerges that Renaissance poets mobilized this trope in a literal, practical mode. We turn now to a brief description of the fruits of these putative strolls by Sperulo and other poets who described the Medici villa, before considering why these *letterati* actually were drawn to the construction site.

Sperulo's *Villa Iulia Medica versibus fabricata* consists of 407 lines of hexameter, preceded by a dedicatory letter addressing the poem to Cardinal Giulio. The work is dated 1 March 1519, and preserved in a presentation manuscript in the

Vatican Library. It was bound as a standalone volume in an opulent, tooled-leather pocket edition, and the two-page opening of the manuscript is illuminated (Plates IX, X). The title page bears the poet's address to Cardinal Giulio, enwreathed in sprigs of myrtle and laurel, and the facing page is decorated with a painted initial, foliate decoration, and the arms of Cardinal Giulio. The high quality and inventiveness of the illumination, the use of Cardinal Giulio's arms, and the dedication all suggest that this manuscript was intended for presentation to him, perhaps at his own request. The elegant chancery cursive script of the manuscript was very likely the poet's own hand.[53] A new critical edition, translation, and gloss of the poem appear as Appendix I; and an analysis of the format of the booklet and its material properties, including the binding, illumination, and handwriting, appears in Appendix II. A short summary of the poem here will reveal the scope of its ideas, and a discussion of the most significant aspects of the work follows in Chapter 3.

The dedicatory epistle sets up several major themes of Sperulo's poem. He claims that he dashed it off quickly, expecting that the shortcomings of his verses would be an inspiration for greater poetic talents – a commonplace apology, and also a claim to poetic *furor*, which belies the labor evident in this carefully crafted work.[54] Most noteworthy for this poet claiming to build in verse, Sperulo expresses the hope that the villa he creates will outlive the building itself, evoking the Horatian *Exegi monumentum* topos – pitting words against monuments in a competition for which will last longer and bring more lasting fame.[55] This imagery was a cliché in Italian humanist poetry, especially among the *Coryciana* poets,[56] but Sperulo acknowledges the trope, and further boasts that he will prove the point: he hopes that with his poem, "it could finally become evident that the Muses build in ink with greater tenacity and more enduringly than architects do with their glue of lime and sand."[57] The poet articulates another *paragone* topos central to the poem (and to the painted and stucco decorations of the villa itself): that the villa and its patrons not only equal but surpass those of antiquity (§2).

Most of the poem is narrated by Father Tiber, the river god, whom Sperulo deems to be taking charge of the villa's construction. Tiber details the supplies and ancient marbles he is ferrying to the villa, discussing the placement of sculptures in the complex and their meanings. He further proposes the subject of battle frescoes, relating long and intricate narratives that he says Raphael will paint. Many of his proposed decorations are designated for specific areas of the villa. The river god also praises the Medici family and their ancestors, real and mythical, showing how each will be represented in an aspect of the villa. He is also clear about which areas of the villa he will not discuss. It is remarkable that the poet provides a detailed and specific description of the decorations for the extensive villa complex, although it was still a very rough construction site.

Sperulo's poem reflects his deep knowledge of ancient and earlier Renaissance villa poetry. His poem is Virgilian in diction, and rich with allusions to ancient

sources including Homer, Virgil, Vitruvius, Pliny, and above all Statius. (Statius' importance for Italian Renaissance art is less widely known than is deserved, a neglect perhaps reflecting the long-standing disregard for Silver Age Latin poets that has recently begun to change.[58]) The whole conception of Sperulo's poem praising the patron through his work is Statian. Sperulo further makes pointed references to the imagery and language of Statius' *Silvae*, from the ruling conceit of a site visit to a villa as the inspiration for writing a poem (as in *Silvae*, 1, 3), to the description of the noise at the villa's construction site, which evokes Statius on the clamor from Domitian's rising equestrian statue.[59] Sperulo's poem also reveals an extensive knowledge of earlier Medici encomia by Florentine poets, and it is larded with references to Medici *imprese* and topoi.[60] Such literary citations reflect the deep familiarity Sperulo and his audience had with classical and contemporary sources, and the intertextual discourse that flourished in the antiquarian culture of humanists, artists, and patrons in the context of the Roman sodalities.

Several other poems were written about Villa Madama, although none so lengthy or specific as Sperulo's has emerged. The renowned poet Marco Girolamo Vida (1485–1566) wrote a panegyric titled "The Genius of the Villa Falcone" (*Genius Falconis Villae*) that was surely written about Villa Madama, sometimes called Villa Falcona, rather than the neighboring villa of Falcone Sinibaldi, as it has sometimes been interpreted.[61] Vida, later dubbed the Christian Virgil, was generously supported by both Medici popes, and was commissioned by Pope Leo to write the epic *Christiad*, which the poet was working on throughout the period of Villa Madama's construction.[62] However, his villa poem provides only a brief and relatively uninformative description of the Medici villa as prelude to an encomium of the patron Corycius, who, Vida tells us, had just visited the villa on the Monte Mario:

> The stranger, coming here from diverse parts of the world, wonders at so sudden a work: the stones gathered together, the masses of rock, quarried from cliffs, rising up to the stars, the learned hands of craftsmen, the varied labor. And deservedly, for who, seeing the situation, the green leafage of the forests, the copious wealth of the perennial spring, the sky kind to the accommodating territory, would not believe that the gods, and the king of the gods, often exchange their starry homes, the golden regions of the sky, for these? Fortunate seat, your fame will live forever, and the ages will praise your eternal name. Often coming from all over to visit you, noble princes and kings clad in purple honor your threshold. Happy seat, blessed with many good things. Yet I will never consider you happier than in this one thing, Corytius, that the father and leader of the Castalian sisters has lately deigned to visit your house, for who, fortunate old man, could hope to equal with singing, you and the outstanding honors of your virtue? Join in songs with me, you surrounding mountains, and pay heed, you nymphs of the Tiber.[63]

The poem is interesting for its reference to visitors from different parts of the world, including leaders, and purple kings, which further bolsters Shearman's proposal of the *hospitium* function of the Medici villa. Moreover, there is a marked similarity of imagery and language between the opening lines of Vida's and Sperulo's poems (lines 1–7): both describe the visitor marveling at a building rising to the sky, the speed of the work, the massed stones, and the labor by the hands of the workers. They may both have been emulating similar models, notably Statius, or perhaps they were responding to each other's descriptions. Vida's poem is undated; its July 1524 publication in the *Coryciana* anthology is a *terminus ante quem*, although his reference to stones and labor suggest that he was writing at the same early stage of construction as Sperulo. But Vida's poem is fundamentally different in conception and scope from Sperulo's, both in length (Vida's is sixty-seven lines, Sperulo's is 407) and in its lack of specificity about the Medici villa; after the scant fourteen lines of mostly formulaic description of the site, Vida turns his attention to praising his patron Corycius for the remainder of the work. Perhaps the poet was trying to court two patrons at once with this poem, suggesting that it may have been conceived for performance before both of them, perhaps at the Medici villa site (a point to which I will return).

The rivalry between two other *Coryciana* poets provides evidence of another poem about the Medici villa: Mario Equicola (*c.* 1470–1525) wrote a stream of poetic invective against Antonio Tebaldeo, charging that his bad poetry about the Medici villa was an affront to the noble building:

> Away, if you will, swiftly take away from here the most inauspicious verses of the worst poet, perversely composed for the praise of the noble villa which Giulio de' Medici had begun to construct by the banks of the Tiber, of nearly regal magnificence. I call upon you, immortal gods, and your protection. Is that man so lost in a cloud of audacity that he would dare while you are still alive to befoul such a noble work with filthy verses? That man, that Teobaldi, whom only girls in charge of feeding little geese approve in the awful smelling swamps of Ferrara, while they sing his insipid dirges.[64]

Equicola's harangue has come to light, whereas Tebaldeo's maligned panegyric on the villa unfortunately has not, despite efforts to find it by several scholars of the poet and the villa.[65] Equicola's criticism reflects his bitter and long-standing enmity with Tebaldeo; they had been on opposite sides of a barbed polemic about the use of the vernacular and Ciceronian rhetoric in 1512–13, when they were in the service of Isabella d'Este, and they traded other vicious communications.[66] In reality, the works of both these poets were highly esteemed in papal circles, especially those of Raphael's friend Tebaldeo, who was also favored by the Medici: Pierio Valeriano later named Tebaldeo among the interlocutors in his dialogue on the vernacular set at the Medici villa, reflecting his status in this cohort.[67]

It is not immediately clear whether the writing of poems about the Medici villa was coordinated. There is no clear evidence connecting the poems, and the scant information we have about their patronage does not clarify the question.[68] Sperulo suggests that he hopes Cardinal Giulio will reward the speed with which he completed the poem (dedicatory letter, §3), indicating that the poet indeed hoped for some recompense, or perhaps that the patron had set the timetable.[69] Sperulo could have taken the initiative to write the poem, or he could have been asked to do so. In either case, he was not an independent poet seeking patronage, but rather was an insider in the Leonine Curia, as noted above, and he was close to the circle of patrons and artists planning for the villa, as the following chapters will demonstrate.

There was a humanist tradition of composing numerous poems about a single building for a specially planned campaign or event, following the practice of Statius for the Emperor Domitian.[70] For example, Giannantonio Campano's poems record late quattrocento convivia hosted in Rome by Pietro Riario (1445–74).[71] The poems on the Chigi villa were probably coordinated to provide the theme of a dinner gathering, or a series of such convivia.[72] Filippo Beroaldo the Younger sketches this scenario in his tongue-in-cheek introductory ode to Blosio Palladio's poem, in which Beroaldo begs Chigi to cut short his tour of the villa and serve the dinner and wine so that he (Beroaldo) will be drunk when Blosio sings his poem – a witty twist on ancient symposiastic literature:

> While you lead us around your villa's dining rooms
> And stroll through all the gardens, my dear Chigi, the
> Time goes by and my guts are
> Shuddering from starvation.
> Don't dare think that my stomach feeds on painting,
> Noble though it may be: come on, get on with it.
> Leave admiration until we're drunk;
> It's no use till I'm plastered.
> Then by all means let Blosius sing his poetry
> Thus your villa's esteem will grow but the villa
> Will proclaim your name more
> Brilliantly to the future.[73]

The coordinated presentation and publication of all the Chigi villa poems may reflect their origin in a commission from Chigi himself.[74] Tebaldeo's poems about the Villa Mellini refer to Lampridio's Pindaric ode about the same villa, suggesting another such scenario.[75] At these convivia, poetry was often recited to the addressee, surrounded by others who constituted the audience for it. In the case of a powerful patron such as Giulio de' Medici, the venue would surely have been suitably distinguished and convenient to him, perhaps in the Cancelleria, the Vatican, or his villa. Valeriano's *Dialogo della volgar lingua*,

written during the period of the villa's construction and describing a dinner party there hosted by Cardinal Giulio, reflects the actual practice of holding gatherings at the unfinished villa site. His inclusion of contemporary humanists such as Colocci and Tebaldeo among the invitees further fixes this portrait of a humanist gathering there;[76] and one of the interlocutors comments that Cardinal Giulio is not wont to invite sycophantic guests, but rather favors conversation with *letterati* that would bear fruit.[77]

The Villa Madama poems were likely part of a coordinated campaign, and were perhaps even composed for an event at the villa's construction site. In any event, given the common practice of circulating manuscripts, interacting on collaborative projects, and performing works for each other at gatherings, Roman humanists certainly anticipated that their poetry would be read or heard and criticized by their colleagues. As noted, Sperulo anticipates such competition in his dedication to Cardinal Giulio:

> If you shall receive my work favorably … you will perhaps see to it that anything unsuccessful in my efforts will turn me into an inspiration for greater talents. Nothing would please me more; I *want* to be surpassed in praising you, so long as I may be judged to have competed to the best of my ability. (§4)

Perhaps Sperulo hoped that other humanists would write poems praising his own, as they had done for the Chigi panegyrists. Thus, Sperulo suggests that he anticipated an audience for the poem beyond Cardinal Giulio, which is consistent with humanist practice.[78]

The element of competition is fundamental to these literary exercises. Each poet competes with the others; the poet building with words competes with the architect, as Sperulo also mentions in his dedicatory letter, and they all seek to best their ancient predecessors. Their discourse of verbal sparring was in part a revival of ancient custom, but also reflected the reality of rivalries and competition for patronage.[79] Lampridio made explicit this culture of poetic competition by comparing humanist performances to Olympic athletic competitions.[80] Some poetic competitions were actually staged, such as the annual contest arranged by Goritz, which Paolo Giovio credited as the main attraction that drew humanists to Rome after Leo's magnanimity.[81] This environment accounts for some of the boastful tone of the works; in their villa poems, Blosio and Sperulo emulate Statius' bravura declaration of poetic *furor*, claiming that they, too, dashed off these long and complex works in just a day or two.[82] Indeed, Renaissance villa poems, and the *silva* form in general, became demonstrations of poetic facility and *sprezzatura*, at times associated with improvisation and a performance context.[83] The intertextual nature of the Renaissance poems reflected this competition. The poets' creative appropriation and transformation of numerous ancient sources was another fundamental aspect of this poetic culture of one-upmanship. If literary competition

had a distinguished provenance, it was also a practical exigency of survival in Renaissance Rome, as poets bolstered their reputations, jockeyed for favor, and vied for commissions.[84]

Thus, Sperulo's poem, far from being merely the inspired product of his afternoon walk, is a carefully crafted rhetorical demonstration, and part of a long tradition.[85] Remarkably, however, Sperulo's poem stands apart from traditional villa descriptions, as well as the other poems on the Medici *hospitium*, for its specificity to an actual villa; and he eschews the traditional tropes of villa literature, such as the opposition of city and country life, or the ideology of *la vita in villa*, presumably irrelevant to this as-yet-uninhabited construction site. Instead, the poet tells us what the Medici villa will look like. Part *ekphrasis* of the actual villa complex to date, part proposal, part poetic topoi, and part exposition of meta-themes for the villa's landscape, architecture, and imagery, the work challenges the modern reader to distinguish its various levels and literary codes — a challenge taken up in the chapters that follow.

CHAPTER THREE

SPERULO'S VISION

THE CURIAL HUMANIST FRANCESCO SPERULO CLAIMED TO build the Medici villa in verse, constructing the edifice in 407 lines of hexameter, preceded by a prose letter dedicating the work to Cardinal Giulio de' Medici. The poet praises his patron and Pope Leo, as well as their Medici ancestors, but most of all he talks about the villa they are just beginning to build on the Monte Mario, describing it as if he can already see it. As we have seen, Sperulo's poem was one of several works written about the Medici villa, and was based on a long and rich literary tradition of villa panegyrics. Yet his poem was highly unusual for its length, its specificity to the actual villa, some of its subject matter, and the very fact of praising an actual building not yet built. Here, we take up the poet's vision of the villa, examining it in the context of literary tradition and Medici dynastic ideology, beginning with a brief synopsis of the poem's scope and structure.

THE POET AS MEDICI *VATES*

Sperulo attributes almost all of his poem to Father Tiber; the first eleven lines of the poem establish that Tiber is managing the villa's construction, and line 12 through the penultimate line 406 is an extended quote from the river god. His tasks include supplying materials on rafts, encouraging the workers to best the ancients (8–14), and excavating ancient marbles and transporting them to the villa (44). Father Tiber lavishly praises

the site (14–21) and extols Cardinal Giulio for using art to elevate a site graced by Nature (22–32). Tiber commences his description of the villa by pointing out ancient marbles that he is placing there (47–77). He then praises at length the Medici ancestors beginning with Giovanni di Bicci (78–204), tracing the family back to the Etruscan king Porsenna, drawing on traditional imagery of the Etruscan origin of Tuscany and the Medici family.[1] (Figure 25 contains a tree of Medici family members mentioned in the poem; and as seen in Figure 28 below, Raphael's associates later gave visual form to the notion of Etruria as the home of the Medici in a Vatican fresco.) The river god proclaims that statues of many of the Medici forebears are to be in the villa, and he specifies the location of most of these sculptures in the *coenatio*, or dining room, as he refers to the garden loggia (206–8). He proposes that a Parian marble sculpture of Lorenzo the Magnificent be placed among the Muses for an unspecified site (189–92), and he challenges Raphael to determine where in the house he will place it (160–4). Tiber then turns his attention to the living Medici. He assigns parts of the villa to living Medici family members as figurative seats: to Lorenzo,

GIOVANNI DI BICCI
1360 – 1429

COSIMO IL VECCHIO
1389 – 1464

PIERO IL GOTTOSO
1416 – 1469

GIOVANNI
1421 – 1463

LORENZO IL MAGNIFICO
1449 – 1492

GIULIANO
1453 – 1478

PIERO
1472 – 1503

GIOVANNI
1475 – 1521
POPE LEO X,
R. 1513 – 1521

GIULIANO,
DUKE OF NEMOURS
1479 – 1516
M. FILIBERTA OF SAVOY
1498 – 1524

GIULIO
1478 – 1534
POPE CLEMENT VII,
R. 1523 – 1534

LORENZO,
DUKE OF URBINO
1492 – MAY 4, 1519
M. MADELEINE DE LA TOUR D'AUVERGNE
C.1500 – APRIL 28, 1519

25. Tree of Medici family members mentioned in Sperulo's poem.

26. Schematic plan of U 273A showing specific areas of Villa Madama for which Sperulo proposes decorations: (A) the garden loggia, to contain the proposed sculptures of Medici ancestors (lines 206–8); (B) tower overlooking the south and the Tiber, to be decorated with paintings of the Triumph of Clemency (lines 226–44); and (C) the central loggia overlooking Rome – the figurative seat of Pope Leo – to be decorated with battle paintings (lines 270–340).

Duke of Urbino, he allots an unspecified atrium (245–59), and for Pope Leo he designates the privileged central Tiber loggia, with the view of the Milvian Bridge and Rome, as a kind of papal benediction loggia (270–3). (See the plan in Figure 26 for this loggia and other areas mentioned by Sperulo.) Whereas each of the defunct ancestors would be represented in sculpture, each of the living family members would be immortalized in paintings. Murals celebrating Leo's clemency were to be in the east tower (226–44), identified in plan in Figure 26. For Leo's loggia, Father Tiber proposes painted scenes in which his brother river gods allegorically represent sites of Leo's triumphs, historic and imagined, which he delegates to Raphael to paint. One mural would depict battle columns urged on by the Ebro, Rhône, and Po rivers, representing a historic battle in the Italian Wars (278–340). Another scene would prophesy Leo's defeat of the Ottoman Turks, represented by eastern river gods and rulers chained as prisoners of war and brought back to Leo's peaceful empire (341–56). Tiber suggests that Cardinal Giulio and Duke Lorenzo should also be depicted participating in this battle (357–71). The Tiber concludes his description of these paintings by exhorting Cardinal Giulio to be inspired by the scenes (372–7). He then passes quickly over the remainder of the estate, merely listing the theater, baths, gardens, fishpond, hippodrome, and stables (378–91); and he insists once more that he is busy with pressing tasks, such as searching out marbles and other decorations for the complex (391–6), although for his patron the burden is light (403–5). He notes that Pomona herself will be the gardener,

contributing marvels of nature, and he closes the poem as he opens it, with more imagery of a pleasant, verdant site (398–402).

Sperulo couches his poem as a series of walks; he claims at the outset that his walk at the villa site inspired him to conceive the poem (a Statian conceit, as noted), and he further refers to Cardinal Giulio himself strolling through the villa (*spatiatus*, 221 and gloss notes 84, 88). The poet also points to specific places for his proposed decorations (128, 156–8 and gloss note 54), suggesting that the poem was conceived as a walk-through with Cardinal Giulio, whether metaphorical or literal. However, the poem does not represent a logical itinerary, as it jumps around from one end of the compound to the other and back again.

Beginning with the title and dedication of the poem, Sperulo addresses the important issue of the villa's patronage, which is significant to historians because the relative contribution of Leo and Giulio has never been clear.[2] Sperulo designates the villa as Cardinal Giulio's in the poem's title – the *Villa Iulia Medica* – and with his dedication to Cardinal Giulio, as well as in the illumination of Giulio's arms (Plate X). The first sentence notes that the villa is being constructed at Giulio's expense (dedicatory letter, §1). The poet refers to Giulio as the author (singular) of the villa (94) and as Tiber's master at the villa (404), and also says the site waited for Giulio (29). Although Sperulo assigns specific areas of the villa as the figurative seats of Pope Leo and Duke Lorenzo, the poet addresses Giulio as if the entire villa is his, describing how Giulio will stroll among the ancestor sculptures in the garden loggia (221–5) and regard murals in the tower overlooking the south (226–44). Equicola, in his harangue, had also referred to Giulio as building the villa. Cardinal Giulio was certainly well suited to run the project for several reasons. As the vice chancellor of the church, he had responsibility for diplomatic affairs, so the construction of a *hospitium* to welcome visiting dignitaries fit squarely within his responsibilities. Giulio was further an experienced patron of architecture, with proven abilities and interests in many aspects of construction.[3] Sperulo's goal here was surely to accentuate the Medici ownership of the villa beyond a Medici pontificate; putting the villa in Giulio's hands would ensure that the villa was designated as part of the family's patrimony rather than a papal possession. So, the poet's emphasis on Giulio's patronage – and specifically his financing – surely reflected this Medici strategy. The illumination of the presentation manuscript further suggests the pragmatic goal of promoting the villa as a Medici family endeavor; blazoning Cardinal Giulio's arms along with other family emblems on this "villa constructed in verse" was an overt claim of family ownership, akin to placing arms on the actual family palace and villas (discussed in Appendix II). But Sperulo also gives a more nuanced image of the villa's patronage. He provides an intriguing view

of how the pope and his cousin shared power in this Medici pontificate, describing that Leo rules the world, while Giulio is the agent of his material business:

> He has an unfraternal love of your intelligence and your heart, ripe for responsibilities, yet he fraternally takes the reins of the city with you as deputy: to you he leaves the weight of affairs. He exercises his will and pacifies the world through your labors. Himself intent on sacred duties, he disposes and approves all things through your agency, and each decision is brought to fulfillment by your command. (72–7)

Sperulo's conceit suggests the involvement of both Leo and Giulio in conceiving and executing projects. It is perhaps telling that the decorations Sperulo prescribes for the villa feature both Leonine and Giulian imagery.[4] This conception is consonant with the long-standing Medici tendency toward joint endeavors.[5] Sperulo suggests that Leo gave the impetus to this project, but that the villa was built through Giulio's agency – a notion that fits well with known facts.

The poem is dense with Medicean imagery. As noted, Medicean dynastic and ideological constructs formulated in the Florence of Cosimo il Vecchio or Lorenzo reappeared in Leonine Rome, where they were adjusted for a Roman, papal environment;[6] and Sperulo reveals his familiarity with the family's traditional repertory of imagery, as well as Leonine papal panegyrics. He emphasizes notions such as the eternal spring associated with the Medici (127, 167, 208, 228), Medici astrological and cosmological themes emphasizing the stars, sun, and the globe (22, 70, 109–10, 116, 182, 211, 219, 370, 406, and gloss notes 15, 35, 51, 80, 83), Leo as bringer of peace (75, 184), and the Medici restoration of a new Golden Age to Rome (340). (These themes would indeed be central to the decorations later executed at the villa.[7]) For example, Sperulo, addressing Pope Leo, calls for the paintings in the villa to depict how, "governing the earth with restful peace, you restore to Rome the Golden Age of Saturn" (339–40). The gloss in Appendix 1 details many more of these Medici tags, from botanical symbolism to *imprese*.

Sperulo dates his poem 1 March 1519, providing a *terminus* for its actual composition, although the date was undoubtedly chosen for symbolic reasons that reflect these Medicean themes. The *kalends*, or first of March, was the first day of the Roman year when, according to ancient tradition, Mars laid down his arms to promote the cause of peace.[8] March marks the end of winter in Italy, so this month also represented the coming of spring and the associated rebirth of nature; Cato the Elder specified that farmers pray to Mars in this month for the revival of their land and crops.[9] The arrival of the new year and the cyclical, regenerative power of nature were associated in Medicean iconography with the eternal return of the Medici family, and their restoration of a new Age of

Gold. Thus, the return of the Medici was celebrated by this date associated with the flowering of springtime, and with peace. It remains less clear when Sperulo actually composed his poem. It certainly could not have been much later than the dedication date, for in the poem Sperulo refers to Lorenzo, Duke of Urbino, as a great leader and a vital force in the Medici dynasty,[10] when in fact he was gravely ill with tuberculosis from mid-November 1518 until his death on 4 May 1519. Presumably, Sperulo composed his poem before the severity of Lorenzo's illness was known or communicated – perhaps in January – and he later recorded it in the presentation manuscript.[11]

Fundamental to the structure of the poem is the *romanitas* of the Medici, and their place in Roman history. As noted, a prime function of Medicean rhetoric in the Leonine pontificate was to Romanize the Florentine Medici, emphasize the union of Florence and Rome, and thus legitimize their temporal power in the Eternal City. The 1513 theatrical celebration on the Capitoline to bestow Roman citizenships on Giuliano and Lorenzo de' Medici is the best known and most elaborate example of this strategy.[12] Leo's commission to decorate the Palazzo dei Conservatori on the Capitoline, with a seated statue of the Pope by Domenico Aimo (*c.* 1470–1539) and battle frescoes by Jacopo Ripanda (*c.* 1465–*c.* 1516), was another contemporary example of visual propaganda on this theme.[13] Sperulo's poem shows that this issue was still relevant in 1519. He uses several methods to Romanize the Medici by establishing dynastic links – real and mythical – to ancient Rome. Virgil had codified the mythical origins of the Julian house for his patron Augustus in the *Aeneid*, in which the poet describes Venus and Aeneas as ancestors of Julius Caesar and his son Augustus, thereby tracing the whole history of Rome from its origins to the Golden Age of Augustus.[14] Sperulo, in his effort to Romanize and legitimize Medicean rule, co-opts the very structure of Virgil's Augustan propaganda. Both poets articulated a vision of the new world order for their patrons, who surpass their predecessors by restoring peace to the world. Like Virgil narrating the career of Aeneas, Sperulo traces the past adventures of Medici family members, looking back at their history, and forward to adumbrate the villa as the microcosm of a new Christian empire they are founding under Leo.[15] Sperulo evokes the ancient/modern *paragone*, declaring that the marvelous villa, and the victorious campaigns of Leo and Giulio, will supersede even the pinnacle of the ancient Roman empire.[16] He casts Leo and Giulio as the metaphorical heirs of the peace-bringing Venus because of their gift of Christian peace to the world. Just as Leo was styled as a new Augustus, Cardinal Giulio was linked to Julius Caesar.[17] Thus, Sperulo traces the arc of Roman history from the founding of Rome to the Golden Age of the Medici.[18] Significantly, the poet achieves this feat by claiming the role of Medici *vates*, or poet-seer, composing his vision of the villa's decorative complex.

Sperulo ascribes his vision of the unbuilt Medici villa to his narrator, Father Tiber. This choice of spokesperson is richly symbolic. Virgil and earlier Renaissance poets had used the personified Tiber for brief passages, most notably to foretell Aeneas' founding of Rome.[19] But Sperulo uses the river god's voice for virtually the whole poem, which served his goals in several ways. First, the Roman voice of the Tiber was central to Sperulo's strategy of Romanizing the Medici. He introduces his poem's narrator saying, "Father Tiber himself, hastening in his Tuscan stream" (8), which stresses the fact that this most conspicuously Roman of symbols had its source in Tuscany. The Tiber had been frequently described by ancient Roman poets and geographers as being Tuscan or Etruscan, an allusion to the source of the river in the Tuscan Apennines and to its function as the eastern border of Etruria.[20] Even before Sperulo, Medici image-makers had made much of this fluvial geography. In the 1513 Capitoline festivities, a personification of the Tiber spoke to the Arno saying:

> O Arno, since we were born together from fraternal waters, which rise almost from the same source, and we both flow into one sea, the fates intend that your people will be called mine, which from Leo you can expect. He will give the Italians eternal peace and will calm the current turmoil; kings will look here to seek peace, and will want to follow his commandments.[21]

River imagery also dominated the speech of Clarice Orsini, another character in this 1513 theatrical scene who, as a descendant of the noble Roman Orsini family and the mother of Pope Leo and Giuliano de' Medici, was prominently featured for her contribution to Medici *romanitas*. She addressed her son Giuliano and grandson Lorenzo saying, "Rome wants to gather you in her blessed lap and to make you her own; by nature you are Tuscans, but Roman by privilege. In any case, both peoples are united by blood, just as the Tiber is said to be Tuscan."[22] The climax of the Capitoline entertainment featured *soavissima musica* with the nymphs of the Tiber and the Arno singing in unison.[23] These *intermezzi* had been devised by members of the Roman Academy, notably Inghirami, and served as the basis for later Leonine imagery, so it is no surprise that Sperulo was closely familiar with this Tiber construct.[24] Andrea Fulvio utilized the same information in his 1513 poem on the antiquities of Rome that was dedicated to Pope Leo, emphasizing the Tuscan source of the Tiber.[25] The 1512 discovery of the ancient reclining statue of the Tiber in Rome had prompted new humanist study of river gods in this decade, and a new emphasis on their inclusion in visual as well as verbal imagery.[26] Raphael had already depicted Father Tiber and his brother river gods as locative deities in the borders of the Sistine Chapel tapestries for Leo X, pairing the reclining Arno and Tiber to bookend the scene now believed to depict Cardinal Giovanni's arrival

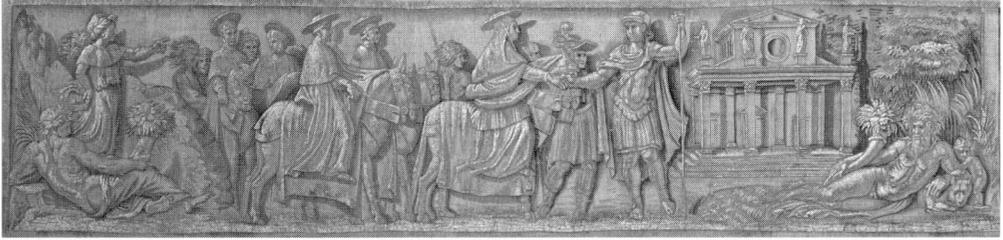

27. Raphael, woven by Pieter van Aelst, *The Arrival of Cardinal Giovanni de' Medici in Rome in 1492, Flanked by the River Gods Arno and Tiber,* from *Scenes from the Life of Leo X,* borders to the *Acts of the Apostles* tapestries for the Sistine Chapel, 1516–19, Vatican Museums.

in Rome in 1492 (Figure 27).[27] Sperulo proposed that river gods be protagonists for frescoes in the Medici villa, and although these paintings were never executed, river gods would be depicted at the villa in stucco reliefs instead: an exedra in the garden loggia intersperses figures of the Tiber, Arno, Nile, and Tigris with fictive cameos of Venus Victrix, alluding to Medici triumph in different parts of the world. (Visible in Plate VIII; underneath five hexagonal stucco cameos of Venus are four elongated hexagonal compartments containing the river gods.) Within a short period of time, river gods would figure prominently in other Medici commissions in Florence and Clementine Rome, from the New Sacristy to the Sala di Costantino (Figure 28).[28] So Sperulo chose as his narrator Father Tiber, whose essential *romanitas* belies his Tuscan origin, like that of the Medici, and whose eternal flow symbolizes the Medicean theme of eternal return.

Perhaps the most compelling reason Sperulo put most of his poem in the mouth of Father Tiber was his role as a prophet. Sperulo says it was the river god and his nymphs who foresaw that the (Tuscan) Medici would add this villa to his (Tuscan) riverbank, so the whole poem becomes an extended prophecy and *ekphrasis* by Father Tiber:

> But the nymphs – my charges – who born in Apennine rivulets strive so much on their wanderings from this source and that to combine themselves with me, so that our mixed and combined waters may wash the sacred walls of queenly Rome … These goddesses decreed that the man who would cherish the spot would be from among the foremost men of Tuscany, and that he would proceed to add this embellishment to the Tuscan river-bank. Nor did my spirit, which pondered this decree long ago in its prophetic heart, deceive me. And having long sought marks of honor for so magnificent a Lar, I carry hither numerous marbles pulled out of ancient ruins. Come, men, learn how each of them should be disposed in its specified place! Let this work rise under my auspices! (33–46)[29]

Like Virgil, Sperulo uses the Tiber to foretell the future glories of Rome. In the *Aeneid,* when Aeneas reaches Latium, Father Tiber appears to him in a

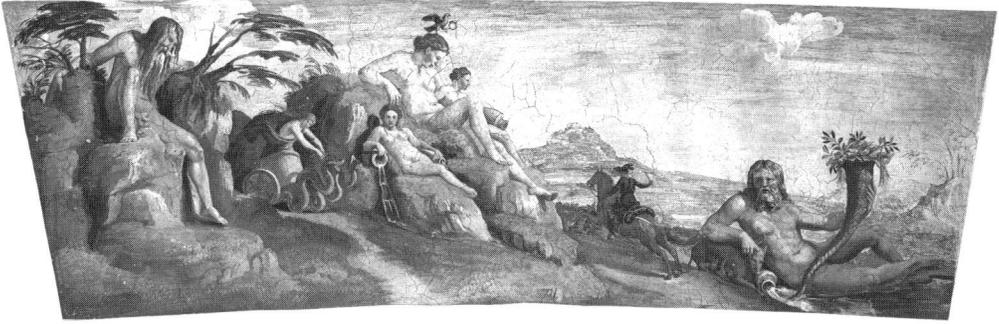

28. Associates of Raphael, *Etruria, Home of the Medici, c.* 1523, frescoed west window embrasure, Sala di Costantino, Vatican Palace. This visualization of the topography of Etruria portrays the joint source of the Arno and Tiber in Tuscan Etruria, reflecting contemporary imagery emphasizing the Etruscan origin of the Medici, and the close connections between Rome and Etruria/Florence. Left to right are: the Apennine; Ceres; *Fluentia*/Florence bearing the Medici *impresa* of a falcon and diamond ring and flanked by water nymphs; a rider; and the Tiber holding a cornucopia of wheat and laurel.

dream, telling him of the site where Rome will be founded by his descendants (*Aeneid*, VIII, 36–65), a literary set piece later given visual form by Salvator Rosa (Figure 29).[30] Likewise, Sperulo's Tiber says he had long foretold that Leo would be father of the world (105–6), and that he and his nymphs had decreed that the Medici would raise a villa on this site (39–42). In addition, just as Virgil uses the legendary *ekphrasis* of the shield of Aeneas to foretell the great deeds of his descendants (*Aeneid*, VIII, 102–11), Sperulo creates *ekphrases* of the villa's proposed paintings to prophesy the future heroic deeds of the Medici (278–373). Each poet portrays his patron's reign as a predestined age of gold, and as the culmination of Roman history.[31] But unlike Virgil, Sperulo has Father Tiber narrate the whole poem – including the *ekphrases* and prophesies – thereby invoking the ancient authority of Tiber's oracular pronouncements to validate the poet's own prediction of a Medici reign of gold, centered at their Tiber-side villa. Thus, Father Tiber is Sperulo's authorial voice – and Sperulo *is* Father Tiber. The abundant waters of the Tiber become a metaphor for the copious inventive powers of the poet, as well as an analogy for the orator's directed, persuasive flow of words.[32]

In the dedicatory letter with his poem, Sperulo identifies himself with another prophet: Hephaestus/Vulcan, god of all artificers. Sperulo asks Cardinal Giulio, "If you shall receive my work favorably, forged in my heart as though on a kind of anvil by the hammer of devotion" (§4), suggesting that the poet, as the blacksmith god, is forging the literary edifice. The opening lines of the poem, evoking Statius on the clangor of erecting a bronze equestrian statue, underscore another metalworking metaphor.[33] This personification had been used by poets from Homer and Virgil to Poliziano, and Sperulo alludes to these sources for specific reasons. First, he combines elements of the lame god's role

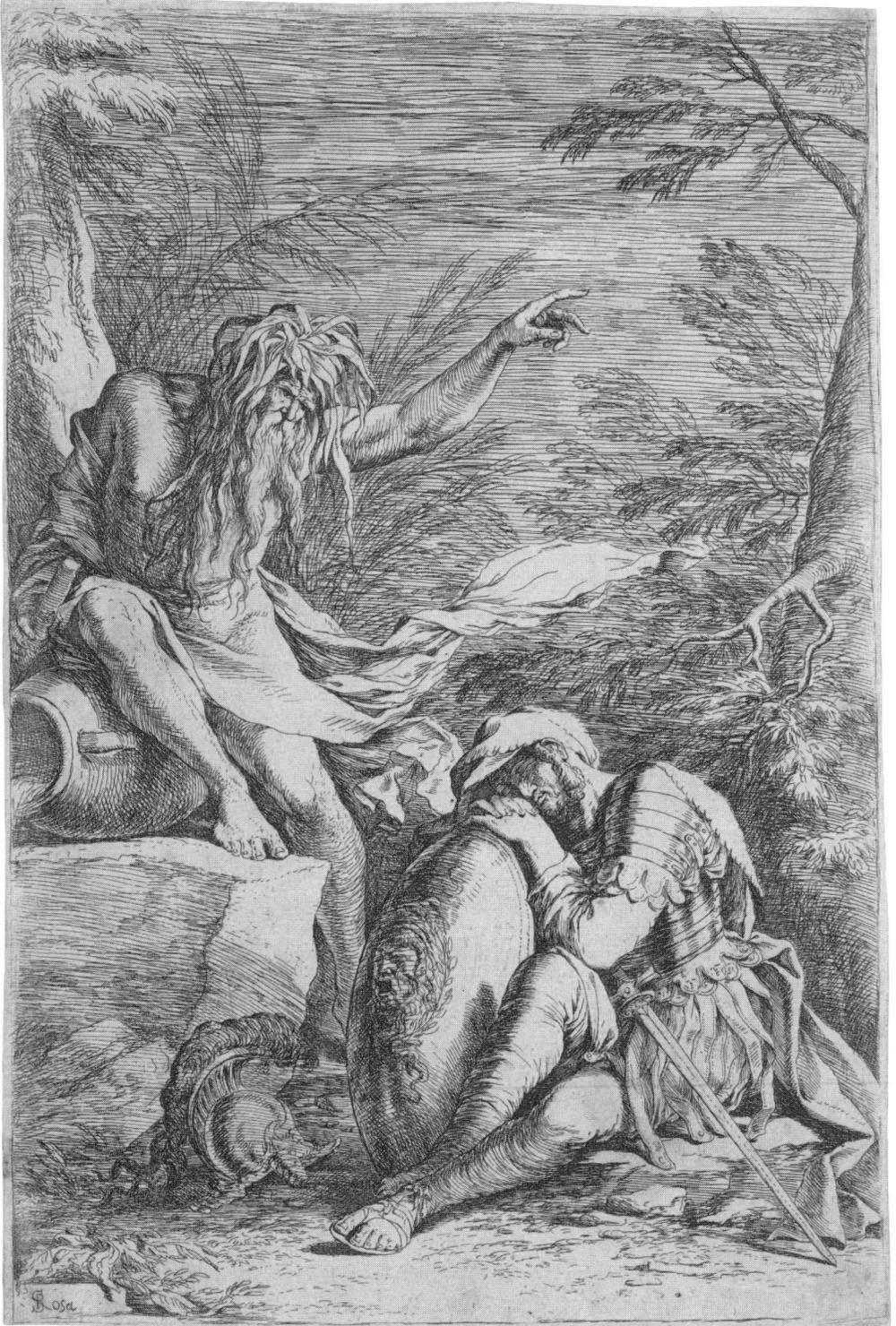

29. Salvator Rosa, *The Dream of Aeneas*, 1663–4, etching and drypoint, Metropolitan Museum, New York.

in both Homer's and Virgil's accounts of the shield – the most famous *ekphrases* in western literature. The contrast between Homer's and Virgil's treatment of the shield had been noted as early as the fourth-century commentary of Servius, and thus was surely familiar to Sperulo. In Homer's epic, Hephaestus is characterized as a *deus artifex*, and the account of his making the shield for Achilles becomes a metaphor for the creation of the whole world and cosmos[34] – a fitting association for Sperulo who is envisioning the Medici villa, which is a microcosm of Leo's realm. Virgil's account of the shield of Aeneas instead emphasizes Vulcan's prophetic powers to foretell the history of Rome, which is given visual form as narrative scenes on the shield. Virgil specifically says of the shield, "There the story of Italy and the triumphs of Rome had the Lord of Fire fashioned, not unversed in prophecy or unknowing of the age to come."[35] Sperulo specifically adopts the tone of Virgil's Vulcan – who encourages his Cyclops-blacksmiths working in the vaults of Mount Aetna to forge the shield – for the speeches of Father Tiber, who exhorts his men at the Medici villa. Once again, by adducing the characters and speech associated with prophecies that have already come to pass, Sperulo presents his own predictions as destiny. Sperulo combines the Homerian emphasis on the shield's production with the Virgilian emphasis on prophecy of the founding of Rome and the triumphs of peace-bringing Augustus. By borrowing frameworks from Homer and Virgil, Sperulo characterizes himself as a prophetic *deus artifex* for the Medici, who are establishing a new peaceful Christian empire in Rome.

Other attributes of the god Vulcan were even more important to Sperulo's goals. As the smith of Jupiter, Vulcan was the divine artisan responsible for forging the great god's thunderbolts – an appropriate choice for a Curial image-maker for Pope Leo, who was styled as Jupiter. In addition, significantly for a poet claiming to build a villa, Vulcan was credited with erecting the first buildings, as Vitruvius recorded,[36] most notably Venus' house and garden on Cyprus – a sort of divine villa, as described in Claudian's *Epithalamium*:

> Vulcan, so it is said, purchased the kisses of his wife by offering her these walls and towers. The fields within glow; unworked by any hand, they flower eternally, content with Zephyr as their gardener … From afar the house of the goddess shines, reflecting the green of the surrounding grove. Vulcan also built this of precious stones, joining their golden worth to art.[37]

Poliziano, who had also styled himself as Vulcan in his Medici *Stanze*, drew on these conceits about Vulcan's house for Venus, in which the workmanship exceeds the precious materials and eternal springtime reigns, and he too forged *ekphrastic* reliefs for the bronze doors of Venus' palace.[38]

Sperulo expands on this traditional imagery of Vulcan and Venus by characterizing the entire Medici villa as the realm of Venus Genetrix.[39] This

represented an important step in Medici image-making, building on Laurentian imagery.[40] Poliziano's commentary on Statius' *Silvae*, 1, 2 (the *Epithalamium in Stellam et Violentillam*) had glossed the generative qualities of Venus in writings by Lucretius, Columella, and the Servian Virgil,[41] and as Charles Dempsey noted, a passage in this *silva* of Statius about the generative Venus bringing eternally recurring spring was a fundamental source for the Medici imagery of eternal return.[42] Sperulo refers to the same Statian text to set up the Roman Medici villa as the realm of Venus; in Sperulo's poem, near the beginning of Father Tiber's speech, the river god introduces the Medici villa by specifically echoing the passage of Statius' poem in which Venus descends to earth to visit the house of the poet Stella (14–18, and gloss notes 12, 13). Sperulo also evokes the realm of Venus with his references to myrtle (31) and his imagery of the lilies of Florence springing from the conches of Venus (126). The illuminated title page of Sperulo's poem features a cartouche of myrtle and laurel encircling the title, revealing from the outset the centrality of Venereal imagery to the poem (Plate IX). Most significantly, Sperulo proposes installing at the villa a relief from the Temple of Venus Genetrix, which, as we shall see below, he uses to trace Medici genealogy back to the goddess herself (60–3). Thus, Sperulo/Vulcan, as the wordsmith/blacksmith, forges an earthly palace for Venus Genetrix, who will find herself at home in the peaceful, bountiful, ever-verdant seat of the Medici pontificate. Additionally, with this conceit, Sperulo declares his poem to be a gift from the goddess Venus herself. In Virgil's account, the shield is a gift to Aeneas from Venus who bade Vulcan to execute it; likewise, Sperulo's literary villa is a gift to the Medici from Venus who will inhabit it, forged by Vulcan/Sperulo, the amanuensis and villa-designer of Venus herself.

Sperulo's use of spokespersons draws on rhetorical models, as well as poetic models from Homer, Virgil, and Statius to Poliziano. Sperulo's personification as Hephaestus/Vulcan in the dedicatory letter uses the rhetorical technique of *ethopoeia*; and his presentation of the poem itself as a speech by Father Tiber is an example of *prosopopoeia*. As we have seen, unlike Homer and Virgil who used this device in discrete set pieces for important speeches, Sperulo sets nearly the whole poem in Tiber's voice. Most basically, Sperulo invokes the authoritative personae, voice, and style of these deities to valorize his own proposals for the villa. Moreover, by adducing the characters and speech associated with prophecies that have already come to pass, he presents his own predictions as destiny. These mythological authorial personae are common devices, but at another level they can reflect a poet's voice in the real world.[43] Thus, Sperulo claims the mantle of the Medici *vates*.

Through these visionary authorial personae, Sperulo asserts his own prophetic ability to envision the completed Medici villa before it is built – a kind of prolepsis. Sperulo also claims to be an overseer at the villa, doing the tasks he attributes to Father Tiber: choosing marbles from among the ruins,

transporting them to the villa site, directing their placement, managing the work site, and proposing decorations. He says, "And having long sought marks of honor for so magnificent a Lar, I carry hither numerous marbles pulled out of ancient ruins" (43–5), suggesting that Sperulo was going to ancient sites and pinpointing marbles and antiquities for use in the villa —which was actually the job of Raphael himself as Leo's Prefect of Marbles. Sperulo concludes his description of the proposed murals saying, "These deeds, truly, I see with foreknowledge of the fates, as if already done and I want them now added to the belvedere by the painters" (372–3) – a startlingly imperious statement. Elsewhere, Sperulo addresses Raphael in an apostrophe, challenging the artist to place a proposed statue of Lorenzo the Magnificent in the villa (160–4). The poet professes to be so busy with his pressing tasks at the house that he cannot take time to say more about the Medici ancestors (188–9). A closer look at his proposals for sculpture, spoils, and murals for the villa makes it clear that Sperulo was indeed doing some of the tasks he claimed.

SPERULO GIVES MEANING TO ANCIENT MARBLES

Sperulo claims his main role is selecting ancient sculpture and spoils, transporting them to the villa, and directing their placement. The poet cries, "Come, men, learn how each of them [the ancient marbles] should be disposed in its specified place. Let this work rise under my auspices!" (45–6). He proceeds to describe specific spoils, enumerating the various types of colored marble available to decorate the villa, and indicating pieces as "this" and "those" as if he is pointing to them (53–66). For each one, he emphasizes, or if need be invents, a provenance and proposes its use in the villa. The poet sums up his task by stressing that, "Now, it is necessary to search out the different marbles and the many columns to be placed around the planned courtyards … for no part shall be without exotic marble, and the house shall incorporate nothing cheap" (391–6). He ornaments his descriptions with topoi from ancient authors including Pliny, Statius, and Suetonius, and some of the marble revetments and columns he describes seem to have been poetic fiction.[44] But I do not believe he was just being allusive, for some of his descriptions can be identified as specific marbles.

In fact, the Medici villa did boast extensive sculptural decorations, although they have been dispersed and are little known today.[45] The garden loggia and the gardens were originally filled with sculpture and architectural spoils, mostly antique and some modern, which included figures, colossi, reliefs, revetments, altars, fountain sculptures, sarcophagi, and carved basins. Thirty-five niches were built to be filled with figural sculpture and, at one point, the villa probably housed about sixty-five figural sculptures – a large number before even considering the many other kinds of sculpture and ornament that made up

this collection. Plates XVIII and XIX depict the garden loggia when it was still filled with sculpture, variously documenting or imagining specific works. (See also Figures 74, 76, and 77.)

Sperulo's formulation of visual imagery focuses extensively on the disposition of sculpture and spoils. Just as he linked the origins of the Medici to ancient Rome in verse, he emphasized their lineage by tracing the provenance of ancient marbles to be displayed in the villa. As noted above, the poet tells us that Father Tiber himself has sought out ancient marbles to honor the villa, has carried them there, and directs the workers where to place each piece. Tiber describes several marbles of particular significance:

> there [you can see] those [marbles] that were at the height of their beauty in the Paphian sanctuary. Then, long afterwards, Caesar, when he ruled the world, offered them to be part of the famous shrine of Venus Genetrix, whom the Roman descendants of Aeneas used to worship with clouds of incense as the author of their race and rule. (59–63)

This passage explains that Julius Caesar took a marble from Venus' sanctuary at Paphos (on the island of Cyprus) to install in the Temple of Venus Genetrix, which he erected in his forum in Rome. This Roman temple honored his mythical ancestress, who had granted him a great victory, and it was built as a pledge of peace.[46] As mother of Aeneas, Venus was the ancestress of all Rome. Thus, the translation of the marble from Venus' Paphian sanctuary to the Rome of Julius Caesar, and finally to the Medici villa, was a powerful signifier that the peace-bringing Medici inherited the mantle of Roman rule.

This account of marble translation sounds like a poetic conceit, but in fact there *was* a marble from the Temple of Venus Genetrix at Villa Madama – a little-known white marble relief now in Naples (Figure 30). At once an architectural fragment and a relief sculpture, this Trajanic piece depicts two *erotes* sacrificing two bulls on either side of a candelabrum – a so-called *erotes tauroctonoi* relief.[47] This rare theme was probably an adaptation of classical Greek prototypes of winged Victories sacrificing bulls – the *Nike tauroctona* motif, familiar to Renaissance antiquarians from the Basilica Ulpia – with both subjects symbolizing victory.[48] Sperulo's mention is unlikely to be a coincidence, for the relief was installed as a focal point of the garden loggia: I believe that one entire wall elevation was designed around it, as I determined from the visual evidence of a mid-sixteenth-century drawing (Figures 31, 32), and by measuring the relief and the remaining lacuna in the wall at the villa (Figures 33, 34).[49] Since construction of the garden loggia probably occurred in the winter of 1519–20,[50] this elevation was designed in Raphael's lifetime, showing that he was involved in generating some elements of the decorative program before his death. Additionally, the date of Sperulo's poem falls in between the design and construction dates of the loggia, so the poet evidently knew of the plans for the sculpture, or even played a formative role in featuring it so prominently.[51]

Sperulo's mention of this relief is also significant because he specifies that the creators of Villa Madama were aware of its provenance from the Temple of Venus Genetrix, which is currently thought to have been correctly identified only in the nineteenth century. This temple had been the subject of early sixteenth-century topographical research, as we know from the writings of Andrea Fulvio, although I have found no evidence that any other Renaissance architect or antiquarian correctly identified it. Sperulo suggests that the creators of the Medici villa knew the ruins of the Temple of Venus Genetrix, and made use of its spoils for a precise ideological purpose: the relief was chosen to be a focal point of the great garden loggia as a trophy of legitimate Roman rule and of peace. Julius Caesar had dedicated his forum and the Temple of Venus Genetrix on the last day of his triumph, glorifying the goddess as ancestress of himself and all Rome.[52] Sperulo's assertion of the marble's Paphian provenance is probably a poetic invention,[53] allowing the poet to trace the trophy directly to Venus, ancestress of Rome and goddess of peace, just as Virgil had traced the genealogy of Augustus. So with the Venus Genetrix relief, the Medici, too, emphasized their *romanitas* as descendants of Venus and the Caesars. The relief's association with Venus in her role as *genetrix* is also apposite for this villa designated as the realm of this goddess. Indeed, imagery of Venus Genetrix and her attributes of fecundity, bounty, and peace-giving victory appear throughout the villa; for example, see Plate VIII for fictive cameos of Venus Victrix, and oval painted depictions of Venus on the vault above based on reverse-*ekphrases* from Philostratus.

The important evidence that Sperulo was proposing a setting in the villa for an actual work of art leads us to consider the possibility that some of the other set pieces he described involved real works, too. Sperulo mentions another marble that he proposed installing in the villa, suggesting that it justified the Medicean succession by their gift of peace to the world:

> This Numidian marble column, inscribed to the fatherland in honor of its father, the sons of Romulus set up in the middle of the forum as a pledge of peace and empire devoted to Iulo. It is you, Giulio, who deserve these marbles owing to the memorable gift of peace you have given to your country and the world. (64–7)

These lines evoke a well-known passage from Suetonius, who described how after the funeral of Julius Caesar, a solid column of Numidian marble was set up in the Forum and inscribed PARENTI PATRIAE.[54] Sperulo may simply have been making a literary reference, but it is also possible that the Medici had a Numidian marble column, now lost, which Sperulo claimed to be the one mentioned by Suetonius.[55] In any event, Sperulo was certainly alluding to Cosimo de' Medici's designation as *pater patriae* in Florence,[56] emphasizing the family's inheritance of the power of the Caesars. According to Sperulo, the column had been installed in the ancient forum as a *pledge of peace*, and now would

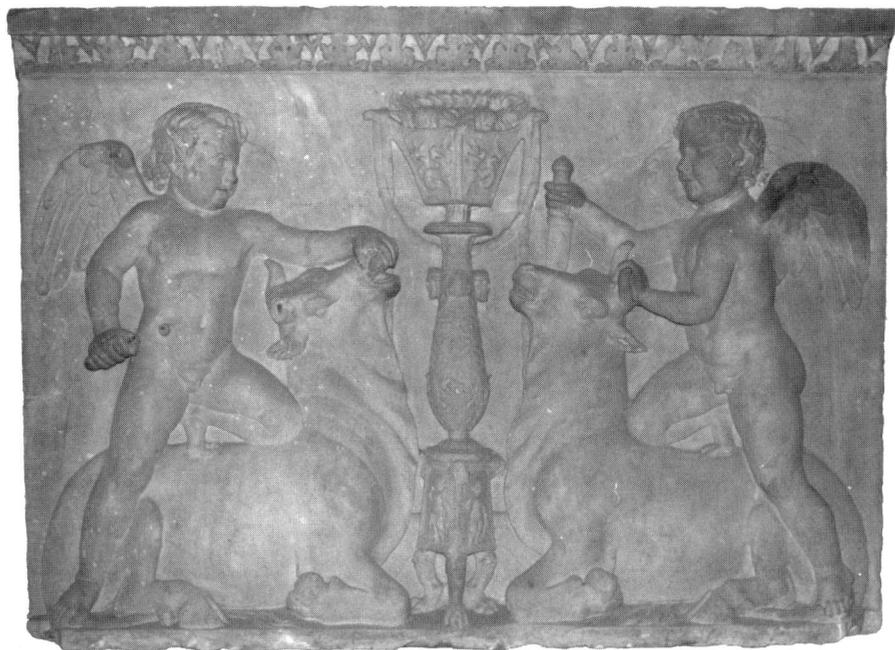

30. *Erotes tauroctonoi*, Museo Archeologico Nazionale di Napoli, inv. 6718; Trajanic relief from the Temple of Venus Genetrix in Rome, formerly in Villa Madama.

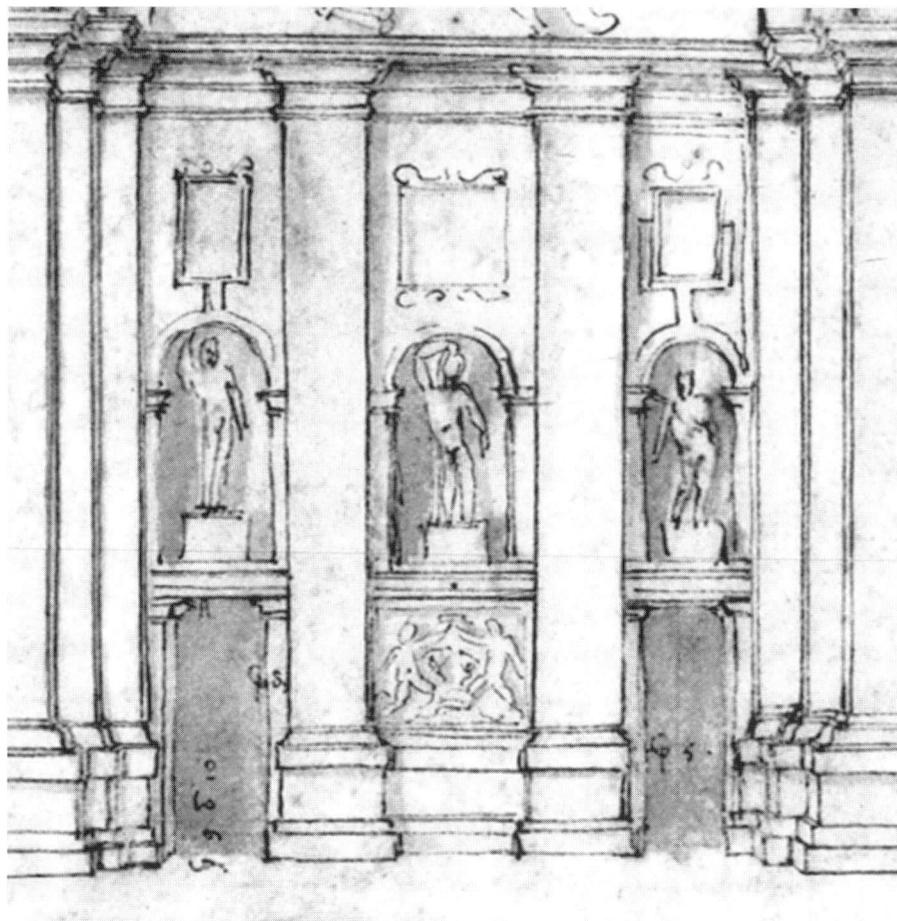

31. Anonymous, Villa Madama, garden loggia, northeast wall; detail showing area where the *erotes tauroctonoi* relief was installed, mid-sixteenth-century drawing, private collection.

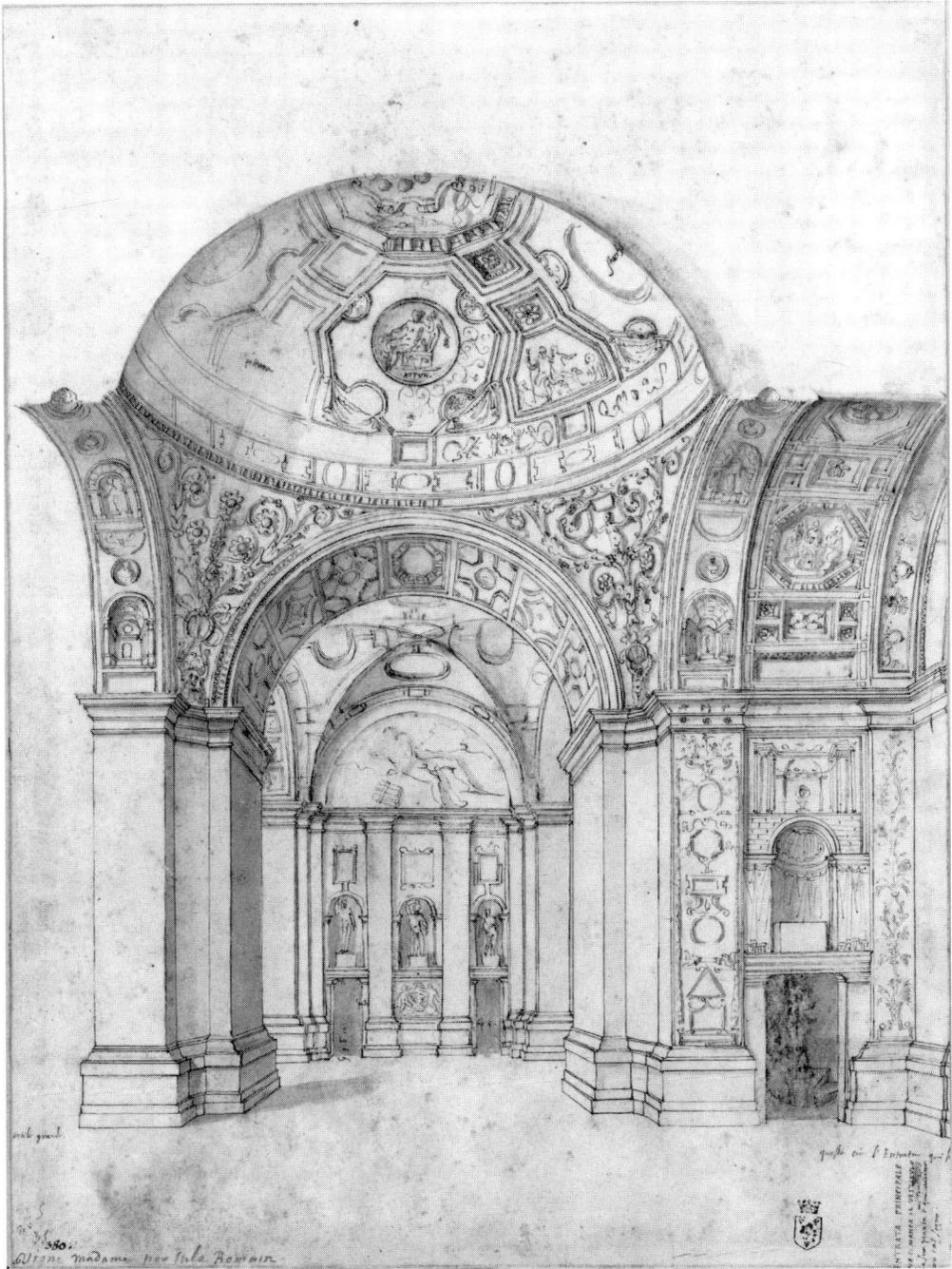

32. Anonymous, Villa Madama, garden loggia, northeast wall; mid–sixteenth-century drawing, private collection.

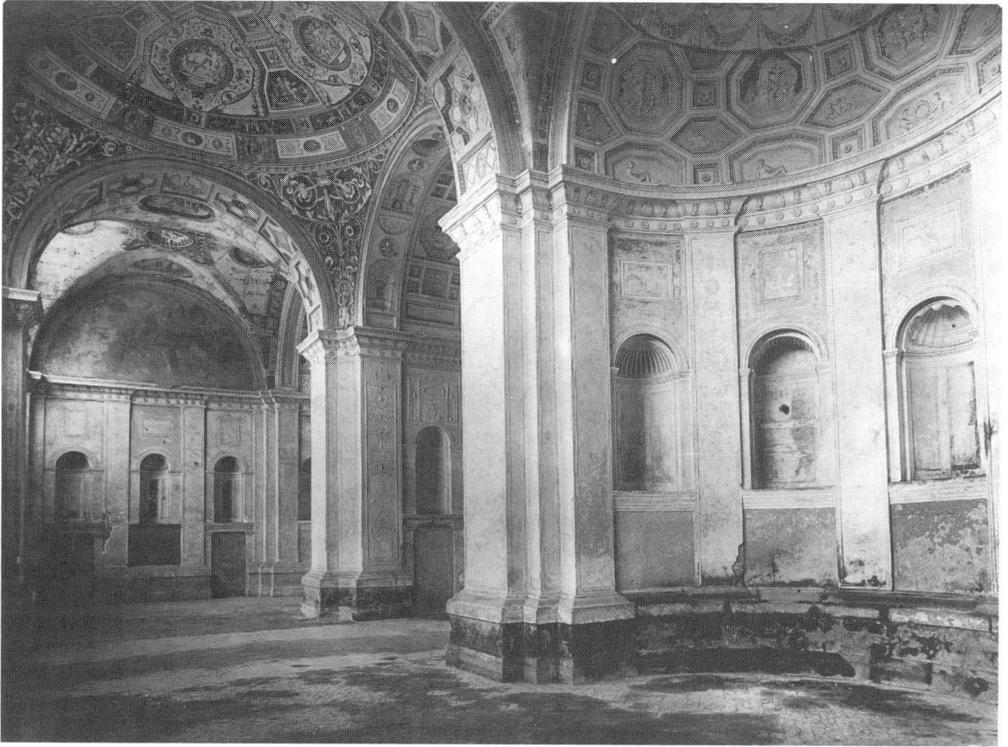

33. Romualdo Moscioni, Villa Madama, garden loggia, view of northeast wall *c.* 1885–9 showing black patch where the *erotes tauroctonoi* relief was removed.

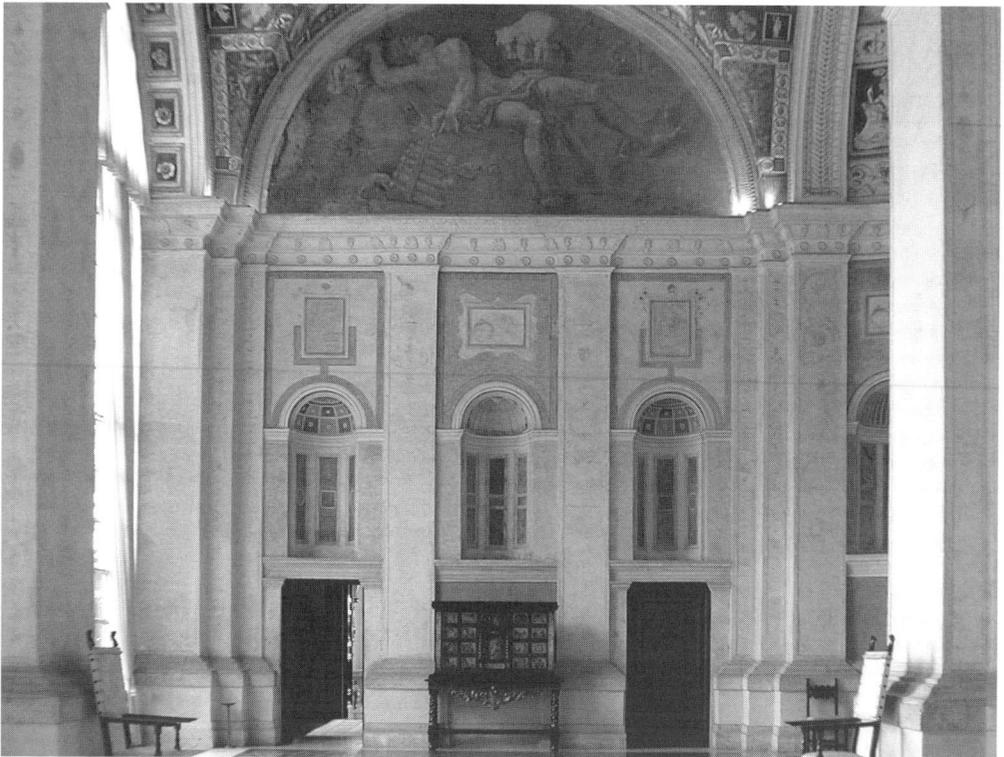

34. Villa Madama, garden loggia, northeast wall. The relief was inset in the panel behind the cabinet.

be installed in the Medici *hospitium* as a reward for *peace achieved*. Thus, the column was owed to the Medici as the true bringers of peace, demonstrating that the pontificate of Leo X surpassed the ancient reign because of the Medicean gift of peace to the world. As noted above, Cardinal Giulio was sometimes styled as the inheritor of the mantle of Julius Caesar. With Sperulo's conceptions for both the column and the Venus Genetrix relief, the poet emphasizes the Giulio/Julius Caesar conceit, the *romanitas* of the Medici, the legitimacy of Medicean rule, and the Medici as bringers of peace – surpassing even the pinnacle of ancient Roman civilization.

With these *spolia* and throughout the poem, Sperulo underlines the central role of sculpture and spoils at Villa Madama.[57] His earlier participation in the poetic campaign about the *Laocoön* takes on new importance in this context; Sperulo was closely attuned to the essential role of marbles in the visual–verbal matrix, as well as the power of poetry to create new meanings for archeological finds. Although the appropriation of ancient spoils by the papacy is a familiar aspect of the Renaissance cultural romance with antiquity, Sperulo's villa poem provides precious and unusually specific examples of an ideological construct and associated justification for such installations.

ENVISIONING PAINTINGS: BATTLES AND CLEMENCY

The decorations Sperulo envisions in the villa also include murals that distilled the most significant contemporary political issues into teeming battle scenes. These proposals build on a long tradition of battle imagery in word and image. Virgil, Plutarch, and Livy provided the textual models, on which contemporaries such as Ariosto were also riffing at this moment. Leonardo's *Battle of Anghiari* and his written prescription on how to paint battles were both bibles for artists and patrons in this period, and they further served to canonize the battle scene, long a staple of town hall decoration, as one of the highest forms of narrative painting. Lorenzo de' Medici had set an important precedent for appropriating battle paintings for private domestic use when he installed Paolo Uccello's triptych depicting the *Battle of San Romano* in his camera of the Palazzo Medici.[58] Several other Leonine projects featured battle imagery at this moment, notably Jacopo Ripanda's Roman battle frescoes in the Palazzo dei Conservatori and Raphael's *Battle of the Milvian Bridge* in the Vatican Sala di Costantino (Plate XV). So, the content and form of Sperulo's proposed frescoes for the Medici papal *hospitium* had rich and timely associations.

Sperulo calls for two battle scenes to be painted by Raphael in the central Tiber loggia of the villa, which the poet designates as Leo's seat in the villa (*sedes*),[59] identified in plan in Figure 26. The first scene, which the poet describes in exceptional detail (278–340), refers to the historic Battle of

Ravenna in 1512.[60] One of the most significant and bloody confrontations in the Italian wars, the battle involved French, Spanish, and Italian troops, which are symbolized in the poem by personifications of the Ebro, Rhône, and Po rivers. Leo (at the time of the battle still *in minoribus*) had been the commander of the papal troops and was captured; his subsequent escape had been construed as the miraculous product of divine intervention, and a harbinger of his pontificate. Leo later stressed the importance of this portent, and Raphael included the narrative among his scenes from the life of Leo in the fictive relief borders for the Sistine Chapel tapestries (Figure 35).[61] Thus, Sperulo casts this important battle as foretelling Leo's restoration of peace to the world and the Golden Age of Saturn to Rome.

Sperulo's second painted scene for Leo's loggia was to feature an imagined battle against the Ottoman Turks and the ensuing triumph of Leo and Giulio drawn on golden chariots, with the Tigris, Euphrates, and Hydaspes (present-day Jhelum) rivers in chains, together with the captive Ottoman rulers (341–71). This imagery reflected the contemporary preoccupation with the perceived Turkish threat to Europe and Christianity. The exhortation for a Christian peace and a united crusade against the Ottoman Turks had been a humanistic and diplomatic cliché since the fall of Constantinople in 1453.[62] But the issue took on new urgency between 1516 and 1520, with Ottoman victories in the east, the sporadic appearance of Turkish ships off the coast of Italy, and intelligence reports about the rapidly growing Turkish fleet.[63] Letters of Cardinal Giulio and his diplomatic liaisons are full of references to the movements of Turkish ships off Civitavecchia, suggesting the imminence with which the threat was felt.[64] In January 1518, Egidio of Viterbo, a Curial humanist and leading papal advisor, wrote of the Turks, "We are

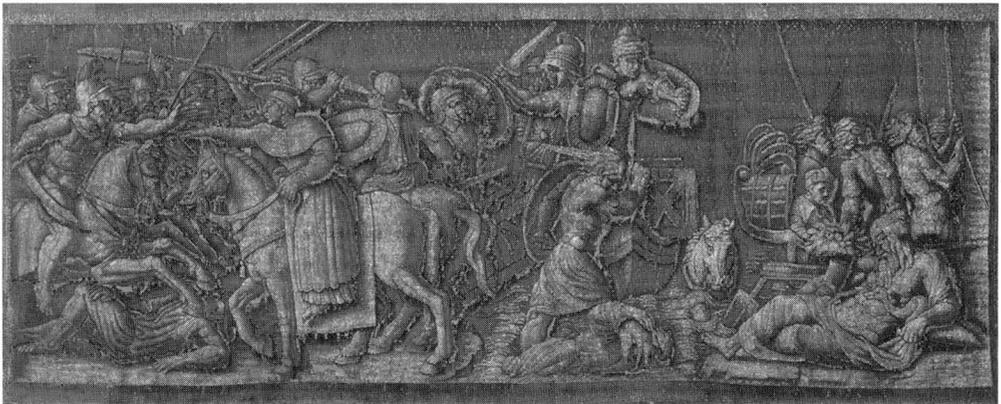

35. Raphael, woven by Pieter van Aelst, *The Capture of Cardinal Giovanni de' Medici by French Troops in the Battle of Ravenna in 1512*, from *Scenes from the Life of Leo X*, borders to the *Acts of the Apostles* tapestries for the Sistine Chapel, 1516–19, Vatican Museums.

terrified … We fear that Italy and Rome are about to be destroyed."[65] The extent to which religious, political, or financial issues were behind talk of a crusade against the Turks is debatable, but papal appeals to European powers for financial and military support for this cause were a central point of diplomatic exchange at this time. Thus, Sperulo's suggestion to depict such a crusade in the papal *hospitium* to welcome foreign dignitaries was not tired rhetoric, but rather reflected a key political issue of the day. This issue was also directly related to the ideology of Leo as *Rex pacificus*, for the precondition of a crusade against the Turks was a truce among European nations.[66] Sperulo expresses the same paradoxical conceit equating an anti-Turkish crusade with peace when he refers to Leo, "by whose command discordant Strife has bowed its head to peace, and it threatens only easterners" (183–4). Here, Sperulo and other Leonine image-makers drew on Augustan tropes of peace at home that freed the emperor to wage war against eastern "barbarians."[67] This subject also figured in decorations in several of the Vatican Palace Stanze, including the Sala di Costantino murals that present Constantine as a model for Leo's crusade against the Turks.[68] The imagery of Raphael's *Transfiguration* has also been interpreted in connection with the "Turkish peril" and the Medici handling of it, as healers of the world's sickness.[69] Sperulo specifically sets this imagery at the papal *hospitium* in the loggia he designates as Leo's seat, which looks directly to the Milvian Bridge, the famous site of Constantinian victory, further underscoring this Leonine-Constantinian imagery.[70] Moreover, Sperulo's proposal for this papal loggia was surely a reference to the earliest papal benediction loggia, that of Boniface VIII at the Lateran, which was decorated with frescoes of Constantine's baptism and founding of that basilica.[71] Thus, we see the coeval formulation of Constantinian imagery for the Medici papal villa and Vatican halls of state, as well as the formulation of battle imagery for projects in the villa, the Vatican, and the Palace of the Conservators on the Capitoline. The confluence of this imagery surely reflected coordinated discussions among papal image-makers for all these projects.

Sperulo proposed another highly topical issue as a subject for wall paintings: the Triumph of Clemency, specifically the clemency of Leo in the face of the recent conspiracy against him (226–44). The poet intended these murals for one of the villa's towers; although his description of physical space is characteristically vague, he probably meant the east tower, which would place the paintings in Raphael's proposed winter *diaeta* (see plan, Figure 26).[72] Sperulo says, "the divine Clemency of Leone, which is embodied by the pigments of Apellean art, will breathe upon me" (231–2), noting Leo's mercy to the conspirators. He describes how Clemency should be depicted on a chariot drawn by the symbols of the four Evangelists (233–44), an image that evokes the divine throne prophesied by Ezekiel (and also surely depends on Raphael's

recent design for the *Vision of Ezekiel*).[73] If this triumph was envisioned for the glazed *diaeta* – perhaps as a band of murals above the windows, or else in the six sections of wall between the windows in a progressive series akin to Mantegna's *Triumphs of Caesar* – it would constitute a spectacular proposal for one of the villa's largest and most novel spaces.[74]

The notion of praising a ruler's clemency is an ancient topos, which had been exploited by the Medici since Cosimo il Vecchio.[75] Leo had been hailed for his clemency while still *in minoribus* in Florence, an important factor in his subsequent election to the papacy;[76] and the alleged conspiracy of cardinals to kill him in 1517 had represented another opportunity for a prominent display of this virtue. The real motivation for Leo's clemency in this situation has been questioned since Leo's time, when there were allegations that the pope had pardoned the conspirators to extort money from them; and most recent scholars believe that the conspiracy never actually occurred at all, but rather was spuriously devised by Leo to extort money from his rivals, squash their power, and stack the College of Cardinals.[77] In any case, the subject of the conspiracy consumed the Curia in 1517–18, and it continued to be discussed throughout the following year. Several humanists wrote poetry and letters about the event, including Colocci, Tebaldeo, and possibly Egidio of Viterbo.[78] Sperulo himself had written the elegy *Ad Leonem X de sua clementia elegia xviiii* celebrating the final pardon accorded by the pope to Cardinal Raffaelle Riario.[79] (The poem, BAV, Vat. Lat. 1673, fols. 102v–103r, appears in Appendix III.) This elegy was probably written around Christmas of 1518, right after the pardon and just a few months before the poet's description of the villa.[80] Sperulo praises Leo as a powerful and noble lion, capable of righteous fury as well as the peaceful clemency to spare traitors.[81] The work draws on such literary models as Cicero's *For Marcellus*, a panegyric praising Caesar for his clemency to Marcellus who had backed Pompey in the civil war, and Seneca's *On Clemency*, written to Nero and modeled on Hellenistic kingship treatises (and these works were also models for Sperulo's villa poem).[82] Taken together, Sperulo's poem about Leo's clemency and his proposal for murals of the Triumph of Clemency in the Medici villa provide an interesting example of a humanist at work, in this case forging Curial propaganda as well as Medicean ideology, and its translation into visual imagery. (Thereafter, the continued importance of this imagery of clemency may be seen in the Sala di Costantino imagery, where the enthroned figure of Clement I is given Leo's features [see Figure 65 below]; and in Cardinal Giulio's choice of a papal name.)

The murals Sperulo envisions thematize the poet's powers of prophecy (although these powers would turn out to be more successful for the marble set pieces he proposed for the villa than the murals, as his ideas for paintings were soon made obsolete by shifting political conditions).[83] In his proposals

for all three murals, Sperulo/Father Tiber encapsulates Leonine history as a vision for painted decorations at the villa in the same way that Virgil's Tiber foretold the history of Rome as scenes for Aeneas' shield. In each case, the narrator interweaves historical battles and triumphs from the past with imagined ones in the future to reify his vision of a triumphant and peaceful empire under his patron.[84] At the same time, Ariosto was working with tools of *ekphrasis* and prophecy in connection with battle imagery in the *Orlando furioso*, at that moment undergoing revisions and topical for Curial humanists.[85] His famous set piece (Canto 33, 5–58) was a Virgilian *ekphrasis* of battle murals that conflate past and future events to predict the outcome of the French–Italian wars. Ariosto proclaims that no artist, ancient or modern, has this power to paint the future; it is instead the work of magic demons, summoned by the prophet Merlin. Sperulo declares that he indeed has such visionary powers, and that Raphael is to execute the poet's vision. Christian Kleinbub has suggested a connection between this passage in the *Orlando* and Raphael's thematization of the visionary in paintings such as the *Transfiguration*.[86] Sperulo places himself directly in competition with Raphael through these mural proposals, especially his description of Clemency's chariot that conjures Ezekiel's vision, to which Raphael had recently given visual form.[87] So, this power to see what does not exist – the future outcome of a war, a villa still on the drawing board, or the godhead itself – emerges as a contemporary marker of the creative power of the artist. This *paragone* among visual artists, wordsmiths, and even supernatural powers is central to Sperulo's conceit that he is building the villa in verse, and evident in his challenges to Raphael in the poem. The illumination of the presentation manuscript further engages these issues, suggesting that the poem is a portrait of the villa; or a building medal in verse (as shown in Appendix II).

With his proposed battle scenes and throughout the poem, Sperulo places a strong emphasis on notions of poetic and artistic invention, and he evokes the *paragone* of art and nature, of modernity and antiquity, and especially of word and image. He declares that the painted and sculpted decorations he foresees will breathe with life (*spirare*, 192, 232, 342 and gloss notes 73, 90, 122); and he repeatedly suggests that living Medici family members will engage with their ancestors, represented in marble (gloss notes 73, 76, and 102). Sperulo declares from the outset that his villa will outlast that of the architects (dedicatory letter, §2).[88] The poet praises Raphael as a superlative painter who rivals and will here surpass Apelles (161, 275), but tells him what to paint and where to paint it; and he chooses sculptures, and specifies where to place them, too. Most remarkably, Sperulo never recognizes Raphael's role as architect of the complex. The poet even mentions measurement, traditionally the domain of the architect, declaring that he (Sperulo) was engaged in measuring columns, and he exhorts the architects to plan the dimensions of rooms around his choice of sculpture and

spoils (*commensa, commetior*, 79 and gloss note 40; *dimensa, dimetior*, 392 and gloss note 136). It is striking that Sperulo claims to be directing important aspects of the work, and suppresses Raphael's responsibility and creative powers. The poet's emphatic declaration of his prophetic powers to envision the new villa and "construct" it in verse is a bold claim for the power of word.

From these literary boasts, we turn next to consider the relation between the poet's and architect's writings and the architectural planning for the villa at this time, and to assess the actual agency of Sperulo's literary villa in the development of the physical one.

CHAPTER FOUR

ENCOMIA OF THE UNBUILT

W HILE SPERULO WAS MAKING CLAIMS FOR THE POWER OF the poet based on his prophetic ability to see the villa before it existed, the architects designing the villa were obviously envisioning the unbuilt complex themselves. Raphael recorded his ideas for the villa using traditional architect's tools such as ground plans, and also in words. As discussed in Chapter 1, his letter describing Villa Madama is a verbal analogue of a master plan, tracing a Plinian *percorso* through the grand villa complex. This chapter considers the relation between these two proleptic descriptions of the villa, analyzing the literary modes in which both authors were working, and the functions of their descriptions.

BUILDING THE VILLA IN VERSE AND PROSE: SPERULO'S AND RAPHAEL'S DESCRIPTIONS

There has been disagreement about the relative chronology of Sperulo's poem and Raphael's letter (Figure 36). The poem is dated 1 March 1519, although it may have been composed a little earlier; and the letter is generally thought to have been written some time in winter 1518–19 (although this date has in part been based on the relative chronology with the poem). Shearman insisted that Raphael's letter was the earlier text and the source for Sperulo's poem, remarking that, "It seems inherently unlikely that Raphael would think the relatively incidental, descriptive parts of this shamelessly encomiastic poem

36. Raphael (in the hand of a copyist), *Letter Describing Villa Madama*, Florence, Archivio di Stato, MAP 94, letter 162, cc. 214r.

worth imitating; his creativity has its own resources of a very different, and as it were professional, nature … Moreover, to give precedence to Sperulo is implicitly to attribute to him deeply meditated philosophical-hygienic aspects of Raphael's design, fundamentally controlling it."[1] But the assumption that primacy of writing reflects the invention of every idea in the description emerges as faulty logic, as this analysis will show. Shearman also argues for the primacy of Raphael's letter on the grounds that Sperulo copied Raphael's discussion of siting according to the sun and the winds; but in fact, Sperulo's description is much more directly indebted to Statius than to Raphael or his models for this passage, Pliny and Vitruvius. The same point can be offered for Sperulo's discussion of how the building would be protected from the extremes of weather – another topos. Although the architects actually did have to think about winds and seasonal comfort in their siting and design, when it came to writing about it, architect as well as poet looked to literary models rather than the site itself. Unlike Shearman, Frommel, followed by Jacks, Camesasca and Piazza, and Di Teodoro, take the view that Sperulo wrote first.[2]

In fact, the only part of Sperulo's poem that bears any resemblance to Raphael's letter is a fourteen-line section near the very end of this 407-line poem – and it is a simple list of items that Sperulo says he will *not* discuss. Significantly, Sperulo glosses over elements such as the theater, baths, gardens, and stables in a simple list, saying, "The other elements of the great house, above and below, I pass over in silence … All this better anon" (378–91). Of course, these were the areas built in a later phase or, in many cases, not at all; but more importantly, these elements that Sperulo leaves aside are the exact items Raphael focuses on in his letter. These items are set apart in a *praeteritio* – an ironic rhetorical device by which an author claims to ignore a subject, while actually bringing it to the reader's attention.[3] Sperulo calls attention to this device by introducing the passage with the words *praetereo tacitus* – "I pass over in silence" (379; Figure 37). He could not possibly have chosen to set aside in this pointed way the very subjects the architect discussed without some knowledge of Raphael's letter. This observation is the most telling indication that Sperulo knew Raphael's epistle.[4]

However, there is no compelling evidence in the two texts that Sperulo necessarily *read* Raphael's letter; it is plausible that the poet compiled a list of the villa's highlights in conversation with Raphael or an associate, who could have described his letter project to Sperulo and sketched a plan, labeling important spaces. Or, he might have heard it read aloud. Thus, while I agree with Shearman that Sperulo alludes to Raphael's design for the villa, I do not subscribe to his assumption that one text depends directly on the other. At best, Sperulo may have seen the letter briefly without taking notes or copying it – a practice of restricted access sometimes imposed by humanists, including Pietro Bembo.[5] Such a scenario would explain why Sperulo's list

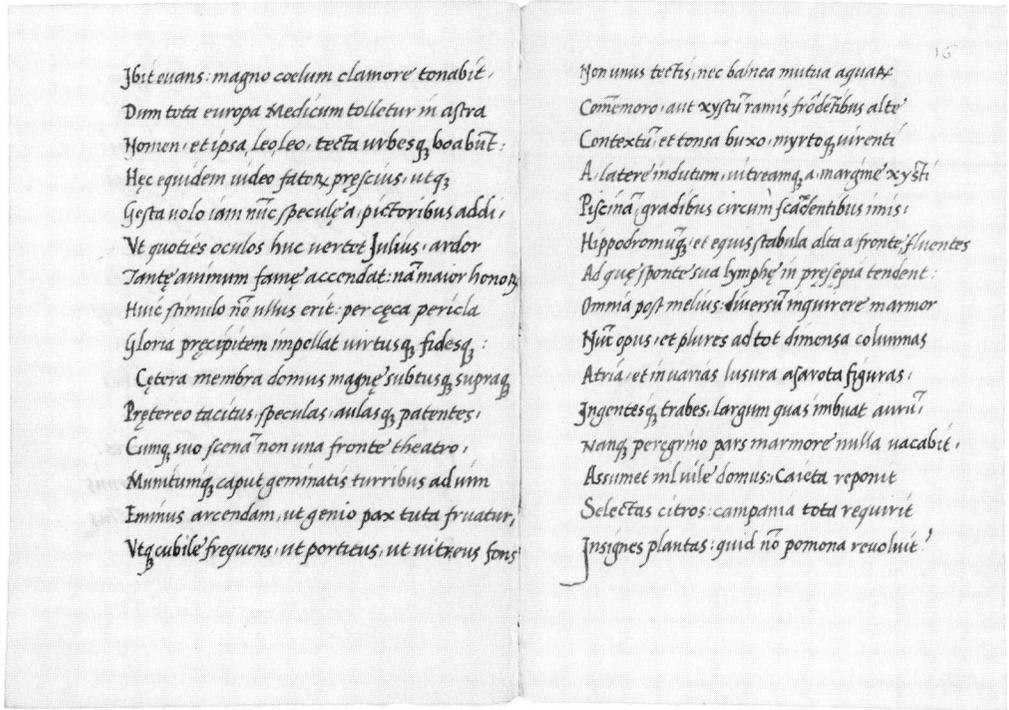

Jbit euans: magno coelum clamore tonabit,
Dum tota europa Medicum tolletur in astra
Nomen et ipsa, Leo Leo, tecta urbesq, boabut:
Hec equidem video fator, prescius, utq;
Gesta nolo iam nuc specule a pictoribus addi,
Vt quoties oculos huc vertet Julius, ardor
Tante animum fame accendat: nam maior honor,
Huic stimulo no ullus erit: per egca pericla
Gloria precipitem impellat virtusq, fidesq,:
 Cetera membra domus magne subtusq, supraq,
Pretereo tacitus: speculas, aulasq, patentes,
Cumq, suo scena non una fronte theatro,
Munitumq, caput geminatis turribus ad vnum
Emmus arcendam, ut genio pax tuta fruatur,
Vtq, cubile frequens, ut porticus, ut vitreus fons

Non vnus tectis, nec balnea mutua aquat,
Comemoro aut xystu ramis frodentibus alte
Contextu et tonsa buxo, myrtoq, virenti
A latere indutum, vitreamq, a margine xysti
Piscina, gradibus circum scadentibus imis,
Hippodromuq, et equis stabula alta a fronte, fluentes
Ad que sponte sua lymphe in presepia tendent,
Omnia post melius diversu inquirere marmor
Huic opus: et plures ad tot dimensa columnas
Atria, et in varias lusura a savota figuras,
Ingentesq, trabes, largum quas imbuat auru,
Nanq, peregrimo pars marmore nulla vacabit,
Assumet mihi mille domus: Caieta reponit
Selectas citros: campania tota requirit
Insignes plantas: quid no pomona revoluit,

37. Francesco Sperulo, *Villa Iulia Medica versibus fabricata*, 1519. BAV, Vat. Lat. 5812, fols. 15v–16r: the *praeteritio* listing items the poet sets aside.

includes some of the same unusual Plinian vocabulary used by Raphael (such as *xystus* and hippodrome[6]) and details dear to the architect, such as running water in the stable stalls and recycled water in the baths; but also why Sperulo's list follows a completely different order from the letter;[7] why he uses some unusual words completely differently than Raphael (e.g. Sperulo uses *coenatio* to describe the garden loggia, whereas Raphael uses *cenatione* to designate an outdoor dining area flanking the fishpond);[8] and why Sperulo proposes battle paintings for the central Tiber loggia, an impossible setting for murals because its walls were broken up by doors, niches, columns, and open arches, as Raphael's letter clearly describes and the plans show.[9] These discrepancies suggest that the poet did not study Raphael's letter in much detail, if he saw it at all. Indeed, it is difficult to imagine why Raphael would care to circulate an unfinished draft – unless there was a more finished version that has not come down to us. Sperulo's list reads almost as an afterthought, and the tone at the end of his poem is disjointed, suggesting the possibility that he learned about the contents of Raphael's letter just as he was finishing the work. The poem would thus provide a *terminus ante quem* for the letter – if one can speak of a *terminus* for a letter for which no finished version has ever emerged. The most plausible scenario is that the two works were being written around the same time.

Revealingly, the very fact that Sperulo was privy to Raphael's ideas, whether on paper or in person, is crucial evidence because it shows that the poet was engaged with some of the villa planners, in addition to his connections to its Medici patrons. Sperulo may also have seen a master plan for the villa, presumably U 273A; his description of some places in the villa fairly accurately reflects the plan of the complex, although he is vague about other spaces, he does not grasp the relation of plan to site, and he seems to misinterpret the plan to represent the fishpond as adjacent to the *xystus*, whereas the pond was to be one storey below, as indicated by the stairs in the plan and specified in Raphael's letter (see Plates III–V and Figures 52, 57).[10] Sperulo's presence in this milieu further suggests that his poem may have been commissioned, rather than written independently in the hope of additional patronage.[11] It is also noteworthy that the poet evidently knew Raphael's letter, but did not choose to praise the many extravagant and unusual *all'antica* features that the villa's architect and designer thought most important. Rather, Sperulo discusses completely different material than Raphael does. Sperulo's pointed *praeteritio* reads as an insider's reference to Raphael's letter, with no need to duplicate the architect's content. Moreover, what immediately follows the *praeteritio* is the line summarizing what Father Tiber/Sperulo says is his main task: "Now, it is necessary to search out the different marbles and the many columns to be placed around the planned courtyards" (391–3). Thus, the poet is summing up his own responsibilities at the villa, and distinguishing them from those of the architect.

Certainly, the two works reflect very different literary forms, functions, and authors. Raphael's vernacular letter walks the patron bodily through the villa, giving a specific and concrete description of the ground plans. Although he cloaked his description in Plinian language, Raphael's draft reflects scant attention to literary craft; Shearman noted the "semi-literate nature of this raw text," and Frommel identified entire passages lifted directly from Vitruvius.[12] These flaws surely reflect that what survives is a rough draft of the architect's ideas, before he or Castiglione had a chance to polish it,[13] but also a lack of range and sophistication at literary bricolage. As Shearman noted in a discussion of Raphael's literary range in his sonnets, to which he compared the Villa Madama letter, "his reading seems occasioned by the job in hand, making Petrarchan sonnets in the one case or a Plinian letter in the other, and is scarce evidence of a structural part of his culture."[14] By contrast, Sperulo's poem is a literary exercise in neo-Latin hexameters involving concepts, ideology, and decorations; the poet displays an extensive knowledge of ancient literature and a highly sophisticated ability to evoke and transform his models. His sloppy use of architectural vocabulary and misunderstanding of the plan, on the other hand, reflect his lack of expertise in that area.[15]

One fundamental similarity between Raphael's letter and Sperulo's poem is vital: both were written to describe a villa that was not yet built. Scholars

have long accepted Raphael's letter as a proposal of the artist's ideas. I believe that Sperulo, too, was proposing ideas for the villa complex. Although the letter and poem are very different products, they may well have been conceived in the same milieu and timeframe, and for similar purposes. Both texts function as proleptic memory palaces, which present their author's visionary ideas for specific aspects of the villa. Sperulo's *praeteritio* concludes with the phrase "All this better anon" (391), further suggesting that the listener will hear about these items from Raphael later, and thus that the two descriptions were intended to be read for the same audience. Humanist gatherings could be the occasion for poetic correspondence, a literary practice involving works that reply to each other in a pseudo-exchange.[16] One can visualize Sperulo and Raphael performing these works as an intertextual discourse before Cardinal Giulio, perhaps at a construction-site convivium on the Monte Mario that also included Tebaldeo, Vida, Equicola, and Goritz.[17] As noted above, such an event was probably the occasion for reciting poems about Chigi's villa; and Valeriano's *Dialogo* presents just such a scenario at Villa Madama.[18] This would explain the composition of all these written works describing the unfinished Medici villa, including Vida's reference to Goritz visiting the construction site. Rugged banquet settings were not uncommon in this circle; some of the same people famously picnicked in the ruins of the Domus Aurea and of Hadrian's Villa, and banqueted in villa gardens and in Agostino Chigi's unfinished stables (the latter admittedly camouflaged with luxurious tapestries as a joke). Other gatherings are recorded at the Medici site itself, even when the villa was in the very early stages of construction: just two weeks after Sperulo dated his poem, Pope Leo passed the entire day at the site, just for pleasure,[19] and he hosted Baldassare Castiglione for dinner there three months later (in June), and the Duke of Ferrara's agent in October.[20] In sum, what better place for a convivium than the site of the rising villa conceived as the Leonine utopia for living *all'antica*? If such an event actually happened, Raphael's "walk-through" could have functioned not just as verbal metaphor, but also as a performative experience, as he led his patrons and listeners physically through the site – a point to which I will return in Chapter 6.

HORTATORY *EKPHRASIS*

At this point, we may return to the issue raised at the outset: the function of poetry celebrating a villa that did not yet exist. It is striking that many of the Renaissance poems discussed in Chapter 2 were written while the villas were still in construction, including those about Villa Madama, Chigi's Roman villa, and Poggio a Caiano[21] (although I do not believe that Poliziano's poems about Poggio a Caiano were descriptive or prescriptive in the same way as those of the Roman poets). There were surely compelling reasons for Roman

humanists to produce numerous full-length poems praising non-existent or partially built villas.

The most obvious purpose of such Renaissance villa poetry was to advertise the goals of the builder and frame the reception of the building. It is well known that humanists functioned as propagandists for the papal Curia, as well as for wealthy patrons like Agostino Chigi (who as a papal banker moved in the same circles).[22] Villa Madama was surprisingly familiar to contemporary patrons and artists, although it is less so to us because of a variety of later circumstances. The villa poetry of Sperulo and others may have contributed to the reputation of the villa in its own day. Certainly words could be produced very quickly relative to buildings, and they were impervious to the risks of delay and non-completion that plagued physical construction. Thus poetry could announce a project, and proleptically shape its reception. (In Sperulo's case, the fact that only a single pocket-sized manuscript copy of his poem is known to exist suggests the target audience was local and that they experienced the poem through performance; it could have been held and read aloud, or passed around to a select group, but it evidently was not intended to announce the villa to a broad audience.)

More importantly, the basic function of these proleptic villa poems by Sperulo and his contemporaries was to serve as conceptual proposals for villa architecture and decoration. Blosio Palladio, in the dedication to his 1512 panegyric about the Chigi villa, identifies his work as a *sylva*, and, like Statius, Blosio plays with the meaning of the word as a piece of wood or raw material ready to be worked up.[23] This imagery goes further than the proverbial apology/boast about a literary work tossed off quickly, a device also used by Statius, Blosio, and Sperulo.[24] Blosio offers his patron an axe to cut, prune, purify, and refine the work, and he goes on to specify that he sings of things unbuilt but planned or in the patron's mind. Thus, unlike Statius who wrote of completed buildings, Blosio parallels the notions that his poem and the Chigi villa plan are works in progress. He subtly suggests that he presents the patron with much material with which to work, while preserving the appearance that the patron is the author.[25] We have seen how Sperulo, in the voice of Father Tiber, says, "Let this work rise under my auspices!" (46), challenges Raphael about the placement of the sculpture (160–4), and directs what the artist should paint (372–3). These are poetic devices, but they suggest the poet's role in formulating and proposing ideas. Sperulo's frequent use of the hortatory subjunctive in his poem also emphasizes this role.[26] The poets, at the same time they were celebrating a villa and its patron, were offering ideas to the patrons and artists, in a mode I would like to call hortatory *ekphrasis*.

I have found no direct antecedents in ancient literature or rhetoric for this mode: an extended and specific description of an actual place that does not yet exist, and an exhortation to realize it. Instead, Sperulo's work draws on many models, none of them an exact template. As we have seen, his principal model was Statius, the first to devote an entire poem to the description of a work of

art, whose *Silvae* provided an appropriate model in their novel combination of the encomium of a patron and a description of his artistic patronage. But unlike Sperulo, Statius had described extant works, including villas – as did Pliny, the preeminent model for prose villa descriptions, and most other writers describing actual villas, from Horace to Fortunatus.

One interesting example of ancient proleptic villa description can be found in the letters of Cicero to Quintus. These epistles served the ostensibly practical function of updating Cicero's brother on the construction of his villa while he was away at war, but they were also literary narratives of the coming-into-existence of a villa, as Ann Kuttner interprets them.[27] This mix of hands-on details at the construction site with a literary portrait of the villa as a site of imagination was surely a stimulus for Renaissance villa writers, although Cicero's letters do not seem prescriptive in the sense of Sperulo's work.[28]

The long and rich history of *ekphrasis* does not provide a direct model for Sperulo's work either. *Ekphrastic* descriptions of architecture and works of art appeared in the overlapping genres of poetry and rhetoric, both embraced by Renaissance humanists for their shared emphasis on writings of praise.[29] As is well known, the Greek and Byzantine traditions of architectural *ekphrasis* had been introduced to Italy by Manuel Chrysolorus in the early quattrocento.[30] Interestingly, Chrysolorus was a close friend in Rome of Poggio Bracciolini,[31] who had rediscovered Statius' *Silvae*; one can imagine their discussions of converging *ekphrastic* models, which were important for later Roman humanists. (Curiously, however, the importance of Statius' work has been virtually ignored in the voluminous modern literature devoted to *ekphrasis*.[32]) Because Sperulo describes not only the villa building itself, but its painted battle scenes, sculptures, and grounds, the poet draws on a range of *ekphrastic* models from ancient rhetoric and literature. But ancient *ekphrases/descriptiones*, unlike Sperulo's poem, describe either real, extant structures such as the villa panegyrics discussed, or fictional visions. The latter tradition of describing the imaginary – sometimes called *topothesia* or notional *ekphrasis*[33] – has been traced to Homer's Shield of Achilles, and the key model for our Renaissance villa poets was surely Virgil's well-known description of the unbuilt Carthaginian Temple.[34] As we have seen, Ariosto was working in this mode, too. Imagined and real environments had been interwoven in literature from ancient rhetorical exercises in the *ars memoriae* tradition to the *Hypnerotomachia Poliphili*'s notional *ekphrases* of architecture.[35] Philostratus' *Imagines* served as an important set piece of *ekphrasis*, in particular of paintings in a villa (which may or may not have existed – and it is unclear which option Renaissance readers believed); these *ekphrases* would come to be used as the source of decorations in the Medici villa. Filarete's description of the imaginary utopian city of Sforzinda blurred the lines between the visionary, the fantastical, and a plan for action.[36] Other quattrocento fantastical descriptions of gold-, gem-, and pearl-studded palaces, from St. Peter's to the real Medici palace in Florence, served as allegories of the Heavenly Jerusalem or

38. Fra Carnevale, *The Ideal City*, c. 1480–4. The Walters Art Museum, Baltimore.

Temple of Solomon, or simply as extravagant praise of a patron, but not as literal description.[37] The notion of an actual villa that existed first in the humanist's mind may be found in a 1488 letter by Marsilio Ficino, who described his walk in the Fiesolan Hills together with Pico della Mirandola discussing their imaginary ideal villa, only to see it suddenly materialize before their eyes; but Ficino used this conceit to praise an already-extant villa, as he himself makes clear.[38] We may even think of a visual analogue, such as the so-called Ideal City panels (Figure 38), which Richard Krautheimer proposed served a hortatory function, although these panels were more likely utopian models than plans for specific action.[39] All these examples, therefore, are different from describing an actual building that was not yet completed. Sperulo's *ekphrasis* of the Medici villa is neither mimetic nor fictional nor allegorical: it is proleptic, and hortatory.

THE INVENTIVE ASSEMBLAGE OF LITERARY AND RHETORICAL GENRES

It emerges that there was no direct model for Sperulo's proleptic and hortatory verse. Further, it did not fit neatly into any literary category; rather, Sperulo's poem represents an inventive assemblage of literary and rhetorical genres. Panegyric is the closest mode to Sperulo's poem, without providing a direct model. Sperulo incorporates the classical topoi of panegyric literature – praise of illustrious ancestors and valor in battle – in his proposed decorations for the Medici villa. Since the Hellenistic period, panegyrics, or encomia, of patrons had been composed in verse and prose;[40] and significantly for our subject, it was Statius who provided the model for encomiastic, or epideictic poetry – that is, poetry that adapts elements of epideictic rhetoric, the branch of oratory related to praise and blame.[41] (This perhaps suggests another reason for the appeal of Statius' *Silvae* to Renaissance humanists, for epideixis dominated Renaissance humanist discourse and sermons and was a crucial tool of Curial propaganda.[42]) Panegyrics could encompass architectural *ekphrasis* as one element of praise.[43] As noted, Statius' villa poems expanded on this tradition.[44]

A few Renaissance panegyrics were surely well-known examples for Sperulo and his contemporaries, if not direct models. Manetti's panegyric of Nicholas V, written after the pontiff's death, included an *ekphrasis* of new St. Peter's as if it were already complete, although his digression on the basilica was not at all specific to the building, instead comprising tropes of praise to provide a worthy backdrop for his culminating narrative of imperial coronation.[45] Likewise, Francesco Albertini's guide to Rome, published in 1510 and dedicated to Pope Julius II, was effectively an encomium of the pope's architectural and urbanistic projects; but Albertini's descriptions are relatively brief and formulaic, praising even St. Peter's primarily for the magnificence of the project as measured by its scale and columns.[46] Such panegyrics provided essential models of architectural *ekphrasis* of an unfinished, real building – and specifically of St. Peter's, addressed to its papal patrons – but these prose works did not provide the template for Sperulo's long and detailed descriptive poem, or its hortatory aspect.

The prescriptive aspect of Renaissance poetry such as Sperulo's derives from protreptic discourse, a late antique form of panegyric combining praise of a living ruler with hopes and exhortations for his future actions.[47] Such works were often written by advisors to young rulers who did not yet have a track record to praise, and thus the writers incorporated predictions and prescriptions for a future program of great deeds. Such speeches of advice, or suasory, also drew on the deliberative branch of oratory, which provided a model for prescribing a course of action.[48] This kind of protreptic praise was known to Renaissance readers in works by Cicero praising Caesar, Pliny on Trajan, Seneca to Nero, and even Statius to Domitian.[49] Some of these protreptic works emphasizing the virtue of clemency – notably Cicero's praise of the *clementia Caesaris* and Seneca's treatise *De clementia* – were Sperulo's very models for his earlier elegy on the clemency of Pope Leo; so Sperulo was intimately familiar with their advisory, protreptic, hortatory mode. Sperulo's villa poem augments the traditional scope of late antique protreptic panegyric to prescribe the program for his patron's artistic and architectural achievements. And although he was not the first Renaissance writer to exhort a pope to build, his prescription was unusually specific and detailed.[50] Most importantly, Sperulo shifts the emphasis of traditional panegyric; the primary focus of his poem is not praise of the patron, but rather extended *ekphrasis* and exhortation. Neither is it conventional metonymic praise of the patron via description of his commission, for Sperulo composed detailed *ekphrases* of unexecuted architecture, landscape, sculpture, and paintings, and he used the rhetoric of persuasion to urge his patron to realize the poet's own ideas.[51] As we have seen, the villa he describes and praises is not the work of the patron or even the architect, but the poet's own vision, which he exhorts them to follow.

Therefore, there are parallels for the various elements of Sperulo's poem, but no genre or example fully corresponds to his synthesis of elements. Although

he never uses the word *silva* (curiously!), Sperulo follows Statius' example in creating a genre-bending fusion of literary and rhetorical modes.[52] As we have seen, Sperulo's encomiastic poem takes from epic poetry its form, diction, and narrative and temporal structure: heroic hexameters are placed in the mouths of mythological spokespersons, who describe the past and future glories of the Medici. Additionally, Sperulo adapts the device of notional *ekphrasis*, perhaps via Cicero, to describe the real-but-not-yet-built; and he transposes his description to the prescriptive tone of protreptic panegyric. That is, Sperulo combined elements of epic poetry, protreptic panegyric, and notional *ekphrasis* in the mode that I am calling hortatory *ekphrasis*.

Thus, the panegyric describing an actual but unbuilt villa, in verse or prose, seems to be a sub-genre, and one that flourished in Renaissance Italy. Sperulo did not invent this genre; his Roman colleagues Blosio and Gallo seem to have done something similar in the Chigi villa panegyrics a few years earlier,[53] and future research may present earlier examples, perhaps in the circle of quattrocento humanists such as Poliziano or Pontano.[54] But Sperulo made brilliantly effective use of this mode, and claimed for himself unusually explicitly the roles of inventor and site boss – the embodiment of the poet as master builder.[55] Through his prophetic personae and his use of hortatory *ekphrasis*, Sperulo characterized himself as a visionary *vates* for the Medici. His sophisticated citation of a rich array of sources and genres displayed his copious erudition and established him as a *poeta doctus*. He also claimed the mantle of the *deus artifex*, who envisions and actually builds the villa. In all these ways, he presented his ideas to Raphael and to his Medici patrons, along with a heavy dose of self-promotion. Sperulo's writing aimed to be persuasive at multiple levels: to forge decorative imagery that would convincingly present Medici messages to the villa's distinguished visitors, to persuade the artists and patrons to adopt and execute his ideas, and to convince them of his importance as a poet, humanist, and advisor in the Curial equipe.

We may see one response to Sperulo's bombastic claims in a wickedly pointed satire of Roman literary culture written just a few years after Sperulo's villa poem. In his *Dialogo contra i poeti* written by 1525, Francesco Berni attacked "professional" poets, excoriating them as vicious slanderers, inept and derivative versifiers, and time-wasting sycophants.[56] As secretary to the papal datary Giovan Matteo Giberti living in the Vatican, Berni had ample opportunity to sort through these poets' offerings, which he notes were often recorded in lavish, gilt-edged small volumes that included prefaces written in capital letters, polished prefatory letters, and illuminated capitals – a description that is markedly similar to Sperulo's *libretto*.[57] Although Berni was primarily targeting hopeful, would-be courtiers, unlike the Medici Curial insider we have seen Sperulo to have been, Berni's withering assessment reflects some humanists' fatigue with the exaggerated rhetoric and backbiting tactics in this competitive

milieu. Significantly for this narrative, Berni caricatured the conceit of the poet as builder by likening poets to masons and manual workers (*muratori o manovali*) with Apollo as their foreman (*capomaestro*), at once recognizing and subverting the master builder topos and poetic claims to architectural invention.[58] Berni's satire suggests the prominence of this trope in the early 1520s; his dialogue may reflect a response to poems such as the Chigi and Medici villa descriptions, and in particular to Sperulo's poem that so prominently features the conceit of building in verse, and the poet's role as site boss.

POETRY AND PLANNING

However inflated Sperulo's claims, his hortatory *ekphrasis* was indeed written at the right moment to serve as a proposal for certain aspects of Raphael's Medici villa, as we may determine by considering the poem within the design and construction timeline. Frommel's study of the villa's construction remains the standard narrative.[59] Fine-tuning the chronology has long been problematic since so few of the surviving plans or documents are dated – Sperulo's being a rare exception – and there is still little agreement over the dating of the manuscripts of the letter to Leo X and the letter on Villa Madama.[60] Construction at the villa probably began in the late summer of 1518, when materials were ordered for the site.[61] The transition between the two major surviving plans for the villa, from U 273A to U 314A, has been dated beginning from late 1518 to mid-1519, using Sperulo's poem dated 1 March 1519 as a *terminus ante quem* for Raphael's villa letter that contains elements of both plans. If we accept the hypothesis proposed here that Raphael's and Sperulo's descriptions were roughly coeval, then fundamental changes to the basic plan were evidently being worked out in the first quarter of 1519 – changes that would result in U 314A. It remains unclear when U 314A was stabilized; Frommel has interpreted the additions and corrections to the plan to represent changes after Raphael's death, although in light of the iterative design process during Raphael's lifetime proposed here, those changes seem equally plausible while he was alive. Whenever this master ground plan was finalized, it was certainly well after Sperulo wrote his poem, and thus construction could not have been very far along at the time he was writing; at most the foundations and basement storey were in progress, but the rooms he described on the piano nobile were probably determined but unbuilt. So, important changes to the basic plan were probably being worked out in the first months of 1519.

It is striking that the general ideas and themes for the decorative imagery were being sketched out at this early stage – when ground plans were still being set and before walls were even erected. It is also notable that these proposals were for the entire villa complex, not just the wing built in the first and, as it turned out, only phase of construction. For example, Sperulo proposes murals for the central and southernmost parts of the villa, which were never built (Figure 26). The garden

loggia is the space Sperulo describes most vividly and concretely, suggesting that there was a certain focus on this section, or perhaps that it was already beginning to take form. Frommel puts the start of the loggia's construction between spring 1519 and winter 1519–20.[62] Sperulo's description accurately evokes the plan of the loggia from a vantage point under its central dome vault looking northeast (visible in Figure 18), "which on the right looks onto the grand vestibule, on the left onto ever blooming gardens" (207–8). (Like Raphael's description rooted in the ground plan, this language also calls to mind the scenario of patrons and designers at a construction site convivium, with the poet performing these lines while gesturing at the muddy fields that would be verdant gardens.) In contrast to Sperulo's sharply defined description of the garden loggia, his references to other areas of the villa are vague. His setting for some of the proposed murals in Leo's planned central loggia, designed with almost no wall space, was particularly improbable. Sperulo could have been confused, or he might intentionally have fudged the designated location in order to set his triumphal battle paintings in Leo's figurative seat in the villa – the central loggia, with significant views of the Milvian Bridge, site of the Constantinian victory and symbolic of the source of papal temporal power. Or perhaps he was urging the architects to reconfigure the elevations of Leo's loggia to accommodate his proposed murals, which would indeed have contributed to a richly symbolic set piece.[63] Alternately, his proposal could simply reflect that variant ideas were on the table at once. This loggia was not fully constructed, so the mismatch of Sperulo's suggestions and its features may simply have reflected that it was being planned in less detail by all concerned. Thus, it was probably around the time of Sperulo's poem that plans for the garden loggia were the focus of major revisions.

It is not always clear when, and to what extent, Sperulo was generating his own ideas rather than compiling and articulating the ideas of others. We lack drawings or other evidence to date the development of particular wall elevations. In certain cases, Sperulo was surely describing already-established plans made known to him by Raphael or his fellow architects. However, it is clear that Sperulo was not just passively transcribing others' ideas – he was pitching many of his own. The many wide-ranging literary sources for much of his proposed villa imagery are the contribution of a sophisticated *letterato*. Sperulo's poem is analogous to a modern white paper – that is, a position document prepared by a policy expert for a government or corporation to formulate the organization's position on an issue. Often such a work is an amalgam of executive directives, expert testimony, and the writer's own ideas, integrated into a single document. This is not to diminish the author's importance by suggesting that every idea in the work is not original. Sperulo's gathering of ideas, contribution of new ones, citation of ancient literary prototypes, and synthesis of all these elements into a cohesive whole constituted valuable work – a practice acknowledged in discussions of authorship from medieval scholasticism to

postmodern theory.[64] The frequent association of villa poetry with the *silva* is particularly appropriate to this kind of task, as *silvae*, since antiquity, designated compendia of miscellaneous, varied, and sometimes even disordered content.[65] In fact, contrary to our modern notions of originality and literary merit, this amassing and arranging of varied content was considered a badge of the copious erudition and even *ingenium* and *furor* of the poet.[66]

In short, Sperulo's work cannot simply be dismissed as derivative poetry, as empty flattery, or as a string of conventional tropes; rather, it was efficacious poetry, written for a specific purpose. His poem "constructing" the Medici villa lays out a detailed set of ideas, and exhorts Cardinal Giulio and Raphael to enact them. John D'Amico showed how Curial humanists employed neo-Latin as an effective tool to advance the religious and political ideals of the papacy;[67] Sperulo's poem suggests that neo-Latin could further be used as a tool for proposing and critiquing architectural and visual imagery. Renaissance poetry served a crucial social and communicative function, which necessitated that poets use familiar forms, diction, metaphors, and models that would be clearly understood by their literate audience.[68] The coding in Sperulo's poem was readily apparent to its target audience, even if it seems abstruse and overly elaborated to us today; the literary quotations, Medici tags, references to the ideas of colleagues, challenges to Raphael, and the poet's own ideas – all wrapped in Statian structure and couched in Virgilian hexameter – constituted clear communication with the required authority and scholarly apparatus.

Sperulo was engaged with the inner circle of the villa's planners, as we have seen from the fact that he was privy to some of Raphael's ideas, as well as the ground plans. Likewise, Sperulo's knowledge of antiquities and marbles available for use in the project certainly came not from a stroll through the construction site, but from access to the Medici collections. His post as papal chamberlain meant he was a valued member of the Medici Curial *famiglia*, and his earlier elegy on Leo's clemency shows that he had already been instrumental to the Medici in crafting the papal response to the alleged conspiracy. With his villa poem, he applied his literary skills to the task of proposing ideas for the design and decoration of their villa project. In this way, he deployed poetry as a design tool: his "building in verse" took the form of hortatory *ekphrasis*. The poet further emphasized his participation in this endeavor by writing the presentation manuscript of the villa poem in his own hand, a signal of authorial presence (for which see Appendix II). We generally think that the tools of the Renaissance architect were drawings and models; in this scenario, text was also a tool, and Raphael himself joined the poets in envisioning the villa in words. Considering the poems of Sperulo and other humanists together with the letter of Raphael opens a new context for looking at the role of text in the design process. The following chapters further examine what they were actually designing with words, and how text could be a tool of design.

CHAPTER FIVE

METASTRUCTURES OF WORD AND IMAGE

MULTIVALENT CONCEPTUAL PROGRAMS

We have seen poets working with architects to build the villa with words, but what exactly were they constructing? Historians of art and architecture usually speak of the *program* for an ensemble or building, typically in the sense of a description of ideological or iconographic subject matter to be expressed in the work. This notion is problematic for several reasons, beginning with the anachronistic term *program* itself, which first came into use in the eighteenth century, and in a different context. Sixteenth-century writers referred instead to the notion of *invenzione*, a term drawn from rhetoric and, confusingly, used to designate conceptual, verbal, or visual ideas.[1] Much of the literature about programs or inventions has focused on painting, and occasionally sculpture, the media most closely associated with the visual formulation of text-based narratives.[2] Our limited knowledge of such programs is based on extant written examples. The survival of a number of programs from the mid-sixteenth century coincides with the taste for increasingly complex, recondite imagery, although this obviously varied by patron and the nature of the commission.[3] Contemporary sources earlier in the century are scarce, and varied in their appreciation of such complexity.[4] Paolo Cortesi, writing in 1510, advocated learned and abstruse decorative schemes for the erudite audiences visiting a cardinal's palace.[5] Although Cardinal Giulio knew Cortesi's work, he specifically expressed his wishes that the imagery for his villa be familiar and

straightforward – "so that it is not necessary for the painter to add: 'this is a horse'."[6] (Of course, this statement needs to be interpreted in the context of the jocular repartée between the Cardinal and his agent Mario Maffei in Rome, with the understanding that what constituted straightforward imagery for Cardinal Giulio could still seem complex by modern standards.) But there is little evidence about the generation of programs or inventions for the first half of the sixteenth century in general, and for the Raphael school in particular, which may partly reflect a culture of orality, and of collaborators working together face to face.

The notion of a program for architecture is necessarily somewhat different than in representational media; the subject of whether and how verbal ideas could be translated into architectural design has proved to be problematic.[7] Nor has much information emerged to clarify the contribution of humanists to architectural projects; even the role of Alberti at St. Peter's, to take perhaps the best-known example, remains the subject of considerable speculation and disagreement.[8] Manfredo Tafuri addressed how the production of meaning was conceptualized in architecture in early cinquecento Rome, and while he acknowledged the shared mindset of architects and humanists, he cautioned against "naively" assuming any direct "influence" of humanist ideas on painters or architects.[9] In an essay published in 1982, James Ackerman challenged architectural historians to consider what he called programs that "bring architecture into being"; in his view, such programs were framed by the visions, needs, and desires of patrons operating in a specific social and cultural context, their ideas springing from ideologies of which they often were not even conscious.[10] Of course, attention to socio-political, economic, and cultural aspects of architecture have augmented formal and technical approaches to architectural history throughout the last half of the twentieth century, spurred in part by Tafuri. But the notion of an architectural program in Renaissance building remains elusive. The masterful analysis by Christine Smith and Joseph O'Connor of Giannozzo Manetti's descriptions of Florence Cathedral and his biography of Pope Nicholas V as a builder demonstrate the power of architectural *ekphrasis* to convey a patron's goals and visitors' reactions, and thus to give a building meaning.[11] Marie Tanner has considered what she calls "programmatic antiquarianism" in the formation of plans for St. Peter's, looking at symbolism or iconography of architecture in the sense that Panofsky or Krautheimer used the terms, and Nicholas Temple has traced "paradigmatic themes" in many projects of Julius II.[12] But these notions of program or meaning in art and architecture do not correspond exactly to the scenario proposed here for the Medici villa, where the planners generated what I see as early-stage frameworks that could simultaneously involve conceptual, functional, and spatial aspects of architecture and decoration. Sperulo was considering ideas that could be represented in paintings, the placement of sculptures, and larger spatial constructs; and

Raphael's planning vision encompassed conceptual ideas in addition to traditional architectural concerns of structure, spatial relation, and style.

This chapter analyzes these frameworks proposed for the Medici villa from the earliest design phases, which I am calling metastructures of word and image. (A discussion of the relative roles of advisors, artists, and patrons in generating them will follow in the next chapter.) The Medici villa was designed to convey messages of papal primacy and Medici "dynasty and destiny," inflected for a verdant *locus amoenus*.[13] What emerges is a dense layering of conceits, although each one is readily comprehensible. Remarkably, sculpture and spoils were the impetus for many of these conceptual programs. As discussed in the previous two chapters, Sperulo reveals that the choice and placement of significant ancient sculpture and marbles was an important task, which received concerted attention surprisingly early in the villa's planning process. The poet, in the voice of Father Tiber, says that rafts of ancient marbles and spoils were taken up the river to the villa, and he repeatedly insists that his main role is to choose marbles from the ancient ruins and direct their placement in the villa; and indeed, we saw that one of his descriptions can be identified as a specific marble. Sperulo wrote his poem during the redesign of the architectural plans from U 273A to U 314A. Additionally, it will become clear in this chapter that the placement of sculpture and spoils was a major consideration in this redesign. We have also seen Sperulo at work as an image-maker crafting Medici ideology, as in the case of his elegy on Leo's clemency in response to the putative conspiracy of cardinals. The examples that follow show how Sperulo, Raphael, and the villa's planners formulated conceptual metastructures for the villa (and beyond), weaving together ideological, philological, and archeological notions that could be expressed in a variety of media. The final section addresses the power of antiquities in generating these metastructures, considering the implications of this practice for architectural design and the notion of architectural program.

Topography of Christian Triumph

If the villa's site near the juncture of via Cassia and via Flaminia was chosen as an ideal spot for functional requirements of staging ceremonies of entry to the Vatican,[14] its proximity to two deeply symbolic Roman toponyms served as the basis for a metastructure about the basis of papal authority: the cross of Monte Mario and the Milvian Bridge. This construct turned on a central element of Leonine papal ideology, which cast the Constantinian era as a forerunner of Leo's pontificate. This was part of an overarching construct about papal sovereignty – the goal for a universal church uniting east and west, as well as spiritual and temporal authority – in a microcosm of God's kingdom on earth.[15] With plans for the Medici papal villa, Constantine's victory at

the Milvian Bridge and his vision of the cross that inspired it were localized, mapped, and represented in many media. This set piece would be embodied in the disposition of roads, sight lines, architecture, and decoration to create a network of meanings, in dialogue with the Vatican itself. If much of this information is well known, its implications have yet to be fully explored.[16]

The Milvian Bridge symbolized the victorious entry of Constantine, and thus of Christianity, into Rome.[17] By association, it also symbolized the emperor's subsequent Donation of temporal power to the papacy, the legitimacy of which was once again a topical issue. As we have seen, the villa overlooks this symbolic bridge; Raphael designed a straight road running from the bridge to the main central entrance of the villa on axis, above which was the loggia Sperulo designated as Leo's seat in the villa (visible in the model in Figure 14, and in plan in Figure 26). In his letter, Raphael drew attention to the view from this loggia to the bridge, noting that, "From this spot, one may see the road leading straight from the villa to the Ponte Milvio, the beautiful countryside, the Tiber, and Rome."[18] So, from his loggia, Leo would be able to survey the vast lands of the Papal States he controlled, directly above the historic spot symbolic of Constantine − a striking example of the sovereign gaze.[19] The coeval planning of the Vatican Sala di Costantino decorations served to reinforce this point. Among the murals designed for this room during Raphael's lifetime was the main scene on one long wall representing the *Battle of the Milvian Bridge*, a subject new to the visual tradition of Constantinian imagery; this fresco would include an image of Villa Madama under construction on the hillside just above the Milvian Bridge, as it was sited in reality (Plates XV, XVI), pointedly emphasizing the geographic and symbolic association between the pope's villa and this historic battle site.[20] The proposed decoration of Leo's villa loggia was also related to this imagery. In Leonine ideology, Constantine's victory over the "tyrant" Maxentius was cast as a precursor to a contemporary crusade uniting European powers against the Turks, considered the modern enemies of the Christian faith − a central point of contemporary diplomatic strategy; and Sperulo's proposal for the decoration of Leo's villa loggia called for frescoes of Leo leading a crusade against the Ottoman Turks (discussed in Chapter 3). Thus, with the plans for this loggia, its sight lines, and decorations, Raphael and Sperulo both emphasized topical ideas about the basis of papal sovereignty and Christian hegemony as a justification for current political goals. Moreover, Raphael's letter and Sperulo's poem reveal that sight lines and decorations were being considered at this stage, while plans were still in flux, presumably in some sort of coordinated discussions. Clearly, plans for the villa and the Vatican hall also evolved in tandem to express fundamental messages about the unity of the church under Leo, the new Constantine.

The other nearby toponym, the cross of Monte Mario, would also be key to this imagery. The villa was frequently called the *vigna sotto la croce di Monte*

Mario, a reference to a cross at the site of the fourteenth-century Oratorio della Croce, just up the hill.[21] In particular, Castiglione describes the villa this way in a letter of May 1519, suggesting that this name was fundamental to the villa's identity.[22] Beyond a physical locator, this cross was a symbolic toponym of long-standing importance, as suggested by its frequent mention in diplomatic sources.[23] Visitors to the Oratorio della Croce had been granted indulgences since 1470, and the cross at this site had been an important stop for collect prayers – as was the Milvian Bridge – in the Roman Major Litany, a medieval stational liturgy that was evidently deeply seated in Roman collective memory.[24] The cross is visible on the mid-seicento map in the Catasto Alessandrino (Figure 39), located just above Villa Madama on the Via Triumphalis. This favored ceremonial and pilgrimage route into Rome and the Vatican traversed Monte Mario and was punctuated by six crosses, including the cross of Monte Mario, symbolizing the churches of Rome (the seventh being St. Peter's itself, the final destination of this road), and loosely evoking the Stations of the Cross. The indulgences and crosses sacralized the hillside, and also made the

39. Arch. Francesco Contini, *Strada per la Croce di Monte Mario*; for the catasto of Pope Alexander VII, leadpoint and watercolor, 1665–7; ASR, Catasto Alessandrino, b. 433, 41. Detail showing the Villa Madama and the cross of Monte Mario just above it along the Via Triumphalis. The legend includes: (19) [Oratorio di] S. Croce nella salita del Monte Mario; (20) Signor Urbano Mellino (Villa Mellini); (22) Strade che vanno a Madama; (23) Bosco di Madama; (24) Prati di Madama; (38) Strada che da ponte Molle va a porta Angelica Castello.

route along Monte Mario a prefiguration of Roman pilgrimage. Thus, the sacred mountain that was home to the Medici papal *hospitium* symbolized Roman pilgrimage and Christian triumph.[25] Further, it emerges that the cross of Monte Mario also came to be interpreted figuratively in connection with Constantine's vision. Early textual sources do not locate his vision chronologically or geographically, but it became conflated with the cross of Monte Mario in sources from the seventeenth century onward, possibly fostered by the connection of cross and bridge in a coordinated ensemble at the Medici papal villa.

Most significantly for this papal *hospitium*, embassies of obeisance to the pope and retinues arriving for imperial coronations had traditionally traversed the Monte Mario, from the time of Leo III and Charlemagne to Leo X and ambassadors of Charles V, establishing the hill's association with the submission of the *Imperium Christianum* to the papacy. This imagery was also reflected in Raphael's Vatican Stanze frescoes.[26] Thus, we see how the rich history of this zone on the Monte Mario evoked traditions of various ceremonies of entry, in a conflation of sacred and secular rituals.

So the Medici villa was sited under the sign of the cross and overlooking the Milvian Bridge, evoking at once the sources of religious and temporal authority of the papacy. Raphael's proposed roads formed a straight line from cross to bridge, and thus a direct connection from one toponymic symbol of Christian triumph to another. They bisected the villa on axis, crossing the other axis formed by the road from the Vatican Palace and St. Peter's, at the center of the unusual circular courtyard – which itself had a dual spiritual and temporal significance.[27] This crossing suggests the *omphalos* or *umbilicus mundi* (navel of the world), understood to have been transferred from Greece to the ancient Roman Forum, and then to the medieval Capitoline;[28] perhaps the villa's planners thought it then belonged at the center of the Medici papal *hospitium*, a microcosm of Leo's papal realm and entry point to Rome and the Vatican.

This geometry would be clear not only in plan, but experientially. For a ceremonial entry to Rome and the Vatican, visitors were intended to follow the route from the Milvian Bridge up the hillside along the straight road leading to the villa above and, after a respite and welcome at the villa, the procession would either proceed up to the cross of Monte Mario and into Rome along the Via Triumphalis, or else descend from the villa to take the straight road across Prati (later Via Angelica, visible in Figure 39).[29] These roads were designed to prescribe the motion of the visitors: royal and imperial embassies ascending the hillside would perform their obeisance to the Medici pope whose seat was above them, and witness the sign of the cross above the Medici papal *hospitium*.[30]

After a stop at the villa, diplomatic visitors would ultimately reach the Vatican. Those invited to the Sala di Costantino, at times used as a banquet hall or as Leo's throne room,[31] would see the *hospitium* depicted on the hillside above the bridge – visual imagery orienting them and reinforcing the significance of the journey they had made. In contrast to the fresco's *all'antica* representation of the Milvian Bridge (by then rebuilt), the realistic portrait of the papal villa served to pinpoint the location.[32] And when visitors looked out of the window of this room, they could see across the Belvedere Courtyard north to the Monte Mario, from which they had just traveled.[33] Thus, this historic Constantinian narrative of entry would be localized, and reenacted by important visitors. Drawing on mnemonic methods used since Roman antiquity that anchored memory to significant places,[34] this construct would marshal participants to create meanings through motion and vision, in a multisensory experience engaging different media, unfolding over space and time.

Thus, Raphael and his cohort organized the siting of the Medici villa, the configuration of roads leading to it, the disposition of focused views, and select decorations in the villa and the Vatican Stanze in a coordinated metastructure reflecting Leonine papal ideology. The Medici papal *hospitium* – which would be joined to the Via Triumphalis, set under the physical and conceptual image of the cross, and set above the site of Constantine's victory inspired by it – embodied these messages of Christian and Medicean triumph, which were reinforced on arrival at the Vatican Palace. This design would shape visitor experience, and even historical understanding. The multimedia, spatio-decorative construct was conceived to orchestrate the dynamic ritual of entry into the urban fabric of the city; the kinesthetic experience of visitors and their movement through the landscape would compose narrative geography from the Milvian Bridge through the Medici papal *hospitium*, and across the Monte Mario to the Mons Vaticanus. In so doing, this construct marshaled the imagery of the papal *hospitium* and the Vatican Stanze into a potent ensemble that spanned two hillsides.[35]

Although this construct was not fully realized, embassies did enter Rome via the villa following part of this plan; and as in other aspects of the master plan, Raphael's methods of incorporating landscape and symbolic topography in broad programmatic constructs were well known and would increasingly come to characterize late cinquecento and seicento design practice.

Parnassus

Another metastructure drew on the rich symbolism of place on the Monte Mario. In a seemingly simpler conceit, Sperulo proposes for the Medici villa a figure of Lorenzo the Magnificent as Apollo, which he specifies should

be placed among the Muses. The poet addresses Lorenzo directly, saying: "Come here and let this be the abode for yourself and the Muses … so that I may see you breathing in Parian marble" (189–92). Of course, to make a god breathe in marble, typically Parian, was a trope commonly evoked as a demonstration of the sculptor's skill; Sperulo instead draws on this conceit to flatter Lorenzo with the status of a god. Lorenzo had traditionally been styled as Apollo, with whom he shared the laurel device, and quattrocento poets praised him as the glory of the Muses; Sperulo's particular emphasis on Lorenzo is consistent with the importance of imagery from Laurentian Florence, especially Poggio a Caiano, throughout Villa Madama.[36] Lorenzo's son Leo had also been associated with Apollo; in particular, he was characterized as Apollo Musagetes in a 1517 poem.[37] Sperulo's proposal for a Parian marble Lorenzo/Apollo among the Muses, beyond praising this important ancestor, presented the Medici villa as Apollo's realm: Parnassus. Since antiquity, Monte Mario had been known as one of three hills that made up the *Montes Vaticani*; in fact, the Monte Mario, Janiculum, and Vatican hills all technically make up the Janiculum ridge.[38] So the well-known Renaissance designation of the Vatican hill as Parnassus, familiar from Raphael's eponymous fresco in the Stanza della Segnatura (Figure 40), extended to the site of the villa on the Monte Mario as well, an identification that Sperulo was keen to play up.[39]

More than a poetic conceit, however, Sperulo's proposal for a figure of Lorenzo/Apollo among the Muses was probably a reference to the group of nine ancient marble sculptures of the Muses that actually were at the Medici villa. Pirro Ligorio described a group of seven *Muses* taken from the Emperor Hadrian's Villa in Tivoli to Villa Madama, and he specified that they were of Parian marble.[40] This group of seven *Muses*, some sitting and some standing, came from a cycle called the Thespiades (Figures 41–7).[41] Also at Villa Madama was one other *Muse* (the so-called *Farnese Melpomene*, Figure 48) and a draped female figure that could easily have been restored as a *Muse* (the so-called *Niobide*, Figure 49).[42] This collection of figures suggests that the Medici wanted to display a full complement of nine *Muses*. No complete group of Thespiades had yet been excavated, and it has been thought that no one yet knew that these ancient Muse groups combined standing and sitting figures.[43] But the Raphael school must have had some ancient evidence, from Hadrian's Villa or elsewhere, that the sitting and standing Muses belonged together, for that was exactly how Raphael had depicted them in his *Parnassus* fresco. No evidence has emerged for a figure of Apollo at the villa, nor an ancient fragment that might have been completed as one; this was surely an important reason for Sperulo's suggestion to create a Parian marble figure of Lorenzo/Apollo.[44]

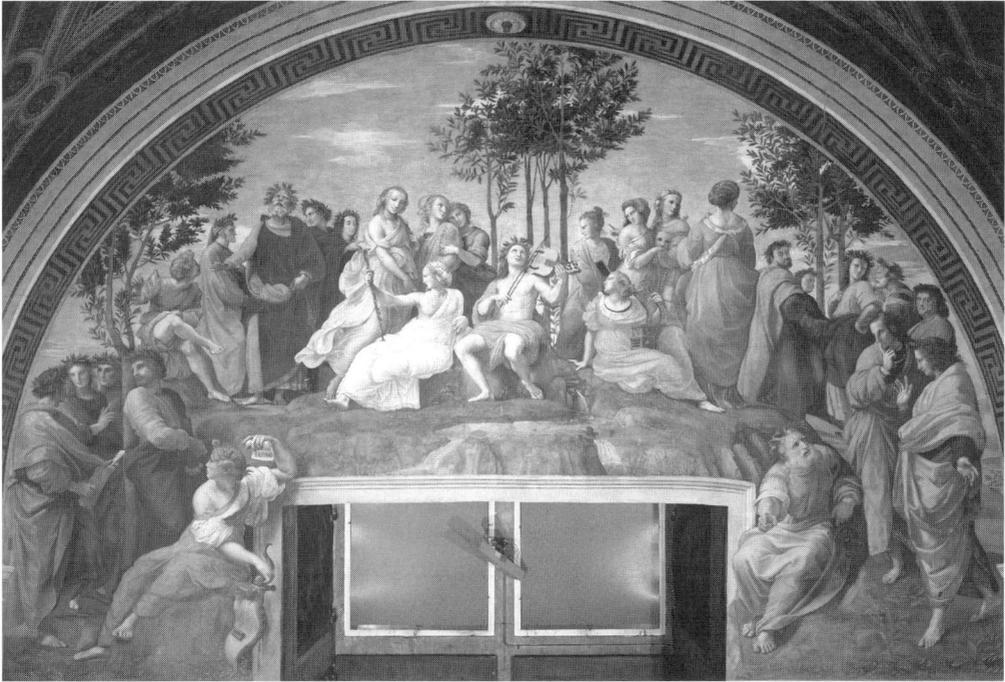

40. Raphael, *Parnassus*, 1509–11, Stanza della Segnatura, Vatican Palace.

We do not know whether the *Muses* were ever installed at the villa, or for which part they were intended; but an invaluable group of nine monumental *Muses*, some with a prestigious provenance from an imperial villa, would certainly have inspired a significant setting. Heemskerck's drawings of *c.* 1532–6 show the *Muses* as unrestored and missing heads, arms, and attributes (Figures 50, 51), suggesting that they had not yet been installed.[45] (I believe papal taste and decorum favored fully restored ancient figural sculpture whenever possible, in contrast to some contemporary, fragment-filled sculpture gardens illustrated by Heemskerck and described by Aldrovandi.[46]) A few hypotheses for the intended installation of the *Muses* are relevant here. The figures were too large for the niches in the garden loggia, and there is no space inside the villa that could accommodate a large group of figures together, so they must have been intended for an unbuilt area of the villa or for an outdoor setting. They may have been intended for the villa's theater, although there is no logical placement for a set of nine sculptures (or ten counting an Apollo) in the theater as drawn in either U 273A or U 314A.[47] Sperulo's proposal for Lorenzo/Apollo among the *Muses*, and his challenge to Raphael about where in the villa he would put Lorenzo, suggests that the villa's planners were considering the placement of this group when he was writing in early 1519 (Sperulo, 164, 189–92). Perhaps they were considering another use for the *Muses*, since the theater was not being built in the first phase.

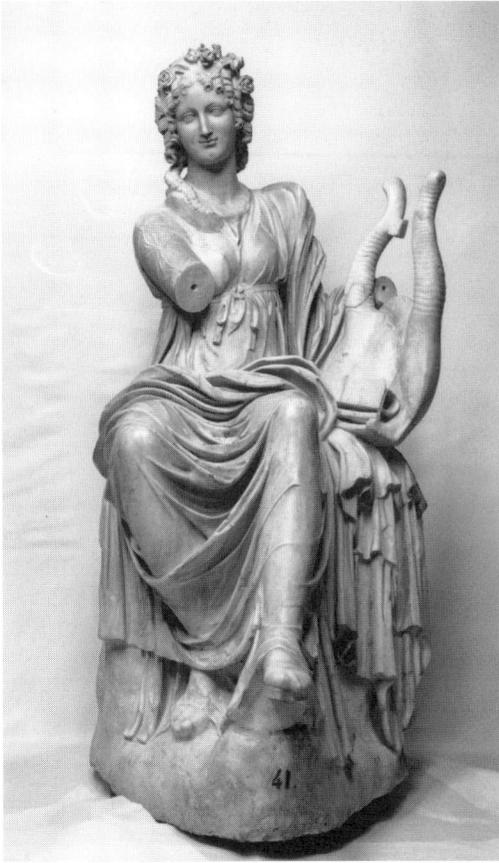

41. *Terpsichore*, Museo del Prado, inv. 429.

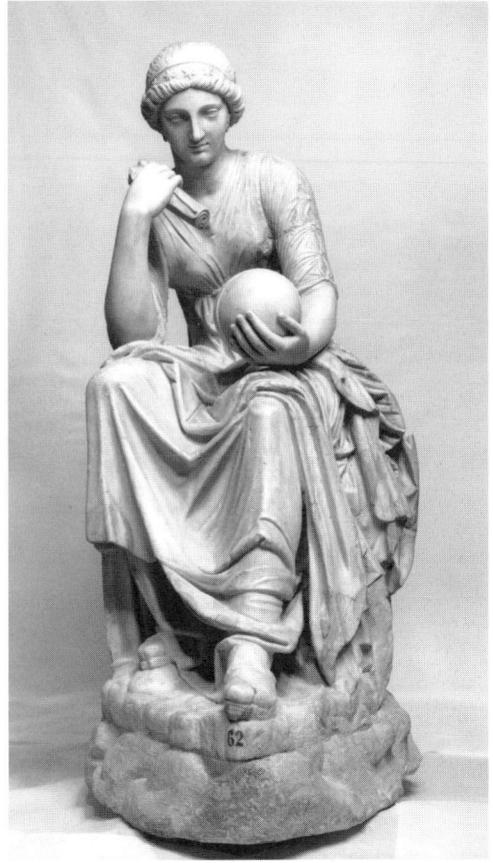

42. *Urania*, Museo del Prado, inv. 436.

One of the major changes to the villa's plan between U 273A and U 314A was the configuration of the fishpond. The earlier plan called for a pond ringed with tiered benches facing a niche-studded wall, similar to a *scaenae frons*. In the later plan that was followed for the actual building, the seating was eliminated and a tri-lobed ambulatory was added behind the fishpond, effectively creating grottoes under the garden, accessible by stairs at either end of the garden (Figures 52, 53). Each of these three exedrae behind the pond contains three niches (Figure 54).[48] Spring water piped from the hillside flowed from above the grottoes to fill the fishpond. Because Muses were traditionally associated with grottoes and springs, and because these nine large niches are appropriately scaled for the large Muse sculptures,[49] this ensemble was very possibly intended to be a grotto of the Muses – a *musaeum all'antica*.[50]

This waterside ambulatory allowed guests to stroll along the length of the pond through cool, damp grottoes (Figure 55), with views across the pond of the Tiber valley to Rome. From this ambulatory, one still sees the jet of spring water arching from a spout above the central grotto, and hears it splash

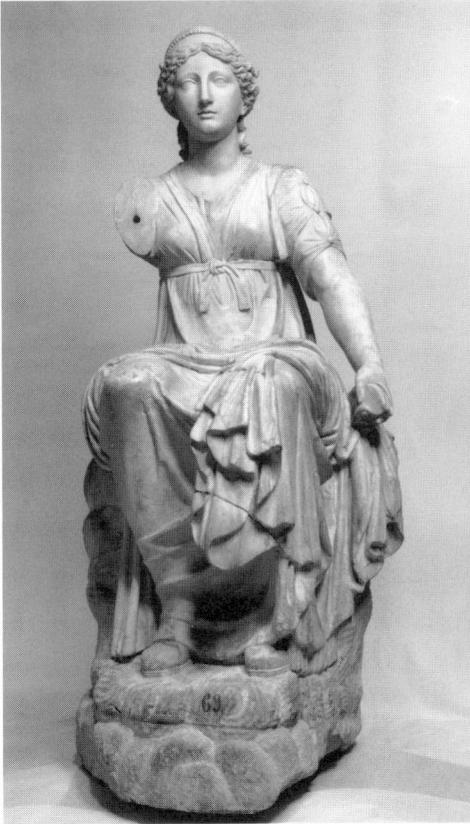

43. *Clio*, Museo del Prado, inv. 401.

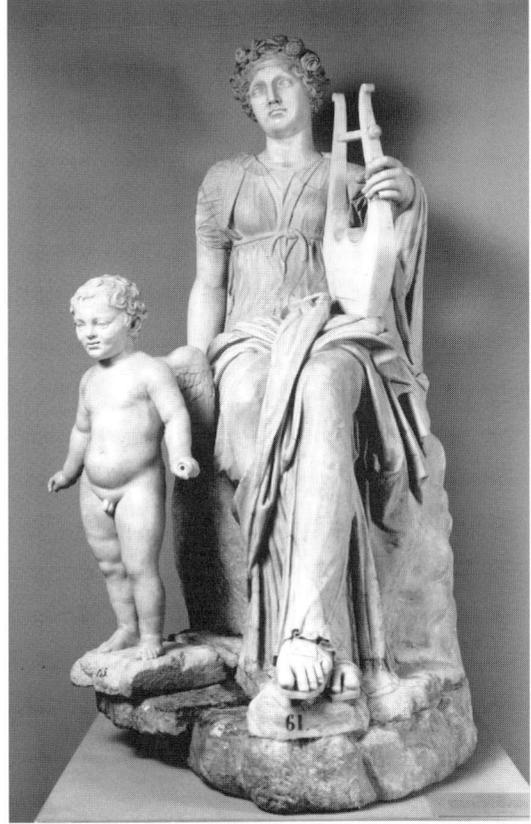

44. *Thalia*, Museo del Prado, inv. 373.

into the pond. These watery exedrae are reminiscent of the small conversation niches in Roman imperial grottoes. Although there is no evidence these sites were known in the early cinquecento, there were evocative literary descriptions, notably that of Pliny, who specifically prescribed caves encrusted in pumice for the Muses' haunts.[51] The fishpond niches were indeed decorated with *spugna* (spongestone) when Charles Percier and Pierre F. L. Fontaine visited Villa Madama in the early nineteenth century, although no evidence has emerged to determine whether this decoration dated to the Medici era or later.[52] Propertius also described a cave of the Muses, through which Apollo leads him, and one of the Muses instructs him to cease writing martial verse and write love poetry instead – imagery that would have been consonant with the ambulatory as well as the themes of peace and *omnia vincit Amor* at Villa Madama, and the peaceful Leo as Apollo Musagetes.[53] Ancient scholars and poets often claimed that they gave their intellectual banquets at the gathering places of the Muses.[54] Raphael's letter specifies a dining area at the northern end of this pond for just such a purpose; his description of the fishpond conflates elements of both surviving

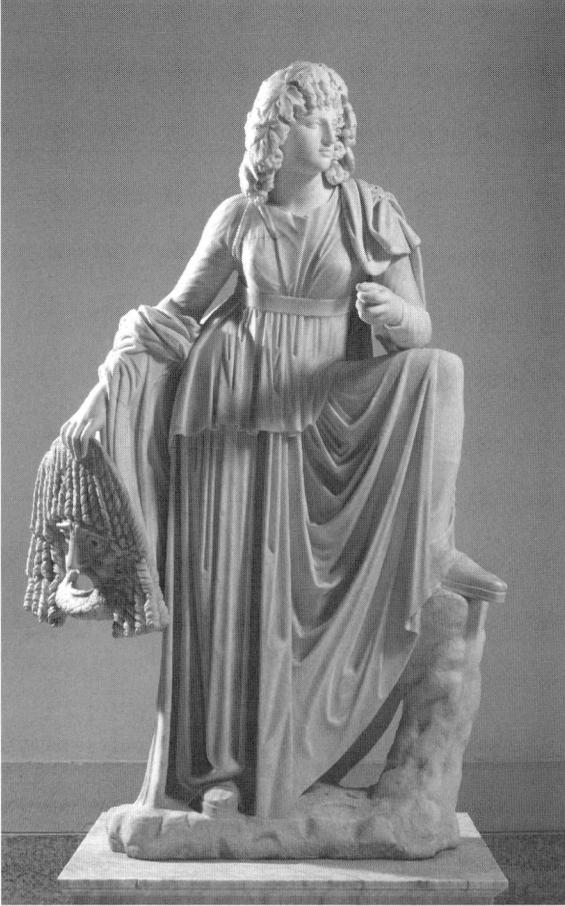

45. *Melpomene*, Nationalmuseum, Stockholm, inv. sk4.

master plans,[55] and this dining area appears only in the later one, which means that this new conception of the area was under discussion at the time he was writing (see Figure 56, and cf. plans in Figures 57, 58). Of course, in the early cinquecento, a fountain designed as a grotto of the Muses was de rigueur for the simplest villa,[56] but monumental sculptural *musaea* did not yet exist; to possess a group of nine ancient *Muses* as well as abundant natural springs was a rare, if not unique, combination at this time. In the Medici villa as built, there is no other place that could accommodate a group of nine *Muses*, and no other group of sculpture that would suggest a need for nine large niches behind the fishpond. One flaw in this hypothesis is the lack of a spot for an Apollo, unless it could have been placed in the dining area at the northwest end of the pond, shown in U 314A with an exedra at its head (Figure 58). Or perhaps Leo in his personification as Apollo Musagetes could complete the group as he strolled through the grottoes (just as Isabella d'Este and later Christina of Sweden each fashioned themselves as the tenth Muse). Alternatively, perhaps Sperulo was drawing attention to this missing Lorenzo/Apollo as a hole in the sculpture

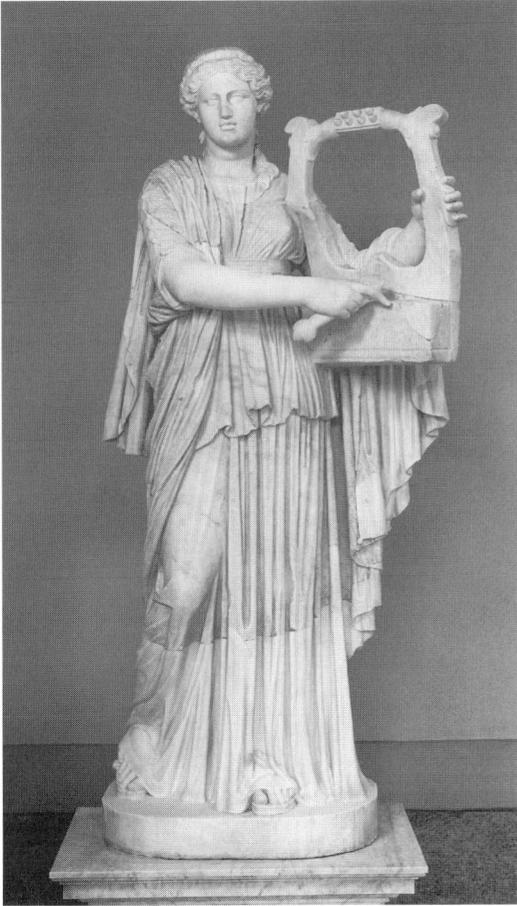

46. *Erato*, Nationalmuseum, Stockholm, inv. sk7.

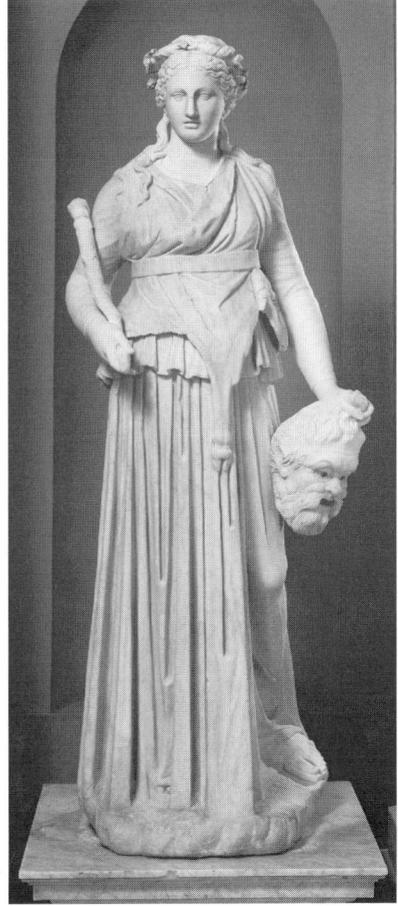

47. *Muse with nebris*, Stockholm Nationalmuseum, inv. sk5.

collection, and the lack of a seat for it as a flaw in the architect's plan. This would explain his forceful apostrophe to Raphael ("where, in what part, will you place the immortal glory of the house [Lorenzo]?," 164) and his direct invocation to Lorenzo to come inhabit the villa (189–90). Whatever their intention for the *Muses*, it seems clear that the villa planners were grappling with ideas for the installation of this prestigious group in some kind of *musaeum* in early 1519.[57] This ambitious ensemble was apparently never fully executed, although the fishpond ambulatory surely served as a refreshing *locus amoenus*, and it may have received other decoration. Moreover, although the sculptures of the *Muses* apparently remained unrestored and uninstalled, their presence at the villa was known to contemporaries, as we know from the drawings of Heemskerck and others, and these ideas for a *musaeum* probably were, too – like many other uncompleted aspects of the villa complex. In fact, the popularity of *musaea* in the following decades surely owed something to the unexecuted ideas of Raphael, Sperulo, and their collaborators.[58]

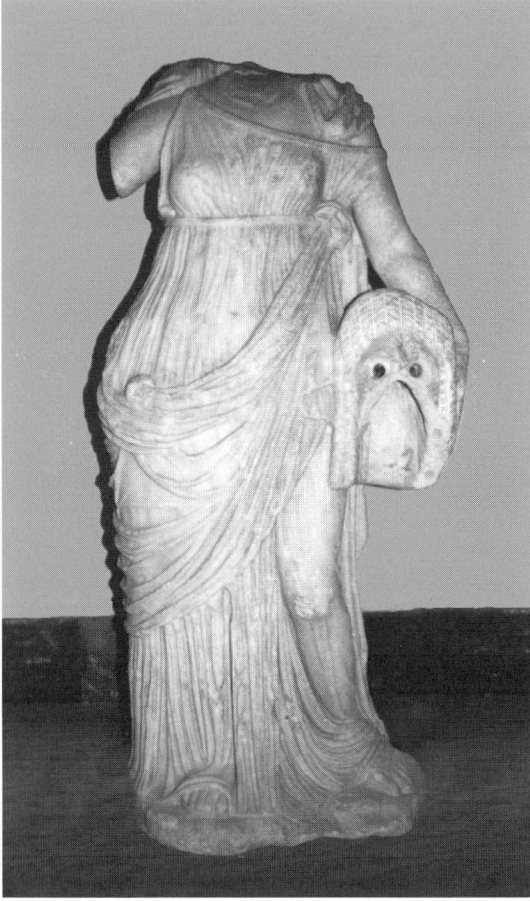

48. *Melpomene (so-called Farnese Melpomene)*, Museo
Archeologico Nazionale di Napoli, inv. 6400.

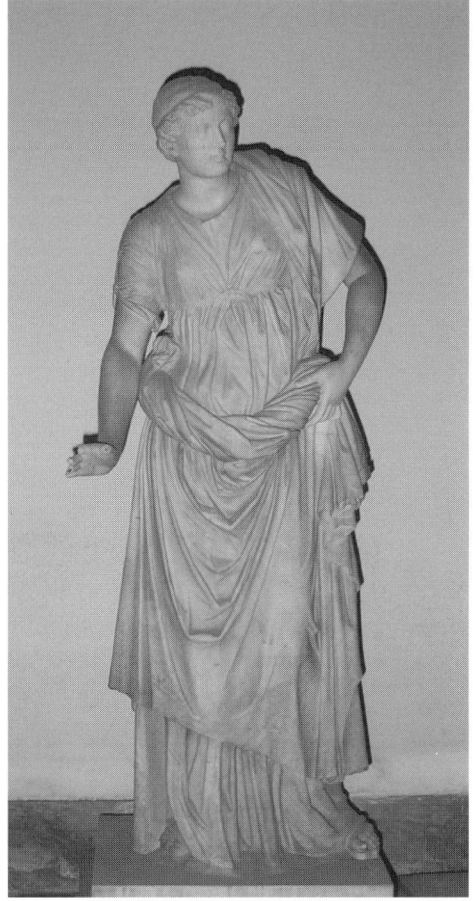

49. *Muse, or so-called Niobide*, Museo
Archeologico Nazionale di Napoli, inv. 6391.

This ensemble would also have constituted an innovative and early instance
of a water theater, which is typically associated with much later villas, particu-
larly the seicento examples at Villa Aldobrandini in Frascati and Isola Bella.[59]
While U 273A and U 314A reveal significantly different ideas for this area,
both treatments of the pond reflect the notion of theater. In U 273A, the
fishpond was framed by a *scenae frons*-like screen for sculpture and facing
seating, while in U 314A the ambulatory behind the pond allows for a more
performative conception, in which the grottoes provided both stage and bel-
vedere; human and marble protagonists could mingle, and spectators could
watch this performance from the dining area adjoining the pool (Figure 56).
From the form of the niches, we can surmise that the sculptures would have
been placed at ground level, not elevated on pedestals, increasing the imme-
diacy of this connection. The configuration of this grotto recalls ancient com-
plexes with cool, damp caves for dining amid monumental sculptures such
as Sperlonga and Baia (although it is not clear that they were known to the

50. Marten van Heemskerck, *Seated Muses at Villa Madama* (left to right *Urania* and *Terpsichore*), Berlin, Staatliche Museen Kupferstichkabinett, Inv. Nr. 79 D 2, Römische Skizzenbücher, I, fol. 34r.

51. Marten van Heemskerck, *Muses at Villa Madama* (left to right *Thalia, Clio, Muse with nebris, Niobide*), Berlin, Staatliche Museen Kupferstichkabinett, Inv. Nr. 79 D 2, Römische Skizzenbücher, I, fol. 34v.

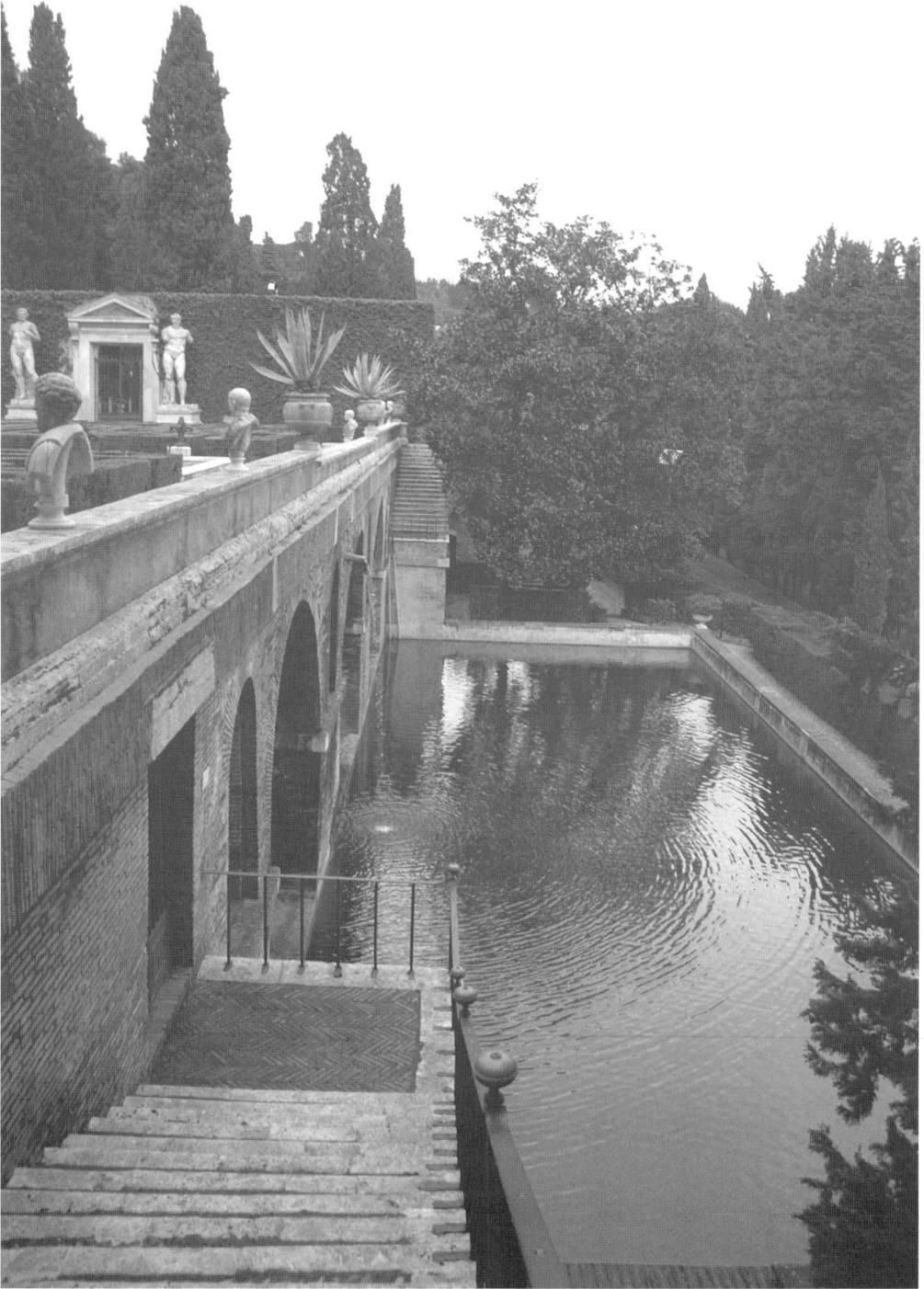

52. Villa Madama, stairs from the inner garden leading down to the fishpond, and to the ambulatory behind it.

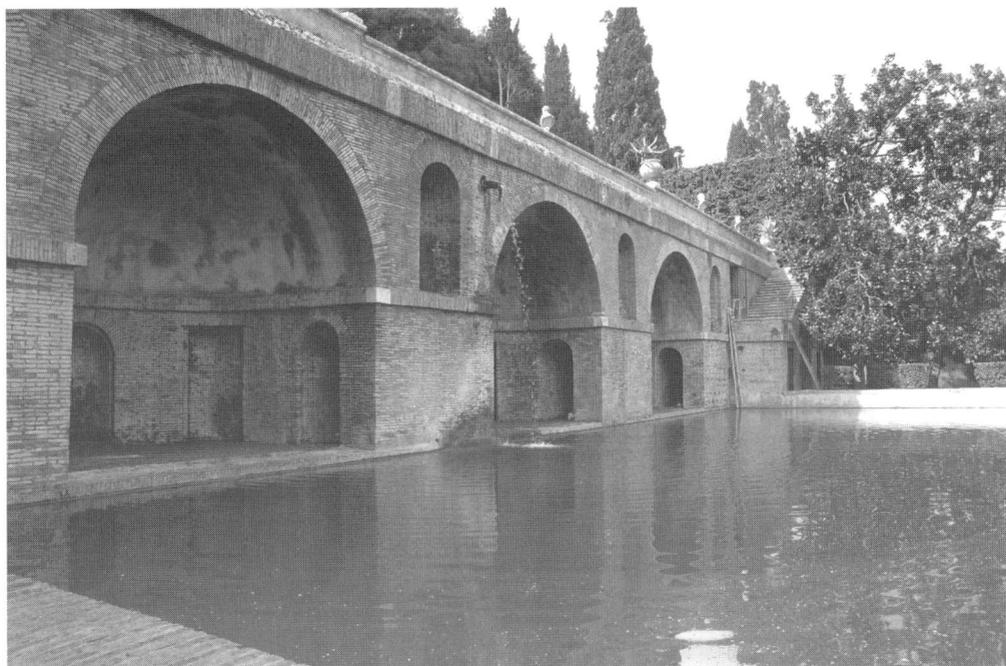

53. Villa Madama, fishpond and tri-lobed ambulatory behind it.

Raphael school) and extant models such as the watery dining pavilion of the Serapeum/Canopus at Hadrian's villa, the nymphaeum-theater of a villa near the Arcinelli, and perhaps the ruins of the Villa Vopiscus, all in Tivoli.[60] Assuming the Medici grotto was intended as a *musaeum* gives this water theater a specific charge. Muses and bathing nymphs were conflated in early cinquecento verbal and visual imagery, notably in Raphael's *Parnassus* fresco;[61] the design of this grotto as a poolside ambulatory where Leo, Giulio, and guests could walk among life-sized marble *Muse*-bathers at the water's edge realizes this conceit in particularly playful terms. Of course, the cave of the Muses had been understood to be a gathering places for poets since Plato; and Raphael designated this area as a setting for Leo's and Giulio's *convivia* at the villa. This setting recalled Leo's use of the Sala delle Muse at the papal hunting lodge, La Magliana, which was decorated with monumental frescoes of Apollo and the nine Muses, and used for dining and entertainment by poets and musicians.[62] At the Medici villa, the fishpond dining area presumably was used, even if the *Muse* sculptures were not (yet) installed; we may imagine diners at the end of the pond, entertained by poets and musicians, who perhaps strolled through the grotto.[63] Had the *Muses* been in situ, the contemporary poets mixing with the Muses in their grotto by a splashing spring would enact a tableau vivant of Raphael's *Parnassus* fresco. Thus, this novel ensemble – at once nymphaeum, belvedere, *coenatio*, and possibly *musaeum* – was surely an important

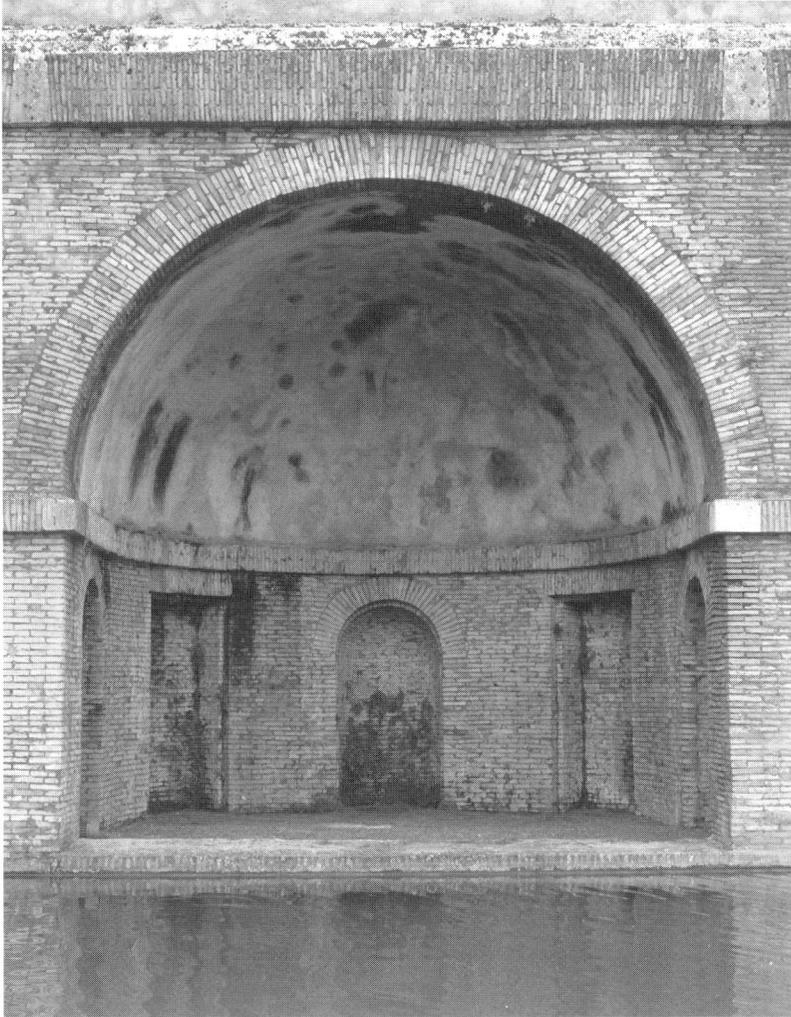

54. Villa Madama, fishpond exedra with three sculpture niches.

early contribution to the development of the water theater.[64] Furthermore, it constitutes another multimedia *hospitium* to the Vatican, its meanings activated by human participation: in this case, staging the Parnassus.[65]

The Realm of Venus Genetrix

Sperulo expanded on Venus imagery familiar from Laurentian Florence and cinquecento Rome to designate the Medici papal villa as the realm of Venus Genetrix (as noted in Chapter 3). The poetic tradition of praising a site as the garden of Venus, or as a place worthy for her to visit, was often connected with her role as the goddess of conjugal love, notably at Agostino Chigi's Roman villa. At Villa Madama, as at Poggio a Caiano, the emphasis is placed instead on Venus

55. Villa Madama, ambulatory along the fishpond, with three grotto-like exedrae, each with three sculpture niches.

in her role as *genetrix*, characterized by her fecundity, bounty, and peace-giving victory.[66] Venus Genetrix had been prominent in Laurentian visual imagery, as in Botticelli's painted *poesie* of the *Primavera* and the *Birth of Venus*, and reliefs on the portico frieze at Poggio a Caiano.[67] In particular, the association of the generative Venus with the eternal return of the new year each spring was the basis for the Medici metaphor of eternal return and political stability, as in Lorenzo's motto *Le tems revient*.[68] Poliziano had formulated Venus imagery based on the newly redis-covered *De rerum natura* of Lucretius, among other ancient sources on the subject of Venus as a Nature goddess, associated with the fructifying power of earth and gardens.[69] Sperulo drew on this imagery of the generative Venus, and related it to Leonine notions of peace and concord, thereby translating Laurentian concepts for the Roman papal *hospitium*.

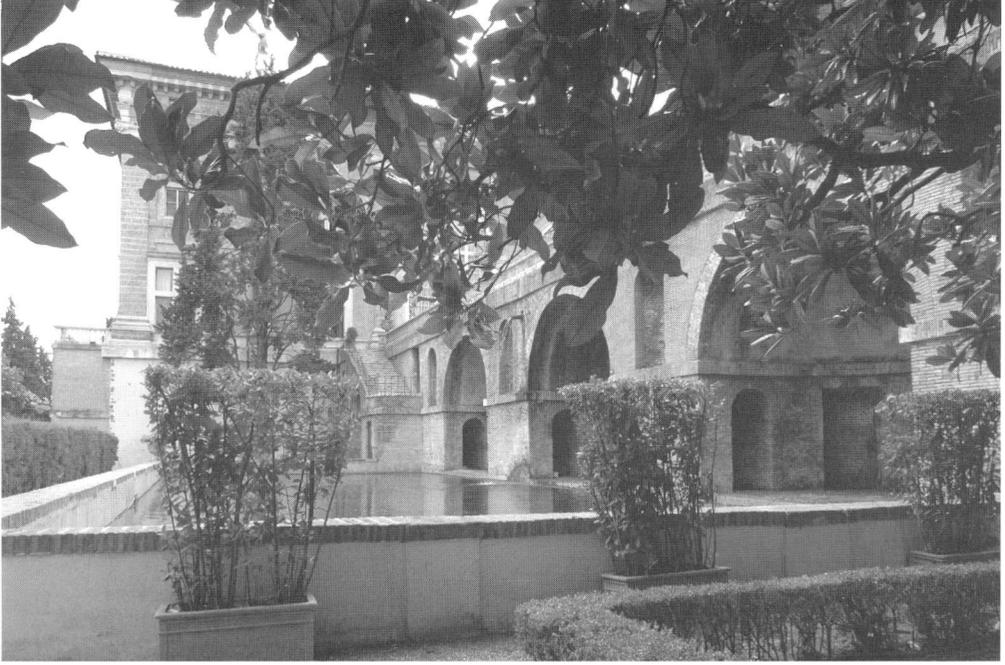

56. Villa Madama, view from the area adjacent to the fishpond described by Raphael as a dining area (*cenatione*).

To incorporate this imagery in the villa, Sperulo proposed a new context for the relief from the Temple of Venus Genetrix (Figure 30). As we saw, he presents this relief as a spoil symbolizing the *romanitas* of the Medici via their filiation from Venus and Aeneas, and as a trophy of just and peaceful rule. He proclaims that the Medici deserved this and other antiquities as their just reward for restoring peace to the world, evoking the ancient Roman understanding that sculptural spoils symbolized military triumph and the ensuing *pax romana*. Sperulo's proposed metastructure would indeed be embodied in the architecture; this relief became the centerpiece of one wall of the garden loggia (Figures 31, 32), which was designed around it, apparently during Raphael's lifetime. This imagery would later be deployed throughout the villa's painted and stucco decorations, which are filled with figurations of *omnia vincit Amor* and images of peace-bringing Victory and Venus (Plate VIII).

Temple of Peace

I believe the notion of peace was also encoded in the architecture; several aspects of the garden loggia, like the fictive architecture in the *School of Athens*, evoke what was then called the Temple of Peace, now identified as the Basilica of Constantine and Maxentius. Étienne Dupérac recorded its appearance in the mid-sixteenth century in an engraving, noting the remnants of stucco in the ceiling coffers (Figure 59). Then as now, we see approximately half of the

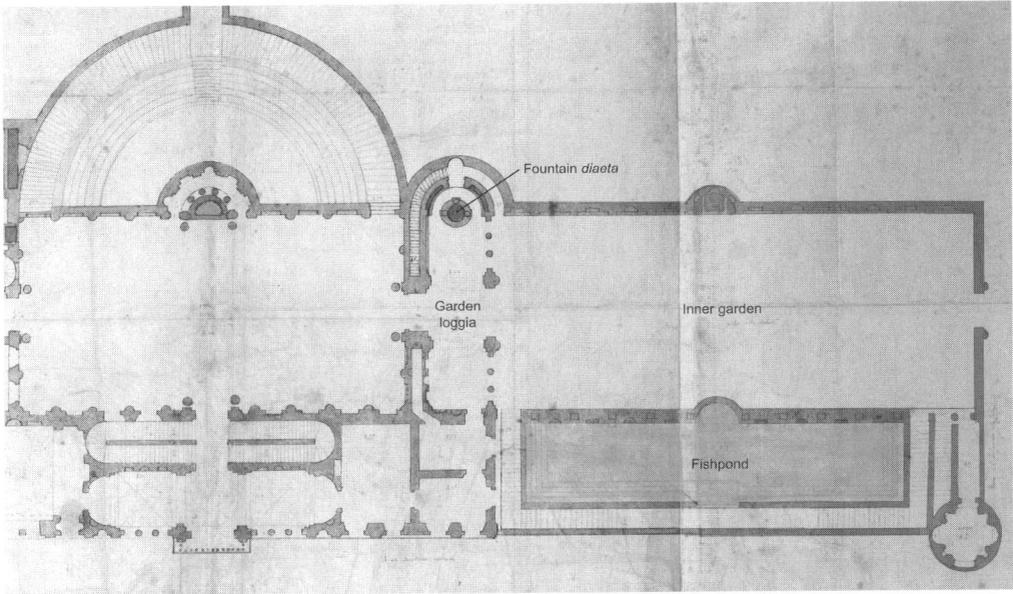

57. Plan for Villa Madama, annotated detail of U 273A (Plate v) indicating the garden loggia with fountain *diaeta*, inner garden, and fishpond.

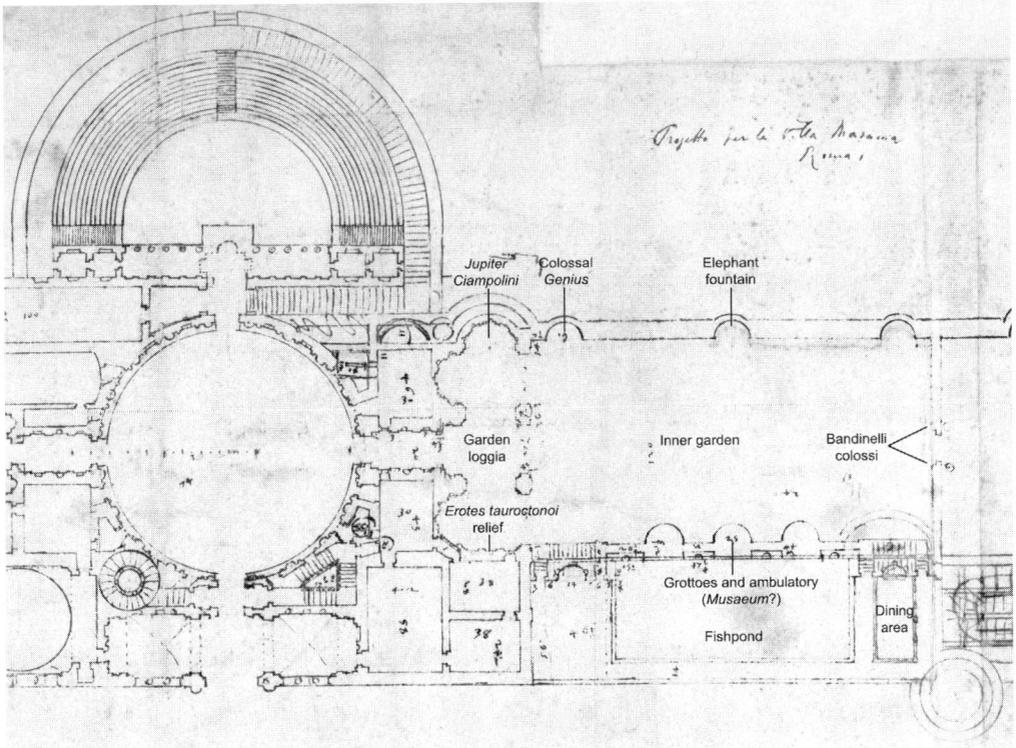

58. Plan for Villa Madama, annotated detail of U 314A (Plate vi) indicating the garden loggia, inner garden, and fishpond, as well as sculptures that would be installed in these areas.

Vestigi del Tempio della pace edificate da Vespasiano Imperatore qual mondo gli autori et vestigi che si ut deno fumo di maggiori, di più belli, et ricchi Templi di Roma perche ui fu riposto tutti le richezze et ornamenti del Tempio di Salamone, che vede Tito nel suo triompho in Roma, era in questo Tempio si vede nelle volte bellis partimenti di stucco ul siuede ama uira colonna di marmoro in opera dordine, orintio em li suimembri la maggiore leghadari che siuede in Roma

59. Étienne Dupérac, *The Basilica of Constantine and Maxentius*, then identified as the Temple of Peace, engraving.

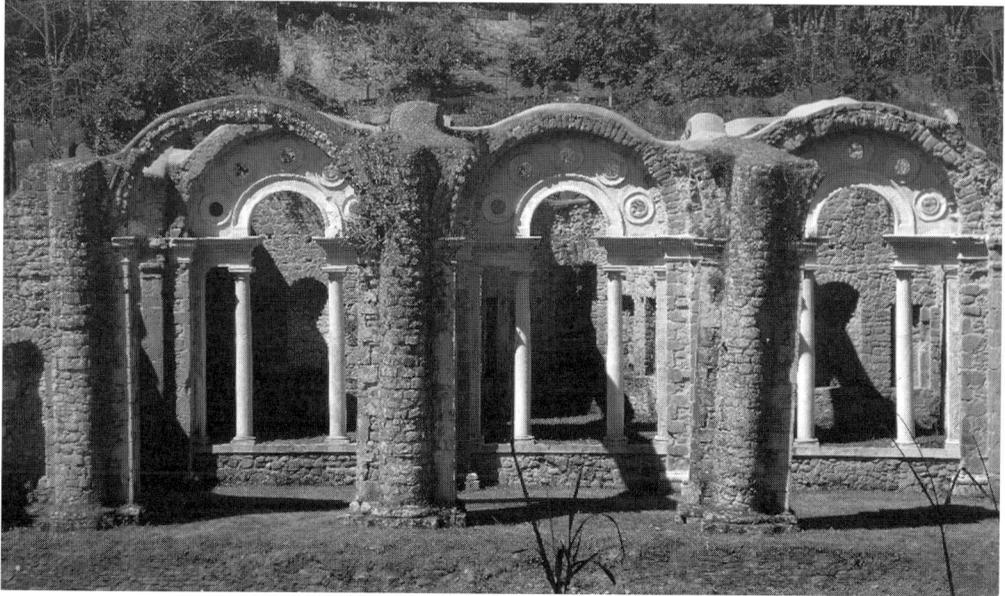

60. Donato Bramante, Colonna Nymphaeum, Genazzano.

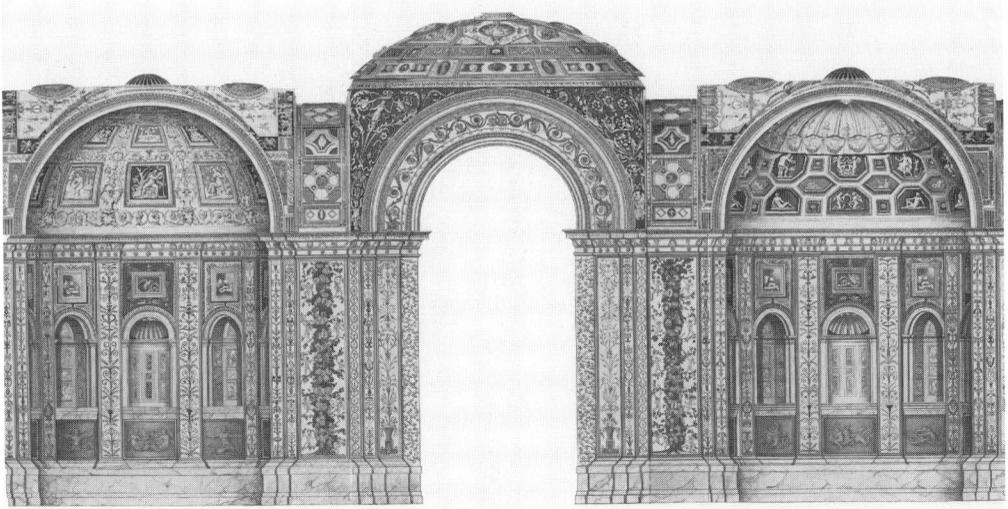

61. Villa Madama, garden loggia, watercolor, *c.* 1927. From W. E. Greenwood, *The Villa Madama*, New York, 1928.

basilican structure, viewed from the Forum as if looking at a longitudinal section. The villa's garden loggia resembles several aspects of this basilica's plan, elevation, and decoration, notably the scale, triad of arched openings, lofty stuccoed vaults, and sculpture niches (Figure 61). Of course, the garden loggia's plan was directly indebted to several models, especially the earlier Medici villa at Fiesole and Bramante's Nymphaeum for the Colonna family at Genazzano (Figure 60), which was conceived as a sort of villa–pavilion or early folly.[70] But these works were laterally symmetric, whereas the asymmetry of the Medici villa's garden loggia has bothered visitors since Serlio and Palladio: it is flat at one end (where the Venus Genetrix relief is installed) but has a rounded exedra at the other.[71] This detail evokes a modified basilican plan, roughly similar to that of the ruined Basilica of Constantine and Maxentius, of which one aisle remained standing.

The symbolism of the so-called Temple of Peace made it a potent model for Renaissance builders. Listed by Pliny as one of the eighteen marvelous buildings in ancient Rome,[72] it was believed to have crumbled the night Christ was born. Thus, it symbolized the pagan order vanquished by the new Christian era, and ruins evoking this legend often appear in the background of Renaissance nativity scenes.[73] It was famously a model for Bramante's St. Peter's and, as Tanner proposes, was linked to the desire for a papal crusade to recapture the Holy Land.[74] For all these reasons, it was apposite for Pope Leo's program of peace and crusade.

Further, both the basilica and the Villa Madama loggia featured a seated-ruler colossus in the exedra at the head: the seated marble colossus in the Roman basilica had been discovered in the 1480s,[75] and Villa Madama would house the seated *Jupiter Ciampolini* (Figures 62, 63).[76] One of

62. Marten van Heemskerck, *Jupiter Ciampolini* in the garden loggia of Villa Madama, detail; Berlin, Staatliche Museen Kupferstichkabinett, Inv. Nr. 79 D 2, Römische Skizzenbücher, I, fol. 24r.

63. *Jupiter Ciampolini*, Museo Archeologico Nazionale di Napoli, s.n.

the major changes in the villa's design between the two surviving ground plans – eliminating a fountain and built-in seats at the head of the loggia and expanding the exedra there – was probably done to accommodate this *Jupiter* (Figures 57, 58).[77] It makes sense that this major design change was undertaken for a valid reason; eliminating a prominent indoor fountain described by Raphael in his letter, for which there were ample natural springs nearby, would surely have been done only if the planners had another important focal point for this space in mind. We lack evidence to show exactly when this *Jupiter* was purchased or considered for the villa. The generally held view that the Medici had acquired this figure by 1519 is based on a mistranslation of Sperulo, who does not, in fact, mention it directly.[78] Although Raphael's letter describes the fountain *diaeta* of U 273A rather than the *Jupiter* at the head of the garden loggia, he evidently changed ideas by the time U 314A was drafted. Possibly, the figure was acquired along with other Ciampolini works in September 1520,[79] although the plans to do so may well have been in the works earlier, and Raphael had probably

known the work for some time.[80] Although Sperulo does not mention the *Jupiter*, the preponderance of Jovian imagery he proposes, and the many ways the sculpture fits neatly into the overall architectural and decorative scheme, do suggest that it was the impetus and focal point for the redesign of this exedra. The villa's planners must have had it in mind, if not in hand, during the discussions of new ground plans. In fact, the figure was broken in half and missing a torso before coming to the villa, and it was not immediately apparent that it represented Jupiter; I believe it was restored by the Raphael equipe to serve as the head of this loggia.[81] Although we lack specific evidence to date the acquisition of the *Jupiter* or the idea for its ultimate use, the weight of evidence suggests that the decision to deploy it as a Jupiter was under discussion in early 1519.

Therefore, the grandest space of the Medici papal villa contained multivalent references to the majestic ancient basilica that symbolized Christian triumph and peace – in plan, painted and sculptured decorations, and ancient sculptures. These allusions to the Temple of Peace announced Villa Madama as microcosm of the new order: the triumphant, peace-bringing Medicean papal empire. This bold architectural statement of Medici power was all the more emphatic because it translated sacred architectural forms to domestic architecture (a strategy long used by the Medici, as in the novel temple front of Lorenzo's Villa Poggio a Caiano). Villa Madama's garden loggia, with its central domed vault over a modified basilican plan, may also have recalled Bramante's plan for St. Peter's, famously dubbed the dome of the Pantheon over the vaults of the Temple of Peace.[82] Thus, in addition to Sperulo's literary notions for the garden loggia, archeological prototypes also served as models for this space.

Coenatio Iovis

At the same time Sperulo was among the planners positioning the garden loggia as the Temple of Peace, the poet also referred to it as a *coenatio*, or dining room. At one level, Sperulo was conceptually linking the major representational space of the villa to the central social activity of villas celebrated in ancient literature: dining.[83] But his choice of vocabulary and description evokes specific sources. Sperulo's use of the word *coenatio* is curious. In his letter, Raphael used the Italianized *cenatione*, after Pliny's *cenatio*; but importantly, Sperulo isn't directly copying Raphael here, for Sperulo uses the term to designate the garden loggia, whereas Raphael employs it to designate the outdoor dining area at the end of the fishpond. (Also, Sperulo uses the word before his fourteen-line *praeteritio* of borrowings from Raphael's letter.) Nor is the poet studying Pliny, who uses *cenatio* for an informal dining room to entertain his personal friends, and *triclinium* for the main dining room in his Tuscan villa.[84] Perhaps significantly, Columella uses *coenatio* twice in his discussion of the three parts of a villa – the exact section that Sangallo copied onto one

of his drawings either for Villa Madama or an ideal villa, suggesting the passage was discussed by architects and humanists as they developed the plans.[85] Sperulo also specifically evokes Statius' *ekphrasis* of Domitian's banquet hall in his palace on the Palatine hill, which Statius compares to that of Jupiter.[86] The emperor's hall had one hundred marble columns, and Numidian marble vied with Phrygian purple stone. In Sperulo's vision for the Medici villa, he also mentions numerous columns, one of Numidian marble (whether real or imagined) and others of colored marbles. His *ekphrasis* further resonated with dining halls of ancient rulers of Rome and Olympus.

The monumental, enthroned figure of the *Jupiter Ciampolini* later installed at the head of the garden loggia would make this association explicit. There were ancient architectural prototypes of long dining rooms with an apse at the head for the enthroned emperor, although it is not clear if these remains were known in the Renaissance.[87] As literary metaphor, Sperulo's *concetto* for the Medici garden loggia would also have reminded his audience of the Loggia di Psiche vault in Agostino Chigi's Tiber villa, where the Raphael school was engaged at that moment painting the banquet of Olympian gods hosted by Jupiter, and the fictive pergola through which the Olympians seemed to float in and out of the loggia. This concept had been celebrated in the earlier Chigi villa poems, which announce that Jupiter would fly down to join Chigi and his guests.[88] Sperulo borrowed this image of the Olympians descending to dine, commonly invoked by his fellow Coryciana poets, and recast it for the Medici papal *coenatio* where the figure of Jupiter himself would be physically present in sculpture, and analogically in the person of Pope Leo, often styled as Jupiter. This Leo–Jupiter connection was familiar from text and visual imagery, most explicitly in the *c.* 1518 sculpture of Leo as a seated, Jupiter-like figure by Domenico Aimo (Figure 64), which had just recently been installed in the Palazzo dei Conservatori on the Capitoline, where it was praised by poets – another example of visual–verbal set pieces involving poetry and visual media in this Curial milieu.[89] The contemporaneous fresco in the Vatican Sala di Costantino depicting the enthroned Pope Clement I with Leo's features further conflated this imagery of the enthroned Leo–Jupiter with the tradition of enthroned popes, after that of Roman emperors (Figure 65). Thus, in plan as well as in sculptural decoration, the garden loggia of the Medici villa could represent the dining room of Jupiter, as well as the Temple of Peace.

The painted decorations eventually executed at the opposite end of the garden loggia (Plate VII) may have cited another *all'antica* reference to imperial dining, this time an archeological model. The sprawling pose and cave setting of Giulio Romano's painted lunette of *Polyphemus* are startlingly evocative of ancient *Polyphemus* sculpture groups, such as those in the imperial dining grottoes at Sperlonga, Baia, and possibly even the Serapeum/Canopus of Hadrian's

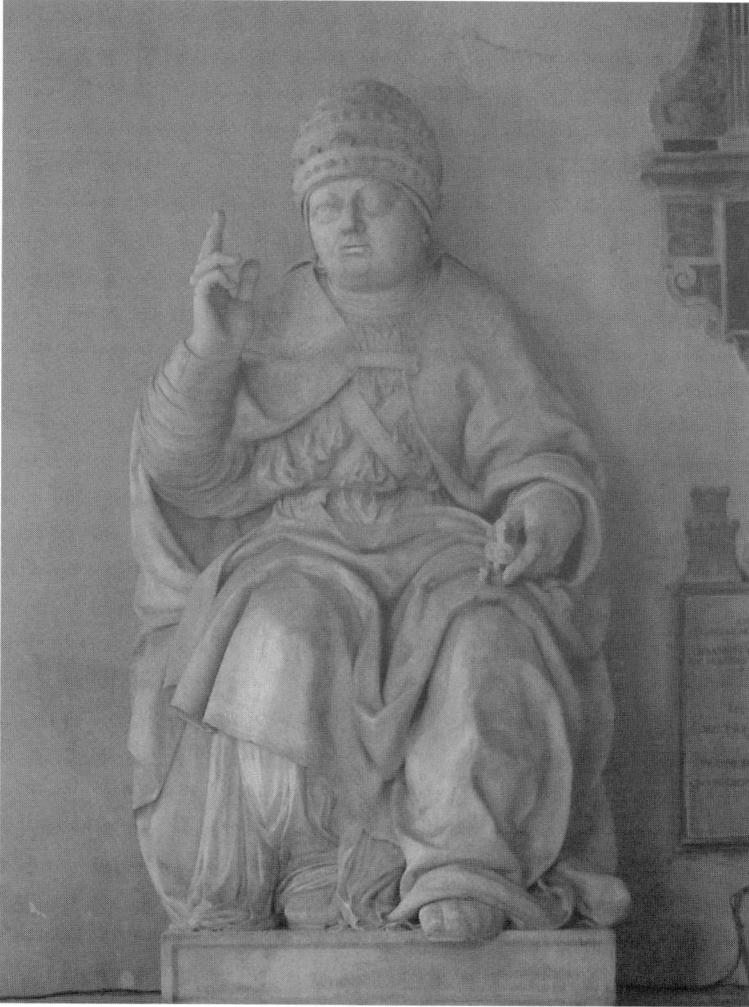

64. Domenico Aimo, *Leo X, c.* 1518, Santa Maria in Aracoeli, Rome.

Villa (Figures 66–9).[90] The pose of Giulio's *Polyphemus* is nearly a mirror image of the ancient sculptural figure leaning back on a rocky outcropping, one arm draped across the torso, another thrown backward across the rock, with the head tilted back. There is no evidence that the Raphael school knew any of these ensembles, nor do there seem to be any literary descriptions or other imagery recording them, such as ancient gems known to the Renaissance, but Giulio's *Polyphemus* would suggest otherwise, as does the conception of the fishpond as watery dining pavilion populated with monumental sculptures, discussed above. Thus, with metastructures for the fishpond as a *musaeum*-water theater and the garden loggia as the *Coenatio Iovis*, the villa's planners developed multimedia spaces that could be used for papal dining, with multivalent ancient references.

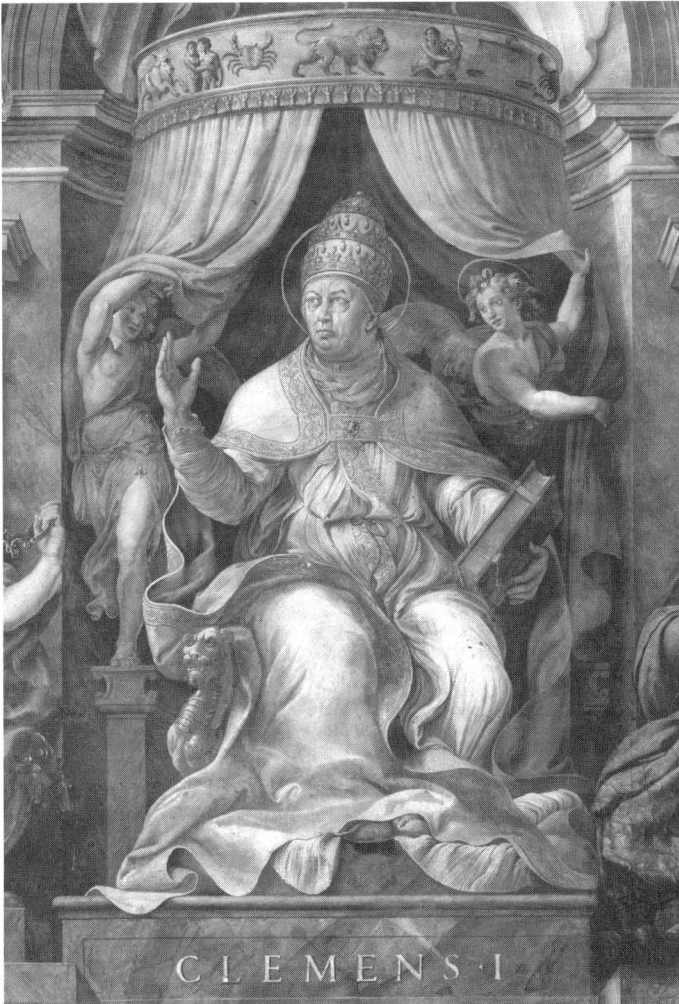

65. Raphael school, *Pope Clement I, with the features of Leo X*, Sala di Costantino, Vatican Palace.

Medici Ancestor Gallery

Sperulo made another proposal for the garden loggia of the villa as a Medici ancestor gallery; in fact, his major proposal for figural sculpture at the villa is for a group of about a dozen Medici ancestors to be represented in marble there, beginning with Giovanni di Bicci. The poet addresses Cardinal Giulio saying, "You, Giulio, having strolled among your mighty friends, fixing your eyes on your father and regarding the serene face of your uncle, will admire the palpable majesty of each, and although your evident virtue needs no spur, you will want to seem to them to have done well" (221–5). Sperulo specifies, "let empty places (*sedes*) be left throughout the proportionate halls for illustrious statues (*statuis*) of your Medici ancestors, about whom their life-giving progeny may justly boast" (78–81). His use of the word *sedes* could have meant

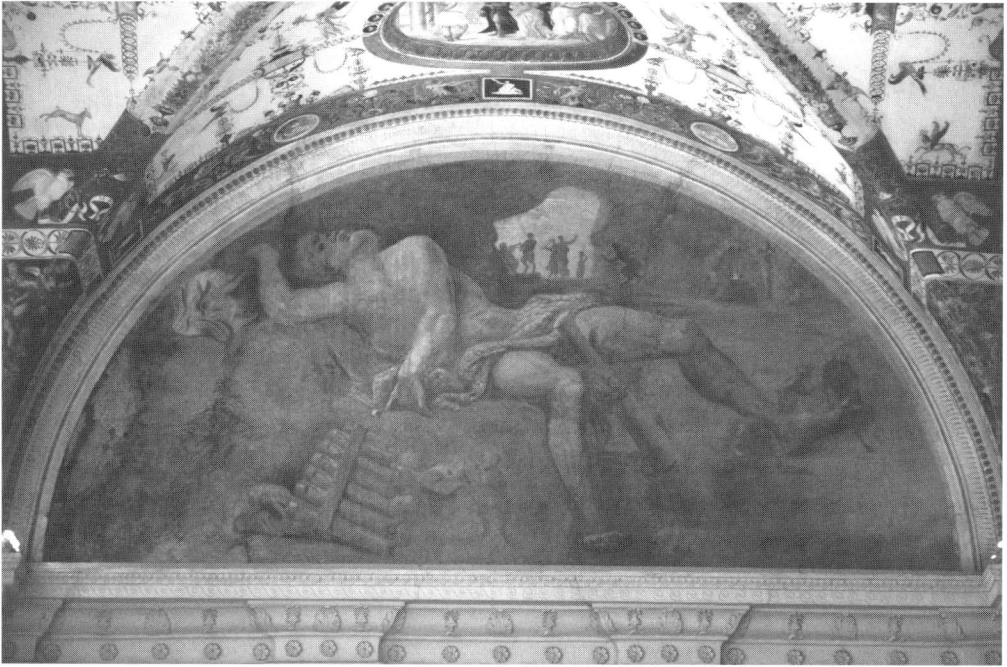

66. Giulio Romano, *Polyphemus*, fresco on the northeastern wall of the garden loggia (opposite the *Jupiter Ciampolini*), Villa Madama.

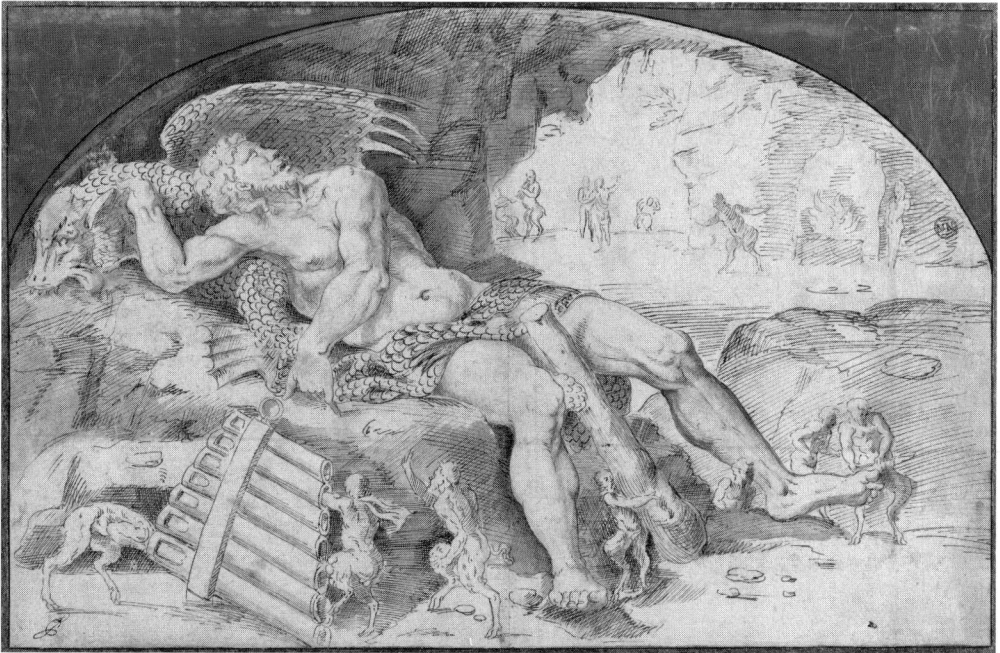

67. Unknown sixteenth century artist, drawing, probably a copy after a lost preparatory drawing by Giulio Romano for the *Polyphemus* fresco, Louvre, Département des Arts graphiques, inv. 3672.

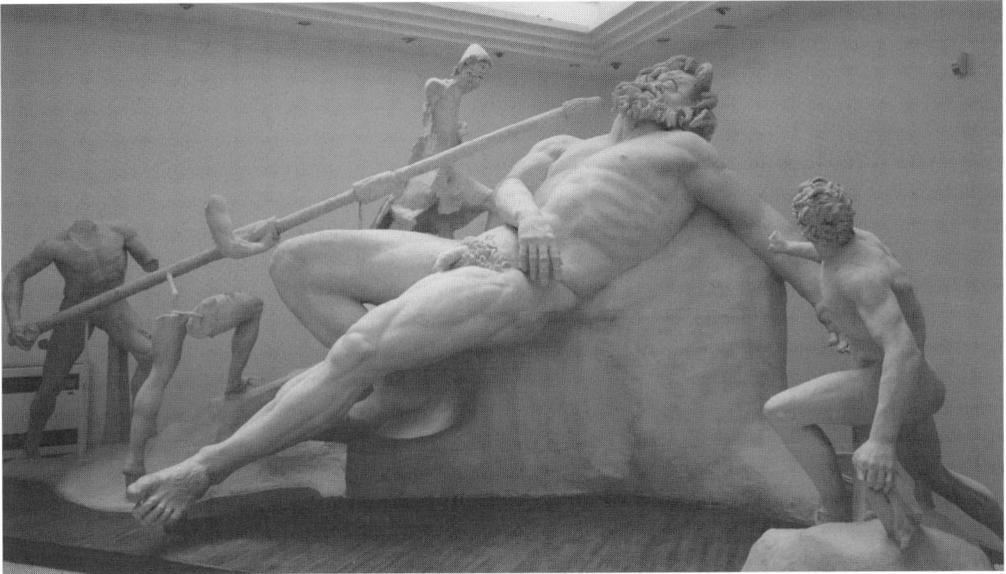

68. *Polyphemus group* from the grotto of Tiberius' villa at Sperlonga, now in the Museo Archeologico Nazionale, Sperlonga.

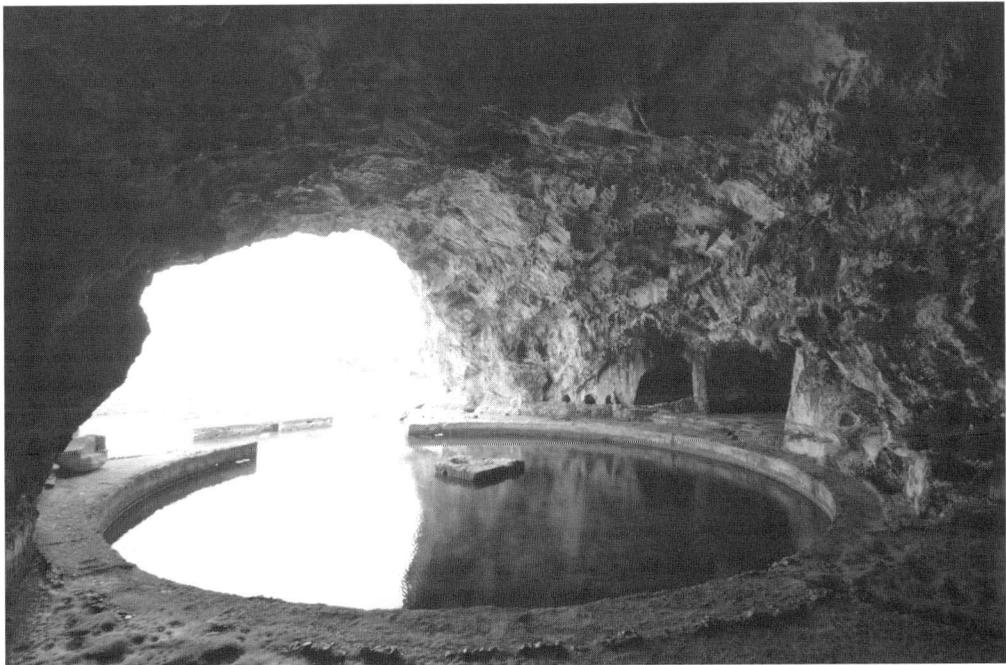

69. Grotto of Tiberius' villa at Sperlonga; view from the platform where the *Polyphemus* group was installed.

"places" (e.g. niches) as well as "seats," so it is not clear whether he intended seated or standing figures. There is no evidence that ancestor sculptures were ever begun for the villa. Conceivably, the poet was simply using the conception of an ancestor gallery to frame his encomium of the family, or suggesting the use of antique sculptures to represent Medici ancestors metaphorically; but his words instead suggest that he intended physical sculptures, and literal likenesses. (It is even possible that they considered sculpting Medici portrait heads to be attached to headless ancient sculptures.[91]) Sperulo locates most of these ancestor sculptures in the villa's great garden loggia, and in fact this space was being redesigned around the time of the poem with eighteen new niches for sculpture – a point to which I will return. These niches average about 5½ feet in height, so the sculptures would presumably have been about life-size, standing figures.

Sperulo's proposal for an ancestor gallery *all'antica* drew on ancient traditions, including the display of ancestor images in the atria of homes.[92] Foremost among ancient prototypes was Augustus' collection, familiar to Renaissance readers from the descriptions by Virgil and Ovid. In the Forum of Augustus, the emperor mixed figures of his ancestors with selected great men of Rome to trace his authority back to Rome's founders; and Virgil envisioned a similar sculpture collection for him in a bucolic setting in the *Georgics*.[93] Medieval and earlier Renaissance depictions of *uomini famosi* sometimes mixed ancestors and great men, although such cycles in private palaces and villas were typically composed of paintings or busts, and most often set in relatively small rooms such as *studioli* or libraries.[94] Several quattrocento fresco cycles provided monumental painted models in domestic settings for the scenario Sperulo was proposing in marble: frescoes in the Ducal Palace in Urbino by Giovanni Boccati (well known to the young Raphael), in the Casa Panigarola in Milan (sometimes attributed to Bramante), and in a loggia of the Villa Carducci in Legnaia, outside Florence, where Andrea del Castagno's *Famous Men and Women* presented fictive sculptures of illustrious figures and ancestors engaged in discourse across their fictive niches.[95] Sculpted ancestor busts were sometimes placed in domestic courtyards; notably, Lorenzo had a series of ancient heads of *uomini illustri* installed over the doors of the Palazzo Medici courtyard in Florence.[96] It is possible that the drawing for Villa Madama's courtyard elevation, with the inset relief bust, represented such a scheme, and another idea in play for commemorating the Medici forebears (Figure 70).[97]

By contrast, Sperulo's proposal to create marble figural sculpture of about a dozen ancestors was an extravagant one, in keeping with other aspirations for the scale and scope of this villa, which was perhaps one reason why the figures were not executed. Another reason was surely the death of Lorenzo, Duke of Urbino, a couple of months after Sperulo's poem – the second of the young capitani whose early deaths dashed Medicean dynastic plans and prompted the

70. Collaborator of Raphael, project for the elevation of the circular courtyard of Villa Madama, RIBA n. XIII–11.

Medici to commemorate their family members instead via a funerary chapel in Florence. As is well known, Cardinal Giulio redirected Michelangelo to take on this project in the New Sacristy of the family's parish church of San Lorenzo in Florence later in 1519, to include tombs for several family members, and possibly his own. The framework for Michelangelo's famous ensemble and the sculptures of seated Medici family members in niches has many significant resonances with Sperulo's ideas for the Roman villa (Figures 71, 72).[98] A more extensive Medici ancestor gallery of monumental figural sculpture in niches and exedrae would be realized beginning c. 1540 in the Sala del Cinquecento of the Palazzo Vecchio by Baccio Bandinelli and other sculptors (Figure 73);[99] and indeed the Medici may have had Bandinelli in mind for the Villa Madama ancestor gallery while that project was still in play.[100] The Roman nobles' tradition of displaying antiquities as markers of a family's ancient lineage has been contrasted with the emerging taste of Curial patrons for displaying ancient sculpture for aesthetic and humanistic reasons in the late quattrocento and early cinquecento.[101] Sperulo's proposal reveals that these two conceptions could be made to commingle. Although his proposed ancestor gallery remained unexecuted at the villa, his notion that the Medici should use antiquities to Romanize themselves and trace their ancestry to the founders of Rome would indeed be adopted there. Heemskerck documented one exedra of the garden

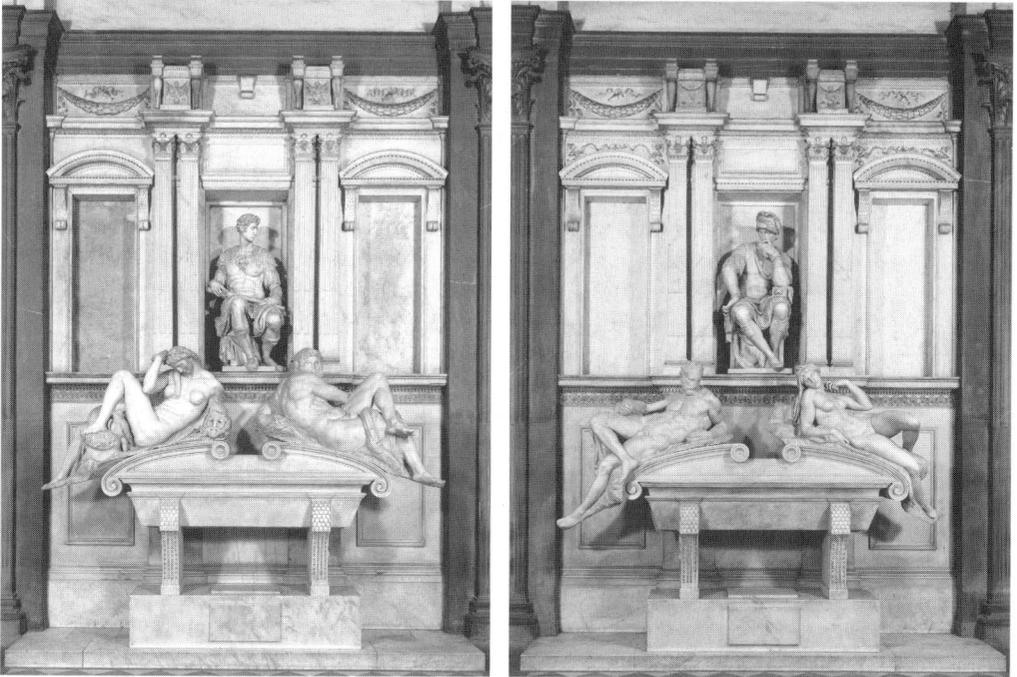

71. and 72. Michelangelo, *Tomb of Giuliano de' Medici, Duke of Nemours* (left) and *Tomb of Lorenzo de' Medici, Duke of Urbino* (right), begun 1519; New Sacristy, San Lorenzo, Florence.

loggia when it was peopled with sculpture, some of which can be identified (Figures 74, 75); and Giovanni Volpato and Charles-Louis Clerisseau were among the eighteenth-century visitors to the villa whose fantastical views of the garden loggia evoke the richness of the sculpture decoration, if not an accurate record (Figure 76, Plates XVIII, XIX).

∽

Thus, humanists, architects, and other planners generated high-level conceptual structures linking the Monte Mario to the authority of the cross and Constantine; proposing the hillside as the seat of the Muses and a new Parnassus; designating the villa as the realm of Venus Genetrix; and casting the great garden loggia as the Temple of Peace, the dining hall of Jupiter, and an ancestor gallery. The Monte Mario, the villa complex, or even a single loggia could represent multiple concepts simultaneously. And these conceptual notions could be embodied in many media, from siting, roads, and views to architectural plan and elevation, and the disposition of sculptures and painted decoration.

It emerges that all these elements developed in an ongoing dialogue, and this discourse began remarkably early in the villa's planning process. Not surprisingly, many of these concepts would evolve considerably throughout the

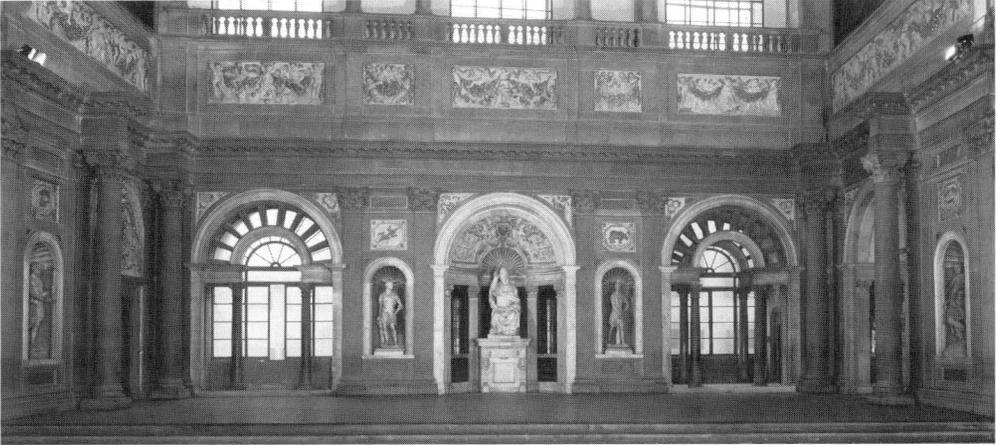

73. Baccio Bandinelli, sculptures of Medici ancestors, Salone del Cinquecento, Palazzo Vecchio, Florence.

course of planning and building, or fall by the wayside altogether. Sperulo's claim that he was involved in choosing antiquities and transporting them to the villa while its walls were still rising reflects the fact that he actually was contributing ideas about how to display sculptures and spoils, and perhaps even searching them out. Consonant with the contemporary climate of archeological and philological study of the antique, poets as well as architects and archeologists contributed ideas based on archeological as well as literary sources. Sperulo's hortatory *ekphrasis* of the villa provided a wealth of ideas, some of which were implemented, such as the prominent installation of the relief from the Temple of Venus Genetrix, and some of which were not, such as the ancestor sculptures. Although his proposal for ancestor sculptures was not realized at the villa, his ideas may have taken root in the family's Florentine ensembles instead. And his emphasis on the continuity of Medicean lineage from the founders and rulers of ancient Rome via their inheritance of marbles was realized at the villa in the collection of ancient sculpture and spoils gathered there. His emphasis on Medici *romanitas* and rule is directly reflected in specific antiquities and the decorations that would surround them.

THE GENERATIVE POWER OF MARBLES

Significantly, for many of these metastructures, important antiquities provided a generative impetus. Considering Sperulo's proleptic descriptions along with the actual sculpture and spoils originally at Villa Madama reveals how antiquities were recontextualized in new ways by Raphael and his collaborators; and how antiquities were generative for multivalent conceptual programs for the

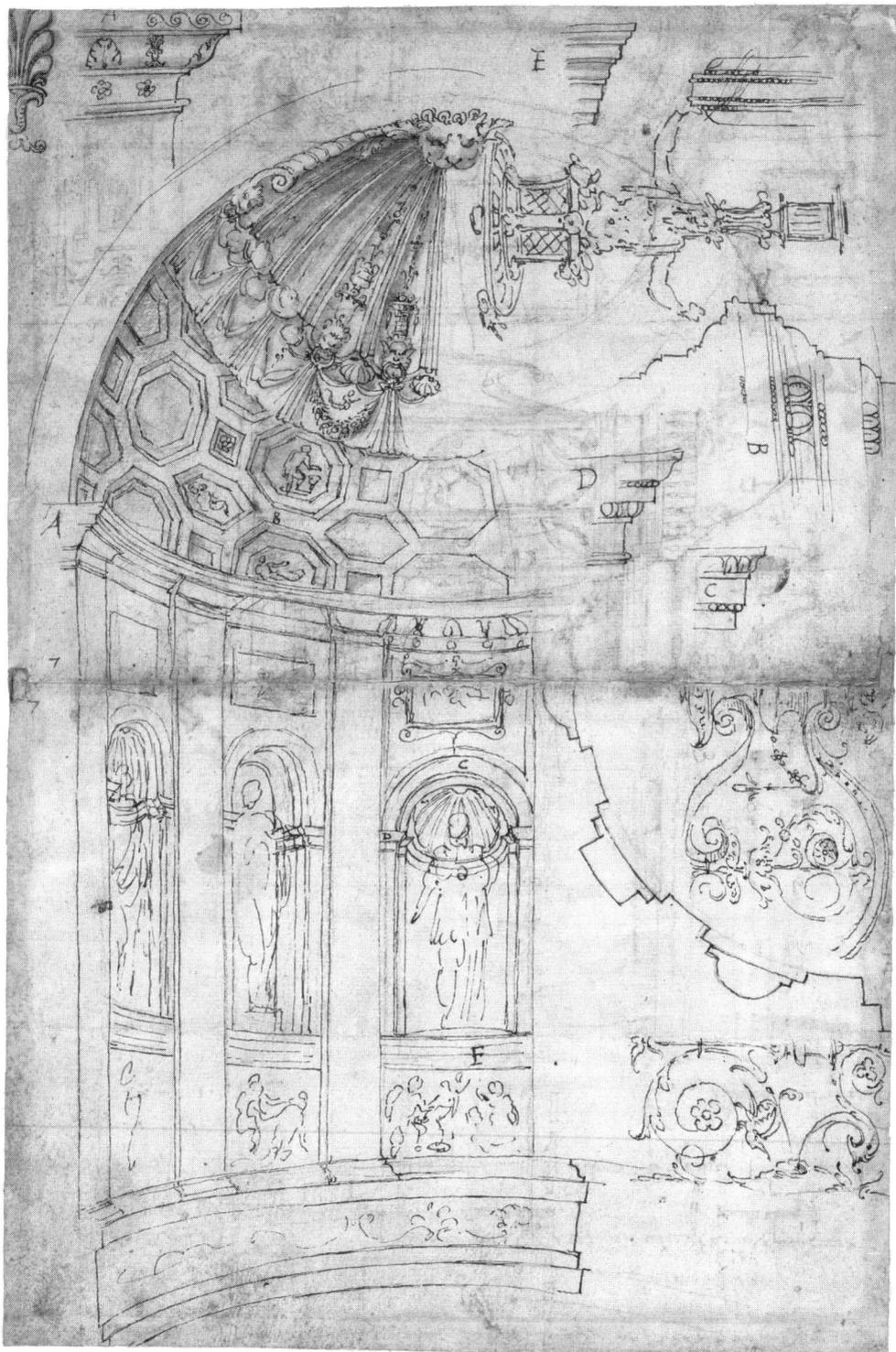

74. Marten van Heemskerck, Villa Madama, garden loggia, exedra with sculptures including the *Genius Augusti* in the center; Berlin, Staatliche Museen Kupferstichkabinett, Inv. Nr. 79 D 2, Römische Skizzenbücher, II, fol. 73r.

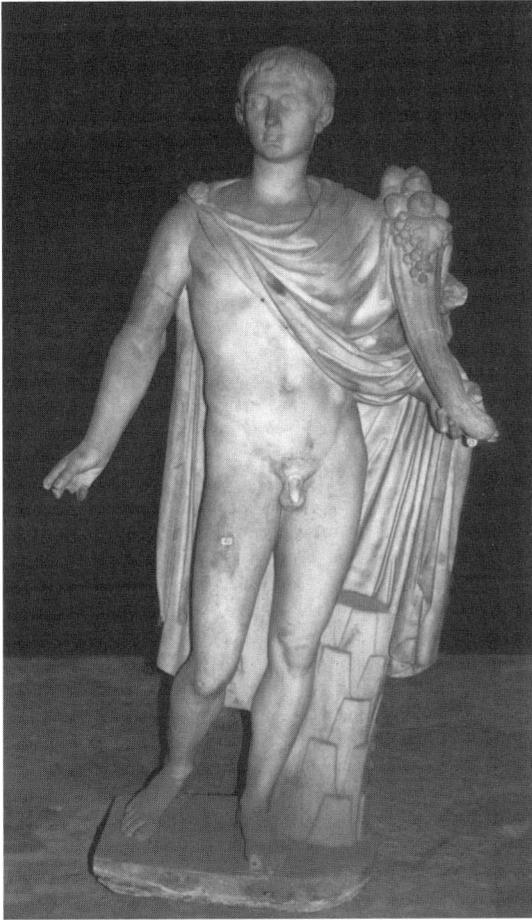

75. *Standing Genius with Cornucopia (so-called Genius Augusti)*, Museo Archeologico Nazionale di Napoli, inv. 6053.

villa complex, and for architecture and decoration. It is striking that Sperulo's poetic evocation of a marble from Venus Genetrix corresponded to an actual relief from her temple, which would be the focal point around which an entire elevation was designed at one end of the garden loggia; and that this loggia that Sperulo described in terms of the *Coenatio Iovis* and Temple of Peace would be reconfigured with an apse at its head to house a colossal enthroned *Jupiter* at the opposite end. The Venus Genetrix relief is the most straightforward illustration of this process, but the web of evidence for the other metastructures suggests that these ideas were under discussion, and evolving rapidly.

These case studies provide valuable, specific examples of how the inclusion of sculptures and spoils was an impetus for some of the major changes to the villa's ground plan. As we have seen, it was in early 1519, when Sperulo was writing, that many changes to the basic plan were being worked out – changes

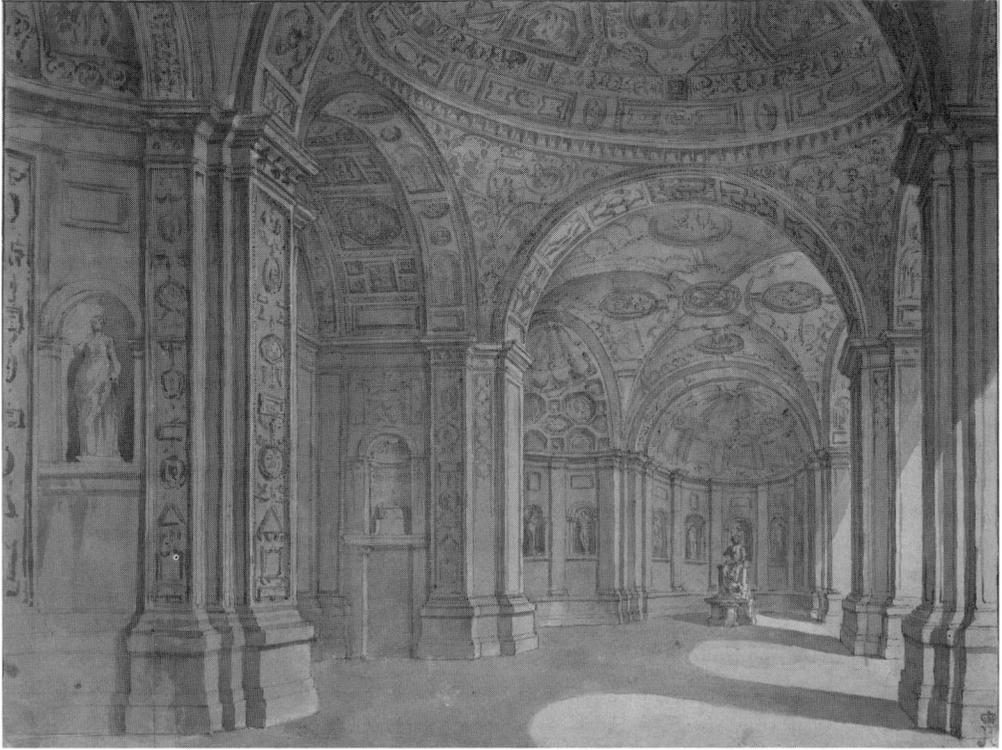

76. Charles-Louis Clerisseau, *Interior of the Villa Madama*, between 1750 and 1755, pen and brown wash, brush and brown and gray wash, State Hermitage Museum, St. Petersburg.

that differentiated the two major surviving plans for the villa, U 273A and U 314A. As proposed in Chapter 4, Raphael's letter probably dates from around the same time. Both Sperulo and Raphael discussed ideas that would appear in the later plan. And true to Sperulo's word, many of the significant changes in U 314A involved areas that would accommodate specific sculptures. The garden loggia Sperulo wanted to have filled with ancestor sculptures was indeed being redesigned around this time with niches for eighteen sculptural figures: two exedrae housing ten sculpture niches were added (Cf. Figures 57, 58), although they would eventually be filled with antiquities rather than ancestors. Also in the garden loggia, the fountain *diaeta* shown in U 273A and described by Raphael was converted into an exedra probably intended to house the giant seated *Jupiter Ciampolini*, corresponding to Sperulo's imagery of the *Coenatio Iovis* and the Temple of Peace. The *Jupiter Ciampolini* was probably the reason for this change. The wall of the inner garden was also modified, replacing seven small niches with three large ones; the left niche was probably designed to house the colossal *Genius*, judging from the perfect scale of the niche for the sculpture (Figures 77, 78). At the fishpond, the tiers of seating ringing the pond and facing a proscenium-like wall in U 273A were replaced by the tri-lobed

ambulatory, creating grottoes for sculpture – perhaps to create a *musaeum* to house the nine ancient *Muses* and characterize the site as Parnassus (Figures 53, 57, 58). It is remarkable that this level of attention was given to sculpture by architects, and so early in the course of their planning.

The planners were therefore assembling sculptures and spoils for the villa, and using them to generate set pieces of architectural plan, elevation, and decoration. Some of these constructs were instrumental in formulating design changes from U 273A to U 314A. What do we know about what sculptures actually were at the planners' disposal at this stage? A full treatment of the problematic vicissitudes of the rich collection of ancient sculpture and spoils assembled for the Medici papal villa is beyond the scope of the present study, but a few observations can be brought to bear here.[102] The collection was by no means rich enough at the moment Sperulo was writing to allow them to populate the plan fully. Beyond his oblique reference to the *Muses* and Jovian constructs, Sperulo makes no mention of ancient figural sculptures for the villa. (Assertions that he mentions figures of Jupiter and Silenus are erroneous.[103]) This fact suggests that few significant ancient sculptures had been collected or earmarked for the villa by early 1519. Neither does Raphael mention figural sculptures in his description of the villa, although his omission may reflect epistolary convention, for Pliny's villa descriptions do not include figural sculptures either.[104] They must have had the *Jupiter Ciampolini* and colossal *Genius* in mind by the time U 314A was drafted, since that plan seems custom-tailored for those figures. Thus, plans to populate the villa with sculpture were in process in early 1519, and they were still ongoing in June 1520, as we know from Cardinal Giulio's letter in response to questions from Mario Maffei about whether to transfer to the villa sculptures stored at the Palazzo Medici near Piazza Navona,[105] or even make some out of stucco.[106] Given Raphael's papal mandate to collect ancient marbles and stones for the construction of St. Peter's, we may assume that as spoils became available they were known to the planners of both papal projects – basilica and villa. There was surely discussion of where certain spoils could best be used. These ideas would have evolved with the changing vicissitudes of both grand projects, and the availability of antiquities. Sperulo may well have been proposing installations in the Medici villa for specific spoils that were ultimately used elsewhere because plans changed, or because he envisioned placing them in sections of the villa that were never built. New finds and acquisitions must also have forced changes in plans. I am not suggesting there was a single moment or phase when plans were adjusted to accommodate sculpture; rather, it seems to have been an iterative process. U 273A already indicated many niches and spaces for sculpture, but their placement seems rather generic and does not correspond to specific works that would actually be installed at the villa, as is the case with U 314A.

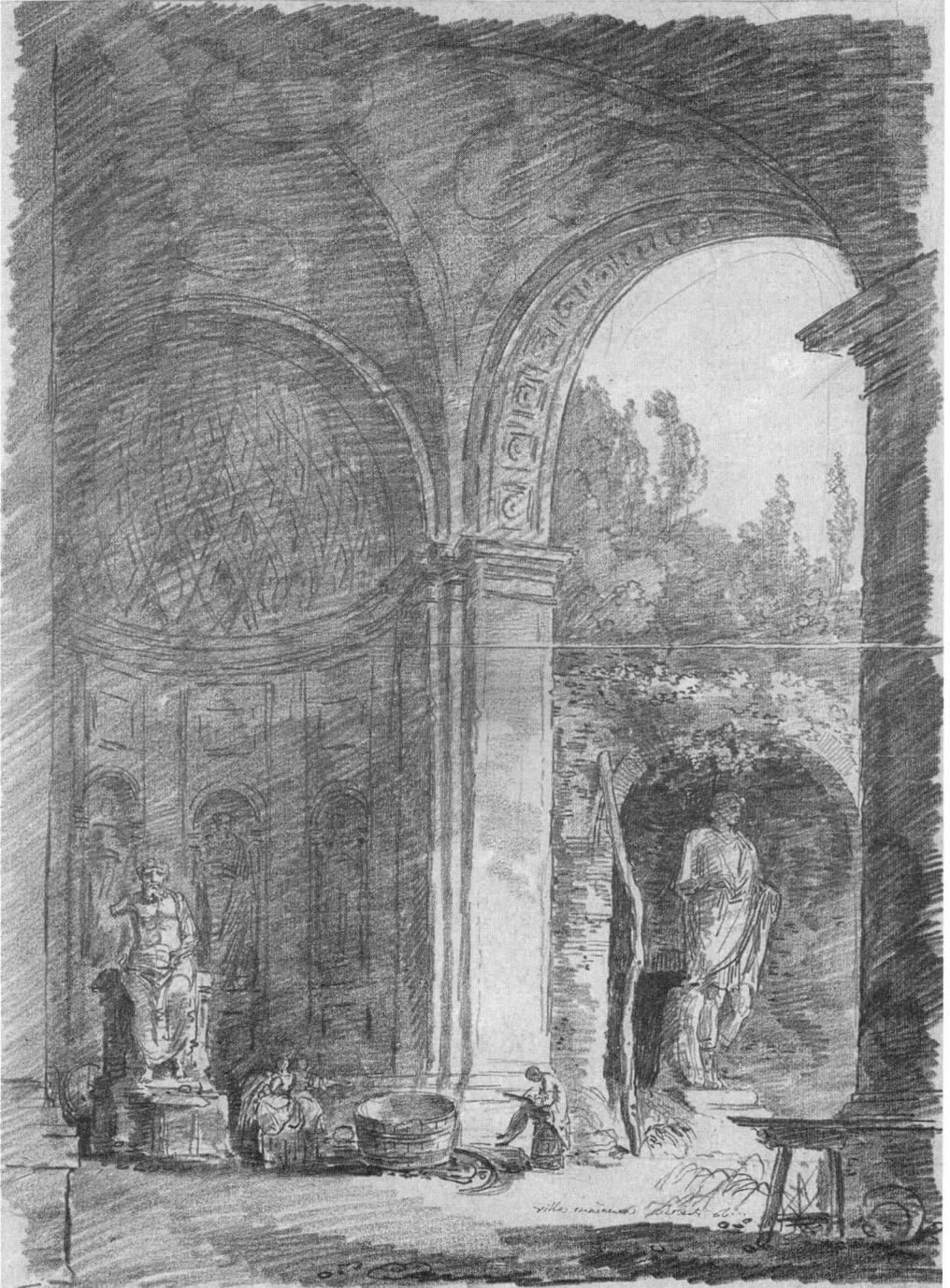

77. Hubert Robert, *Draughtsman Sketching at the Villa Madama*, which records sculptures still in situ, including the colossal *Genius of the Roman People* in the garden niche at right; red chalk drawing, Thaw Collection, The Pierpont Morgan Library.

78. *Genius of the Roman People*, Museo Archeologico Nazionale di Napoli, inv. 5975.

Just as specific sculptures and spoils were driving changes in architectural plan, they were generative for elevations and for the decorative and iconographic program, too. The elevation of the northeast wall of the garden loggia was designed to accommodate the Venus Genetrix relief, which was embedded in the physical fabric of the villa, and would later inspire the decorative scheme in the surrounding panels. Similarly, the *Jupiter Ciampolini* at the other end of the loggia was the point of departure for the architectural plan, and also for the surrounding painted and stucco decorations, which symbolize Medici rule and Leo as Jupiter.[107]

This generative use of sculpture and spoils to shape the design at Villa Madama was clearly understood by Raphael's contemporaries and successors, a point later made explicit in the work of Bartolomeo Ammannati. The mid-sixteenth-century Villa Giulia was the next great papal villa/*hospitium* built in Rome,

and its designers responded to Raphael's Medici villa in meaningful ways. Like Raphael, Ammannati wrote an epistolary description of his project, but this time the architect went further to specify how the buildings were designed to incorporate many specific ancient sculpture and architectural spoils.[108]

Antiquities held special importance for the papacy as signifiers of the continuity of temporal power from the Roman empire to the Christian *res publica*. Pope Leo's brief stipulating that St. Peter's should be built out of stones excavated from the ruins of Rome, rather than with imported stones, arose from practical considerations, but also functioned perfectly as metaphor.[109] Sperulo's poem assigns the same symbolic resonance to the ancient marbles used at the Medici papal *hospitium*. As we saw in Chapter 3, he attaches ideological constructs to marbles, such as the antiquities "owed" to the Medici for their gift of peace to the world; the marbles he uses to trace Medici ancestry to Julius Caesar, Venus, and the founders of Rome; and the works whose provenances he embellishes with literary and historical allusions. Moreover, spoils were crucial for the villa on the Monte Mario because the site had not been built on in antiquity. Sperulo specifically notes this fact in his description of the site, saying, "I am amazed that no one before, when great Rome was rising everywhere, chose such an ornament for himself to augment his fame and provide solace for his existence" (24–6). His mention of the marbles from the Temple of Venus Genetrix, among other sites, dignified the villa by tying it to these ancient precincts. Sperulo also metaphorically links the material permanence of marble with the "eternal return" of the Medici family. Thus, the spoils symbolized not only political and religious victory, but also the Medicean conquest of time itself.[110]

But the private possession of sculpture and spoils could also be problematic. Pliny claimed the recontextualization of important sculpture for public display to be the task of the benevolent ruler, specifically noting the example of Vespasian (in contrast to Nero). He further declared the Temple of Peace as the most appropriate site for them: "about the list of works [of sculpture] I have referred to, all the most celebrated have now been dedicated by the emperor Vespasian in the Temple of Peace and his other public buildings; they had been looted by Nero, who conveyed them all to Rome and arranged them in the sitting-rooms of his Golden Mansion."[111] Ironically, the Medici villa – which Sperulo emphasized was being funded by the family – was the kind of private residence Pliny was critiquing as a site for sculpture.[112] Thus the conception of the villa's garden loggia as a new Temple of Peace for Leo, the *Rex pacificus*, and Sperulo's conceit that the Venus Genetrix relief was owed to the peace-bringing Medici were surely conceived as rationalizations for this sculptural display.

Of course, the recontextualization of ancient sculpture and spoils was conditioned by the practical issue of availability. Significant antiquities were not plentiful at this moment, even for the pope with Raphael as his Prefect of Marbles. The villa's planners had to work with what they could get, and they rearranged the pieces into a story about the Medici. Sperulo could recontextualize and

allegorize spoils on paper the same way he built a new sentence with famil-
iar words and literary references, thereby changing their meaning to forge a
Medici narrative, which could be designed into the physical complex.

This evidence that ancient and modern sculptures played a programmatic role
at the Medici papal villa is noteworthy, since scholars of early cinquecento antiq-
uities collections have debated whether or not the works were arranged to con-
stitute iconographic programs.[113] In part, this practice followed papal precedent
in the Sculpture Court of the Vatican Belvedere, populated by the figures of the
Laocoön, so-called *Cleopatra*, and *Apollo Belvedere* in a loosely configured Virgilian
program.[114] At the Medici villa, however, the sculptures and spoils were not limited
to a single-medium plan, but further served a larger purpose as generative impulses
for the metastructures involving architecture and decoration in all media.

This brings us back to the issue of what constituted a program or invention
in the early sixteenth century, discussed at the outset of this chapter. Discussions
of meaning in architecture, especially secular, are sometimes met with skepti-
cism by contemporary historians of architecture, who dismiss such readings as
old-fashioned, unsubstantiated, or impossibly arcane.[115] Sperulo's poem unam-
biguously shows that conceptual frameworks of meaning were being discussed
at an early stage of the villa's design (whoever invented them, and whether or
not they were all eventually deployed.) His plan, once we decode the language
and references, has all the clarity of a modern corporate white paper, to reprise
the analogy of the previous chapter: it begins with fundamental messages such
as peace and just rule, and proposes specific ways to convey them in a variety of
media. Much of his imagery turns out to be surprisingly common: gods who
come to dine (especially Jupiter and Venus), the site as Parnassus, and the com-
memoration of ancestors. But he has invented many layers of meaning, couched
them masterfully with literary codes, inflected them for the Medici family and
papal Rome, and proposed some concrete ways of actualizing them in the villa.
Fundamentally important for this papal *hospitium* that functioned as an outpost
of the Vatican, the built environment and decorative imagery needed to convey
clearly these crucial messages – as popes relied on the visual arts to do in the
Vatican itself. The metastructures sketched above certainly would not prompt
any artist to point out a horse to Cardinal Giulio; this imagery was readily appar-
ent to elite viewers. The poet constructs a conceptual framework, and, together
with other planners, proposes set pieces to express a variety of meanings.

Thus, literary, archeological, and ideological constructs were embodied in
the villa complex, from architectural plan and elevation to sculpture, spoils, and
wall decoration. Significantly, these metastructures of word and image were
formulated from the earliest stages of design. The contribution of ideas from
different knowledge systems was the product of collaboration and negotia-
tion among a group of specialists; the next chapter examines the roles of these
various players, and the processes by which they generated these conceptual
structures.

CHAPTER SIX

DYNAMIC DESIGN

Fʀᴏᴍ ᴛʜᴇ ᴀɴᴀʟʏsɪs ᴏғ ᴘᴏᴇᴛʀʏ ᴀɴᴅ ᴘʀᴏsᴇ ᴛᴇxᴛs, ɢʀᴏᴜɴᴅ plans, and antiquities, it emerges that the Medici villa was designed via an intense collaboration and cross-fertilization of ideas among architects and humanists. As we have seen, they conceived multivalent frameworks of word and image that could be realized in the villa complex at many stages of design and execution, from ground plans to decorations. It has long been recognized that Raphael was assisted in the villa project by Antonio da Sangallo the Younger, Giovan Francesco da Sangallo, Giulio Romano, and other talented artists and architects whose drawings document their presence in Raphael's workshop. Likewise, their engaged Medici patrons certainly provided ideas. This analysis of texts, notably Sperulo's poem, reveals the involvement of humanists, who contributed to functional as well as visual and spatial constructs, and did so surprisingly early in the planning process. This chapter reconsiders the roles of architect and so-called humanist advisor, who were engaged in what I characterize as an iterative, collaborative design process that extended over the long time period such a building project required. This scenario of creative collaboration is at odds with the concept of a building or even a poem as an autonomous work of art, which raises interesting questions of architectural authorship and the nature of invention in the early cinquecento, a pivotal time for the role of the architect.

RECONFIGURING THE ROLES OF ARTISTS AND ADVISORS

Collaboration was a hallmark of Raphael's working methods, as recent scholarship has recognized – a necessity given the staggering array of colossal projects he directed simultaneously; but there is a dearth of evidence about the specific nature of his interactions with collaborators, within the workshop and beyond.[1] He had an extraordinary ability to attract and develop brilliant artists, and he seemed comfortable giving some of them an unusual degree of creative control, most famously his right-hand assistant Giulio Romano. Raphael's Louvre self-portrait with another man, perhaps Giulio, seems to illustrate the nature of this dynamic with his younger associates (Figure 79).[2] Celio Calcagnini (1479–1541), a humanist and former Ferrarese ambassador to the Holy See, remarked of Raphael that, despite his astounding achievements, "He is so far from preening because of it that, to the contrary, he spontaneously makes himself accessible and friendly to all, shunning no one's admonition or discussion, since no one rejoices more readily than he that his plans are called into doubt or dispute, and thinks that the reward of life is to be taught and to teach."[3] This letter was written late in Raphael's life (1519–20) and perhaps amplified after his death, so we may take the tribute with a grain of salt, but praise for taking constructive criticism is uncommon, suggesting that Raphael actually did have a reputation for being receptive to his associates' ideas and accommodating criticism in the design process.

Raphael surely developed collaborative design processes suited to colossal commissions from his earliest Roman papal projects in the Vatican Stanze, where he worked with Inghirami, among other humanists, as well as Bramante, architect of the "new Rome" rising on either side of the papal rooms, and Pope Julius himself. In fact, the painted imagery in Julius II's private library was coordinated with the partially built structures of new St. Peter's and the Belvedere Courtyard, views to specific topographic markers, and sculpture installations in the Belvedere Statue Court – all of which proclaimed coordinated messages of the Vatican as a new Parnassus, Pope Julius as Apollo, and his new Christian Rome as the fulfillment of learning.[4] Scholars have worked to tease out the contributions of the collaborators in devising this scheme in the absence of much hard evidence.[5] In any case, this project was surely crucial in developing Raphael's ability to work with a range of specialists to map ideas across representational and spatial media. Beginning with this project, his brilliance in visual–verbal collaboration and his aptitude for thinking in many media on a grand scale were surely among the talents that powered his meteoric rise from painter to Rome's foremost artist-architect and impresario. Although Inghirami died in September 1516, before planning for the colossal-scale Medici villa was under way, he had been an essential mentor to Raphael, whose many portraits suggest the artist's debt to his humanist friend.[6] Inghirami was also an

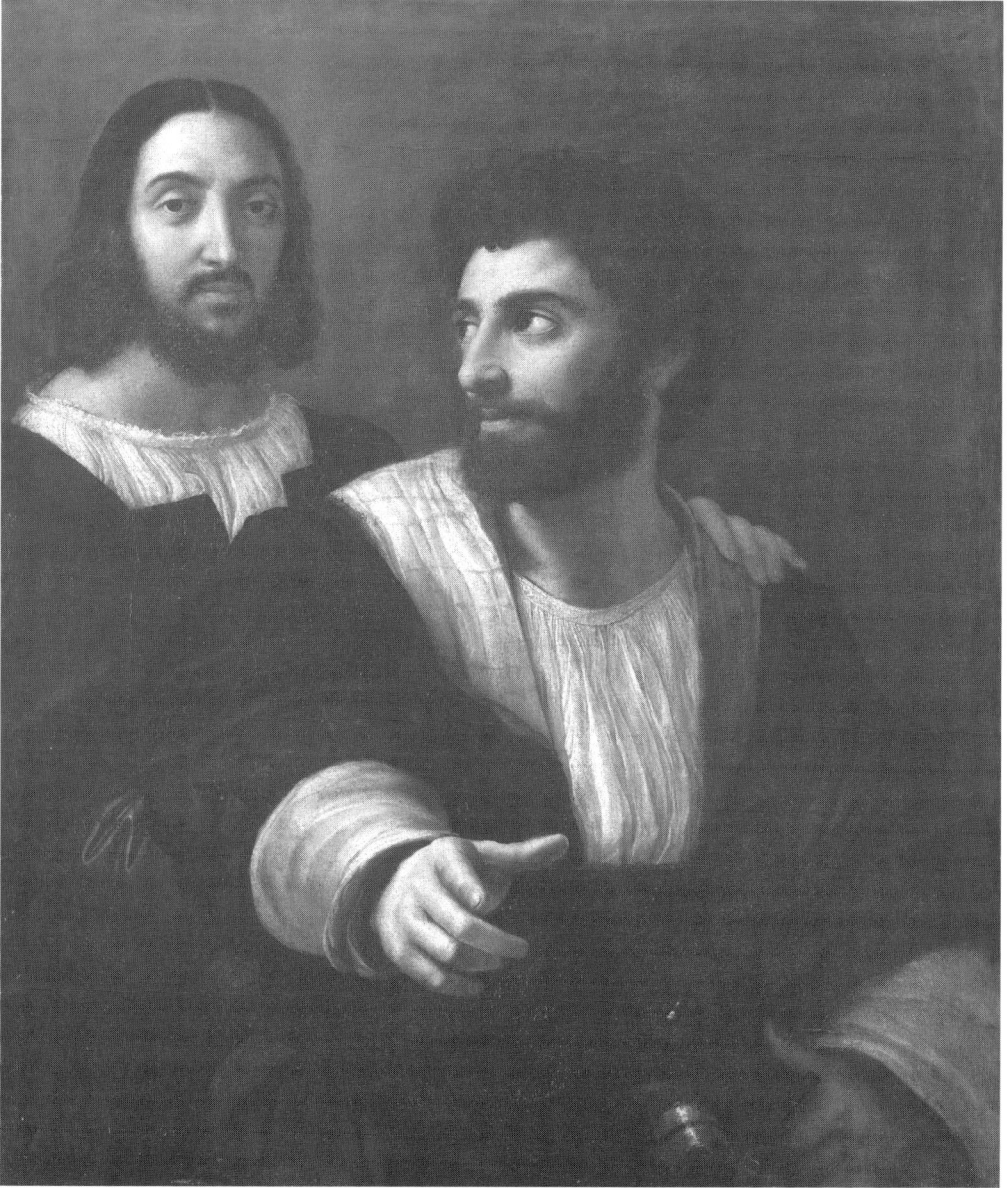

79. Raphael, *Self-Portrait (with Giulio Romano?)*, 1518–20, Louvre.

important image-maker for the Medici; he had spent time in Florence as a guest of Lorenzo the Magnificent, where he perhaps absorbed the Medici penchant for representing brilliant visual–verbal conceits in many media, from poetry and song to paintings and festivals, and he put these talents to work conceiving the Medici festivities on the Campidoglio in 1513.[7]

What *is* known about Raphael's working process suggests that it varied by project and collaborator.[8] By the time he began work on the Medici villa, in addition to managing his own workshop, Raphael had several years of

experience in the Fabbrica of St. Peter's; there, despite his role as Chief Architect, he had to collaborate with other architects and negotiate his way through a large and hierarchical system run by the powerful project manager Giuliano Leno (*c.* 1478–1530).[9] The Medici villa enabled a very different style of working; as Raphael's one opportunity to design a freestanding building in its landscape from its inception, the project allowed him greater creative and organizational freedom than at St. Peter's, although even here he had to contend with other forces, as we have seen with the pugnacious Sperulo. The many ground plans drafted by Antonio da Sangallo and Giovan Francesco da Sangallo document their participation in the project, but leave unresolved questions about their contributions to its ideation. In general, Raphael and Antonio da Sangallo the Younger were a complementary pair, thanks to Raphael's fertile inventiveness and scenographic vision, and Sangallo's precise draftsmanship and structural expertise. Sangallo had been named *co-adiutore* of St. Peter's in 1518, and thus the two worked in tandem on both projects. At the villa, Sangallo evidently handled the difficult, sloping site, which was prone to landslides, based on his execution of U 314A and a number of studies preliminary to it, although the contribution of each architect to the project remains unclear.[10]

For his part, Sperulo distilled a large dose of Medicean ideology into a general program of sculptures, spoils, and mural paintings that would constitute a Medici *res gestae*, layering their family history onto that of Rome. His task was to devise overarching conceptual, decorative, and functional constructs, without working them out in specific detail. His poem furnishes conceptual proposals at a formative early stage of the design process, and it is no surprise that these ideas would have evolved considerably during the execution of the villa. As we saw, his most timely and successful proposals were his plans for sculptural set pieces, formulated in tandem with evolving ground plans and elevations. By contrast, his proposed mural paintings were never executed; changes in the political scene would have rendered them obsolete by the time the villa was built and decorated.[11] Indeed, the iconography of paintings was often the last piece of an ensemble to be worked out.[12] The well-known letters of Cardinal Giulio to Mario Maffei in June 1520 show that they were discussing specific iconographic content a year after Sperulo wrote his poem – so the planning was long and collaborative indeed.[13]

The idea that a minor humanist such as Sperulo was proposing ideas to his patron and especially to an artist of Raphael's stature challenges our assumptions about the creative process. In fact, Maffei, better known as a Medici agent, provides concrete evidence of a minor humanist playing a similarly important role, and in the same environment.[14] Like Sperulo, Maffei was also a humanist and occasional diplomat, active in the papal Curia and in Roman humanist circles. The two surviving letters of Cardinal Giulio to Maffei of June 1520 reveal that he served as a sort of project manager for

the villa during Giulio's absences from Rome. Maffei's responsibilities there ranged from proposing iconography and managing artists – notably Giulio Romano and Giovanni da Udine who were battling for control of Raphael's workshop after his death – to designing hydraulics and planting trees. Maffei had an easy rapport with Cardinal Giulio, who looked forward to his witty missives, and the two enjoyed an uneven *amicitia*,[15] although Maffei's personal letters reveal the ongoing anxiety of a courtier strategizing to please his patron and secure his position, and hoping for favors in return, such as rooms in the Vatican and a red hat. (Particularly interesting is Maffei's ongoing anxiety about appropriate symbolic gifts for his patron, from fruit and candles to a pair of peacocks sent by his nephew from Volterra, one of which falls ill, prompting a string of desperate reports on the bird's health.[16]) Even before his work at Villa Madama, Maffei had been valued in Roman circles for his management of building projects, including work at St. Peter's. And as we have seen, Maffei devoted his poetry as well as physical energies to his own villas in Rome and Volterra. His correspondence with his nephew richly documents his practical experience renovating his family villa in Volterra and his love of plantings, although, frustratingly, his letters make no mention of his work on the Medici villa beyond a reference to planting trees and some pruning.[17] We lack sufficient evidence to frame the dates of Maffei's and Sperulo's work at the villa.[18] It is possible, though improbable, that Maffei was Sperulo's successor; more likely, since their strengths lay in different areas, the two were active in different capacities.[19]

Other humanists and artists were surely involved in various capacities, too. The simultaneous planning for projects by the same Medici patrons at Villa Madama, the Sala di Costantino, San Lorenzo, and the villa of Poggio a Caiano certainly fostered exchange among them.[20] For example, Paolo Giovio's responsibility for the program of frescoes at Poggio begun in 1519 places him among the group of Medici image-makers at exactly the same moment, and in a role similar to that of Sperulo and Maffei.[21] Although Giovio was away from Rome in early 1519 when Sperulo must have been writing his poem, one can imagine that Giovio, with his long-standing interest in *villeggiatura* and villa description, contributed to and benefited from verbal and written interchanges of ideas about villa building – perhaps while he was still in Rome, or when he was with Cardinal Giulio in Florence.[22] Ariosto was surely contributing ideas in both locations; he visited the dying Duke Lorenzo de' Medici in Florence in late February 1519, which prompted him to write a poem about self-renewing laurel that would be used as the basis of decorations for Poggio,[23] but during the period of the papal villa's design he was based in Rome, where he collaborated with Raphael to stage *I suppositi* in the Vatican in early March 1519.

Pietro Bembo's prominent position as Pope Leo's Secretary of Briefs placed him in the thick of Curial projects throughout this period; between his friendship with Raphael, their collaboration on Cardinal Bibbiena's *stufetta*, and Bembo's interest in *villeggiatura*, it would be surprising if he had not been involved in conversations planning the Medici villa.[24] Pierio Valeriano, who served as Cardinal Giulio's secretary and who set his dialogue about the vernacular in the garden of Giulio's villa, was likely among the *letterati* privy to its planning as well. Similarly, we may only hypothesize that another contributor to this discourse may have been Raphael's great friend Baldassare Castiglione, who collaborated to present a literary portrait of Raphael's ideas in the letter to Leo X and the *certa Idea* letter, and who was probably intended to polish Raphael's letter describing the villa, of which he owned a copy.[25] Castiglione was absent from Rome from mid-1516 until late May 1519, but he quickly got up to speed on Raphael's projects at first hand on his return and began promoting them; by mid-June, he had dined with Pope Leo at the construction site of the villa and written to Isabella d'Este describing the "excellentissima" villa project and Raphael's superlative new use of stucco in the Vatican Logge.[26] We may imagine the mental storehouse of Medici and papal imagery known to this cohort, who could creatively trade and translate ideas for different projects and settings. And if, in the initial stages of the project, the idea for a papal *hospitium* was under consideration by the time of the April 1516 Tivoli field trip, then Raphael, Castiglione, Bembo, and their other humanist friends may well have discussed archeological and textual remains of Tiburtine *villeggiatura* specifically in connection with the Medici villa.

This collaborative effort also included the close participation of its Medici patrons. Pope Leo and Cardinal Giulio, raised in the sophisticated Laurentian cultural milieu that included Poliziano, Botticelli, Bertoldo, Michelangelo, and the Sangallos, were well versed in matters of collaboration among patrons, humanists, artists, and architects. The erudite Leo was known for his facility in neo-Latin discourse with elite humanist colleagues, and Cardinal Giulio was an astute and unusually engaged patron of the visual arts, as Reiss has emphasized, further suggesting that he surely pored over the villa plans as he did the better-documented Florentine projects of Michelangelo.[27] Furthermore, Giulio's diplomatic responsibilities as vice chancellor of the church from 1517 made it his duty to ensure that the Medici papal *hospitium* would be "on message" with the Vatican communications strategy, as well as family dynastic ideology. Although Giulio's responsibilities in Florence required him to spend considerable time away from Rome during the villa project, his letters to Mario Maffei document the remarkable extent to which the patron remained involved in many aspects of the villa's planning, down to practical matters at

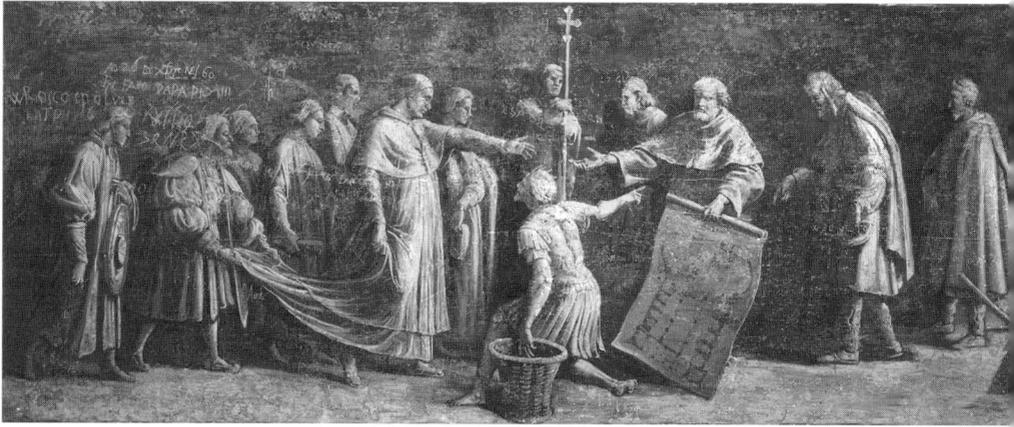

80. Raphael school, *Foundation of Old Saint Peter's and Constantine's Presentation of the Plan to Pope Silvester* (with the features of Antonio da Sangallo and Clement VII, respectively), Sala di Costantino, Vatican Palace.

the construction site.[28] Sperulo's dedicatory letter evokes a technical passage in Vitruvius about lime-slaking, which was certainly known to the visual artists and probably to Giulio, who was so interested in the process of stucco facture that he was even familiar with the stucco tools on site; this reference illustrates the intersection of literary, conceptual, and artisanal aspects of this collaborative process.[29] The Raphael school's monochrome dado painting in the Sala di Costantino depicting Antonio da Sangallo presenting the plan of St. Peter's to Pope Clement (a visual analogue for Constantine presenting his plan for the basilica to Pope Silvester) sets this presentation at the worksite – perhaps a reflection of Clement's engagement with the architectural process, at times via site visits (Figure 80).

In addition to Sperulo's carefully crafted poetic proposal, more informal oral exchanges surely characterized the design process (and Sperulo's poem itself may have benefited from the input and emendation of colleagues).[30] We may imagine a roomful of architects, humanists, and occasionally patrons standing over the plans, discussing conceptual and spatial structures and their literary and archeological sources. The well-known early seicento paintings of Michelangelo presenting plans and models to Leo X and Paul IV (Figures 81, 82), despite being anachronistic inventions commissioned by the Buonarroti family, probably reflect the general practice of such gatherings, often involving the participation of artist, patrons, and many advisors. That Antonio da Sangallo jotted a significant passage about the parts of a villa from Columella's *De re rustica* onto a ground plan for an ideal villa, or Villa Madama itself, suggests just such a scenario.[31] The presence of so many of these players under the Vatican roof fostered impromptu exchanges, too, as we see in a letter by Pietro Bembo to Cardinal Bibbiena, in which he interrupts himself to say that Raphael has just popped in asking for more *historie* to paint in the Cardinal's

stufetta – which is additionally a fascinating snapshot of the piecemeal way projects could proceed.[32] When Cardinal Giulio assumed the papacy, Maffei began lobbying for rooms in the Vatican, complaining in letters to his nephew that he needed them to do his work; while he waited for them to become available, he would take meals with the *famiglia* there during the day.[33] The role of verbal communication is noteworthy here; the sparse surviving documentation for the villa's design may in part reflect the collaborative brainstorming by planners who worked together face to face.[34]

This dialogic environment illustrates why the term *humanist advisor* can be a misnomer, since it suggests a one-way flow of advice. In part, this is a function of the surviving evidence, notably written iconographic programs from the mid to late sixteenth century for complex, abstruse humanist schemes, which suggest a clear split between the poetic invention of an iconographic advisor and the execution by an artist.[35] Many discussions of the roles of patrons, advisors, and artists in this period characterize the design process in such one-way terms, from the patron as the instigator and/or advisor as ideator, to the artist as executant. Salvatore Settis discusses the roles of collaborators in terms borrowed from the *ars rhetorica*, an analogy that builds on Alberti's exhortation to use rhetorical models as the basis of pictorial composition, and Baxandall's analysis of it; and Settis posits, if not a specific parallel, an epistemological similarity in the way orators and painters designate phases of creating. He simplifies this process to the rhetorical categories of *inventio, dispositio*, and *compositio*, which he loosely associates with the patron, advisor, and artist, respectively, although he acknowledges that the "alchemy" of participants was in reality more complex.[36] Building on this model, Antonio Pinelli associates the trio of patron, advisor, and artist with intention, invention, and artifice, respectively.[37] Reiss characterizes the exchange between patron and artists as a "multi-lane highway."[38]

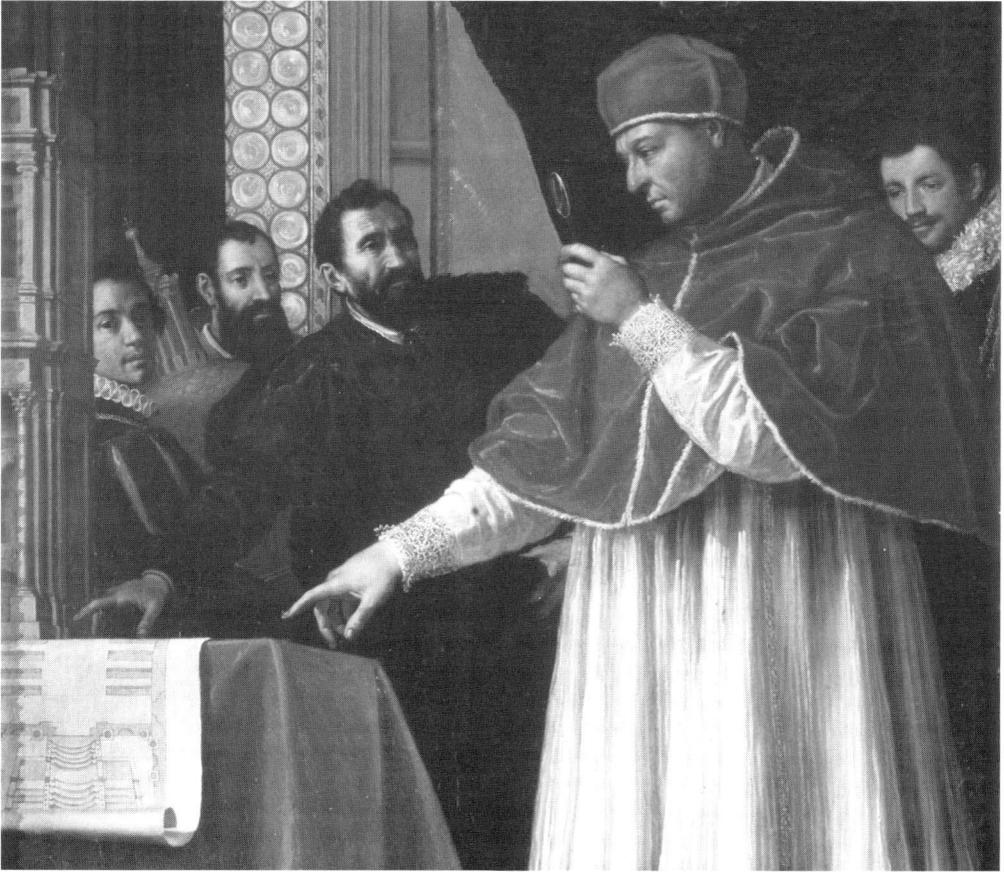

81. Jacopo Chimenti da Empoli, *Michelangelo Presenting Pope Leo X and Cardinal Giulio de'
Medici his Models for the Façade of San Lorenzo and the Cappella Medicea, and his Project Drawing
for the Biblioteca Laurenziana*, detail, Florence, Casa Buonarroti.

Another instance of this sort of interchange among a network of collabo-
rators occurred in the circle of Raffaelle Riario during the planning of the
Cancelleria, as Margaret Daly Davis has shown. Humanists and architects
worked together on an edition of Vitruvius and the revival of ancient theater,
an enterprise with roots in the household of Girolamo Riario (where Luca
Pacioli described the collaboration among figures "de diverse faculta") and
in the court of Urbino.[39] In each of these cases, the humanists' contribution
seems to have been directed toward clarifying and emulating Vitruvian formal
prescriptions, rather than generating the sort of conceptual ideas I have traced
at the Medici villa. Nonetheless, these examples suggest that such visual–verbal
collaboration in the architectural design process may have been a widespread
and varied practice.

Most cases of documented exchange between artist and advisor are lim-
ited to painting and sculpture, and to late-stage details of iconography.[40]

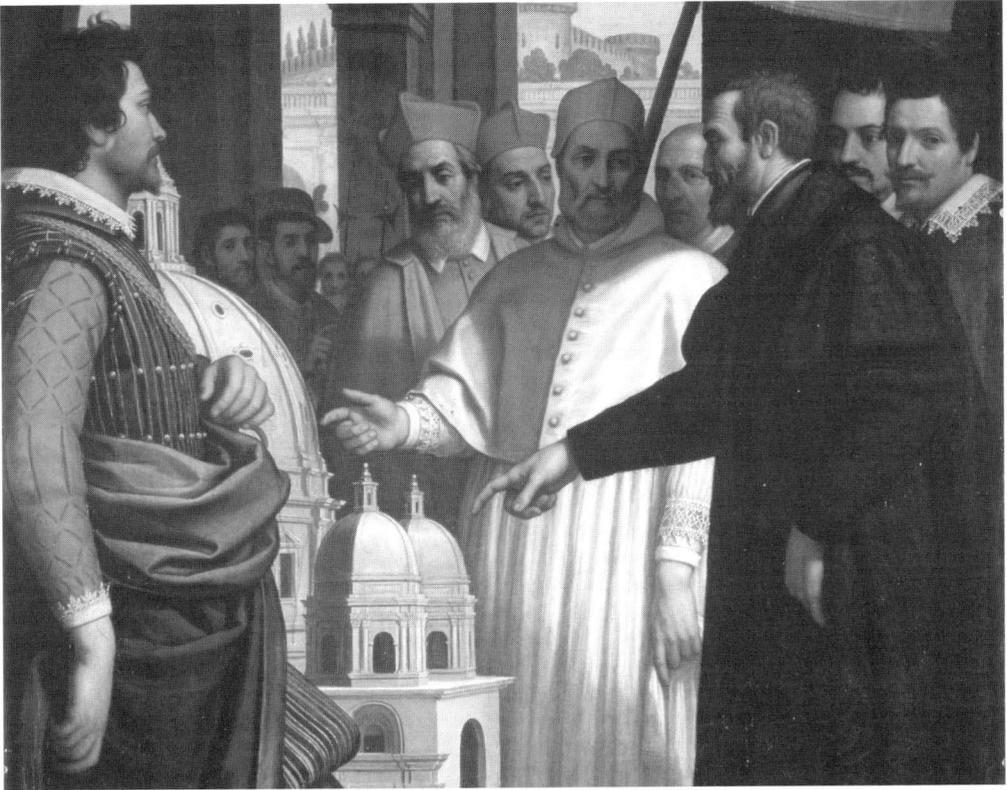

82. Domenico Cresti da Passignano, *Michelangelo Presenting his Model to Pope Paul IV*, detail, Florence, Casa Buonarroti.

Federico Zuccaro, who worked with many illustrious humanists to develop his painted schemes, illustrated this kind of exchange in a drawing of himself with the humanist Vincenzo Borghini working out inventions for the cupola frescoes in the Florentine Duomo (Figure 83). Both figures point at a book open on the table, and Borghini also gestures at the scale model of one section of the dome – or perhaps at the actual Duomo just outside the window, while Zuccaro holds a rolled drawing. They are accompanied by a sketchy female figure, probably a personification of invention, and the sleeping Giorgio Vasari, reflecting his contribution to the project until his death. Thus, Zuccaro depicts the process of invention as a dialogue; but unlike the scenario at Villa Madama, the building was built and the spatial parameters were firmly in place, and the dialogue is about the comparatively late-stage details of iconography.[41] None of these scenarios or approaches is exactly like the collaborative *modus operandi* we have seen among the planners of Villa Madama, who generated concept and design in an iterative process, in ongoing dialogue with each other.

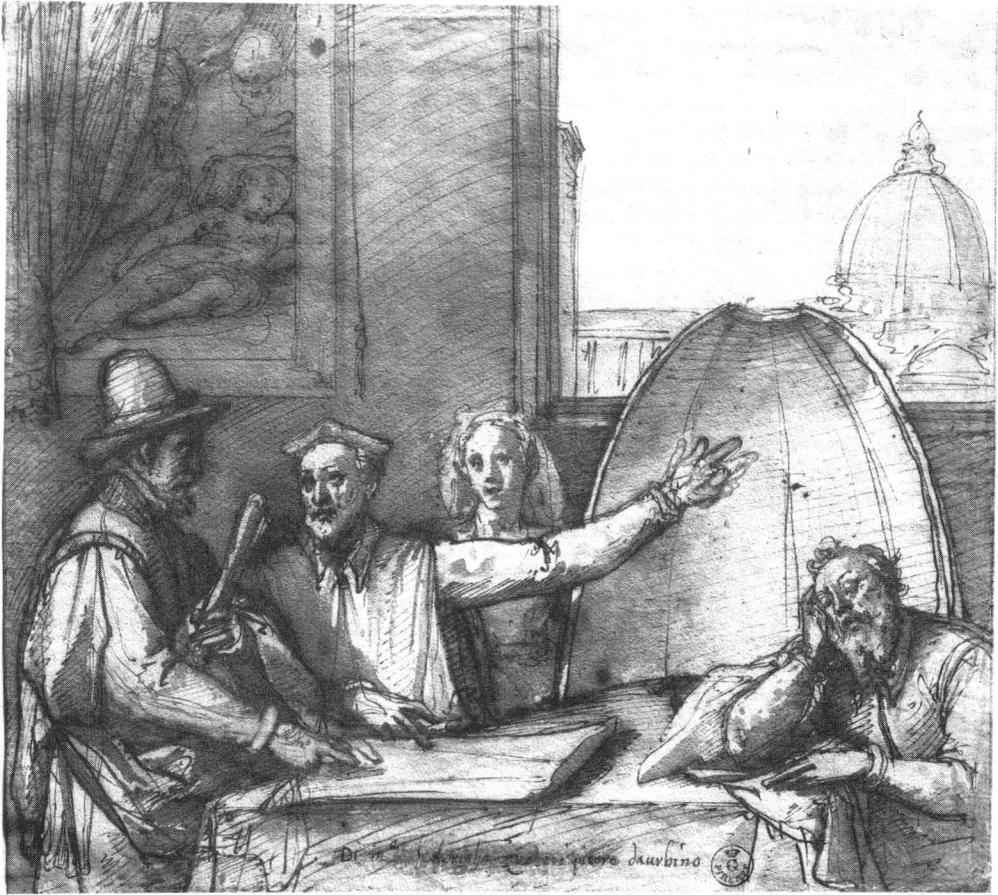

83. Federico Zuccaro, *Federico Zuccaro and Vincenzo Borghini Discuss the Decorative Program for the Dome of Florence Cathedral*, Uffizi, Gabinetto Disegni e Stampe, 11043F.

POETRY AS DESIGN TOOL

This portrait of collaboration among architects and wordsmiths raises several basic questions. What constituted architectural design in early sixteenth-century terms? Would Raphael and his colleagues have distinguished between what we might call an "intellectual" and "formal" plan for the villa? Can we truly say that a poet was engaged in architectural design, and that poetry could be a design tool? The evidence presented here for a dialectical design process substantiates the conclusion that language and text were not ancillary to Renaissance architectural design, but could be an integral part of it. It would be artificial to separate the humanists' formulation of conceptual structures from the visual and spatial tasks of architectural design, since both occurred in tandem. Although Sperulo could not literally "construct" anything, he was doing more than contributing a metaphorical poem; his proposals were factored into the design process, so that architectural plans evolved in dialogue

with the poet's ideas. Moreover, although Sperulo's approach to ideation was mediated by literature, his purview included physical as well as conceptual aspects of the project: choosing and determining the placement of significant marbles, which in turn drove changes to ground plans and elevations. Of course, the poet was unconcerned with fundamental architectural issues such as structure, the disposition of space, or the properties of materials. But Sperulo's claim that he was measuring columns and directing the architects to plan the scale of rooms according to his selection of sculptures and spoils, however exaggerated, suggests that he was aware of these issues, presumably because he was present for discussions of them.[42] In sum, the poet was engaged in imaginative activity that contributed to architectural elements of design, which is to say that he did indeed participate in the design process. This is not to suggest that Sperulo was embedded in the project, nor to equate the significance of his contributions with those of the architects. What these findings do show is that Renaissance design was not an autonomous discourse exclusively concerned with spatial, structural, and stylistic issues; rather, it could encompass varied voices. Architectural planning, now as then, is a socially complex activity, involving a range of services, functions, and professionals. This study reveals that Renaissance architectural design could be a collective process engaging diverse practitioners and their tools of both word and image – text and drawings – as complementary modes for proposing ideas, and for developing design.

PERFORMING THE PLANS

This dynamic collaboration occurred in a performative arena. Much of the evidence discussed so far – the internal evidence in the poems on the Medici villa by Sperulo, Tebaldeo, Vida, and Equicola, and the context of contemporary professional and social practice – points to the fact that these works were intended to be recited at a convivium.[43] That several poems and a letter by the architect himself were all written in the early phases of construction suggest the possibility of a coordinated campaign. The practice of coordinating poems describing a building as the centerpiece of a convivium was familiar in Rome, from the gatherings of Pietro Riario to those of Agostino Chigi, so it is difficult to imagine that the works describing the prestigious Medici papal *hospitium* did not merit a similar event. The interlocutors in Valeriano's dialogue tell us that Cardinal Giulio held such dinners at his unfinished villa, and that he preferred his humanist gatherings to be productive.[44] Vida praises the Medici construction site, and Goritz for visiting it, suggesting that Goritz was there with them, and the poem served to flatter both patrons at once. Sperulo says to Cardinal Giulio, "I want to be surpassed in praising you" (dedicatory letter, §4), implying that other panegyrics will follow; perhaps, like the convivium at Chigi's villa, shorter poems responded to longer ones. Sperulo's *praeteritio* setting aside the

very items in Raphael's letter concludes by saying "All this better anon" (391), which suggests that Raphael's epistle would follow – an example of the practice of poetic correspondence. These works were surely performed at one or more convivia; perhaps held where Sperulo's references to this or that marble could have been spoken in front of the actual pieces, or at the villa's site.

Indeed oral publication of poetry was one of its social functions.[45] At dinners and other social gatherings, poetry could be read aloud or recited from memory, in its entirety or by presenting sections of longer works.[46] The epideictic and deliberative oratory favored by Sperulo traditionally had a social function, presumably reflecting this role of poetry. Sperulo's tasks probably ran the gamut from informal conversation to recitation, and eventually the recording of his verse in a presentation manuscript. The intended audience of the poetry by Sperulo and others, and surely Raphael's letter, too, was Cardinal Giulio.[47] Raphael and his artists did not read Latin, nor have time to pore over proposals in hexameters; presumably the real exchange of ideas and collaboration took place verbally in the workshop and in impromptu corridor-chats in the Vatican, as well as in convivia. Sperulo's poem could have been recorded in writing before or after its performance; written and oral publication often worked in tandem, or even as an iterative dialogue.[48] Recording single poems in manuscript form was a typical product of such events,[49] and patrons sometimes requested a manuscript copy of verbal presentations.[50] That Sperulo's villa poem was recorded in a luxurious leather-bound edition as a high-quality illuminated manuscript with Giulio's arms would indeed suggest that the manuscript was a request from Cardinal Giulio (see Appendix II). That it was produced as a pocket-sized booklet surely suggests it was intended for transport, like personal devotional books, contemporary guidebooks to Rome, or the novel *libelli portatiles* of classical and contemporary literature that Aldus Manutius had introduced in 1501.

The composition and recitation of poetry often served to mark specific events, as described in Chapter 2, just as Statius and fellow poets had been invited to mark special occasions with poetry recitations at banquets at Domitian's court. Riccardo Pacciani speculated that Sperulo's poem may have been intended to mark the inauguration of work at the villa site, in his analysis of a letter of 13 March 1519 by the Este agent in Rome reporting that the pope planned to spend 40,000 ducats on his villa; Shearman later showed this to be impossible, but Pacciani may have been on to something in linking the poem to an event.[51] The anniversary of Leo's elevation (11 March) or the inauguration of a new phase of work at the villa related to the initiation of the new plan U 314A could have been the impetus for composing verse and prose descriptions, and for a gathering. Most likely, Cardinal Giulio convened a group when he wanted to check on the progress of his villa or prompt the planners for ideas and updates on the plans. An ambiguously worded letter reports that

Giulio and/or Leo rode to the villa the morning of 15 January 1519;[52] and just a week later, Giulio left Rome for a few months to tend to the ailing Lorenzo in Florence.[53] Since the 1 March date of Sperulo's manuscript is a *terminus*, and since the poem refers to Duke Lorenzo as a vital force, it was probably written before the gravity of Lorenzo's illness was widely known; therefore, the composition of the poem and a putative convivium may have occurred by mid-January of 1519, and the manuscript have been produced thereafter.[54]

This performative culture was a direct revival of ancient poetic tradition, but Renaissance artists and patrons evidently harnessed this practice for productive purposes.[55] Thus, design could be a performative, and even improvisational process, involving poets skilled at presenting their ideas in *silvae* (representations of poetic inspiration and raw material ready to be worked up) and artists generating ground plans, drawings for decorations, and even prose. That poets often recited their works is well known; literary performance was not a working habit for architects, although one could construe an architect's site walk-through as performance. If Raphael did recite his letter in an event on the Monte Mario, then his epistolary walk-through of the villa was not only literary metaphor but a schematic for embodied experience, which opens a new interpretation of his letter as a script for performing the plans.

COLLABORATION AND COMPETITION

Sperulo's poem also exposes a less convivial side of this collaboration: it could be sharply agonistic.[56] His authorial personifications as the prophets Tiber and Hephaestus/Vulcan, also a sculptor-architect, proclaim his role as advisor, even if they perhaps exaggerate his actual importance. This boastful rhetoric reflects the aggressive climate of competition and self-promotion engendered by the constant jockeying for patronage. Humanists likened their own professional arena to Olympic competition,[57] and indeed, multiple poets may have contributed their ideas for the villa as competition pieces. Sperulo's reputation would be gauged by comparing his poem to the others describing the Medici villa, as well as to earlier works of his Roman humanist colleagues, notably the poems about the Palazzo dei Conservatori decorations and the Chigi villa.

This culture of competition was not limited to humanists; artists often criticized and undermined their competitors to bolster their own reputations, get jobs, or maintain creative control. Raphael did not have to worry about getting work at this point in his career, but he did have other concerns. At the same time he was designing the villa, he was facing a daunting challenge from his rival Sebastiano del Piombo, who was aided by Michelangelo, for the reputation of top painter in Rome. While Sebastiano and Raphael were painting their scenes of the *Raising of Lazarus* and the *Transfiguration* commissioned by Cardinal Giulio for the Cathedral of Narbonne, Raphael actively

campaigned to keep the two works from being seen together in the criti-
cal, discerning environment of Rome.[58] (Michelangelo resorted to even more
underhand and shameless machinations to discredit competitors and even
collaborators to keep control of his projects.) Despite Raphael's reputation
for collaboration and congeniality, his role as Chief Architect of St. Peter's
required a shrewd ability to navigate the politics of the Fabbrica to advance his
ideas. Criticism was part of the ongoing design process at St. Peter's, as Bram
Kempers reminds us; the response to plans, whether positive, neutral, or nega-
tive, had an important effect on subsequent rounds of plans, as well as on their
reception.[59] Significantly, even artists at the level of Raphael and Michelangelo
had to fight for their ideas and control of their projects. Like other artists, they
enlisted powerful intermediaries, or even went to the patron directly to attain
their goals. Agosti has proposed that Giovio was actually the *deus ex machina*
behind the Raphael–Sebastiano rivalry, spurring Cardinal Giulio to pit them
against each other.[60] Whether the idea came from Giovio or Giulio himself,
this intense competition not only was a fact of life among high-powered pro-
fessionals, but was actively encouraged and even staged by their patrons.

This ruthless arena is the setting for what I see as Sperulo's challenge to
Raphael. Rather than the more familiar scenario of competing poets or
painters, here instead we have a notable instance of a wordsmith confront-
ing an artist. Sperulo's abrasive challenges to Raphael suggest a certain anxi-
ety of influence. Surprisingly, the poet never acknowledges Raphael as the
villa's architect, or as anything other than a painter; Sperulo's poem relegates
Raphael to executing the directives of Father Tiber – that is, the poet himself.
Sperulo's spokesperson Hephaestus – the rival of master craftsman Daedalus –
was another coded challenge that could not have been lost on his listeners.[61]
Additionally, Sperulo takes on the role of critic when he challenges Raphael
about where to place a sculpture of Lorenzo/Apollo among the *Muses*, which
highlighted a hole in the sculpture collection and perhaps one in the archi-
tect's plan as well. In fact, there was a clear element of one-upmanship in the
very fact of writing apostrophes to Raphael in a language in which the art-
ist was not proficient. Perhaps Sperulo's downplaying of Raphael's authority
reflected the poet's inexperience at working on such a large and complex
architectural project. More likely, it was a gambit to gain power in the project
and favor with Cardinal Giulio. Perhaps the poet was actually making a bid to
be chosen as site boss, like his poetic alter ego, although his skills were hardly
suited for the role. Whatever his motives, issuing directions to the architect
and critiquing flaws in his plan in a neo-Latin work directed to the patron
and other advisors reveal Sperulo as an opportunistic tactician.

Sperulo's maneuver was not simply careerist jockeying, however, but
reflected a larger issue: the question of who should control the process of
invention. Devising conceptual *invenzioni* was traditionally a job of humanists,

and we have seen how Sperulo formulated metastructures of word and image involving specific antiquities and proposed murals. But this practice of using sculpture set pieces to generate architectural plan and elevation conflated traditional roles of advisor and architect. (This crossover was surely complicated by the fact that the poet was proposing ancient sculptural ensembles to Raphael, the Prefect of Marbles.) Sperulo effectively petitions their mutual patron to keep Raphael in his place as a painter-executor, and leave the intellectual work formulating metastructures to the humanist. Therefore, his poem tells us that the decision of who controlled the intellectual work of invention – architect or humanist – could be open to debate; and that the invention of the villa was understood to encompass verbal narrative as well as visual/spatial plans. This challenge to control invention is a striking manifestation of the paragonal competition between word and image. But in this scenario, the rivalry is not only theoretical, but real: poets claiming to build with words actually *were* contributing ideas to the architects. Thus, Sperulo's challenge to Raphael provides a revealing episode in the long-running struggle for primacy between the sister arts of word and image.

AUTHORSHIP AND BUILDING PRACTICE

These tensions were intensified by the changing roles of artists and architects – changes for which Raphael provided a notable impetus. Indeed, at this pivotal time in the early sixteenth century, leading artists were increasingly understood to be inventive creative powers, on an intellectual par with literary colleagues, and appreciated for their ideas, which could be separated from execution. The emphasis on theoretical notions of *disegno* led to a separation of idea and facture in artistic practice: that is, the act of art could be equated with *disegno* or *Idea* rather than execution.[62] Raphael was instrumental in facilitating this split; as noted previously, his solution to the burdens of success and the pressure of many simultaneous projects involved giving more latitude to assistants and associates than most artists up to that point. At the same time, architecture was beginning to shed its image as a manual practice, and notions of the architect as author were gaining ground.[63] Of course, there have been various types of architect-authors from Vitruvius to Aldo Rossi; Marvin Trachtenberg has proposed that Alberti was responsible for the modern invention of the architect as author, pointing out the affinity of Albertian thought and modern architectural megalomania.[64] Also, historians in recent decades have problematized the notion of architectural authorship by contrasting individual and collaborative paradigms, drawing on studies of literature; many writings on modern architecture have rejected the model of the heroic architect, which ignores collaboration as a sort of "family secret," to shine a light on collaborative modes of architectural practice that variously engage engineers,

builders, patrons, partners, and critics.[65] Rather than thinking of authorship and collaboration as dichotomous, this analysis suggests that individual and collective paradigms of authorship could coexist, even in the same project. Raphael claimed for himself the role of architect-author of the villa with his Plinian letter description of his planned estate; and contemporaries including Castiglione referred to the villa as Raphael's, notwithstanding the number of contributors to its ideation.[66] Yet Raphael participated in a collective approach to design (either willingly or by necessity) at every stage of the process. We may think of the villa as "a Raphael" in the sense of a product of the Raphael workshop, as Renaissance audiences did, further acknowledging that multiple, not always harmonious voices were effectively part of the enterprise.[67] It is revealing that on the one hand, in the corporate environment of the St. Peter's Fabbrica, designed to function over the long term despite a revolving roster of chief architects, Sangallo took the novel step of labeling drawings to distinguish individual architects' ideas and contributions to the project – a marker of emerging notions of the architect-author; yet at the Medici villa, he did no such thing. Presumably, the collective process of ideation and drafting for both projects was a given, as was the understanding that the Medici villa was Raphael's. In both cases, designs attributed to the chief architect as author encompass input from many other people, eliding boundaries between individual attribution and collective authorship.

This evidence for the dynamic planning process further suggests that we should revise traditional notions of artistic intentionality in this environment, again adapting methodologies from contemporary editorial theorists who have called into question the notion of authorial intention in text.[68] This study focuses on discrete periods for which we have surviving evidence, but this is not to suggest that any one moment was a determining point of the project. Rather, there were many such instances, and the design of the villa was iterative over the course of the project. Thus, rather than approaching ground plans and documents as static decrees of "intention" fixed at an initial point or any other given moment, we may think of a transformative model of planning, which allows for the collective processes of design, construction, and decoration, with evolving, even conflicting visions along the way.[69] Moreover, ideation emerges as a collective process of negotiation. Ackerman's characterization of design as a transactional field is apt here: an "open field system in which architectural decisions are made through an unlimited number of transactions among a variety of people ... interested in the making of a particular building."[70]

The transforming power of time is a fundamental factor in such a colossal endeavor as the Medici villa complex. The planned scale and scope of the project were enormous, encompassing the excavation of the rugged, steep hillside, terracing of the landscape, planting extensive gardens, hydraulic engineering to tap sources, and installing water and drainage conduits for baths,

pools, and fountains, as well as building and decorating the villa itself, with its rich freight of decorations and marbles. Thus, the villa's creators knew from the start that this was a *grand projet* that would involve them for years. At a practical level, patrons and architects alike recognized they might not survive to see the completion of such a large project. Building planners routinely ensured that their ideas were recorded for posterity in plans, medals, and models, as well as in descriptions, in the hope that these ideas would be carried forward by their successors, and in any event would be known to future generations.[71] The descriptions by Raphael, Sperulo, and other poets celebrating unbuilt or half-built structures served this documentary function too, and were part of the representational system by which architecture was presented. (It was fitting that poets often evoked the poetic *silvae* symbolizing improvisation and unfinished raw material as models for these *ekphrases* of the unbuilt or unfinished.)

Building over long periods of time had important implications for architectural practice, as many scholars have analyzed.[72] Ackerman proposed a biological metaphor for the design process, musing that:

> Perhaps the character of Renaissance architecture owes much to the fact that its monuments started, not from a complete idea, fixed in the symbolism of the blueprint, but from flexible impressions constantly susceptible to change. The ultimate statement, like that of the sculptor, evolved in the process of creating the mass itself. This way of conceiving architecture explains also the peculiarly biological character of Italian Renaissance building. The large monuments that took more than a decade to complete seldom followed an original conception, but evolved like a living organism in their growth.[73]

This characterization corresponds closely to Raphael's process as it has emerged in this study, although different architects favored different approaches. By contrast, we may think of Alberti as architect-author, whose famous instructions to Matteo de' Pasti, his site architect in Rimini, stipulated that the Tempio Malatestiana be executed exactly as Alberti directed so as not to destroy all his beautiful harmony; or later, Michelangelo, who famously raced to build St. Peter's to the point that his work could not be altered or even destroyed, as he had done to the work of previous architects, including Raphael. Howard Burns analyzed Michelangelo's strategies to secure the integrity of his St. Peter's designs, which he called "building against time."[74] Trachtenberg stepped back chronologically to examine different approaches to building over time, distinguishing between what he calls building in- and out-of-time; the first he defines as the *longue durée* process that characterized large, extended projects of the Middle Ages and early Renaissance, and his second mode is characterized by the Albertian architect-as-author who designs the entire building before the start of construction, to be built exactly to his design without changes.[75] Of course, the reality of architectural practice did not change

overnight, as Trachtenberg acknowledges; in cinquecento building projects, significant changes to the design continued to be made during construction.[76] As Alexander Nagel and Christopher Wood note, the authorial mode of production has come into and out of play in various periods; instead, they develop the notion of a work of art as a "recursive structure."[77]

The process of Raphael and his associates at Villa Madama was certainly a hybrid encompassing aspects of different modes. Their design process combined elements of individual and collective authorship, as discussed, and qualities of building in- and out-of-time as Trachtenberg defined them. A comprehensive plan was drawn up for the entire estate before construction began – not just the wing constructed in the first phase – and construction indeed followed the unifying vision set forth in U 314A, consistent with the Albertian authorship model. However, this plan was the collective work of Raphael and Sangallo, with contributions by many other participants, including non-architects. What is more, they did not flesh out the plans of each part of the monumental complex in equal detail. We glimpse how remarkably fluid and flexible the dynamic mode of design was for this project in Raphael's letter and Sperulo's poem. For example, Raphael stipulates some of the architectural orders, but leaves others to be determined later,[78] and he suggests general types of decoration, but explicitly leaves the details to be worked out, "secondo ch'è piaciuto allo art[e]fice."[79] Although both writers consider the whole villa complex, they give more detailed and plausible proposals for the areas of the villa that are in progress, and devote less attention to elements that were not yet begun, such as gardens and stables; it appears that they were not fully planned ahead of time. Thus, in this important independent, ex-novo late project, we see that Raphael facilitated a flexible and open approach to architectural design, consonant with his approach in other media, and in contrast to Alberti and Michelangelo. But if the villa emerged via a process of what Trachtenberg has called "continual revision," it did not exactly follow the cathedrals model. It had long been standard practice to leave technical challenges to be worked out in the course of building, as in the collective planning of a monumental building project with a committee of architect, builders, master masons, and communal patrons that could extend over decades, if not centuries. But at the Medici villa, significantly, the process of invention was collective from the outset. Even in the initial phase of the project, when the original patrons and architects were first planning the complex, the design process was iterative and dynamic. It encompassed the ideas of a varied group of planners and different systems of knowledge, which continued throughout the course of designing, building, and decorating. This multi-epistemic process allowed for flexibility in design, and further enabled the evolution of form and meaning in a dialectical exchange.

The iterative, collective aspects of design are represented in a drawing by Jacopo Bertoja showing a group of architects and humanists at the construction site of a tempietto of Hercules (Figures 84, 85). The drawing is preparatory

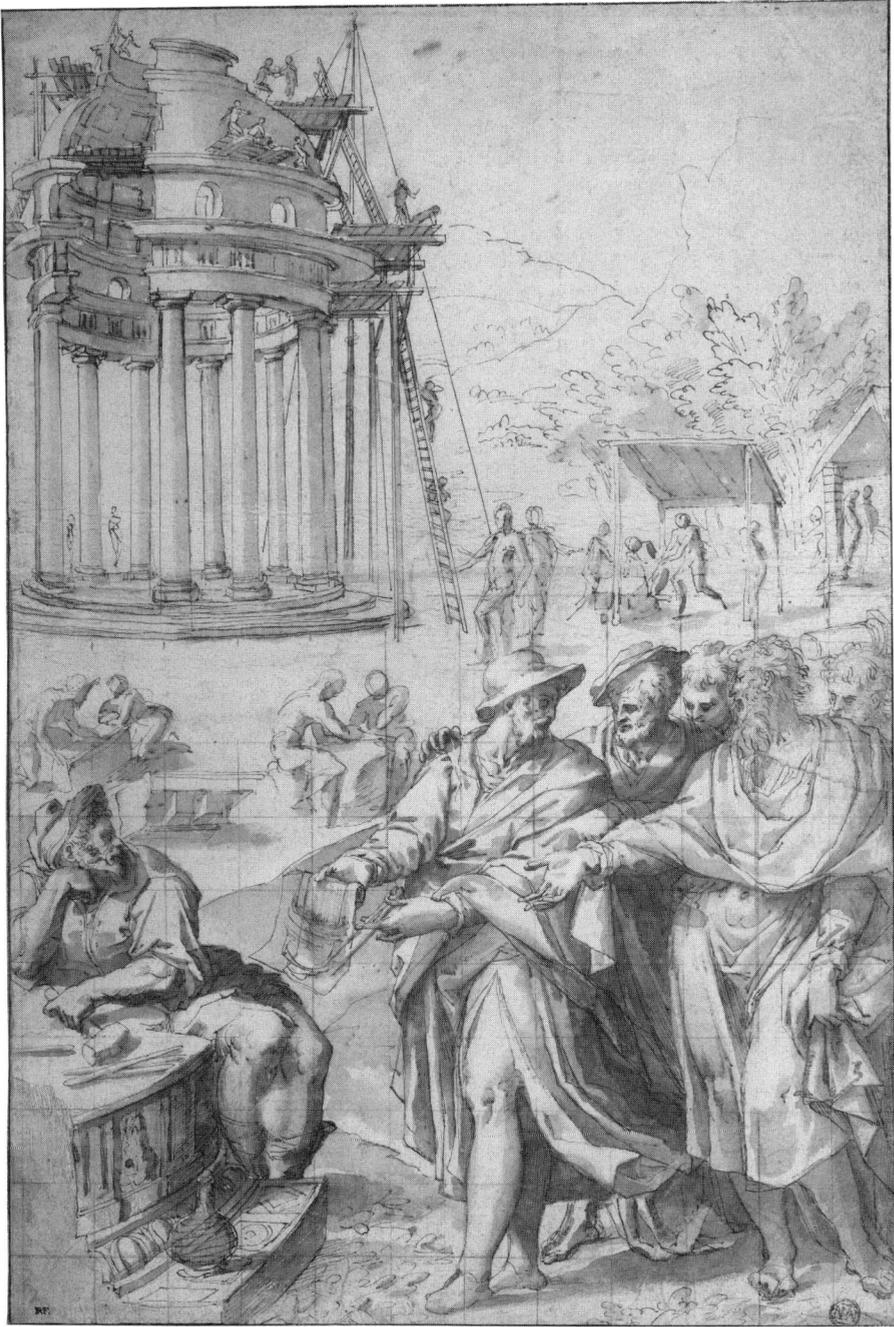

84. Jacopo Bertoja, *Construction of a Round Temple*, study for fresco decorations, Sala d'Ercole, Villa Caprarola; Louvre, Cabinet des Dessins, 10678r.

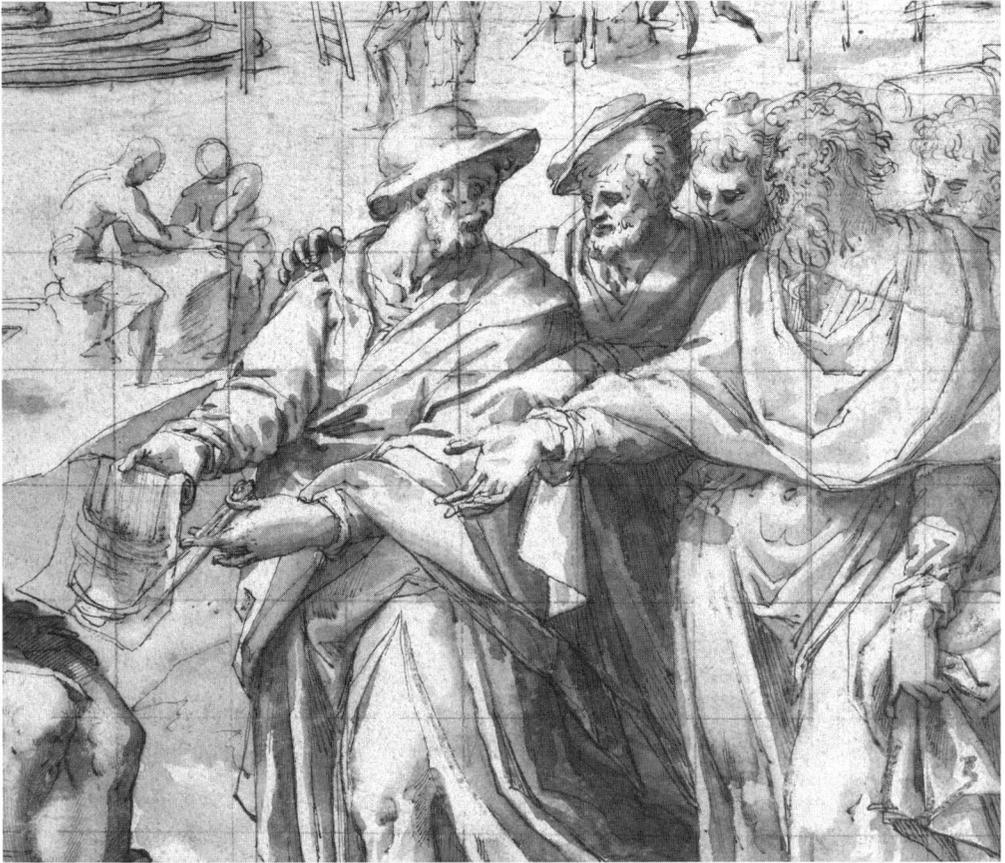

85. Jacopo Bertoja, detail of Figure 84 depicting Vignola with other architects and humanists discussing plans for a temple at its construction site.

for a fresco he painted in the Sala d'Ercole of the Farnese villa in Caprarola, *c.* 1566–9. (I illustrate the drawing, which is more detailed and legible than the fresco.) The composition relates the Labors of Hercules to the surrounding countryside and thus is self-referential to the design of the Farnese villa, so we may read the figure of the architect as Vignola, and the humanists perhaps as Fulvio Orsini, Annibale Caro, and/or Onofrio Panvinio.[80] Construction is already well under way, but the architect, bearing a drawing and compass, strides toward the master mason who awaits instructions, sitting head in hand, idly holding his hammer, slumped over a chunk of frieze in a thoughtful pose recalling Heraclitus in the *School of Athens*. Vignola is at center, with perhaps a fellow architect behind him wearing a similar hat, looking over his shoulder at the foremost humanist, identifiable by his Plato-like beard and classicizing garb and stance (visible in the detail in Figure 85). Vignola points to his drawing of the base of an Ionic column; the humanist speaking to the architect extends his right arm toward the drawing, too, with an open-palmed gesture, perhaps signaling that he is asking a question.[81] The architect behind them

points forward, either at the drawing or at the frieze, his hand just above the humanist's in a Leonardesque network of gestures. It is interesting that the humanist follows traditionally Roman practice by gesturing with the right hand and restraining the left with his garment, whereas both architects gesture with their left hands, and the humanist faces and gestures in the same direction, as Quintilian stipulates, while the figure of Vignola strides and gestures in a forward direction, looking backward at his speaking colleague. This may simply reflect compositional necessity, but it may also suggest the architect's and humanist's very different contributions via drawings and words. However vague the gestures or artificial the scenario (not to mention how fantastical the construction methods!), it is notable for our purposes that the artist placed the focus on architects and humanists in animated dialogue over still-evolving ideas while walking around a construction site.

MODERN RUINS AND THE CULTURE OF COMING-TO-BE

The predominance of lengthy building projects resulted in a landscape of partially finished buildings. Renaissance attitudes toward the *non-finito* in architecture were at odds with those toward unfinished works in the figurative media of painting and sculpture. For Renaissance audiences, the completion and perfection of a work were one and the same quality, and the goal.[82] This was certainly true of painting and sculpture at the beginning of the sixteenth century, and Raphael's associates were restoring and completing fragmentary figural sculpture at Villa Madama to make it whole and perfect.[83] In the case of architecture, however, the many years necessary for building projects required a certain tolerance for, and even appreciation of, the unfinished.

The fact that Villa Madama was frequented by its patrons and distinguished guests during various stages of its completion supports this view. As we have seen, Pope Leo spent the entire day there, just for pleasure, on 13 March 1519.[84] Early visitors included Goritz, who went to the villa while the walls were still rising, as Vida chronicled; Baldassare Castiglione, who dined there with Pope Leo in June 1519; and the Duke of Ferrara's agent, who also recorded going there with the pope in October of the same year.[85] As discussed, Valeriano's *Dialogo* of *c.* 1524 set at the Medici villa surely reflected the general practice of literary gatherings there, if not a specific event. Many other documents from 1520 to 1525 record visits, meals, and musical performances at the unfinished villa, some of which provide valuable early testimony of the acceptability of the unfinished and imperfect.[86] In fact, these visits seem to have been understood as privileged previews, described in letters to those outside Rome eager for updates. In March 1524, Ludovico Cati described a dinner party he attended at the villa with Baldassare Castiglione, Paolo Giovio, Mario Maffei, and Carlo Ariosto (Ludovico's younger brother); Cati raved that he had never

seen anything like the villa, however *imperfecta*.[87] (Nor did the guests confine their attention to finished areas of the villa, for Cati went on to describe the wonderful water-spouting elephant in the garden – part of a fountain that was not finished until two years later.) Isabella d'Este voiced a similar reaction when she attended a dinner at the villa in May 1525: describing what is presumably the garden loggia, she noted that this space pleased her most of all, and that it was already filled with antiquities, even though it was still *imperfecta*.[88] Such reports of building-in-progress served to publicize the structures long before their completion and frame their reception; these accounts seem to have been part of the fabric of protracted Renaissance construction.[89] It is significant that water flowed from a partially completed fountain, and ancient sculpture had already been placed in the unfinished building. These indications of comfort with the partially built precede evidence for the acceptability of the *non-finito* in other media, such as Vasari's praise for Michelangelo's unfinished works of sculpture.[90] This practice of frequenting partially built sites lends further plausibility to the hypothetical construction site *convivium* among patrons and planners.

Christof Thoenes has proposed that the image of Renaissance Rome came to include not just ancient ruins but "new ruins" as well – unfinished building projects, from the Belvedere Courtyard to St. Peter's itself.[91] Contemporaries grasped the parallel condition of half-extant ancient and modern works, both in ambiguous states of decay or growth, renovation or construction. Bramante's Prevedari engraving (Figure 86) of a partially built or partially ruined structure exemplifies this ambiguity;[92] and his fragmentary Genazzano nymphaeum (Figure 60) may have been conceived as an artificial ruin, or early folly.[93] Mantegna and Leonardo called attention to this conflation of building site and ruin in their paintings.[94] Raphael frequently depicted this new view of ruins, ancient and modern, as part of the image of urban daily life, as in the background of the Vatican Stanza della Segnatura and Stanza di Eliodoro frescoes (e.g. Figure 87).[95] The slightly later image of Villa Madama itself as a construction site in the background of the Vatican Sala di Costantino mural, above the historic Battle of the Milvian Bridge (Figure 88), inserts the Medici villa into this series of images of ancient/modern ruins. The images of the raising of Lazarus set in front of the Medici villa, ambiguously depicted as half-built or ruined, further demonstrate the understanding of the villa in this context (Figures 1, 2). At one level, Sperulo's encomium of a construction site is a verbal counterpart of this visual tradition.

This equation of the *non-finito* with the ruin suggests that Renaissance artists and architects perceived the generative power of buildings in both incomplete states.[96] Certainly in Rome, the fascination with ancient ruins was coupled with the stimulation to complete them through an act of artistic imagination.[97] Vasari claimed that "Brunelleschi became capable of seeing Rome in his

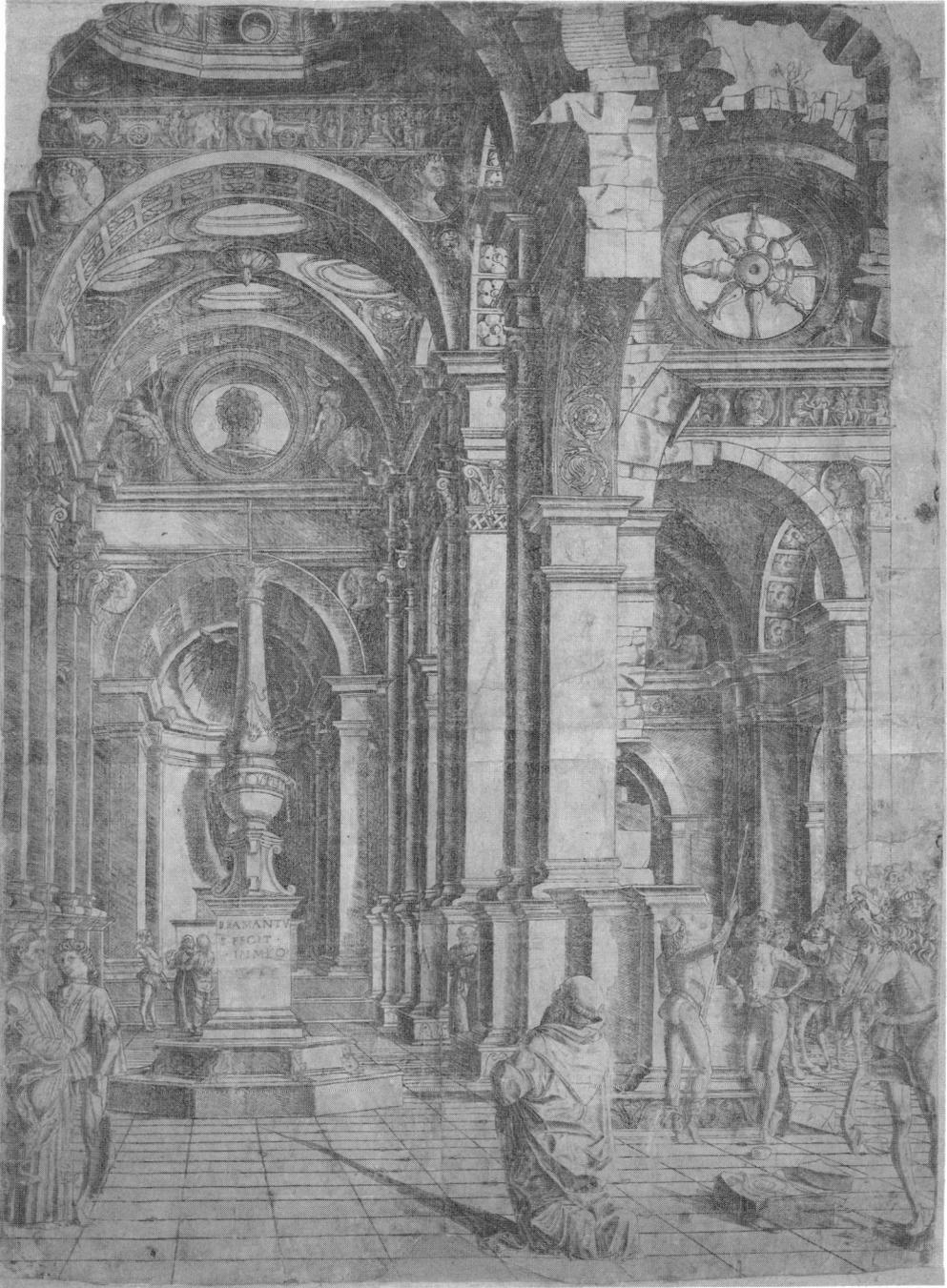

86. Bernardo Prevedari, after Donato Bramante, *Interior of a Ruined Church or Temple with Figures*, engraving, 1481. The British Museum, v, 1.69.

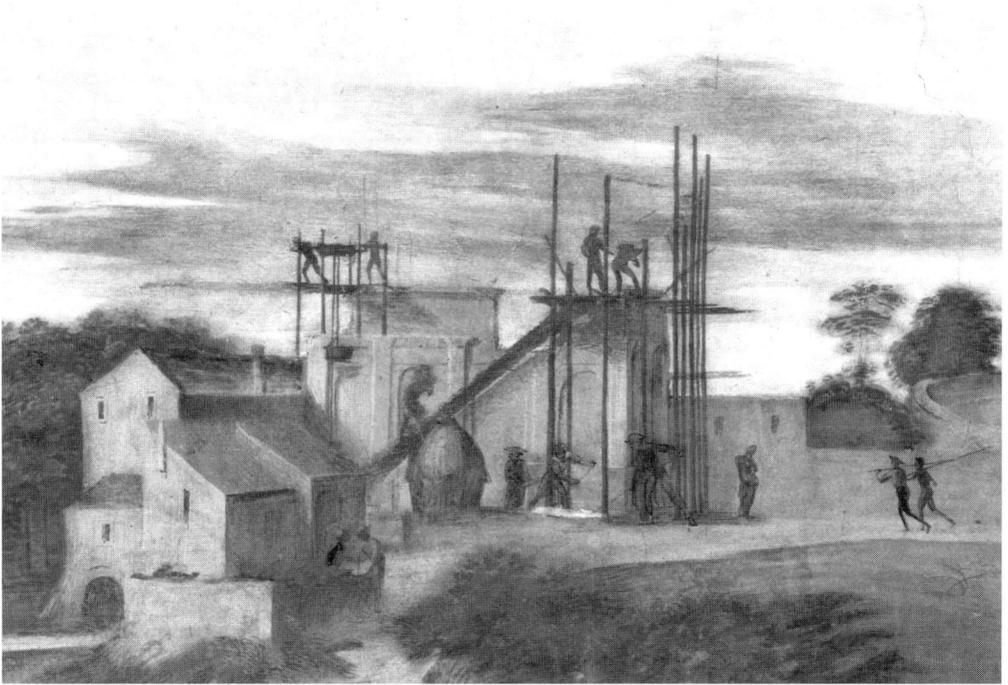

87. Raphael, *Disputation over the Sacrament*, detail of ruins and "modern ruins" in the background, 1509–10, Stanza della Segnatura, Vatican Palace.

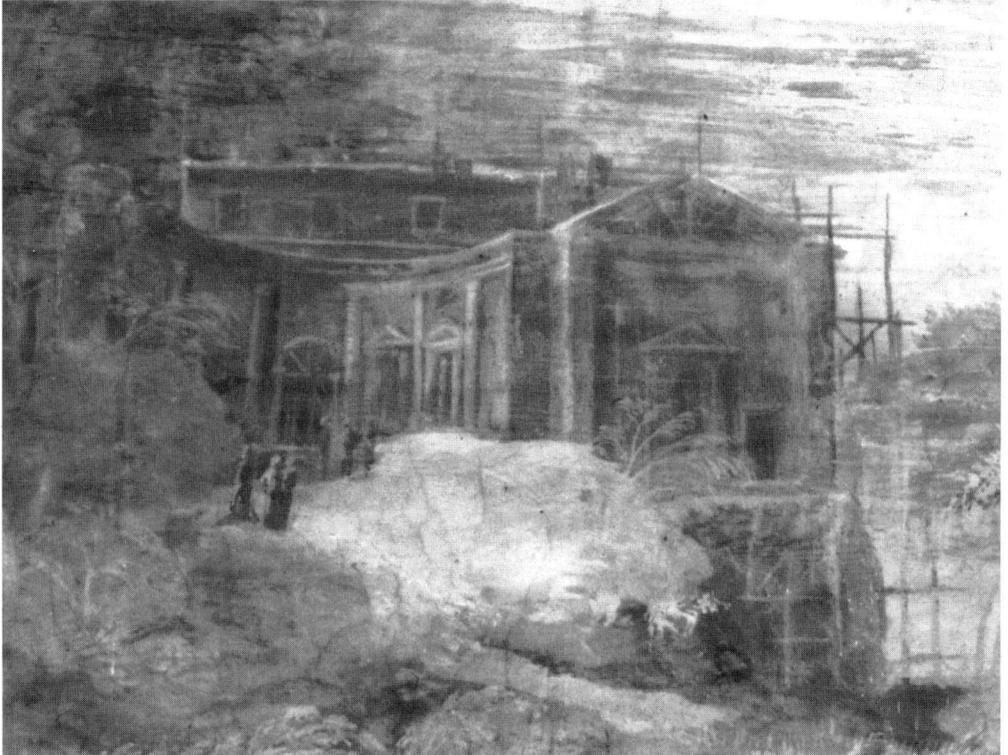

88. Raphael and associates, *Battle of the Milvian Bridge*, detail of the Villa Madama under construction on the hillside of Monte Mario overlooking the bridge, Sala di Costantino, Vatican Palace.

imagination as it stood before it fell."[98] The depiction of the partially built Villa Madama in its scaffolding in the Sala di Costantino invites the viewer to do the same. In fact, the choice in this prominent Vatican hall to represent the papal *hospitium* this way, rather than painting a proleptic visualization of the grand planned complex, was surely intended to emphasize the villa's character as an *all'antica* modern ruin.[99] Thus, Sperulo's description of the muddy construction site as a *locus amoenus* that inspired his poetry was, at one level, literally true; the literary walkabouts and gatherings documented at the villa's construction site are reminiscent of the picnics in the crumbling ruins of Nero's Domus Aurea or Hadrian's Villa undertaken by Raphael and his fellow artists and literary friends. Wordsmiths and visual artists found inspiration in ruins, ancient and modern. And these ruins became part of the verbal and visual narrative of Rome that they jointly forged.[100]

The marked contrast between projects visualized and executed in early sixteenth-century Rome was partially a function of the new gigantism favored by patrons, seen in commissions from the Belvedere Courtyard to Villa Madama, and notably in new St. Peter's and Michelangelo's ill-fated Julius tomb. Naturally, this taste for the colossal fostered long-term projects, with many major changes of plan along the way. As the sixteenth century increasingly came to be characterized by the disparity between grandiose ideas and feasible projects,[101] these ambitious mega-projects engendered the perception that conceiving great works could be a more valuable marker of artistic genius than completing them. This appreciation of the unbuilt and the partially built reflected changing attitudes toward the status of the architect, the separation of idea and facture, and the understanding of architecture as idea.[102] Although a very partially executed villa complex was never the goal of Raphael or his Medici patrons, the villa as constructed, and Raphael's unexecuted ideas for it, were assiduously studied and would have important echoes among the designs of his contemporaries and followers. Thus, although the Medici villa was not completed, its planners were eminently successful: Villa Madama as it might have been has danced in the minds of architects from Raphael's day forward, as we may see especially vividly in the so-called reconstructions by the nineteenth-century architect-scholars Percier and Fontaine, Henri Jean Émile Bénard (Figure 89), and Geymüller, or even in the wooden model of 1983 (Figures 13, 14).

Additionally, the dialectical invention of conceptual ideas, text, and visual elements became part of the art form; as we have seen, the iterative, collaborative design process, more than a means to an end, was a valorized form of cultural discourse in itself. In part, this emphasis on process was a pragmatic adaptation to the extended timeframe of such a grand project. It was also a function of the transforming power of time in a culture that was, by necessity, fully comfortable with half-standing buildings, from construction sites to ruins,

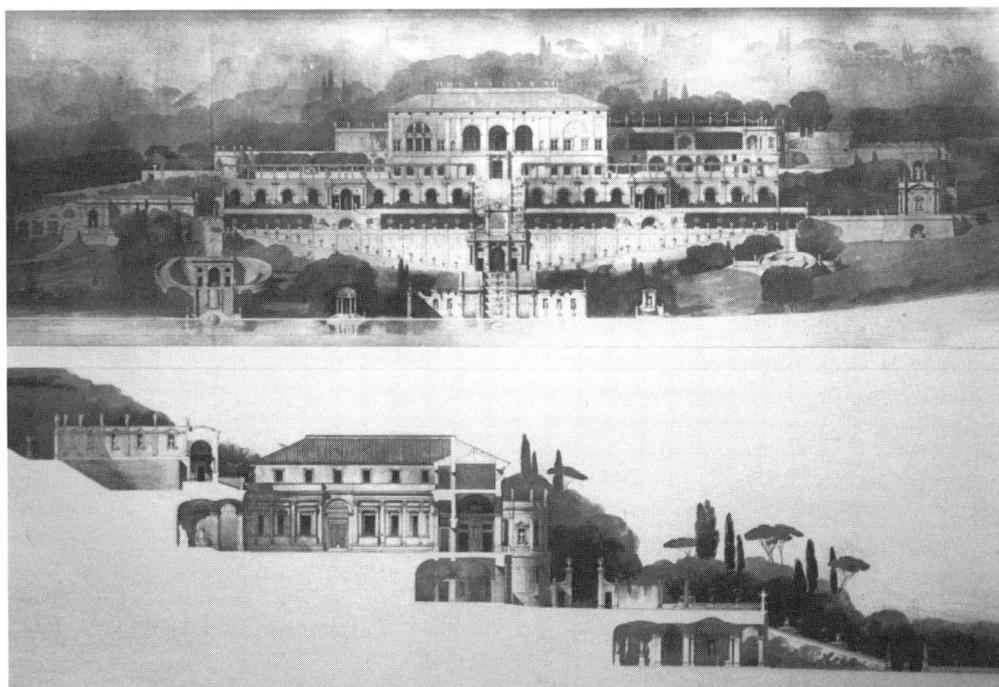

89. *Reconstruction of Villa Madama*, after the drawings of Henri Jean Émile Bénard, 1871; héliogravure, J. Chauvet.

and deeply attuned to the processes of building and renovation. At another level, this focus on the process of architectural invention reflects long-standing Aristotelian ideas about praxis. In his discussion of the distinction between art (*techne*) and science (*episteme*) in the *Nicomachean Ethics*, Aristotle considers art, and in particular architectural skill, to be concerned with making, stating that, "All Art deals with bringing something into existence."[103] Although Aristotle's conception of *techne* or *ars* does not correspond completely to the Renaissance or modern definitions of art, his emphasis on all arts, especially architecture, as a process of coming-into-existence – or *poiesis* – was fundamentally important for the Renaissance understanding of art.[104] Michel Jeanneret has characterized what he calls the "metamorphic sensibility" or "transformist philosophy" underpinning sixteenth-century culture, an outgrowth of both natural philosophy and theology, consonant with the understanding of the world as a microcosm of the continually gestating cosmos; and he relates this worldview to the preponderance of unfinished Renaissance literary masterworks presented as works in progress, from Leonardo's notebooks to Montaigne's *Essais*.[105] As he and other scholars have noted, even the introduction of the printing press did not establish the equation of publication with a finished work; rather, this deeply held understanding of work as *poietic* process was reflected in the literary habit of continual revision, which was standard practice

among sixteenth-century humanists, and notably among Raphael's humanist friends.[106] In particular, Castiglione seems to have revisited the three surviving drafts of the Letter to Leo X over a several-year period, as he also did with the manuscript of the *Cortegiano*, and his poetry.[107] Ariosto was revising the *princeps* edition of his *Orlando furioso* during the same period. Bembo continued to revise some of his poems even after they were published in print; such activities fostered the understanding that the process of revision itself could be valued more highly than the product.[108] Although the imperatives to complete a stone and mortar building and a text necessarily differed, long and iterative processes characterized building and writing projects alike. Thus, the *poietic* process of invention was a mindset shared by architects and humanists, for whom process and transformation were part of the art form.

Like a modern ruin, the partially built villa on the Monte Mario was a stimulus to the imagination of architects, humanists, and patrons, who sought to realize their visions for it. For reasons both cultural and practical, this cohort collaborated to design, occupy, and celebrate the unfinished building in vibrant and creative ways. They also reflexively recorded their own ideas and roles in the process as part of the narrative. This account of the coming-into-being of the Medici villa as an architectural and literary edifice turns on issues of *ut lingua architectura*, which are drawn together in the Conclusion.

CONCLUSION: BUILDING WITH MORTAR AND VERSE

THIS NARRATIVE OF THE INTERACTIVE INVENTION OF VERBAL IDEAS, architecture, and decorative forms at Villa Madama opens a window into the inextricably linked visual and verbal culture of early modern papal Rome, and into the working processes of Raphael at the height of his powers as architect and visual culture impresario. Like St. Peter's and the Vatican Palace Stanze, Villa Madama was a laboratory for creating a new system of design and a new visual language – a rhetorical visuality – that would parallel humanist attempts to proclaim the *renovatio imperii* using neo-Latin. As we have seen, the designs for the Medici villa were produced not only on the architect's drawing board, but also in words: ideas were articulated and elaborated in verse by poets, and in prose by the architect himself. Artists, humanists, and patrons collaborated to produce not simply what art historians call a program or iconography, but complex metastructures of word and image that were embodied in the villa project and its realization. This study has shown how at Villa Madama, the verbal and visual modes of ideation were not parallel, but inextricably connected.

The previous chapters have presented a rare portrait of collaboration, which emerges as a dynamic working method in which concept and design evolved dialectically. On the work table and in social convivia, humanists, artists, and patrons rehearsed their ideas in verse, prose, and plans. This collective design process was performative: a product of a culture of orality and, at times, of improvisation (or at least, claims to such spontaneous creativity – a pretext Castiglione lampooned in his *Book of the Courtier*).[1] It was also competitive, as

artists and wordsmiths vied to promote their ideas. Their notion of the villa evoked ancient prototypes, both literary and extant, from descriptions by Pliny, Statius, and other authors to the ruins of Hadrian's villa complex in Tivoli. The wordsmiths and architects at Villa Madama sought to realize in verbal and visual terms their vision of an *all'antica* Roman villa; they selected elements of the classical past and brought them together in a new synthesis, thereby creating a new paradigm of the villa for the early modern Medici papacy. In so doing, they enacted a fascinating chapter in the long struggle for primacy of the arts of word and image.

In what turns out to be a proleptic poem describing Villa Madama, Francesco Sperulo claimed to construct the villa with words. Poets since Pindar have claimed to build with verse, but, as this study has demonstrated, Sperulo was doing just that, and in an unusually literal way. He applied his literary skills to a real-life project and did so with a remarkable degree of specificity, deploying Virgilian hexameter as a practical tool for designing and decorating a building. Sperulo's claim to build the villa in verse was at once metaphor and coded proposal, adhering to literary conventions of textual communication appropriate to its elite audiences. This study has revealed its importance as a kind of white paper in neo-Latin, the lingua franca of this circle of Medici patrons and Curial humanists working with Raphael.

Considering literary and architectural plans for the Medici villa in the context of Roman social and intellectual culture has allowed a new perspective on the design process. This approach to the proleptic poetry and Raphael's letter describing the unbuilt villa has revealed their function and agency to propose ideas, amplify plans, and frame the reception of the villa. I have suggested that the writings by Sperulo, Tebaldeo, Vida, Equicola, and Raphael were all composed around the same time and perhaps intended for performance in convivia, even at the villa's construction site. Thus, we may think of these *ekphrases* being staged as a kind of performance art. This interpretation opens a new reading of Raphael's letter, suggesting it as the script for an embodied presentation of the architect's plans.

This line of inquiry has also led to a reassessment of the interaction between architects and advisors. Sperulo turns out to have been an advisor for his Medici patrons, and a contributor to the circle of villa planners, like the better-known Medici humanist agent Mario Maffei. I have proposed that Sperulo's role in this collaborative milieu consisted of proposing conceptual structures that encompassed architecture, decoration, and function at a formative stage of the villa planning. It also emerges that he had been involved in the effort to publicize Leo's clemency toward the cardinals who had supposedly conspired against him in 1517, as shown by the poem in Appendix III; so, Sperulo was evidently well suited to distill Medicean ideology, literary metaphor, and information about ancient spoils into proposals for the villa. Although he was

no Virgil, Sperulo was an accomplished poet and humanist who employed his considerable knowledge and facility with Latin and Greek literature in his day job as a papal chamberlain and *diacono*, and effectively, as a Curial image-maker.

Sperulo's poem about the Medici villa turns out to be a masterpiece of a little-known mode I have identified as "hortatory *ekphrasis*." He praised the unbuilt villa, exhorting both patron and artist to follow his ideas. This very particular Renaissance genre, seemingly without a direct ancient model, was an assemblage of elements selected from ancient literature and rhetoric. Roman humanists created poetry by selecting different elements from epic poetry, protreptic panegyric, and notional *ekphrasis*, in an example of *citazionismo*. Thus, Renaissance poetry, in this mode of hortatory *ekphrasis*, could be a utilitarian instrument of architectural design. Words were tools, used not just for the presentation and dissemination of plans, but also for proposing and working out ideas. The agency of the wordsmiths is noteworthy in this context; the dialectic of architecture and literature is not a theoretical concept, but a mode of thinking, a working discourse.

This narrative of collaborative design comes to a head at the time of a major redesign of the villa project. Both Sperulo's poem and Raphael's letter, which I have proposed were roughly coeval, were probably being written in early 1519, when a major design change was under way that would distinguish the two major surviving ground plans for the Medici villa. I have proposed that the placement and recontextualization of significant antiquities was a generative force during this reformulation of plans, and shown Sperulo's involvement at this juncture. The poet, in the authorial voice of Father Tiber, emphasizes that his job includes choosing ancient sculpture and spoils, envisioning conceptual and physical environments for them, and directing their installation. Thus, Sperulo shows that antiquities were not simply installed like trophies in the modern fabric but – through the collaboration of humanists and architects – could be used to generate the actual elevations in which they were to be installed. Chapter 5 presented specific examples of this, including the ancient relief from the Temple of Venus Genetrix that was the impetus for Sperulo's conception, Raphael's elevation, and surrounding decorations. This scenario overturns standard assumptions about the basic sequence of design, construction, and decoration. We normally think a building is built, then decorated, then praised by writers; in the present narrative, poetry was prospective, and important marble decorations were the impetus for architectural design.

Such a working process could engender tension and conflict, as artists and wordsmiths jockeyed to promote their ideas and navigate their careers. Sperulo's abrasive tone and his sharp challenges to Raphael in a poem addressed to their mutual patron, in a language Raphael did not read, show the poet trying to do an end-run around the architect. It is striking that Raphael, despite his position as the foremost architect in Renaissance Rome at this moment, had to

contend with adversarial critics like Sperulo at Villa Madama: even Raphael had to engage in negotiation and persuasion to get his ideas built. Thus, we may also read Sperulo's poem and Raphael's letter describing the villa as each artist's codification of his own ideas at a crucial juncture – as a bid to the patron and also a memo to posterity.

Most significantly, Sperulo's challenge to Raphael brings the sometimes agonistic relation of word and image into the foreground. Formulating what the Renaissance called *invenzioni*, or iconographic programs, was normally the role of the wordsmith; thus, at the Medici villa, formulating what I describe as metastructures involving sculptural set pieces was what Sperulo claimed as his job. But Raphael had recently been made Prefect of Marbles, with such power that no stone in Rome could be moved without his permission. At a crucial juncture in the villa project, Sperulo saw an opportunity to expand his creative authority. Creativity was understood in the Renaissance as a process of selection; fragments of ancient literary and material culture were reused, recontextualized, and recomposed into recombinant discourses, a parallel process for wordsmiths and artists.[2] Using ancient sculpture and spoils to generate new conceptual and spatial contexts went to the core of this creative act, but it complicated traditional job descriptions of architect and advisor, and the understanding of invention itself. So, Sperulo was challenging Raphael's authority to control the "act of art" in this process – that is, whether the poet with his narrative description, or architect with visual and spatial plans should control the process of invention. Of course, Raphael, with his astounding workload of projects in many media and disciplines, had evolved a working process in which the act of art lay in his own invention or *Idea*, the execution of which could be delegated to a range of associates and assistants. Thanks to Raphael's creative processes (and literary pals such as Castiglione who celebrated them), he gave an important impetus to the emerging understanding of the artist as idea-person, and to the artistic split between idea and facture. Sperulo's unsuccessful attempt to outflank Raphael is thus a revealing and specific manifestation of the continually shifting relation of word and image in sixteenth-century Italy, reflecting tensions over changing ideas about the roles of artists and advisors, and the nature of invention itself.

This revisionist account of architectural design as a dynamic, collective process engaging different epistemes has important implications for our understanding of the relation of architecture and language, meaning in architecture, and the ways that idea could become form. Unlike earlier studies of *ut lingua architectura* that have focused on issues of architectural style, the use of ornament, and the language of the orders,[3] this narrative has instead demonstrated how notions of *ut poesis architectura* that would later be articulated in mid-sixteenth-century treatise literature were incorporated in architectural practice in Raphael's circle. As we have seen, Raphael's rhetorical visuality was not only

a linguistic analogy; and in the case of Sperulo's poem, text is not only meta-
phorical architecture, but also a proposal for creating the real thing. Patterns of
invention arose most likely from the practical modality of artists and architects
working with humanists, engaged in the kind of collaborative practice I have
been describing.

Such visual–verbal collaboration opens new possibilities for thinking about
the design process, from ideation through representation and building. In the
collective *modus operandi* I have discussed, the tools to accomplish the job
included poetry and prose, as well as drawings and ground plans. That is not
to say that word and image were directly cognate intellectual processes; artists
and wordsmiths each had different tools, goals, and separate areas of expertise.
But we see them working in tandem – and sometimes in conflict – throughout
the long design process, as ideas and forms evolved in dialogue, competition,
and negotiation with each other. Nor am I suggesting that we can take the
design process at Villa Madama as a normative case study; patterns of idea-
tion varied by artist and patron, and even between projects of a given artist,
or elements thereof, as we have seen in the case of Raphael. But this scenario
demonstrates that architectural drawings and models alone are not sufficient to
express the idea of a building in this milieu; words, spoken and written, were
also instrumental in formulating architectural ideas. Notably, even Rome's
foremost architect couched his ideas in words as well as drawings; Raphael
turned to prose to amplify the plans for the villa, his most ambitious project,
in the Plinian epistle that he perhaps recited aloud, or even performed onsite.
Thus, like his humanist colleagues and patrons, Raphael also worked out his
ideas and communicated them via literary forms. The logocentric mindset of
Curial culture reflected the linguistic *forma mentis* of all the participants in this
circle, even the artists. Moreover, poetry, in its role as a generative tool, could
further convey abstract modes of knowledge.

This study provides an important demonstration of how architecture could
embody discursive ideas, including philological and poetic modes of thought.
Alberto Pérez-Gómez has long called for more attention to the poetic and
metaphorical character of architectural thinking and design, especially at this
moment in the early cinquecento, which coincides with the void in surviving
written works on Italian architectural theory.[4] At one level, the mutual depend-
ence of architecture and humanism was a legacy of Alberti, who had functioned
as a humanist counselor as much as an architect,[5] (and as the Petrarch of archi-
tectural theory, as Trachtenberg has dubbed him.[6]) The collaborative design
process I have sketched specifically illustrates how rich, multivalent meanings
could be represented in architecture, as seen in the discussion of metastructures
for the garden loggia of the Medici villa, which included archeological, poetic,
and ideological notions. These case studies demonstrate that early sixteenth-
century architectural thinking encompassed a broader epistemological scope

than was later codified in mid-century treatises.[7] Nor was this rich discourse primarily based on architectural theory, but, rather, it was a function of different patterns of knowledge harnessed in the service of praxis. These findings illustrate that connections between language and architectural design practice remain a fertile ground for exploration.[8]

The use of hortatory *ekphrasis* I have traced in Raphael's ambient has provided a striking example. This verbal tool plugged into the larger collective enterprise to revive the corpse of ancient Rome. This initiative was closely associated with Raphael as the Christ-like healer of Rome reborn; in particular, Villa Madama was understood as his Lazarus, celebrated in visual imagery depicting this miracle at the villa site (Figures 1, 2). Using a language of rebirth, revivification, and healing, Raphael and other artists and *letterati* re-membered sculpture, buildings, and the city of Rome itself. They used methods of composition in what may be seen as an early practice of creating a verbal–visual exquisite corpse.[9] Humanists addressed the burgeoning population of ancient sculpture – mutilated bodies that were exhumed from the ground and made whole by salvific acts of physical restoration by artists, and virtual restorations by poets. Artists competed to create the missing arm of the *Laocoön* using wax and marble, just as poets competed to complete the sculpture using words, some in the form of *ekphrasis*. Significant sculptures were recontextualized, in poetry and in actuality, and thereby given new meaning and new life, such as the *Laocoön* and other famous figures in the Vatican Belvedere. Sperulo himself engaged in this enterprise, from his poem about the *Laocoön* to his proposals to recontextualize specific ancient sculptures in the Medici villa; as we saw with the Venus Genetrix relief, he spun a metastructure about Medici rule encompassing word and image, which Raphael would actually design into an elevation of the building. The poet also suggests they were considering how to display the then-broken bodies of nine sculptures of the Muses assembled at the villa (Figures 50, 51), an ambitious ensemble that remained unrealized, and a stimulus to later artists. The Raphael equipe also created the missing head and torso to complete the colossal seated *Jupiter Ciampolini*, which would be a focal point of the villa's main representation space and an impetus for architectural plan and decoration, perhaps in connection with Sperulo's Jovian conceits. These imaginative encounters with the fragmentary physical remains of antiquity fostered a culture of re-membering, and of virtual completion. Conditioned by the physical and conceptual parallel between old and new ruins in Rome, poets could look at a half-built structure and bring before the eyes a completed work in perfect form. Verbal restoration was a form of imaginative visualization. Thus, we may see *ekphrastic* completion as a literary mind-set, further mobilized as a practical tool for scenario planning. It was deployed by humanists accustomed to working with artists and architects, who were engaged in physical restoration and the creation of new forms. At the Medici

villa, the power of *ekphrastic* agency was coupled with that of artistic *techne* to bring the villa into being.

These proleptic villa descriptions are a fascinating example of the epistemology of the imaginary shaping the real, which has been analyzed from Aristotle to Paul Ricoeur.[10] The capacity of Renaissance thinkers to visualize the non-extant was shaped by literary traditions: notional *ekphrases* from Homer and Virgil to Ariosto, the imaginary sites described by Petrarch and Boccaccio, or the dreamscapes of the *Hypnerotomachia Polifili*. Mnemonic practices also fostered the ability to build first in the mind's eye; the trope of the poet as master builder functioned as metaphor, and additionally reflected mental techniques of composition using locational memory. Carruthers further proposes that medieval monastic projects were understood to have been based on proleptic visions, most famously Abbot Gunzo's vision for Cluny, a practice linked to divine revelations such as Ezekiel's temple-city.[11] We may see specific parallels between the way poets' and artists' prophetic fictions were given visual form in the Roman Renaissance, an intellectual culture attuned to plays on reality and illusion in many epistemes. Ariosto's *I suppositi* (staged in the Vatican in early 1519 with Raphael's collaboration on the sets) played on the ambiguity of reality and illusion; at the same time, the poet was revising and holding readings of his *Orlando furioso*, in which he declares the supernatural ability of the poet to see the outcome of contemporary events. Around the same time, Raphael thematized *fantasia* by giving visual form to the invisible in painted works, from his great visionary altarpieces to the Vatican fresco of *The Vision of Constantine*, a process that Kleinbub has likened to Augustinian notions of "imaginative vision."[12] Sperulo, in the authorial voices of the prophetic Tiber and Hephaestus, uses *enargeia* to bring his textual villa vividly to view in the mind's eye, as Quintilian had advocated the orator should display facts "in their living truth to the eyes of the mind."[13] The power to visualize the non-existent – whether a future event, Constantine's vision of the cross, or a villa – was a badge of the *ingenium* of the artist. Humanists and artists engaged in a metaconversation about the nature of vision, invention, and the relative powers of word and image to express them; and at the same time, their creative visualizations could be harnessed to inspire and shape reality.

I have proposed that Sperulo's vivid *ekphrasis* was, at one level, a portrait of the villa. Portraiture was traditionally the genre in which the paragonal discourse pitting painting against poetry played out with special emphasis, as painters and poets vied to demonstrate whose medium could more fully capture the internal and external image of a beloved.[14] Castiglione characterized his *Book of the Courtier* as a portrait of the Court of Urbino; he specifically likened it to portraits by Raphael and Michelangelo, in comparison to whom he humbly called himself a second-rate painter, thereby subverting the usual play of painters who would be poets, and also illustrating the currency and

flexibility of this discourse.[15] Sperulo's textual portrait of a building connects architecture to this conversation about portraiture – a variation on issues of *ut architectura poesis* that would be articulated by later theorists. This notion of Sperulo's poem as a portrait of the villa is implicit in his text, and was further given visual form in the illumination of the presentation manuscript (analyzed in Appendix II), which evokes the pairing of likeness and *impresa* on painted and medallic portraits. The imagery also suggests the poem as a verbal equivalent of a building medal, which could commemorate an architect's proleptic vision of the unbuilt edifice.[16] With both these conceits of a verbal portrait and a foundation medal in verse, Sperulo's poem engages the *paragone* of visual artists and poets, making a strong claim for the poet's superior power to envision, persuade, and inspire. In this case, the competition of word and image was not just figurative, but also real: an actual, sharp-elbowed battle over the power of invention, waged by the poet claiming to build his villa in verse.

Sperulo alludes to the *paragone* of poetry and architecture throughout the poem, with special emphasis at the beginning and end. In his dedicatory letter to Cardinal Giulio, Sperulo declares that the villa he builds with ink will outlast that of the architects with their glue of lime and sand, evoking the Horatian trope equating durability with immortality.[17] I have suggested that this seemingly peculiar conceit about glue is in fact a Vitruvian reference to stucco, a lime-and-sand mixture that is essentially a fine-grained mortar.[18] Sperulo thus particularizes the words-versus-monuments topos to the Medici villa, where the newly chic material of stucco was to articulate every surface inside and out, from architectural shell and ornament to decoration.[19] So, the poet pits his villa of ink and verse against that of his architect colleagues working with mortar and stucco. And he closes his poem by saying his work for Cardinal Giulio is a pleasure, at once playing on a Medici *impresa* (his burden is easy) and also citing a passage in Statius in which Pleasure records (*scripsisse*) the plans for a villa. The ancient poet used the verb *scribere*, which can refer to a visual or textual representation, one of his many plays on the visual and the verbal to underscore their paragonal nature. Sperulo cites this passage in the last line of his visionary *ekphrasis*, the poet's parting shot for the power of text in this battle of word and image.[20]

As it turns out, both the literary and the built versions of the Medici villa have survived. Neither represents a perfect or completed product, and neither is well understood today. To Renaissance contemporaries, however, this dialectic of literature and architecture constituted an essence of the Medici villa. Thus, Sperulo's villa built in hexameters functioned on several interpretative levels: as coded proposal for the villa complex; as a metonym of the poet himself, and of his patron; as a claim for the primacy of word; and as a metaphorical equivalent of the villa, just as Statius' choice of the Latin word *silva* – with its associations with the raw material of literary composition or

building – reflected the ancient poet's equation of poem and estate.[21] The villa, more than a building type, was a cultural ideal; and the villa as a cultural edifice encompassed text as well as stone.

The texts by Sperulo, Tebaldeo, Vida, and Raphael himself celebrated the bringing into existence of the villa as an important narrative in its own right, for philosophical as well as practical reasons. Aristotle's notion of *poiesis* common to all the arts has been fundamental to artists' conceptions of their endeavors from antiquity forward. Homer's account of the shield of Achilles, the great epic set piece of *ekphrasis*, celebrates not the shield itself, but the process of making it. Cicero had reified coming-into-existence as a worthwhile literary subject in his letters to his brother Quintus narrating the progress of his unfinished villa.[22] Bertoja's image of Vignola and his humanist advisors discussing plans at the construction site records the designers' roles in fashioning the Farnese villa at Caprarola (Figures 84, 85). Working in a very different context, French architect Marcel Lods made photographic documentation of every stage of the construction and life of his buildings, considering all phases part of the "constructed reality" of the work; and Sergei Eisenstein noted of the cinematic montage, "The spectator not only sees the represented element of the finished work, but also experiences the dynamic process of the emergence and assembly of the image."[23] We may further see Sperulo's hortatory *ekphrasis* as a *poietic* narrative in this long tradition celebrating the process of ideation itself. So, the dialectical practice of invention in this cultural matrix engaged architectural design in larger, self-reflexive discourses about the relative powers of word and image to envision new things, and the *poietic* processes of making them.

☙

There is an irony in analyzing the coming-to-be of a villa that never did fully come to be – at least not in the form envisioned by anyone associated with its planning. Despite their acceptance of iterative, long-term planning and the attendant necessity of living with partially finished modern ruins, and even their celebration of continually evolving design processes, the villa's planners surely never imagined that setbacks would limit the villa complex to such a kernel of its intended scope. But the tragedy of the villa (to borrow the conceit that Ascanio Condivi famously applied to Michelangelo's downscaling of the Julius tomb) turns out to have had some remarkably interesting and productive consequences. The partially built state of the villa has ensured its status as a sort of *revenant*, never finished, eternally coming to be, which has been a stimulus to the imagination down to the present. In the Eternal City known for its juxtaposition of ancient and modern ruins, various kinds of pilgrims to the Monte Mario have found inspiration in Raphael's ruin: from Serlio and Palladio in the mid-sixteenth century, through Grand Tourists, to nineteenth- and early twentieth-century photographers and Prix de Rome winners,

scholars, architects and urban planners, and finally modern conservators and historians. Like Brunelleschi, who could see ancient Rome in his mind's eye as it was before the fall, they could visualize aspects of the villa as it was, or might have been. The varied responses to the fragmentary villa have generated a rich body of virtual restorations. Like a Roman Renaissance Pergamum or Palestrina, Raphael's grand project has thus continued to be an impetus for virtual completion and re-imagination, enabling centuries of thinkers to participate in the enterprise of reviving the corpse; like Raphael and Sperulo, we continue to build the villa in drawings and prose, if not in mortar and verse.

APPENDIX I

Francesco Sperulo, *Villa Iulia Medica versibus fabricata /
The Villa Giulia Medicea Constructed in Verse*
(BAV, Vat. Lat. 5812)[1]

CRITICAL EDITION AND TRANSLATION BY NICOLETTA MARCELLI AND GLOSS BY THE AUTHOR

TRANSLATOR'S NOTE ON THE CRITICAL EDITION AND TRANSLATION

Although the manuscript Vat. Lat. 5812 appears to be written in Sperulo's hand, for the sake of clarity, some changes in the orthography have been made as follows:

- I distinguish *u* and *v*, when it occurs as a consonant (e.g., *dedicatory letter*, §4: *tentauerim* > *tentaverim*; line 13: *renouare* > *renovare*, etc.).
- For the diphthong *ae*, I do not distinguish between *ae, æ*, and *ę*, as Sperulo does, because this alternation could generate confusion, so all three forms are indicated as *ae*.
- Like many other humanists of the fifteenth and sixteenth centuries (see Ugolino Verino, *Epigrammi*, ed. Francesco Bausi [Messina, 1998], 177), Sperulo uses the superscript *o* to indicate the vocative, which in this edition has been signaled only by encapsulating the word(s) in commas.

The paleographical abbreviations (e.g. line 31: *myrtiq3* > *myrtique*; line 94: *prioR* > *priorum*; line 230: *int'* > *inter*) and suspensions (e.g. the horizontal stroke interlined for *m* and *n*) have been silently expanded or written out in full.

[1] Editions of the poem have been published and translated by Shearman, *Sources*, vol. 1, 414–38; and Gwynne, *Patterns of Patronage*, vol. 2, 97–150.

As for punctuation, Sperulo uses many punctuation marks, sometimes in a very modern way, such as exclamation marks (e.g. line 153), although in most cases the original punctuation leads to confusion, if not a complete misunderstanding of the text. Thus, for the sake of clarity and readability, I choose to abide by modern punctuation criteria, also adding quotation marks to speeches.

A similar solution has been applied to capital letters, both for proper names (whether real or mythological) and for adjectives (e.g. line 87: *eois* > *Eois*), while titles, such as *Dux, Cardinal*, and *Rex*, are edited with lower case. Capital letters at the beginning of each line are given in lower case for the sake of clarity.

Latin words with particular or unusual orthography are explained in the footnotes.

Editing a text preserved in only one manuscript sometimes can be a challenging process, because we cannot possibly solve textual problems with the help of other witnesses, and eventually they may be insoluble. Luckily, this has not been the case, but, though this illuminated and lavish manuscript has been copied very accurately in terms of text coherence, some misspellings or mistakes inevitably occurred. I have proceeded with corrections, explaining in the footnotes my interventions.

Line numbers have been added to the poem, and paragraph numbers to the dedicatory letter in prose.

In the translation, proper names are given in Italian, as most members of the Medici family are known (e.g. Giulio de' Medici).

Ad reverendissimum dominum Iulium Medicem Sanctae Romanae Ecclesiae presby-
terum cardinalem et vice cancellarium humillimus servus Franciscus Sperulus villam
Iuliam Medicam versibus fabricatam mittit.

1. Nudiustertius observantia mea, quae erga te cum multis certat, superiorem esse adhuc illi video neminem, fecit ut tempus deambulationi designatum converterem ad visendam villam quae ad primum fere lapidem mira tibi impensa extruitur.

2. Vix primo lustrata obtuitu, ita me situs et amoenitas loci, magnitudo ac varietas aedium antiquitatis non aemula modo, sed longe victrix, affecit ut alio mox omni ex officina mea reiecto, hoc unum opus ipse quoque fabricandum susceperim, sperans, si feliciter cederet – quod quidem summae est aleae – dignosci demum facile posse, ut tenacius et sane perennius nigro suo Musae aedificant, quam calcis et arenae glutino architecti.

3. Idque iam quantum per vires licuit meas perfectum celeritas ipsa, quae praefuit ut ad te mittam, persuadet pollicita gratiam, quam forte ex ingenii studiorumque industria sperare non liceat.

4. Quod si grate exceperis opus, mihi in corde quasi in incude quadam pietatis malleo fabricatum, forsan efficies, ut maioribus ingeniis assequendi, quod minus feliciter ego tentaverim, oestrum videar iniecisse; quo nihil aeque gratum contingat mihi, cupido superari in praeconiis tuis, dum pro viribus certasse iudicari possim.

5. Vale spes et praesidium omnium bonorum.

6. Romae, calendis Martiis, a Servatoris nostri natalibus anno MDXVIIII.

> Quae nova tam celeri surgunt praetoria ductu?
> Cui tantus circum sudat labor? Undique ferro
> crebrae instant in saxa manus: descendit aperto
> vasta solo² moles, unde ingens scandit in astra
> tectorum vertex. Operum certamine multo 5
> per septena vagus mirantis culmina Romae
> it fragor et curvis resonat de vallibus echo.
> Ipse pater Thybris Thusco festinus in amne
> vicinumque procurat opus, ratibusque ministrat
> materiem, et varios laetus discurrit in usus 10
> hortaturque viros, stimulisque ingentibus urget:
> "Eia agite! extinctos ausi priscae artis honores
> reddere et excelsis renovare penatibus urbem,
> maturate, viri, praestans opus! Aethere ab ipso
> cum superi terrena volent invisere nusquam 15
> dignius esse queat sedes: hic bruma tepebit,
> algebitque aestas varium nec sentiet annum,
> utque domus volet, inversis dominabitur horis;
> non quisquam madidi flatus hic horreat austri
> pestiferos hospes, se Vaticanus Iaccho 20
> obiicit, extantique iugo bibit ipse venenum.
> Nempe Syracusia sic vos extollitis arte,
> quem natura dedit non parvis usibus olim

² *descendit aperto … solo: descendo* with dative case is of poetic usage only, see for example Ovid, *Met.*, III,14.

To the most reverend Lord Giulio de' Medici, Cardinal Priest and Vice Chancellor of the Holy Roman Church, his most humble servant Francesco Sperulo sends *The Villa Giulia Medicea Constructed in Verse.*[1]

1. The day before yesterday my respect for you – which is greater than anyone else's, though it competes with many others – caused me to devote my daily walk to visiting the villa you are constructing at extraordinary expense a mile from the city.

2. As soon as I saw it, I was so struck by its pleasing situation[2] and the size and variety of its apartments (which not only rival but even far surpass antiquity),[3] that I immediately abandoned my other projects and undertook that I, too, should also engage in building this same work. I hoped that, if it should go forward happily – a risky business indeed! – that it could finally become evident that the Muses build in ink with greater tenacity and more enduringly than architects do with their glue of lime and sand.[4]

3. That task now being finished, as far as my powers permitted, Swiftness herself, my commander, urged me to send it to you, promising a gratitude which mental industry and laborious research may not perhaps hope for.[5]

4. If you shall receive my work favorably, forged in my heart as though on a kind of anvil by the hammer of devotion,[6] you will perhaps see to it that anything unsuccessful in my efforts will turn me into an inspiration for greater talents. Nothing would please me more; I *want* to be surpassed in praising you, so long as I may be judged to have competed to the best of my ability.

5. Farewell, hope and defense of all good men.

6. Rome, 1 March 1519

> [1–7] What extraordinary new mansion[7] is this, rising so swiftly? To what end is there so much labor and sweat all around? Everywhere crowds of febrile workers, iron tools in hand, fall upon the stones. Vast foundations are laid in the open ground, from which an enormous mountain-peak of roofline climbs toward the stars.[8] The clangor from the arduous work wanders through the seven hills of marveling Rome, the winding valleys echoing with the sound.[9]
>
> [8–11] Father Tiber himself, hastening in his Tuscan stream,[10] takes charge of the nearby work. He supplies material on rafts and happily runs to and fro on various tasks, exhorting men and spurring them on mightily:
>
> [12–21] "Come on, men![11] Dare to revive the splendor of ancient art and renew the city with its own lofty household gods! Bring this excellent work to fruition! When the gods above fly from their aetherial home to visit earth,[12] there can be no worthier abode for them. Here winter is warm and summer cool; here changes of season are not felt, and, as the house shall intend, it will be ruled by hours running backwards.[13] Here no one should shiver at the pestilential blowing of the damp South Wind: the hospitable Vatican Hill will block its raging storm,[14] and swallow up its poison in the rise of its ridge.

tam blande complexa locum. Mirabar ut ante
nemo decus tantum, passim cum surgeret ingens 25
Roma, sibi ad famam legeret vitaeque levamen
debita nimirum sedes ingentibus illa
viribus, excelsisque animis, non divitis auri,
sed famae decorumque avidis te, maxime Iuli,
et vitrei circum fontes et amoena vireta,[3] 30
et placidi saltus, lauri myrtique manebant,
te collis Baccho sacer, innuptaeque Dianae.
At Nymphae, mea cura, vagis quae cursibus alveo
Apenninigenae tot se committere certant
hinc atque inde meo, mixtae ut socialibus undis 35
reginae mecum lambant sacra moenia Romae,
mirantes persaepe locum, qui primus ab urbe
sese offert cultu atque situ dignissimus artis
auxilio: fore de Thuscis primatibus illum
qui coleret Thuscisque ornatum hunc addere ripis 40
pergeret, edixere deae; nec me meus olim
hoc animus volvens praesago in corde fefellit.
Iamdudumque Lari tanto scrutatus honores,
eruta de priscis huc marmora densa ruinis
conveho. Adeste, viri! cognoscite singula certis 45
disponenda locis, meque hoc opus auspice surgat!
 En Libycum in primo niteat quod limine marmor,
aeratosque ferat postes et grande figuret
vestibulum, ut multa subeuntis imagine ludat
detineatque oculos; iamque hinc miracula surgant: 50
id Capitolino defossum in colle repertum est,
et quondam ornavit limen sublime Tonantis.
 Synnadicum hoc variam faciem et maculosus ophites
reddat ubique domus; his atria magna columnis,
quas modo Luculli detexit durus in hortis 55
agricola – hi quoque nam curvo exercentur aratro –
nitantur; caesae[4] quae sunt e marmore eodem
quo scisso, mirum!, Sileni emersit imago.
Taenareis haec caesa iugis atque illa virebant
aede prius Paphia; longo post[5] tempore Caesar 60
sceptra tenens rerum, clara Genitricis in aede
esse dedit Veneris, multo quam thure Quirites
Aeneadae authorem[6] generis regnique colebant.

[3] *vireta*: *viretum* less correctly than *virectum*. Poetic usage: see gloss note 16.

[4] ms *caese*, erroneously; *caesae* is referred to *quae* and his *columnis* above line 54.

[5] *post*: the same as *postea*.

[6] *authorem*: *author* alternative form used instead of the more common *auctor*. The difference depends on etymology: whereas the classical form *auctor* comes from the Latin verb *augeo* – thus *auctor* means also "the one who makes something grow" or "the creator" – during the Middle Ages and Renaissance, some writers preferred *author*, a form claimed to derive from the Greek noun αὐθέντης, which means "someone who has the power to act," "author" in the broadest sense.

[22–46] "Thus you are surely raising up with Syracusan art[15] a place that Nature, caressing it in her embrace, gave for no trivial purposes. I am amazed that no one before, when great Rome was rising everywhere, chose such an ornament for himself to augment his fame and provide solace for his existence. Doubtless that abode was destined for great strength and lofty souls that were eager for fame and distinction, not gold and riches. The glassy springs surrounding it, the pleasant greenery[16] and peaceful groves of laurel[17] and myrtle[18] waited for you, greatest Giulio; for you waited the hill sacred to Bacchus and unwed Diana. But the nymphs – my charges – who born in Apennine rivulets strive so much on their wanderings from this source and that to combine themselves with me, so that our mixed and combined waters may wash the sacred walls of queenly Rome – [these nymphs] have very often marveled at the spot, the first place out of the city that offers itself as worthiest of art's assistance for its fruitfulness and situation. These goddesses decreed that the man who would cherish the spot would be from among the foremost men of Tuscany, and that he would proceed to add this embellishment to the Tuscan river-bank.[19] Nor did my spirit, which pondered this decree long ago in its prophetic heart, deceive me. And having long sought marks of honor for so magnificent a Lar,[20] I carry hither numerous marbles pulled out of ancient ruins. Come, men, learn how each of them should be disposed in its specified place! Let this work rise under my auspices![21]

[47–52] "Behold! Let the Libyan marble gleam upon the outer threshold and bear the bronze door posts, giving shape to the great vestibule,[22] so that it may play many games with the image of someone entering and catch his gaze. Now let miracles arise from hence! It [i.e. the Libyan marble] was discovered buried on the Capitoline Hill, and once adorned the lofty threshold of the Thunderer.[23]

[53–63] "Let this Synnadic marble[24] and speckled serpentine give variety to the appearance of the house;[25] let its great courtyards[26] gleam with those columns which a hardy farmer recently uncovered in the gardens of Lucullus[27] (for these, too, are worked by the curved plough). The columns were quarried from the same marble from which an image of Silenus – how astonishing! – emerged when the marble was split.[28] Here [you can see] marbles cut from the crags of Taenaros,[29] and there those that were at the height of their beauty in the Paphian sanctuary.[30] Then, long afterwards, Caesar, when he ruled the world, offered them to be part of the famous shrine of Venus Genetrix,[31] whom the Roman descendants of Aeneas[32] used to worship with clouds of incense as the author of their race and rule.

Hanc Numidam patriae inscriptam de patris honore,
Romulidae in pacisque et regni pignus Iulo 65
constituere fori in medio, tibi debita, Iuli,
ob patriae atque orbi pacis memorabile donum.
Nam, cum civili fremerent passim omnia Marte,
sanguinis et rivi fluerent, miserata Leonem
astra dedere patrem rerum, qui numine certo 70
parceret inflexis debellaretque protervos.
Ille tuum ingenium maturaque pectora curis
non ut frater amans, frater licet urbis habenas
te subeunte regit, rerum tibi pondera linquit,
subque tuis voluit pacatque laboribus orbem: 75
intentus nanque[7] ipse sacris, tecum omnia nutu
digerit, inde tuo peraguntur singula ductu.

At vos huc aures animumque advertite: sedes
linquantur vacuae commensa per atria claris
maiorum statuis Medicum, quibus alma propago 80
se merito iactare queat. Quos ordine cunctos
si memorare velim, magnaeque exordia gentis
prodita Thuscorum priscis annalibus, aevum
Porsennae repetam doctasque evolvere Athenas
conveniat, quibus illa duces dedit inclyta proles, 85
Argivos lata dum sub ditione tenebant.
Quid mirum regnis, si nunc Leo summus Eois
tantum inhiat? Magnis proavi calcaribus urgent
et nativa animos succendit flamma nepotum.
Quare ego, qui Thuscos tot iam volventibus annis 90
Alluo, multa sciens, ne vos sermone fatigem
praetereo, et raros tam lata e stirpe reponi
hic iubeo, ut claris tendant in saecula gestis,
et domus authoris[8] pretio magnisque priorum
surgat imaginibus vixque uni cedat Olympo. 95

Iani[9] prima locum serie sibi poscit, ab annis
Daedala quem teneris exercens Curia, demum
consiliis foetum atque animis invita roganti
restituit patriae; ostendit tum denique nostras
posse aliquid tum Roma preces, germanus obortis 100
cum toties Arnus lachrymis instaret, ut illud,
me poscente, decus Thuscas pateretur in oras
vertere iter, magnoque viri haec langueret amore.
Nec prius evicta est sacra quam sorte nepotes
inde fore Augustos docui mundique parentem 105
te, Leo, quem lassis iam tum pia numina rebus
spondebant bellis finem scelerique nefando.

[7] *nanque*: alternative form commonly used in neo-Latin instead of *namque*.

[8] See note 4.

[9] *Iani*: unless it is a mistake for the nominative case *Ianus*, this form seems a sort of allusive invention built up from the Latin *Ianus* and the vernacular Janni/Gianni, diminutive for Giovanni still in use today in Tuscany.

[64–77] "This Numidian marble column, inscribed to the father-land in honor of its father, the sons of Romulus set up in the middle of the forum[33] as a pledge of peace and empire devoted to Iulo.[34] It is you, Giulio, who deserve these marbles owing to the memorable gift of peace you have given to your country and the world. For when civil war roared everywhere and rivers flowed with blood, the merciful stars granted that Leone should be the father of the world,[35] who with divine authority might spare those who bowed before him and might subdue the impudent.[36] He has an unfraternal love of your intelligence and your heart, ripe for responsibilities, yet he fraternally takes the reins of the city with you as deputy: to you he leaves the weight of affairs. He exercises his will and pacifies the world through your labors.[37] Himself intent on sacred duties, he disposes and approves all things through your agency, and each decision is brought to fulfillment by your command.[38]

[78–95] "But you – turn your ears and your attention to this: let empty places[39] be left throughout the proportionate[40] halls for illustrious statues of your Medici ancestors,[41] about whom their life-giving progeny[42] may justly boast. If I wished to commemorate all of these in sequence, and the ancestry of the great family recorded in the ancient annals of the Tuscans, I would recall the age of Porsenna,[43] and it would be proper to recount learned Athens, to which that famous line gave leaders when they held the Argives under their wide dominion. What wonder if supreme Leone now so greatly aspires to eastern king-doms?[44] The ancestors spur him on mightily, and a native fire inflames the spirits of the [Medici] descendants. Therefore, I [Tiber], who for so many cycles of years have already bathed the Tuscans, knowingly set aside much lest I tire you with my words, and from such a wide line-age I command only the most distinguished to be set out here, that they may persist through the ages by their illustrious deeds. And let the house rise worthy of its author,[45] and with the great images of the ancestors, ceding scarcely to Olympus alone.

[96–107] "Janus [Giovanni][46] requests for himself the first place in order, whom the skillful Curia,[47] employing him from tender years, finally restored the son [i.e. Giovanni] unwillingly to a supplicating homeland, filled with wisdom and courage. Then at last Rome showed that our prayers could achieve something, for so many times brother Arno insisted, with tears in his eyes, that upon my request Rome should consent that such a glorious man turn his path into Tuscan regions and this country should suffer for great love of the man; nor was she won over until I determined that by sacred lot his descendants would be Augusti, and you, Leone, the father of the world: then the just gods pledged you to our exhausted affairs and sent you as an end to wars and to accursed crime.

Multa licet scribi laudum praeconia possint,
huic circum tamen illud erit, quo sidera adisse
quippe reor magnum patriae quod gignere Cosmum 110
dii dederint, decus Ethruscum, virtutibus ingens;
qui partum post nomen opum, cum posset habenas
arbitrio solus moderari, magna senatus
reddere iura, domi privatam degere vitam
maluit, ac civis dici fautorque bonorum, 115
consiliis opibusque potens atque indole *Cosmus*.
Quae templa eximis erexit sedibus! auro
quam largo fulgere trabes! divumque in honorem
iussit ut unus opes fluere! ut torpentia lucro
pectora Thuscorum stimulis excivit in omnis[10] 120
mox decorum laudumque vias! Florentia coelo
sic caput erexit, nuncque est pulcherrima rerum.
Quam bene praesagi *Cosmum* dixere parentes!
Quam vox haec superum ornatus praenuncia tanti!
Huic sedem ex adamante date! huic deserviat aurum 125
eque Cytheriacis stent circum lilia conchis,
stetque aeternus honor gemma ex Erythreide veris.
 Natorum statuis post hunc vacet aurea sedes
petrique atque iterum Iani: duo pignora nunquam
aemula sic genitoris erunt; hic fundere larga 130
dona manu ac patriis miseram studiosus ab oris
pauperiem procul exilio damnare, leporum
laetitiaeque sator, semperque in gaudia pendens
publica, praecipuos iuvenum inter fulgere coetus,
ignarus scelerum, virtutum percitus oestro 135
indolis, at tantae immaturo funere Parca
spem tulit ac populo questum lachrimasque reliquit.
 Petro magna domus et vasti cura peculi
a puero cordi semper fuit addere partis
metiri impensam nec, dum res posceret, arcae 140
parcere mordacesque in se transferre parentis
longaevi curas et rerum pondera iniqua.
O pietas natique fides! o provida mentis
consilia et cauti vitae in discrimina gressus!
Non ideo tamen ad rerum consulta minorem 145
quis putet, heheu! sacra pedum importunaque pestis,
et magnis infesta viris, quae gesta morata es
publica in hoc? Dum Seditio clam serpere plebem
coepisset proceresque inter, multisque sibique
instructas fraudes in apertum educere divum 150
munere posse datum est, quanto cum pondere turbas
ipse domi obsessus morbo, stratusque cubili

[10] *omnis*: ms *omneis* erroneously, then corrected. It is difficult to determine who was responsible for this
correction.

[108–27] "Although many proclamations of praises can be written about this topic, still that by which he [Giovanni] attained the stars – I believe – will be that the gods granted him to beget great Cosimo[48] for the fatherland, Etruscan glory, he who, great in virtues, having acquired the fame of riches, when he could have controlled alone the reins by his judgement, preferred to restore the great authority of the republican institutions,[49] lead a private life at home, and be held a citizen,[50] supporter of the worthy, strong in counsel and wealth, and *Cosmus* by nature.[51] What temples did he erect in distinct places! With what lavish gold did the beams gleam! How many riches did he, and he alone, order to flow in honor of the gods! And [how much] did he stir up by example the hearts of Tuscans, sluggish with money, and soon spur them into the ways of distinction and fame! Thus Florence raised her head to heaven, and is now the fairest of all; with what perfect foresight did his parents call him *Cosmus*! What voice from above was this, prophecy of such an ornament! Give him an adamantine throne, let gold be his faithful servant, and let lilies from Cytherean conches stand around,[52] and let stand eternal the grace of spring from the Erythraean jewel.[53]

[128–37] "In front of him,[54] you [Giulio] prescribe that there should be a splendid place[55] free for the statues of his sons Piero and Giovanni again:[56] there shall never be two blessed children who so emulate their begetter; the latter poured forth gifts with munificent hand,[57] and far from his native land,[58] fervidly eager to banish poverty into exile, sower of pleasures and joy, always outstanding during public festivities, he glittered among the foremost companies of the young, knowing no crime, animated by a virtuous passion; but Parca[59] took away the hopes for so great a talent with an untimely burial, and left to the people grief and tears.

[138–58] "To Piero a great estate and the care of vast possessions were of concern from childhood: to add accounts, measure expense, but not to spare the treasure-chest when the matter required it, to transfer to himself the consuming cares of his aged father and the heavy burden of affairs. O dutiful respect and filial loyalty! O provident advice of a wise mind and careful pacing of the decisive moments of life![60] Nobody, to be sure, should think him inferior at making decisions about affairs – alas, accursed and importunate disease of the feet,[61] enemy of great men, what public deeds did you frustrate by behaving this way? While Discord secretly began to insinuate itself between the plebs and the aristocracy, and thanks to the gods the traps prepared for him and many others were brought into plain sight,[62] with what gravity did he, himself, besieged by sickness in his house and prostrate on his bed, settle the civil disorders and deflate blown-up hatred and

composuit tumidumque odium compressit et iras!
Libera quid medio egisset facundia tunc tunc
illa foro, blandique gravis presentia vultus? 155
ergo ambo expressere patrem, quaeque inclyta in uno,
sed virtus non una fuit, divisa in utroque
luxit et in dulci vidit se germine Cosmus.

 Nunc orti ex Petro Laurens Iulusque sequuntur
ordine: verte aures, animumque huc verte Raphael! 160
Cuius Apelleos virtus aequare colores
ausa, Syracusii laudes livere magistri,
et priscos nostro cogit concurrere saeclo,
qua decus immortale domus, qua parte locabis?

 En Laurens, olim cuius virtutibus orbis, 165
non Ethrusca modo res floruit, annus ut almo
veris ubique solet cultu, sacra tempora laurus
non simplex circum vatis meat: hic, velut isthmos
ne freta concurrant prohibet, sic undique Martem,
qui nos tam longa post clade afflixit, ahenis[11] 170
continuit vinctum nodis, vetuitque cruentum
effurere, ardentesque minas animosque repressit.
Huius enim docto Pax magna in pectore cudens
consilia, Eoïs Italos in foedere certo
esse dabat, nedum civili a labe retraxit. 175
At postquam immiti rapuit Mors funere, Thuscos
Seditio abripuit, rupto Mars foedere gentes
in ferrum cladesque vocat, tumuere cruore
flumina civili: Rhodanus concurrit Ibero
et cursum Eridani caedes utriusque morata est. 180
Nec dum finis erat, nisi tanto e semine cretum
conciliata orbi tribuissent astra Leonem,
imperio cuius discordia prelia paci
submisere caput, tantumque minantur Eois.

 O felix Laurens, quae tu praestare nequisti 185
ulterius, nato demum concessa tueris
praestari ac tanto gaudes cessisse ministro.
Sed quota sit laudum pars nunc, nam dicere plura
instans cura domus tantae vetat. Huc age, sedem
ipse tibi et Musis, quas nullo in turbine rerum 190
e bello pacique instans procul esse ferebas,
delige, ut in Pario spirantem marmore cernam.
Sit tecum luctusque meus, luctusque tuorum
Iulius, infanda quem proditione dederunt
inter sacra neci, vix te evadente, nocentes. 195

[11] *ahenis*: alternative form for *aenis* < *aenus*, more frequently used in poetry than *aeneus/aheneus*. For the insert of *h* see Gellius, *Attic Nights*, II, 3: "Qua ratione verbis quibusdam vocabulisque veteres immiserint 'h' litterae spiritum."

anger! What would that fluent eloquence have achieved if exercised in public, and the serious bearing of his persuasive countenance? So both reflected their father [Cosimo], and any celebrated deed in the one – but not one was the virtue – shone separately in each son, and Cosimo could see himself in his sweet seed.[63]

[159–64] "Now, born from Piero, Lorenzo and Giuliano[64] follow in sequence. Raphael, turn your ears, turn hither your mind, whose excellence, daring to equal the painting of Apelles, makes the fame of the Syracusan master envious and the ancients compete with our age;[65] where, in what part, will you place the immortal glory of the house?[66]

[165–84] "Behold! Lorenzo, by whose virtues the whole world, not just the Etruscan state, once flourished; as the season spreads everywhere the life-giving ornament of spring,[67] so not just a plain laurel encircles the sacred temples of the poet; he, like an isthmus preventing the seas clashing, everywhere restrained Mars (who afterwards afflicted us with so long a disaster),[68] bound him with bronze ties, forbade him to wreak bloodshed, and extinguished blazing threats and passions. For Peace, forging great counsels in this man's breast, made possible a fixed treaty between the Italians and the Easterners, and by all means put an end to internal fighting [throughout Italy]. But after Death abducted him with cruel burial, Sedition grasped the Tuscans, and Mars, the truce broken, called the peoples to sword and massacres, the rivers swelled with civil blood: the Rhône clashed with the Ebro, and the collision of both prevented the Po from coursing freely.[69] Nor would there then have been an end if the stars had not agreed to give Leone to the world,[70] he who was born of so great a seed, by whose command discordant Strife has bowed its head to peace, and it [i.e. discordant Strife] threatens only Easterners.[71]

[185–204] "O fortunate Lorenzo, what you yourself could no longer provide, you ensure is supplied to your son at last, and you delight in yielding to so great an agent. But, however plentiful may be the praises now, the care of such a house urgently prevents us from saying more.[72] Come here and let this be the abode for yourself and the Muses, whom you, attentive to war and peace, could not bear to have far away in any tumult of affairs, so that I may see you breathing in Parian marble.[73] Let Giuliano[74] be with you, my grief and your grief, whom assassins consigned to death with infamous treachery at the holy mass, yourself [Lorenzo] barely escaping; even Virtue herself, protesting at that wound, burst forth: "There will come, will come, the time for a filial avenger, criminal hand, you who have dared to shed so noble a blood; the penalty that they will force you to pay now will seem mild to you:

Ipsa quidem virtus illo de vulnere clamans
Prosiliit: – Venient, venient sua tempora nato
ultori, scelerata manus, quae sanguine tanto es
ausa madere: levis quam nunc te pendere cogent
poena erit, in miseros surgent graviora nepotes –. 200
Dixit, et in cunis tibi sese, ut forte iacebas,
insinuans, magno implevit genitoris amore,
felicesque simul Iuli concrevit in annos,
et modo te rerum gaudet temone potiri.

 Sed quid moesta cano? quid laetis tristia iungo? 205
Quo dolor incautum rapuit? Coenatio sedem
ergo det his statuis, quae a dextra spectat in ingens
vestibulum, a laeva vernantes semper in hortos,
Aeolias hinc inde minas, quibus aedita circum
defendit tecti moles; exurat hianti 210
ut libet ore canis segetes, huc sentiet aestus
praescriptum violentus iter, nec viribus ullis
efficiet, gelidas ne non fons evomat undas,
et circum virides lauros citrosque perennes
irriget ac totum sibi non domus instruat annum. 215
Hic, quando hybernis circum montana rigebunt
culmina frigoribus, tepido sol aureus ortu
occasuque aderit, vitreasque admissus utrinque
per speculas, magnum invitus retrahetur in orbem,
ad reditumque urgebit equos serusque recedet. 220
Tu, Iuli, hic magnos inter spatiatus amicos
in genitore oculos figens, patruique serenos
suspiciens vultus, praesens mirabere numen
amborum, et quamquam stimulis tua cognita virtus
non eget, his cupies et profecisse videri. 225
 Parte alia, de turre udum quae spectat ad Austrum
consurgat specula, unde meum conversus in amnem
Iulius aeternum Thuscis ver numine ripis
praesenti sublimis alat, tunc tunc ego felix,
tunc venerandus ero, et cuncta inter flumina princeps. 230
Hac divina mihi Clementia parte Leonis
spiret Apelleae formata coloribus artis,
ut struxere necem mansueto ac tale verenti
nil penitus, divisque ideo servatus ab ipsis
supplicibusque ut prompta fuit non parcere tantum, 235
sed trepidos firmare animos, servare in honore,
divitiis augere, et amicum tollere nullum
de numero, nisi quem sceleris non passa voluntas
poenituisse fuit dira, et dignissima cunctis
suppliciis, hominumque omni de sorte moveri. 240
Ipsa hilaris curru aurato devecta per urbes,
corniger hinc taurus, Libycus Leo quem trahat inde,

worse things will rise against your wretched grandsons." She spoke, and slipping into your crib [Cardinal Giulio],[75] as you chanced to lie, filled you with a great love for your father and, oh Giulio, that love so grew with the blessed years and now your father[76] delights in your taking the helm of affairs.

[205–25] "But why do I sing sad things? Why do I join the sad to the joyful? Whither does grief draw me unawares? Therefore let a place be given to these statues in the dining-hall,[77] which on the right looks onto the grand vestibule, on the left onto ever blooming gardens:[78] the mass of the roof built all round provides shelter from the Aeolian threats.[79] Let the dog-star with wide-open mouth scorch the crops as it will,[80] hither the fierce summer will realize that its effects are restrained, nor by any force may it prevail: it will happen that the fountain gushes forth cool waters and irrigates the green laurels and the perennial citrons,[81] and not only the house, but the season itself shall be ruled. Here, when the mountainous heights all round are rigid with frost, the golden sun will be warm at rising and setting, admitted on all sides through glazed windows,[82] [and] will withdraw unwillingly to his great orbit; he will urge his horses to return, and will delay his retreat.[83] You, [Cardinal] Giulio, having strolled[84] among your mighty friends, fixing your eyes on your father and regarding the serene face of your uncle, will admire the palpable majesty of each, and although your evident virtue needs no spur, you will want to seem to them to have done well.[85]

[226–44] "In another part, from the tower which looks out on the damp south,[86] let a belvedere[87] arise, whence [Cardinal] Giulio,[88] looking toward my stream, may nourish from on high, with his noble presence, eternal spring on Tuscan banks:[89] then, then will I rejoice, then be worthy of worship, and first among rivers. From this place the divine clemency of Leone, which is embodied by the pigments of Apellean art, will breathe upon me:[90] when they prepared to murder a man so gentle, who did not at all fear such [death] – and for this reason he was saved by the gods themselves – then [Clemency][91] was prompt not only to spare suppliants,[92] but also to strengthen wavering spirits, maintain [suppliants] in honor, raise through richness, and strike no friends from the list except those whom fierce will did not allow to repent, [thus they are] most worthy of all tortures and of being

post aquila et facies hominis Clementia divum
aemula quadriiugis quoque sacris digna triumphet.
 Ad tua iam descendo, ducum nunc maxime, Laurens, 245
atria, perspicuis longum spectanda columnis,
quae Scauri domibus nunc exquiruntur in ipsis,
actutumque veham. Magni genitoris imago
hic sedeat, nymphae Lyris[12] cui bella gerenti
barbariem adversus pro libertate Latina 250
instruxere dolos, tacitasque tulere sub undas,
sive rebelli odio, iuvenis seu lumine captae;
Ascanii haud clamatus Hylas in margine tantum,
Pïerus Euboico quantum est in littore,[13] adusque
Caietam umbrosae per florida regna Maricae. 255
Hic tu illum tandem teque ille suosque nepotes,
quos sperare tibi magno de sanguine regum
contigit, ut Medicum proles in saecula tendat,
aspicies, hic laeta parens, hic maxima coniunx.
 Sed mihi prae querulo demum precordia luctu 260
rumpantur, divo si sedem hic ponere Iulo
admonear, Iulo ingenti virtutis alumno,
quem viduo Philiberta toro castissima coniunx
plorat adhuc thalamoque illam assentire secundo
non regina soror precibus, non iussa nepotis 265
regia persuadent questu lachrymisque madentem.
Quare illum coelo, cuius praereptus obivit
invidia, penitus linquamus, ut ipsa dolori
conferat – heu miserum auxilium et lachrymabile! – Lethe.
 At medio specula assurgens quae spectat ad Eurum 270
ac Boream, et quicquid circumque infraque supraque
pulchri Roma tenet, sublimi lumine lustrat,
haec tua sit sedes, Leo rex hominumque paterque.
Erigat hic sensus artem ingeniumque Raphael,
hic sit Apelleas studium superare figuras, 275
hic tolli sibi nomen amet, spes aemula ut omnes
destituat, solo admirandi ardore relicto.
Instructas acies hinc quas hortatur Iberus,
illinc quas Rhodanus paries ferat, utque tubarum
audito hortatu, infestis mox utraque signis 280
concurrit: non densa solet sic horrida grando
hybernique imbres ruere, ut per inane ruebat
telorum omne genus, plumbique a sulphure glandes
contortae et ferri moles ex aere frementi
et iam laeta dabat victoria gramen Ibero, 285

[12] *Lyris*: less correct than *Liris*.
[13] *littore*: stands for *litore*. This use of double consonants is very common in neo-Latin poetry for metrical
 purposes.

removed from the whole condition of mankind. Herself [Clemency], filled with joy, drawn through the cities on a golden chariot, here by a horned bull and there a Libyan lion, next an eagle and the face of a man, Clemency, rival of the gods, will triumph, worthy even of the holy quadriga.[93]

[245–59] "Already I go down to your halls, Lorenzo [Duke of Urbino],[94] now the greatest of dukes, to be gazed upon long with their translucent columns which are now sought in the very houses of Scaurus,[95] and forthwith I carry them here; let the image of the great begetter [Piero][96] be placed[97] here, for whom, making war for the liberty of Latium against barbarism, the nymphs of the river Liri[98] prepared snares and carried him under the silent waters either because they hated him, the rebel, or were seized by the brilliance of his youth; nor was Hylas lamented on the Ascanius river bank as much as Piero was on the Euboean shore up to Gaeta, [99] through the flowery realm of shady Marica.[100] Here, at last!, you shall see him, and he shall see you and his descendants, whom you may expect from the grand blood of kings, so that the seed of the Medici may last for ever; here stands the happy mother [Madeleine],[101] here the greatest spouse.[102]

[260–9] "But finally my heart will break with plaintive grief, if I am reminded to put here a place for superb Giuliano [Duke of Nemours],[103] Giuliano the great student of virtue, for whom Philiberta[104] most chaste spouse weeps on her widowed couch; neither the Queen her sister[105] with her prayers nor the royal commands of her nephew[106] can persuade her, still mourning with grief and tears, to a second marriage. Therefore let us leave him in the deepest heavens, by whose envy snatched off he died, so that Lethe herself, alas! miserable and tearful aid, may contribute to grief.

[270–303] "And the belvedere rising in the center which looks out to the east and north, and with elevated gaze covers whatever beauties Rome encompasses all around, above and below, let this be your seat, Leone, king and father of mankind.[107] Here[108] let Raphael elevate the skill and ingenuity[109] of visual experience, here let him be zealous to surpass the forms of Apelles, here let him find pleasure in his exalted fame so that everyone abandons any hope of emulating him, only the fervor of admiration remaining.

cum mox, Hestensis sese dux vertit ad artem,
cui genitore olim revocante et turpe putante,
a puero incubuit. Nempe inter inertia semper
instrumenta necis, fauces versatus ahenas[14]
sulphuris et nitri cumulos, vix dignus haberi 290
sceptrum humili gestare manu, sed fata ferebant
artibus his olim rerum discrimina solvi.
Machina nanque[15] illo ductante opponitur omnis
vincentum lateri, magno haec cum murmure densos
impetit, et larga solvit cum caede maniplos: 295
cernere erat galeas vulsa cervice rotari
brachia, thoracasque, et crura trementia leto;
It cruor undatim, surguntque cadavere montes,
infelix facies rerum et lachrymanda Latinis,
et Rhodano non laeta, aeque et funebris Ibero. 300
Tum quibus ardebant animoso in pectore laudes,
instaurare aciem, cornu revocare solutum,
tendereque ad pulchram caeco in discrimine mortem.
 Infami at plures pugna nutante saluti
consuluere fuga, sed non fortissimus heros, 305
famaque belligerae Petrus iam summa Navarrae,
non virtus Cardona aevo mandata perenni,
non tu, summe Leo, qui tum vice fructus eadem
quam modo demandas aliis, praecepta facessens
pontificis, clamore viros hortaris in arma 310
magnanimo, praescripta tibi nanque arma, diuque
dum retines pugnam, demum interceptus ab hoste
captivus traheris, regi admirabile pignus.
Iamque per Eridanum te traiectura patentem
hostilis properat manus, indignatus ab alto 315
exerit amne caput, conchaque immane strepenti
– res mira! – intonuit fluviorum protinus ut rex,
omnia concurrunt ingenti rura tumultu,
ad sonitumque patris circum bacchantur agrestes.

[14] *ahenas*: see note 10.
[15] See above line 76.

"Behold! On this side, the wall bears armies arrayed,[110] those the Ebro exhorts, on the other side those the Rhône [exhorts],[111] as if as soon as the incitement of trumpets is heard, they immediately engage each other in battle: not thus do swelling hail and winter rains fall, as through the air every kind of weapon fell, bullets of lead propelled by sulfur and a mass of iron from rumbling bronze; and joyful Victory was already giving the palm to the Ebro, when suddenly the Este Duke[112] turned to the craft he had known since childhood, his father long ago dissuading him and considering it ignoble; in fact, always among lifeless instruments of death, he was devoted to bronze mouths and to heaps of sulfur and niter,[113] when you would have considered him hardly able to hold a stick with his little hand, but long ago the Fates had decreed that by these arts struggles would be decided. For, with him directing, the whole formation opposes the winning side, and with a great roar it falls on crowded ranks, and clears them with great slaughter. One could discern helmets spinning with neck torn away, arms, torsos, and legs trembling with fear of death; blood flows in waves, and mountains of corpses rise, a wretched vision of things, at once lamentable for the Italian, miserable for the Rhône, and equally mournful for the Ebro. Then those in whose courageous breast fame burned [began to] renew the battle formation, recall the disordered wing, and seek a fair death in the blind conflict.

[304–19] "Yet many cowards, the battle faltering, took thought for safety by flight, but not the mightiest of heroes, Petrus,[114] already the greatest pride of warlike Navarre, not Cardona,[115] virtue to be remembered forever, not you, greatest Leo, who once did in your turn what now you entrust others to do;[116] you carrying out the precepts of the Pope, exhort the men to battle with bold call, for arms are ordered upon you, and while you continue the fight for so long, at last captured by the enemy you are dragged as a captive, a splendid hostage for the King. Already the enemy force hastens to take you across the open Po [who], indignant, raises his head from the deep bed, and (remarkable thing), a conch sounding fearsomely, as soon as the king of rivers thunders, from all over the countryside people run up with mighty confusion, and at the sound of their father the rustics rage round about.

Tum Mutinae decus et fidei, succensus amoris 320
excelsique animi stimulo atque ardore iuventae,
solus[16] in armigeros te circum gaesa tenentes
irruit incautos et agrestum voce paventes,
distinuitque adeo, evadendi ut facta potestas
sit tibi, dein magno percussus vulnere ripis 325
concidit Eridani, Gallis fugientibus instant
indigenae ac demum tibi diis gratissime et illi
parta salus. Debes Mutinae, quae tempore duro
nec semel una fuit fidei tibi sedula custos,
nec deerit − non vana loquor: si proruat aether 330
omnis, erunt Mutinae fidissima pectora casus.
 At quae cura tui superis fuit! ut tua virtus
premia tum demum, cum visa est obruta cuique
accepit! Patriae primum tibi redditae habenae,
quas dolus abstulerat fratri, nec mensibus annum 335
demensis, solio excelso Romana potestas
unde orbi dat iura sedes, rarumque senatum
luminibus merito ascitis lucere frequentem
iussisti et placida terras cum pace gubernans,
aurea restituis Saturni tempora Romae. 340
 Ordine sed postquam cuncta haec color arte magistra
fecerit, ut credant oculi spirare figuras,
addi etiam maiora peto: persuasa moveri
bella Asiae te, summe Leo, duce et auspice, latos
restitui imperio fines, Solymasque receptas 345
exuere infandos mores, vitamque ferinam,
quem et nasci videre, colant de more Tonantem,
quem videre mori, et magnae post funera mortis
scandere sidereos cunctis mirantibus orbes;
atque ubi solennes ritus festosque sacrarit 350
more dies, clarosque illis praefecerit oris
rectores, magna Hesperia repetente parentem,
Auratis tandem vectus Leo regna quadrigis
Europae repetet plaudentis vincula Idaspem,
Euphratem, Tigrimque trahent cervice rebelli 355
iam dignante, iugumque et regis sceptra Latini.
 Tu quoque gestorum consors revehere quadriga
consiliis animisque potens et robore, Iuli,
regnatorem Asiae devinctum colla catenis,
quas meret, et nexos genitori pone superbo, 360
turpiter ire iubens natos proceresque ducesque,
expectata dabis magnae spectacula demum
Ausoniae, et quamvis magnos spectare triumphos
contigerit nobis olim florente Quiritum
imperio, tamen his dicas, tu Roma, minores. 365

[16] *Mutinae decus … succensus … solus*: about the syntax, see gloss note 117.

[320–40] "Then, oh glory of faithful Modena [Andrea Guidoni]![117] inflamed with love for a noble spirit [i.e. Leone], and with the ardor of youth, alone hurls himself on the spear-bearing soldiers around you, unwary and scared by the shouts of the peasants, and detains them until you have the chance to escape, and then falls with a grave wound on the banks of the Po; the locals pursue the fleeing French, and at last you reach a safety most welcome to the gods as to him [i.e. Guidoni]. You are in debt to Modena, who in a difficult time, and not just once, was the sole eager keeper of faith to you, nor shall he abandon you; neither do I speak vainly: if the whole sky falls the most faithful hearts will be found in Modena in every eventuality. But what care did the gods have of you! For your virtue only then received its reward, when to everyone it seemed overwhelmed. First the reins of the fatherland, which trickery had wrested from your brother, were restored to you;[118] not a whole year having passed, you sit on the exalted throne whence Roman authority gives laws to the world, and you have ordered the scanty Senate[119] to become numerous and illustrious by creating eminent members,[120] and governing the earth with restful peace, you restore to Rome the Golden Age of Saturn.[121]

[341–56] "But after paint has shaped all these deeds in sequence with magisterial skill, so that the eyes believe the forms to be breathing,[122] I ask for still greater to be added: the wars of Asia, which you, greatest Leo, as inspirer and leader, exhorted [the European princes] to fight, the broad bounds of empire to be restored, and, once Jerusalem was reconquered, to drive out shameful customs and beastly life; they [the people of Jerusalem], who saw born the Thunderer[123] shall worship rightly, they who saw him die, and, after the rites of his great death, ascend the stellar spheres to universal wonder [i.e. the resurrection of Christ]. And when he [Leone] shall have celebrated properly the solemn rites and feast days, and shall have placed illustrious governors in those regions, with Italy reclaiming her father, then Leone borne on golden chariots shall return to the kingdoms of an applauding Europe, [and] Hydaspes, Euphrates, and Tigris, their rebellious necks now bowed, shall bear the chains, the yoke,[124] and the scepter of the Latin king.

[357–65] "You too, Giulio, sharer of these deeds, strong in counsel, spirit, and might, shall be borne on a chariot: you shall chain the defeated ruler of Asia, you shall tie with deserved bonds the arrogant father [Selim I],[125] forcing his children, the nobles and the generals to walk in shame; you shall at last give to great Italy[126] its longed-for spectacle; and although it fell to us to watch great triumphs when the Empire of Roman citizens[127] flourished, yet you, Rome, will say that they were inferior to these.

Ipse etiam Laurens, nitidis spectandus in armis,
Bistonio dux vectus equo, lauroque revinctus
laurigeros inter reges pubemque Latinam
ibit ovans: magno coelum clamore tonabit,
dum tota Europa Medicum tolletur in astra 370
nomen et ipsa, Leo, Leo! tecta urbesque boabunt.
Haec equidem video fatorum praescius utque
gesta volo iam nunc speculae a pictoribus addi,
ut quoties oculos huc vertet Iulius, ardor
tantae animum famae accendat; nam maior honorum 375
huic stimulo non ullus erit: per caeca pericla
gloria praecipitem impellat virtusque fidesque.
 Cetera membra domus magnae subtusque supraque
praetereo tacitus, speculas, aulasque patentes,
cumque suo scenam non una fronte theatro, 380
munitumque caput geminatis turribus ad vim
eminus arcendam, ut genio pax tuta fruatur,
utque cubile frequens, ut porticus, ut vitreus fons
non unus tectis, nec balnea mutua aquarum
commemoro, aut xystum ramis frondentibus alte 385
contextum, et tonsa buxo, myrtoque virenti;
a latere indutum, vitreamque a margine xysti
piscinam, gradibus circum scandentibus imis,
hippodromumque et equis stabula alta a fronte, fluentes
ad quae sponte sua lymphae in praesaepia tendent: 390
omnia post melius. Diversum inquirere marmor
nunc opus, et plures ad tot dimensa columnas
atria, et in varias lusura asarota figuras
ingentesque trabes, largum quas imbuat aurum;
nanque peregrino pars marmore nulla vacabit 395
assumet nil vile domus: Caieta reponit
selectas citros, Campania tota requirit
insignes plantas, quid non Pomona revolvit?
Ipsa hortos colere ac maturo tempore ramos
Inserere, ut varios diversa ex arbore fructus 400
una ferat, totumque vireta graventur in annum
pollicita est, hic regna sibi, hic fore Thessala Tempe.
Non unus Thybrim versat labor, undique curae
impendent gratae ob dominum cui blanda Voluptas
frena gerit, Virtusque comes, Concordia custos, 405
Sidera amica, Leo frater, deus, arbiter et rex".
 Dixit arenosoque caput mox condidit alveo.

[366–77] "Also the general Lorenzo[128] himself, admirable in his gleaming weapons, the duke riding a Thracian horse, and wreathed with laurel, shall go triumphant among the laurel-bearing kings and the Latin youth; heaven shall thunder with the great clamor, while Europe raises the Medici name up to the stars, and the buildings themselves and the cities shall roar: Leone, Leone! These deeds, truly, I see with foreknowledge of the fates, as if already done and I want them now added to the belvedere[129] by the painters, so that whenever Giulio casts his eyes hither, the desire for such fame might inflame his mind; for there shall be no spur to honor greater than this: may glory, courage, and faith impel him headlong through hidden dangers.

[378–91] "The other elements of the great house, above and below, I pass over in silence,[130] the many belvedere and open courtyards and the stage of the theater with not just one backdrop[131] and the head[132] fortified by twin towers to prevent attack a long way off, so that in safety and peace one might enjoy the amenity [of the place]; likewise the many resting-places, the porticoes, the several fountains shining indoors, not to mention the circulating baths of water, nor the xystus woven above with leafy branches and clad on one side with clipped box and green myrtle, nor the transparent fishpond next to the xystus[133] with steps all round ascending from the depths,[134] nor the hippodrome and the lofty-fronted horse-stables, to which water will flow of its own accord to the mangers. All this better anon.

[391–407] "Now,[135] it is necessary to search out the different marbles and the many columns to be placed around the planned courtyards[136] and the mosaic floors[137] contriving varied figures, and the huge roof-beams clad in plentiful gold; for no part shall be without exotic marble, and the house shall incorporate nothing cheap: Gaeta contributes choice citron trees,[138] all Campania provides the most noble seedlings, what does Pomona not revive?[139] She, indeed, shall cultivate the orchard and graft the branches at the right moment, so that one and the same tree could bear various fruits[140] and the greenery[141] shall be weighed down all year: here would be her realm, here her Thessalian Tempe.[142] Not one labor alone exercises the Tiber, from every side impend pleasing cares, because of the master; his reins are plied by blandishing Pleasure,[143] and Virtue is the companion, Harmony the guard, Constellations the friends, brother Leone, God, judge and king".

Thus he spoke, and then buried his head in the sandy river-bed.[144]

GLOSS

1. In the address to Cardinal Giulio that titles the poem, Sperulo uses *fabricatum* to emphasize that his role is practical as well as metaphorical; throughout the poem, he claims to be on site and physically working with materials, devising placement of marbles, and bringing the villa into being.

2. The topos of the *locus amoenus*, used by ancient poets to describe villas and natural beauty; for which, Curtius, *European Literature and the Latin Middle Ages*, 190–202; Newlands, "The Transformation of the 'Locus Amoenus' in Roman Poetry." See also lines 30 and 401–2; the poet effectively opens and closes the poem with this imagery.

3. The first of several references to the ambition for the villa to surpass antiquity. See also lines 12, 163, and 275.

4. The Horatian topos of which will last longer, poetry or monuments (Horace, *Odes*, III, 30), frequently evoked by Renaissance poets, discussed in Chapter 2, p. 55 and notes 55–6. Sperulo's odd conceit about a glue made of lime and sand (the ingredients of stucco) and his use of *glutinum*, a relatively unusual word mostly used in technical literature, refers to Vitruvius' description of lime-slaking for stucco facture: "cum vero pinguis fuerit et recte macerata, circa id ferramentum uti glutinum haerens omni ratione probabit esse temperatam" ("when, however, the lime is rich and duly slaked, it clings round the tool like glue, and shows that it is properly mixed"): Vitruvius, *De architectura*, VII, 2.2. That the poet knew this technical passage suggests exchange between artists and wordsmiths about their ancient sources, as discussed on pp. 124–5 and 148–9. Thus, Sperulo transforms the words-versus-marbles topos into ink-versus-stucco, particularizing it for the Medici villa, where the newly revived material of stucco would articulate every surface.

5. The poet hopes that Cardinal Giulio will reward the speed with which he completed the poem – ostensibly in just two days, as he says at the outset. Speed of execution was a trope of apology and also a badge of poetic *furor* and *ingenium*; see Chapter 2 p. 59 and notes 82–3.

6. An image of the poet as blacksmith, evoking Vulcan/Hephaestus, the god of all artificers, with the power of prophecy. In Virgil, *Aeneid*, VIII, 626–8, Vulcan forges the Shield of Aeneas that foretells the story of Italy and the triumphs of Rome: "Illic res Italas Romanorumque triumphos haud vatum ignarus venturique aevi fecerat ignipotens." ("There the story of Italy and the triumphs of Rome had the Lord of Fire fashioned, not unversed in prophecy or unknowing of the age to come.") For Vulcan as one of Sperulo's authorial personae, see pp. 69–72.

7. In classical Latin, a *praetorium* signified a large mansion or palace, from the dwelling of a *praetor*, or Roman magistrate (OLD, *praetorium*, def. 3). Sperulo's choice of the word reflects Statius' usage of it for the twin mansions on either side of the river Anio that comprised the villa of Manilius Vopiscus at Tibur ("alternas servant praetoria ripas," Statius, *Silvae*, I, 3, 25). See also the discussion in Newlands, *Statius' Silvae and the Poetics of Empire*, 179.

8. The poetic conceit of a building so vast that the roofline approaches the stars or heaven itself is perhaps drawn from Statius' encomium of Domitian's Palatine palace (*Silvae*, IV, 2, 30–1); the impossibility in masonry construction of foundations being laid at the same time that the roof was being built reflects the poetic rather than documentary nature of this passage.

9. Sperulo announces his debt to Statius with several references in the opening lines of the poem, literally echoing the ancient poet's description of construction noise. Lines 1–3 evoke Statius' *silva* about Domitian's construction of a road in Campania: "Quis duri silicis gravisque ferri / immanis sonus aequori propinquum / saxosae latus Appiae replevit?" ("What monstrous sound of hard flint and heavy iron has filled paved Appia on the side that borders the sea?"): Statius, *Silvae*, IV, 3, 1–3. Lines 5–7 draw on two further passages from Statius: *Silvae*, I, 1, 63–5, on the sound of Domitian's equestrian monument being raised: "strepit ardua pulsa / machina; continuus septem per culmina Martis / it fragor et magnae vincit vaga murmura Romae." ("The lofty scaffolding is loud with hammer strokes and an incessant din runs through Mars' seven hills, drowning the vagrant noises of great Rome."); and *Silvae* IV, 3, 61–4 on the building of Domitian's road: "Fervent litora mobilesque silvae. / it longus medias fragor per urbes / atque echo simul hinc et inde fractam / Gauro Massicus uvifer remittit." ("The shore and waving woods are astir. The lengthy din travels through the towns between and grapy [e.g. vine-bearing] Massicus sends back to Gaurus the echo broken at either end.") Of course, this

imagery subverts the more tranquil sounds normally associated with a *locus amoenus*; on sound in poetic landscape, see Newlands, "The Transformation of the 'Locus Amoenus' in Roman Poetry," 94–5. Furthermore, Statius' passage about Domitian's statue evokes Virgil's Cyclops forging the shield of Aeneas, so, at another level, this is also an intertextual riff on the creative power of the poet.

10. An echo of the phrase, "pater ipse suberbus aquarum Ausonidum Eridanus," referring to the Po, in Silius Italicus, *Punica*, IX, 187–8. The seventeen-book epic *Punica* was discovered in 1417, and its importance for Renaissance humanists has been little studied. That Silius Italicus was a collector of art and owned several villas, including one of Cicero's, may have made him an attractive model for Sperulo's villa poem.

11. *hortatur … Eia agite!* (11–12): from the beginning of Father Tiber's speech, Sperulo emphasizes its hortatory nature using vocabulary and the hortatory subjunctive. For Tiber as Sperulo's authorial persona, and the suggestion that the poet actually *was* engaged in many of the tasks the Tiber claims to be doing, see pp. 67–9, 72–3 and *passim*; for the poem as an example of a poetic genre I identify as hortatory *ekphrasis*, see p. 91.

12. The conceit of a villa so marvelous that the gods fly down to visit was familiar from other Coryciana poems, including the Chigi villa panegyrics of Blosio and Gallo.

13. An evocation of Statius, *Silvae* I, 2, *Epithalamium in Stellam et Violentillam*, lines 156–7 on Venus' visit to the house of Stella: "hic Sirius alget, / bruma tepet, versumque domus sibi tempeat annum." ("Here Sirius is chill, midwinter warm. The house tempers the changing year to its liking.") Sperulo further presents a situation in which all ordinary rules and categories are subverted.

14. *Iaccho*: from *Iacchus*, an epithet for Bacchus (often used as a synonym for "wine"), but here a synonym for *strepitus* or *clamor*, which derives from the Bacchantes and their wild shouts during rituals: *Iacchè, Iacchè*, etc. Sperulo uses the word as a metaphor for the violence of the South Wind. (NM)

15. Perhaps a reference to the extraordinary war booty of fine paintings and sculptures taken back to Rome after Marcellus' Siege of Syracuse, which initiated the Roman enthusiasm for Greek works of art, according to Livy, *History of Rome*, XXV, 40, 1 –3; also described by Polybius, *The Histories*, IX, 10. Gwynne, *Patterns of Patronage*, vol. 2, 124–5, offers the interesting interpretation that it instead relates to the skill of Archimedes with his globe (*sphaerae mundi*), suggesting that it likens the villa to the globe. This reading would be consonant with Sperulo's engagement with cosmological and astrological imagery that would later appear in the villa, which was cast as a microcosm of Leo's realm, and of the cosmos. This imagery was also consistent with the poet's repeated references to Cosmus and meanings attached to the Medici *palle*; and perhaps also constituted a play on the poet's own name, sometimes spelled Sferolo. See p. 23, lines 70, 109–10, 116, 182, 211, 219, 370, 406, and gloss notes 35, 51, 80, 83 below. This imagery predated, and perhaps prefigured, Cardinal Giulio's 1522 *impresa Candor illaesus*, which included an image of a crystal sphere, and which would be prominently featured in the villa's decorations.

16. A variation on the *locus amoenus*, for which see the dedicatory letter, §2. Sperulo's *amoena vireta* (see also line 401; for the form *vireta* see note 2 to the Latin) recalls some classical sources: *virecta* is a Virgilian coinage (*Aeneid*, VI, 639–40: "locos beatos et *amoena virecta* / fortunatorum nemorum sedisque beatas", later borrowed by Prudentius, where it is Paradise itself. Prudentius, *Cathamerinon*, hymn III, 101–5: "Tunc per *amoena virecta* iubet / frondicomis habitare locis, / ver ubi perpetuum redolet / prataque multicolora latex / quadrifluo celer amne rigat," in Aurelii Prudentii Clementis, *Carmina*, ed. Mauricii P. Cunningham, Corpus Christianorum, Series Latina 126 (Turnhout, 1966), 14; see also Apuleius, *Metamorphoses*, IV, 2: "laetissima virecta." The English *greenery* allows for various forms of green places. See "greeneries" in P. Vergili Maronis, Aeneidos Liber sextus, with a commentary by R. G. Austin (Oxford, 1977), 203. (NM)

17. Laurel was sacred to Apollo, and of course was an emblem of Lorenzo de' Medici. Petrarch used laurel as a symbol of immortality, and Poliziano and other Laurentian panegyrists had played on laurel/Lorenzo as a metaphor of Medici stability. It was further connected with Venus; Poliziano mentioned laurel among the plants in the Garden of Love, and Lorenzo's own poetry places laurel among the perfumed trees of Venus: Levi D'Ancona, *Botticelli's*

Primavera, 43, 83–4. Pliny recorded that the laurel was an emblem of victory and peace, was the most beautiful tree on Mount Parnassus, and was pleasing to Apollo: Pliny, *Natural History*, xv, 40. Laurel traditionally formed the crown for poets and for triumphs. Laurel is intertwined with myrtle on the illuminated title page of Sperulo's poem (Plate IX); the illumination is analyzed in the following appendix.

18. Myrtle was sacred to Venus. In antiquity, crowns of myrtle were awarded to poets celebrating love (Ovid, *The Art of Love*, II, 733–4) and to generals who conquered without bloodshed (Pliny, *Natural History*, xv, 38, 125). In Poliziano's *Stanze*, Galatea wears myrtle (as well as roses) and Botticelli's Venus in the *Primavera* is framed with myrtle: Levi D'Ancona, *Botticelli's* Primavera, 86–7. As noted above, myrtle and laurel are intertwined on the illuminated title page of Sperulo's poem (Plate IX).

19. For the left bank of the Tiber as Tuscan or Etruscan, see Chapter 3, p. 67 and note 20.

20. Sperulo casts Cardinal Giulio as one of the *Lares*, gods who take care of a home and the people within it. (NM)

21. A play on Ovid's *Fasti*, IV, 830, when the king says to Jupiter, "auspicibus vobis hoc mihi surgat opus." ("Under your auspices may this my fabric rise!")

22. Perhaps he was here referring to the main entrance from the Vatican road, which as Raphael described, would lead into a vestibule (Raphael/Dewez, 22, §3–4). Although Sperulo loosely frames his poem as a walkabout, his description does not follow any logical itinerary, jumping from one end of the complex to another and back.

23. Sperulo's claim that highly polished Libyan marble from the Temple of Jupiter Tonans on the Capitoline would adorn the threshold and walls of the villa's vestibule evokes Pliny's reference to solid polished blocks of marble on the walls of this temple (*Natural History*, XXXVI, 8, 50). No vestige has been found of this temple, as noted by P. Gros, "Iuppiter Tonans, aedes" in *LTUR*, vol. 3, 159–60. Sperulo could have invented this provenance, drawing on the Plinian account, in order to emphasize Leo/Jupiter ideology, which would be prevalent in the villa, as it was at the Vatican and the Capitoline. However, this provenance might actually have been true, because Pirro Ligorio recorded excavations at this temple and its despoliation for use at St. Peter's. (As pointed out by Shearman, who considered this a unique reference to real marbles among Sperulo's otherwise literary descriptions: Shearman, *Sources*, vol. 1, 436.) Ligorio claims that Pentellic columns were taken from Jupiter's Temple to St. Peter's; see Lanciani, *Storia degli scavi e notizie intorno alle collezioni romane di antichita* (Rome, 1902), II/2, 94. In any case, Sperulo intended these revetments for one of the grand main entrances to the villa, in parts of the complex that were never executed.

24. Synnadic marble came from the quarries of Docimium, a city in Phrygia, Asia Minor. The quarries were under imperial control from the time of Tiberius and produced white and pavonazetto marble used for large-scale imperial building projects, including the Forum of Trajan in Rome: OCD, 489, 1463; Pliny, *Natural History*, XXXV, 1, 3.

25. In this passage, the poet enumerates the kinds of marble available to be installed in the villa, and in some cases their provenance.

26. Sperulo consistently uses *atria* to refer to spaces with significant marbles or spoils (lines 54–6, 79–81, 245–7, 391–3) although he does not specify exact locations of these in the villa.

27. There is sharp disagreement about whether the ruins of the gardens of Lucullus were known, or identified as such, in 1519; see Moneti, "Forma e posizione della villa degli horti Luculliani secondo i rilievi rinascimentale: la loro influenza sui progetti del Belvedere e delle Ville Madama, Barbaro e Aldobrandini [part 1]," *Palladio* 12 (1993): 5–24, at 13–14 (citing this passage of Sperulo as his only evidence that it was known to the Raphael school); and the response by Henri Broise and Vincent Jolivet, "A proposito di Andrea Moneti e la villa degli horti Luculliani, con una replica dell'autore," *Palladio* 20 (1997): 119–25. Lucullus' villa was located on the Pincian hill, partly on the site of the later Villa Medici, although the Medici did not yet own this site in 1519. I think Sperulo's reference is more likely based on a literary source, rather than an archeological one. Georgia Clarke notes that Lucullus

became almost a generic encomiastic term for a patron of architecture in this period: *Roman House – Renaissance Palaces*, 33–4.

28. A reference to a Plinian topos (*Natural History*, XXXVI, 4, 14): "Sed in Pariorum mirabile proditur, glaeba lapidis unius cuneis dividentium soluta, imaginem Sileni intus extitisse." ("As for the quarries of Paros, there is an extraordinary tradition that once, when the stone-breakers split a single block with their wedges, a likeness of Silenus was found inside.") A similar tale is told by Cicero, but the figure of Pan instead emerges: Cicero, *De divinatione*, I, 13, 23. Alberti repeats the Plinian tale, suggesting its familiarity to Renaissance audiences. The story reflects the topos of art created by nature, which is discussed by H. W. Janson, "The 'Image Made by Chance' in Renaissance Thought," in *Sixteen Studies* (New York, 1973), 53–74, and was important for the villa and its garden decorations. This passage from Sperulo has been misinterpreted to mean that there was a figural sculpture of Silenus at the villa; rather, Sperulo describes that these columns are of the same Parian marble as described by Pliny.

29. The Peloponnesian peninsula of Taenarum was home to quarries of rosso antico and black "Taenarian" marble. OCD, 1471.

30. The sanctuary of Aphrodite at Paphos. *Virebant* (59) could be read literally as the color green, although there is no textual or archeological evidence for green marble from Paphos or the Temple of Venus Genetrix; rather, Sperulo probably meant it metaphorically as the height of bloom or beauty, as translated here.

31. See Chapter 3, pp. 74–8 and notes 46–53 for the suggestion that Sperulo may have been referring to an actual marble from the Temple of Venus Genetrix that was, in fact, installed in the Medici villa.

32. *Quirites* was a name given to the collective citizens of Rome in their peacetime functions (OLD, "quirites" def. 1), and thus appropriate to the worship of peace-bringing Venus.

33. Suetonius (*Lives of the Caesars*, "Divus Iulius," 85) describes how, following the death of Julius Caesar, a 20-foot column of solid Numidian marble, inscribed "To the Father of his Country," was set up in the Forum: "Postea solidam columnam prope viginti pedum lapidis Numidici in Foro statuit inscripsitque "PARENTI PATRIAE." Whether the Medici actually had this or any other Numidian marble column is unknown (see the discussion in Chapter 3, pp. 75, 79 and notes 54–5). Numidian marble, a yellow African marble now known as *giallo antico*, was quarried in ancient Chemtou in Numidia: Gabriele Borghini, *Marmi antichi*, (Rome, 2001), 214–15, with bibliography. Under Julius Caesar, the great Numidian quarries passed from the patrimony of the Numidian kings to the Romans when the province of Africa expanded eastward in 46 BCE: J. B. Ward-Perkins, "Tripolitania and the Marble Trade," *Journal of Roman Studies* 41 (1951): 89–104, at 96; H. G. Horn, "Die antiken Steinbrüche von Chemtou Simitthus," in *Die Numider: Reiter und Könige nördlich der Sahara* (Bonn, 1979), 178–80. About literary references to Numidian marble, Valérie Maugan-Chemin, "Les couleurs du marbre chez Pline l'Ancien, Martial et Stace," in *Couleurs et matières dans l'Antiquité*, ed. Agnès Rouveret, Sandrine Dubel, and Valérie Naas (Paris, 2006), 103–26, at 111–12.

34. Iulo here carried the double meaning of Aeneas' son, ancestor of the Romans, and also Julius Caesar, to whom the column was dedicated (see previous note). This makes sense because the *gens Iulia* had Venus and Aeneas among their ancestors and divine protectors.

35. Astrological themes characteristic of Leonine imagery, including Leo's predestination to rule, run throughout the poem; see also lines 182, 370, 406. Sperulo is probably referring here to Leo's capture and escape at the Battle of Ravenna, which had been construed as miraculous and a harbinger of his papacy; the poet prescribes mural paintings of this battle for the villa in lines 274–340.

36. Line 71 is an echo of the Virgilian "parcere subjectis et debellare superbos" (Virgil, *Aeneid*, VI, 853), the mission of the Roman race, an observation I owe to James Hankins. This is also a Christian reference to Leo as *alter Christus*, and to his clemency, especially in the aftermath of the putative conspiracy against him; for which see lines 231–44 and notes 90–2 below.

37. A reference to the labors of Hercules, common in Medicean and Leonine imagery, drawing on Hercules' importance as a symbol of Florence. (For the representation of Hercules in the

sigillo used in the Chancery to sign official documents: Nicoletta Marcelli, *Gentile Becchi: il poeta, il vescovo, l'uomo* (Florence, 2015), 235–6 and nn. 51–2.)

38. For Leo and Giulio's joint patronage, see pp. 64–5. Sperulo's text here also closely reflects the ambiguous political situation in Florence: Leo was the governor of the city, but current affairs were administrated by Giulio on his behalf.

39. Sperulo uses the noun *sedes* and the verb *sedeo* in different senses: here as sites for sculptures of ancestors – which could mean thrones or simply places – and elsewhere to designate areas of the villa as figurative seats for the living Medici, or as the villa as an abode (see also lines 16, 27, 125, 128, 189, 206, 249, 261, 273, 337). It is unclear whether he is proposing seated or standing figures. Strikingly, the notion of thrones left empty took visual form in the marble decorations of the Medici New Sacristy, begun for Pope Leo and Cardinal Giulio in the same year as Sperulo's poem (1519); see the discussion in Chapter 5, pp. 130–1 and note 98.

40. *commensa*, from *commetior*; an exhortation to the architects, while they are still refining the plans, to leave room for sculpture in their measured halls, suggesting that the size of rooms and the placement of statues were being planned together at this time; discussed on pp. 83–4 and Chapter 6, section on "Poetry as design tool." See also his use of *dimensa* (392) and note 136 below.

41. From lines 78 to 208, Sperulo uses the conceit of a proposed ancestor sculpture gallery as a framework for the encomium of Medici forebears, which he concludes by specifying that they should all be placed in a *coenatio* – the villa's garden loggia. See Chapters 3–5 for discussion of this proposal in the context of the villa's planning and its literary antecedents. See Figure 25 for a tree of Medici family members mentioned in the poem.

42. With the use of *almus*, normally reserved for divinities, the poet is crediting the Medici family with divine, life-giving power. (NM)

43. Lars Porsenna, king of Clusium, one of the twelve cities of Etruria, who was important in the history of Rome at the beginning of the Republic. Sperulo is thus linking the Medici to Rome's Etruscan founders, and making the Etruscan/Tuscan–Roman link.

44. A reference to the perceived Turkish peril at this time, as discussed in Chapter 3, pp. 80–1 and notes 62–9.

45. The conceit of the patron as author; see the Introduction, p. 5 and note 18.

46. Giovanni di Bicci (1368–1429). About the form *Iani*, see the note to the Latin, line 96. The use of IANI is also surely a play on Janus, who controlled war and peace and the coming of the new year, and who was prominently featured in the façade frieze at Poggio, developed by Poliziano and executed at the time of Lorenzo; Sperulo is here linking the family founder to the god who controls the cycle of time.

47. *Daedala Curia* (97): an unusual, if not original, conceit likening the Papal Curia to the Daedalian Senate. The skillful Curia is further a metaphor for the Roman papacy, and, more generally, for Rome itself, where Giovanni de' Medici resided from *c.* 1385 to 1402, during which time he became the banker to the papacy and established the Medici Bank as one of the wealthiest in Europe. Daedalus was renowned for his skills as the architect of the labyrinth in Crete; in Latin the corresponding adjective *daedalius/daedalus* (lower case) means "skillful, dexterous" in a broader sense, here especially referring to the outstanding diplomatic and political skills of the Roman Curia. (NM)

48. Cosimo il Vecchio (1389–1464).

49. Florence, of course, did not have a Senate; this is another Romanization or a metaphor for the main Florentine institutions: I Tre Maggiori, i.e. the Gonfaloniere di Giustizia, Priori, and Collegi.

50. Machiavelli, in his history of Florence of *c.* 1520–25 written for Medici patrons, articulated a similar view of Cosimo's patrician propriety: "And although these dwellings and all [Cosimo's] other works and actions were kingly, and he alone in Florence was prince, nonetheless, so tempered was he by his prudence that he never overstepped civil modesty." Machiavelli, *Florentine Histories*, 281. For the issue of how direct or ambiguous Cosimo's control and visual patronage were, see most recently Dale Kent, *Cosimo de' Medici and the Florentine Renaissance*, ch. XV, with extensive earlier bibliography. Nicoletta Marcelli notes that the tropes of praise Sperulo uses throughout the poem, and especially in praise of

Cosimo, reveal his deep familiarity with earlier poetry about the Medici, especially from the time of Lorenzo the Magnificent; for which, see the section on poetry dedicated to Cosimo with earlier bibliography in Marcelli, *Gentile Becchi*, 219–52.

51. *Cosmus* is an allusive play on the Greek word κόσμος, which could mean either *world* or *rule* or, more rarely, *glory*. This was a popular topos among the poets close to Lorenzo the Magnificent, especially Naldo Naldi, Cristoforo Landino, and Gentile Becchi. (NM)

52. The image of the lilies of Florence springing from the conches of Roman Venus is part of the poet's imagery that Romanizes the Tuscan Medici (see also p. 20). This phrase also alludes to imagery of the generative Venus familiar from Laurentian Florence, especially in Poliziano's *Stanze*, I, 99–101 and Botticelli's painted *poesie*, which would figure prominently in the decorative imagery of Villa Madama (discussed on pp. 71–2, 74–8 and 116–18).

53. The eternal spring associated with the Medici, which Sperulo mentions many times (see also gloss notes 78, 89). The conceit was particularly associated with Lorenzo, as in his motto *Le tems revient* (for which see pp. 20, 50 and 116–17). The fantastical description of a jeweled setting for the sculpture of Cosimo reflects the tradition of such *ekphrases* as allegories of the Heavenly Jerusalem (for which see Chapter 4, pp. 92–3 and note 37), and is surely a marker of the importance the poet is attaching to this sculpture, rather than a literal proposal.

54. In lines 128 and again in 156–8, he is being unusually specific about location, here using *post hunc* to indicate the physical placement of these statues, rather than succession in a list. (NM) This language is consonant with the function of the poem as a walkthrough, whether literary or literal.

55. Here *aureus* is used metaphorically for places, as in many early Christian authors: *aurea Roma* in Juvencus, *Evangeliorum libri IV*, praef. v. 2: "Inmortale nihil mundi conpage tenetur, / Non orbis, non regna hominum, non aurea Roma, / Non mare, non tellus, non ignea sidera caeli"; and especially for Paradise, see Paulinus Bishop of Aquileia, *Regula fidei* (poem), "Hac Petrus in clavi caelorum limina pandit / *Aurea* ruricolas reserans *ad regna* phalanges," in *L'œuvre poétique de Paulin d'Aquilée*, edition critique avec introduction et commentaire de Dag Norberg (Stockholm, 1979), 92. (NM)

56. Cosimo's sons: Piero il Gottoso (1416–69) and Giovanni de' Medici (1421–63). For empty thrones, see lines 78–9 and note 39 above.

57. *Larga ... manus*: a topos used by Medicean poets to indicate the family's munificence, especially that of Cosimo. See Gentile Becchi's poem praising Cosimo's *Larga manus*, in Marcelli, *Gentile Becchi*, 225 and 231 n. 10. This imagery was perhaps related to the *manu fortis* of David and Hercules, but emphasizing a different type of power: a magnanimous/generous hand, as Becchi and Sperulo use it, as opposed to a strong hand.

58. The poet alludes to Giovanni's stay in Ferrara as the head of the Medici Bank branch, where he acquired a refined and humanistic education. (NM)

59. One of the three goddesses of fate and human destiny.

60. This echoes what Machiavelli says about *respettivo* and *impetuoso* as different behaviors, appropriate to varied situations: *Il principe*, ch. 25.

61. A reference to Piero's gout.

62. The failed conspiracy organized by Dietisalvi Neroni, Agnolo Acciaiuoli, and Luca Pitti in 1466.

63. The poet is suggesting that the statue of Cosimo should face those of his two sons; see also line 128. The imagery of propagating a branch from shoots evokes the Medici *imprese* of laurel-Lorenzo, and the *broncone* symbolic of Medici restoration. For which, Cox-Rearick, *Dynasty and Destiny*; and Francesco Bausi, "Il broncone e la fenice," Archivio storico italiano 552 (1992): 437–54. For *broncone* in the illumination of Sperulo's manuscript, see Appendix II.

64. The brothers Lorenzo il Magnifico (1449–92) and Giuliano de' Medici (1453–78). Sperulo refers to Giuliano as *Julus*, following Poliziano's practice in the *Stanze* of calling him *Iulo*, after Aeneas' son.

65. Raphael's paintings will make Apelles, the Syracusan master, turn green with envy.

66. Sperulo is challenging Raphael about where to place the figure of Lorenzo the Magnificent in the house. For the poet's proposal, see, lines 189–92 and note 73 below.

67. Another reference to the eternal return of spring under the Medici.

68. A reference to the Medici exile and the Italian wars after 1494.

69. The Rhône represents France, the Ebro Spain, and the Po Italy in this description of the Italian wars.

70. Pope Leo X, formerly Giovanni de' Medici, son of Lorenzo il Magnifico. A reference to the astrological topos that he was predestined for the papacy. See line 70 and note 35 above.

71. The topos of Leo as *Rex pacificus*, who tried to achieve a peace among the European powers to unite them in a crusade against the Turks.

72. The poet is claiming that his actual responsibilities at the villa are more pressing than an encomium.

73. The notion of a marble Lorenzo-as-Apollo surrounded by the Muses presents the villa as Parnassus, evoking topoi of *otium* associated with *villeggiatura*, and also the trope of the living, breathing statue. Further, the poet is probably making a literal proposal for using the ancient sculptures of the *Muses*, some from Hadrian's Villa, which were at Villa Madama, for which see Chapter 5, section on "Parnassus"; for this proposal as a challenge to Raphael, see above line 164 and pp. 83–4, 107, 110–11 and 156–7.

74. Giuliano de' Medici (1453–78), who was murdered in the Florentine Duomo in the Pazzi conspiracy.

75. The poet is addressing Cardinal Giulio de' Medici, son of the murdered Giuliano.

76. Here the text is vague about who delights in Giulio's accomplishments: Virtue or his father Giuliano. The latter choice is consistent with other sections in which the poet has living Medici family members interact with "living" statues of deceased ancestors (e.g. lines 256–9).

77. Lines 206–8 wrap up the encomium of ancestors, proposing that most of their sculptures be placed in the *coenatio*, or dining hall; it is clear from Sperulo's description of a grand vestibule on the right, gardens on the left, that he is referring to the garden loggia, as if he were standing in it, back to the hillside, facing the long façade of the building (see plans in Figures 15, 26). For Sperulo's choice of the word *coenatio* and literary models, including Statius' description of Domitian's banquet hall, and his metaphorical construct for this space as the *coenatio Iovis*, see pp. 124–6.

78. Another reference to the eternal spring of the Medici reign (see also gloss notes 53, 90), and to the motto GLOVIS, used at Poggio a Caiano and elsewhere.

79. Aeolus (in line 209), the ruler of the winds, who lived in the Aeolian (Lipari) Islands; Homer makes him human (*Odyssey*, x, 1–79), whereas he appears as a minor deity in Virgil, *Aeneid*, I, 52.

80. The conceit that a villa will withstand the scorching heat of the Dog Star, from Statius, who notes that, "Sirius' hot star did not bark" (illum nec calido latravit Sirius astro) at one who experienced the chill (*glaciale*) villa of Manilius Vopiscus at Tibur (*Silvae*, I, 3, 5). The Dog Star was also important in Pope Leo's horoscope, related to the Sun and creation; thus it appears in the astrological iconography of the Sala dei Pontefice in the Vatican and the imagery of the Poggio a Caiano frescoes, planned contemporaneously with Villa Madama and Sperulo's poem; see Cox-Rearick, *Dynasty and Destiny*, 195 and *passim*; and Susan Regan McKillop, Franciabigio (Berkeley, 1974), 76. (Some depictions of dogs refer to the Dog Star, or jokingly to early Medici *stemme* with dogs; a later fresco at Poggio by Allori depicts a dog bearing a written message of warning for Medici opponents: *si latrabitis, latrabo* [if you bark, I too will bark], surely reflecting the ongoing intertextuality of Medici imagery: Cox-Rearick, *Dynasty and Destiny*, 107–8.)

81. Evergreen laurel and everlasting citrus suggest the immortality of the Medici. For laurel, see line 31 and note 17 above. Citrus, especially oranges, were Medici emblems because of their similarity to the Medici *palle*, and from a play on the Latin term for oranges, *Citrus medica*, or the confusingly named *mala medica*. An orange grove with laurel was the background setting for Botticelli's *Primavera*. Valeriano recorded that, under Clement VII, the Medici interpreted the health of a citrus grove as a harbinger of family fortune: Valeriano, *Hieroglyphica*, lib. III, ch. III, under "Creta." Citrus was also associated with the Garden of the Hesperides and with Venus. Hesperidian Garden imagery was a Medici topos invoked from the gardens of Lorenzo de' Medici and the decorations of Poggio a Caiano to the Vatican Belvedere under Leo X: Levi D'Ancona, *Botticelli's* Primavera, 42–3, 87–9; and Cox-Rearick, *Dynasty and Destiny*, 48 and *passim*. In Raphael's letter describing the villa, his only reference to specific

plants is to sour orange trees (*melangholi*, or *mala medica/arancio amaro*) in an interior garden court (Figure 15). For the suggestion that Pontano's "De hortis Hesperidum" was conceived as a Medici panegyric and later used by Giovio as the basis for painted iconography at Poggio a Caiano, see Strunck, "Pontormo und Pontano," discussed in Chapter 4, note 54.

82. *Hic ... Per speculas*: Sperulo seemingly describes the tower ringed with glazed windows, a feature described by Raphael as the winter *diaeta* and shown in plan in U 273A (Plate V, Figures 15, 26); but that glazed room was planned in the east tower, and it would be odd for the poet to interrupt a discussion of the garden loggia and inner garden to jump to the other end of the villa, only to jump back to conclude the long section about Giulio's ancestor gallery. Alternatively, perhaps the poet confused the towers; or he mistakenly thought the north tower would also be ringed with windows (although none are shown in either masterplan, and Raphael stipulates that the north tower will house a chapel: Raphael/Dewez, 28 §17). Possibly Sperulo is simply evoking the trope of the villa's comfort in all seasons with this vague reference to summer and winter quarters, rather than referring to a particular location; and the *Hic* would thus refer generally to the villa complex. (NB Gwynne conflates Raphael's description of the glazed *diaeta* in the east tower with that of the chapel in the north tower, thereby compounding the confusion about Sperulo's intended locations: Gwynne, *Patterns of Patronage*, vol. 2, 136.) For more on the towers, see Chapter 3, pp. 81–2 and notes 72 and 74; and note 86 below.

83. The conceit that even the Sun will reconfigure his path to spend more time at the Medici villa; he will urge his horses to return to it as early as possible each morning, and delay his retreat from it each evening.

84. The vocabulary of a stroll or walk-about (*spatiatus*, 221) suggests the poem was conceived as a walk-through with the patron, either metaphorical or literal. That the poem was possibly intended to be recited, perhaps on-site at the villa, is suggested in Chapter 6 in the section "Performing the plans."

85. Subverts the traditional role of portrait/ancestor gallery; Giulio is so virtuous he does not need inspiration from his ancestors, but rather he will wish for them to see his virtues. This also reflects the conceit that the sculptures are alive.

86. The poet uses *turre* in lines 226 and 381 to designate the towers designed for the corners of the villa, visible in the plans, and described by Raphael in his letter using the word *torrione* (tower), and *turrione* (bastion) for a tower's ground storey. Sperulo here specifies a tower overlooking the damp south (technically impossible as the hillside blocks the view due south) from which Giulio will face the Tiber; presumably the poet saw the plan, without understanding its relation to the topography. Most likely, he meant the east tower (see Figure 26), which Raphael's letter specifies would house a winter *diaeta* ringed with glass windows (Raphael/Dewez, 23–4 §7–8). The murals may have been intended as a band above the windows, or else between windows; there is sufficient wall space to allow for paintings, although the visibility would not be ideal. However, as one of the largest and most novel spaces planned for the villa, the *diaeta* would merit significant decoration. Alternatively, perhaps Sperulo meant the south tower. For more on these murals and their setting, Chapter 3, pp. 81–2, especially notes 72, 74. See also note 82 above and Chapter 4, p. 88 and note 15 for discussion of the poet's lack of clarity about the site of these murals and other issues of architectural interpretation. (NB Gwynne mistakenly sets these murals in the north tower, which is impossible since Sperulo specifically describes a tower overlooking the south, and because the north tower to contain a chapel was planned without windows, as seen in both masterplans; Gwynne, *Patterns of Patronage*, vol. 2, 137. See note 82 above.)

87. Sperulo uses *specula* in the sense of a belvedere, whether in the corner towers as in this case, or in the central loggia designated as Leo's seat (line 270).

88. Cardinal Giulio continues his stroll, begun at line 221 (*spatiatus*).

89. Another reference to eternal spring under the Medici, and the Tuscan bank of the Tiber. (See also notes 53 and 78 above.)

90. What follows is the poet's proposal for a series of paintings in the villa, this one depicting the Triumph of Clemency, specifically the clemency of Leo. For the subject of Medicean and Leonine clemency, and Sperulo's proposed murals, see pp. 81–2. Sperulo himself had written an earlier poem celebrating Leo's clemency: *Ad Leonem X de sua clementia elegia*

xviiii, for which see Appendix III. Once again, the poet invokes the trope of art so vivid it breathes.

91. Clemency, as embodied in Leo. A reference to the putative plot to murder Leo X, and his clemency toward the conspirators who were allowed to live. For the conspiracy, see Chapter 3, p. 82 and note 77.

92. Line 235 recalls the first line of Sperulo's elegy on Leo's clemency: "Parcere supplicibus gaudet generosa leonum"; in Appendix III.

93. The triumph of Clemency is to be depicted on a cart drawn by the four symbols of the Evangelists, a reference to Ezekiel's prophecy that the new throne of God shall be in the form of a chariot drawn by the four living creatures, symbolizing the Gospels (Ezekiel 1:5–14). For the metaphor of the four Evangelists as a chariot team in Christian imagery (the *Quadriga Domini*), Michael Jacoff, *The Horses of San Marco and the Quadriga of the Lord* (Princeton, 1993), 12–20. As Nicoletta Marcelli observes, like many Medici panegyrists before him, Sperulo combined the Old Testament tradition with that of ancient Rome in this passage: Pliny (*Natural History*, XXXV, 157) records that the sculptor Vulca di Veio shaped the terracotta quadriga that was placed on the pediment of the Temple of Jupiter Capitolinus; during the ceremony of the *triumphus*, the victorious captain, like a hero worthy of divine honors, rode on a wagon pulled by four white horses along the Via Sacra up to the Capitoline Hill. Sperulo's passage is also surely a reference to Raphael's design for *The Vision of Ezekiel* in which God the Father is shown as Jupiter borne aloft by the four creatures (executed as a painting, probably by Giulio Romano, and a tapestry, possibly for Leo's *letto de paramento*): another instance of the *paragone* of poet and painter to envision the invisible, discussed on pp. 82–4 and 176. For Raphael's design, the attribution of the painting, and history of the tapestry, Henry and Joannides, *Late Raphael*, 109–17.

94. Lorenzo, Duke of Urbino (1492 to 4 May 1519). As he does for other living Medici family members, the poet assigns an area of the villa to Duke Lorenzo, here unspecified *atria*. For Lorenzo, see also line 366 and note 128 below. For the chronology of Lorenzo's illness and death in relation to Sperulo's composition of the poem, see Chapter 3, p. 66 and note 11, Chapter 5, pp. 130–1 and note 98, and p. 155.

95. Pliny refers to the 360 columns set up by Marcus Scaurus in a temporary theater, the largest of which was later placed in Scaurus' house on the Palatine, which Pliny censures among the early examples of the extravagant use of marble for private dwellings: Pliny, *Natural History*, XXXVI, 2, 5–6. Sperulo's evocation of such a splendid temporary theater might be a reference to the Medici Capitoline theater erected in 1513.

96. Piero de' Medici (1472–1503).

97. See above note 39 for the ambiguity of whether Sperulo was specifying that the sculptures be seated.

98. *nimphae Lyris* (nymphs of the river Liri). *Liris flumen* (also written *Lyris*), known from Pliny, *Natural History*, II, 227, stands for the whole basin of the Liri–Gari–Garigliano. From the confluence of Liri and Gari, the river Garigliano begins, site of the battle during which Piero died. (NM)

99. Reference to the death by drowning of Piero de' Medici, who was fighting with the French against Spain at the time. The mythological Hylas drowned when the nymphs who fell in love with him pulled him under, and his Argonaut colleagues searched at length for him in vain. Sperulo's conceit echoes two passages, one from Statius, *Silvae*, I, 2, 199: "quantum non clamatus Hylas" ("never was Hylas so clamored"), which was itself drawn from Virgil, *Eclogues*, VI, 44: "clamassent, ut litus 'Hyla, Hyla' omne sonaret" ("[the seamen] called on him, 'till the whole shore echoed 'Hylas Hylas!'"); and the other from Propertius, *Elegies*, I, 20, where the myth of Hylas is connected to the river Ascanius in Bithynia, where the mournful episode took place (see Pliny, *Natural History*, V, 121 [32]: "Aeolis proxuma est, quondam Moesia appellata, et quae Hellesponto adiacet Troas. Ibi a Phocaea Ascanius portus."). *Euboico … in littore*: Sperulo uses this epithet to refer to Cuma, the ancient colony founded by the Greeks from the Euboean region in the eighth century BCE. The Euboean shore from Cuma to Gaeta is where the river Liri floods into the Tyrrhenian Sea.

100. *Marica* is the nymph of the shore where the river Liri flows into the Tyrrhenian Sea; for which, Horace, *Odes*, III, 17, 7–8: "et innantem Maricae / litoribus tenuisse Lirim" ("and Latium's River Liris where it floods the shores of the nymph Marica"), but Sperulo probably had in mind Lucan, *Civil War*, II, 424: "umbrosae Liris per regna Maricae."

101. Duke Lorenzo's wife, Madeleine de la Tour d'Auvergne (*c.* 1500 to 28 April 1519), was a niece of Francis I, and was then about seven months pregnant with Catherine de' Medici; thus, the descendants expected by Lorenzo from the grand blood of kings would be regarded by the statue of Piero.

102. An emphatic double exclamation referring to Madeleine, who is both pregnant (*parens*) and the most honorable spouse (*coniunx*), and not a reference to the placement of sculptures. (NM) Here, Sperulo once again suggests the interaction of the living with their ancestors represented by "living" statues.

103. Giuliano, Duke of Nemours (1479–1516). Once again, it is ambiguous whether *sedem* (261) stipulates a seat, throne, or simply place for this figure. For the conceit of the empty throne in the New Sacristy, begun later this same year to house the tomb of Giuliano, see lines 78–9 and note 39 above, and Chapter 5, p. 131 and note 98.

104. Filiberta of Savoy (1498–1524), daughter of Philip, Duke of Savoy. Her 1515 marriage to Giuliano was arranged in conjunction with the alliance between Leo X and the French king, Louis XII.

105. Louise of Savoy.

106. Louise of Savoy's son, King Francis I, Duke of Angoulême.

107. For the importance of this central loggia designated as Leo's seat, like a papal benediction loggia, see the discussion in Chapter 5, section on "Topography of Christian triumph." The loggia is visible in the model and plan in Figures 14, 15.

108. From 274 to 276, Sperulo uses a series of adverbs (*hic ... hinc* and *illinc*) to emphasize the importance of the proposed decorations in Leo's loggia, further stressing that these mural paintings will stand as a milestone in the rebirth of the excellence of the arts, equaling and surpassing those of the ancients – another instance of the *paragone* with antiquity that the poet sets out in the dedicatory letter. (NM)

109. For the pairing of *ars* (skill, craft) and *ingenium* (innate talent, evoking notions of genius and inspiration, and drawn from classical literary or rhetorical theory and applied by Renaissance humanists to the visual arts), Baxandall, *Giotto and the Orators*, 15–17; and Kemp, "From 'Mimesis' to 'Fantasia'," 392–3.

110. The following battle description proposes a depiction of the historic Battle of Ravenna of 1512. The passage evokes ancient authors such as Livy, and also Leonardo's description of how to represent a battle (Kemp, *Leonardo on Painting*, 228–33), as well as his legendary *Battle of Anghiari*. Leonardo also specifically discussed the *paragone* between the poet's and painter's depiction of a battle (*ibid.* 28) – a comparison that Sperulo invites the reader to make. This was a topical issue; at the time Sperulo was writing, Raphael was designing the *Battle at the Milvian Bridge* mural painting for the Vatican Sala di Costantino, and Ariosto was revising his *Orlando furioso* with its *ekphrastic* battle set pieces that thematized the visionary, prophetic power of the poet; on these humanists and artists in a competition and a meta-conversation about the nature of invention and the relative power of word and image, see above note 93 and pp. 82–4 and 176–8.

111. In the prescriptions for battle paintings, Sperulo/Tiber describes rivers – e.g. Tiber's brothers – urging on the troops, an important early instance of personifications of these locative deities prescribed for the visual arts. For his proposed mural about the Battle of Ravenna, the Ebro and Rhône rivers represent Spain and France, respectively. It is also clear from lines 315–16 below, describing the Po sounding his conch shell, that the poet intends the river gods to be depicted as figures actively taking part in the battles, rather than as static place markers in the recumbent pose of ancient statues as Raphael had depicted them in the Sistine Chapel tapestries; for which see p. 80.

112. Duke Alfonso d'Este, one of the greatest experts in weapons and cannons of his time, who had an extraordinary set of firearms; his role in this battle was crucial.

113. That is, cannons and gunpowder.

114. Pietro/Pedro Navarro, the leader of the allied Spanish and papal infantry in the Battle of Ravenna.

115. The Spanish Viceroy Ramón de Cardona, commander of the allied Spanish and papal armies in the Battle of Ravenna.

116. That is, Leo personally did the tasks he now asks others to do.

117. Gwynne (*Patterns of Patronage*, 144) unlocked this cryptic passage by identifying the *Mutinae decus* (320) as a metaphor for Andrea Guidoni from Modena, a fellow papal chamberlain with Sperulo. The fact that *decus Mutinae* (neutral) refers to a man explains the odd concordance with the male *succensus* and *solus*. Thus, according to Sperulo, when Leo was being transported as a prisoner of war after the Battle of Ravenna, Guidoni enabled Leo's miraculous escape at Pieve del Cairo, in Lomellina, near Valenza Po. (For the escape, see Marco Pellegrini, *Leone X*, in *Enciclopedia dei Papi*, vol. 3, 42–64.) Even before the episode of the escape, and when Leo was still cardinal and vice-legate in Romagna, Andrea Guidoni was one of his associates: see Ottorino Montenovesi, "Documenti pergamenacei di Romagna nell'Archivio di Stato di Roma," in *Atti e memorie della Regia Deputazione di storia patria per le provincie di Romagna*, ser. IV, xvi (1926), 71–106, and 99–100 about Bagnacavallo: "Budrio, 12 marzo [1511] 1512. Il cardinale Giovanni de' Medici nomina Andrea Guidoni alla parrocchia di S. Antonio di Maseria. Maseria, 23 marzo 1512. Nicola de Zingolis, contadino, riconosce … di lavorare a tenimento di proprietà della parrocchia di S. Antonio di Maseria, per conto di Andrea dei Guidoni, *chierico modenese*, rettore della parrocchia medesima … Maseria, 23 marzo 1512. Andrea dei Guidoni, di cui sopra, prende possesso della parrocchia di S. Antonio." Then, after assuming the papacy, Leo rewarded Guidoni for his loyalty by giving him the title of chamberlain as well as other ecclesiastical privileges: see Mariano Armellini, *Le chiese di Roma dal secolo IV al XIX, seconda ed. accresciuta e migliorata* (Rome, 1891), 349: "Ad Andrea Guidoni chierico di Modena, cameriere segreto di Leone X, concessione di sito per fabbricare *ab ecclesia s. Blasii novi prope ripas fluminis longitudinis XVI cannarum usque ad portum aquariolorum. Datum in Camera apostolica*, 22 Aug. 1514." (NM)

118. A reference to Piero de' Medici, brother of Leo, who was forced to leave Florence and fled into exile in 1494.

119. The College of Cardinals.

120. A positive spin on the large number of new cardinals (43) named by Leo; for which, Conrad Eubel, *Hierarchia catholica medii et recentioris aevi* (Regensberg, 1923), vol. 3, 13–18.

121. The topos that the Medici are restoring the Golden Age.

122. Another reference to painted forms so vivid they breathe.

123. Jupiter the Thunderer here represents God/Christ, as in Dante and earlier neo-Latin poetry. (NM)

124. A reference to the Medici *impresa* consisting of a corpus of a yoke and ring and the *anime* of *Suave* and *N*, which are explained by the text *Anulus nectit iugum suave* (The ring unites, the yoke is easy). Paolo Giovio recorded the origin of the phrase in Matthew 11:30, "Iugum meum suave est onus meum leve." ("My yoke is easy and my burden is light."): Giovio, *Dialogo dell'imprese militari et amorose* (Rome, 1555). 39. The complete *impresa* was used by Cosimo il Vecchio, by Lorenzo, and extensively by Pope Leo; he had received the yoke while still *in minoribus*, probably in 1512. See Shearman, *Raphael's Cartoons*, 85–9; Reiss, "Cardinal Giulio de' Medici as a Patron of Art," 133, 150 n. 18, 19; Cox-Rearick, *Dynasty and Destiny*, 87–8, 36ff and pl. 70; and Rousseau, "The Yoke *Impresa* of Leo X," 113–26. See also lines 404–5 and note 143 below.

125. Selim I, Sultan of the Ottoman Empire, 1512–20. A reference to the topical issue of brokering a peace among European rulers to facilitate a united crusade against the Ottoman Turks, discussed in Chapter 3, pp. 80–1 and note 66. See also Chapter 3, note 83 for the fast-changing political circumstances that rendered irrelevant Sperulo's proposed frescoes by the time the villa was actually decorated.

126. Ausonia (363) was a poetic designation for Italy, familiar from works of Virgil, Ovid, and Statius, among other poets.

127. As noted for line 62, *Quirites* designated Roman citizens in their peacetime functions; thus, Sperulo emphasizes that the Medici restoration of peace will surpass the ancient *pax romana*.

128. Duke Lorenzo (1492 to 4 May 1519). Curiously, Sperulo foretells Lorenzo's future glorious military exploits, when in fact the Duke was already fatally ill with tuberculosis; for the chronology of Lorenzo's illness and Sperulo's poem, see above note 94; Chapter 3, p. 66 and note 11; Chapter 5, pp. 130–1 and note 98; and p. 155.

129. *specula*, the same as in line 270, where the *ekphrasis* of battle paintings begins. As noted above, this belvedere is the central loggia designated by the poet as Leo's seat. For the impossibility of executing murals in this open loggia as designed with little wall space, see the discussion in Chapter 4, p. 88 and note 9.

130. With the phrase *praetereo tacitus* (I pass over in silence) Sperulo introduces a significant *praeteritio*, an ironic rhetorical device by which the poet claims to ignore a subject while bringing it to the reader's attention. This highly significant passage of Sperulo's poem effectively sets aside the very subjects that Raphael treats in his epistolary description of the villa, revealing the poet to be privy to Raphael's ideas and thus engaged with the villa planners. However, the variations in Sperulo's list suggest that Sperulo did not actually see, or spend much time with, Raphael's letter. The relation of the two descriptions is discussed in the first section of Chapter 4.

131. The notion of having multiple backdrops is drawn from Virgil (*Georgics*, III, 21–5), who mentions one of the faces of a set of reversible scenery: "Iam nunc sollemnis ducere pompas / ad delubra iuvat caesosque videre iuuencos, / vel *scaena ut versis discedat frontibus* utque / purpurea intexti tollant aulaea Britanni." ("Even now I long to escort the stately procession to the shrine and witness the slaughter of the steers; and see how the scene on the stage changes as the sets revolve and how Britons raise the crimson curtain they are woven into.")

 Raphael mentions painted screens as acoustical aids in the theater, but does not otherwise mention scenery (Raphael/Dewez, 29 §20). As Sperulo was surely aware, the design of Villa Madama's theater was guided by intensive study of the ancient theater by Fra Giocondo, Antonio da Sangallo, and others in this circle; for which, Christoph L. Frommel, "Raffaello e il teatro alla corte di Leone X," *Bollettino del Centro internazionale di studi di architettura Andrea Palladio* 16 (1974): 173–87.

132. The use of *caput* (head) as well as *membra* (limbs; three lines above) reflects the body/building topos.

133. *a margine xystus* (387) suggests that the poet may have been looking at a plan for the villa without completely understanding it, since the *xystus* (inner garden) and fishpond are represented as contiguous in the masterplans that conflate elements from different storeys, although these two areas are on different levels, as the stairways in the plans express. Raphael, in his letter, clearly describes that the *xystus* overlooks the fishpond 4 canne below that is reached by large staircases, so Sperulo is not following Raphael's text here (Raphael/Dewez, 27 §16). See plans in Plate V and Figures 15, 57.

134. The steps around the *peschiera* (a detail borrowed from the villa of Poggioreale in Naples) are shown in the earlier masterplan (U 273A, Plate V and Figures 15, 57) and also described in Raphael's letter as a place to sit or stretch out (Raphael/Dewez, 27 §16), although they were eliminated with the redesign of the fishpond and adjacent areas in the later masterplan (U 314A, Plate VI and Figure 58). For the suggestion that this area was under discussion at the time Sperulo and Raphael were writing, see Chapter 5, pp. 109–11 and note 57.

135. The poet concludes his *praeteritio* of elements he will not discuss – those which Raphael does – by saying "All this better anon" (*Omnia post melius*), suggesting that the reader/listener can learn about those from Raphael later. In the following sentence, he switches the focus to his own tasks, which he stresses are pressing.

136. *dimensa, dimetior* (392): the poet uses the rare *dimensa* to refer to the courtyards that have been measured and designed by the architects, for which he is choosing marble columns. Raphael's letter includes specific measurements for each room, and since Vitruvius, measurement had been a tool of the architect and a marker of his *ingenium*. The poet is improbably suggesting that he could determine the placement of columns, bolstering his claim to join the architects in "constructing" the villa; and once again claiming that the architects should take into account his proposed selection of spoils as they finalize the plans; see above line 79 and note 40 for gloss to *commensa*. For *dimensa*, see also Cicero, *Epistles to*

Atticus, I, 2 (I, 6): "Domum Rabirianam Neapoli, quam tu iam dimensam et exaedifi-catam animo habebas, M. Fontius emit" ("The Rabirius house in Naples, which is already laid out and architecturally complete in your mind, has been bought by M. Fonteius"); Tacitus, *Annals*, XV, 43: "Ceterum urbis quae domui supererant non, ut post Gallica incendia, nulla distinctione nec passim erecta, sed dimensis vicorum ordinibus et latis viarum spatiis cohibitaque aedificiorum altitudine ac patefactis areis additisque porticibus, quae frontem insularum protegerent" ("Of Rome, meanwhile, so much was left unoccupied by his mansion, was not built up, as it had been after its burning by the Gauls, without any regularity or in any fashion, but with rows of streets according to measurement, with broad thorough-fares, with a restriction on the height of houses, with open spaces, and further addition of colonnades, as a protection to the frontage of the blocks of tenements") (trans. A. J. Church and W. J. Brodribb, London, *c.* 1876).

137. *asarota:* a reference to Pliny's and Statius' descriptions of the famous "unswept floor" mosaic in Pergamum. Pliny, *Natural History*, XXXVI, 184: "In this latter field [mosaic] the most famous exponent was Sosus, who at Pergamum laid the floor of what is known in Greek as 'the Unswept Room' because, by means of small cubes tinted in various shades, he represented on the floor refuse from the dinner table and other sweepings, making them appear as if they had been left there." "celeberrimus fuit in hoc genere Sosus, qui Pergami stravit quem vocant asaroton oecon, quoniam purgamenta cenae in pavimentis quaeque everri solent velut relicta fecerat parvis e tessellis tinctisque in varios colores." Statius made reference to this floor in his description of the Tiburtine villa of Manilius Vopiscus: "floor where the ground rejoiced in painting's variety, with strange shapes surpassing the Unswept Pavement" ("solum, varias ubi picta per artes gaudet humus superatque novis asarota figuris"): Statius, *Silvae*, I, 3, 56. Alberti mentions the unswept floor in Pergamum as an appropriate model for a dining room in a private building: Alberti, *On the Art of Building in Ten Books*, trans. Joseph Rykwert, Neil Leach and Robert Tavernor (Cambridge, MA, 1988), IX, 4. For Poliziano's gloss on the term in Statius' *Silvae*, Cesarini Martinelli, *Commento inedito alle* Selve *di Stazio di Poliziano*, 284–5. The current floors in Villa Madama are a product of twentieth-century restoration; I have not yet found any clear evidence for the original floors.

138. Gaeta was the source of the best citrus trees. Pope Clement would indeed later order fruit trees for the villa from there, as recorded in his correspondence of 1525 with Mario Maffei, as noted by Shearman, *Sources*, vol. 1, 438 and 604. Also, another allusion to the villa as the Garden of the Hesperides (see note 81 above).

139. Pomona, goddess of fruit trees, orchards, and gardens, was fundamental to the imagery being designed concurrently for Pontormo's lunette fresco in the Salone of the Medici villa of Poggio a Caiano. Here, the notion that she revives all plantings represents the eternal renewal of the Medici.

140. A popular grafting technique that allows a tree to bear different fruits, which the poet lists among the marvels at this extraordinary villa. Such products embody the contemporary notion of a "third nature," produced by the conjoined efforts of nature and art; for which, Lazzaro, *The Italian Renaissance Garden*, 8–16 and *passim*.

141. *vireta* (401): see line 30, note 16 above, and the following note.

142. *Thessala Tempe* (402): another poetic topos for a pleasant green place (e.g. Virgil, *Georgics*, IV, 317: *Peneia Tempe*, after the river Peneus in Thessaly). With this image, and that of the *vireta* in the previous line, the poet closes the poem as he opened it, with classical imagery of a pleasant green place (*amoenitas loci* in the dedicatory letter, §2; *amoena vireta* [30]).

143. The notion that Pleasure bears Cardinal Giulio's reins is another reference to the Medici *impresa* explained by the text *Anulus nectit iugum suave* (The ring unites, the yoke is easy), and its source in Matthew 11:30: "Iugum meum suave est onus meum leve" ("My yoke is easy and my burden is light"); for which see line 356 and note 124 above. Here it becomes a conceit of Sperulo's work: the poet, personified by Father Tiber, is saying that his work for Cardinal Giulio is a pleasure. This is also a reference to Statius, *Silvae* I, 3, 9, where Pleasure draws the plans for the Vopiscus villa, once again validating the poet's proposal: "Pleasure herself is said with tender hand to have traced with you" ("ipsa manu tenera tecum scripsisse Voluptas"). The verb *scribere* can refer to text or visual representation, and

Statius pointedly played with these meanings throughout his *ekphrastic silvae* to underscore the paragonal nature of the visual and verbal; see Adam R. Marshall, "*Spectandi Voluptas*: *Ecphrasis* and Poetic Immortality in Statius' *Silvae* 1.1," *Classical Journal* 106.3 (2011): 321–47 at 332–3. Although he declares the burden light, Sperulo perhaps reminds his patron of his many labors in closing in hope of a payment.

144. Evokes the last line of Father Tiber's prophecy of the founding of Rome in Virgil, *Aeneid*, VIII, 66–7: "Dixit, deinde lacu fluvius se condidit alto ima petens."

APPENDIX II

Francesco Sperulo, *Villa Iulia Medica versibus fabricata* (BAV, Vat. Lat. 5812)

ANALYSIS OF THE PRESENTATION MANUSCRIPT

Francesco Sperulo's *Villa Iulia Medica versibus fabricata* survives in a single copy: an illuminated presentation manuscript that is the standalone work in an elegant miniature leather-bound volume, housed in the Vatican Library. The poem itself consists of 407 lines of hexameter, preceded by a dedicatory letter to Cardinal Giulio de' Medici dated 1 March 1519. A new critical edition, translation, and gloss appear in Appendix 1. If the content of Sperulo's poem has received scant scholarly attention, the manuscript itself has not yet been studied at all.[1]

This pocket volume, measuring 6.8 × 4.7 inches, remains in its original tooled-leather binding (Plate XII).[2] Both front and back covers bear the same pattern: a circle containing a six-pointed star with a four-leaf sprig at its center, surrounded by four quarter-circles, each containing wavy, sun-like rays; and all surrounded by a foliate border. The booklet contains seventeen parchment folios measuring 6.7 × 4.5 inches, the edges of which are gilded.

The two-page opening of the manuscript is illuminated (Plates IX, X and Figure 90). The title page on the left spread consists of a wreath framing the address: "Ad r[everendissi]mum d[ominum] Iulium Medicem S[anctae] R[omanae] E[cclesiae] presbyterum cardinalem et vice cancellarium humillimus servus Franciscus Sperulus villam Iuliam Medicam versibus fabricatam mittit" (To the most reverend Lord Giulio de' Medici, Cardinal Priest and Vice Chancellor of the Holy Roman Church, his most humble servant Francesco

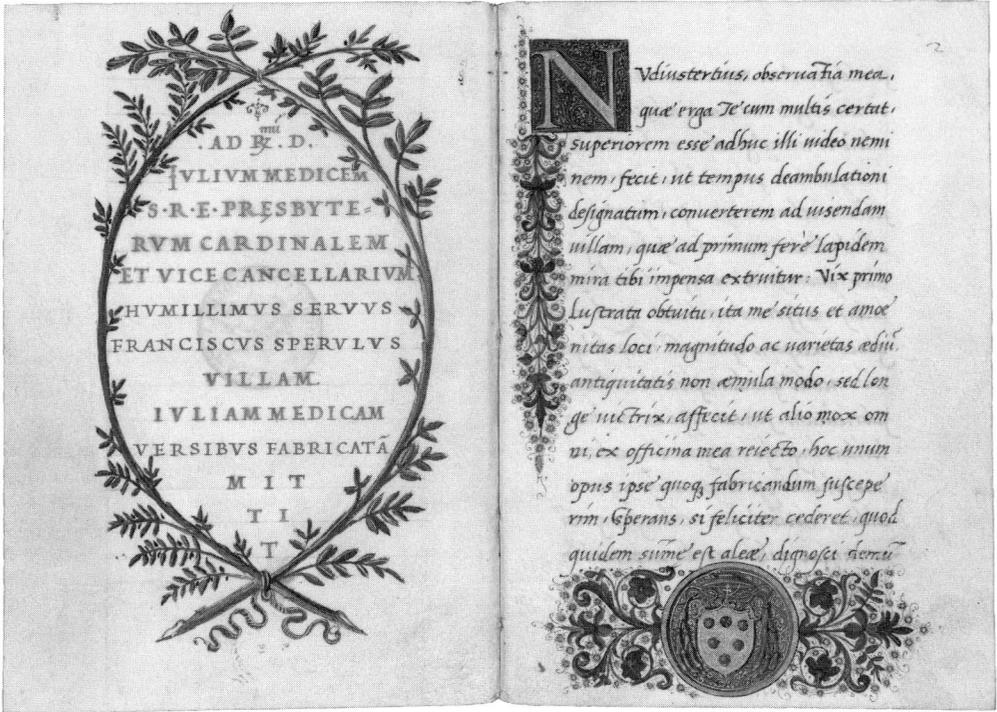

90. Francesco Sperulo, *Villa Iulia Medica versibus fabricata*, 1519, BAV, Vat. Lat. 5812, fols. 1v–2r.

Sperulo sends *The Villa Giulia Medicea Constructed in Verse*).This text itself forms part of the decoration: it is written in Latin square capitals in the style of an ancient inscription, each line centered within the wreath; faint traces of ruling for each line are visible. The mandorla-shaped wreath is formed by crossed branches probably intended to represent myrtle and laurel, symbols of Venus and the Medici,[3] which are angle-cut at the bottom in the form of *broncone*, the emblematic device of Medici renewal.[4] These branches are tied together with ribbons, which flutter like an *all'antica* banderole at the bottom of the page.

Opposite this sheet is the first page of the prose dedication, which is decorated with a painted initial and white vine-stem decoration (*bianchi girari*) in the margin and at the base of the page, where these foliate rinceaux flank a fictive bronze medal with the arms of Cardinal Giulio: an escutcheon bearing Medici *palle*, one blue with gold lilies, topped with a red cardinal's hat and suspended tassels. The initial is painted in gold to suggest a Roman square capital in relief, surrounded by tiny gold foliage on a blue square ground. The following page also features a painted initial to mark the beginning of the poem (Plate XI). The dedicatory letter and the poem itself are written in chancery cursive (*cancellaresca corsiva*).[5] All the pages are faintly ruled; occasional erasures and the graceful hand minimize the impact of corrections.

The elegant script and the delicate, gilded illumination are both of very high quality, a judgement for which I am grateful to Jonathan J. G. Alexander. This opulent treatment of the poem, together with the use of Cardinal Giulio's arms and the dedication to him, suggest that this manuscript was intended for presentation to him and probably at his request, rather than an initiative of the poet. It is possible that Sperulo recited the poem first, and Cardinal Giulio subsequently requested that it be recorded.[6] Giulio commissioned a handful of other manuscripts around this time, notably Egidio da Viterbo's book on the Hebrew alphabet (BAV, Vat. Lat. 5808) of 1517;[7] an edition of Lucian's *Dialoghi maritimi* (BAV, Vat. Lat. 5802) produced in 1519 (Plates XIII, XIV);[8] and an opulent Missal of 1520, now in Berlin.[9]

Despite the high quality of the illumination of Sperulo's poem, it is difficult to make an attribution based on its relatively simple and non-figurative imagery. The illumination is very close to the style of the Florentine Attavante degli Attavanti,[10] who worked in Rome at the end of his life, and who probably illuminated the manuscript of Lucian's *Dialoghi maritimi* produced for Cardinal Giulio. In particular, the white vine-stem decoration and circular medals bearing the arms of Cardinal Giulio are strikingly similar in the manuscripts of Sperulo's and Lucian's poems, which may be seen in a comparison of Plates X, XIII, and XIV.[11] There is a remarkable variety of foliate forms in the Lucian manuscript and no two pages are alike, but the palette and style of blue and red flowers (vaguely like daisies and irises) and the golden, dandelion-like orbs, as well as the scrolling foliate forms, are very close in the two manuscripts. The Lucian boasts more extensive illumination and use of glossy gold leaf, but the two manuscripts look to have been painted by the same hand, or a very close associate in the same workshop.

The illumination is not extensive, but it engages the content of the poetry in interesting ways. The wreath that frames the title page is unusual both for its mandorla shape and for its composition of two branches (Figure 90). At one level, it suggests mandorla-shaped cardinal's seals, such as that of Cardinal Giulio, which were used in the papal Chancery then headed by Giulio and staffed by the scriptors who recorded such poetry.[12] This imagery evoking a cardinal's seal rendered in Medici *broncone* is another striking link to Cardinal Giulio.

Curiously, the unusual mandorla shape and two-branch composition of the title page wreath are very close to the personal device of Bernardo Bembo: an elongated wreath of laurel and palm sprigs framing the motto *virtus et honor* (Figure 91).[13] His device was surely familiar to Sperulo's cohort, since Bernardo Bembo had been a fixture in Laurentian Florence, and his son Pietro was part of this circle in Curial Rome. The elder Bembo's device appeared on many objects, including manuscripts, notably his copy of Pliny's villa letters (Figure 92);[14] possibly his son Pietro had this or other pieces of his

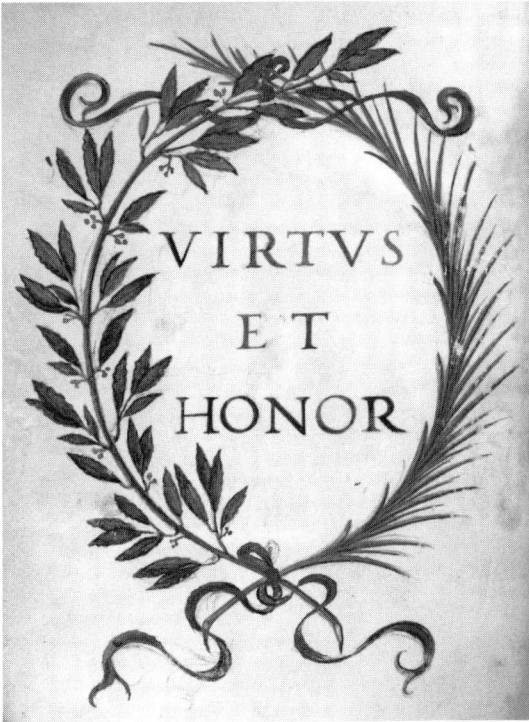

91. Personal device of Bernardo Bembo: an elongated wreath of laurel and palm sprigs tied by ribbons, framing the motto *virtus et honor*; in Paolo Marsi, *Bembicae peregrinae*, fifteenth century, Eton College Collections, MS 156, fol. IIIv.

92. Bernardo Bembo's personal device on the first folio of his copy of Pliny the Younger, *Epistolarum libri IX*, Treviso: Ioannes Vercellius, 1483.

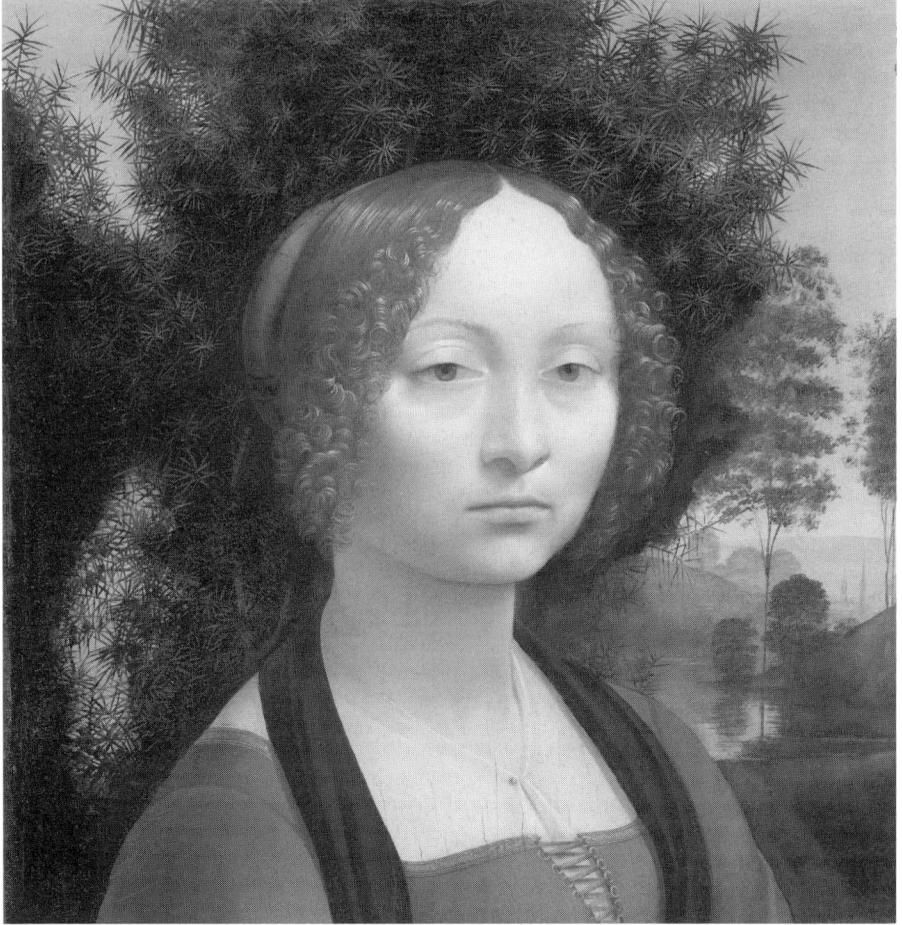

93 and 94. Leonardo, *Portrait of Ginevra de' Benci*, recto and verso; the panel has been cut down at the bottom, truncating the likeness and the wreath.

father's library with him in Rome at this time. Perhaps Sperulo's small volume declared his connection to the Bembos. Or, Sperulo could have emulated their device to formulate this very similar *impresa* for himself, although we lack any other examples to support this possibility. Sperulo and his illuminator may also have chosen this wreath for iconographical reasons. Strikingly, the elder Bembo's device appeared on the reverse of Leonardo's double-sided portrait of *Ginevra de' Benci* (Figures 93, 94).[15] As is well known, Leonardo's portrait reflects the tradition of double-sided medallic portraits, in which the combination of a visual likeness with an emblem together constitute the portrait.[16] Visually, the opening page spread of Sperulo's manuscript loosely suggests this double-sided imagery of Leonardo's painting and portrait medals. The title page for the villa built in verse functions as a verbal likeness; picked out in red ink are the words *humillimus servus Franciscus Sperulus* and *versibus*

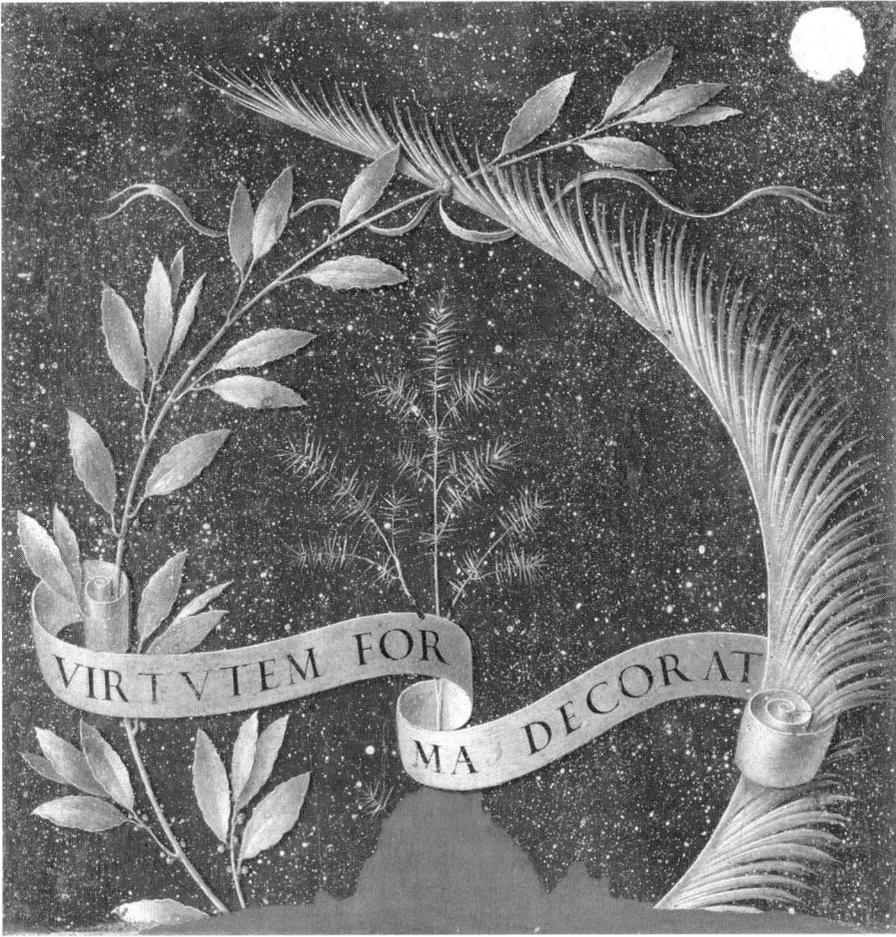

fabricatam, emphasizing the poet's claim to be giving form to the villa in verse. The opposing page functions as the verso; Giulio's arms in the fictive bronze medal makes the conceit explicit. (Although, admittedly, bronze medallions decorated manuscripts for many other subjects.) But here the wreath encircles the textual image of the villa, rather than a motto.[17] This imagery pairing a verbal "likeness" of the villa with the patron's arms on a fictive bronze medal is apt for this poem that is effectively a portrait of the building. Moreover, this imagery evokes the tradition of producing medals to commemorate new building initiatives, notably the medals commemorating the beginning of St. Peter's, traditionally attributed to Caradosso but recently given to Bramante himself; one displays a portrait of the patron on the obverse with the proposed new basilica on the reverse (Figure 95), while another features Bramante's own self-portrait *all'antica*, and on the reverse a personification of Architecture

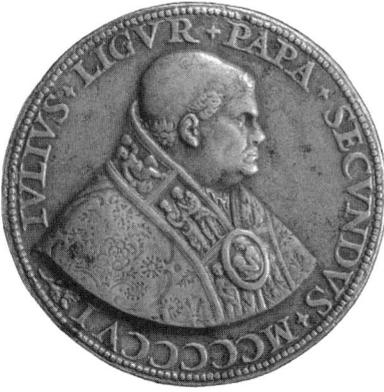

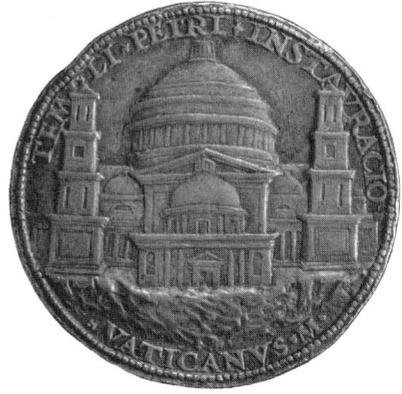

95. Donato Bramante or Cristoforo Foppa (Caradosso), *Medal Commemorating the Building of St. Peters*, with a portrait of Julius II (obverse) and St. Peter's (reverse), 1506, The British Museum, G3,PMAE3.5.

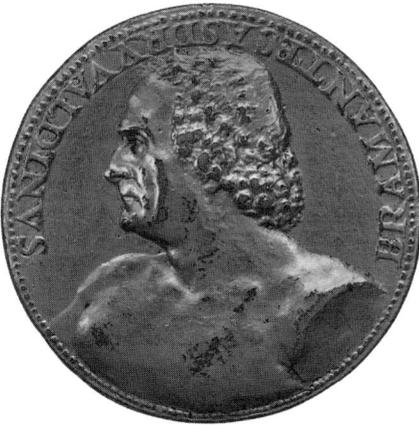

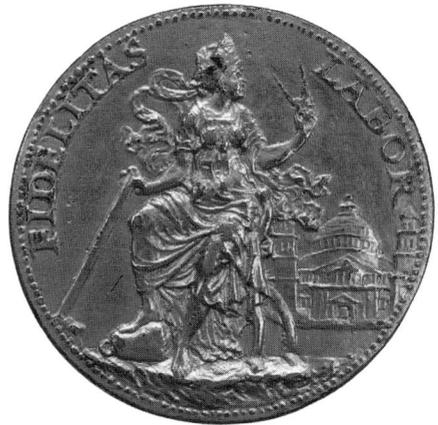

96. Donato Bramante, formerly attributed to Cristoforo Foppa (Caradosso), *Medal Commemorating the Building of St. Peters*, with a portrait of Bramante (obverse) and personification of the architect and St. Peter's (reverse), 1506, The British Museum, 1923,0611.8.

holding her tools in front of the architect's vision of the unbuilt basilica (Figure 96).[18] Thus, Sperulo's poem is at one level a foundation medal in verse, as well as a prospective portrait of the unbuilt villa.

The prominent and inventive use of Medici devices on the manuscript suggests a focus on this aspect of the illumination. The Medici emblems posted on this textual villa echo the practice on brick and mortar buildings, such as the Medici *palle* above the portal of Villa Poggio a Caiano. Moreover, this visual identification of the family with the villa built in verse may have been a

significant issue because they were at pains to establish that this papal *hospitium* would remain a Medici possession beyond Leo's pontificate – surely one objective of Sperulo's poem.[19] Moreover, notably absent from the illumination is a visual image of the planned villa, which would be characteristic of a foundational medal; either it was too soon in the design process or, more likely, such an image was the province of Raphael, not the poet. Instead, Sperulo's verbal likeness is ornamented with heraldic imagery and decorative words – apposite for his villa built with verse and ink, which, he boasted, would outlive that of the architects.[20]

Identifying the hand of the scriptor leads to an interesting conclusion. The style and quality of the hand at first suggest a professional scriptor in the circle of Ludovico degli Arrighi, known as Il Vicentino, who was active in the Vatican Chancery, which was overseen by Cardinal Giulio.[21] Arrighi was an occasional collaborator with Raphael and copied several works for Giulio, including the Lucian dialogues and the Berlin Missal. But while the hand of Sperulo's manuscript is close to that of Arrighi, it is more slanted; nor is it an exact match with the hands of other known copyists in his circle, notably Genesius de la Barrera, Fausto Capodiferro, or Giovanni Francesco Vitali.[22] The signature (or closing mark) on the last page of Sperulo's villa poem (Figure 97) is in the same ink as the rest of the poem; it consists of a stylized s or elongated volute crowned with three x's, which is similar to, but slightly different from, the signatures of Genesius and Vitali.[23] The same signature also appears at the end of Sperulo's elegy on Leo's clemency (Figure 98), part of a compilation of Sperulo's works in BAV, Vat. Lat. 1673.[24] Moreover, the hand of both manuscripts looks to be the same, although that of the villa poem is considerably neater and more formal, while that of the elegy is somewhat more natural. Other than a discrepancy in the capital V's, the letter forms are very similar, notably the unusual tails of the minuscule g's. Tamburini considers the entire manuscript of Vat. Lat. 1673 to be autograph.[25] Most likely, Sperulo wrote both manuscripts himself.[26] If this was the case, the elegance of the hand in the villa poem and its closeness to Arrighi's might suggest Sperulo had a close connection to Giulio's Chancery. More importantly, this would mean the author prepared the presentation manuscript himself for his patron Cardinal Giulio. There are other examples of this practice of author as self-scriptor by prominent humanists, from Giovanni Sabadino degli Arienti in Bologna to Machiavelli and Antonfrancesco Doni in Florence; these works were often addressed to important patrons, including a poem by Evangelista Maddaleni Capodiferro who wrote a presentation manuscript of his own work for Pope Clement VII.[27] This practice was specially valued for conveying a sense of the author's presence.[28] If we accept that Sperulo was indeed the scriptor of his own manuscripts, then we may interpret his presentation manuscript as another tool to curry favor in the competitive arena of Roman humanists.

Non unus Thybrim uersat labor, undiq cure
Jmpendent grate ob dominu: cui blanda uoluptas
Frena gerit, uirtusq comes, concordia custos,
Sidera amica, Leo frater, deus arbiter et Rex:
Dixit: arenosoq caput mox condidit alueo:

97. Francesco Sperulo, *Villa Iulia Medica versibus fabricata*, 1519, BAV, Vat. Lat. 5812, fol. 16v; detail of the final page of the manuscript with the signature or closing mark, probably in Sperulo's hand.

The inventiveness of the imagery and the prominent use of Medici devices, along with the high quality of the script, illumination, and binding, suggest that considerable attention was given to producing the manuscript, which would be consistent with a Medici commission. One can imagine that this imagery was devised in conversation between poet and illuminator, in a verbal dialogue much like the collaborative pattern I have sketched for design of the villa itself.[29]

98. Francesco Sperulo, *Ad Leonem X de sua clementia elegia xviiii*, BAV, Vat. Lat. 1673, fol. 103r, detail.

APPENDIX III

Francesco Sperulo, *Ad Leonem X de sua clementia elegia xviiii* (BAV, Vat. Lat. 1673, fols. 102v–103r)

Author's transcription, preserving the capitalization and punctuation of the manuscript, apparently autograph, but spelling out abbreviations.

102v Parcere supplicibus gaudet generosa Leonum
 Ira: magisque nihil quam superasse iuvat:
 Si tamen hostis amet contra temerarius ire,
 Et nequeat cautus subdere frena timor,
 Tum cauda ardescens surgentia terga flagellat, 5
 Inque cruorem furens protinus ira natat:
 Imperiumque olli natura dedisse ferarum
 Censetur: tanti est nobilis ille furor:
 Quod si nativo decus hoc fera sentit ab usu,
 Quod nam hominum studio par decus esse queat! 10
 Ergo tibi imperium superi quam iure dederunt
 Summe Leo! rerum quam bene te esse caput!
 Nomine in hoc omen: secum gerit imperii vim,
 Interque astra Leo non satis unus erat:
 Tu quoque fulgebis tanto sublimius: ipse 15
 Quanto homini praestas, praestat et ille feris:
 Iam tu materies de nobilitatem: Nepotes
 Exemplo minuent maxima quaeque tuo:
 Namque per insidias solum non nuper ademptus
 Monstrasti mentis culmina quanta tuae: 20
 Vicisti, arbitriumque tibi vitaeque necisque

Hostis erat: totum hoc denique in hostem fuit:
 Ultoris iustas animi cognoscere vires
 Commeritus, sero poenituisse gemit:
At lachrymis culpam fassus precibusque, superbae 25
 Sensit inexhaustam nobilitatis opem:
Quem dudum impietas stimulis male torxit iniquis,
 Iustitiae hunc pietas de manibus rapuit:
Perderem qui voluit modo te livore, salutem
 Supplicibus lachrymis te tribuisse videt, 30
Miratur, votisque pavet felicibus: usque
 Est adeo errati conscia culpa sui:
Servatas miratur opes, miratur honores:
 Et quem crudelem fecerat, esse pium:
Admonitusque sui, nunc demum vivere coepit, 35
 Profecit tecum crimine quippe suo:
Inter sacra, virum paci et tibi qui fuit hostis,
 En circum pacis munera ferre iubes:
Et placidem amplexus lachrymis testaris obortis
 Plus licuisse illi, quam libuisse tibi: 40
Quodque animi est insigne tui, sponte arma trementi
 Restituis: rursus fiet an ille nocens!
Unguibus ex aquilae sic lapsa columba reverti
 Audeat: an parvum pignus in hoste timor!
Vindicta o felix, in qua de pace triumphat 45
 Victor: et in victo culpa triumphus erit.

Finis tertii libri, seguitur quartus in Laudem Virginis et matris dei Mariae

103r (margin, at line 25)

NOTES

PREFACE

1. Christoph L. Frommel, Stefano Ray, and Manfredo Tafuri, eds., *Raffaello architetto*, with important contributions by Howard Burns and Arnold Nesselrath (Rome, 1984).
2. Caroline Elam, "The Raphael Conference in Rome," *Burlington Magazine* 125 (1983): 437–9, at 439.
3. John Shearman, *Raphael in Early Modern Sources*, 2 vols. (New Haven, 2003), vol. 1, 414–38.
4. Yvonne Elet, "Papal *Villeggiatura* in Early Modern Rome: Poetry, Stucco and Spoils at Raphael's Villa Madama," Ph.D. diss., New York University, 2007.
5. Paul Gwynne, *Patterns of Patronage in Renaissance Rome. Francesco Sperulo: Poet, Prelate, Soldier, Spy*, 2 vols. (Bern, 2015).

INTRODUCTION

1. BAV, Vat. Lat. 5812. All references to this poem are to Appendix 1 herein containing a critical edition and English translation by Nicoletta Marcelli and gloss by the author. See below p. 6 and *passim*, and note 22 for discussion of the poem, with bibliography and earlier editions.
2. Along with the *Transfiguration* and the Sala di Costantino murals in the Vatican.
3. The most comprehensive treatment of the villa to date was undertaken by Renato Lefevre, a cultural historian and politician: Renato Lefevre, *Villa Madama* (Rome, 1973), reprinted with expanded bibliography in 1984; subsequent references are to the 1984 edition. Among his numerous articles about the villa is a useful 1983 historiography: Lefevre, "Interrogativi sulla 'vigna del Papa' a Monte Mario," *Accademie e biblioteche d'Italia*

51.4–5 (1983): 259–82. The villa's function as papal *hospitium* to welcome foreign dignitaries was proposed by John Shearman, "A Functional Interpretation of Villa Madama," *Römisches Jahrbuch für Kunstgeschichte* 20 (1983): 313–27. Shearman's collection of Raphael sources added a few new documents to the villa literature: Shearman, *Raphael in Early Modern Sources*. The reconstruction of architectural plans for the complex are discussed below, pp. 7–8 and notes 28–31; and its patronage at p. 5 and notes 19, 32. The multimedia decorations of the villa complex – frescoes, stuccoes, sculpture, antiquities, and fountains – have received scant art-historical study and remain imperfectly understood. Concise summaries of the villa's architecture and decoration can be found in David Coffin, *The Villa in the Life of Renaissance Rome* (Princeton, 1979), 245–57, and Roger Jones and Nicholas Penny, *Raphael* (New Haven, 1983), 226–34, 247–8. A recent work on the villa, with incomplete bibliography, is Caterina Napoleone, ed., *Villa Madama: Raphael's Dream*, trans. Simon Turner (Turin, 2007). The monographic literature on Raphael and his associates, notably Giulio Romano and Giovanni da Udine, provides further background on the villa's decorations. See also Elet, "Papal *villeggiatura* in early modern Rome." I am preparing a monograph on the villa.
4. Sperulo mentions the "situs et amoenitas loci" (dedicatory letter, §5), subverting the poetic topos of the *locus amoenus*, or pleasant place, to describe instead a noisy construction site. For the *locus amoenus* to describe ideal landscape and villas in Roman antiquity, see Ernst Robert Curtius, *European Literature and the Latin Middle Ages*, trans. Willard R. Trask (New York, 1953), 190–202; Carole Elizabeth

Newlands, "The Transformation of the 'Locus Amoenus' in Roman Poetry" (Ph.D. diss., University of California, Berkeley, 1984).

5. The conceit of building with words was common among Greek and Roman poets, notably Ovid and Pindar, who wrote, "Let us set up golden columns to support the strong-walled porch of our abode and construct, as it were, a splendid palace; for when a work is begun, it is necessary to make its front shine from afar." Pindar, *Olympian Odes*, VI, 1. Ovid begins his epilogue to the *Metamorphoses* 14.871, saying, "And now I have built a work" (Iamque opus exegi). And Propertius boasts he will lay out buildings and the walls of Rome in verse (*Elegies* 4.1, 55–70). The device reflects the multiple meanings of the Latin *monumentum* as a commemorative object, a written memorial, or a literary work (OLD, *monumentum*, definitions 1, 4, 5); although, curiously, Sperulo never uses this word. This metaphor of text as building and the related Horatian topos about which will be more durable and bring more everlasting fame, words or objects, are discussed in Chapter 2 notes 55, 56 and Appendix 1, gloss note 4. For Sperulo's transposition of the words-vs.-marbles topos into ink-vs.-stucco, see the Conclusion p. 177 and Appendix 1, dedicatory letter §2 and gloss note 4. For the trope of the poet as master builder in medieval and Renaissance thought, see below pp. 54, 95, 96, 176, Chapter 2 note 50 and Chapter 4 note 58.

6. A fuller discussion of Roman political and humanist culture with bibliography appears in Chapter 1.

7. Linda Wolk-Simon discusses Raphael as the paradigm of the "universal artist-impresario" and the fact that no one stepped up to assume that role in Rome after his death, instead tracing an increased specialization among Roman artists in the following decade: in "Competition, Collaboration, and Specialization in the Roman Art World, 1520–27," in *The Pontificate of Clement VII: History, Politics, Culture*, ed. Kenneth Gouwens and Sheryl E. Reiss (Aldershot, 2005), 253–76.

8. See especially Kim E. Butler, "'Reddita lux est': Raphael and the Pursuit of Sacred Eloquence in Leonine Rome," in *Artists at Court: Image-Making and Identity, 1300–1550*, ed. Stephen J. Campbell (Chicago, 2004), 138–48; Bram Kempers, "Words, Images and All the Pope's Men. Raphael's Stanza della Segnatura and the Synthesis of Divine Wisdom," in *History of Concepts: Comparative Perspectives*, ed. Iain Hampsher-Monk, Karin Tilmans, and Frank van Vree (Amsterdam, 1998), 131–65 and 264–9; John W. O'Malley, *Praise and Blame in Renaissance Rome: Rhetoric, Doctrine and Reform in the Sacred Orators of the Papal Court, c. 1450–1521* (Durham, NC, 1979); Stefano Ray, *Raffaello architetto: linguaggio artistico e ideologia nel Rinascimento romano* (Rome, 1974); Ingrid Rowland, "The Intellectual Background of the School of Athens," in *Raphael's School of Athens*, ed. Marcia Hall (Cambridge, 1997), 131–70, among other sources by Rowland cited herein; John Shearman, *Raphael's Cartoons in the Collection of Her Majesty the Queen and the Tapestries for the Sistine Chapel* (London, 1972); and Kathleen Weil-Garris, "La morte di Raffaello e la 'Trasfigurazione'," in *Raffaello e l'Europa: Atti del IV Corso internazionale di alta cultura*, ed. Marcello Fagiolo and Maria Luisa Madonna (Rome, 1990), 177–90.

9. In order to give the palm to his hero Michelangelo as the all-round painter-sculptor-architect, Vasari suppressed Raphael's wide-ranging activities, instead crowning him "prince of painters." On Vasari's *Life of Raphael*, David Cast, *The Delight of Art: Giorgio Vasari and the Traditions of Humanist Discourse* (University Park, PA, 2009), 136–41; Patricia Lee Rubin, *Giorgio Vasari: Art and History* (New Haven, 1995), 357–401.

10. For which, Alina A. Payne, "Architectural History and the History of Art. A Suspended Dialogue," *Journal of the Society of Architectural Historians* 58 (1999): 292–9; on the tension between the unity and disunity of the arts of painting, sculpture, and architecture in Renaissance critical language and in practice, David Cast, "On the Unity/Disunity of the Arts: Vasari (and Others) on Architecture," in *Rethinking the High Renaissance: The Culture of the Visual Arts in Early Sixteenth-Century Rome*, ed. Jill Burke (Farnham, 2012), 129–43; on the divorce between architecture and the figurative arts in the seventeenth to twenty-first centuries, Joseph Rykwert, *The Judicious Eye: Architecture against the Other Arts* (Chicago, 2008); for shifting boundaries between architecture and the representational arts in modern and postmodern art, taking off from the work of Rosalind Krauss, see Spyros Papapetros

and Julian Rose, eds., *Retracing the Expanded Field: Encounters between Art and Architecture* (Cambridge, MA, 2014).

11. On the relation of media in Raphael's oeuvre, Kathleen Weil-Garris Brandt, "Raffaello e la scultura del cinquecento," in *Raffaello in Vaticano* (Milan, 1984), 221–31.

12. Howard Burns, "Painter-Architects in Italy during the Quattrocento and Cinquecento," in *The Notion of the Painter-Architect in Italy and the Southern Low Countries*, ed. Piet Lombaerde (Turnhout, 2014), 1–8.

13. Bette Talvacchia, "Raphael's Workshop and the Development of a Managerial Style," in *The Cambridge Companion to Raphael*, ed. Marcia Hall (Cambridge, 2005), 167–85; and Wolk-Simon, "Competition, Collaboration, and Specialization," 253–60, with a synoptic discussion of the subject with earlier bibliography.

14. A phrase coined by Alexander Nagel in concert with recent studies in many disciplines focusing on the non-heroic; Nagel, *The Controversy of Renaissance Art* (Chicago, 2011), 1–3 and *passim*. For the rejection of the triumphant model of artist-heroes, see also Ernst Kris and Otto Kurz, *Legend, Myth, and Magic in the Image of the Artist: A Historical Experiment* (New Haven, 1979), originally published as *Die Legende vom Künstler: ein historischer Versuch*, 1934; Patricia Emison, *Creating the "Divine" Artist, from Dante to Michelangelo* (Leiden, 2004).

15. For Raphael's workshop: Konrad Oberhuber, "Raffaello," in *La bottega dell'artista tra Medioevo e Rinascimento*, ed. Roberto Cassanelli (Milan, 1998), 257–74; John Shearman, "Raffaello e la bottega," in *Raffaello in Vaticano* (Milan, 1984), 258–63; Shearman, "The Organization of Raphael's Workshop," *Art Institute of Chicago Centennial Lectures, Museum Studies* 10 (1983): 41–57; Shearman, "Raphael's Unexecuted Projects for the Stanze," in *Walter Friedlaender zum 90 Geburtstag: eine Festgabe seiner europäischen Schüler, Freunde, und Verehrer* (Berlin, 1965), 158–80; Shearman, "Die Loggia der Psyche in der Villa Farnesina und die Probleme der letzten Phase von Raffaels graphischem Stil," *Jahrbuch der Kunsthistorichen Sammlungen in Wien* 60 (1964): 59–100; Talvacchia, "Raphael's Workshop"; Tom Henry and Paul Joannides, "Raphael and his Workshop between 1513 and 1525: 'per la mano di maestro Rafaello e Joanne Francesco e Giulio sui discepoli'," in *Late Raphael*, Exh. Cat., ed. Tom Henry and Paul Joannides (Madrid, 2012), 41–3 and *passim*; Nicole Dacos, *Le Logge di Raffaello* (Rome, 1986); Wolk-Simon, "Competition, Collaboration, and Specialization," 254–6.

16. A point noted by Melissa Meriam Bullard, "Heroes and their Workshops: Medici Patronage and the Problem of Shared Agency," *Journal of Medieval and Renaissance Studies* 24 (1994): 179–98. Among the rare studies dedicated to the subject of collaboration in the visual arts, see Wolk-Simon, "Competition, Collaboration, and Specialization"; and the essays in the classic collection by Wendy Stedman Sheard and John Paoletti, eds., *Collaboration in Italian Renaissance Art* (New Haven, 1978). See also Anthony Grafton's discussion of individual versus collaborative modes of humanist endeavor compared to modern scientific laboratories, in *Worlds Made by Words: Scholarship and Community in the Modern West* (Cambridge, MA, 2009). Ann Blair is currently working on a project about collaborative working processes of early modern humanists.

17. The flourishing field of patronage studies has employed methodologies from social history and anthropology to bring to light creative exchange between artists and highly engaged patrons, revealing the patrons' contributions. For an excellent brief historiography of the study of Italian Renaissance patrons and agents, focused on Raphael's Rome, with earlier bibliography, see Sheryl E. Reiss, "Raphael and his Patrons: From the Court of Urbino to the Curia and Rome," in *The Cambridge Companion to Raphael*, 36–55, at 37 and nn. 9–15; and Reiss, "A Taxonomy of Art Patronage in Renaissance Italy," in *A Companion to Renaissance and Baroque Art*, ed. Babette Bohn and James M. Saslow (New York, 2013), 23–43; see also Guy Fitch Lytle and Stephen Orgel, eds., *Patronage in the Renaissance* (Princeton, 1981).

18. On the patron as architectural author, Christof Thoenes, "'Il carico imposto dall'economia'. Appunti su committenza ed economia dai trattati di architettura del Rinascimento," in *Sostegno e adornamento: saggi sull'architettura del Rinascimento* (Milan, 1998), 177–85. Giovanni Pontano advocated that the patron should be the *auctor* of his buildings in the *De magnificentia*, and signed his own chapel (completed

c. 1490) PONTANVS FECIT; discussed in Bianca de Divitiis, "Giovanni Pontano and his Idea of Patronage," in *Some Degree of Happiness: studi di storia dell'architettura in onore di Howard Burns*, ed. Maria Beltramini and Caroline Elam (Pisa, 2010), 107–31, at 109 and n. 4; and de Divitiis, "PONTANVS FECIT: Inscriptions and Artistic Authorship in the Pontano Chapel," *California Italian Studies* 3 (2012): 1–36. De Divitiis notes that Pontano is at once patron, architect, and antiquarian for this project that he claims to have made; and, significantly for the present study, I would add the role of humanist "advisor." I owe the last reference to Charlotte Nichols. Raffaelle Riario's inscription on the Cancelleria façade is a prominent Roman example of a patron's declaration of authorship; for which, Christoph Luitpold Frommel, "Raffaele Riario committente della Cancelleria," in *Arte, committenza ed economia a Roma e nelle corti del Rinascimento*, ed. Christoph Luitpold Frommel and Arnold Esch (Turin, 1995), 197–211. On the patron as author of a body of work, Ernst H. Gombrich, "The Early Medici as Patrons of Art: A Survey of Primary Sources," in *Italian Renaissance Studies*, ed. E. F. Jacob (London, 1960), 279–311; Dale Kent, *Cosimo de' Medici and the Florentine Renaissance* (New Haven, 2000).

19. As Sheryl E. Reiss has characterized Giulio de' Medici, and demonstrated in her extensive writings on his patronage; see especially Reiss, "Raphael, Pope Leo X, and Cardinal Giulio de' Medici," in *Late Raphael*, ed. Miguel Falomir (Madrid, 2013), 14–25, with earlier bibliography in nn. 8–9; Reiss, "Cardinal Giulio de' Medici as a Patron of Art, 1513–1523" (Ph.D. diss., Princeton, 1992), *passim* and especially 622–4; Reiss, "Clemens VII," in *Hoch Renaissance im Vatikan: Kunst und Kultur im Rom der Papste, 1503–1534* (Ostfildern, 1999), 55–69; Reiss, "Adrian VI, Clement VII, and Art," in *The Pontificate of Clement VII*, 339–62; and her forthcoming book, *Giulio de' Medici: A Renaissance Maecenas*. For Giulio's remarkable working relationship with Michelangelo, Caroline Elam, "Michelangelo and the Clementine Architectural Style," in *The Pontificate of Clement VII*, 199–226; and William Wallace, who described Giulio as "both patron and collaborator" to Michelangelo, in William E. Wallace, "Clement VII and Michelangelo: An Anatomy of Patronage," in *ibid.* 189–98, at

192. The collaborative, hands-on character of Medici architectural patronage has also been emphasized by Lillie and Bullard among others: Amanda Lillie, "Giovanni di Cosimo and the Villa Medici at Fiesole," in *Piero de' Medici "il Gottoso" 1416–1469*, ed. A. Beyer and B. Boucher (Berlin, 1993), 189–205; and Bullard, "Heroes and their Workshops." See also D. Kent, *Cosimo de' Medici*; and further sources in Chapter 3 note 5.

20. Maria Teresa Sambin de Norcen devised the term "cortigiano architetto" to characterize the Ferrarese patrician Bartolomeo Pendaglia, who built a villa at Consandolo for himself while serving as *fattore generale* for the Este, supervising aspects of the construction of the Este villa at Belriguardo; Sambin de Norcen, *Il cortigiano architetto: edilizia, politica, umanesimo nel quattrocento ferrarese* (Venice, 2012). For Maffei, Sheryl E. Reiss, "Giulio de' Medici and Mario Maffei: A Renaissance Friendship and the Villa Madama," in *Coming About: A Festschrift for John Shearman*, ed. Lars Jones and Louisa Matthew (Cambridge, MA, 2001), 281–8, with earlier bibliography on Maffei and brief discussion of other Medici agents. Maffei's role is discussed further below with sources in Chapter 1, pp. 22–3 and notes 44, 47 and in Chapter 6, pp. 145–6 and notes 15–19.

21. The role of humanists in architecture has prompted little attention beyond discussions of architect-theorists such as Alberti and Filarete. Discussion of the roles of advisors with bibliography follows in Chapters 5 and 6.

22. Sperulo's poem was cited by Ludwig von Pastor, *Geschichte der Päpste* (Berlin, 1907), vol. 4, part 2, 548 n. 1; Mario Emilio Cosenza, *Biographical and Bibliographical Dictionary of the Italian Humanists and of the World of Classical Scholarship in Italy, 1300–1800* (Boston, 1962), vol. 4, 3307; and P. O. Kristeller, *Iter Italicum* (London and Leiden, 1963), vol. 2, 335. Christoph Frommel published and discussed the lines that most explicitly describe the villa's planned decoration or state of construction; Christoph Luitpold Frommel, "Die architektonische Planung der Villa Madama," *Römisches Jahrbuch für Kunstgeschichte* 15 (1975): 62, 79–80; and Frommel, *Raffaello architetto*, 319–20. The poem had been brought to Frommel's attention by John Shearman (acknowledged by Frommel, "Die architektonische Planung," 62). Shearman published an additional two lines of

what he called this "unattractive poem," in Shearman, "A Functional Interpretation of Villa Madama," 315 and n. 3. Additional lines were cited and discussed in Reiss, "Cardinal Giulio de' Medici as a Patron of Art," 361 and notes on 395–6. The manuscript was exhibited in 1985: Giovanni Morello, ed., *Raffaello e la Roma dei Papi*, Exh. Cat (Rome, 1986), cat. 89, 80. The poem was first published in its entirety (together with an English translation) in 2003 by Shearman, *Sources*, vol. 1, 414–38, although he dismissed it as a "shamelessly encomiastic" work. (This 407-line poem has also been described pejoratively as a *poemetto*.) The analysis in this volume is based on a new critical edition and translation by Nicoletta Marcelli, with a gloss by the author (in Appendix 1).

23. Paul Gwynne, *Patterns of Patronage in Renaissance Rome. Francesco Sperulo: Poet, Prelate, Soldier, Spy*, 2 vols. (Bern, 2015), with a critical edition and translation of Sperulo's complete oeuvre including his villa poem, analysis of his style and sources, and biography. As noted in the Preface, Gwynne's work appeared just as the present book was going into production, making it impossible to respond to it thoroughly herein.

24. First published in Philip E. Foster, "Raphael on the Villa Madama: The Text of a Lost Letter," *Römisches Jahrbuch für Kunstgeschichte* 11 (1967–8): 308–12; see most recently Shearman, *Sources*, vol. 1, 405–13, with extensive earlier bibliography, especially by Francesco Paolo di Teodoro and Christof Thoenes. An annotated Italian/English language edition appears in Guy Dewez, *Villa Madama: A Memoir Relating to Raphael's Project* (London, 1993), hereinafter Raphael/Dewez.

25. Discussed by Ann C. Huppert, "Envisioning New St. Peter's. Perspectival Drawings and the Process of Design," *Journal of the Society of Architectural Historians* 68 (2009): 158–77, at 159–60.

26. For example, Caroline Elam, "The Raphael Conference in Rome."

27. That is, rapid rough sketches of initial ideas, a practice of exploration and invention given an important impetus by Leonardo; for which, Carmen C. Bambach, *Leonardo da Vinci Master Draftsman*, Exh. Cat. (New York, 2003), 21–2.

28. Heinrich von Geymüller, *Raffaello studiato come architetto* (Milan, 1884); Theobald Hofmann, *Raffael in seiner Bedeutung als Architekt*, vol. 1, *Villa Madama zu Rom* (Zittau, 1900); John Shearman, "Raphael … 'fa il Bramante'," in *Studies in Renaissance and Baroque Art Presented to Anthony Blunt on his 60th Birthday* (London, 1967), 12–17; Shearman, "Raphael as Architect," *Journal of the Royal Society of Arts* 116 (1968), 388–409; Shearman, "The Born Architect?," *Studies in the History of Art* 17 (1986) 203–10; Ray, *Raffaello architetto: linguaggio artistico e ideologia*; Christoph L. Frommel, "Bramantes 'Ninfeo' in Genazzano," *Römisches Jahrbuch für Kunstgeschichte* 12 (1969): 137–60; Frommel, "Raffaello e il teatro alla corte di Leone X," *Bollettino del Centro internazionale di studi di architettura Andrea Palladio* 16 (1974): 173–87; Frommel, "Die architektonische Planung der Villa Madama"; Frommel et al., *Raffaello architetto*; Dewez, *Villa Madama*; David R. Coffin, "The Plans of the Villa Madama," *Art Bulletin* 49 (1967): 111–22; Coffin, *The Villa in the Life of Renaissance Rome*, 245–57; Sabine Eiche, "A New Look at Three Drawings for Villa Madama and Some Related Images," *Mitteilungen des Kunsthistorischen Institutes in Florenz* 36.3 (1992): 275–86; Guido Beltramini and Howard Burns, eds., *Andrea Palladio e la villa veneta da Petrarca a Carlo Scarpa*, Exh. Cat. (Venice, 2005), 242–5 (entry by Maddalena Scimemi).

29. The sole surviving drawing for the villa attributed to Raphael's hand is U 1356Ar, a precise drawing of three garden rooms showing their geometric forms, patterns of circulation down the sloping site, and the placement of sculpture and fountains. Frommel, *Raffaello architetto*, 330.

30. Christoph Luitpold Frommel, "Introduction. Antonio da Sangallo the Younger and the Practice of Architecture in the Renaissance," in *The Architectural Drawings of Antonio da Sangallo the Younger and his Circle*, vol. 2, *Churches, Villas, the Pantheon, Tombs, and Ancient Inscriptions*, ed. Christoph Luitpold Frommel and Nicholas Adams (New York, 1994), 1–21, at 14.

31. On the respective contributions of Raphael and Antonio da Sangallo the Younger, see Frommel, "Villa Madama," in *Raffaello architetto*, 311–56; Frommel, "Raffael und Antonio da

Sangallo der Jungere," in *Raffaello a Roma: Atti del convegno, 1983* (Rome, 1986), 261–304; Frommel, "Raffaello e Antonio da Sangallo il Giovane," in *Architettura del Rinascimento alla corte papale* (Milan, 2003), 280–97; Frommel, "Le opere romane di Giulio," in *Giulio Romano*, Exh. Cat. (Milan, 1989), 98–103 and 290–1; Frommel, "Die architektonische Planung der Villa Madama." In his analysis of the most significant surviving drawing for the villa, Fritz-Eugen Keller suggests that U 314A (Plate VI herein, discussed in Chapter 1) reflects "intensive discussion" between Raphael and Antonio: F.-E. Keller, "Catalogue Entry, U 314A recto," in *Architectural Drawings of Antonio da Sangallo the Younger*, vol. 2, 137–8. Stefano Ray also interpreted various aspects of the architecture of Raphael, Antonio da Sangallo, and other associates who worked at Villa Madama: Stefano Ray, "Villa Madama a Roma," *L'Architettura* 14 (1969): 822–9; Ray, *Raffaello architetto: linguaggio artistico e ideologia*; Ray, "Antonio da Sangallo il Giovane e Raffaello. I connotati di un confronto," in *Antonio da Sangallo il Giovane: la vita e l'opera. Atti del XXII congresso di storia dell'architettura, Rome, 1986*, ed. Gianfranco Spagnesi (Rome, 1986), 43–62; Ray, "Palazzo e villa: Roma, 1510–1550," in *Il Palazzo dal Rinascimento a oggi : Atti del convegno, 1988*, ed. Simonetta Valtieri (Rome, 1988), 93–100; Ray, "Raffaello architetto, la costruzione dello spazio," in *Raffaello e l'Europa*, 131–52; Ray, *Lo specchio del Cosmo: da Brunelleschi a Palladio: itinerario nell'architettura del Rinascimento* (Rome, 1991). See also Coffin, "Plans of the Villa Madama" and Eiche, "A New Look at Three Drawings for Villa Madama."

32. Reiss plausibly suggests that Cardinal Giulio must have studied and discussed the plans for the villa, consistent with his practice in Michelangelo's Florentine projects: "Raphael, Pope Leo X, and Cardinal Giulio de' Medici," 22.

33. Christof Thoenes, "Neue Beobachtungen an Bramantes St.-Peter-Entwürfen," in *Opus incertum: italienische Studien aus drei Jahrzehnten* (Munich, 2002), 381–417, at 386.

34. On the methodologies and limitations of architectural reconstruction, see Christoph Luitpold Frommel, "La restitution des edifices de la Renaissance: problèmes de crédibilité," in *Archives et histoire de l'architecture: Actes du colloque, Paris, 1988*, ed. Pierre Joly (Paris, 1990), 285–304; and Guy Dewez, "La Villa Madama: peut-on imaginer l'œuvre de Raphael?," in *ibid*. 304–23.

35. Stefano Ray, "Il volo di Icaro. Raffaello architettura e cultura," in *Raffaello architetto*, ed. Frommel et al., 47–58.

36. For the letters between Cardinal Giulio and Mario Maffei, Shearman, *Sources*, vol. 1, 599–601 and 602–5 with earlier bibliography, notably Reiss, "Giulio de' Medici and Mario Maffei"; Renato Lefevre, "Un prelato del '500, Mario Maffei e la costruzione di Villa Madama," *L'Urbe* 32.3 (1969): 1–11; and Lefevre, "La 'Vigna del Cardinale de' Medici' e il vescovo d'Aquino," *Strenna dei Romanisti* 22 (1961): 171–7. For payment documents, Lefevre, *Villa Madama*, 119, 139, 146–7, 153 nn. 83, 86, 87, 89–92; Shearman, "A Functional Interpretation of Villa Madama," 316; Shearman, *Sources*, vol. 1, 771–2 (but NB payments from the *Entrata e uscita* of Clement VII in the ASR listed as unpublished were in fact published by Lefevre, *Villa Madama*; Elet, "Papal *villeggiatura*," 43 n. 56; and Chapter 1 note 107.

37. See especially Amanda Lillie, "The Humanist Villa Revisited," in *Language and Images of Renaissance Italy*, ed. Alison Brown (Oxford, 1995), 193–215; and Lillie, "Fiesole: Locus amoenus or Penitential Landscape?," *I Tatti Studies: Essays in the Renaissance* 11 (2008): 11–55.

38. Nadja Aksamija, "Architecture and Poetry in the Making of a Christian Cicero: Giovanni Battista Campeggi's Tuscolano and the Literary Culture of the Villa in Counter-Reformation Bologna," *I Tatti Studies: Essays in the Renaissance* 13 (2011): 127–91.

39. Among the works on Quattrocento Ferrara by Maria Teresa Sambin de Norcen in the notes and bibliography, see especially "'Ut apud Plinium': giardino e paesaggio a Belriguardo nel Quattrocento," in *Delizie in villa: il giardino rinascimentale e i suoi committenti*, ed. Gianni Venturi and Francesco Ceccarelli (Florence, 2008), 65–90; and Sambin de Norcen, *Le ville di Leonello d'Este: Ferrara e le sue campagne agli arbori dell'età moderna* (Venice, 2012). Paola Modesti analyzes a 1535–6 description of Poggioreale, among other sources, to reconstruct the cinquecento appearance of this important villa in Naples, later destroyed, in Modesti, *Le delizie ritrovate: Poggioreale e la villa del Rinascimento nella Napoli aragonese* (Florence, 2014).

40. As noted by Kenneth Gouwens, "Perceiving the Past: Renaissance Humanism after the 'Cognitive Turn'," *American Historical Review* 103 (1998): 55–82, at 79–82.

41. Among the vast bibliography on this subject, see Caroline Elam, "Drawings as Documents: The Problem of the San Lorenzo Façade," *Studies in the History of Art* 33 (1992): 98–114; Cammy Brothers, "Architecture, History, Archeology: Drawing Ancient Rome in the Letter to Leo X and in Sixteenth-Century Practice," in *Coming About*, 135–40; Marco Frascari, Jonathan Hale, and Bradley Starkey, eds., *From Models to Drawings: Imagination and Representation in Architecture* (London, 2007); Hooman Koliji, *In-Between: Architectural Drawing and Imaginative Knowledge in Islamic and Western Traditions* (Farnham, 2015).

42. See the important work of Brian Richardson cited herein, especially *Manuscript Culture in Renaissance Italy* (Cambridge, 2009). His research builds on the fundamental works of Armando Petrucci; e.g. *La descrizione del manoscritto: storia, problemi, modelli* (Rome, 2001).

43. Historians of Italian Renaissance literature, following those of English literature, have recently begun to integrate literary analysis, the history of literary culture, and book history, as noted by Brian Richardson, "The Diffusion of Literature in Renaissance Italy. The Case of Pietro Bembo," in *Literary Cultures and the Material Book*, ed. Simon Eliot, Andrew Nash, and Ian Willison (London, 2007), 175–89. For a thoughtful historiography of socio-cultural approaches to Italian manuscript studies, see the Preface by Fillipo de Vivo and Brian Richardson and review essay by Simone Testa in a special issue of *Italian Studies* 66 (2011).

44. Lauro Martines, *Society and History in English Renaissance Verse* (Oxford, 1985), 20, 53, and *passim*.

45. Susanna de Beer, *The Poetics of Patronage: Poetry as Self-Advancement in Giannantonio Campano* (Turnhout, 2013); and David Rijser, *Raphael's Poetics: Art and Poetry in High Renaissance Rome* (Amsterdam, 2012).

46. Among many possible examples, Dorothy Metzger Habel, *When All of Rome Was under Construction: The Building Process in Baroque Rome* (University Park, PA, 2013), who considers the voices of a variety of "stakeholders" in what she terms the "incubation of architecture"; Marvin Trachtenberg, *Building-in-Time:*

From Giotto to Alberti and Modern Oblivion (New Haven, 2010); and Raffaella Fabiani Giannetto, *Medici Gardens: From Making to Design* (Philadelphia, 2008). See also the project of the Biblioteca Hertziana in Rome and the Max-Planck-Institut für Wissenschaftsgeschichte in Berlin on Wissensgeschichte der Architektur/ Epistemic History of Architecture (http:// wissensgeschichte.biblhertz.it/WdA/WdA/ WdA_coll/description/#Deutsch).

47. Among the large literature on this subject, notably at St. Peter's, see especially Nicoletta Marconi, *Edificando Roma Barocca: Macchine, apparati, maestranze e cantieri tra XVI e XVIII secolo* (Città di Castello, 2004), 25–7 and *passim*.

48. For which, see discussion in Chapter 5 with bibliography.

49. Among the rich bibliography on these subjects, Martin Kemp, "From 'Mimesis' to 'Fantasia': The Quattrocento Vocabulary of Creation, Inspiration and Genius in the Visual Arts," *Viator* 8 (1977): 347–98; Michael Baxandall, *Giotto and the Orators* (Oxford, 1971), 15ff.

50. For the notion of efficacy in text, images, and the art of memory, see the essays in *Efficacité/Efficacy: How To Do Things with Words and Images?*, ed. Véronique Plesch, Catriona MacLeod, and Jans Baetens (Amsterdam, 2011).

51. Caroline Van Eck, *Classical Rhetoric and the Visual Arts in Early Modern Europe* (Cambridge, 2007), 37; Daniel Willis, *The Emerald City and Other Essays on the Architectural Imagination* (New York, 1999), 114.

52. Editorial theory opened up studies of textual process by considering different textual states of a work – including so-called ugly manuscripts emended by the artist's hand – along with editorial performance and the processes of composition. For example, H. Wayne Storey, "Dirty Manuscripts and Textual Cultures. Introduction to *Textual Cultures* 1.1," *Textual Cultures: Texts, Contexts, Interpretation* 1.1 (2006): 1–4.

53. Mario Carpo, *Alberti, Raffaello, Serlio e Camillo* (Geneva, 1993), 9–10, 52–5, and *passim*, highlighting the importance of Pietro Bembo's *Prose della volgar lingua*, Giulio Camillo Delminio's *Trattato dell'imitazione* (*c.* 1530), and his *Topica o vero dell'elocuzione* (*c.* 1540). For Cicero's comparison between ornament as an assemblage of words or decorative building elements, see *De oratore*, XXXIX, 134; and

the discussion in Alina Payne, *The Architectural Treatise in the Italian Renaissance: Architectural Invention, Ornament and Literary Culture* (Cambridge, 1999), 63ff. Charles Dempsey characterizes Botticelli's *Primavera* as a material manifestation of a poetic invention, "bringing together material derived from and rationalized by a large number of ancient authors" to create a new synthesis, providing an example of this process in an earlier Medicean context: Charles Dempsey, *The Portrayal of Love: Botticelli's* Primavera *and Humanist Culture at the Time of Lorenzo the Magnificent* (Princeton, 1992), 19 and *passim*.

54. Among many recent works on the subject of *ut lingua architectura* see especially Payne, *The Architectural Treatise*; Payne, "*Ut poesis architectura*: Tectonics and Poetics in Architectural Criticism circa 1570," in *Antiquity and its Interpreters*, ed. Alina Payne, Ann Kuttner, and Rebekah Smick (Cambridge, 2000), 145–58; the essays in Georgia Clarke and Paul Crossley, eds., *Architecture and Language: Constructing Identity in European Architecture, c. 1000–1650* (Cambridge, 2000); Alberto Pérez-Gómez, *Built upon Love: Architectural Longing after Ethics and Aesthetics* (Cambridge, 2006); and Roy Eriksen, *The Building in the Text: Alberti to Shakespeare and Milton* (University Park, PA, 2001), which presents a "topomorphic reading" of spatial patterns in the composition of poetry. For the parallel notion of *ut pictura poesis*, Renssalaer W. Lee, *Ut pictura poesis: The Humanistic Theory of Painting* (New York, 1967); Martin Schwartz, "Ut pictura poesis," Chicago School of Media Theory blog, https://lucian.uchicago.edu/blogs/mediatheory/keywords/ut-pictura-poesis/.

55. On Michelangelo and language see Caroline Elam, "'Tuscan Dispositions': Michelangelo's Florentine Architectural Vocabulary and its Reception," *Renaissance Studies* 19.1 (2005), 46–82; and Elam, "Michelangelo and the Clementine Architectural Style," in *The Pontificate of Clement VII*, 199–226.

56. Hans H. Aurenhammer, "*Multa aedium exempla variarum imaginum atque operum*. Das Problem der *imitatio* in der italienischen Architektur des frühen 16. Jahrhunderts," in *Intertextualität in der Frühen Neuzeit: Studien zu ihren theoretischen und praktischen Perspektiven* (Frankfurt, 1994), 533–605; David Hemsoll, "A Question of Language: Raphael, Michelangelo and the Art of Architectural Imitation," in *Raising the Eyebrow: John Onians and World Art Studies: An Album Amicorum in his Honour*, ed. Lauren Golden and Martin Kemp (Oxford, 2001); and Elam, "Raphael's New Architectural Agenda," in *Imitation, Representation and Printing in the Italian Renaissance*, ed. Roy Eriksen and Magne Malmanger (Pisa and Rome, 2009), 209–31. Cf. Guido Beltramini, who invokes Tafuri's caution of the risks of direct translation from one discipline to another; in Beltramini, "Pietro Bembo e l'architettura," in *Pietro Bembo e l'invenzione del Rinascimento*, ed. Guido Beltramini, Davide Gasparotto, and Adolfo Tura (Venice, 2013), 12–31, at 25. The notion of selection in Raphael's art and architecture is discussed in Chapter 1 pp. 45–6.

57. Although, as Caroline van Eck notes, the purpose of this abstract analogy was to rationalize architecture as an Aristotelian *scienza: Classical Rhetoric and the Visual Arts*, 37–46 and *passim*.

58. Ideas about style (*maniera*) and order (*ordine*) would be canonized into a theory of the orders by Sebastiano Serlio, who first codified sixteenth-century architectural thought in the late 1530s, much of it drawing heavily on Peruzzi and the works of Raphael and Bramante. The period of Villa Madama's planning and construction in the second two decades of the sixteenth century coincides with the lacuna in surviving theoretical writings on art and architecture, so in matters of architecture and language we are left to triangulate among quattrocento treatises, those of the mid-cinquecento, and early cinquecento evidence gleaned from other types of writing, as well as the buildings themselves.

59. W. J. T. Mitchell, *Iconology: Image, Text, Ideology* (Chicago, 1987); Mitchell, "Word and Image," in *Critical Terms for Art History*, ed. Robert S. Nelson and Richard Shiff (Chicago, 1996), 49. For an analysis of *ekphrasis* as a struggle for mastery between the sister arts, James A. W. Heffernan, *Museum of Words: The Poetics of Ekphrasis from Homer to Ashbery* (Chicago, 1993).

60. For humanism as "an outlook on education," Ingrid Rowland, *The Culture of the High Renaissance: Ancients and Moderns in Sixteenth-Century Rome* (Cambridge, 1998), 10; for additional literature on humanism, see Chapter 1 note 18 and *passim*.

61. A subject I treated in my dissertation (Elet, "Papal *villeggiatura*") and will address in a monograph encompassing the architecture, decoration, landscape, and gardens of the Medici villa complex.

62. Mary Carruthers, "The Concept of 'Ductus'. Or Journeying through a Work of Art," in Carruthers, *Rhetoric beyond Words* (Cambridge, 2010), 190–213.

63. Michel Jeanneret notes the surprising number of Renaissance literary masterworks that were presented as works in progress "in the image of a universe in perpetual gestation"; Jeanneret, *Perpetual Motion: Transforming Shapes in the Renaissance from da Vinci to Montaigne*, trans. Nidra Poller (Baltimore, 2001), 197.

1 REVIVING THE CORPSE

1. "Tu quoque dum toto laniatam corpore Romam / Componis miro Raphael ingenio, / Atque Vrbis lacerum ferro, ignis, annisque cadaver, / Ad vitam … Te dudum extinctis reddere posse animam"; text and translation in Shearman, *Sources*, vol. 1, 650–3.

2. Nancy Vickers, "The Body Re-Membered: Petrarchan Lyric and the Strategies of Description," in *Mimesis: From Mirror to Method, Augustine to Descartes*, ed. John D. Lyons and Stephen G. Nichols, Jr. (Hanover, 1982), 101–9.

3. As characterized by Leonard Barkan, *Unearthing the Past: Archeology and Aesthetics in the Making of Renaissance Culture* (New Haven, 1999), 119–207 and *passim*.

4. For literary sources of the Rome-as-cadaver metaphor, Shearman, *Sources*, vol. 1, 528–9 with earlier bibliography.

5. On the Hebrew etymology of his namesake, the Archangel Raphael, as *Medicina Dei* ("God heals"), and the imagery of Raphael as Esculapius and divine healer: Weil-Garris, "La morte di Raffaello e la 'Trasfigurazione'," 185 and *passim*. For the representation of this imagery in Raphael's late paintings, and thus during his lifetime, Butler, "'Reddita lux est'." See also Reiss, "Raphael, Pope Leo X, and Cardinal Giulio de' Medici," n. 57 with earlier bibliography on this imagery and the association of the divine healer imagery (*Christus medicus*) with Medici patrons.

6. "vedendo quasi un cadavero di quella nobil patria …. Onde quelle famose opere … per dir così, l'ossa del corpo senza carne." From the autograph Castiglione manuscript in Mantua, Shearman, *Sources*, vol. 1, 501–2. The letter and issues about its authorship are discussed further below, p. 28 and note 86.

7. For the poems at Raphael's death, Shearman, *Sources*, vol. 1, 639–62; Weil-Garris, "La morte di Raffaello," 177–90; and Giovanna Perini, "Carmi inediti su Raffaello e sull'arte della prima metà del cinquecento a Roma e Ferrara e il mondo dei *Coryciana*," *Römisches Jahrbuch der Biblioteca Hertziana* 32 (1997/8), 369–407.

8. On the equation of ancient ruins and "new ruins," see the discussion in Chapter 6 with relevant sources.

9. The classic studies on *villeggiatura* and villa ideology are: James Ackerman, *The Villa: Form and Ideology of Country Houses* (Princeton, 1990), which focused on the relation of villa ideology and architectural form; David R. Coffin, *The Villa in the Life of Renaissance Rome* (Princeton, 1979); Coffin, *Gardens and Gardening in Papal Rome*; Pierre de la Ruffinière Du Prey, *The Villas of Pliny from Antiquity to Posterity* (Chicago, 1994); William MacDonald and John Pinto, *Hadrian's Villa and its Legacy* (New Haven, 1995); Amanda Lillie, "The Humanist Villa Revisited"; and Beltramini and Burns, eds., *Andrea Palladio e la villa veneta*.

10. Sabine Eiche identified the architecture in the background of these images as Villa Madama in the catalogue entry in *Renaissance Architecture from Brunelleschi to Michelangelo: The Representation of Architecture*, ed. Henry A. Millon and Vittorio Lampugnani (Milan, 1994), 563. To my knowledge, no previous study has interpreted the confluence of subject and setting in these works. Lombard's drawing, dated 1544, was probably intended for a painting, but later reused for the engraving after 1548, as proposed by Cécile Oger, who notes the existence of two other Lombard workshop drawings related to this one: Cécile Oger, "Les pratiques de copies au sein de l'atelier de Lombard," in *Lambert Lombard: peintre de la Renaissance Liège 1505/06–1566*, Exh. Cat. ed. Godelieve Denhaene (Brussels, 2006), 107–12. Lombard's drawings further detail his fascination with Muses; possibly he studied the ancient sculptures of the Muses at Villa Madama while he was there. See for example the sketchbook sheet of twelve seated figures in his Arenberg Album, illustrated in *Lambert Lombard*, 374 cat. 34 and fig. 325. (For the Muses at the Medici villa, see

Chapter 5 below.) For Lombard's appropriation of Raphael as a model, his study of Muses, and the Lazarus drawing and print, Godelieve Denhaene, *Lambert Lombard: Renaissance et humanisme à Liège* (Anvers, 1990), 77–100. On the context for Lombard's Roman studies and Cock's prints of his work, *Hieronymous Cock: The Renaissance in Print*, Exh. Cat., ed. Joris van Grieken, Ger Luijten, and Jan van der Stock (New Haven, 2013).

11. For Lombard's depiction of the villa as ambiguously half-built or ruined in the context of contemporary notions conflating ancient and modern ruins, see Chapter 6 p. 164.

12. About Leo's pontificate: Roscoe, *The Life and Pontificate of Leo the Tenth*, trans. and revised by Thomas Roscoe, 6th edn., 2 vols. (London, 1853); Pastor, *Geschichte der Päpste*, vols. 7–8 (1898–1913); Maurizio Gattoni da Camogli, *Leone X e la geopolitica dello Stato Pontificio, 1513–1521* (Città del Vaticano, 2000); Marco Pellegrini, "Leone X," in *Enciclopedia dei Papi*, vol. 2 (Rome, 2000); Nicoletta Baldini and Monica Bietti, eds. *Nello splendore mediceo: Papa Leone X e Firenze*, Exh. Cat. (Florence, 2013); Marcello Simonetta, *Volpi e leoni: i Medici, Machiavelli e la rovina d'Italia* (Milan, 2014), 93–232.

13. Discussed below with sources, Chapter 3 p. 82 and nn. 77–80.

14. John M. McManamon, S.J., "Marketing a Medici Regime: The Funeral Oration of Marcello Virgilio Adriani for Giuliano de' Medici (1516)," *Renaissance Quarterly* 44 (1991): 4ff with earlier bibliography.

15. For which see Francesco P. di Teodoro, *Ritratto di Leone X di Raffaello Sanzio* (Milan, 1998); Nelson H. Minnich, "Raphael's Portrait *Leo X with Cardinals Giulio de' Medici and Luigi de' Rossi*: A Religious Interpretation," *Renaissance Quarterly* 56 (2003): 1005–52; Joanna Woods-Marsden, "One Artist, Two Sitters, One Role: Raphael's Papal Portraits," in *The Cambridge Companion to Raphael,* 128–40; Jürg Meyer zur Capellen, *Raphael: A Critical Catalogue of his Paintings* (Landshut, 2008), vol. 3: cat. 81, 162–7 with earlier sources.

16. On the culture of Rome in the early sixteenth century, see especially Charles L. Stinger, *The Renaissance in Rome* (Bloomington, 1985); Rowland, *Culture of the High Renaissance.* Among the large bibliography on Roman Golden Age imagery, E. H. Gombrich, "Renaissance and Golden Age," *Journal of the Warburg and Courtauld Institutes* 24 (1961):

306–9; Jeffrey Glodzik, "Vergilianism in Early Cinquecento Rome: Egidio Gallo and the Vision of Roman Destiny," *Sixteenth Century Journal* 45 (2014): 73–98.

17. James Hankins has traced the meanings of the term *res publica* in ancient and Renaissance sources, finding the origin of the modern notion of a republic as a non-monarchical form of government in quattrocento Italy: Hankins, "Exclusivist Republicanism and the Non-Monarchical Republic," *Political Theory* 38 (2010), 452–82. I refer to the notion of the papacy as a *res publica cristiana* in the sense he traces to the late fifteenth century, which was engrained by the time of Machiavelli and Castiglione.

18. Among the vast bibliography on Roman Renaissance humanism, see especially John D'Amico, *Renaissance Humanism in Papal Rome: Humanists and Churchmen on the Eve of Reformation* (Baltimore, 1983), 134ff; the collected articles of James Hankins, *Humanism and Platonism in the Italian Renaissance* (Rome, 2003); Kenneth Gouwens, *Remembering the Renaissance: Humanist Narratives of the Sack of Rome* (Leiden, 1998), 8–30; Gouwens, "Perceiving the Past: Renaissance Humanism after the 'Cognitive Turn'"; and David Cast, "Humanism and Art," in *Renaissance Humanism: Foundations, Forms, and Legacy*, ed. Albert Rabil, Jr. (Philadelphia, 1988): 412–49. On the Leonine rhetoric of peace, Shearman, *Raphael's Cartoons*; and Janet Cox-Rearick, *Dynasty and Destiny in Medici Art: Pontormo, Leo X, and the Two Cosimos* (Princeton, 1984).

19. As characterized by P. Godman, *From Poliziano to Machiavelli: Florentine Humanism in the High Renaissance* (Princeton, 1998), 3. See also G. B. Picotti, *La giovinezza di Leone X* (Milan, 1927), 265–7.

20. See Sheryl E. Reiss, "'Per havere tutte le opere … Da Monsignor Reverendissimo': Artists Seeking the Favor of Cardinal Giulio de' Medici," in *The Possessions of a Cardinal: Politics, Piety, and Art, 1450–1700*, ed. Mary Hollingsworth and Carol Richardson (University Park, PA, 2010), 113–31, at 115 and n. 18 with earlier bibliography.

21. Among the large and scattered literature on Medici imagery, see especially Cox-Rearick, *Dynasty and Destiny*; Shearman, *Raphael's Cartoons*; Dempsey, *The Portrayal of Love*; Mirella Levi D'Ancona, *Botticelli's* Primavera: *A Botanical Interpretation Including Astrology,*

Alchemy and the Medici (Florence, 1983); Claudia Rousseau, "*Cosimo I de' Medici and Astrology: The Symbolism of Prophecy*" (Ph.D. diss., Columbia University, 1983); Anthony M. Cummings, *The Politicized Muse: Music for Medici Festivals, 1512–1537* (Princeton, 1992); and Cummings, *The Lion's Ear: Pope Leo X, the Renaissance Papacy, and Music* (Ann Arbor, 2012).

22. Gombrich, "Renaissance and Golden Age"; for the notion of Leo-Augustus succeeding Julius-Caesar on the throne of St. Peters in contemporary imagery, Shearman, *Raphael's Cartoons*, 3.

23. Claudia Rousseau, "The Yoke *Impresa* of Leo X," *Mitteilungen des Kunsthistorischen Institutes in Florenz* 33 (1989): 113–26; Francesco Bausi, "Il broncone e la fenice," *Archivio storico italiano* 552 (1992): 437–54; Cox-Rearick, *Dynasty and Destiny*.

24. Cox-Rearick, *Dynasty and Destiny*, 48 and *passim*; Levi-D'Ancona, *Botticelli's* Primavera; and Yvan Loskoutoff, "Le symbolisme des *palle* Médicéennes à la Villa Madama," *Journal des Savants* (2001): 351–91.

25. For the social and intellectual life of these sodalities in early cinquecento Rome, see especially Domenico Gnoli, "Orti letterati nella Roma di Leone X," in *Roma di Leon X* (Milan, 1938), 136–63; Vincenzo De Caprio, "L'area umanistica romano (1513–1527)," *Studi romani* 29 (1981): 321–35; D'Amico, *Renaissance Humanism*, 89–112; Julia Haig Gaisser, "The Rise and Fall of Goritz' Feasts," *Renaissance Quarterly* 48 (1995): 41–57; Gaisser, *Pierio Valeriano on the Ill Fortune of Learned Men: A Renaissance Humanist and his World* (Ann Arbor, 1999*)*, 23ff, 45–7, and *passim*; and Gaisser, "The Mirror of Humanism: Self-Reflection in the Roman Academy," in *On Renaissance Academies: Proceedings of the International Conference "From the Roman Academy to the Danish Academy in Rome,"* ed. Marianne Pade (Rome, 2011), 123–32. For shared intellectual habits in quattrocento and cinquecento sodalities, and in different cities, Vincenzo De Caprio, "I cenacoli umanistici," in *Letteratura italiana: il letterato e le istituzioni*, vol. 1, ed. Alberto Asor Rosa (Turin, 1982), 799–822; Rowland, *Culture of the High Renaissance*.

26. On the difficulties and uncertainties of earning a living via literary patronage in Leonine and Clementine Rome, Julia Haig Gaisser, "Seeking Patronage under the Medici Popes: A Tale of Two Humanists," in *The Pontificate of Clement VII*, 293–309; and Gaisser, *Pierio Valeriano on the Ill Fortune of Learned Men*.

27. Josef Ijsewijn, ed., *Coryciana: critice edidit, carminibus extravagantibus auxit, praefatione et annotationibus instruxit* (Rome, 1997); Ijsewijn, "Poetry in a Roman Garden: The *Coryciana*," in *Latin Poetry and the Classical Tradition: Essays in Medieval and Renaissance Literature*, ed. Peter Godman and Oswyn Murray (Oxford, 1990), 211–31; and Rosenna Alhaique Pettinelli, "Punti di vista sull'arte nei poeti dei *Coryciana*," *Rassegna della letteratura italiana* 90 (1986): 41–54; Phyllis Pray Bober, "The 'Coryciana' and the Nymph Corycia," *Journal of the Warburg and Courtauld Institutes* 40 (1977): 223–39; Virginia Bonito, "*The Saint Anne Altar in Sant'Agostino, Rome*" (Ph.D. diss., New York University, 1983); and Bonito, "The Saint Anne Altar in Sant'Agostino in Rome: A New Discovery," *Burlington Magazine* 122 (1980): 805–12.

28. The Academy first flourished under Pomponio Leto, and it was subsequently headed by Paolo Cortesi, followed by Colocci, who probably took over when Cortesi left Rome in 1503. For Colocci, see Rowland, *Culture of the High Renaissance*, 7ff and *passim*, with bibliography at 255 n. 1. For his collaboration with Raphael, see below p. 26 and note 76.

29. Gaisser, "The Rise and Fall of Goritz's Feasts"; Rowland, *Culture of the High Renaissance*, chs. 6 and 7; Phyllis Pray Bober, "Appropriation Contexts: *Decor, Furor Bacchicus, Convivium*," in *Antiquity and its Interpreters*, 238ff; Bober, "The 'Coryciana' and the Nymph Corycia"; Gnoli, "Orti letterari," 136–63; T. C. Price Zimmermann, "Renaissance Symposia," in *Essays Presented to Myron P. Gilmore*, vol. 1 (Florence, 1978): 363–74; T. C. Price Zimmermann and Saul Levin, "Fabio Vigile's 'Poem of the Pheasant': Humanist Conviviality in Renaissance Rome," in *Rome in the Renaissance: The City and the Myth*, ed. P. A. Ramsey (Binghamton, 1982), 265–78; D'Amico, *Renaissance Humanism*, 89–112; and De Caprio, "I cenacoli umanistici."

30. As Blosio Palladio described in his introduction to the *Coryciana*, noted by Bonito, "The Saint Anne Altar" (1983), 177 n. 261. For the argument that early modern wall-writing of various sorts was more widespread than we

have known, Juliet Fleming, *Graffiti and the Writing Arts of Early Modern England* (London, 2001). That this practice was especially associated with villas is suggested by Varro; in his discussion of the ideal villa in his dedication of the third book of his *De re rustica* to his friend Pinnius, he says, "For just as you had a villa noteworthy for its frescoing, inlaid work, and handsome mosaic floors, but thought it was not fine enough until its walls were adorned also by your writings, so I, that it might be farther adorned with fruit, so far as I could make it so, am sending this to you, recalling as I do the conversations which we held on the subject of the complete villa." ("Cum enim villam haberes opere tectorio et intestino ac pavimentis nobilibus lithostrotis spectandam et parum putasses esse, ni tuis quoque litteris exornati parietes essent, ego quoque, quo ornatior ea esse posset fructu, quod facere possem, haec ad te misi, recordatus de ea re sermones, quos de villa perfecta habuissemus.") Varro, *De re rustica* III, 1, 10; from Harrison Boyd Ash, ed., *Marcus Porcius Cato: On Agriculture*, trans. William Davis Hooper (Cambridge, MA, 1993).

31. Brian Richardson, "'Recitato e cantato': The Oral Diffusion of Lyric Poetry in Sixteenth-Century Italy," in *Theatre, Opera, and Performance in Italy from the Fifteenth Century to the Present: Essays in Honour of Richard Andrews*, ed. Brian Richardson, Simon Gilson, and Catherine Keen (Leeds, 2004), 67–82. See also the website "Italian Voices. Oral Culture, Manuscript and Print in Early Modern Italy, 1450–1700" (http://arts.leeds.ac.uk/italianvoices/).

32. "Nulla enim commercia maiorem conciliant amiciciae coniunctionem quam convictus, quam simul ali, et enutriri, unde sodales et sodalitium, pro amicorum eorum collegio qui saepe simul cenitant. Cuiusmodi Romae habetis Sadoletum, Gyberticum, Coritianum, Colotiacum, Melineum, Cursiacum, Blosianum, et alia." From Valeriano's lectures on Catullus of 1521–2, in a gloss on the term *sodalis* in Catullus 12. As pointed out by Gaisser, with citation and translation in "The Mirror of Humanism," 123.

33. The variously convivial, competitive, and collaborative aspects of humanist culture have been fruitfully traced in other contexts as well; see Adrian Armstrong, *The Virtuoso Circle: Competition, Collaboration, and Complexity in*

Late Medieval French Poetry (Tempe, AZ, 2012); Grafton, *Worlds Made by Words*; and Cast, *The Delight of Art*, 35–65. Ann Blair is working on humanist collaboration, as noted in the Introduction, note 16.

34. Gaisser, "Seeking Patronage under the Medici Popes"; Gaisser, *Pierio Valeriano on the Ill Fortune of Learned Men*; Anne Reynolds, *Renaissance Humanism at the Court of Clement VII: Francesco Berni's* Dialogue against Poets *in Context* (New York, 1997), 154–6, 158–9 and *passim*; and Vincenzo De Caprio, "Intellettuali e mercato del lavoro nella Roma Medicea," *Studi romani* 29 (1981): 29–46, at 34–6, on the system of Italian Renaissance literary patronage as an exchange of goods and services, and the tensions inherent in the systems of *mecenatismo* and *clientelismo*. See also Chapter 2 pp. 59–60 and notes 79–80.

35. This theme is explicit in Arsilli's "De poetis urbanis" in the *Coryciana*. For discussion of this, Ijsewijn, "Poetry in a Roman Garden," 216.

36. Gombrich, "Renaissance and Golden Age," 307.

37. D'Amico, *Renaissance Humanism*, 87, 238–40 and *passim*; Gaisser, "Seeking Patronage under the Medici Popes," 308–9 and *passim*; and Gaisser, *Pierio Valeriano on the Ill Fortune of Learned Men*.

38. Reynolds, *Renaissance Humanism at the Court of Clement VII*.

39. For which, Gouwens, *Remembering the Renaissance*; Gaisser, *Pierio Valeriano on the Ill Fortune of Learned Men*.

40. Beltramini et al., *Pietro Bembo e l'invenzione del Rinascimento*, entry by Carlo Vecce, "Il 'cantiere romano'," 276–83; and Claudio Vela, Cat. 4.1, 250–1. The work was published in 1525.

41. Pierio Valeriano, "Dialogo della volgar lingua," in *Discussioni linguistiche del cinquecento*, ed. Mario Pozzi (Turin, 1988), 37–93; for which, see Chapter 2 pp. 58–9 and notes 76, 77. I am grateful to Caroline Elam who first brought this work to my attention, and to Sheryl Reiss for this citation. For Valeriano, Gaisser, *Pierio Valeriano on the Ill Fortune of Learned Men*; Kenneth Gouwens, "L'umanesimo al tempo di Pierio Valeriano: la cultura locale, la fama, e la *Respublica litterarum* nella prima metà del cinquecento," in *Bellunesi e Feltrini tra Umanesimo e Rinascimento: filologia, erudizione e biblioteche*, ed.

Paolo Pellegrini (Rome and Padua, 2006), 3–10; and Gouwens, *Remembering the Renaissance*, 143–9.

42. As noted by Rowland, *Culture of the High Renaissance*, 250–3.

43. Gaisser, "Mirror of Humanism," 128–9.

44. Reiss, "Giulio de' Medici and Mario Maffei," with additional earlier sources; D'Amico, *Renaissance Humanism*, 85–8; Lefevre, "Un prelato del '500, Mario Maffei e la costruzione di Villa Madama"; Lefevre, "La 'Vigna del Cardinale de' Medici' e il vescovo d'Aquino"; Luigi Pescetti, "Mario Maffei (1463–1537)," *Rassegna volterrana* 6 (1932): 66–91.

45. In 1517, he entered the household of Cardinal Giulio, with whom he went to Florence in January 1519. T. C. Price Zimmermann, *Paolo Giovio: The Historian and the Crisis of Sixteenth-Century Italy* (Princeton, 1995), chs. 2 and 3. On his role as artistic advisor in this period, Barbara Agosti, *Paolo Giovio: uno storico lombardo nella cultura artistica del cinquecento* (Florence, 2008), 10–34.

46. Ijsewijn, *Coryciana/critice edidit*, 344–59.

47. "Est Marius versu, pergrato et scommate notus, / Cui virides colles ruraque amaena placent. / Saepius inde novem vocat ad vineta Sorores, / Munifica impendens citria poma manu, / Promittitque rosas, violas, vaccinia et alba / Lilia, cum primo vere tepescet humus." In Francesco Arsilli, *De poetis urbanis*, lines 147–52, in Ijsewijn, *Coryciana/critice edidit*, 344–59. For his villas, D'Amico, *Renaissance Humanism*, 86 and 271 nn. 134–5. Maffei's letters about his Volterra villa and his role as a Medici agent are discussed in Chapter 6, pp. 145–6.

48. For which, see the discussion in the context of Plinian villa literature in Chapter 2 pp. 47, 49 and note 4.

49. Inghirami's villa was described by Albertini in 1509; discussed by Christiane Joost-Gaugier, *Raphael's Stanza della Segnatura: Meaning and Invention* (Cambridge, 2002), 31 and 187 n. 50.

50. See now Gwynne, *Patterns of Patronage*, for a complete account of Sperulo's career and works.

51. His Borgia panegyric is in the BAV, Vat. Lat. 5205, fols. 1r–30v, published by W. W. Woodward, *Cesare Borgia: A Biography* (London, 1913), 438–55, and discussed by R. Garnett, "A Laureate of Caesar Borgia," *English Historical Review* 17 (1902): 15–19; Cosenza,

Biographical and Bibliographical Dictionary of the Italian Humanists, vol. 4, 3307; and Davide Canfora, "'Carmine studioso, tamen veridico': encomio, poesia e storiografia nell'epica di Francesco Sperulo," in *Il Principe e la storia: Atti del convegno Scandiano 18–20 settembre 2003*, ed. Tina Matarrese and Cristina Montagnani (Novara, 2005), 291–8. Sperulo also composed a series of epigrams to Cesare Borgia, in BAV, Vat. Lat. 5205, fols. 31v–40, as noted by Filippo Tamburini, *Santi e peccatori: confessioni e suppliche dai Registri della Penitenzieria dell'Archivio Segreto Vaticano 1451–1586* (Milan, 1995), 209.

52. The *Rotulus* of Leo's papal court from 1514 to 1516 listed Sperulo among the *cubicularii* as Dominus Franciscus Sperulus (a lay title), also naming the *famuli* in his personal service: Matheus Ricus, Tertonensis dioc., Ioannes Bartholomeus de Arofis, and Ioannes de Furno, Gebenensis dioc. In Alessandro Ferrajoli, *Il ruolo della corte di Leone X (1514–16)*, ed. Vincenzo De Caprio (Rome, 1984), 20. On the role of the *cubicularius*, Christopher S. Celenza, *Renaissance Humanism and the Papal Curia: Lapo da Castiglionchio the Younger's* De curiae commodis (Ann Arbor, 1999), 167 and n. 44; W. von Hoffman, *Forschungen zur Geschichte der kurialen Behörden vom Schisma bis zur Reformation*, vol. 1 (Rome, 1914), 160–1 n. 4; and Peter Partner, *The Pope's Men: Papal Civil Service in the Renaissance* (Oxford, 1990), 61, who notes that the choice to represent Sigismondo de' Conti in his robes of the papal chamberlain in Raphael's *Madonna di Foligno* reflects the dignity of this post.

53. Although its annual pension of grain was given to another papal *familiare*, Lorenzo Parmenio da San Ginesio. Tamburini, *Santi e peccatori*, 207–10 n. 5; and Rita Andreina, "Per la storia della Vaticana nel primo Rinascimento," in *Le origini della Biblioteca Vaticana tra umanesimo e Rinascimento (1447–1534)*, vol. 1, ed. Antonio Manfredi (Città del Vaticano, 2010), 237–308, at 266.

54. "Mandamus quatenus Francisco Sperulo diacono et Vincentio Pinpinello subdiacono, dum per nos divina ministeria celebrantur inter missarum solemnia in capella nostra in lingua greca ad serviendum deputatis, ducatos quinque auri de cam. pro eorum quolibet singulo mense persolvi faciant. Datum Rome apud Sanctum Petrum MDXVIII, die septima mensis aprilis." G. Amati, "Notizia di

55. Vittorio Fanelli, "Il ginnasio greco di Leone X a Roma," *Studi romani* 9 (1961): 379–93.

56. Sperulo was involved in negotiations for a marriage, revealed by two of Castiglione's letters from July and August of 1519; Baldassare Castiglione, *Le Lettere*, ed. Guido La Rocca, vol. 1 (Milan, 1978), 451, 482. I have not yet consulted the unpublished letters between Sperulo and Duke Francesco Maria I della Rovere of 1522–3, presumably also detailing his diplomatic responsibilities; Albano Sorbelli and Giuseppe Mazzatinti, *Inventari dei manoscritti delle biblioteche d'Italia/Pesaro*, vol. 33 (Florence, 1925), 177, 180, 181. I owe this source to James Hankins.

57. G. F. Lancellotti, *Ludovici Lazzarelli septempedani Poetæ Laureati Bombyx Accesserunt ipsius aliorumque poetarum carmina* (Aesii, 1765), 38, without source. He was presumably ordained after 1516, at which time he was still listed by a lay title in the papal Rotulus (as in note 52 above), and after serving as deacon, recorded 7 April 1518 (as in note 54 above).

58. Sperulo held the bishopric of San Leone in Calabria from 18 January 1525 to 1526, when he gave up the post to his relative Anselmo Sferolo; in Tamburini, *Santi e peccatori*, 209, who also notes that Sperulo served as head priest of Bettona, without dates; Giuseppe Cappelletti, *Le chiese d'Italia: dalla loro origine sino ai nostri giorni*, vol. 21 (Venice, 1870), 256.

59. Francesco Speroli, *Oratio pro inita pace inter augustissimum Caesarem Carolum & Franciscum regem Christianissimum, Romae in templo Divae Mariae, quae de Populo dicitur, anno MDXXVI, VI Idus Martias habita per Reverendum Patrem Franciscum episcopum Sperulum* (Rome, 1526); and Speroli, *Oratio R. in Christo P.D. Francisci Speruli episcopi S. Leonis habita in pontificiis Sacris Clementis VII ob memorabilem cladem, quam impii Tartari, auspiciis serenissimi Sigismundi regis, a Poloniis nuper acceperunt, ubi obiter de Polonorum cum Tartaris nativo odio, & utriusque gentis moribus, institutis, ac gestis agitur, cum brevi descriptione Sarmatiae Poloniaeque* (Rome, 1527?).

60. BAV, Vat. Lat. 1673, fols. 2r–3r.

61. *Francisci Speruli de Laocoonte in Titi imperatoris domo reperto*, BAV, Vat. Lat. 3351, c. 150v. Originally published as Evangelista Maddaleni Capodiferro in Hubert Janitschek, "Ein Hofpoet Leo's X über Künstler und Kunstwerke," *Repertorium für Kunstwissenschaft* 3 (1880): 52–60, at 55; the poem is included as Sperulo's in Salvatore Settis, *Laocoonte: fama e stile* (Rome, 1999), in the appendix by Sonia Maffei, 130–1.

62. For Sperulo's poems in the *Coryciana*, Ijsewijn, *Coryciana/critice edidit*, 42–3, 58, 88–9, 109. Franciscus Sperulus appears in Paolo Giovio's list of Coryciana members who had died by 1548: *Corytianae Academiae Fato functi, qui sub Leone floruerunt*, ASF, Carte Strozziane, fol. 353, 16, published in Federico Ubaldini, *Vita di mons. Angelo Colocci: edizione del testo originale italiano (Barb. Lat. 4882)*, ed. Vittorio Fanelli (Città del Vaticano, 1969), 114–15.

63. Reg. Lat. 2019, fol. 168, published in Lancellotti, *Ludovici Lazzarelli*, 91–4.

64. *Ad Leonem X de sua clementia elegia xviiii*, BAV, Vat. Lat. 1673, fols. 102v–103r, which appeared in Elet, "Papal *villeggiatura*," Appendix B, and is discussed further in Chapter 3, p. 82 and notes 79–81.

65. For a listing of Sperulo's known works, Kristeller, *Iter Italicum*, vol. 2, 54–5, 114, 335, 352, 353, 371, 373–4, 412, 584 and vol. 4, 63; Lilio Gregorio Giraldi, "De poetis suorum temporum," in *Opera omnia* (Leyden, 1696), vol. 2, 542; *C.A.L.M.A. Compendium Auctorum Latinorum Medii Aevi, 500–1500* (Florence, 2011), vol. 3, 544; and Girolamo Tiraboschi, *Storia della letteratura italiana* (Milan, 1822–6), vol. 13, 1979–80. Most notably, a collection of his writings in BAV, Vat. Lat. 1673, contains poems dedicated to Cesare Borgia, Corycius, several cardinals, Duke Lorenzo de' Medici, and Leo X. For Sperulo's hand, see Appendix II.

66. Gwynne, *Patterns of Patronage*.

67. Arsilli says, "Sperulo is celebrated for his elegies while he sings of loves, he is burning while he sings of the wars of heroes, nor is he the less when the lyre which is a rival to the Aolian poet, having been struck, sings its soft measures." (trans. Alan Fishbone.) "Sperulus est elegis cultus, dum cantat amores, / Arduus, heroum dum fera bella canit. / Nec minor in lyricis, cum barbitos aemula vati / Aeolio molles concinit icta modos." In Francesco Arsilli, *De poetis urbanis* (lines 75–8), in Ijsewijn, *Coryciana/critice edidit*, 344–59.

68. "But surely I cannot pass over Francesco Sperulo of Camerino. He composed books of

elegies on conjugal love, epigrams, and lyric poems, as well as something that is incomplete and that he is still working on today, the achievements of Cesare Borgia, duke of Valentinois, and Alexander VI. He also wrote on the elements of human life, from infancy and, as Lucilius says, from a mother's 'purse', right to what happens after death; he gave this work a Greek title, *Anthropographia* or *Andropaedia*. But the style is harsh and the content is very idiosyncratic." "Sed numquid Franciscum Sphaerulum Camertem praeteream? Qui elegiarum libros de amore coniugali, epigrammata et lyricos versus composuit et, quae imperfecta ad hanc diem habet in manu, Caesaris Borgiae Valentini gesta et Alexandri VI, item hominis institutiones ab infantia et matris, ut ait Lucilius, 'bulga' ad ipsum usque post mortem statum, quod opus ille Graeca voce Anthropographia vel Andropaedia inscribit. Sed durus hic et sui iudicii ubique." In Lilio Gregorio Giraldi, *Modern Poets*, ed. and trans. John N. Grant (Cambridge, MA, 2011), 86–7. (Originally published 1551.)

69. The quality of his poetry is consonant with this assessment; it is accomplished and rich in its references, but he was no Poliziano.

70. Giovanni Santi's literary output was unique among quattrocento artists, as noted by Tom Henry and Carol Plazzota, "Raphael: From Urbino to Rome," in *Raphael from Urbino to Rome*, Exh. Cat., ed. Hugo Chapman, Tom Henry, and Carol Plazzotta (London, 2004), 15–65, at 20. On Raphael's early training, see also Kim E. Butler, "Giovanni Santi, Raphael, and Quattrocento Sculpture," *Artibus et historiae* 30 (2009): 15–39; and Butler, "La *Cronaca rimata* di Giovanni Santi e Raffaello," in *Raffaello e Urbino: la formazione giovanile e i rapporti con la città natale*, Exh. Cat., ed. Lorenza Mochi Onori (Milan, 2009), 38–43; and Matteo Burioni, "Die Immunität Raffaels. Lehre, Nachahmung und Wettstreit in der Begegnung mit Pietro Perugino," in *Perugino Raffaels Meister*, Exh. Cat., ed. Andreas Schumacher (Ostfildern, 2011), 129–51. I owe the last source to Robert Williams.

71. Pierluigi Panza, "Quando l'architetto fa il poeta. Il Paradiso nelle liriche milanesi del Bramante, tra Alberti, Bellincioni e Leonardo," forthcoming in the Acts of the conference *Bramante e l'architettura lombarda dell'quattrocento*, held in Milan, 28–9 October, 2014; I am indebted to the author for kindly discussing this material and sharing a pre-publication copy. See also Carlo Bertelli, "Architecto doctissimo," in *Bramante e la sua cerchia a Milano e in Lombardia 1480–1500*, ed. Luciano Patetta (Milan, 2001), 67–75.

72. On his sonnets, variously dated from 1508 to 1511, Ettore Camesasca and Giovanni M. Piazza, *Raffaello: gli scritti* (Milan, 1993), 111–42; Shearman, *Sources*, vol. 1, 130–43.

73. All the more so assuming Raphael did have a hand in writing the *certa Idea* manifesto together with Castiglione, for which see below pp. 45–6 and notes 124–6.

74. Among the vast bibliography on Raphael's visual rhetoric and literary modes, see most recently Butler, "'Reddita lux est'"; Patricia Reilly, "Raphael's *Fire in the Borgo* and the Italian Pictorial Vernacular," *Art Bulletin* 92 (2010): 308–25; and Rijser, *Raphael's Poetics*, all with earlier sources.

75. As proposed by Ray, "Il volo di Icaro." For a recent overview of Raphael's relationships with humanists, Ingrid D. Rowland, "Raphael and the Roman Academy," in *On Renaissance Academies*, 133–46.

76. Ingrid D. Rowland, "Angleo Colocci ed i suoi rapporti con Raffaello," *Res publica litterarum* 14 (1991): 217–28; Rowland, "Raphael, Angelo Colocci, and the Genesis of the Architectural Orders," *Art Bulletin* 76 (1994): 81–104; Roberto Weiss, "Andrea Fulvio antiquario romano (c. 1470–1527)," *Annali della Scuola normale superiore di Pisa* ser. 2, 28 (1959): 1–44.

77. For the *Quos Ego* print of Marcantonio Raimondi as a frontispiece by or after Raphael for an illustrated *Aeneid*: Henri Delaborde, *Marc-Antoine Raimondi: étude historique et critique suivie d'un catalogue raisonné des œuvres du maître* (Paris, 1888), 146; and Carla Lord, "Raphael, Marcantonio Raimondi, and Virgil," *Source* 3 (1984): 23–33. Cf. Christian Kleinbub, "Raphael's *Quos Ego*: forgotten document of the Renaissance *Paragone*," *Word and Image* 28 (2012): 287–301. On the play of media in this print, see Kleinbub and also Madeleine Viljoen, "Prints and False Antiquities in the Age of Raphael," *Print Quarterly* 21 (2004): 235–47.

78. Margaret Daly Davis, "I geroglifici in marmo di Pierio Valeriano," *Labyrinthos* 17/18 (1990): 56ff.

79. Jürg Meyer zur Capellen, "Baldassare Castiglione and Antonio Tebaldeo – Raphael Portrays Two of his Friends," in *The Portrait of Baldassare Castiglione & the Madonna dell'Impannata Northwick: Two Studies on Raphael* (Frankfurt, 2011), 9–32; Meyer zur Capellen, *Raphael: A Critical Catalogue*, cat. 74, 120–6, cat. 76, 130–4; and Henry and Joannides, *Late Raphael*, 284–8, 292–6.

80. Bembo declared, "Io gli ho una grande invidia, chè penso di farmi ritrarre ancho io un giornò." Shearman, *Sources*, vol. 1, 240.

81. On Raphael and Bembo, Vittoria Romani, "Raffaello e Pietro Bembo negli anni di Giulio II," in *Pietro Bembo e le arti*, ed. Guido Beltramini, Howard Burns, and Davide Gasparotto (Venice, 2013), 339–56. Cf. Rowland, who doubts the friendship of Raphael and Bembo: Rowland, "Raphael and the Roman Academy," 141.

82. Meyer zur Capellen, *Raphael: A Critical Catalogue*, cat. 69, 90–3; Joost-Gaugier, *Raphael's Stanza della Segnatura*, 158–61; Giovanni Batistini, "Raphael's Portrait of Fedra Inghirami," *Burlington Magazine* 138 (1996): 541–5, a source I owe to Sheryl Reiss. For Raphael's collaboration with Inghirami, see also the discussion in Chapter 6, pp. 143–4, with notes and bibliography.

83. On the lost portrait, Meyer zur Capellen, *Raphael: A Critical Catalogue*, 19ff, cat. 75, 127–9. For Pietro Bembo's description of Raphael's lost portrait and Tebaldeo's sonnet written in response to it: Shearman, *Sources*, vol. 1, 240–1 and 277–8; and Basile and Marchand, *Tebaldeo Rime*, vol. 1, 150 n. 14 and vol. 3, 1, 438–9. About Vasari's assertion that Tebaldeo is depicted in the *Parnassus* fresco and various interpretations about which figure represents him: Dominique Cordellier and Bernadette Py, *Raphael: son atelier, ses copistes, vol. 5, Inventaire général des dessins italiens* (Paris, 1992), 127–8; Deoclecio Redig de Campos, *The Stanze of Raphael* (Rome, 1968), 31–2; Redig de Campos, "Dei ritratti di Antonio Tebaldeo e di alcuni altri nel 'Parnaso' di Raffaello," *Archivio della Società romana di storia patria* 75 (1952): 51ff; and Jonathan Unglaub, "Bernardo Accolti, Raphael's *Parnassus* and a New Portrait by Andrea del Sarto," *Burlington Magazine* 149 (2007): 14–22. Jürg Meyer zur Capellen advises caution about the Vasarian account, since Tebaldeo was not active in the Curia

of Julius II: Meyer zur Capellen, "Baldassare Castiglione and Antonio Tebaldeo," 26.

84. The comedy, a riff on the ambiguity of reality and illusion, was staged on 6 March 1519 by Cardinal Cibo, and Leo X returned to Rome specifically to attend it; a letter of Benedetto Buondelmonti reported that Raphael's sets were highly praised. See the letters in Shearman, *Sources*, vol. 1, 439–43 (documents 1519/17, 1519/19, 1519/20, and 1519/21). For the proposed connection of the drawing in Figure 10 to the event, Frommel et al., *Raffaello architetto*, cat. 2.11.1, 225–8 (entry by C. L. Frommel).

85. Notably, the *certa Idea* letter, the letter to Leo X, and the letter on Villa Madama, discussed below. On the reciprocal self-fashioning of this pair, John Shearman, "Castiglione's Portrait of Raphael," *Mitteilungen der Kunsthistorischen Institut in Florenz* 38 (1994): 69–97; and Ita MacCarthy, "Grace and the 'Reach of Art' in Castiglione and Raphael," *Word and Image* 25 (2009): 33–45.

86. The letter to Leo X, known in three manuscript copies, raises complex issues of attribution, but is generally accepted as a work of Raphael and Castiglione, possibly with input from Pietro Bembo, Colocci, or Fabio Calvo, who may have taken over the project after Raphael's death. See especially Francesco P. Di Teodoro, *Raffaello, Baldassar Castiglione e La Lettera a Leone X* (Bologna, 2003); Christof Thoenes, "La 'Lettera' a Leone X," in *Raffaello a Roma*, 373–81; and for the three manuscript copies of the letter, commentary, attribution, and chronology, see Shearman, *Sources*, vol. 1, 500–45 with extensive earlier bibliography, including Rowland's proposal for the involvement of Colocci. Bembo's role is discussed by Shearman, and further by Beltramini, "Pietro Bembo e l'architettura," 17. As to the letter's dating, I find persuasive Shearman's conclusion that the three manuscripts were written over a period of time, *c.* 1515–19.

87. Castiglione had a copy of Raphael's villa letter in his possession in Mantua, as he mentions in a letter of 1522; Shearman, *Sources*, vol. 1, 724, doc. 1522/6. For the raw literary nature of the surviving drafts, see Chapter 4, p. 89 and notes 12–14.

88. On antiquarian culture in this period, see especially Philip J. Jacks, *The Antiquarian and the Myth of Antiquity: The Origins of Rome in*

Renaissance Thought (Cambridge, 1993); Silvia Danesi Squarzina, ed., *Roma, centro ideale della cultura dell'Antico nei secoli XV e XVI* (Milan, 1989); and Roberto Weiss, *The Renaissance Discovery of Classical Antiquity* (Oxford, 1988).

89. As noted by Arnold Nesselrath, "Raphael's Archaeological Method," in *Raffaello a Roma*, 357–71.

90. For the letter's function as dedicatory *epistola* first noted by Anton Springer, see *ibid*. 363.

91. For a clarification of Raphael's role as Prefect of Marbles, see the discussion in Shearman, *Sources*, vol. 1, 209ff; F. Castagnoli, "Raffaello e le antichità di Roma," in *Raffaello: l'opera, le fonti, la fortuna*, ed. Mario Salmi (Novara, 1968); Simonetta Valtieri and Enzo Bentivoglio, "Sanzio sovrintendente. Una lettera inedita di Raffaello," *L'architettura: cronache e storia* 17 (1971): 476–84; Ray, *Raffaello architetto: linguaggio artistico e ideologia*, 268 and *passim*; and Gabriele Morolli, *"Le belle forme degli edifici antichi": Raffaello e il progetto del primo trattato rinascimentale sulle antichità di Roma* (Florence, 1984), 35ff.

92. "Raffaello Urbinati. Cum ad Principis Apostolorum phanum Romanum exaedificandum maxime intersit ut lapidum marmorisque materia, qua abundare nos oportet, domi potius habeatur quam peregre advehatur, exploratum autem mihi sit magnam eius rei copiam Urbis ruinas suppeditare, effodique passim omnis generis saxa fere ab omnibus, qui Romae quique etiam prope Romam aedificare aliquid, vel omnino terram vertere parumper moliuntur. Te, quo magistro eius aedificationis utor, cuiusque tum artis peritiam tum probitatem et perspexi multis in rebus, et probavi, marmorum et lapidum omnium qui Romae, quique extra Romam denum milium passuum spatio, posthac eruentur, praefectum facio ea de causa ut quae ad eius phani aedifacationem idonea erunt, mihi emas. Quare mando omnibus hominibus, mediocribus, summis, infimis, quae posthac marmora quaeque saxa omnis generis intra eum, quem dixi, loci spatium eruent, effodient, ut te earum rerum praefectum de singulis erutis effossisve quam primum certiorem faciant. Id qui triduo non fecerit, ei a centum usque ad mille num[m]um aureorum, quae tibi videbitur mulcta esto. Praeterea, quoniam certior sum factus multum antiqui marmoris et saxi litteris monumentisque incisi, quae quidem saepe monumenta notam aliquam egregiam prae se ferunt, quaeque servari operae praetium esset ad cultum litterarum Romanique sermonis elegantiam excolendam, a fabris marmorariis eo pro materia utentibus temere secari, ita ut inscriptiones aboleantur, mando omnibus qui caedendi marmoris artem Romae exercent ut sine tuo iussu aut permissu lapidem ullum inscriptum caedere secareve ne audeant, eadem illi mulcta adhibita, qui secus atque iubeo fecerit. Dat. sexto Kalendis septembris, anno tertio, Roma." Text and translation in Shearman, *Sources*, vol. 1, 207–11, with earlier bibliography. See also Chapter 5, pp. 140–1.

93. For a later documented tale of papal "spin doctoring" in which appropriated spoils putatively designated for St. Peter's were in fact used elsewhere, we may consider Louise Rice's discovery that the bronze appropriated from the Pantheon portico by Pope Innocent VIII Barberini, which was justified for its reuse in Bernini's *Baldacchino* for St. Peter's, was in reality used entirely for making cannons. Rice, "Bernini and the Pantheon Bronze," in *Sonderdruck aus Sankt Peter in Rom 1506–2006*, ed. Georg Satzinger and Sebastian Schütze (Munich, 2008), 337–52.

94. This paradox has been most fully analyzed by Thomas M. Greene, "The Double Task of the Humanist Imagination," in *Rome in the Renaissance: The City and the Myth*, ed. P. A. Ramsey (Binghamton, NY, 1982), 41–54; and David Karmon, *The Ruin of the Eternal City: Antiquity and Preservation in Renaissance Rome* (Oxford, 2011), 88–92.

95. Brothers, "Architecture, History, Archeology"; on Raphael "as a scholar and an archaeologist in the modern sense of the word," Nesselrath, "Raphael's Archaeological Method." See also Howard Burns and Arnold Nesselrath, "Raffaello e l'antico," in *Raffaello architetto*, 379–450; and Hubertus Günther, "Raffaels Romplan," *Sitzungsberichte der Kunstgeschichtlichen Gesellschaft zu Berlin* 31 (1982/3): 12–15.

96. Raphael's decoration of the Vatican Stanze and the construction of new St. Peter's were seen by some contemporaries as reflecting the reform of the Church. See O'Malley, *Praise and Blame in Renaissance Rome*, 224–5, citing Giles of Viterbo and Raffaele Brandolini. For a discussion of how Raphael gives visual form to the humanist enterprise to synthesize all wisdom – human and divine, ancient

and modern – in the Stanza della Segnatura, Kempers, "Words, Images and All the Pope's Men."

97. Christoph Frommel, "La Villa Madama e la tipologia della villa romana nel cinquecento," *Bollettino del Centro internazionale di studi di architettura Andrea Palladio* 11 (1969): 47–64; Inge Jackson Reist, "Raphael and the Humanist Villa," *Source: Notes in the History of Art* 3 (1984): 13–28.

98. Sources about the villa's architectural plans appear in the Introduction, notes 28–32.

99. As proposed by Shearman, "A Functional Interpretation of Villa Madama," 315 n. 2.

100. First proposed by Lefevre, with additional evidence discussed by Reiss, "Cardinal Giulio de' Medici as a Patron of Art" 364–5ff.

101. On the siting of the villa, Yvonne Elet, "Raphael and the Roads to Rome. Designing for Diplomatic Encounters at Villa Madama," *I Tatti Studies in the Italian Renaissance* 19.1 (2016): 143–75, and Chapter 5 herein. For literary tropes about siting according to healthy winds in relation to Cortesi's extended discussion of the subject, Kathleen Weil-Garris and John d'Amico, eds., *The Renaissance Cardinal's Ideal Palace: A Chapter from Cortesi's* De Cardinalatu (Rome, 1980), 73–5 and 101 n. 20. For further discussion of Sperulo and Raphael on this point, see p. 87.

102. Deborah Howard, "Seasonal Apartments in Renaissance Italy," *Artibus et historiae* 22 (2001): 127–35.

103. The topographical symbolism of the villa's siting, roads, and sight lines will be considered in Chapter 5.

104. On the inclusion of chapels in earlier Medici villas, as well as religious and sacred elements of villa life, Amanda Lillie, "Cappelle e chiese delle ville Medicee ai tempi di Michelozzo," in *Michelozzo: scultore e architetto (1396–1472)*, ed. Gabriele Morolli (Florence, 1998), 89–97; Lillie, "The Patronage of Villa Chapels and Oratories near Florence: A Typology of Private Religion," in *With or Without the Medici: Studies in Tuscan Art and Patronage 1434–1530*, ed. Eckhart Marchand and Alison Wright (Aldershot, 1998), 23–4; and Lillie, "Fiesole: Locus Amoenus or Penitential Landscape?" For sacred *villeggiatura*, see also Chapter 5, note 25.

105. For Medici imagery of bitter oranges, see Appendix 1, line 214 and gloss note 81.

106. The design and construction timeline is discussed below, with earlier bibliography, in Chapter 4, section on "Poetry and Planning".

107. A series of payments to Bartolomeo Gualfreducci da Pistoia, "soprastante della vignia sotto la + a monti mari," in 1528–9 are in ASF, Corporazioni religiose soppresse dal governo francese, 102, no. 329, fol. 6, mentioned in Shearman, "A Functional Interpretation of Villa Madama," 316 n. 8. It has passed unnoticed that Felicie Lombardo is listed as the "nuovo soprastante" in July 1529; ASF, Corporazioni religiose soppresse dal governo francese, 102, no. 329, fol. 22. Clement was in somewhat dire straits in 1528 (as Sheryl Reiss reminds me), making it unlikely that he was ordering new work at that date.

108. For further detail, Elet, "Papal *villeggiatura*," 42–4.

109. For the post-Medici history, see *ibid.* 44–6 with earlier bibliography. I am presently preparing an article on patronage at the villa by its owners in the 1920s and 1930s, Carlo, Count Dentice di Frasso, and his wife, Dorothy Cadwell Taylor, and will treat the restoration history of the villa in the monograph.

110. Sheryl E. Reiss, "'Villa Falcona': The Name Intended for the Villa Madama in Rome," *Burlington Magazine* 137 (1995): 740–2.

111. On the Raphael school and stucco, see Elet, "Papal *villeggiatura*," chs. 4 and 5. I am preparing a book on stucco in the art and architecture of early modern Italy.

112. Claudia Lazzaro, *The Italian Renaissance Garden: From the Conventions of Planting, Design, and Ornament to the Grand Gardens of Sixteenth-Century Central Italy* (New Haven, 1990).

113. For which, Elet, "Papal *villeggiatura*," ch. 3.

114. See Nicole Hegener, *DIVI IACOBI EQVES: Selbstdarstellung im Werk des florentiner Bildhauers Baccio Bandinelli* (Munich and Berlin, 2008), 128–33.

115. Cardinal Giulio wrote to Mario Maffei, 4 June 1520: "Ché anche noi non siamo contenti di quei duo pazzi, Vostra Paternità veda di accordarli se si può che Giovanni da Uddine faccia i stucchi e Julio dipinga le storie, o al manco faccia i dissegni et Uddine dipinga; però Vostra Paternità veda di assetarla a suo modo pur che l'opra si faccia e perfettamente, e ci levi questa molestia." And again on 17 June: "Ci piace che quelli duo cervelli fantastichi dipintori siano d'accordo e che lavorino." Shearman, *Sources*,

vol. 1, 600, 603. The cardinal is recognizing Giulio Romano as the one to generate the drawings, which is interesting in light of the struggles over *invenzione* discussed in Chapter 6 pp. 156–7.

116. Amanda Lillie, "Villa Medici a Fiesole," in *Andrea Palladio e la villa veneta*, 219–20, with earlier bibliography.

117. Philip E. Foster, *A Study of Lorenzo de' Medici's Villa at Poggio a Caiano* (New York, 1978); and F. W. Kent, *Lorenzo de' Medici and the Art of Magnificence* (Baltimore, 2004), especially ch. V, "Lorenzo, 'Fine Husbandman' and Villa Builder, 1483–1492."

118. As emphasized by Reiss, "Cardinal Giulio de' Medici as a Patron of Art," ix.

119. Ackerman, *The Villa*, ch. 3, "The Early Villas of the Medici"; and Du Prey, *The Villas of Pliny from Antiquity to Posterity*.

120. Lillie, "The Humanist Villa Revisited."

121. Discussed further below in the context of literary exchange between Florence and Naples on the subject of *villeggiatura*; see Chapter 2, pp. 52–3 and notes 36–7.

122. See now Modesti, *Le delizie ritrovate*, which treats Poggioreale, its appearance at various stages, its architectural debts to Laurentian Florence and Giuliano da Maiano, the visits of Fra Giocondo and Peruzzi, and the villa as a model for Villa Madama. She also analyzes a little-known encomiastic villa dialogue by Agostino Landulfo on the model of Bembo's *Asolani* describing Poggioreale in 1535–6, ostensibly recording a dialogue held for the visit of Charles V and Margarita of Austria, then engaged to Alessandro de' Medici, to whom the work is dedicated; *ibid.* 3–4, 197–202 and *passim*. This discourse honoring the bride to be – who would later inherit Villa Madama – raises the possibility that some features of Poggioreale may have been an inspiration not only for the architectural design by Raphael and associates, but also for later upgrades and alterations by Madama Margarita.

123. Mary Carruthers, *The Craft of Thought: Meditation, Rhetoric, and the Making of Images, 400–1200* (Cambridge, 1998), 10–12 and *passim*.

124. Shearman proposed the letter was written by Castiglione: Shearman, *Sources*, vol. 1, 734–41, with extensive earlier bibliography, especially Shearman, "Castiglione's Portrait of Raphael," 69–97.

125. For which, Baxandall, *Giotto and the Orators*, 35–8; Elizabeth C. Mansfield, *Too Beautiful to Picture: Zeuxis, Myth, and Mimesis* (Minneapolis, 2007).

126. Eugenio Battisti, "Il concetto di imitazione nel cinquecento italiano," in *Rinascimento e barocco* (Turin, 1960), 175–215, at 182 and *passim*. The *Idea quaedam* is discussed in Pico's famous dialogue with Bembo about imitation; for which, see also Paola Barocchi, ed., *Scritti d'arte del cinquecento*, vol. 2 (Milan, 1973); and Shearman, *Sources*, vol. 1, 737. For the Pico–Bembo exchange, see most recently James Ackerman, "Imitation," in *Antiquity and its Interpreters*, 11, 15 n. 20 with bibliography; and Leonard Barkan, "The Heritage of Zeuxis. Painting, Rhetoric, and History," in *Antiquity and its Interpreters*, 102. On the importance of the dialogue for Raphael, see Paul Davies and David Hemsoll, "Sanmicheli's Architecture and Literary Theory," in *Architecture and Language*, 104ff.

127. I leave aside now consideration of the related issue of how Raphael's synthesis of many media in the decorative complex at Villa Madama engages issues of language and the composite, for which Elet, "Papal *villeggiatura*," 311–23.

128. The architecture–body metaphor, significantly, was also specifically related to the notion of assemblage in writings from Leonardo to Serlio. See Payne, *The Architectural Treatise*, 64–9, for the assemblage metaphor that connected buildings, poems, and bodies. The notion of composition in Leonardo's writings is interesting for this point. Kemp has called attention to Leonardo's use of the two-stage method of *resolutio* and *compositio* in some of his late anatomical drawings of *c.* 1515, pointing out how Leonardo applied traditional scientific methods to the painter's comprehension and imaginative recreation of nature; Leonardo drew on the writings of Peckham, Paul of Venice, Hugo of Siena, and Galen. For which, see Martin Kemp, "Dissection and Divinity in Leonardo's Late Anatomies," *Journal of the Warburg and Courtauld Institutes* 35 (1972): 221–2; Kemp, "Leonardo's Early Skull Studies," *Journal of the Warburg and Courtauld Institutes* 34 (1971): 133 and *passim*; and Claire Farago, "The Classification of the Visual Arts in the Renaissance," in *The Shapes of Knowledge from the Renaissance to the Enlightenment*, ed. Donald R. Kelley and Richard H. Popkin (Dordrecht, 1991), 31. Further, Leonardo's interest in siting the faculties of imagination, fantasy, and

intellect in the human body, as well as determining their relation to artistic invention, exemplifies his tendency to relate epistemological processes from different areas of the arts, sciences, and natural philosophy: Kemp, "Leonardo's Early Skull Studies," 119, 132.

2 WRITING ARCHITECTURE

1. Ackerman, *The Villa*, 35–42.

2. On literary forms associated with villas, Bernhard Rupprecht, *Villa: Zur Geschichte eines Ideals* (Berlin, 1966); Sonia Maffei, ed., *Paolo Giovio scritti d'arte: lessico ed ecfrasi* (Pisa, 1999); A. R. Littlewood, "Ancient Literary Evidence for the Pleasure Gardens of Roman Country Villas," in *Ancient Roman Villa Gardens: The Tenth Dumbarton Oaks Colloquium on the History of Landscape Architecture, 1987*, ed. Elisabeth Blair Macdougall (Washington, DC, 1987); Perrine Galand-Hallyn and Carlos Lévy, eds., *La villa et l'univers familial dans l'Antiquité et à la Renaissance* (Paris, 2008); Guy P. R. Métraux, "Some Other Literary Villas of Roman Antiquity besides Pliny's," in *Tributes to Pierre du Prey: Architecture and the Classical Tradition, from Pliny to Posterity*, ed. Matthew M. Reeve (New York and Turnhout, 2014), 27–40; Aksamija, "Architecture and Poetry"; and Christopher Pastore, "Expanding Antiquity: Andrea Navagero and Villa Culture in the Cinquecento Veneto" (Ph.D. diss., University of Pennsylvania, 2003). Ancient writers who described villas in verse included Horace, Statius, Martial, Ausonius, Fortunatus, Catullus, and Sidonius; and in prose, Horace, Seneca, Cicero, Pliny the Elder, Pliny the Younger, Plutarch, Sidonius, and Gregory of Nyssa.

3. Du Prey, *The Villas of Pliny from Antiquity to Posterity*; Maffei, *Paolo Giovio*, 24–47.

4. For Giovio's letter, S. Della Torre, "L'inedita opera prima di Paolo Giovio ed il museo: l'interesse di un umanista per il tema della villa," in *Atti del convegno Paolo Giovio: il Rinascimento e la memoria* (Como, 1985); Maffei, *Paolo Giovio*, 2–16 and *passim*; Zimmermann, *Paolo Giovio*, 4–5.

5. William H. Sherman, "'Nota Bembe': How Bembo the Elder read his Pliny the Younger," in *Pietro Bembo e le arti*, 119–33. Sherman, who identified the Elder Bembo's copy of Pliny

at Stanford, discusses the writings of both Bembos on their villa and *villeggiatura*, with earlier bibliography. On Pietro Bembo and *villeggiatura* at the Villa Bembo at Santa Maria Non and other villas acquired later, Pastore, "Expanding Antiquity," 285–336.

6. As pointed out by Sambin de Norcen, who discusses the rediscovery in 1419 of the most complete manuscript of Pliny's letters by Guarino da Verona, part of the Este circle, and discusses Plinian villa epistles written by Guarino, Angelo Decembrio, Giovanni Sabadino degli Arienti, and Pietro Donato Avogaro: Sambin de Norcen, "'Ut apud Plinium'," 72 and 84–8; and Sambin de Norcen, "I miti di Belriguardo," in *Nuovi antichi: committenti, cantieri, architetti 1400–1600*, ed. Richard Schofield (Milan, 2004), 17–65, at 21–7 and 43ff. See also the discussions in Sambin de Norcen, *Il cortigiano architetto*; and Sambin de Norcen, *Ville di Leonello d'Este*. For Sabadino's villa descriptions, Werner L. Gundersheimer, *Art and Life at the Court of Ercole I d'Este: the* De triumphis religionis *of Giovanni Sabadino degli Arienti* (Geneva, 1972).

7. See note 2 above.

8. O. B. Hardison, *The Enduring Monument: A Study of the Idea of Praise in Renaissance Literary Theory and Practice* (Chapel Hill, 1962), ch. 11: "Rhetoric, Poetics, and the Theory of Praise" and *passim*.

9. D'Amico, *Renaissance Humanism*; Domenico Gnoli, *La Roma di Leon X* (Milan, 1938), 136ff; Bonner Mitchell, *Rome in the High Renaissance: The Age of Leo X* (Norman, OK, 1973), chapter on "The Life of Letters," 79ff; and Craig Kallendorf, *In Praise of Aeneas: Virgil and Epideictic Rhetoric in the Early Italian Renaissance* (Hanover, 1989).

10. Glodzik, "Vergilianism in Early Cinquecento Rome"; Mario Di Cesare, *Vida's* Christiad *and Vergilian Epic* (New York, 1964); and Luba Freedman, *The Classical Pastoral in the Visual Arts* (New York, 1989).

11. John W. Geyssen, *Imperial Panegyric in Statius: A Literary Commentary on Silvae 1.1* (New York, 1996), 9 and *passim*.

12. Statius, *Silvae*, I, 3 and II, 2 on the Tiburtine villa of Manilius Vopiscus and the Villa of Pollius Felix near Sorrento, respectively. Additionally, *Silvae*, III, 1 describes a temple to Hercules in the Sorrentine villa.

13. Newlands discusses the innovations of Statius in poetry, as well as Pliny the Younger in prose, in Newlands, "The Transformation of the 'Locus Amoenus'," 123–4, 137; and Newlands, Statius' Silvae and the Poetics of Empire (Cambridge, 2002). On Statius' villa poems, see also Hubert Cancik, Untersuchungen zur lyrischen Kunst des P. Papinius Statius (Hildesheim, 1965); and Noelle K. Zeiner, Nothing Ordinary Here: Statius as Creator of Distinction in the Sylvae (New York, 2005), with earlier bibliography. On Statius' novel fusion of genres, Stephen Thomas Newmyer, The Silvae of Statius: Structure and Theme (Leiden, 1979), 40 and passim. On visual representations of villas as a precursor to Statius' verbal descriptions, Bettina Bergmann, "Painted Perspectives of a Villa Visit: Landscape as Status and Metaphor," in Roman Art in the Private Sphere, ed. E. K. Gazda (Ann Arbor, 1991), 49–70, a source I owe to Eve D'Ambra.

14. OCD, "silva," 1408; OLD, "silua," 1762. On the etymology of the word in Latin and Greek and its use in poetry and rhetoric, Newmyer, The Silvae of Statius, 3–9. For further discussion of the silva, see below pp. 51–2, 59 and notes 20, 26, 28 and 83; Chapter 4, pp. 91, 95, 98 and notes 23, 52, 65; Chapter 6, pp. 155 and 159; and Conclusion pp. 177–8 and note 21.

15. For quattrocento editions of the Silvae, see A. Wasserstein, "The Manuscript Tradition of Statius' Silvae," Classical Quarterly n.s. 3 (1953): 69–78; and M. D. Reeve, "Statius' Silvae in the Fifteenth Century," Classical Quarterly n.s. 27 (1977): 202–25. For Statius's influence in sixteenth-century France, Perrine Galand-Hallyn, "Quelques coincidences (paradoxales?) entre L'Épitre aux Pisons d'Horace et la poétique de la Silve (au début du XVIe siècle en France)," Bibliothèque d'Humanisme et Renaissance 60 (1998): 609–39.

16. On Poliziano's courses at the Studio Fiorentino, Isidoro Del Lungo, ed., Angelo Poliziano: le selve e la strega: prolusioni nello studio fiorentino (1482–1492) (Florence, 1925), 231–41. For his commentary on Statius, Lucia Cesarini Martinelli, ed., Commento inedito alle Selve di Stazio di Poliziano (Florence, 1978); Cesarini Martinelli, "Un ritrovamento Polizianesco: il fascicolo perduto del commento alle Selve di Stazio," Rinascimento 22 (1982): 183–212.

17. As noted by Dempsey, The Portrayal of Love, 44ff, 47 n. 66, and passim.

18. For Calderini and Perotti, see Lucia Cesarini Martinelli, "Poliziano e Stazio: un commento umanistico," in Il Poliziano Latino, ed. Paolo Viti (Galatina, 1996), 65; John Dunston, "Studies in Domizio Calderini," Italia medioevale e umanistica 11 (1968): 71–150; and Carlo Dionisotti, "Calderini, Poliziano e altri," Italia medioevale e umanistica 11 (1968): 151–86. For Parrhasius, see Reeve, "Statius' Silvae in the Fifteenth Century," 19. Susanna de Beer notes the importance of Statius for Giannantonio Campano's panegyric of Pietro Riario; since some of Campano's poetry for Riario ended up in the collection of Colocci, it was well known to Roman humanists into the sixteenth century. De Beer, Poetics of Patronage, 187–94, 204–5, 208–11.

19. That the putative figure of Statius has features similar to Raphael's own was first proposed by Bellori, and is considered a self-portrait signature by Joost-Gaugier, Raphael's Stanza della Segnatura, 163 and pl. 12. See also Unglaub, "Bernardo Accolti, Raphael's Parnassus, and a New Portrait," 15 n. 10, with earlier bibliography. I find it difficult to accept this figure as a self-portrait.

20. Poliziano and Battista Spagnoli Mantuanus are credited with the flowering of the silva form; Juan F. Alcina, "Notas sobre la silva neolatina," in La silva: i encuentro internacional sobre poesia del siglo de oro, Sevilla–Córdoba, 1990, ed. Begona Lopez Bueno (Seville and Cordoba, 1991), 131–2, 139. See also Hilaire Kallendorf and Craig Kallendorf, "Introduction. 'Conversations with the Dead': Quevedo's Annotation and Imitation of Statius," in Francisco de Quevedo, Silvas, trans. Hilaire Kallendorf (Lima, 2011), 23–85, especially 62–70; they note that the silva became the premier genre of Spanish Baroque poetry (61) and discuss Quevedo's silva (n. 30), a villa description of a casa de campo built for Ferdinand and Isabella (70–80 and 269–76). For the silva in England, David Hill Radcliffe, "Sylvan States: Social and Literary Formations in Sylvae by Jonson and Cowley," Journal of English Literary History 55 (1988): 797–809.

21. Lillie provides a nuanced discussion of the notion of the humanist villa, individuating different ways a villa might be considered humanist: Lillie, "The Humanist Villa Revisited."

22. For listings of early modern villa poetry: Carlo Caruso, "Poesia umanistica di villa," in *"Feconde venner le carte": studi in onore di Ottavio Besomi*, ed. Tatiana Crivelli (Bellinzona, 1997), vol. 2, 272–94; Donatella Manzoli, "Ville e palazzi di Roma nelle descrizioni Latine tra Rinascimento e Barocco," *Studi romani* 16 (2008): 109–66; and Maffei, *Paolo Giovio*, part I.

23. Notably, the 1485 neo-Latin letter by Michele Verino praising Poggio a Caiano before it is built, when only the foundations are visible; in Armando F. Verde, *Lo studio fiorentino 1473–1503: ricerche e documenti*, vol. 3, 2 (Pistoia, 1977), 696–7.

24. For which, Rab Hatfield, "Some Unknown Descriptions of the Medici Palace in 1459," *Art Bulletin* 52 (1970): 232–49; and Christine Smith, *Architecture in the Culture of Early Humanism: Ethics, Aesthetics, and Eloquence 1400–1470* (New York, 1992), 195.

25. Alessandro Braccesi, "Ad eundem descriptio horti Laurentii Medicis," in *Alexandri Braccii Carmina*, ed. Alexander Perosa (Florence, 1943), 75–7; E. H. Gombrich, "Alberto Avogadro's Descriptions of the Badia of Fiesole and of the Villa of Careggi," *Italia medioevale e umanistica* 5 (1962): 217–29.

26. Poliziano's *silva* "Rusticus" published in 1483 describes the Medici villa at Fiesole, especially in lines 11–16, 557–69. See Maffei, *Paolo Giovio*, 15 n. 38; Del Lungo, ed. *Angelo Poliziano: le selve e la strega*, 33–64. Poliziano's *silva* "Nutricia" also treats the Fiesole villa; for which, Perrine Galand-Hallyn, "Aspects du discours humaniste sur la villa au XVIᵉ siècle," in *La villa et l'univers familial de l'Antiquité à la Renaissance*, ed. Perrine Galand-Hallyn and Carlos Lévy (Paris, 2008), 119. Poliziano's poems were published by Isidoro Del Lungo, ed., *Prose volgari inedite e poesie Latine e Greche edite e inedite di Angelo Ambrogini Poliziano* (Florence, 1867). See most recently Angelo Poliziano, *Silvae*, ed. and trans. Charles Fantazzi (Cambridge, MA, 2004).

27. Foster, *A Study of Lorenzo de' Medici's Villa*, 63–6, 71–2, 109–10, 221–2 for discussion of the poems by Angelo Poliziano, Ugolino Verino, and Naldo Naldi; and Julian M. Kliemann, "*Politische und humanistiche Ideen der Medici in der Villa Poggio a Caiano*" (Ph.D. diss., Heidelberg University, 1976), 148–56. For Lorenzo's toponymic poem *Ambra*: Lorenzo de' Medici, *Ambra (Descriptio Hiemis)*, ed. Rossella Bessi (Florence, 1986).

28. As Nicoletta Marcelli has proposed in "Cultural Gatherings in an 'Open' Space: the Orti Oricellari circle (1502-1522)," forthcoming in *Interpres. Rivista di studi quattrocenteschi*; I am grateful to her for sharing and discussing an excerpt from her book in progress on the Orti Oricellari. For Crinito's text, Galand-Hallyn, "Aspects du discours," 133–5 with French translation. For the Orti Oricellari, Felix Gilbert, "Bernardo Rucellai and the Orti Oricellari: A Study on the Origin of Modern Political Thought," *Journal of the Warburg and Courtauld Institutes* 12 (1949): 101–31.

29. Amanda Lillie, "Francesco Sassetti and his Villa at La Pietra," in *Oxford, China and Italy: Writings in Honour of Sir Harold Acton on his Eightieth Birthday*, ed. Edward Chaney and Neil Ritchie (London, 1984), 84–5.

30. For poetry by Pontano and also Francesco Patrizi, Bishop of Gaeta, about Poggioreale, see George Hersey, "Water-Works and Water-Play in Renaissance Naples," in *Fons Sapientiae: Renaissance Garden Fountains*, ed. Elisabeth Blair MacDougall (Washington, DC, 1978), 61–83; Maffei, *Paolo Giovio*, 18 and 81–2; Pontano, *Baiae*, trans. Rodney Dennis (Cambridge MA, 2006); and on his descriptions of his own villas, Carol Kidwell, *Pontano: Poet & Prime Minister* (London, 1991), 104ff and 114. For Pontano's declaration in the *De magnificentia* that the patron should be the *auctor* of buildings he commissions, and the suggestion that Pontano may himself have been involved in architectural projects, see the Introduction, p. 5 and note 18. For Pontano's villas in the Neapolitan Vomero district and on Ischia, De Divitiis, "Giovanni Pontano and His Idea of Patronage," 111 n. 10 with further bibliography.

31. Published in Jacopo Sannazaro, *Poemata ex antiquis editionibus accuratissime descripta* (Patavii, 1731); and discussed in Jacopo Sannazaro, *Arcadia and Piscatorial Eclogues*, ed. and trans. Ralph Nash (Detroit, 1966), 9. In addition, Sannazaro may have been resident at villa Poggioreale when he was finishing his *Arcadia*; Modesti, *Le delizie ritrovate*, 42.

32. Anne Bouscharain, "L'éloge de la villa humaniste dans une silve de Battista Spagnoli, le Mantouan: la *Villa Refrigerii* (c. 1478)," in *La villa et l'univers familial dans l'Antiquité et à la Renaissance*, 93–116.

33. Gallo's and Blosio's poems were published in 1511 and 1512, respectively. Ingrid D. Rowland, "Some panegyrics to Agostino Chigi," *Journal of the Warburg and Courtauld Institutes* 47 (1984):

194–9; Rowland, "Render unto Caesar the Things Which Are Caesar's: Humanism and the Arts in the Patronage of Agostino Chigi," *Renaissance Quarterly* 39 (1986): 673–730, at 688–9 and *passim*; Mary Quinlan-McGrath, "*The Villa of Agostino Chigi: The Poems and Paintings*" (Ph.D. diss., University of Chicago, 1983); Quinlan-McGrath, "Aegidius Gallus, *De Viridario Augustini Chigii Vera Libellus*. Introduction, Latin Text and English Translation," *Humanistica Lovaniensia* 38 (1989): 1–99; Quinlan-McGrath, "Blosius Palladius, *Suburbanum Augustini Chisii*. Introduction, Latin Text and English Translation," *Humanistica Lovaniensia* 39 (1990): 93–156; and Michael Dewar, "Encomium of Agostino Chigi and Pope Julius II in the *Suburbanum Augustini Chisii* of Blosio Palladio," *Res publica litterarum* 14 (1991): 61–8.

34. Girolamo Borgia, *Ecloga Felix*, BAV, Vat. Lat. 5225, fols. 1013v–1015v, discussed by Rowland, "Raphael, Angelo Colocci, and the Genesis of the Architectural Orders," 84 n. 22; and Rowland, *Culture of the High Renaissance*, 182–3.

35. "In Petri Melini Villam, Ubi Ille Poetas de More Familia Coena exceperat," in Benedictus Lampridius, *Carmina* (Venice, 1550), fols. 27r–37v. Discussed by Stella P. Revard, "Lampridio and the Poetic Sodalities in Rome in the 1510s and 1520s," in *Acta Conventus Neo-Latini Bariensis: Proceedings of the Ninth International Congress of Neo-Latin Studies*, ed. Rhoda Schnur (Tempe, AZ, 1998), 499–507. Lampridio, professor in Leo's Collegio dei Greci, adapted Pindar's proper triadic form in an attempt to create newly expressive neo-Latin verse; Carol Maddison, *Apollo and the Nine: A History of the Ode* (Baltimore, MD, 1960), 105–9. Lampridio's ode laments the loss of Mellini's brother Celso, who died 20 November 1519, making his death a *terminus post quem* for the poem, and thus it was written at least six months after Sperulo's villa poem. Lampridio also wrote a melancholy post-Sack ode on the olive villa of Cardinal Lorenzo Pucci: "Ad Olivetum Villam Laurentii Paccii Card. Sanctorum Quatuor," *Carmina*, 12v–14r. For Tebaldeo on the Villa Mellini, BAV, Vat. Lat. 2835, fol. 186r (191r mechanical) and 220v (225v mechanical), both of which reference the ode of Lampridius. For Villa Mellini, Sandro Santolini, "Due esempi di residenze suburbane sul Monte Mario a Roma: la Villa Mellini e i Casali Strozzi," in *Delizie in villa*, 229–68.

36. For Colocci's admiration for Pontano and the close connection between the Roman and Pontanian academies, S. Lattès, "Recherches sur la bibliothèque d'Angelo Colocci," *Mélanges d'archéologie et d'histoire* 48 (1931): 332. On Poliziano expressing his admiration to Pontano for his work, Kidwell, *Pontano*, 305–9.

37. For diplomatic and architectural exchanges between Lorenzo and Alfonso II of Aragon, Caroline Elam, "Art and diplomacy in Renaissance Florence," *Journal of the Royal Society of Arts* 136 (1988): 813–26; Francesco Quinterio, "Il rapporto con le corti italiane e europee," in *L'architettura di Lorenzo il Magnifico*, ed. Gabriele Morolli, Cristina Acidini Luchinat, and Luciano Marchetti (Milan, 1992); Humfrey Butters, "Lorenzo and Naples," in *Lorenzo il Magnifico e il suo mondo*, ed. Gian Carlo Garfagnini (Florence, 1994), 143–51; and Bianca de Divitiis, "Giuliano da Sangallo in the Kingdom of Naples: Architecture and Cultural Exchange," *Journal of the Society of Architectural Historians* 74 (2015): 152–78. See also the discussion of Florence–Naples architectural exchange in the previous chapter, p. 45 and n. 122. On Pontano's role as first secretary, Kidwell, *Pontano*, ch. 10 and *passim*. For the proposed connection between Pontano's "De hortis Hesperidum" and the Medici, see Chapter 4, note 54.

38. An observation I owe to Nicoletta Marcelli.

39. Ingrid D. Rowland, "Il giardino trans Tiberim di Agostino Chigi," in C. Benocci, ed., *I giardini Chigi tra Siena e Roma: dal cinquecento agli inizi dell'ottocento* (Siena, 2005), 57–72, at 62–3.

40. For a discussion of how Italian and Islamic garden aesthetics emerged in part from parallel poetic traditions, Cammy Brothers, "The Renaissance reception of the Alhambra: The Letters of Andrea Navagero and the Palace of Charles V," *Muqarnas* 11 (1994): 79–102, at 92 and *passim*.

41. Intertextual and also metatextual aspects of villa literature are treated by Galand-Hallyn, "Aspects du discours"; and Galand-Hallyn, *Le reflet des fleurs: description et métalangage poétique d'Homère à la Renaissance* (Geneva, 1994). Colocci's manuscript collections interspersing excerpts from ancient and modern poets provides a striking illustration of this intertextual

discourse; as noted by Lattès, "Recherches sur la bibliothèque d'Angelo Colocci," 333. My discussion of villa literature culminates with Roman humanist culture at the time of Raphael, leaving aside the tradition thereafter.

42. On Virgilian models for the particular or universal, Alastair Fowler, "Georgic and Pastoral: Laws of Genre in the Seventeenth Century," in *Culture and Cultivation in Early Modern England: Writing and the Land*, ed. Michael Leslie and Timothy Raylor (Leicester, 1992), 81–8; Kari Boyd McBride notes the importance of this model for English country house discourse, which surely owed something to the earlier Italian models discussed herein. McBride, *Country House Discourse in Early Modern England: A Cultural Study of Landscape and Legitimacy* (Farnham, 2001), 7.

43. The attribution to the Roman Francesco Colonna, Lord of Palestrina, was first proposed by Maurizio Calvesi, *Il Sogno di Polifilo* (Rome, 1983). There has been a recent accumulation of evidence in support of Calvesi's attribution, although to my mind the question remains unresolved. For a discussion of the issue, favoring the traditional attribution to the Venetian Dominican Friar Francesco Colonna, with earlier bibliography, see Brian Curran, *The Egyptian Renaissance: The Afterlife of Ancient Egypt in Early Modern Italy* (Chicago, 2007), ch. 7. Other attributions that have been proposed are to Alberti, writing under the pseudonym, which, like Curran, I find unlikely. In a forthcoming work, Tracey Eve Winton proposes that the *Hypnerotomachia* was a collaboration by multiple authors in the circle of Ficino, tracing a parallel between Polifilo's journey and Ficino's notion of the ascent of the soul to knowledge; verbal communication, Alberto Pérez-Gómez, 25 November 2013; and on his site www.po lyphilo.com/introduction.swf.

44. Rowland notes that the book "struck a deep chord" for Colocci, in *Culture of the High Renaissance*, 59–67. For the issue of how Roman the archeological references really were, see her interesting discussion in *ibid.* 272–3 n. 37. Among the arguments that the *Hypnerotomachia* alludes to actual Roman topography, see especially Fabio Benzi, "Percorso reale in sogno di Polifilo, dal tempio della Fortuna di Palestrina a Palazzo Colonna in Roma," *Storia dell'arte* 93–4 (1998): 198–206.

45. For Cleopatra/Ariadne, Francis Haskell and Nicholas Penny, *Taste and the Antique: The Lure of Classical Sculpture, 1500–1900* (New Haven, 1982), 186–7.

46. Bonito, "The Saint Anne Altar" (1983).

47. One of the poems by Caius Silvanus makes a similar point: "Tres supero homines tres ornavere, Corytus Sculptorque, et vates, aerae, manu, fidibus." (Three men have furnished three gods: Corytius, the sculptor, and the poet, with money, hand and lyre.); text and translation in Bonito, "The Saint Anne Altar" (1983), 294, poem 83.

48. Despite the vast bibliography devoted to ancient and modern *ekphrasis* in rhetoric, literature, and history, there has been relatively scant attention paid to description of architecture. Christine Smith traces architectural *ekphrasis* in the Greek and Byzantine literary traditions, especially Second Sophistic orators, and its introduction to Italy by Chrysoloras: Smith, *Architecture in the Culture of Early Humanism*, chs. 7 and 9; Smith, "Christian Rhetoric in Eusebius' Panegyric at Tyre," *Vigiliae Christianae* 43 (1989): 226–47. See also Eleanor Winsor Leach, *The Rhetoric of Space: Literary and Artistic Representations of Landscape in Republican and Augustan Rome* (Princeton, 1988), especially 73–8; and Ann Kuttner, "Prospects of Patronage: Realism and *Romanitas* in the Architectural Vistas of the 2nd Style," in *The Roman Villa: Villa Urbana. First Williams Symposium on Classical Architecture Held at the University of Pennsylvania*, ed. Alfred Frazer (Philadelphia, 1998), 93–107. Christine Smith and Joseph O'Connor are preparing an annotated corpus of Greek and Latin architectural descriptions written between 300 and 1500. On *ekphrasis* in general, see the recent study with bibliography by Ruth Webb, *Ekphrasis, Imagination and Persuasion in Ancient Rhetorical Theory and Practice* (Farnham, 2009).

49. Mary Carruthers, "Collective Memory and *Memoria rerum*. An Architecture for Thinking," in Carruthers, *The Craft of Thought*, 7–21, with earlier bibliography, especially by Carruthers and Frances Yates.

50. Demonstrated by Mary Carruthers, "The Poet as Master Builder: Composition and Locational Memory in the Middle Ages," *New Literary History* 24 (1993): 881–904. See also E. N. Tigerstedt, "The Poet as Creator:

Origins of a Metaphor," *Comparative Literature Studies* 5 (1968): 455–88; and Koliji, *In-Between*.

51. Timothy M. O'Sullivan, *Walking in Roman Culture* (Cambridge, 2011), ch. 4, "Cicero's Legs," 77–96. For Mario Maffei's undated letter that mentions walking with Cardinal Giulio at the villa (at a pace that left Maffei limping), Reiss, "Villa Falcona," 742 and n. 12.

52. Ruurd R. Nauta, "Statius in the *Silvae*," in *The Poetry of Statius*, ed. Johannes J. L. Smolenaars et al. (Leiden, 2008), 161–4.

53. For Sperulo's villa poem as autograph, see Appendix II.

54. About issues of poetic *furor* and the poem written quickly, see below p. 59, and notes 82 and 83; and Appendix I, gloss note 5.

55. Horace, *Odes* III, 30. Another among many ancient models for this trope was known in the *Elegiae in Maecenatem*, then thought to be by Ovid: "Marbles will be held in scorn; victorious over monuments – the books of men; through genius one lives, all else will be subject to death" (marmora temnentur, vincent monimenta libelli:/vivitur ingenio, cetera mortis erunt). In Mary Miller, "The *Elegiae in Maecenatem* with Introduction, Text, Translation and Commentary" (Ph.D. diss., University of Pennsylvania, 1942), 75. Biondo Flavio evoked this trope in his dedication of *Roma instaurata* to Eugenius IV, concluding by musing whether the restoration in mortar, brick, stone, and bronze, or that in letters, would last better and longer: Cesare D'Onofrio, *Visitiamo Roma nel quattrocento: la città degli umanisti* (Rome, 1989), 100.

56. The *Exegi monumentum* topos was clearly articulated by Battista Casalius, Marc Antonio Casanova, and Aegidius Gallus with regard to the Villa Chigi, as pointed out by Quinlan-McGrath, "The Villa of Agostino Chigi," 4. Rowland publishes and translates the relevant poem of Casanova in "Some Panegyrics to Agostino Chigi," 198–9 and n. 33. An example is provided by Cursius Carpinetanus in a poem about Palladio's panegyric, published and translated by Quinlan-McGrath, "Blosius Palladius," 110–11: "Chigi and Blosius, you each erected an outstanding villa, but / each is not of an equal fate. However golden be yours, Chigi, / it is subject to the ages; but the wood planted by Blosius, will be eternal." ("Chisius et Blossi villam erexistis, uterque / Egregiam: sed non utraque sorte pari est. / Aurea sit quamvis tua Chisi, obnoxia seclis: / Quae sata per Blosium sylva, peremnis erit.") The topos is also discussed by John O'Malley, "The Vatican Library and the School of Athens: A Text of Battista Casali, 1508," *Journal of Medieval and Renaissance Studies* 7 (1977): 272.

57. Sperulo, dedicatory letter, §2. (For the notion of a glue of lime and sand as particularizing the topos to the use of stucco at the Medici villa, see Appendix I, gloss note 4.)

58. Poliziano himself alluded to the prejudice against Silver Age authors, defending their writing style as neither corrupt nor depraved but simply different: Sarah Stever Gravelle, "Humanist Attitudes to Convention and Innovation in the Fifteenth Century," *Journal of Medieval and Renaissance Studies* 11 (1981): 201. This prejudice continued even in modern scholarship; among recent work rehabilitating Statius' importance in articulating Domitianic ideology, Newlands, *Statius' Silvae*. The *Silvae* have been recognized as important sources for villa poetry, for which Caruso, "Poesia umanistica di villa," 52 and *passim*; and especially the villa poems of Blosio and Gallo. Blosio himself declared his debt to Statius in the preface to his poem on the Chigi villa: Quinlan-McGrath, "The Villa of Agostino Chigi," 186ff and 402–3; Quinlan-McGrath, "Blosius Palladius," 99ff; Michael Dewar, "Blosio Palladio and the *Silvae* of Statius," *Studi umanistici piceni* 10 (1990): 59–64; and Rijser, *Raphael's Poetics*, 319–24. Charles Dempsey emphasizes the importance of Statius' *Epithalamium in Stellam et Violentillam* (*Silvae*, 1, 2) for Poliziano, and thus for Botticelli's *Primavera*, in Dempsey, *The Portrayal of Love*, 47 and *passim*. On Statius as a model for Campano, de Beer, *The Poetics of Patronage*, 210–11.

59. See Appendix I, gloss for Sperulo's borrowings from Statius, e.g. notes 7–9 for his citations to several of the *Silvae* in the first lines of the poem.

60. I am indebted to Nicoletta Marcelli for the observation about earlier Florentine poetic sources. For Medici imprese and topoi, see the gloss.

61. Published in the *Coryciana*: Hieronymi Vidae, *Carmen*. "Genius Falconis Villae," in *Coryciana* (Rome, 1524), and included in M. H. Vidae, *Opera omnia* (Patavii, 1731), vol. 2, 158–60. The text is in Ijsewijn, *Coryciana/critice edidit*, 328–30. An English translation is given in Bonito, "The Saint Anne Altar" (1983), 315–19.

Ijsewijn assumes the poem is about Sinibaldo's villa, as does Quinlan-McGrath, "Aegidius Gallus," 5–6 n. 20. Most recently, Shearman, *Sources*, vol. 1, 774–8, includes a transcription and English translation of the poem, and he also recognizes its subject as Villa Madama. For an early identifier of Villa Madama as Villa Falcona, Reiss, "'Villa Falcona'."

62. Di Cesare, *Vida's* Christiad *and Vergilian Epic*. The appellation of the Christian Virgil is due to Ariosto, *Orlando furioso*, XLVI, 13.

63. "Huc hospes veniens diversis partibus orbis / Tam subitum miratur opus, congestaque saxa, / Rupibus excisas attolli ad sidera moles, / Artificumque manus doctas, variumque laborem. / Et merito quis enim cernens positusque locorum, / Silvarumque comas virides, largasque perennis / Fontis opes, caelumque habili regione benignum, / Non credat his saepe Deos, Regemque Deorum / Sidereas mutare domos, caeli aurea templa? / Fortunata loci sedes, tua gloria semper / Vivet, et aeternum laudabunt saecula nomen. / Egregii proceres, te te undique saepe frequentem, / Et tua purpurei dignantur limina Reges. / Fortunata bonis multis, sedesque beata. / Non tamen hoc unque mihi eris felicior uno, / Quod tua castalidum pater, hortatorque sororum, / Corycius, nuper dignatus visere tecta est, / Nam quis te, atque tuae egregios virtutis honores / Fortunate senex speret se aequare canendo? / Vos circumfusi mecum, vos carmina montes / Iungite, vos nymphae tiberinides addite mentem." Transcription and translation by Bonito, "The Saint Anne Altar" (1983), 315–19.

64. "Apage, sultis, vos inauspicatissimos / Vorsus cito auferte hinc poetae pessimi, / Factos sinistre in laudem villae nobilis / Quam Medices ad Tiberim incipissit [*sic*] struere / Regia prope Iulius magnificentia. / Vos, immortales dii, et vestram imploro fidem, / Adeone perditae est nebulo iste audaciae, / Ut tam nobile opus tam cacatis versibus / Vobis viventibus inquinari audeat? / Iste iste Tubaldeus, quem solae probant / Prefectae anserculis pascundis virgines / Ad graveolentis paludes Ferrariens / Insulsas eius dum cantitant nenias." Biblioteca Universitaria di Bologna, cod. 400, c. 27B–28B, published by Filippo Cavicchi, "Una vendetta dell'Equicola," *Giornale storico della letteratura italiana* 37 (1901): 94–8; trans. Alan Fishbone.

65. Pastor (IV, part 1, 447) noted of Tebaldeo that "auch die Villa des Kardinals Medici auf dem Monte Mario hat er verherrlicht" without providing a citation, presumably based on Equicola's reference. Lefevre recorded looking for the poem in vain (*Villa Madama*, 131 n. 70) as did Shearman (*Sources*, vol. 1, 662), who additionally noted that the poem is unknown to Marchand, an editor of Tebaldeo's complete works: Tania Basile and Jean-Jacques Marchand, eds., *Antonio Tebaldeo: Rime* (Ferrara, 1989). I have looked in the Vatican Library without finding this poem. It could have been among the notes and books that Tebaldeo lost during the Sack of Rome; André Chastel, *The Sack of Rome* (Princeton, 1983). Colocci saved and annotated many of Tebaldeo's works, but the villa poem has not emerged among them. The late Stefano Ray noted in passing that the poet Tebaldeo celebrated Villa Madama in 1521, without citation, suggesting that Ray may have known the poem – unless he, too, was citing Pastor: Ray, *Raffaello architetto: linguaggio artistico e ideologia*, 177.

66. Cavicchi, "Una vendetta dell'Equicola"; Stephen Kolsky, *Mario Equicola: The Real Courtier* (Geneva, 1991), 137ff and 238 n. 27; Richardson, *Manuscript Culture in Renaissance Italy*, 123–4.

67. Valeriano, "Dialogo della volgar lingua." On the Medici appreciation of Tebaldeo, see also the following note.

68. I have searched payment records for the villa in the ASR and ASF without finding any evidence of a payment to Sperulo. Vida's poem makes clear that Corycius was the patron, and thus perhaps his poem was Goritz's gift to Giulio de' Medici. The *spese minuti* of the Camera Apostolica include a 200-ducat payment to the poet Tebaldeo dated 9 July 1518 (ASR Camerale I, 1489, 58r), the purpose of which is not stated, but this payment was surely too early for a villa panegyric. Presumably it was also too high a sum; however, Leo could pay extravagant sums for poetry, notably 4,000 ducats to Angelo Colocci for one forty-line poem, discussed by Gaisser, *Pierio Valeriano on the Ill Fortune of Learned Men*, 55.

69. The poet's request also reflects the tensions inherent in the literary patronage process discussed above. For poets' boasts about speed of

composition, see Chapter 2, p. 59 and notes 82 and 83; and Appendix 1, gloss note 5.

70. For a late cinquecento example of coordinated literary production describing a villa outside Bologna, Aksamija, "Architecture and Poetry in the Making of a Christian Cicero."

71. De Beer, *The Poetics of Patronage*, 204.

72. The poems' function as dinner entertainment is discussed by Rowland, "Some Panegyrics to Agostino Chigi," 198. On Renaissance humanist convivia, see above.

73. "Dum tu circumagis nos bone Chissie / Per coenacula Villae et viridaria / Perlustras [*sic*] abit hora: et / Intestina quatit fames: / Nec tu crede meum pascere nobili / Pictura stomachum: Quod reliqui est age / Miremur bene poti. / Nil non me saturum iuuat: / Tunc sane et Blosius carmina queis tuae / Villae crescit honos continat: at tuum / Nomen posteritati / Villa clarius indicet." Citation and translation from Rowland, "Some Panegyrics to Agostino Chigi," 198. See also Quinlan-McGrath, "Blosius Palladius," 108.

74. Quinlan-McGrath, "The Villa of Agostino Chigi," 3, states that they were commissioned by Chigi, without citation.

75. For which, see above, p. 52 and note 35.

76. In the dialogue, the character of Colocci excuses himself for having missed a planned dinner with his interlocutor Antonio Matteazzi, saying that just as Colocci had left his villa to go to Matteazzi's, he ran into Cardinal Giulio going to his own *vigna* in the company of some *letterati*, and the cardinal invited Colocci to join them. Colocci says, "Io veniva dalla mia vigna, per trovarmi a cena con voi secondo la promessa, e fuori della porta m'incontrai nel Cardinal de' Medici, che andava alla sua vigna con una compagnia d'uomini letterati; e avendogli io fatto riverenza e lasciatol passare, mi mesi per venir di lungo, ma Sua Signoria mandò un palafreniero a invitarmi, ch'io andassi a cena con quegli uomini da bene. Così colto all'improvisa non seppi e non ardi' ricusar il favore, massime che sapete come io ho bisogno che Sua Signoria raccommandi la cosa mia a Leone; onde mi pareva aver avuto buon incontro di poterli così parlar a modo mio." The pragmatic note that Colocci really needed the face time with Cardinal Giulio, who could intercede with the Pope on his behalf, prompts his friend to reply teasingly

that Colocci will be *incapellato* soon. Valeriano, "Dialogo della volgar lingua," 46–7.

77. "so che il Cardinal de' Medici non è di quei signori che vogliono a tavola e da per tutto far adorar la maestà, ma vuol trar frutto dalla conversazione, specialmente degli omini di lettere, che si trattengono dai grandi e s'accarezzano per aver commodità di poter in ogni luogo, in ogni tempo imparar qualche cosa." Valeriano, "Dialogo della volgar lingua," 48.

78. Richardson notes that although dedications incorporated into the manuscript of a poem (as Sperulo's was) could be truly private documents, more often they tacitly address a larger audience: Richardson, *Manuscript Culture in Renaissance Italy*, 202–3.

79. Such competition became increasingly vitriolic as the 1520s progressed. See Gouwens, "Perceiving the Past," 74; Gouwens, *Remembering the Renaissance*; Reynolds, *Renaissance Humanism at the Court of Clement VII*, characterizing a climate of "dissension, debate and rivalry" among poets in Clementine Rome, 9 and *passim*; Gaisser, "The Rise and Fall of Goritz's Feasts"; and Gaisser, "Seeking Patronage under the Medici Popes." See also Chapter 1, p. 21 and note 34.

80. Discussed in Revard, "Lampridio and the Poetic Sodalities," 503, citing Lampridio's Pindaric ode about Villa Mellini.

81. As noted by Bonito, "The Saint Anne Altar" (1983), 179 n. 266.

82. Poetic boasts about speed of composition, or *celeritas*, were a badge of poetic *furor* and *ingenium*, often linked to an improvisatory context. Statius, in the preface to Book I of his *Silvae*, claims that all its contents were written in the heat of the moment, and that he spent no longer than one or two days on any of these poems; he cites among his witnesses to this fact Manilius Vopiscus, who attests that the poem about his villa was done in one day: Statius, *Silvae*, 1, 3–15. Statius' disclaimer is discussed by Newlands, *Statius' Silvae*, 33–4. Blosio Palladio uses the same image that his poem poured forth in heat (Quinlan-McGrath, "Blosius Palladius," 113, preface line 6). Sperulo similarly claims to have written his 407-line poem in under two days; in his dedicatory letter (§1, 3), he specifies that he conceived the idea on his visit to the villa site the day before yesterday, and that the poem is now finished. The speed of writing was also a

key advantage of poets who built with words, in competition with architects.

83. In Roman rhetoric, the *silva* came to designate an unpolished rough draft, often hastily composed; Newmyer, *The* Silvae *of Statius*, 6. Quintilian associated the *silva* with off-the-cuff writing in a pejorative sense: Quintilian, *Institutio oratoria*, X, 3, 17. For Statius' reference to performance and improvisational context, Newlands, *Statius' Silvae*, 31. For Renaissance poets and artists, the *silva* form evoked the ideal of creating ever greater things without effort, thereby displaying one's facility at accomplishing difficult tasks, and preserving the freshness of inspiration. For Statius and Renaissance humanists on the *furor rhetoricus*, Galand-Hallyn, *Le reflet des fleurs*, 498–500; and Cesarini Martinelli, "Poliziano e Stazio," 68–9. For additional significance of the *silva* form, see above pp. 51–2 and notes 20, 26, and 28; Chapter 4, pp. 91, 95 and 98, and notes 23, 52, and 65; pp. 155 and 159; and Conclusion pp. 177–8 and note 21. On improvisation, James Haar, *Essays on Italian Poetry and Music in the Renaissance, 1350–1600* (Berkeley, 1986), 76–99.

84. See Chapter 1, p. 21 and note 34; and pp. 155–7, considering competition among visual artists, and between artists and wordsmiths.

85. For a note of caution on reading any sixteenth-century poetry as spontaneous or as personal expression without recognizing the rhetorical underpinning, A. Leigh De Neef, "Epideictic Rhetoric and the Renaissance Lyric," *Journal of Medieval and Renaissance Studies* 3 (1973): 207–8.

3 SPERULO'S VISION

1. Sperulo is thus linking the Medici to Rome's Etruscan founders, and further making the Etruscan/Tuscan–Roman link. For the role of Porsenna in Medici imagery, especially the 1513 Capitoline theater version of Etruscan history, Fabrizio Cruciani, *Il Teatro del Campidoglio e le feste romane del 1513* (Milan, 1969), 29; and Giovanni Cipriani, *Il mito etrusco nel Rinascimento fiorentino* (Florence, 1980). For a variation on historical myth of Rome's Etruscan prehistory, Rowland, "Render unto Caesar," 716–21. On the Medici and Etruscan imagery in the New Sacristy of San Lorenzo and Poggio a Caiano, Kathleen Weil-Garris Posner, "Comments on the Medici Chapel and Pontormo's Lunette at Poggio a Caiano,"

Burlington Magazine 115 (1973): 640–9, at 649. For the painted window embrasure in the Sala di Costantino representing Etruria as the home of the Medici, Rolf Quednau, *Die Sala di Costantino im Vatikanischen Palast: zur Dekoration der beiden Medici-Päpste Leo X und Clemens VII* (Hildesheim, 1979), 500–4 and fig. 30. I am grateful to Sheryl Reiss for pointing out the connection to this image, reproduced as Figure 28 herein.

2. Shearman, while acknowledging the ambiguity of evidence for the villa's patronage, favored Leo: Shearman, "A Functional Interpretation of Villa Madama," 315, 323; and Shearman, "A Note on the Chronology of Villa Madama," *Burlington Magazine* 129 (1987): 181. (Shearman cited Sperulo out of context to suggest that the villa was the *Sedes Leonis* [Shearman, "A Functional Interpretation of Villa Madama," 315, 323]; in fact, it is clear that Sperulo's statement, "Let this be your seat, Leo," refers to a particular room, not the entire villa, and the poet similarly assigns a seat to Duke Lorenzo, and to other living Medici family members.) Cf. Reiss, who sees Giulio as the patron (as in Reiss, "Cardinal Giulio de' Medici as a Patron of Art," 357ff), although in recent work she has discussed the cooperative patronage of Giulio and Leo, as in Reiss, "'Per havere tutte le opere'."

3. As shown by Reiss, *ibid., passim*.

4. For example, see the discussions below of Leonine imagery in the battle paintings, which would also include the figures of Giulio and Duke Lorenzo, references to Leo's clemency, and marbles with a provenance from Julius Caesar now owed to Giulio.

5. Amanda Lillie rebuts the myth of the "lone patron," characterizing many early Medicean commissions as family endeavors: Lillie, "Giovanni di Cosimo," 189–205; and Melissa Meriam Bullard discusses a history of participatory patronage under Cosimo and Lorenzo in Florence, in "Heroes and their Workshops," 179–98. Among the studies of Medici patronage by John T. Paoletti, see "Fraternal Piety and Family Power: The Artistic Patronage of Cosimo and Lorenzo de' Medici," in *Cosimo "Il Vecchio" de' Medici, 1389–1464*, ed. F. Ames-Lewis (Oxford, 1992), 195–219. For shared projects of Pope Leo and Cardinal Giulio, Reiss, "'Per havere tutte le opere'."

6. See p. 20.

7. For which, Elet, "Papal *villeggiatura*," 53–65 and *passim* with earlier bibliography, especially Claudia Cieri Via, "Villa Madama: una residenza 'solare' per i Medici a Roma," in *Roma nella svolta tra quattro e cinquecento*, ed. Stefano Colonna (Rome, 2004), 349–74.

8. For example, Ovid, *Fasti*, III, 135–75. On the *kalends* of March, Mars says, "Now for the first time in the year am I, a god of war, invoked to promote the pursuits of peace" (*Fasti*, III, 173).

9. Cato, *On Agriculture*, 141. See also H. H. Scullard, *Festivals and Ceremonies of the Roman Republic* (London, 1981), 84–7.

10. As he does for all living family members, Sperulo assigns Duke Lorenzo a section of the villa (lines 245–6); and the poet also proposes that the Duke be portrayed as a glorious victor in battle murals predicting a triumphal Medici crusade against the Ottoman Turks (discussed below): "Also the general Lorenzo himself, admirable in his gleaming weapons, the duke riding a Thracian horse, and wreathed with laurel, shall go triumphant among the laurel-bearing kings and the Latin youth; heaven shall thunder with the great clamor, while Europe raises the Medici name up to the stars" (366–71).

11. For Lorenzo's illness and death, probably of pulmonary tuberculosis, Ann G. Carmichael, "The Health Status of Florentines in the Fifteenth Century," in *Life and Death in Fifteenth-Century Florence*, ed. Marcel Tetel, Ronald G. Witt, and Rona Goffen (Durham, NC, 1989), 28–45, at 29–31. The Duke's doctors and caretakers seemed to interpret optimistically his series of remissions and relapses in January–April 1519. Lorenzo's secretary Goro Gheri kept a daily chronicle of the Duke's symptoms and traded letters about his condition with Cardinal Giulio. Gheri recorded that the Duke was doing well in January and was thought to be cured, despite intermittent bouts of fever, pains, and digestive upsets. But the Duke's decision to make the 15-km ride from Careggi to Poggio a Caiano on 19 February set him back; one observer noted during this trek, "fu visto da ognuno che pareva mezo morto." For this and Gheri's diary, Gaetano Pieraccini, *La stirpe de' Medici di Cafaggiolo: saggio di ricerche sulla trasmissione ereditaria dei caratteri biologici* (Florence, 1924), vol. 1, 269–79, who additionally considered the Duke to have had intestinal tuberculosis.

I owe these sources to Sheryl Reiss. Lorenzo was quite ill in late February when visited by Ariosto, who wrote a poem metaphorically linking the Duke to the resurrection of laurel after the harsh winter (Reiss, "Cardinal Giulio de' Medici as a Patron of Art," 286 and n. 250; 465–6; 484); so presumably Ariosto would have taken news of Lorenzo's grave condition back to Rome in late February, if Cardinal Giulio had not communicated it himself. Thus, I think Sperulo must have composed his poem before this time, perhaps in January. For the implications of the poem's dating, see also Chapter 5, note 98; pp. 154–5; and Appendix 1, gloss notes 94 and 128.

12. Cruciani, *Teatro del Campidoglio*.

13. Hans Henrik Brummer and Tore Jansen, "Art, Literature, and Politics: An Episode in the Roman Renaissance," *Konsthistorisk Tidskrift* 45 (1976): 79–93; F. Saxl, "The Capitol during the Renaissance – A Symbol of the Imperial Idea," *Lectures*, vol. 1 (London, 1957), 200–14; Monika Butzek, *Die kommunalen Repräsentationsstatuen der Päpste des 16. Jahrhunderts in Bologna, Perugia und Rom* (Bad Honnef, 1978), 204–5; Sybille Ebert-Schifferer, "Ripandas Kapitolinischer Freskenzyklus und die Selbstdarstellung der Konservatoren um 1500," *Römisches Jahrbuch für Kunstgeschichte (Jahrbuch der Bibliotheca Hertziana)* 23/24 (1988): 76–218; Jan de Jong, *The Power and the Glorification: Papal Pretensions and the Art of Propaganda in the Fifteenth and Sixteenth Centuries* (Philadelphia, 2013), ch. 3.

14. Paul Zanker, *The Power of Images in the Age of Augustus*, trans. Alan Shapiro (Ann Arbor, 1988), 193 and *passim*.

15. About forward/backward time in the *Aeneid*, Page DuBois, *History, Rhetorical Description and the Epic* (Cambridge, 1982), 49.

16. For example, he notes that several aspects of the villa "not only rival but even far surpass antiquity" (dedicatory letter, §2); and Father Tiber exhorts his workers saying, "Dare to revive the splendor of ancient art" (12); he notes that Raphael will make Apelles and the ancients compete with him (160–3), and will surpass Apelles (275); and Tiber says to Giulio, predicting a papal victory over the Ottomans in the east, "you shall at last give to great Italy its longed-for spectacle; and although it fell to us to watch great triumphs when the Empire of Roman citizens flourished, yet you, Rome, will say that they were inferior to these" (362–5).

17. For Giulio-Julius Caesar: Reiss, "Cardinal Giulio de' Medici as a Patron of Art," 191, 215 n. 240. Of course, Pope Julius II had made use of Julius Caesar imagery first.

18. Sperulo's source here was probably a similar historical narrative that had been sketched in an oration written by Blosio Palladio in 1518 to commemorate the new sculpture of Leo to be placed on the Capitoline. For which, D'Amico, *Renaissance Humanism*, 134–7.

19. Virgil, *Aeneid*, VIII, 36–65 in which the Tiber foretells Aeneas' founding of Rome. For the varied uses of rivers as poetic voice throughout Virgil's oeuvre, Prudence J. Jones, *Reading Rivers in Roman Literature and Culture* (Lanham, MD, 2005), with earlier bibliography. On the personified Tiber and Roman identity in ancient art and literature, see Gretchen E. Meyers, "The Divine River: Ancient Roman Identity and the Image of Tiberinus," in *The Nature and Function of Water, Baths, Bathing, and Hygiene from Antiquity through the Renaissance*, ed. Cynthia Kosso and Anne Scott (Leiden, 2009), 233–47. For the personification of the Tiber in one section of Blosio Palladio's poem on the Chigi villa, Quinlan-McGrath, "Blosius Palladius," 105. Statius uses the river Volturnus as narrator in *Silvae*, IV, 3, 67–94, although the subservient role of the river creates a much different effect: Newlands, *Statius' Silvae*, 301ff. Sperulo's emphasis on the Tiber and his river nymphs was also surely meant to evoke Poliziano's and Lorenzo de' Medici's poems about Poggio a Caiano, in which the villa is personified as the nymph Ambra, daughter of the river Ombrone, an Arno tributary.

20. The Tiber's source is near Arezzo (ancient Arretium) in the Apennines. Virgil speaks of the Tuscan Tiber (*Tuscum Tiberim*) in *Georgics*, I, 499; the Tyrrhenian Tiber in *Aeneid*, VII, 242; and says, "On this side we are hemmed in by the Tuscan [river]" (hinc Tusco claudimur amni) in *Aeneid*, VIII, 473. See also Pliny the Elder, *Natural History*, II, 5, 53; Strabo, *Geography*, V, 2, 1; and Dionysius of Halicarnasus, *Roman Antiquities*, III, 44, 1–2. Because the Tiber formed the east bank of ancient Etruria, the left bank of the Tiber had long been referred to as the Tuscan or Etruscan side. This western bank of the Tiber was famously dotted with villas in Roman antiquity, as it was in the Renaissance. For which, C. L. Frommel, *Die Farnesina und Peruzzis architektonisches Frühwerk* (Berlin, 1961), 163–70. Rowland discusses the conceit that the left bank of the Tiber is notionally in Tuscany, and other Etruscan/Tuscan themes in the patronage of Chigi and Leo X: Rowland, "Render unto Caesar," 716–22.

21. "O Arno, perché noi nascemo inseme di fraterne acque, le quali cadeno quasi de un medemo [*sic*] fonte, et ambo intramo in uno mare, intende gli fati de la tua gente, la quale serà mo chiamata mia, et quello che dal X Leone sperare tu debbi. Costui darà a gli Italiani pace eterna et acquietarà gl'instanti tumulti; gli Re mandaranno a ricercarli pace et volere seguire gli sui commandamenti." From the account of Paulo Palliolo Farnese, cited in Cruciani, *Teatro del Campidoglio*, 57. The figures of the Tiber, the Arno, and Clarice Orsini rode on a carriage with Medici *imprese* at its center (a laurel tree with golden *palle*, gilded lilies, and diamond rings), symbols of Rome (the wolf with Romulus and Remus), and a pelican (symbol of Christ or Charity) bearing the words *Roma omnibus una est*.

22. "Roma desidera haverve raccolti nel suo beato grembo et haverve fatti suoi; de natura siete Thoscani, ma il privilegio vi facia Romani. Ad ogni modo l'una et l'altra gente è congiunta di sangue, imperoché anchora el Tibre se dice essere Thoscano." Cruciani, *Teatro del Campidoglio*, 56. The word *grembo* means both lap and womb, and this passage figuratively suggests the filiation of the Medici from *Mater Roma*. For an ethnographic interpretation of river geography equating shared water sources with shared culture, Jones, *Reading Rivers*, 37–47.

23. Cruciani, *Teatro del Campidoglio*, lxxiii, 55–6. On music for this and other Medici celebrations, Cummings, *The Politicized Muse*, ch. 4 and *passim*.

24. The celebration was directed by Tommaso Inghirami and Camillo Porcari, his student.

25. A. Fulvius, *Antiquaria urbis* (Rome, 1513). In this and in his 1527 prose edition of the work dedicated to Clement VII, Fulvio discusses the Tiber at length, calling it the king of rivers, identifying its Tuscan source, and providing citations from Virgil, Ovid, and others. A. Fulvius, *Antiquitates urbis* (Rome, 1527), fols. 28–9. The first Italian edition is Andrea Fulvio, *Opera di Andrea Fulvio delle antichità della città di Roma*, trans. Paulo dal Rosso (Venice, 1543), 90–2.

26. As pointed out by Ruth Rubinstein, "The Renaissance Discovery of Antique River-God Personifications," in *Scritti di storia dell'arte in onore di Roberto Salvini* (Florence, 1984).

27. Shearman, *Raphael's Cartoons*, 84; Ilaria Romeo, "Raffaello, l'antico e le bordure degli arazzi vaticane," *Xenia* 19 (1990): 41–86; Mark Evans, Clare Browne, and Arnold Nesselrath, eds., *Raphael: Cartoons and Tapestries for the Sistine Chapel* (London, 2010), 72–3.

28. For river god figures in Sperulo's proposed murals for Villa Madama, which were never executed, see below, p. 80. Michelangelo proposed reclining figures of the *Tiber* and *Arno* for Duke Lorenzo's tomb in the Medici New Sacristy, planned shortly after Sperulo's poem (unexecuted but known from a surviving model and drawings); for other resonances between Sperulo's poem and Michelangelo's New Sacristy, Chapter 5, p. 131 and note 98. For the painted west window embrasure of the Sala di Costantino (Figure 28), Quednau, *Sala di Costantino*, 499–504. For the restoration and installation of the ancient sculpture of the Tigris/Arno in the Vatican, probably under Clement VII, Ruth Rubinstein, "The Statue of the River God Tigris or Arno," in *Il cortile delle statue: der Statuenhof des Belvedere im Vatikan*, ed. M Winner, B. Andreae, and C. Pietrangeli (Mainz, 1998), 175–285; and Nicole Hegener, "Clemens curavit, Bandinellus restauravit. Der Flußgott Arno im Statuenhof des vatikanischen Belvedere," in *Zentren und Wirkungsräume der Antikerezeption: zur Bedeutung von Raum und Kommunikation für die neuzeitliche Transformation der griechisch-römischen Antike*, ed. Kathrin Schade and Detlef Rößler (Münster, 2007), 177–99. See also Claudia Lazzaro, "River Gods: Personifying Nature in Sixteenth-Century Italy," *Renaissance Studies* 25 (2011): 70–94.

29. The last clause is a play on Ovid's *Fasti*, IV, 830, when the king says to Jupiter, "auspicibus vobis hoc mihi surgat opus" (Under your auspices may this my fabric rise!) As noted in Appendix I, gloss note 21.

30. As in the *Aeneid* and Rosa's later depiction, Sperulo's Tiber and his brother river gods are active, embodied protagonists; by contrast, Raphael and his associates depict river gods in the reclining pose of ancient marble sculptures, instead using them primarily as locative signifiers. (Rosa's Tiber perhaps owes something to earlier depictions of the Apennine, as in Figure 28, or Giambologna's monumental *Apennino*. In addition to his engraving illustrated here, Rosa also executed a painted variant of the composition, now in the Metropolitan Museum.)

31. When Aeneas visits his father in the underworld, Anchises shows him his descendants – future great Romans – down to Caesar Augustus, whom Anchises predicts will restore the Golden Age to Rome (Virgil, *Aeneid*, VI, 792ff). In Sperulo's poem, Father Tiber says that Leo has restored the Golden Age of Saturn to Rome (340), discussed below.

32. For the continuous one-way flow of a river as an analogy for oratorical composition in the works of Quintilian and Seneca, see Jones, *Reading Rivers*, 51–4; and for the metaphor of water and poetic inspiration, *ibid.*, 56.

33. See Appendix I, gloss note 9.

34. DuBois, *History, Rhetorical Description and the Epic*, 13–21.

35. Virgil, *Aeneid*, VIII, 626–8. "Illic res Italas Romanorumque triumphos haud vatum ignarus venturique aevi fecerat ignipotens."

36. Vitruvius, *On Architecture*, X, II, 1. For Vulcan and the imagery of the early history of civilization, Erwin Panofsky, "The Early History of Man in Two Cycles of Paintings by Piero di Cosimo," in *Studies in Iconology: Humanistic Themes in the Art of the Renaissance* (New York, 1972 [originally 1939]), 33–68. On Vulcan imagery, see also Suzanne Butters, *The Triumph of Vulcan: Sculptor's Tools, Porphyry and the Prince in Ducal Florence* (Florence, 1996); and Dennis V. Geronimus, *Setting Sail for the Vulcan Isle: Piero di Cosimo's* Jason and Queen Hypispyle with the Women of Lemnos *and its Companion Scenes* (New York, 2005).

37. "Mulciber, ut perhibent, his oscula coniugis emit moenibus et tales uxorius obtulit arces. intus rura micant, manibus quae subdita nullis perpetuum florent, Zephyro contenta colono … Procul atria divae permutant radios silvaque obstante virescunt. Lemnius haec etiam gemmis extruxit et auro admiscens artem." Claudian, *Epithalamium*, 58–61, 85–8; in Poliziano, *The Stanze of Angelo Poliziano*, trans. David Quint (Amherst, 1979).

38. Poliziano, *Stanze*, I, 93 and 95ff, in *ibid*.

39. As noted below, imagery of Venus Genetrix and her attributes of fecundity, bounty, and peace-giving victory would indeed be

realized in decorations throughout the villa; see p. 75.

40. This point is discussed further in Chapter 5, pp. 116–18.

41. Cesarini Martinelli, ed., *Commento inedito alle Selve di Stazio di Poliziano*, 247ff; discussed by Dempsey, *The Portrayal of Love*, 44–8.

42. Along with Lucretius and, of course, Virgil; Dempsey, *The Portrayal of Love*, 47 n. 66. Statius, *Silvae*, 1, 2, 184–7: "alituum pecudumque mihi durique ferarum/ non renuere greges; ipsum in conubia terrae/ aethera, cum pluviis rarescunt nubila, solvo. sic rerum series mundique revertitur aetas." (Neither birds nor cattle nor savage packs of wild beasts have said me nay. I melt the very heaven into marriage with earth when rains thin the clouds. So one thing succeeds another and the world's youth returns.)

43. A point that has been observed for Statius in the *Silvae*, significantly for Sperulo. On Statius' self-presentation, Nauta, "Statius in the *Silvae*," 173; and Kathleen Coleman, "Mythological Figures as Spokespersons in Statius' *Silvae*," in *Im Spiegel des Mythos: Bilderwelt und Lebenswelt* (Wiesbaden, 1999), 67–80. I am indebted to Bahadir Yildirim for that reference. For a similar notion a few decades after Sperulo, we may look at Du Bellay's *Poemata* in which the Tyberis is both an authorial voice and also a symbol for the poet himself, as proposed by Perrine Galand-Hallyn, *Les yeux de l'éloquence: poétiques humanistes de l'évidence* (Orléans, 1995): ch. IV.

44. For Sperulo on marble revetments and columns at the villa for which I have not found any trace, and the removal of marbles from the villa, see Elet, "Papal *villeggiatura*," 160–3.

45. Remarkably, the rich Medici collection at the villa passed unnoticed into the margins of the legendary Farnese collection and remained virtually unknown until recently. For the formation of this collection, its passage from the Medici through Margarita of Austria into the Farnese family and then to the Bourbons, and its dispersal, as well as a discussion tracing the works it contained, see Elet, "Papal *villeggiatura*," ch. 3; Federico Rausa, "I marmi antichi di Villa Madama. Storia e fortuna," *Xenia antiqua* 10 (2001): 155–206; Kathleen Wren Christian, *Empire without End:*

Antiquities Collections in Renaissance Rome, c. 1350–1527 (New Haven, 2010).

46. Stefan Weinstock, *Divus Julius* (Oxford, 1971), 80ff.

47. Now in the Museo Archeologico Nazionale di Napoli, inv. 6718, Ruesch 1018. For a discussion of this relief, its excavation history, placement in the loggia, and subsequent history, Elet, "Papal *villeggiatura*," ch. 3, 187–91.

48. F. W. Goethert, "Trajanische Friese," *Jahrbuch des Deutschen Archäologischen Instituts* 51 (1936): 72–81; M. Floriani Squarciapino, "I pannelli decorativi del tempio di Venere Genitrice," Ser. 8, vol. 2, fasc. 2, *Atti dell'Accademia nazionale dei Lincei: memorie, classe di scienze morali, storiche e filologiche* (Rome, 1948–50), 87; and R. Bradley Ulrich, "The Temple of Venus Genetrix in the Forum of Caesar in Rome: The Topography, History, Architecture, and Sculptural Program of the Monument" (Ph.D. diss., Yale University, 1984), 227–8. On the popularity of the Basilica Ulpia motif, Bober and Rubinstein, n. 171.

49. For which, Elet, "Papal *villeggiatura*," 187–91.

50. Frommel, *Raffaello architetto*, 312. See also Frommel, "Die architektonische Planung der Villa Madama," 79–80.

51. The generative power of ancient marbles, and the poet's role in devising their installations, is discussed further in Chapter 5.

52. 26 September 46 BCE; Dio Cassius, *Roman History*, 43, 22, 2.

53. To my knowledge, neither this relief nor any other marble in the Temple of Venus Genetrix is known to have come from Paphos, nor is there a textual, mythical basis for this assertion.

54. Suetonius, *The Lives of the Caesars* (The Deified Julius), 1, LXXXV. On Numidian marble, a yellow marble now known as giallo antico, see the gloss note 33 with bibliography. On the double meaning of Iulo as Aeneas' son, ancestor of the Romans, and Julius Caesar, see gloss note 34.

55. I have found no evidence that a Numidian marble column was ever at Villa Madama, although one could have been removed without documentation. No column with the inscription mentioned by Suetonius has ever come to light. Numidian marble columns were plentiful, however; in fact, the Temple of Venus Genetrix had Numidian marble columns in the interior of its cella, and it is possible that one was recovered at the same time

as the relief. For the columns in the Temple of Venus Genetrix, Giuseppe Lugli, *Roma antica: il centro monumentale* (Rome, 1946), 252; and *LTUR*, II, 307 (P. Gros).

56. Alison M. Brown, "The Humanist Portrait of Cosimo de' Medici, Pater Patriae," *Journal of the Warburg and Courtauld Institutes* 24 (1961): 186–221; Anthony Molho, "Cosimo de' Medici: *Pater Patriae* or *Padrino?*," *Stanford Italian Review* 1 (1979): 5–33; D. Kent, *Cosimo de' Medici*, 9.

57. These are just two among many possible examples of sculptures the poet describes, which are treated further in the discussion of program and metastructures in Chapter 5.

58. Effectively equipping his *camera* like a council hall. Like many aspects of the architecture and decoration of Palazzo Medici, this reflected the long-standing practice of deliberately appropriating civic elements to a private palace to designate the Palazzo Medici as the locus of civic authority. Lorenzo appropriated from an associate this cycle painted decades earlier, the subject of which was associated with Florentine and Medici triumph and peacemaking, and which linked the eras of Cosimo primo and Lorenzo il Magnifico.

59. *Sedes*, line 273, for which see gloss note 39.

60. As noted by Shearman, *Sources*, vol. 1, 437. For this battle, F. L. Taylor, *The Art of War in Italy 1494–1529* (Cambridge, 1921), 180–215; and Roscoe, *The Life and Pontificate of Leo the Tenth*, vol. 1, 259ff.

61. Shearman, *Raphael's Cartoons*, 17–18, 84–5; Romeo, "Raffaello"; Evans et al., *Raphael*, 86–7.

62. James Hankins, "Humanist Crusade Literature in the Age of Mehmed II," *Dumbarton Oaks Papers* 49 (1995): 111–207; Kenneth M. Setton, "Leo X and the Turkish Peril," *Proceedings of the American Philosophical Society* 113 (1969), 367–424; Setton, *The Papacy and the Levant, 1204–1571*, vol. 3 (Philadelphia, 1984), 172–97; Nancy Bisaha, *Creating East and West: Renaissance Humanists and the Ottoman Turks* (University Park, PA, 2004), 174–87.

63. In 1517, Leo granted indulgences for crusaders, and the pontiff appointed a commission of cardinals to study a possible campaign against the Turks. Throughout 1518, discussions among the Vatican and European princes were consumed with the plan for a crusade and the logistics of amassing and financing the necessary troops, as discussed in Setton, "Leo X and the Turkish Peril," 399–405 and *passim*. After the Turkish threat near Loreto, Leo issued a 1519 bull stating that funds earmarked for paving roads and making fountains should instead be used for the fortification of Loreto, as discussed by Eva Renzulli in a talk at the University of Warwick in May 2003. Leo actually called for a war against the Turks in 1519. It was around this time that Mario Equicola wrote a work addressed to Pope Leo urging the crusade: Kolsky, *Mario Equicola*, 165–6.

64. Cesare Guasti, *I Manoscritti Torrigiani donati al R. Archivio di Stato di Firenze* (Florence, 1878), 118 and *passim*.

65. "Romae terror est ingens ... Quae res ita metu praesenti omnes occupat ut actum de Italia et urbe Roma esse videatur." In a letter of 26 January 1518, to the papal nuncio to King Charles of Spain, BAV, Vat. Lat. 3146, fol. 37v. Cited and trans. O'Malley, *Praise and Blame in Renaissance Rome*, 233.

66. The preamble to Leo's bull of 31 December 1518, ratifying the peace treaty of London, declared, "Be glad and rejoice, O Jerusalem, since now your deliverance can be hoped for ... The kings are assembling ... to serve the Lord against the fierce madness of the Turks and against the uncleanliness of Islam." In Setton, "Leo X and the Turkish Peril," 413. On exhortations to war against the Turks to ensure a Christian peace in sermons, O'Malley, *Praise and Blame in Renaissance Rome*, 232–6. For east–west clashes and strife within Christian Europe as a theme of Giovio's *Histories*, Zimmermann, *Paolo Giovio*, 25–26 and *passim*. The notion that local peace was compatible with foreign war was familiar from ancient panegyrics.

67. I owe this observation to Rachel Kousser.

68. Rolf Quednau, "Aspects of Raphael's 'Ultima Maniera' in the Light of the Sala di Costantino," in *Raffaello a Roma*, 247–8; and Quednau, *Sala di Costantino*, 384–98. Related imagery figured in the Vatican Stanza dell'Incendio painted by Raphael, depicting Leo IV's victory over the Saracens at Ostia as a prefiguration of Leo X's close brush with Turkish pirates at Ostia in 1516.

69. Rudolf Preimesberger, "Tragische Motive in Raffaels 'Transfiguration'," *Zeitschrift für Kunstgeschichte* 50 (1987): 97ff with earlier sources; and Kathleen Weil-Garris Posner,

Leonardo and Central Italian Art, 1515–1550 (New York, 1974), 43–8.

70. Raphael, in his letter on the villa, describes this "bellissima lhoggia" with a view overlooking the hippodrome, the beautiful countryside, the Tiber, and Rome. He also points out that the portone under this loggia, one of the main entrances of the villa, opens to the newly built road leading straight to the Milvian bridge, making it look as if the bridge had been built for the villa. Raphael/Dewez, 22 §2, 24–5 §10–11. On the symbolic significance of the villa's siting and views, see Chapter 5, pp. 101–5, and also Elet, "Papal *villeggiatura*," 30–42, and Elet, "Raphael and the Roads to Rome."

71. Ioana Jimborean, "La Loggia delle Benedizioni at St. Peter's in the Quattrocento and the Visualization of Power," in *Perspectives on Public Space in Rome, from Antiquity to the Present Day*, ed. Gregory Smith and Jan Gadeyne (Farnham, 2013), 109–30.

72. Sperulo specifies a tower overlooking the damp south, from which Cardinal Giulio will look toward the Tiber ("Parte alia, de turre udum quae spectat ad Austrum / consurgat specula, unde meum conversus in amnem / Iulius aeternum Thuscis ver numine ripis / praesenti sublimis alat" [226–9]). The hillside of Monte Mario actually blocks the view looking due south from any of the towers; presumably the poet had seen the plan but did not understand its relation to the topography of the site. Most likely, by describing a tower overlooking the south and the Tiber, he means the east tower (see Figure 26). Raphael's letter specifies that this tower would contain a *diaeta* ringed with glass windows for pleasant conversation – presumably Cardinal Giulio's vantage point mentioned by the poet. (Raphael does not specify a function for the south tower, other than noting that both the east and south towers could be used for defense; Raphael/Dewez, 23–4 §4, 7–8. And since Raphael notes the *diaeta* will be above the bastion [*turrione*], I assume he intended only one level of living space in each tower; Raphael/Dewez, 22 n. 4.1 and §7.) This cycle of Clemency paintings could have been intended as a mural band above the windows or else as a series of paintings set between the windows, for which there is enough wall space, although the light would not create ideal viewing conditions. Alternatively, Sperulo could have intended the paintings for the south tower. Most confusingly, he mentions at lines 216–19 an area of the villa where "here … the golden sun will be warm at rising and setting, admitted on all sides through glazed windows" (Hic … tepido sol aureus ortu/ occasuque aderit, vitrasque admissus utrinque/ per speculas); this passage, which would seem to describe the windowed tower, occurs in the middle of his description of the garden loggia and inner garden (i.e. the opposite end of the villa from Raphael's proposed glazed *diaeta*), and it precedes Sperulo's introduction of the south-facing tower with the phrase "In another part" ("Parte alia," 226). Perhaps the poet was confused about where the glazed *diaeta* was to be, or he mistakenly thought the north tower would also be ringed with windows and ignored its function to house the chapel (although a look at U 273A or Raphael's letter would clarify these points). More likely, Sperulo was simply juxtaposing highlights of the summer and winter quarters in this passage at lines 216–19 to address the comfort-in-all-seasons trope, without mind to specific physical location or proposed decoration.

73. For which, see gloss note 93. For Raphael's design for *The Vision of Ezekiel* in which God the Father is shown as Jupiter borne aloft by the four symbols of the Evangelists (executed as a painting probably by Giulio Romano, and a tapestry, possibly for Leo's *letto de paramento*), see Henry and Joannides, eds., *Late Raphael*, 109–17. For the tradition of the *Quadriga Domini*, or the metaphor of the Evangelists as a chariot team, see Michael Jacoff, *The Horses of San Marco and the Quadriga of the Lord* (Princeton, 1993), 12–20.

74. The glazed windows were a novel luxury. As for the scale of the *diaeta*, Raphael stipulates it would be 6 canne in diameter; Dewez notes that assuming a wall thickness of 6 palmi, the interior dimension of the room would be 48 palmi (35.2 feet), although both plans show it as 30 palmi (22 feet). Raphael/Dewez, 23 §7 and n. 7.2.

75. I am indebted to James Hankins for a discussion of this point. A later example of this topos in Medici visual imagery is Bandinelli's *Hercules and Cacus*, for which Pope Clement chose the more restrained subject of Cacus as prisoner rather than Cacus about to be killed: Kathleen Weil-Garris, "On Pedestals:

Michelangelo's *David*, Bandinelli's *Hercules and Cacus* and the Sculpture of the Piazza della Signoria," *Römisches Jahrbuch für Kunstgeschichte* 20 (1983): 397–8.

76. Pellegrini, "Leone X."

77. Paolo Giovio recorded contemporary speculation about Leo's motives: Giovio, *De vita Leonis Decimi Pont. Max* (Florence, 1551), 85. Winspeare and Ferrajoli, following Pastor, believed it was a real conspiracy. Cf. G. B. Picotti, who first proposed instead that the Medici capitalized on Petrucci's actions and invented the conspiracy with the goal of squashing Riario and other enemies, then stacking the College of Cardinals with pro-Medicean allies – a view recently solidified by Kate Lowe and Marcello Simonetta. Alessandro Ferrajoli, *La congiura dei cardinali contro Leone X*, Miscellanea della R. Società romana di storia di patria, vol. 7 (Rome, 1919–20), 140–9; G. B. Picotti, "La congiura dei cardinali contro Leone X," *Rivista storica italiana*, n.s. 1 (1923): 249–67; Fabrizio Winspeare, *La congiura dei cardinali contro Leone X* (Florence, 1957), 159–66 and *passim*; K. Lowe, "An Alternative Account of the Alleged Cardinals' Conspiracy of 1517 against Pope Leo X," *Roma moderna e contemporanea* 11 (2003): 53–78; Simonetta, *Volpi e leoni*, 161–201. For a positive spin on Leo's stacking the College of Cardinals, see Sperulo, Appendix 1, lines 337–40 and gloss notes 119–20.

78. Ferrajoli, *La congiura dei cardinali contro Leone X*, 213–15.

79. The terms of Leo's clemency were that Riario was allowed to live, but was stripped of his honors and the Palazzo della Cancelleria, which he had built.

80. The date of this elegy is not clear. The poem is part of four books with a miscellanea of material presented to Cardinal Rangone. The final book is dated 19 May 1520, and the dedication is given as 1 December 1520. Presumably the poem was written on the occasion of the pardon (in December 1518), as suggested by Ferrajoli, *La congiura dei cardinali contro Leone X*, 213.

81. Imagery that he revisits in the villa poem, especially in lines 71 and 235; see gloss notes 36 and 92.

82. As discussed in the following chapter, p. 94.

83. Charles V was elected as Holy Roman Emperor in June 1519, and he and his rival Francis I began to focus on squaring off against each other rather than the Turks. The death of Sultan Selim in September 1520 and the accession of Suleiman shifted the focus of Ottoman aggression away from the Italian peninsula, and the issue of an anti-Turkish crusade lost its urgency. Moreover, the Lutherans replaced the Turks as the prime threat to the church. For which, Setton, *Leo X and the Turkish Peril*, 419–20. So Sperulo's emphasis on Leo's establishing peace in Europe to wage war against the Turks was outdated by the time the walls were actually built, and decorations were reconsidered in 1520. Additionally, Leo's death in 1521 would have relegated the subjects of his clemency and the Battle of Ravenna to Medici family history, rather than timely subjects. Thus, the very topical program the poet had created was quickly rendered obsolete.

84. On the vision of history in the Virgilian set piece, DuBois, *History, Rhetorical Description and the Epic*, 41ff.

85. As noted above, Ariosto was working in the Vatican to stage his *I suppositi* with Raphael on 6 March 1519, when he was revising the *princeps* edition of the *Orlando furioso*.

86. Christian Kleinbub, *Vision and the Visionary in Raphael* (University Park, PA, 2011), 113.

87. See above, pp. 81–2 and note 73; and Appendix 1 lines 241–4 and gloss note 93.

88. About this topos, see Chapter 2, p. 55 and notes 55–6.

4 ENCOMIA OF THE UNBUILT

1. Shearman, *Sources*, vol. 1, 434.

2. Shearman believed that the poem is based on the letter: Shearman, "A Functional Interpretation of Villa Madama," 315; and Shearman, *Sources*, vol. 1, 410 and 434. Frommel ("Die architektonische Planung der Villa Madama") first dated the letter as 1518–19, noting it as the source for Sperulo, although he later suggested that the letter could postdate the poem: Frommel, *Raffaello architetto*, 325. For the latter interpretation, see also Philip J. Jacks, "The Simulachrum of Fabio Calvo: A View of Roman Architecture *all'antica* in 1527," *Art Bulletin* 72 (1990): 453–81, at 471ff; and Camesasca and Piazza, *Raffaello: gli scritti*, 340ff.

3. Heinrich Lausberg, *Handbook of Literary Rhetoric*, trans. Matthew T. Bliss, Annemiek

Janse, and David E. Orton (Leiden, 1998), §882–6 (pp. 393–4). I am grateful to Jean Sorabella, who first pointed out to me the name of this poetic device, which is also known as paralipsis.

4. The other possibility – that Raphael, having seen Sperulo's poem, decided to focus on these items – is implausible.

5. Bembo sometimes showed others a poem without giving them a copy or allowing them to copy it: Richardson, *Manuscript Culture in Renaissance Italy*, 24–6.

6. Raphael used *hypodromo* (Raphael/Dewez, 25 §12), and Sperulo *hippodromus* (389).

7. Shearman mistakenly says that Sperulo copies the order of items mentioned in Raphael's letter (*Sources*, vol. 1, 434); in fact, the order is very different.

8. For *coenatio/cenatione*, Sperulo, 206 and Raphael/Dewez, 27 §16. Shearman incorrectly notes the word *specula* among Sperulo's borrowings from Raphael's letter: *Sources*, vol. 1, 434; in fact, neither Raphael nor Pliny uses it, but Sperulo does many times, in the sense of a belvedere or loggia.

9. Raphael/Dewez, 24–5 §10–12. Both surviving ground plans detail these architectural features that leave almost no continuous wall space for a mural cycle; see plans in Plates v, vi and the model in Figure 14.

10. See the discussion in Chapter 3, p. 81 and note 72 about the contradictions in Sperulo's proposed placement of the Clemency murals in the villa. For his description of the fishpond abutting the inner garden or *xystus* (*a margine xystus*), see the poem line 387 and gloss note 133.

11. I use loosely the word *commissioned*; on the uncertainty associated with the patronage process for scholar-courtiers of the papal Curia, from lining up work to getting paid for it, see Gaisser, "Seeking Patronage under the Medici Popes," 293–309.

12. Frommel observed that parts of the letter are copied word-for-word from Calvo's translation of Vitruvius, as discussed most recently in Shearman, *Sources*, vol. 1, 410.

13. I think it is likely that Raphael sent a draft to Castiglione to transform the artist's ideas into a more polished and literary product, as proposed by Shearman, "A Functional Interpretation of Villa Madama," 315 n. 2.

14. Shearman, *Sources*, vol. 1, 142.

15. Sperulo's use of architectural vocabulary is inconsistent and at times confusing. He consistently uses *atria* to refer to spaces with significant marbles or spoils (54–6, 79–81, 245–7, 391–3), although he does not specify exact locations. He uses *specula* interchangeably for a loggia (270, 373) and towers (219, 227) designed to have views, so that in a sense, it designates a kind of belvedere. He also uses *turre* for the towers (226, 381), perhaps to indicate the base of the tower, just as Raphael's letter distinguishes between *torrione* (tower) and *turrione* (bastion, or ground storey of the tower). The word *sede* appears eleven times, sometimes to designate figurative seats for the living Medici, or as seats for sculptures of ancestors, which could mean thrones or simply places (16, 27, 78, 125, 128, 189, 206, 249, 261, 273, 337). His only use of the terms *aula, theatro, porticus, balnea, xystus, piscina, hippodrome,* and *stabula* is in the *praeteritio* of subjects he will not discuss, a clear reference to Raphael's letter.

16. De Beer, *The Poetics of Patronage*, 333.

17. See further discussion of this hypothesis in Chapter 6, which additionally considers the travel schedules of the planners around the time of Sperulo's poem.

18. Valeriano's *Dialogo* is discussed on p. 22 and in Chapter 2, pp. 58–9 and notes 76–7.

19. As reported in a letter of Alfonso Paolucci in Rome to Alfonso d'Este in Ferrara, 13 March 1519: in Shearman, *Sources*, vol. 1, 443 (doc. 1519/22).

20. Shearman, *Sources*, vol. 1, 455 (Castiglione), 483–4 (Alfonso Paolucci, the Duke of Ferrara's agent), and 774ff (Vida). (In Chapter 6, the practice of frequenting unfinished buildings is linked to the perception of them as modern ruins.)

21. As for the Villa Madama poems, Vida and Sperulo specify that the construction is in progress; Sperulo's date of 1 March 1519 supports his assertion, and Equicola tells us that Tebaldeo's lost panegyric was written during this period. Both of the major poems about the Chigi villa, dated 1511 and 1512, were written in the middle of its construction. Of the two Poliziano poems about Poggio a Caiano, one states that Lorenzo is about to begin a villa, and the other admires the foundations of the new rising villa. Michele Verino's 1485 short letter

describing Poggio a Caiano also mentions visible foundations.

22. D'Amico, *Renaissance Humanism*, 8ff and *passim*. Rowland dubbed this "an erudite public relations campaign" in Rowland, "Some Panegyrics to Agostino Chigi," 194. See also Quinlan-McGrath, "Blosius Palladius," 102.

23. Galand-Hallyn, "Quelques coincidences (paradoxales?) entre *L'Épitre aux Pisons* d'Horace et la poétique de la *Silve*)," 612, for the etymology of *silva* as *materia* or raw material in Greco-Roman philosophy, from the Greek *hyle*, and the typology of the humanist *silva*. This aspect of the *silva* form in Statius is discussed by David Wray, "Wood: Statius's *Silvae* and the Poetics of Genius," *Arethusa* 40 (2007): 127–43; and by Newlands, "The Transformation of the 'Locus Amoenus'," 151–2, who proposes that, "[Statius'] choice of the term *silvae* to describe these poems suggests that he views them as metaphorical equivalents of the work of reshaping nature to an exciting work of art." She further discusses the multiple associations of the *silva* form in Roman poetry, including "material to be reworked, revised, and contested" in Newlands, *Statius'* Silvae, 36–7. Quintilian, Cicero, and Aulus Gellius also equate the *silva* form with raw material: Quintilian, *Institutio oratoria*, V, 10, 33; Cicero, *De oratore*, XII; and Aulus Gellius, *Attic Nights*, Preface 5–6. James Hankins points out that *silva* is a well-established synonym for *materia* in the medieval and Renaissance exegeses of Plato's *Timaeus*. Poliziano's *silva Manto*, 39–43, playfully compares the poet shaping his song to the woodcutter choosing which trees to fell in the forest (*sylvae*): Poliziano, *Silvae*, 8–9. Italian writers played on *silva/selva*, and the Italian word *selva* has been used to convey something produced with the rapidity and immediacy of a sketch. An interesting later example is Giuseppe Verdi's use of *selva* to designate his first-draft score: Daniela Goldin Folena, "Lessico melodrammatico verdiano," in *Le parole della musica*, ed. Maria Teresa Muraro (Florence, 1995), vol. 2, 232ff, a source I owe to Philip Gossett.

24. On poetry written quickly, see Chapter 2, pp. 58 and 59 and notes 82–3; and Appendix 1, dedicatory letter §3 and gloss note 5.

25. In his dedication to Chigi, Blosio says, "I have sung of the majority of things in the garden … now just begun and planned, as though they were finished … I did not hesitate to weave into my songs, as though already existing, those future things which you had planned in your mind." ("quod in hortis pleraque … iam inchoata et affecta, ceu effecta cecinerim … non dubitavi carminibus intexere, ut iam extantia: quae tu animo destinasses futura.") Citation and translation in Quinlan-McGrath, "Blosius Palladius," 114–15.

26. I owe this observation to James Hankins.

27. I am indebted to Ann Kuttner for bringing these letters to my attention (verbal communication); she also treated them in a 2006 RSA conference talk "Villas in the Mind's Terrain: Realism and Imagination in the Poetry of Horace and Ovid." Cicero, *Letters to Quintus*, especially 3.1.

28. Another villa description of potential interest for this point may be found in the work of Sidonius, the late fifth-century CE author of villa panegyrics in verse and prose, which owed much to the letters of Pliny and the *Silvae* of Statius (the latter debt was acknowledged by Sidonius himself in the postscript to his *Carm.* 22). In this poem describing the Gallic burgus (castle-villa) of Pontius Leontius near Bordeaux, Sidonius prophesies, "Methinks I see the future that is in store for thee, O Castle!" ("cernere iam videor quae sint tibi, Burge, futura"): Sidonius, *Poems and Letters*, 22, 126. The poet seems to be predicting the fame of the castle, not the fact of its existence, as contemporary scholarship has interpreted the poem, to my knowledge. But this apostrophe to the villa was in one sense proleptic and may have been of interest to later villa writers.

29. For a discussion of "rhetorische Ekphrasis" in poetry, Paul Friedländer, *Johannes von Gaza, Paulus Silentiarius und Prokopios von Gaza: Kunstbeschreibungen justinianischer Zeit* (Leipzig and Berlin, 1912, repr. Hildesheim and New York, 1969), 83ff. On the relation of *ekphrasis* and *descriptio*, and its role in Latin poetry as formulated in Horace, *Ars poetica*, 14–19, see Andrew Laird, "*Vt figura poesis*: Writing Art and the Art of Writing," in *Art and Text in Roman Culture*, ed. Jaś Elsner (Cambridge, 1996), 75–102.

30. Smith, *Architecture in the Culture of Early Humanism*, ch. 7; Smith, "Christian Rhetoric in Eusebius' Panegyric," 228, in which she further traces sources of architectural *ekphrasis* in the traditions of *laus urbis* and the

periegesis; Baxandall, *Giotto and the Orators*, 85ff; Friedländer, *Johannes von Gaza, Paulus Silentiarius und Prokopios von Gaza*; John Monfasani, "The Byzantine Rhetorical Tradition and the Renaissance," in *Renaissance Eloquence*, ed. J. J. Murphy (Berkeley, 1983), 174–87.

31. Noted by Christine Smith, *Architecture in the Culture of Early Humanism*, 184.

32. The importance of Statius as a model was discussed by Friedländer in his fundamental 1912 study of *ekphrasis*, and by Cancik in his study of the *Silvae*; but subsequent literature has virtually ignored Statius' contribution; cf. Friedländer, *Johannes von Gaza, Paulus Silentiarius und Prokopios von Gaza*, 60–9 and *passim*; Cancik, *Untersuchungen*, 34–8 and *passim*; Adam R. Marshall, "*Spectandi Voluptas*: *Ecphrasis* and Poetic Immortality in Statius' *Silvae* 1.1," *Classical Journal* 106.3 (2011): 321–47.

33. For *topothesia*, Lausberg, *Handbook of Literary Rhetoric*, §819, pp. 365–6. The term "notional *ekphrasis*" was devised by John Hollander, "The Poetics of Ekphrasis," *Word and Image* 4 (1988): 209ff. Hollander also treats notional *ekphrasis* that is imperative or optative, as in advice-to-an-artist poems from the Hellenistic *Anacreontea* to eighteenth-century England. These poems, which instruct a painter or sculptor to make a work of art, are conceptual riffs on the *ut pictura poesis* tradition rather than a literal exhortation, and thus are a difference genre from the Renaissance villa poems discussed, although they may have been the inspiration for Sperulo's apostrophes to Raphael. See John Hollander, *The Gazer's Spirit: Poems Speaking to Silent Works of Art* (Chicago, 1995), 4, 23–4 and *passim; Elegy and Iambus with the Anacreontea*, trans. J. M. Edmonds (Cambridge, MA, 1954), vol. 2, *Anacreontea*, 3–5, 16, 17.

34. Virgil, *Aeneid*, I, 446ff. This passage was especially resonant for Medicean readers, for the famous Riccardiana Virgil – the manuscript of the *Aeneid* illustrated by Apollonio di Giovanni – depicts the palaces in Carthage and Troy modeled after the Medici Palace in Florence. Discussed by Annabel Patterson, *Pastoral and Ideology: From Virgil to Valéry* (Berkeley and Los Angeles, 1987), 69–72.

35. The Classical texts on such rhetorical exercises are: Cicero, *De inventione rhetorica*, I, 39; Cicero, *Auctor ad Herennium*, III, 16, 29 and III, 17, 30; and Quintilian, *Institutio oratoria*, XI, 2, 17–22. This tradition is discussed in Kuttner, "Prospects of Patronage," 98; Leach, *Rhetoric of Space*, 73–8; and Ann Vasaly, *Representations: Images of the World in Ciceronian Oratory* (Berkeley and Los Angeles, 1993). On imagined and real architectural models for the Hypnerotomachia, see Benzi, "Percorso reale in sogno di Polifilo"; and Marco Ariani, "*Descriptio in somniis*: racconto e *ekphrasis* nella *Hypnerotomachia Poliphili*," in *Storia della lingua e storia dell'arte in Italia: dissimmetrie e intersezioni*, ed. Vittorio Casale and Paolo d'Achille (Florence, 2004), 153–60.

36. Filarete, *Filarete's Treatise on Architecture, Being the Treatise by Antonio di Piero Averlino, Known as Filarete*, ed. and trans. John R. Spencer (New Haven, 1968).

37. On poetic sources for these descriptions, Smith, *Architecture in the Culture of Early Humanism*, 194–5; Christine Smith and Joseph O'Connor, *Building the Kingdom: Giannozzo Manetti on the Material and Spiritual Edifice* (Tempe, AZ, 2006), 66–8.

38. "Descriptio villae salubrie," in Marsilio Ficino, *Opera omnia* (Turin, 1962), vol. 1, 893–4. Ficino specifies that the actual villa they come upon is that of Pier Filippo Pandolfini, originally built by Leonardo d'Arezzo and located near Bocaccio's villa that was the Decameron setting. The fullest treatment of this letter is in André Chastel, *Art et humanisme à Florence au temps de Laurent le Magnifique* (Paris, 1959), 148–9, who rejects a hypothesis that the villa described by Ficino was actually built by Leonardo Bruni. On the letter, see also Ackerman, *The Villa*, 77; Hartmut Biermann, "Lo sviluppo della villa toscana sotto l'influenza umanistica della corte di Lorenzo il Magnifico," *Bollettino del Centro internazionale di studi Andrea Palladio* 11 (1969): 36–46, at 40; Foster, "A Study of Lorenzo de' Medici's Villa at Poggio a Caiano," vol. 1, 21; Fabiani Giannetto, *Medici Gardens*, 144.

39. Richard Krautheimer, "The Panels in Urbino, Baltimore, and Berlin Reconsidered," in *The Renaissance from Brunelleschi to Michelangelo: The Representation of Architecture*, ed. Henry Millon and Vittorio Lampugnani (Milan, 1994), 233–57.

40. On Hellenistic sources of encomiastic *ekphrasis*, Alex Hardie, *Statius and the* Silvae:

Poets, Patrons and Epideixis in the Graeco-Roman World (Liverpool, 1983), 128ff.

41. It was Statius who first applied epideictic formulas to poetry, as observed by Hardison, *The Enduring Monument*, 95. Hardie further calls Statius "the most important exponent of epideixis in poetry," emphasizing Statius' Neapolitan origins and thus his familiarity with Greek display poetry and rhetoric, which he infused into Latin literary models; in Hardie, *Statius and the* Silvae, 74ff, 91–102, and *passim*. On rhetorical formulas in Statius' poems, or rhetorical poetry, Cancik, *Untersuchungen*, 34–7; and Friedländer, *Johannes von Gaza, Paulus Silentiarius und Prokopios von Gaza*, 60–1 and *passim*. For Statius' inventive blurring of genres, see below notes 44 and 52.

42. As shown by O'Malley, *Praise and Blame in Renaissance Rome*. On the importance of epideictic rhetoric for Renaissance lyric poetry, Hardison, *The Enduring Monument*, 95 and *passim*.

43. The inclusion of architecture was common by the second century CE, as in Pliny's panegyric of Trajan, and the practice was revived in the quattrocento by writers including Leonardo Bruni and Giannozo Manetti, as noted by Smith, "Christian Rhetoric in Eusebius' Panegyric," 229–31.

44. For the way Statius draws attention to his creative adaptation of Homeric *ekphrasis* in his villa poems, Adam R. Marshall, "Statius and the *Veteres*: *Silvae* 1.3 and the Homeric House of Alcinous," *Scholia: Natal Studies in Classical Antiquity* 18 (2009): 78–88.

45. As noted by Smith and O'Connor, *Building the Kingdom*, 66–8. They interpret Manetti's *laudatio* of Nicholas' architectural patronage as a posthumous effort to salvage the pontiff's reputation by refuting criticisms of his building project as an incomplete, vainglorious effort and instead describing it as a unified, grand vision. For this and varied interpretations about the reality of the projects Manetti describes, Smith and O'Connor, *Building the Kingdom*, 191–2 and 203–4.

46. Francesco Albertini, "Opusculum de mirabilibus novae & veteris urbis Romae (Rome, 1510)," in *Five Early Guides to Rome and Florence*, ed. Peter Murray (Farnborough, 1972), especially book 3, "De aedificiis ab Iulio Secundo constructis" and *passim*; see also the discussion in Bram Kempers, "Epilogue. A Hybrid History: The Antique Basilica with a Modern Dome," in *Old Saint Peter's, Rome*, ed. Rosamond McKitterick, John Osborne, Carol M. Richardson, and Joanna Story (Cambridge, 2013), 386–403, at 390–4.

47. Susanna Morton Braund, "Praise and Protreptic in Early Imperial Panegyric: Cicero, Seneca, Pliny," in *The Propaganda of Power: The Role of Panegyric in Late Antiquity*, ed. Mary Whitby (Leiden, 1998), 71 and *passim*.

48. I am grateful to Curtis Dozier for this observation. For the hortatory function of deliberative oratory, Quintilian, *Institutio oratoria*, III, 8, 6.

49. Braund, "Praise and Protreptic," 68–74. On Statius' *Silvae*, IV, 1, in which Janus as spokesperson exhorts Domitian to join him in founding a new age of peace, K. M. Coleman, *Statius*. Silvae IV (Oxford, 1988), 62–5.

50. Egidio of Viterbo composed an exhortation urging Pope Leo to finish rebuilding St. Peter's, but in metaphorical rather than specific terms (it will be like the Tower of David), so once again we are not dealing with a direct model for Sperulo's poem. In *Historia viginti saeculorum*, Bib. Angelica ms. Lat. 502, fol. 112, partially cited in Marcello Fagiolo dell'Arco, "La Basilica Vaticana come tempio-mausoleo 'Inter duas metas'. Le idee e i progetti di Alberti, Filarete, Bramante, Peruzzi, Sangallo e Michelangelo," in *Antonio da Sangallo il Giovane*, 208 n. 19, and discussed by Smith, *Architecture in the Culture of Early Humanism*, 52. For another example, chroniclers of Leo's 1515 Florentine entry recorded that a wooden relief sculpture of San Lorenzo decorating the unexecuted façade of the eponymous family church was accompanied by an inscribed plaque exhorting the pontiff to complete the façade. This conceit put the exhortation in the mouth of San Lorenzo, although the brevity of an inscription did not allow for a specific or detailed prescription: Ilaria Ciseri, *L'ingresso trionfale di Leone X in Firenze nel 1515* (Florence, 1990), 137–8 with earlier sources; Reiss, "Cardinal Giulio de' Medici as a Patron of Art," 238; and Reiss, "The Patronage of the Medici Popes at San Lorenzo in the Historiographic Tradition," in *San Lorenzo: A Florentine Church*, ed. Robert Gaston and Louis A. Waldman (Florence, forthcoming).

51. For the poem as a metonym of the patron in French villa poetry, Galand-Hallyn, "Aspects du discours," 143.

52. As noted, Statius' villa poems were a model for the assemblage of elements from many genres to form a new one – specifically the combination of encomium and extended description; see above, p. 93 and notes 41 and 44. For the *silva* from Statius forward as a "cocktail" of literary and rhetorical styles that resists generic classifications, Galand-Hallyn, *Les yeux de l'éloquence*, 24–7, 30 n. 35, and *passim*. On Statius' blurring of genres, see also Newmyer, *The Silvae of Statius*, 17ff, 40, and *passim*. For Statius' engagement with epic poetry to develop new types of *ekphrasis* and panegyric, Marshall, "*Spectandi Voluptas*." Although Sperulo does not identify it as such, his poem is a quintessential *silva* in the sense of its being a collection of varied material, discussed below pp. 97–8 and notes 64–6.

53. It remains unclear whether Blosio's and Gallo's poems were specifically intended as proposals; Quinlan-McGrath, in her dissertation, suggested the possibility that the poets played a formative role in the Farnesina decorations, although she did not return to this idea in her subsequent articles on the two poems: Quinlan-McGrath, "The Villa of Agostino Chigi," 319, 321, 399, 407, 520.

54. As noted above, Poliziano's poems, though written during the construction of Poggio a Caiano, were not specific or prescriptive in the same way as Sperulo's. Christina Strunck has proposed the intriguing hypothesis that Pontano's 1493 poem "De hortis Hesperidum" was written as a Medici panegyric, which was later picked up by Giovio as the source for iconography at Poggio a Caiano: Strunck, "Pontormo und Pontano. Zu Paolo Giovios Programm für die beiden Lünettenfresken in Poggio a Caiano," *Marburger Jahrbuch für Kunstwissenschaft* 26 (1999): 117–37, at 127; one can speculate whether Pontano might originally have intended the poem as a contribution of imagery for Poggio, a building project with which he was surely familiar given his close contacts with Piero de' Medici and Poliziano. The ongoing research of Christine Smith on late quattrocento architectural *ekphrasis* may provide further examples of this genre.

55. For this trope, see Chapter 2, p. 54 and note 50; note 58 below; and p. 176.

56. The work was written in late 1525 and first published in 1526, although perhaps known, circulated, or performed earlier; for which, Reynolds, *Renaissance Humanism at the Court of Clement VII*. On the "professional" exercise of poetry, *ibid.* 119, 339–40 n. 396 and *passim*.

57. On Berni's role as secretary sorting Giberti's unwanted mail, *ibid.* 198–9 and 299 n. 261, and for his description of the lavish volumes, 190–3. For Sperulo's booklet, see Appendix II.

58. For the poet as builder/manual worker, *ibid.* 186–9, 249–54 nn. 88–106, 204–5, and 313 n. 315; in particular, Berni declares that "ll primo exercizio de' poeti fusse il murare" (186) and "tutti i poeti alla fin sono o muratori o manovali" (188).

59. Frommel, *Raffaello architetto*, 311–14; Frommel, "La Villa Madama e la tipologia della villa romana nel cinquecento"; Frommel, "Raffaello e Antonio da Sangallo il Giovane," 289–97, 308; Frommel, "Die architektonische Planung der Villa Madama"; Frommel and Adams, *The Architectural Drawings of Antonio da Sangallo the Younger*, 131ff, cat. entries by Fritz-Eugen Keller; Coffin, "Plans of the Villa Madama"; and Beltramini and Burns, *Andrea Palladio e la villa veneta*, 239–46, with cat. entries by Burns and Scimemi.

60. Although most scholars converge on 1519 as a likely date for the *Letter to Leo*, Shearman convincingly reviews the evidence that the manuscripts were revised over a period of years, perhaps from 1514/15 to 1519: Shearman, *Sources*, vol. 1, 538–43. On the dating of the Villa Madama letter to winter 1518–19, *ibid.* 410 and 434, with earlier bibliography.

61. As noted by Frommel, "Die architektonische Planung der Villa Madama," 85. A letter of 5 August 1518 documents plans for shipping building materials to the site by Giuliano Leno, the foremost project manager in early cinquecento Rome, who also managed aspects of the Fabbrica of St. Peter's; see Shearman, *Sources*, vol. 1, 360 (doc. 1518/56); and Ivana Ait and Manuel Vaquero Piñeiro, *Dai casali alla fabbrica di San Pietro. I Leni: uomini d'affari del Rinascimento* (Rome, 2000,) 167, 194 n. 220, 200 n. 253.

62. Frommel, *Raffaello architetto*, 311–12, 337.

63. For this set piece and the relation of the proposed iconography to the setting in Leo's loggia, and its antecedent in the Lateran benediction loggia, see Chapter 5, pp. 101–5.

64. Most significantly, in Bonaventure's famous formulation of the four ways to write a book, the roles of *scriptor, compilator, commentator,* and *auctor* each depend on others' writings to varying degrees: Alastair J. Minnis, *The Medieval Theory of Authorship: Scholastic and Literary Attitudes in the Later Middle Ages* (Philadelphia, 2012), 94–5.

65. Newmyer, *The Silvae of Statius,* 3–7. The word *silva* was used to refer to a compendium of genres or ideas by Suetonius, *De grammaticis et rhetoribus,* 10, 5; I am grateful to Curtis Dozier for this observation. See also Poliziano's *silva Manto,* 40, comparing the abundance of varied material in poems/woods, in Poliziano, *Silvae,* 8–9; and for a discussion of *docta varietas* in Poliziano's *Sylvae,* Clare E. L. Guest, "*Varietas, poikilia* and the *silva* in Poliziano," *Hermathena* 183 (2007): 9–48.

66. As noted by Guest, *ibid.* 30–1, with respect to Poliziano and Statius.

67. D'Amico, *Renaissance Humanism,* 115–43 and *passim.*

68. Martines, *Society and History in English Renaissance Verse,* 14; Rijser, *Raphael's Poetics.*

5 METASTRUCTURES OF WORD AND IMAGE

1. As noted by Julian Kliemann, "Dall'invenzione al programma," in *Programme et invention dans l'art de la Renaissance,* ed. Michel Hochmann, Julian Kliemann, Philippe Morel, and Jérémie Koering (Rome and Paris, 2008), 17–26. On the use of the terms *invenzione* and *fantasia,* see also Salvatore Settis, "Artisti e committenti fra quattro e cinquecento," *Storia d'Italia: Annali 4. Intellettuali e potere,* ed. Corrado Vivanti (Turin, 1981), 701–61, at 735 and *passim.* Michel Hochmann draws a parallel between the reverse *ekphrasis* – that is, paintings based on *ekphrastic* descriptions of paintings by then lost – and the work of the iconographic advisor devising programs: Hochmann, "*L'ekphrasis* efficace. L'influence des programmes iconographiques sur les peintures et les décors italiens au XVIe siècle," in *Peinture et rhétorique: Actes du colloque de l'Académie de France à Rome,* ed. Olivier Bonfait (Paris, 1994), 43–76.

2. On program and invention, Charles Hope, "Artists, Patrons, and Advisers in the Italian Renaissance," in *Patronage in the Renaissance,* 293–343; Creighton Gilbert, *Italian Art 1400–1500: Sources and Documents* (Evanston, 1980),

xviii–xxvii; Giovanna Sapori, "Dal programma al dipinto: Annibal Caro, Taddeo Zuccari, Giorgio Vasari," in *Storia della lingua e storia dell'arte in Italia: dissimmetrie e intersezioni. Atti del III convegno Associazione per la storia della lingua italiana,* ed. Vittorio Casale and Paolo d'Achille (Florence, 2004), 199–220; Hochmann, et al., *Programme et invention;* and Jérémie Koering, "'Intrecciamento' – Benedetto Lamprido, Giulio Romano et la poétique de la salle de Troie," *Zeitschrift für Kunstgeschichte* 75 (2012): 335–50. On programs for ephemeral festival decorations, R. A. Scorza, "Vincenzo Borghini and Invenzione: The Florentine Apparato of 1565," *Journal of the Warburg and Courtauld Institutes* 44 (1981): 47–75. For the important quattrocento example of Leonardo Bruni's rejected program for Ghiberti's Florence Baptistery doors, Richard Krautheimer and Trude Krautheimer-Hess, *Lorenzo Ghiberti* (Princeton, 1982), vol. 1, 169–72, and vol. 2, 372–3. See also the discussion in Chapter 6 of the roles of artists and advisors, with additional related bibliography.

3. See Hope, "Artists, Patrons, and Advisers"; and especially Clare Robertson, "Annibal Caro as Iconographer. Sources and Method," *Journal of the Warburg and Courtauld Institutes* 45 (1982): 160–81.

4. An early example is Guarino da Verona's written program for the studiolo at Belfiore, of 1447: Anna K. Eörsi, "Lo studiolo di Leonello d'Este e il programma di Guarino da Verona," *Acta historiae artium Academaie scientiarum hungaricae* 21 (1976): 15–52, a source I owe to Nicoletta Marcelli.

5. Weil-Garris and d'Amico, *The Renaissance Cardinal's Ideal Palace,* 90–7.

6. Cardinal Giulio expressed these wishes in a letter to his agent Mario Maffei about the villa of 17 June 1520: "Quanto alle storie o fabule: piacemi siano cose varie, né mi curo siano distese e continuate, e sopratutto desidero siano cose note, acciò non bisogni che 'l pintore vi aggiunga, come fece quello che scrisse: Questo è un cavallo … Cose oscure come ho detto non voglio." In Shearman, *Sources,* vol. 1, 603. For Giulio reading Cortesi, Reiss, "Cardinal Giulio de' Medici as a Patron of Art."

7. I am discussing notions of program or meaning in architecture other than the meanings of the orders, or notions of decorum or magnificence.

8. See Anthony Grafton, *Leon Battista Alberti: Master Builder of the Italian Renaissance* (New York, 2000), chs. VIII, IX and *passim*, with earlier bibliography; and below p. 150 for the collaboration of architects and humanists at the Cancelleria.

9. "an almost precise correspondence can be established between the aesthetic ideas expressed in *The Courtier* and the artistic achievement of the circle in direct contact with the persons who appear in the dialogue. Obviously one should not force the analogy. It would be naïve to propose an *influence* exerted by the ideas of Bembo or Castiglione on painters and architects; nor can the respective aesthetic theories elaborated by these intellectuals be discerned by observing works of art [which presumably express them]. Rather, we can best explore this terrain by using the concept of diffuse mentalities as our guide; metalanguages that obliquely traverse the spaces of architectural language, conditioning their organization and liberating their potentials." Manfredo Tafuri, *Interpreting the Renaissance: Princes, Cities, Architects*, trans. Daniel Sherer (New Haven, 2006), 7.

10. James S. Ackerman, "The Geopolitics of Venetan Architecture in the time of Titian," in *Distance Points: Essays in Theory and Renaissance Art and Architecture* (Cambridge, MA, 1991), 453–94, at 453–4.

11. Smith and O'Connor, *Building the Kingdom*, ix and *passim*.

12. Marie Tanner, *Jerusalem on the Hill: Rome and the Vision of St. Peter's in the Renaissance* (London and Turnhout, 2010), and Nicholas Temple, *Renovatio urbis: Architecture, Urbanism and Ceremony in the Rome of Julius II* (London, 2011)

13. To borrow the title of Cox-Rearick's *Dynasty and Destiny in Medici Art*.

14. As shown by Shearman, "A Functional Interpretation of Villa Madama."

15. For the *Renovatio imperii*, Stinger, *The Renaissance in Rome*, 235–54; for earlier Medici-imperial imagery, Cox-Rearick, *Dynasty and Destiny*; for Leonine Constantinian ideology, Quednau, *Sala di Costantino*.

16. A fuller exposition of this complex multimedia construct with additional bibliography is presented in Elet, "Raphael and the Roads to Rome."

17. Erich Dinkler, *Der Einzug in Jerusalem: Ikonographische Untersuchungen im Anschluss an ein bisher unbekanntes Sarkophagfragment* (Opladen, 1970), 67.

18. "Da questo luoco si può vedere per retta linea la strada que va dalla villa al Ponte Molle, el bel paese, el Tivere et Roma." Raphael/Dewez, 25 §11.

19. Such axial alignments of loggia–road–view can be traced from Augustan Rome to Fascist propaganda newsreels; examples contemporaneous with Villa Madama include Raphael's papal loggia envisioned in *The Fire in the Borgo* fresco, Antonio da Sangallo's U 72Ar and U 73Ar for the St. Peter's benediction loggia, and the Castel Sant'Angelo loggia overlooking the eponymous bridge. For notions of framed vision and dominion symbolized in such ensembles, Tafuri, *Interpreting the Renaissance*, 79 (about Castel Sant'Angelo); Denis Ribouillault, *Rome en ses jardins: paysage et pouvoir au XVIe siècle* (Paris, 2013), 257–315 (on Urbino and Pienza); D. Fairchild Ruggles, *Gardens, Landscape, and Vision in the Palaces of Islamic Spain* (University Park, PA, 2000), 94, 106ff, 203–8 (on the parallel tradition of the *mirador* in Hispano-Islamic palaces).

20. Discussed by Quednau, *Sala di Costantino*, 352, 392. It remains unclear when the Raphael school decided to include the villa in this composition, since it does not appear in the Louvre *modello*.

21. Marc Dykmans, S.J., "Du Monte Mario à l'escalier de Saint-Pierre de Rome," *Mélanges d'archéologie et d'histoire* 80 (1968): 547–94; Thomas Ashby, ed., *La campagna romana al tempo di Paolo III: mappa della campagna romana del 1547 di Eufrosino della Volpaia* (Rome, 1914), 64; Giuseppe Tomassetti, *La campagna romana: antica, medioevale e moderna*, vol. 3 (Rome, 1976), 27; Giuseppe Aldo Rossi, *Monte Mario: profilo storico, artistico e ambientale del colle più alto di Roma* (Rome, 1996), 76–7; Sandro Santolini, "Due esempi di residenze suburbane sul Monte Mario a Roma." See Elet, "Raphael and the Roads to Rome" for further discussion of this toponym.

22. Castiglione in Rome to Isabella d'Este in Mantua: "[Raphael] fassi una vigna anchor del Rev.mo Medici, che serà cosa excellentissima; nostro S.re vi va spesso, e questa è sotto la Croce de Monte Mario," in Shearman, *Sources*, vol. 1, 459.

23. As noted by Shearman, "A Functional Interpretation of Villa Madama," 316, without further discussion of the symbolism.

24. This liturgy developed from the pagan procession of the Robigalia. For which, Joseph Dyer, "Roman Processions of the Major Litany (*litaniae maiores*) from the Sixth to the Twelfth Century," in *Roma Felix – Formation and Reflections of Medieval Rome*, ed. Éamonn Ó Carragáin and Carol Neuman de Vegvar (Aldershot, 2007), 112–37. I am grateful to Joseph Dyer for discussing this material with me and generously sharing further unpublished research, and to Meredith Fluke for bringing his work to my attention.

25. For sacred *villeggiatura*, Amanda Lillie, "The Patronage of Villa Chapels and Oratories near Florence," 23–4; Lillie, "Cappelle e chiese delle ville Medicee ai tempi di Michelozzo"; Lillie, "Fiesole: Locus Amoenus or Penitential Landscape?"; Nadja Aksamija, "Landscape and Sacredness in Late Renaissance 'Villeggiatura'," in *Delizie in Villa* (Florence, 2008), 33–63; Ribouillault, *Rome en ses jardins*, 133–212. On the interest in ancient triumphal processional routes and topographical symbolism for urban planning, architecture, and papal ceremonial, Temple, *Renovatio urbis*.

26. The *Coronation of Charlemagne* fresco evoked legends associating Charlemagne with the Monte Mario; for which, Elet, "Raphael and the Roads to Rome."

27. Loren Partridge, "The Farnese Circular Courtyard at Caprarola. God, Geopolitics, Geneaology and Gender," *Art Bulletin* 83 (2001): 259–93, at 262, 268–9; Hartmut Biermann, "Der runde Hof Betrachtungen zur Villa Madama," *Mitteilungen des Kunsthistorischen Institutes in Florenz* 30 (1986): 493–536.

28. A suggestion I owe to Sheryl Reiss; for the *umbilicus mundi* in relation to Michelangelo's designs for the Capitoline, see Stinger, *Renaissance in Rome*, 264.

29. Either route led to the Porta Viridaria; the portals were reconfigured and renamed later in the cinquecento, so the Catasto Alessandrino map shows these roads leading to Porta Angelica Castello, and the Prati road came to be called Via Angelica.

30. Of course, the villa would accommodate different audiences who arrived by different routes – and even the grading of roads reflected these distinctions. The pope, Cardinal Giulio, and their personal guests arriving from the Vatican (who would include Cardinals, Castiglione, and Isabella d'Este) arrived via a road that ascended so gradually one barely noticed: as Raphael specified, "salice tanto dolcemente che non pare de salire, ma essendo giunto alla villa non se accorgie de essere in alto e de dominare tutto il paese" (Raphael/Dewez, 22 §3). Once at the villa, these privileged guests could share the views that symbolized papal dominion. Formal embassies entering Rome from the north, by contrast, had to ascend the steep road from the Milvian Bridge to the papal *hospitium* far above, performing their trek of obeisance. Once there, had the planned amphitheater been built, they could have looked down the vista on axis to the bridge, reinforcing the route of their journey and its meaning.

31. For the Sala di Costantino as Leo's throne room, Philipp P. Fehl, "Raphael as Historian. Poetry and Historical Accuracy in the Sala di Costantino," *Artibus et historiae* 14 (1993): 9–76, at 15, 49; for other functions for religious and court rituals, banquets, and consistories, Guido Cornini, ed., *Raphael in the Apartments of Julius II and Leo X* (Milan, 1993), 167; and Quednau, *Sala di Costantino*, 44–70.

32. As noted by Quednau, *Sala di Costantino*, 352.

33. The villa itself has never been visible from the Vatican, as it is behind a bend in the hillside; but the Monte Mario dominates the distant view due north-northwest from the Vatican, as depicted in the background of the *Vision of Constantine* fresco in the Sala di Costantino.

34. Frances Yates, *The Art of Memory* (London, 1966), ch. 2; Carruthers, *The Craft of Thought*, 10–21, 40–4; Mary Carruthers, *The Book of Memory: A Study of Memory in Medieval Culture* (Cambridge, 2008), 89–98; Diane Favro, "The Roman Forum and Roman Memory," *Places* 5 (1988): 17–24; Favro, *The Urban Image of Augustan Rome* (Cambridge, 1996), 5–7; Denis Ribouillault, "Landscape 'All'antica' and topographical Anachronism in Roman Fresco Painting of the Sixteenth Century," *Journal of the Warburg and Courtauld Institutes* 71 (2008): 211–37, at 230–1; Amanda Lillie, "Memory of Place: *Luogo* and Lineage in the Countryside," in *Art, Memory, and Family in Renaissance Florence*, ed. Giovanni Ciappelli and Patricia Rubin (Cambridge, 2000), 195–214; Karl Galinsky's *Memoria Romana* project, www.utexas.edu/research/memoria/, which I owe to Rachel Kousser; see Vasaly, *Representations*,

41 and *passim* on the importance of "metaphysical topography."

35. This construct was actually part of a larger urban plan for Rome; on the relation to Raphael's other Leonine urban projects, Manfredo Tafuri, "'Roma instaurata'. Strategie urbane e politiche pontificie nella Roma del primo '500," in *Raffaello architetto*, 59–106, at 85, 94–8; Hubertus Günther, "Die Straßenplanung unter den Medici-Päpsten in Rom (1513–1534)," *Jahrbuch des Zentralinstituts für Kunstgeschichte* (1985): 237–93.

36. Cox-Rearick, *Dynasty and Destiny*, 77 and n. 58. Poliziano, in his *silva Ambra* about Homer, Lorenzo, and Poggio a Caiano, says "Gloria musarum Laurens" (line 600): del Lungo, *Prose volgari*, 333–68. The importance of Apollo–sun imagery throughout Villa Madama's decorations also reflects these associations with Lorenzo.

37. Giulio Simone, *Oratio de poetica et musarum triumpho*, 1517, fol. Eii; cited in Louis Cellauro, "Iconographical Aspects of the Renaissance Villa and Garden: Mount Parnassus, Pegasus and the Muses," *Studies in the History of Gardens & Designed Landscapes* 23 (2003): 43. Leo's association with Apollo also evokes his role as healer.

38. In antiquity, the Monte Mario was known as the *Clivus Cinnae*, one of three hills comprising the *Montes Vaticani*. The name *Monte Mari* is documented as early as the twelfth century, but generally the medieval names for it were *Monte Malo*, as in Dante, or *Mons Gaudii* (Mount of Joy or *Montjoie*). On the history of Monte Mario, Rossi, *Monte Mario*, 12–13; Tomassetti, *La campagna romana*, 80ff; Dykmans, "Du Monte Mario à l'escalier de Saint-Pierre de Rome," 549, 552; "Cinnae clivus," in *LTUR Suburbium*, vol. 2, 102–3 (M. Macciocca); Luciana Frapiselli, *Monte Mario: finestra su Roma* (Rome, 1998); Frapiselli, *La via francigena nel Medioevo da Monte Mario a San Pietro* (Rome, 2003); Frapiselli, *Presenze di grandi a Monte Mario: all'ombra di un antico pino* (Rome, 1979); and Luigi Pallottino, ed., *Monte Mario tra cronica e storia: mostra di dipinti, disegni, stampe e fotographie* (Rome, 1991).

39. For earlier treatments of Parnassus, Elisabeth Schröter, *Die Ikonographie des Themas Parnass vor Raffael: die Schrift- und Bildtraditionen von der Spätantike bis zum 15. Jahrhundert* (Hildesheim, 1977); and Schröter, "Der Vatikan als Hügel Apollons und der Musen. Kunst und Panegyrik von Nikolaus V. bis Julius II," *Römische Quartalschrift für christliche Altertumskunde und Kirchengeschichte* 75 (1980): 208–40.

40. "Le statoe che sono state tolte da questo magnifico et ornatissimo luogo primieramente sono quelle delle nove Muse che siedono, di marmo pario, che sono state trasportate nella vigna di papa Clemente VII presso Roma sul colle detto Monte Mare del Vaticano." Cited in Lefevre, *Villa Madama*, 175.

41. Bober and Rubinstein, 80, §40; Rausa, "Marmi antichi," 159–61, 184, and cat. 1, 4, 10–14; Rausa, "Un gruppo statuario dimenticato: il ciclo delle Muse c.d. *Thespiades* da Villa Adriana," in *Villa Adriana: paesaggio antico e ambiente moderno: elementi di novità e ricerche in corso. Atti del convegno, Rome, 2000*, ed. Anna Maria Reggiani (Milan, 2002), 43–51; J. Raeder, *Die statuarische Ausstattung der Villa Hadriana bei Tivoli* (Frankfurt-am-Main and Bern, 1983), 48–55; Anne-Marie Leander Touati, *Ancient Sculptures in the Royal Museum* (Stockholm, 1998), 111ff; Reiss, "Cardinal Giulio de' Medici as a Patron of Art," 387, 408 n. 179; Coffin, *The Villa in the Life of Renaissance Rome*, 255; Hans Henrik Brummer, *The Muse Gallery of Gustavus III* (Stockholm, 1972); and Antonio Blanco and Manuel Lorente, *Catalogo de la Escultura Museo del Prado*, second edition (Madrid, 1969). The *Muses* were dispersed in two groups: Queen Christina of Sweden requested in 1681 to purchase the four seated *Muses*, which she installed in her Palazzo Riario alla Lungara, along with four other ancient *Muses* and two modern ones, presenting herself as the tenth Muse (as Isabella d'Este had been celebrated). Her Villa Madama *Muses* subsequently passed through the Azzolini and Odescalchi collections to Philip V of Spain, and thus are now in the Prado. In the following century, the remaining Tivoli *Muses* at Villa Madama, after some peregrinations, were sold by Giovanni Volpato in 1784 to King Gustavus III for his Pavilion of the Muses. For the confusion about the later provenance of the *Muse with nebris* (either in Stockholm or location currently unknown, ex-collection Abamalech) see Leander Touati, *Ancient Sculptures in the Royal Museum*, 126–31.

42. Rausa, "Marmi antichi," cat. 18 (*Melpomene Farnese*), cat. 15 (*Niobide*).

43. "Nessuno, né nel cinquecento né nel seicento, sospettava che le due quaterne di statue (o quantomeno una di queste) appartenessero tipologicamente a un celebre ciclo che sarebbe riemerso solo dopo il fortunato scavo del 1774 nella tiburtina villa detta di Cassio, a non molta distanza da Villa Adriana." Rausa, "Un gruppo statuario dimenticato," 44.

44. It is interesting that later the same year Baccio Bandinelli executed his marble figure of *Orpheus/Apollo* to be installed in the courtyard of the Palazzo Medici in Florence, although there is disagreement over whether this commission was initiated in 1518 (Francesco Caglioti, *Donatello e i Medici: storia del David e della Giuditta* [Florence, 2000], 353) or after the death of Lorenzo di Piero in May 1519 when Cardinal Giulio began to take the reins of Florentine government (J. Rogers Mariotti, "Selections from a ledger of Cardinal Giovanni de' Medici, 1512–1513," *Nuovi studi* 6–7 [2001–2]: 103–46).

45. None of Heemskerck's drawings of the *Muses* provides any context, and the sculptures were dispersed before the 1783/6 inventory compiled by Domenico Venuti and Philipp Hackert, the only inventory of the villa's sculptures that specified locations; for which, see Elet, "Papal *villeggiatura*," 155–158 with earlier sources. Pier Leone Ghezzi left an annotated drawing of the *Muse with nebris* dated 1726, noting that the figure "stà nell'entrare nel primo casino in Villa Madama," but the location of a single figure two centuries after the Medici period is scarcely helpful: BAV, Cod. Ottob. Lat. 3109, fol. 106, pub. Lucia Guerrini, *Marmi antichi nei disegni di Pier Leone Ghezzi* (Città del Vaticano, 1971), pl. XVI.

46. For the taste for completed sculpture, and restoration of sculpture at the Medici villa, Elet, "Papal *villeggiatura*," 178–80.

47. Unless perhaps they were intended for a nymphaeum beneath the theater. The theater setting was suggested by Rausa, "Marmi antichi," 172, on the basis that the *Muses* were found in the so-called Odeion, actually a theater, at Hadrian's villa. Ligorio recorded the find spot, which was confirmed by later excavations, although we do not know that Raphael and his circle knew this fact. Kathleen Christian also hypothesizes a theater setting: *Empire without End*, 341. The suitability of *Muses* for a theater makes this a logical assumption, although Raphael tended to transpose his ancient finds into radically different ensembles.

48. Although these sculpture niches were not indicated in plan in U 314A, they were original to the villa, because they are shown in Palladio's drawing of the fishpond in the 1540s (RIBA, Palladio X/18, reproduced in Frommel, *Raffaello architetto*, 339). That they are shallow indentations, rather than full-depth niches might explain why they were not shown in U 314A; in any case, this style of vestigial niche would be well suited to the sculptures of the *Muses*, which are too deep and three-dimensional for traditional sculpture niches. Thus, the figures of the *Muses* would exist in the space of the ambulatory, and at ground level, enhancing the effect of modern poets and patrons mingling with the Muses.

49. The seated Muses range from 50 to 64 inches tall and the standing ones from 70 to 75 inches tall (leaving aside the standing headless *Farnese Melpomene* at 52 inches). The niches range from 90 to 94 inches tall (inside dimensions). Although there has been significant restoration of this grotto, the basic configuration and shape of the exedrae and niches is original, as documented in Palladio's drawing of the 1540s showing the same configuration visible today: three exedrae, each containing three niches in alternating square and rounded shapes. (Palladio shows the central exedra itself as rectangular rather than semicircular, although it is unclear whether this is documentary, or another of his creative corrections, e.g. adding an exedra to the garden loggia to render it symmetrical): Palladio, RIBA X/18, reproduced in Frommel et al., *Raffaello architetto*, 339. The height of the niches must be very close to the original as they are delimited by the string course that runs above them, visible in Palladio's drawing as it is today; see Figures 53–5.

50. On ancient *musaea*, Birgitta Tamm, *Auditorium and Palatium: A Study on Assembly-rooms in Roman Palaces during the 1st Century B.C. and the 1st Century A.D.* (Stockholm, 1963), 168–79; and G. Lugli, "Nymphaea sive musaea," in *Atti del IV congresso nazionale dei studi romani* (Rome, 1938), 155–68. For changing notions of the term in the Renaissance, Paula Findlen, "The Museum: Its Classical Etymology and Renaissance Geneaology," *Journal of the History of Collections* 1 (1989): 59–78.

51. Pliny, *Natural History*, XXXVI, 42, 154: "We must not forget to discuss also the characteristics of pumice. This name, of course, is given to the hollowed rocks in the buildings called by the Greeks 'Homes of the Muses', where such rocks hang from the ceilings so as to create an artificial imitation of a cave." (Non praetermittenda est et pumicum natura. appellantur quidem ita erosa saxa in aedificiis, quae musaea vocant, dependentia ad imaginem specus arte redendam.)

52. Charles Percier and P. F. L. Fontaine recorded that those niches had decoration *en rocaille*; Percier and Fontaine, *Choix des plus célèbres maisons de plaisance de Rome et de ses environs, mesurées et dessinées* (Paris, 1809), 30, planche XI.

53. Propertius, *Elegies*, III, 3.

54. D. Roux, "Le val des Muses et les Musées chez les auteurs anciens," *Bulletin de Correspondence Hellénique* 78 (1954): 38ff.

55. Raphael/Dewez §16.

56. For a recent roundup of cinquecento examples and sources on *Musea*, with earlier bibliography, see Cellauro, "Iconographical Aspects of the Renaissance Villa and Garden," and Cellauro, "The Casino of Pius IV in the Vatican," *Papers of the British School at Rome* 63 (1995): 183–214.

57. As discussed, Sperulo's poem, Raphael's letter, and the design changes from U 273A to U 314A seem to have been taking place in early 1519. That Sperulo was planning for the installation of the *Muses* and Raphael's description of the fishpond using elements from both plans shows that both issues were under consideration at this time. This is consistent with the traditional construction chronology, which puts the execution of the fishpond at summer/fall of 1519.

58. Notable among them Paolo Giovio's Museo, for which, see Della Torre, "L'inedita opera prima di Paolo Giovio ed il museo"; and the mid-sixteenth-century Casino decorated under the Medici Pope Pius IV, which Cellauro proposes was an antiquarian reconstruction of a classical *musaeum*: "The Casino of Pius IV," 183–214.

59. The ponds at Poggioreale in Naples were certainly another early example of this element, and a model for Villa Madama. The Vatican Cortile del Belvedere and the Colonna Nymphaeum in Genazzano, while different conceptions, were at times flooded for *naumachie*, perhaps contributing to the evolving taste for water theater. Also, drawings by Sangallo for a rustic nymphaeum at the northwestern, outermost edge of the Medici villa gardens suggest that they were thinking of yet another water theater at the villa, although perhaps slightly later in the planning process than the fishpond.

60. For these ensembles and the descriptions of them known in the Renaissance, Katherine M. D. Dunbabin, "Convivial Spaces: Dining and Entertainment in the Roman Villa," *Journal of Roman Archaeology* 9 (1996): 66–80; A. F. Stewart, "To Entertain an Emperor: Sperlonga, Laokoon and Tiberius at the Dinner Table," *Journal of Roman Studies* 67 (1977): 76–90; Ann Kuttner, "Delight and Danger in the Roman Water Garden: Sperlonga and Tivoli," in *Landscape Design and the Experience of Motion*, ed. Michel Conan (Washington, DC, 2003), 103–156. For the similarity to the water pond-theater in the ancient villa near the Arcinelli, first noted by Neuerburg, see Burns, "Raffaello e 'quell'antiqua architectura'," in *Raffaello architetto*, ed. Frommel et al., 393 with earlier bibliography. Although it is unclear exactly what Raphael could have seen of the Villa Vopiscus, later excavations revealed a tripartite, concrete barrel-vaulted loggia housing fishponds, tucked underneath a terrace in the hillside – a configuration with striking similarities to the final design for Villa Madama's fishpond and adjacent grottoes; for Vopiscus' villa, James Higginbotham, *Piscinae: Artificial Fishponds in Roman Italy* (Chapel Hill, 1997), 125–8 with additional sources. For further discussion of Sperlonga, Baia, and the Serapeum/Canopus of Hadrian's Villa as possible models for dining at Villa Madama, see the discussion of the *Coenatio Iovis* in this chapter.

61. As noted by Kathleen Wren Christian, "The Multiplicity of the Muses: The Reception of Antique Images of the Muses in Italy, 1400–1600," in *The Muses and their Afterlife in post-Classical Europe*, ed. Claudia Wedepohl, Kathleen W. Christian, and Clare E. L. Guest (London and Turin, 2014), 103–53, at 119. On the connection among *Lymphae, Musae*, and *Nymphae*, Cellauro, "The Casino of Pius IV," 202–5.

62. Anna Cavallaro, "'… quella casa è del papa …': la villa della Magliana e la contesa per il suo possesso alla morte di Leone X," in *Congiure e conflitti: l'affermazione della signoria pontificia su Roma nel Rinascimento: politica, economia e cultura*, ed. M. Chiabò et al. (Rome, 2013), 417–32, at 421; and Cummings, *The Lion's*

Ear, 113–22. The attribution and dating of the frescoes are problematic; they were probably executed by Gerino da Pistoia, commissioned by Cardinal Francesco Alidosi during the pontificate of Julius II, and finished after Alidosi's death during Leo's pontificate; they are now in the Museo di Roma: Anna Cavallaro, *La villa dei papi alla Magliana* (Rome, 2005), 64–7; and Coffin, *The Villa in the Life of Renaissance Rome*, 120–2 (with earlier attribution to Lo Spagna). On La Magliana, see also Marco Dezzi Bardeschi, "L'opera di Giuliano da Sangallo e di Donato Bramante nella fabbrica della villa papale della Magliana," *L'arte* 4 (1971): 111–73.

63. On the culture of music at Leo's convivia, Cummings, *The Lion's Ear*, chs. 4 and 5, and *passim*.

64. Antonio da Sangallo the Younger's U 1267A has drawings for the villa's amphitheater on the recto, and for a garden theater with fountains for the rustic, northwestern area of the villa on the verso, suggesting the possibility that the architects were thinking organically about various notions of theater, aquatic or otherwise; however, it remains unclear if recto/verso were drawn at the same time. For this drawing, Frommel, *Raffaello architetto*, 336; Frommel and Adams, *Architectural Drawings of Antonio da Sangallo*, vol. 2, 225–6 (entry by F. E. Keller). For an interesting analysis of Raphael's and Sangallo's diverse ideas for the villa's main amphitheater (not yet being built in this phase) and their reinterpretation of the theater *all'antica*, Annarosa Cerutti Fusco, "Teatro all'antica e teatro Vitruviano nell'interpretazione di Antonio da Sangallo il Giovane," in *Antonio da Sangallo il Giovane*, 455–69.

65. Themes of the Muses and Parnassus would later be enacted in Medici garden theaters in the villa of Pratolino and in Catherine de' Medici's Tuileries, as well as in the Villa Aldobrandini at Frascati; John Dixon Hunt, "Garden and Theatre," in *Garden and Grove: The Italian Renaissance Garden in the English Imagination* (Philadelphia, 1986), 59–72.

66. The Venus Genetrix type was popular in antiquity for combining the generative fecundity of Venus Felix with the peace-giving victory of Venus Victrix. For which, Robert Schilling, *La religion romaine de Vénus* (Paris, 1982), 315–16 and *passim*; Schilling, "L'évolution du culte de Vénus sous l'Empire romain," in *Dans le sillage de rome: religion,*

poésie, humanisme, ed. R. Schilling (Paris, 1988), 152–257; Ulrich, "The Temple of Venus Genetrix in the Forum of Caesar in Rome," 32–3, 236–7, 259–60. See also Dempsey, *The Portrayal of Love*, 50ff and *passim*. I am indebted to Rachel Kousser for invaluable discussion and bibliography on this subject.

67. Panofsky was the first to propose that the central figure in Botticelli's *Primavera* represented Venus Genetrix: Erwin Panofsky, *Renaissance and Renascences in Western Art* (New York, 1969), 195, 199, and *passim*. The notion was upheld by Dempsey, who further sees Botticelli's *Birth of Venus* as a "seaborne Venus Genetrix": Dempsey, *The Portrayal of Love*, 41ff, 44, and n. 63. At Poggio a Caiano, a figure of Venus Genetrix stands by a Medicean orange grove on the portico frieze, which represented Lorenzo's rule: Cox-Rearick, *Dynasty and Destiny*, 83 and *passim*.

68. As noted by Dempsey, *The Portrayal of Love*, 47 n. 66.

69. The fundamental ancient text about this deity is Lucretius, *De rerum natura*, I, which famously begins, "Aeneadum genetrix, hominum divomque voluptas, alma Venus." Discussed in Cesarini Martinelli, *Commento inedito alle* Selve *di Stazio di Poliziano*, 247ff; and Dempsey, *The Portrayal of Love*, 44–8.

70. Frommel, "Bramantes 'Ninfeo' in Genazzano," 137–60. Although the dating of Bramante's nymphaeum and its relative chronology with Raphael's Villa Madama have been debated, I follow the general consensus that the nymphaeum was earlier.

71. Serlio notes in his description of Villa Madama's garden loggia that the semi-circle at the northeast end was left out, but his plan corrects the asymmetry by adding it nonetheless: Serlio, book III, ch. 4, fol. 70. Palladio's measured drawing of the villa's plan also adds an exedra to correct the asymmetry (RIBA, Palladio X/18, illustrated in Frommel et al., *Raffaello architetto*, 339).

72. Pliny, *Natural History*, XXXVI, 24.

73. The myth appears in Jacobus de Voragine, *The Golden Legend*, trans. William Granger Ryan (Princeton, 1995), 38–9: "[Mary] was a virgin both before and after giving birth, and the fact that she remained a virgin is assured by five proofs … The fifth proof is a miraculous event. As Pope Innocent III testifies, during the twelve years when Rome enjoyed peace, the

Romans built a Temple of Peace and placed a statue of Romulus in it. Apollo was asked how long the temple would stand, and the answer was that it would be until a virgin bore a child. Hearing this, the people said that the temple was eternal, for they thought it impossible that such a thing could happen; and an inscription, TEMPLUM PACIS AETERNUM, was carved over the doors. But in the very night when Mary bore Christ, the temple crumbled to the ground." Giovanni Rucellai echoes this popular tale in his record of his trip to Rome, reflecting its long-standing popularity; in Alessandro Perosa, ed., *Giovanni Rucellai ed il suo zibaldone*, vol. 1, "Il zibaldone quaresimale" (London, 1960), 67–78. On the identification of the Basilica of Constantine and Maxentius in the Middle Ages, see Louis Duchesne, "Notes sur la topographie de Rome au moyen-âge, I: Templum Romae, Templum Romuli," in *Scripta minora: études de topographies romaine et de géographie ecclésiastique [Collection de l'École française de Rome XIII]* (Rome, 1973), 3–15. On the Temple of Peace and the art of memory, see Maria Fabricius Hansen, "Out of Time: Ruins as Places of Remembering in Italian Painting ca. 1500," in *Memory & Oblivion: Proceedings of the XXIXth International Congress of the History of Art held in Amsterdam, 1996* (Dordrecht, 1999), 797ff.

74. Tanner, *Jerusalem on the Hill*, 69 and *passim*.

75. The colossal figure in the so-called Temple of Peace was found during the reign of Innocent VIII (1484–92), who took its head to the Capitoline in 1486 or 1489; this well-known figure of Constantine was variously misidentified in the Renaissance as Commodus, Domitian, Nero, or Apollo. See Bober and Rubinstein, 100, 216–17; Tilmann Buddensieg, "Die Konstantinsbasilika in einer Zeichnung Francescos di Giorgio und der Marmorkoloss Konstantins des Grossen," *Münchner Jahrbuch der bildenden Kunst* 13 (1962): 37–48, especially n. 37. The Constantinian colossus even had a pose similar to that of the *Jupiter Ciampolini* – a seated figure with the right foot forward and the left drawn back – although I am not sure this fact was known to the Renaissance, and the pose is not uncommon; see H. Stuart Jones, *A Catalogue of the Ancient Sculptures Preserved in the Municipal Collections of Rome*, vol. 2, *The Sculptures of the Palazzo dei Conservatori* (Oxford, 1926), 5–6, no. 2, and pl. I. I am indebted to Rachel Kousser for pointing out the parallel to the Constantine colossus.

76. Elet, "Papal *villeggiatura*," ch. 3, 181–7 and *passim*; Rausa, "Marmi antichi," 159 and cat. 27; Christian, *Empire without End*, 305, 340, 342.

77. First suggested by Frommel, *Raffaello architetto*, 312.

78. Fusco and Corti assume that the *Jupiter* was in the possession of the Medici by 1519, based on earlier erroneous translations of a few lines of Sperulo's March 1519 poem: Laurie Fusco and Gino Corti, "Giovanni Ciampolini (d. 1505), a Renaissance Dealer in Rome and his Collection of Antiquities," *Xenia* 21 (1991): 18, 30; in fact, Sperulo does not mention a figural *Jupiter* (see note 103 below).

79. The contract of sale, negotiated by Giulio Romano, does not list specific works. It is published in Rodolfo Lanciani, "La raccolta antiquaria di Giovanni Ciampolini," *Bullettino della Commissione archeologica comunale di Roma* 27 (1899): 109–10.

80. John Shearman hypothesizes that Raphael had studied the figure while it was in the Ciampolini collection, and proposes that a drawing of it in the Codex Escurialensis is a copy after a lost Raphael drawing: Shearman, "Raphael, Rome, and the Codex Escurialensis," *Master Drawings* 15.2 (1977): 128.

81. For example, there is an Aspertini drawing reconstructing this figure as a woman. For the restoration of this figure, Elet, "Papal *villeggiatura*," 177–83, with earlier bibliography.

82. Sigismondo dei Conti, secretary to Julius II, recorded that this had been Bramante's intention.

83. For literary sources on dining, Dunbabin, "Convivial Spaces."

84. Pliny the Younger, *Letters*, v, 5, 19, 21.

85. The annotation, "Columela / la villa sia partita in tre parte / urbana / la rustica /et frutuaria"(Columella, *De re rustica*, 1, 6) is jotted on U 1054Av in Antonio da Sangallo's hand, for which see Frommel and Adams, *Architectural Drawings of Antonio da Sangallo*, vol. 2, 197–8 with earlier bibliography (entry by Fritz-Eugen Keller). Opinions vary as to whether the drawing was a *pensiero* for an ideal villa in the mode of Giuliano da Sangallo (De Angelis d'Ossat, Biermann) or preparatory for Villa Madama (Frommel); whatever the drawing's origin, the presence of many unusual features that would characterize the actual plan of Villa Madama – e.g. the circular courtyard and towers with *diete* – show that this drawing, and presumably Columella's ideas, factored

into discussions of the Medici villa's design at some point. For this, see below p. 148.

86. Statius, *Silvae*, IV, 2. Rather than naming the dining hall specifically, Statius describes a banquet (*cenae*) in Domitian's august edifice (*tectum augustum*). For the importance of Statius to Sperulo and his circle, see Chapter 2. See also Juvenal, *Satire*, VII, 182, in *Juvenal and Persius*.

87. On the apsidal dining room in antiquity, see Simon P. Ellis, "Power, Architecture, and Decor: How the Late Roman Aristocrat Appeared to his Guests," in *Roman Art in the Private Sphere: New Perspectives on the Architecture and Decor of the Domus, Villa, and Insula*, ed. Elaine K. Gazda (Ann Arbor, 1991), 117–34, at 119ff. For a discussion of the commanding position of the emperor at the head of apsidal imperial banquet halls in relation to Statius' *ekphrasis*, see Newlands, *Statius'* Silvae, 266–7.

88. The Chigi frescoes were in part based on the banquet scene from Apuleius and works of the Renaissance poet Niccolò da Correggio; for their ancient literary sources, Quinlan-McGrath, "The Villa of Agostino Chigi," 456–7 and *passim*; and John Shearman, "Die Loggia der Psyche in der Villa Farnesina und die Probleme der Letzen Phase von Raffaels graphischem Stil," *Jahrbuch der Kunsthistorischen Sammlungen in Wien* 60 (1964): 73–4. Martial had praised the dining room of Germanicus as fit for Jupiter to visit: *Epigrams*, 8, 29, 1–4.

89. For contemporary imagery of Leo as Jupiter in this sculpture, decorations at Villa Madama, and other textual and visual sources, notably Domenico Aimo's sculpture of Leo, see Elet, "Papal *villeggiatura*," 184–7 with earlier bibliography; Agosti, *Paolo Giovio*, 18–26; and de Jong, *The Power and the Glorification*, ch. 3.

90. On Giulio's *Polyphemus* as a reverse-*ekphrasis* of a Plinian anecdote and a claim of the artist's ingenium, see Elet, "Papal *villeggiatura*," 61–3. For Polyphemus in the dining areas at Sperlonga and Baia, Bernard Andreae, *Praetorium speluncae: l'antro di Tiberio a Sperlonga ed Ovidio*, trans. Katrin Schlaefke and Felice Constabile (Soveria Mannelli [Catanzaro], 1995); Alessandro Viscogliosi, "Antra cyclopis: osservazioni su una tipologia di coenatio," in *Ulisse: il mito e la memoria*, ed. Bernard Andreae and Claudio Parisi Presicce (Rome, 1996), 252–69; Sorcha Carey, *Pliny's Catalogue of Culture: Art and Empire in the* Natural History

(Oxford, 2003), 114–16; Nicoletta Cassieri, *La Grotta di Tiberio e il Museo archeologico nazionale, Sperlonga* (Rome, 2000); Dunbabin, "Convivial Spaces," 72; Kuttner, "Delight and Danger in the Roman Water Garden," 128; Maria Mangiafesta, "Fortuna del mito di Polifemo nelle collezioni di antichità tra XV e XVII secolo," *Bollettino d'arte* 82 (1997): 44ff; Michael Squire, "Dining with Polyphemus at Sperlonga and Baiae," *Apollo* 158, July (2003): 29–37; and Stewart, "To Entertain an Emperor," 76–90. The dining grotto at Baia, in addition to the *Polyphemus* at one end, had imperial portraits down the side of the space, which would further make it an apt model for Sperulo's conception of the garden loggia as ancestor gallery. For Baia, see Kuttner, "Delight and Danger in the Roman Water Garden," 128 n. 103. For the *Polyphemus group* in the Serapeum/Canopus at Hadrian's Villa, Bernard Andreae, "I gruppi di Polifemo e di Scilla a Villa Adriana," in *Ulisse*, 342–4.

91. A later example of this practice was the portrait head of Alessandro Farnese that was attached to an ancient figural sculpture of Julius Caesar and placed on the Capitoline for his funeral commemoration in 1593. Although this was a temporary installation, it nonetheless suggests the acceptability of a modern likeness grafted on to the body of an ancient hero: Orietta Rossi Pinelli, "Chirurgia della memoria: scultura antica e restauri storici," in *Memoria dell'antico nell'arte italiana*, ed. Salvatore Settis (Turin, 1986), 192–3.

92. For ancestor portraits in atria, Pliny, *Natural History*, XXXV, 2, 6; Vitruvius, *De architectura*, VI, 3, 6; Seneca, *De beneficiis*, III, 28, 2; and Seneca, *Ad Lucilium*, 44.5. Pliny also mentions portraits on shields in houses (*Natural History*, XXXV, 4, 13), ancestor portraits on portals (XXXV, 2, 7), displaying ancestor sculptures that were not one's own (XXXV, 2, 8), and the demise of sculpted and painted depictions of ancestors in favor of images of strangers in order to display more valuable materials (XXXV, 2). A handful of ancient villas have been discovered to have had ancestor portrait galleries, but these were not known in the early sixteenth century: Richard Neudecker, *Die Skulpturen-Ausstattung römischer Villen in Italien* (Mainz am Rhein, 1988), 76; John Bodel, "Monumental Villas and Villa Monuments," *Journal of Roman Archeology* 10 (1997): 5–35, at 18, 27–30.

93. The Forum of Augustus was familiar to Renaissance readers in Virgil, *Aeneid*, VI, 792ff; and Ovid, *Fasti*, V, 551ff; discussed by Zanker, *The Power of Images in the Age of Augustus*, 210–13; and Kuttner, "Prospects of Patronage," 100. For the bucolic precinct of Augustus, Virgil, *Georgics*, III, 2, which I owe to Ann Kuttner.

94. For *uomini famosi* cycles, Jean Alazard, "Sur les hommes illustres," in *Il mondo antico nel Rinascimento: Atti del V convegno internazionale di studi sul Rinascimento, Firenze-Palazzo Strozzi, 2–6 settembre 1956* (Florence, 1958), 275–7; Christiane Joost-Gaugier, "Earliest Beginnings of the Notion of *Uomini Famosi* and the *De viris illustribus* in Greco-Roman Literary Tradition," *Artibus et historiae* 3 (1982): 97–115; L. Klinger Aleci, "Images of Identity. Italian Portrait Collections of the Fifteenth and Sixteenth Centuries," in *The Image of the Individual: Portraits in the Renaissance*, ed. Nicholas Mann and Luke Syson (London, 1998), 67–79; and Georgia Clarke, *Roman House – Renaissance Palaces*, 232ff. Paolo Giovio's Museo built at his Como villa in the 1530s is an interesting post-Villa Madama elaboration of this idea; see Della Torre, "L'inedita opera prima di Paolo Giovio ed il museo"; and Maffei, *Paolo Giovio*.

95. Bramante's project for a chapel at the Villa La Magliana with eight niches for sculptures, which remained unexecuted, may have served as another model. For which, Dezzi Bardeschi, "L'opera di Giuliano da Sangallo e di Donato Bramante nella fabbrica della villa papale della Magliana," 129.

96. M. Donato, "Gli eroi romani tra storia ed 'exemplum'. I primi cicli umanistici di Uomini Famosi," in *Memoria dell'antico nell'arte italiana*, ed. Salvatore Settis (Turin, 1985), vol. 2, 97–152.

97. Various motives, dates, and attributions have been proposed for this drawing, summarized in Beltramini and Burns, *Andrea Palladio e la villa veneta*, 245–6 (Howard Burns). Additionally, for the proposal that it is a fair copy by an assistant of Raphael's and represents his ideas for the elevation of this cortile, Elam, "The Raphael Conference," 438–9.

98. It is further striking that Michelangelo's New Sacristy designs would also include empty thrones and figures of river gods, both of which were featured prominently in Sperulo's proposed decorations for the villa.

Sperulo was writing in early 1519 before the death of Duke Lorenzo on 4 May and Giulio's subsequent proposal for the New Sacristy, but the framework of Sperulo's poem, with its threnody for lost Medici family members and their seats in marble halls, is so startlingly close to the conception for the New Sacristy that it suggests a connection between plans for Villa Madama and the Florentine project. (Although Lorenzo was already critically ill, Sperulo's poem treats him as a vital dynastic hope for the family, suggesting that the poet was unaware of the gravity of the illness when he wrote, as discussed in Chapter 3, p. 66 and note 11; p. 155; and Appendix 1, gloss notes 94 and 128.) In his description of Pope Leo's architectural patronage written in 1524, Stephanus Ioanninensis noted that Leo had ordered polished marble ancestor sculptures for San Lorenzo: in Reiss, "Patronage of the Medici Popes at San Lorenzo," with further discussion of both Medici popes' commemoration of ancestors at San Lorenzo.

99. A project of the young Cosimo I de' Medici beginning *c.* 1541 in conjunction with his transformation of the civic palace into the ducal residence. This Udienza was designed to welcome citizens as well as foreign dignitaries, with an architectural setting by Giuliano di Baccio d'Agnolo and sculptures by Bandinelli, who had been involved at Villa Madama and in other Leonine Roman projects. This ambitious Florentine ancestor gallery took decades to complete, finally finished *c.* 1592 by Giovanni Caccini. See Carlo Francini, "L'Udienza della Sala Grande di Palazzo Vecchio," in *Baccio Bandinelli: scultore e maestro (1493–1560)*, Exh. Cat., ed. Detlef Heikamp and Beatrice Paolozzi Strozzi (Florence, 2014), 202–11; Johannes Myssok, "L'Udienza di Palazzo Vecchio nel contesto internazionale," in *ibid.* 212–29, who notes that Bandinelli has been credited with creating the cinquecento tradition of the secular honorary statue in the Udienza (214) – a conception that was actually in play decades earlier, if not realized; and Hegener, *DIVI IACOBI EQVES*, 492–3 and *passim*, with earlier sources.

100. As Nicole Hegener and I have both surmised: email communication, August – September 2006. For Bandinelli's close relation with the Medici family and Cardinal Giulio and

his presence in Rome, see Hegener, *DIVI IACOBI EQVES*, 85–103 and *passim*.

101. Kathleen Wren Christian, "From Ancestral Cults to Art: The Santacroce Collection of Antiquities," *Annali della Scuola normale superiore di Pisa. Classe di lettere e filosofia* Series IV, 14 (2002): 255–72.

102. For the collection of sculpture and antiquities at the villa, see Chapter 3, pp. 73–4 and note 45.

103. Sperulo has previously been mistranslated or misinterpreted to suggest that there were figures of Silenus and Jupiter in the villa – as in Frommel et al., *Raffaello architetto*, 320; Reiss, "Cardinal Giulio de' Medici as a Patron of Art," 361, 395 n. 37; Fusco and Corti, "Giovanni Ciampolini," 30; and Rausa, "Marmi antichi," 169 and cat. 9 (*Silenus*). The tale of the Silenus in the stone is a Plinian topos, which Sperulo evokes to describe columns that are of the same *kind* of Parian marble in which the Silenus was found (line 58 and gloss note 28). Sperulo's passage about marbles from the Temple of Jupiter Tonans has been mistranslated to refer to a figural sculpture of Jupiter; rather, Sperulo says that marbles came from Jupiter's temple (lines 47–52 and gloss note 23).

104. Raphael makes no mention of any use of figural sculptures or architectural ornament, whereas Pliny does mention columns and marble revetments.

105. Where Leo's own collection had recently been augmented by works he inherited from Alfonsina Orsini. The Palazzo Medici in Rome is the present-day Palazzo Madama, seat of the Senate, near Piazza Navona. Before his pontificate, Giovanni de' Medici had lived in the Palazzo Ottieri, which was famous for its collection of antiquities as well as its library. For that palace, see Christoph Luitpold Frommel, *Der römische Palastbau der Hochrenaissance* (Berlin, 1973), vol. 2, 227. For Leo's collection there, Weil-Garris and d'Amico, *The Renaissance Cardinal's Ideal Palace*, 116–17 and n. 117; M. Müntz, "Les collections d'antiques formées par les Médicis au XVIe siècle," *Mémoires de l'Académie des Inscriptions et Belles Lettres* 35.2 (1896): 88–97; Claude Bellièvre, *Noctes romanae* in Eugène Müntz, "Le Musée du Capitole et les autres collections romaines à la fin du XVe siècle et au commencement du XVIe siècle avec un choix de documents inédits," *Revue archéologique* 43 (1882): 24–37, at 35; and Albertini, *Opusculum de mirabilibus*

novae & veteris urbis Romae, book 3, "De domibus Cardinalium." Alfonsina Orsini died on 7 February 1520, leaving Pope Leo as her heir: Sheryl E. Reiss, "Widow, Mother, Patron of Art: Alfonsina Orsini de' Medici," in *Beyond Isabella: Secular Women Patrons of Art in Renaissance Italy*, ed. Sheryl E. Reiss and David G. Wilkins (Kirksville, MO, 2001), 125–58. However, I have found no documentary or visual evidence that sculptures actually were transferred from the Medici Palace to the villa. Alternatively, Rausa interprets the phrase to mean that antiquities may have been taken from Lorenzo's collection in Florence to Rome, which is an interesting possibility, although no evidence has emerged for this hypothesis either: Rausa, "Marmi antichi," 157 (mis-citing Giulio's letter to read "statue di case," that is, houses in the plural).

106. From the letter of 17 June 1520 from Cardinal Giulio in Florence to Bishop Mario Maffei in Rome: Shearman, *Sources*, vol. 1, 603. On the subject of statues in stucco, see Elet, "Papal *villeggiatura*," 177ff.

107. On the surrounding decorations, Elet, "Papal *villeggiatura*," 186–7.

108. I am grateful to the late Richard Tuttle for bringing this project to my attention. The letter was published in Tilman Falk, "Studien zür Topographie und Geschichte der Villa Giulia in Röm," *Römisches Jahrbuch für Kunstgeschichte* 13 (1971): 171–3, and is discussed in Richard Tuttle, "Vignola e Villa Giulio: il disegno White," *Casabella* 61 (1997): 50–69.

109. Cited and discussed in Chapter 1, pp. 28–30 and note 92.

110. On the Medici and time, Cox-Rearick, *Dynasty and Destiny*, 16–17 and *passim*; Maia Wellington Ghatan, "Michelangelo and the Tomb of Time: The Intellectual Context of the Medici Chapel," in *Studi di storia dell'arte* (Todi, 2002), 59–124. I owe the latter source to Sheryl Reiss.

111. "Atque ex omnibus, quae rettuli, clarissima quaeque in urbe iam sunt dicata a Vespasiano principe in templo Pacis aliisque eius operibus, violentia Neronis in urbem convecta et in sellariis domus aureae disposita." Pliny, *Natural History*, XXXIV, 19, 84. My thanks to Katherine Welch for pointing out this passage.

112. The dual function of the complex as a Medici villa *suburbana* and also as papal *hospitium* surely engendered some tension about its

private/papal function and funding; Sperulo's claim that the villa was built at Giulio's extraordinary expense probably reflected the strategy to keep the villa in the family beyond a Medici pontificate (see above p. 64 and Sperulo, dedicatory letter §1); but that emphasis on a family-owned villa could make the Medici a target of criticism for appropriating antiquities.

113. Henning Wrede, "Römische Antikenprogramme des 16. Jahrhunderts," in *Il cortile delle statue*, 83–115; Wrede, "Antikenstudium und Antikenaufstellung in der Renaissance," *Kölner Jahrbuch* 26 (1993): 11–25; and Christian, "From Ancestral Cults to Art," 262–3; Christian, *Empire without End*, 163–7.

114. Hans Brummer, *The Statue Court in the Vatican Belvedere* (Stockholm, 1970), 216–49; Arnold Nesselrath, "The Imagery of the Belvedere Statue Court under Julius II and Leo X," in *High Renaissance in the Vatican: The Age of Julius II and Leo X*, Exh. Cat., ed. Michiaki Koshikawa and Martha McClintock (Tokyo, 1993); Matthias Winner, Bernard Andreae, and Carlo Pietrangeli, eds., *Il cortile delle statue: der Statuenhof des Belvedere im Vatikan: Akten des internationalen Kongresses zu Ehren von Richard Krautheimer* (Mainz, 1998).

115. Again, I speak of meaning other than the communicative function of the orders, or such general issues as decorum and magnificence.

6 DYNAMIC DESIGN

1. For what is known about Raphael's collaborations, see the Introduction, p. 4, with bibliography in notes 13, 15, and 16; and pp. 26–8.

2. On the convincing identification of the figure as Giulio Romano, with a history of earlier interpretations, Henry and Joannides, *Late Raphael*, 296–300.

3. "Quare tantum abest ut cristas erigat, ut multo magis se omnibus obvium et familiarem ultro reddat, nullius admonitionem aut colloquium refugiens, utpote quo nullus libentius sua commenta in dubium ac disceptationem vocari gaudeat, docerique ac docere vitae praemium putet." Text and translation in Shearman, *Sources*, vol. 1, 546–50.

4. Summarized in Stinger, *The Renaissance in Rome*, 196–9; and see James Ackerman, *The Cortile del Belvedere* (Città del Vaticano, 1954), 125. For the relation of the painted iconography

in the Stanza della Segnatura to the topography of Rome beyond, see also Tafuri, "Roma instaurata," 63; Temple, *Renovatio urbis*, ch. 6; and Christiane Joost-Gaugier, "Some Considerations on the Geography of the Stanza della Segnatura," *Gazette des Beaux-Arts* 124 (1994):223–32.

5. Rowland, "The Intellectual Background of the School of Athens," 139, 159; Joost-Gaugier, *Raphael's Stanza della Segnatura*, 17–21, 158–63; and Paul Taylor, "Julius II and the Stanza della Segnatura," *Journal of the Warburg and Courtauld Institutes* 72 (2009): 103–41.

6. As discussed in Chapter 1, p. 27 and note 82. Shearman surmised that Raphael's Ashmolean drawing was a preliminary idea for a smaller-scale project to remodel a *vigna* Leo had acquired by 7 June 1516; thus, the first ideas for that project might have been in the works before Inghirami died in September of that year. See Shearman, "A Functional Interpretation of Villa Madama," 322; and Shearman, "A Note on the Chronology of Villa Madama," 179–81.

7. By then, Inghirami also served as librarian for Leo X. On Raphael and Inghirami: Rowland, "The Intellectual Background of the School of Athens"; Joost-Gaugier, *Raphael's Stanza della Segnatura*; and P. Künzle, "Raffaels Denkmal für Fedro Inghirami auf dem letzten Arazzo," in *Mélanges Eugène Tisserant* (Rome, 1964), vol. 6, 499–548.

8. A point Arnold Nesselrath has emphasized in his nuanced studies of the Stanze. For sources on Raphael's workshop, see the Introduction, note 15.

9. For Giuliano Leno as "curatore" of the Fabbrica, Ait and Piñeiro, *Dai casali alla fabbrica di San Pietro*, 157–72. For Raphael and the Fabbrica of St. Peters, see Christoph L. Frommel, "Die Peterskirche unter Papst Julius II. im Licht neuer Dokumente," *Römische Jahrbuch für Kunstgeschichte* 16 (1976): 57–136; Frommel, "S. Pietro. Storia della sua costruzione," in *Raffaello architetto*, 241–309; Frommel, "Il cantiere di S. Pietro prima di Michelangelo," in *Les chantiers de la Renaissance*, ed. Jean Guillaume (Tours, 1991), 175–90; Frommel, "St. Peter's: The Early History," in *Renaissance Architecture from Brunelleschi to Michelangelo*, 399–423; Frommel, "The Endless Construction of St. Peter's: Bramante and Raphael," in *ibid.* 598–631; and Arnaldo

Bruschi and Cristiano Tessari, *San Pietro che non c'è: da Bramante a Sangallo il Giovane* (Milan, 1996).

10. For the fundamental analyses of the plans by Frommel, Adams, Ray, and others acknowledging the problematic nature of determining each architect's contributions to their ideation, see the Introduction, pp. 7–8 and notes 28–31, 34.

11. Unfortunately for Sperulo's proposed mural program, the political world order changed dramatically shortly after he finished his poem, as detailed in Chapter 3, p. 82 and note 83.

12. The iconography of paintings was frequently worked out in the later stages of planning for practical reasons, as demonstrated by Kathleen Weil-Garris Brandt, "Michelangelo's Early Projects for the Sistine Ceiling: Their Practical and Artistic Consequences," in *Michelangelo Drawings*, ed. Craig Hugh Smyth (Washington, DC, 1992), 56–87. Bibbiena's *stufetta* offers another example among Raphael's projects, analyzed by Arnold Nesselrath in "L'antico vissuto. La stufetta del cardinal Bibbiena," in *Pietro Bembo e l'invenzione del Rinascimento*, 284–91, at 287–8.

13. Shearman, *Sources*, vol. 1, 599–601, 602–5.

14. For Maffei see the Introduction, pp. 5, 8 and notes 20, 36; and Chapter 1, pp. 22–3 and notes 44, 47.

15. On their friendship and epistolary exchanges, Reiss, "A Renaissance Friendship." On the rhetoric of *amicitia* between *letterato* and patron, de Beer, *The Poetics of Patronage*, ch. 2, especially 111–19.

16. "Li pavoni per adesso non sono da presentare, per che sono spennachiati et le femine non sono da vedere." Mario Maffei in Rome to his nephew Paolo in Volterra, 5 January 1524 (BNCR A95.16/1).

17. Reiss calls attention to Maffei's practical experience with building projects for himself and patrons in "A Renaissance Friendship." Two letters by Maffei mention his work at the Medici villa: in March 1523 he says pruning has been done, and on 25 October 1524 he says he has planted trees there: Reiss, "Cardinal Giulio de' Medici as a Patron of Art," 388 and 411 nn. 220, 221, citing letters in the Biblioteca Comunale Guarnacci, Volterra, Archivio Maffei, filza I. I have been through Maffei's letters in the BNCR and the BAV during the period of Villa Madama's construction without finding new material about his work on the Medici villa (although they provide a

fascinating chronicle of the life of a Curial humanist in contemporary political and social context, from *c.* 1511 to post-Sack.) Alda Spotti has interpreted a 1527 letter written to Maffei with a one-sentence description of the villa to suggest that he was still involved at that date, although the statement that "everything is fine and almost as you left it" ("ogni cosa sta bene et quasi in quel medeximo modo che V.S. li lasciò") does not clarify when Maffei was last there: Alda Spotti, "Mario Maffei e Martino Virgoletta: note a un carteggio della Biblioteca Nazionale di Roma," in *Roma nella svolta tra quattro e cinquecento*, ed. Stefano Colonna (Rome, 2004), 151–8, at 157. In a 1987 talk, John D'Amico proposed that Maffei left Rome a few years before the Sack to tend to his own villa in Volterra because of shrinking opportunities for work in Rome; for which, Gouwens, "L'umanesimo al tempo di Pierio Valeriano," 9 and n. 12. Maffei was also disappointed at not having been made a cardinal.

18. Maffei seems to have been in Rome most of the time from the inception of the Medici villa through early 1527, judging from his frequent letters from Rome now in the BNCR. Gwynne documents that Sperulo was dispatched to Camerino around May 1519 to assist in some cloak-and-dagger marriage negotiations (which would later lead to his involvement with anti-Medicean interests): Gwynne, *Patterns of Patronage*, vol. 1, 31ff. This would explain why his attention was diverted from the villa project shortly after his poem.

19. Lefevre hypothesized, based on the letters, that Maffei was hired after Raphael's death to oversee the project: Lefevre, "Un prelato del '500, Mario Maffei e la costruzione di Villa Madama;" Lefevre, "La 'Vigna del Cardinale de' Medici' e il vescovo d'Aquino." Reiss, pointing out Giulio's practice of hiring overseers at Poggio and San Lorenzo, sensibly notes that there is no reason why Maffei could not have been an agent at Villa Madama before Raphael's death: "Cardinal Giulio de' Medici as a Patron of Art," 373–6.

20. Elet, "Papal *villeggiatura*," 31ff for links between Villa Madama and the Sala di Costantino, 272–4 for shared ideas about stucco at the villa and the New Sacristy, and 314–17 for Medici patronage of materials in Florence and Rome.

21. For which, Julian Kliemann, "Il pensiero di Paolo Giovio nelle pitture eseguite sulle sue

'invenzioni',," in *Paolo Giovio*, 197–223. A striking example of the cross-fertilization of ideas among humanists is Strunck's proposal that Giovio based his program for the north lunette of the Poggio Salone on Pontano's 1493 "De hortis Hesperidum," and her intriguing hypothesis that this poem may originally have been written as a Medici panegyric, for which see Chapter 4, note 54.

22. Giovio went to Florence with Giulio in January 1519. On Giovio as advisor and his interest in *villeggiatura*, see Chapter 1, p. 22–3 and note 45 and Chapter 2, pp 47, 49 and note 4.

23. Summarized in Reiss, "Cardinal Giulio de' Medici as a Patron of Art," 484 with earlier bibliography, especially by Matthias Winner and Julian Kliemann who first connected Ariosto's poem to the Poggio decorations.

24. As noted by Beltramini, "Pietro Bembo e l'architettura," 12, 17–18. Bembo was in Rome during the design phases of the Medici villa discussed herein, although he was away in Venice from May 1519 to April 1520. His inheritance of the family villa in May 1519 surely whetted his interest in villa culture at this time. For Bembo's annotated edition of Pliny's villa letters and his own villa writings, see Chapter 2, p. 48–9 and note 5.

25. Discussed in Chapter 1, pp. 27–8, 33–4, 45–6 and notes 85–7, 99–100, and 124; and Chapter 4, p. 89 and note 13.

26. Castiglione returned to Rome on 26 May 1519, dined with the pope at the villa on 4 June, and wrote to Isabella d'Este about it on 16 June. For this dinner and his letter, Shearman, *Sources*, vol. 1, 455, 459–60 with earlier bibliography. As discussed in Chapter 1, the trio of Raphael, Castiglione, and Bembo fraternized closely and exchanged ideas, as we know from their 1516 field trip to Tivoli, described by Bembo, and from Bembo's involvement in the letter to Leo X. Castiglione also included Bembo as an interlocutor in the *Cortegiano*.

27. Reiss, "Raphael, Pope Leo X, and Cardinal Giulio de' Medici," 22.

28. Reiss has highlighted the hands-on nature of Giulio's patronage, citing the Giulio–Maffei letters about Villa Madama on issues ranging from iconography to hydraulics, and Fattucci's letters that record Giulio's desire to see Michelangelo's drawings for many details of the San Lorenzo and New Sacristy projects:

Reiss, "Cardinal Giulio de' Medici as a Patron of Art," chs. VIII and XI, especially 622–4 and *passim*. Earlier Medici patrons also exhibited this range of involvement in building projects, from descriptive poetry to practical, hands-on issues, as shown by F. W. Kent's revisionist portrait of Lorenzo's patronage, which points out his role as husbandman pruning his own mulberry trees at Poggio a Caiano, and Amanda Lillie's account of how Giovanni di Cosimo oversaw the construction of the Fiesole villa, from structural issues down to the winter protection of the pomegranate plants. Kent, *Lorenzo de' Medici and the Art of Magnificence*, ch. V; and Lillie, "Giovanni di Cosimo."

29. Sperulo, dedicatory letter §2 and gloss note 4; for Cardinal Giulio's letter of 4 June 1520, Shearman, *Sources*, vol. 1, 599–601. For Cardinal Giulio's visits to the construction site, Reiss, "'Per havere tutte le opere'," 127 n. 15.

30. On earlier humanists' practice of the collective emendation of their drafts, Grafton, *Leon Battista Alberti Master Builder*, 53–7.

31. Discussed in Chapter 5, p. 124–5 and note 85.

32. Bembo's letters are in Shearman, *Sources*, vol. 1, 240–6 (documents 1516/8; 1516/10; 1516/11). Discussed by Vittoria Romani, Cat. 4.13 in Beltramini et al., eds., *Pietro Bembo e l'invenzione del Rinascimento*, 259; and Arnold Nesselrath, "L'antico vissuto."

33. "Per ancora non ho stantie in Palazo, ma buone promesse … domattina cominceremo havere el pane di Palazo come familiari." Mario Maffei in Rome to his nephew Paolo in Volterra, 12 December 1523 (ASCR A95.15/2). His increasing frustration at not being given rooms is chronicled in his letters; to my knowledge, he never did receive them. (Nor did he receive a hoped-for cardinalate.)

34. On the differences between patronage at close range and long distance, see Reiss, "Per havere tutte le opere," with earlier sources; and her article in preparation, "*Mandare sempre disegni di quello si fac[i]a, per chontentare el Papa*: The Place of Drawings in the Art Patronage of Giulio de' Medici (Pope Clement VII)."

35. Although these plans may have reflected some verbal back-and-forth communication, they suggest primarily a one-way flow of ideas assigning primary agency to the advisor, as in the well-known example of Annibale Caro and Onofrio Panvinio for Taddeo Zuccaro at

the Farnese villa of Caprarola; see Robertson, "Annibal Caro as iconographer;" and Sapori, "Dal programma al dipinto." Caro's plan for the Stanza della Solitudine dictates to the painter the subjects and figures to be painted in each ceiling compartment, down to minute details – as indeed they were executed.

36. Settis, "Artisti e committente fra quattro e cinquecento," 725–9; Alberti, *Della pittura*, vol. 3, 53.

37. Antonio Pinelli, "Intenzione, invenzione, artifizio. Spunti per una teoria della ricezione dei cicli figurativi di età rinascimentale," in *Programme et invention*, 27–79.

38. Reiss, "A Taxonomy of Art Patronage in Renaissance Italy," 26.

39. Margaret Daly Davis, "'Opus Isodomum' at the Palazzo della Cancelleria. Vitruvian Studies and Archaeological and Antiquarian Interests at the Court of Raffaele Riario," in *Roma centro ideale della cultura dell'antico nei secoli XV e XVI*, 442–57, especially at 447.

40. Clare Robertson, "Paolo Giovio and the 'invenzioni' for the Sala dei Cento Giorni," in *Paolo Giovio*, 225–53, especially at 230–1, tracing the exchange of ideas between Giovio and Vasari for working out details of painted imagery, notably the identity and placement of the personifications between the narrative scenes in this room; and Koering, "'Intrecciamento'," treating interaction between Benedetto Lampridio and Giulio Romano at Palazzo Tè. Baptista Fiera's 1515 dialogue between Mantegna and Momus, in which Mantegna asks his philosopher friends about how to represent the figure of Justice, may in part reflect Mantegna's practice of developing iconography in dialogue with humanists: Baptista Fiera, *De iusticia pingenda: A Dialogue between Mantegna and Momus*, ed. James Wardop (London, 1957); I owe this source to Patricia Emison.

41. This drawing was preparatory for a painting of the same subject, now in the Bibliotheca Hertziana, Rome. The painting diverges significantly from the drawing in composition and details; I illustrate and discuss the drawing because it is more detailed and lively. Among the differences is the treatment of the female figure, who, in the painting, certainly represents a real person, perhaps Francesca Zuccaro, in contrast to the sketchy female of the drawing, more likely personifying invention. I am grateful to Julian Kliemann for discussing the iconography with me. See also the catalogue entry by Massimo Scolari in *Renaissance Architecture from Brunelleschi to Michelangelo*, 589.

42. For these boasts, see pp. 83–4 and gloss notes 40, 136.

43. See Chapter 2, pp. 58–9 and notes 76–8; and Chapter 4 pp. 90, 97, and *passim* on this point.

44. Discussed Chapter 2, p. 59 and note 77.

45. As noted by Brian Richardson, "From Scribal Publication to Print Publication: Pietro Bembo's 'Rime' 1529–1535," *Modern Language Review* 95 (2000): 684–95, at 689.

46. Brian Richardson, "'Recitato et cantato': the oral diffusion of lyric poetry in sixteenth-century Italy," in *Theatre, Opera and Performance in Italy from the Fifteenth Century to the Present: Essays in Honour of Richard Andrews*, ed. Brian Richardson, Simon Gilson, and Catherine Keen (Leeds, 2004), 67–82, at 70.

47. As noted, Sperulo's poem was dedicated to Giulio. I think it most likely that Giulio was also the addressee of Raphael's letter, as proposed by Lefevre and Reiss; see Reiss, "Cardinal Giulio de' Medici as a Patron of Art," 364–5.

48. Richardson has analyzed such practices of "mixed orality" in early cinquecento Italy, noting that, "Print, in other words, was a means of extending into the domain of reading what had pleased a listening audience in public performance. There could thus be a cycle of sung and written transmission, with each type of diffusion leading in turn to the other." Richardson, "'Recitato et cantato'," 73–4, 77; see also Richardson, "Oral Culture in Early Modern Italy: Performance, Language, Religion," *The Italianist* 34 (2014): 313–17.

49. Richardson, "From Scribal Publication to Print Publication," 688.

50. For example, after Egidio di Viterbo delivered a sermon praising Julius II for his proposed project at St. Peter's, the pontiff then requested it in writing, keeping one copy in his library and sending another to a diplomatic contact: Kempers, "Epilogue," 393.

51. Riccardo Pacciani, "New Information on Raphael and Giuliano Leno in the Diplomatic Correspondence of Alfonso I d'Este," *Art Bulletin* 67 (1985): 137–45, at 141; Shearman, *Sources*, vol. 1, 443.

52. A letter of Benedetto Buondelmonti refers to both patrons, then ambiguously says that one or both went "alla sua vignia dove fa murare";

Shearman noted that the villa is variously referred to as Leo's or Giulio's and favored Leo in this reading, but the mention of "dove fa murare" suggests Giulio, since he was in charge of the construction. Shearman, *Sources*, vol. 1, 387–8.

53. Although we lack a complete diary of Giulio's travels, we know that he was in Florence with his ailing nephew Lorenzo by 22 January 1519; he returned to Rome for a consistory on 13 April; he left again for Florence on 3 May; and he returned to Rome in October of that year; for which, Reiss, "Cardinal Giulio de' Medici as a Patron of Art," 286–7, 466, 394 n. 23; Adriano Prosperi, "Clemente VII," *Enciclopedia dei Papi* (Treccani, 2000).

54. For the dating of the poem, see Chapter 3, pp. 65–6 and notes 10–11; pp. 96–7; and Appendix 1 dedicatory letter §6.

55. As Charles Hope observed, there was no ancient precedent for the role of the humanist advisor – at least none that was known to the Renaissance; Hope, "Artists, Patrons, and Advisors," 328.

56. This competitive arena is discussed in Chapter 1, p. 21 and note 34; and Chapter 2, pp. 59–60 and notes 79–81.

57. On poetic contests, which Lampridio likened to Olympic competition, see Chapter 2, p. 59 and note 80.

58. Reiss presents an excellent discussion of artists maneuvering as they vie for patronage, including the Raphael/Sebastiano competition, in "'Per havere tutte le opere'," 123–4 and *passim*, with bibliography in n. 72.

59. Kempers, "Epilogue," 388. Beatriz Colomina stresses the role of critic as collaborator in modern architecture, noting that, "What appears to be criticism or publicity is actually design," in Colomina, "Collaborations: The Private Life of Modern Architecture," *Journal of the Society of Architectural Historians* 58 (1999): 462–71, at 464.

60. Agosti, *Paolo Giovio*, 27.

61. Notably, in Homer's account of the facture of the shield. For the rivalry of Hephaestus and Daedalus, Heffernan, *Museum of Words*, 14–16.

62. Discussed by Kathleen Weil-Garris Brandt, "The Relation of Sculpture and Architecture in the Renaissance," in *The Renaissance from Brunelleschi to Michelangelo*, 74–99 at 85; and Weil-Garris Brandt, "'The Nurse of Settignano': Michelangelo's Beginnings as a Sculptor," in *Genius of the Sculptor in*

Michelangelo's Work (Montreal, 1992), 21–43. For Renaissance notions of *disegno* and *idea*, Magne Malmanger, "Rise and Fall of the Designer," in *Imitation, Representation and Printing in the Italian Renaissance*, ed. Roy Eriksen and Magne Malmanger (Pisa and Rome, 2009), 233–46, with earlier bibliography.

63. For the notion of patron as author, see the Introduction, p. 5 and note 18.

64. Trachtenberg, *Building-in-Time*, 61 and 85–95; and Trachtenberg, "Ayn Rand, Alberti and the Authorial Figure of the Architect," *California Italian Studies* 2 (2011).

65. On literary collaboration, Jack Stillinger, *Multiple Authorship and the Myth of the Author in Criticism and Textual Theory* (New York, 1991). For the notion of collaboration as one of architecture's family secrets, now exposed, Colomina, "Collaborations," 462–71. On collaborative paradigms versus notions of authorship, Hélène Lipstadt, "'Exoticising the Domestic': On New Collaborative Paradigms and Advanced Design Practices," in *Architecture and Authorship*, ed. Tim Anstey, Katja Grillner, and Rolf Hughes (London, 2007), 164–73 and 190–1. For an analysis of different collaborative modes introduced in nineteenth- and twentieth-century architectural practice, including Walter Gropius' experimental Architects Collaborative, Gilbert Herbert and Mark Donchin, eds., *The Collaborators: Interactions in the Architectural Design Process* (Farnham, 2013).

66. For example, Castiglione's letter to Isabella d'Este in which he describes the Vatican Logge as "opra di Raphaello" and goes on to say that Raphael is also creating the villa: "Fassi una vigna anchor." In Shearman, *Sources*, vol. 1, 459.

67. See Henry and Joannides, "Raphael and his Workshop," 18ff on related issues of the tension between invention and execution, and what constituted the hand of Raphael, especially in movable paintings.

68. For example, G. Thomas Tanselle, "The Editorial Problem of Final Authorial Intention," *Studies in Bibliography* 29 (1976): 167–211.

69. For an interesting analogue to these ideas, Federica Goffi uses a phenomenological approach to the building, rebuilding, and renovation of St. Peter's to argue for a new paradigm uniting architecture and conservation in a diachronic understanding of a building. She defines mnemic architecture

as "built conservation always *in-the-mak-ing*" (8) and rejects the notion of "still shot" frozen moments, instead arguing for a phenomenological approach to these palimpsestic transformations: Federica Goffi, *Time Matter(s): Invention and Re-imagination in Built Conservation: The Unfinished Drawing and Building of St. Peter's, The Vatican* (Farnham, 2013).

70. James S. Ackerman, "Transactions in Architectural Design," in *Distance Points*, 23–36. (Originally published in *Critical Inquiry*, 1974.)

71. As noted by Howard Burns, "Building against Time: Renaissance Strategies to Secure Large Churches against Changes to their Design," in *L'église dans l'architecture de la Renaissance: Actes du colloque de Tours, 1990*, ed. Jean Guillaume (Paris, 1995).

72. Among which, Nicola Camerlenghi, "The *Longue Durée* and the Life of Buildings," in *New Approaches to Medieval Architecture*, ed. Robert Bork, William Clark, and Abby McGehee (Farnam, 2011), especially 12–13 with a useful recent analysis of historiographical approaches to building in time, including four-dimensionalism.

73. James Ackerman, "Architectural Practice in the Italian Renaissance," *Journal of the Society of Architectural Historians* 13 (1954): 3–11, at 9.

74. Burns, "Building against Time."

75. Marvin Trachtenberg, "Building outside Time in Alberti's *De re aedificatoria*," *Res* 48 (2005): 123–34; and Trachtenberg, *Building-in-Time*.

76. See also the discussion by Catherine Wilkinson, "The New Professionalism in the Renaissance," in *The Architect: Chapters in the History of the Profession*, ed. Spiro Kostof (New York, 1977), 124–60, at 157.

77. For issues of Renaissance temporalities, Alexander Nagel and Christopher S. Wood, *Anachronic Renaissance* (New York, 2010), 16–17 and *passim*.

78. Frommel notes that in Raphael's description of the villa, he does not mention the two principal Orders to be used, concluding that Raphael left the Orders of the façade and cortile to be determined during construction. Raphael does specify the Doric for the entrance portals and the columns of the Tevere loggia, and Ionic columns for a vestibule, but without discussing the Orders for the façade and cortile: Christoph L. Frommel, "Raffaello e gli ordini architettonici," in *L'emploi des ordres à la Renaissance: Actes du colloque de Tours, 1986*, ed. Jean Guillaume (Paris, 1992), 124.

79. In the letter describing Villa Madama, in reference to fountain design: Raphael/Dewez, 28 §18.

80. On the attribution of the drawing and fresco to Bertoja, the topographical iconography, and the identification of the figures in the fresco itself, see Loren W. Partridge, "The Sala d'Ercole in the Villa Farnese at Caprarola, Part I," *Art Bulletin* 53 (1971): 467–86, at 474 and figs. 5, 18, 19, 20; and Partridge, "The Sala d'Ercole in the Villa Farnese at Caprarola, Part II," *Art Bulletin* 54 (1972): 50–62, especially 53–4. See also Diane De Grazia, *Bertoia, Mirola, and the Farnese Court* (Bologna, 1991), 71, 132 cat. D75.

81. The gesture does not conform specifically to any of the oratorical repertoire set forth in Quintilian, *Institutio oratoria*, XI, 3, 88–136, unless perhaps that of a question (XI, 3, 101); I am indebted to Anthony Corbeill for looking at this drawing and suggesting this possibility, and further noting the traditional restrained left hand of the orator.

82. Reflecting the etymology of *perfetto* (Ciò che non abbisogna, che gli s'aggiunga niente, intero, compiuto. *Crusca*) and of the Latin *perfectus* (Realized to its full extent, complete, perfect; developed or completed so as to have all the desired qualities, perfect, finished. OLD, 1337).

83. Discussed in Elet, "Papal *villeggiatura*," ch. 3, 177–83.

84. As reported in a letter of Alfonso Paolucci in Rome to Alfonso d'Este in Ferrara, 13 March 1519; in Shearman, *Sources*, vol. 1, 443 (doc. 1519/22).

85. Shearman, *Sources*, vol. 1, 455 (Castiglione), 483–4 (Alfonso Paolucci, the Duke of Ferrara's agent), and 774ff (Vida).

86. For musical performances at the villa, Cummings, *The Lion's Ear*, 112–13.

87. "quantunche sia imperfecta, tamen Joanne Antonio non mi recordo havere visto un'altra che si li assomigli, o vi agionghi da uno gran pezo." Shearman, *Sources*, vol. 1, 769ff.

88. "Ma quello che excedeti ogni altro nostro piacere fo la stantia la quale, anchor che imperfecta sii, ne parvi bellissimo, in sito amenissimo,

copiosa di molte e maravigliose antiquitati." In *ibid.* 793. The letter does not specify which room she means, but her description of it as full of antiquities suggests the garden loggia.

89. For example, Albertini's guide to Rome contained encomiastic reports on Julius II's unfinished projects: "Opusculum de mirabilibus novae & veteris urbis Romae (Rome, 1510)," book 3, "De aedificiis ab Iulio Secundo constructis."

90. Vasari praises Michelangelo's unfinished Medici Madonna in both the 1550 and the 1568 editions, saying that "ancora che non siano finite le parti sue, si conosce, nell'essere rimasta abozzata e gradinata, nella imperfezione della bozza la perfezzione dell'opera." Vasari, *Le vite de' più eccellenti pittori scultori e architettori*, ed. Bettarini and Barrochi, VI, 57. Although the patron's ambition was still surely completion; Cardinal Giulio, in his letter about the squabbling artists at the villa after Raphael's death, encourages Maffei to do whatever is necessary to get them to complete the work: "Vostra Paternità veda di assettarla a suo modo pur che l'opra si faccia e perfettamente"; Shearman, *Sources*, vol. 1, 600.

91. Christof Thoenes, "St. Peter als Ruine. Zu einigen Veduten Heemskercks," *Zeitschrift für Kunstgeschichte* 49 (1986): 481–501. For the notion of the Belvedere and St. Peter's as modern ruins, see also Fausto Testa, "'ut ad veterum illa admiranda aedifica accedere videatur.' Il Cortile del Belvedere e la retorica politica del potere pontificio sotto Giulio II," in *Donato Bramante: ricerche, proposte, riletture*, ed. Francesco Paolo Di Teodoro (Urbino, 2001), 229–66. A contemporary reference to St. Peter's as the ruins of Bramante surely reflects this perception, as well as the tongue-in-cheek moniker of the architect as Maestro Ruinante; Curial humanist Filippo Beroaldo, in a 1516 humorous piece in the voice of the recently deceased elephant Hanno, has the elephant say that he wishes, "che 'l mio corpo sia sepulto nel Vaticano tra le ruine de Bramante." In V. Rossi, *Dal Rinascimento al Risorgimento* (Scritti di Critica Letteraria III) (Florence, 1930), 233. On old and new ruins, see also Suzanne B. Butters, "Figments and Fragments: Julius II's Rome," in *Rethinking the High Renaissance: The Culture of the Visual Arts in Early Sixteenth-Century Rome*, ed. Jill Burke (Farnham, 2012), 57–93.

92. Luciano Patetta, ed., *Bramante e la sua cerchia a Milano e in Lombardia 1480–1500* (Milan, 2001), 98–9 (catalogue entry on the Prevedari engraving by Stefano Borsi, with earlier sources).

93. Marina Döring interprets the conflicting evidence that the Genazzano nymphaeum was unfinished by proposing that it was conceived as an artificial ruin – an early folly – and a built version of Bramante's Prevedari engraving: Döring, "La nascita della rovina artificiale nel Rinascimento italiano, ovvero il 'Tempio in rovina' di Bramante a Genazzano," in *Donato Bramante*, 347ff.

94. The background of Andrea Mantegna's fictive view of the Mantuan countryside in the Camera Picta frescoes famously includes Roman-style ruins, but also a scaffolded castle-villa under construction. Also, the background of his 1474 fresco of the ducal family depicts an imaginary castle-style villa under construction in the Mantuan countryside; the villa is completely built, but its tower is still in scaffolding, with workmen on it. The detail is illustrated in Ackerman, *The Villa*, 77 fig. 3.17. Leonardo da Vinci provided a prominent example of the notion of the modern ruin in the background of his *Adoration of the Magi* and its preparatory drawings, replacing the traditional motif of crumbling ruins symbolizing the vanquished pagan order with a construction scene of workmen building a structure very similar to Poggio a Caiano. For the suggestion that this background depicts the rising portico and original stairs of Poggio, see Giuseppe Marchini, "Leonardo e le scale," *Antichità viva* 24 (1985): 180–5, 214; supporting this suggestion see Gabriele Morolli, "Lorenzo, Leonardo e Giuliano: da San Lorenzo al Duomo a Poggio a Caiano. Paralipomeni architettonici minimi in vista del semimellenario della morte del Magnifico," *Quaderni di storia dell'architettura e restauro* 3 (1990): 5–14. However, Caroline Elam doubts this identification based on the relative chronology of the painting and villa, further noting that the combination of portico arches and stairs was not unique to Poggio: verbal communication.

95. As noted by Thoenes, "St. Peter als Ruine."

96. On the unfinished as a stimulus to contemporary architectural imagination, Nicholas Temple and Soumyen Bandyopadhyay,

"Contemplating the Unfinished," in *From Models to Drawings*, 109–19.

97. Greene, "The Double Task of the Humanist Imagination."

98. "Fu tale questo studio, che rimase il suo ingegno capacissimo di poter vedere nella immaginazione Roma, come ella stava quando non era rovinata." Vasari, *Le vite de' più eccellenti pittori scultori e architettori*, ed. Milanesi, II, 338, cited in this context in Greene, "The Double Task of the Humanist Imagination," 43.

99. Cf. the visual representations of Renaissance gardens and landscapes that became popular subjects for villa decoration and prints in the mid-sixteenth century, which often depicted partially built estates as finished. These *vedute* could serve as a kind of prescriptive visualization, and are a later example of the synchronism between design and execution on the one hand, and visual or textual representations. Proleptic garden views are discussed by Denis Ribouillault, "Toward an Archaeology of the Gaze: The Perception and Function of Garden Views in Italian Renaissance Villas," in *Clio in the Italian Garden: Twenty-First-Century Studies in Historical Methods and Theoretical Perspectives*, ed. Mirka Beneš and Michael G. Lee (Washington, DC, 2011), 203–32, especially 205ff. Another such example may be seen in the well-known prints of Michelangelo's Campidoglio, shown as complete long before the fact.

100. On the ruin as a form of discourse that stimulates reflection and engages narrative forms, Ahuvia Kahane, "Image, Word and the Antiquity of Ruins," *European Review of History – Revue européenne d'histoire* 18 (2011): 829–50, as well as his introduction to this volume on the subject of "Antiquity and the Ruin," 631–44.

101. Thoenes sees the disparity between the grandiose and the feasible as a defining characteristic of Roman Renaissance building: Thoenes, "St. Peter als Ruine," 137.

102. On the historiography of attitudes to the unbuilt, Daniel M. Abramson, "Stakes of the Unbuilt," *The Aggregate website* (transparent peer reviewed), http://we-aggregate.org/piece/stakes-of-the-unbuilt, accessed 6 February 2014.

103. Aristotle, *Nicomachean Ethics*, trans. H. Rackham (London and New York, 1926), VI, iv, 2–4.

104. Robert Williams comments: "In a still more all-encompassing, absolute sense, art could be understood as a dynamic principle, a principle of becoming. Aristotle had discussed *techne* in these terms, likening the way a work of art comes into existence to natural processes of formation and transformation … Sixteenth-century writers frequently invoke the definition of art provided in the *Nicomachean Ethics*: 'a rational habit of making (*metá logou poetike*) that reasons truly'." Robert Williams, *Art, Theory, and Culture in Sixteenth-Century Italy* (Cambridge, 1997), 11. For the relevance of this section of the *Nicomachean Ethics* to Alberti's definition of architecture as an art or science, Branko Mitrović, *Serene Greed of the Eye: Leon Battista Alberti and the Philosophical Foundations of Renaissance Architectural Theory* (Berlin, 2005), 66–7.

105. Jeanneret, *Perpetual Motion*.

106. Pietro Floriani, *Bembo e Castiglione: studi sul classicismo del cinquecento* (Rome, 1976), 75–8.

107. Shearman, *Sources*, vol. 1, 539.

108. As noted by Richardson, "From Scribal Publication to Print Publication," 694–5 and n. 38; he analyzes this as a function of poetic practice during the transition from scribal to print publication.

CONCLUSION

1. Castiglione wryly suggests that a sonnet ostensibly improvised by L'Unico Aretino (the poet Bernardo Accolti, famous for this talent) had actually been prepared in advance; in Baldassare Castiglione, *Il Libro del Cortegiano*, I, 9. On varying degrees of improvisation in poetic recitation, Richardson, "'Recitato e Cantato'," 71–2.

2. I owe the term *recombinant discourses* to Katja Brandt, from her Slade lectures delivered in 1997–8.

3. See the discussion in the Introduction, pp. 10–11 and notes 54–8.

4. Pérez-Gómez has further stressed that Renaissance architectural drawings themselves were "value-laden" tools that distilled the visionary power of the architect and poetic nature of architecture, rather than serving simply as "neutral artefacts" of building: Alberto Pérez-Gómez, "Questions of Representation: The Poetic Origin of Architecture," in *From Models to Drawings*, 11–22, at 14; Pérez-Gómez,

Built upon Love: Architectural Longing after Ethics and Aesthetics (Cambridge, MA, 2006); and Pérez-Gómez, *Architecture and the Crisis of Modern Science* (Cambridge, MA, 1983), Introduction. His call has resonated with thinkers interested in the relation of history, theory, and practice of architecture, seeking to understand metaphorical and symbolic aspects of architectural design in historic context and their applications for contemporary practice; e.g. the essays in *The Humanities in Architectural Design: A Contemporary and Historical Perspective*, ed. Soumyen Bandyopadhyay, Jane Lomholt, Nicholas Temple, and Renée Tobe (London, 2010); and Frascari et al., *From Models to Drawings*.

5. For the dialectic of humanistic inquiry and design ideas in Alberti's thinking, Nikolaos-Ion Terzoglu, "The Human Mind and Design Creativity. Leon Battista Alberti and *lineamenta*," in *The Humanities in Architectural Design*, 136–59.

6. Trachtenberg, *Building-in-Time*, 61.

7. A point that has been made by Pérez-Gómez, *Built upon Love*, 155–7.

8. On the use of literary writing as a practical tool for contemporary architectural design and planning, Klaske Havik, *Urban Literacy: Reading and Writing Architecture* (Rotterdam, 2014).

9. This early modern exquisite corpse was very different from the random aspect of the eponymous Surrealist game, but shared with it the practice of a collective enterprise to bring together disparate elements to compose a whole, drawing on the anthropological metaphor. In her study of architectural conservation as a creative spur to invention, Federica Goffi traces the exquisite corpse metaphor from the assemblage of physical spoils in Renaissance building, especially at St. Peter's, to contemporary architecture: Goffi, *Time Matter(s)*, 97–122.

10. For the phenomenology of fiction as "productive" or "reality shaping," Paul Ricoeur, "The Function of Fiction in Shaping Reality," *Man and World: An International Philosophical Review* 12 (1979): 123–41. For recent approaches to the imaginary made manifest via visual and verbal means, Claus Clüver, Matthijs Engelberts, and Véronique Plesch, eds., *The Imaginary: Word and Image / L'imaginaire: text et image* (Leiden, 2015). On the ontology of imagined worlds in medieval thought, east and west, and the

power of the "imaginal" for worldmaking, Koliji, *In-Between*, 33 and *passim*.

11. Carruthers, "The Poet as Master Builder."

12. Kleinbub, *Vision and the Visionary in Raphael*, 111–15 and *passim*.

13. Quintilian, *Institutio oratoria*, VIII, 4, 62–3. On *enargeia* in Cicero as well as Quintilian, Vasaly, *Representations*, 88–104.

14. Among the vast bibliography on the subject, see especially John Shearman, "Portraits and Poets," in *Only Connect: Art and the Spectator in the Italian Renaissance* (Princeton, 1992), 108–48; Lina Bolzoni, *Il cuore di cristallo: ragionamenti d'amore, poesia e ritratto nel Rinascimento* (Turin, 2010), part II; and Elizabeth Cropper, "On Beautiful Women. Parmigianino, Petrarchism, and the Vernacular Style," *Art Bulletin* 58 (1976): 374–94.

15. "And since, while they lived, you did not know the Duchess or the others who are dead … in order to make you acquainted with them, in so far as I can, after their death, I send you this book as a portrait of the Court of Urbino, not by the hand of Raphael or Michelangelo, but by that of a lowly painter and one who only knows how to draw the main lines, without adorning the truth with pretty colors or making, by perspective art, that which is not seem to be." Baldassare Castiglione, *The Book of the Courtier*, trans. Charles S. Singleton (New York, 1959), 3. This metaphor actually appeared in a dedicatory epistle that postdated the treatise itself and is known from the 1528 edition; on this point, and on the *Courtier* as portrait, Robert W. Hanning, "Castiglione's Verbal Portrait: Structures and Strategies," in *Castiglione: The Ideal and the Real in Renaissance Culture*, ed. Robert W. Hanning and David Rosand (New Haven, 1983), 131–41.

16. Conversely, building medals could function as a visual panegyric of the patron via a building project, or serve to link a patron to his seat of rule, as in Matteo de' Pasti's medal of Sigismondo Malatesta with the castle of Rimini on the reverse.

17. For the Horatian *Exegi monumentum* topos, see Chapter 2, p. 55 and notes 55–6.

18. See Appendix 1, dedicatory letter, §2 and gloss note 4 for the Vitruvian source and the suggestion that this conceit refers to stucco, particularizing the words-versus-marbles topos to the Medici villa.

19. Elet, "Papal *villeggiatura*," chs. 4 and 5, which I will treat further in a book on early modern stucco.

20. In Father Tiber's final sentence, he declares that his tasks are pleasing because of his patron, and Pleasure holds his reins (403–5); for the relation of this conceit to the Medici device *iugum suave* (the yoke is easy), and to Statius' *Silvae*, 1, 3 in which Pleasure draws the plans for Vopiscus' villa, see Appendix 1, gloss note 143. On Statius' plays on the visual/verbal, Marshall, "*Spectandi Voluptas*," 332–3.

21. On this metaphor of text as building, Quinlan-McGrath, "The Villa of Agostino Chigi," 4–5; and Lina Bolzoni, *The Gallery of Memory: Literary and Iconographic Models in the Age of the Printing Press*, trans. Jeremy Parzen (Toronto, 2001), 191–6. See Aksamija, "Architecture and Poetry in the Making of a Christian Cicero" on the textual villa as simulacrum; and Galand-Hallyn, "Aspects du discours," 143, on villa poetry as metonym of poet or dedicatee.

22. As noted by Ann Kuttner. For Cicero's letters, see Chapter 4, p. 92 and note 27.

23. Sergei Eisenstein, *Film Sense* (New York, 1942), 4; and for Marcel Lods, see David Leatherbarrow and Mohsen Mostafavi, *Surface Architecture* (Cambridge, MA, 2002), 157–60.

APPENDIX II

1. The manuscript was exhibited in the 1985 Vatican exhibition without attribution of the scriptor or illuminator: Giovanni Morello, ed., *Raffaello e la Roma dei Papi*, Exh. Cat. (Rome, 1986), cat. 89. I am very grateful to Jonathan J. G. Alexander for generously sharing his observations on the style, quality, and attribution of the script and illumination of this manuscript, and to Paolo Vian, Director of the Department of Manuscripts, Biblioteca Apostolica Vaticana, for examining the manuscript with me.

2. I am indebted to Paolo Vian for the observation that the binding is consistent with the date of the poem, and that the BAV would have had no reason to rebind it.

3. For the symbolism of myrtle and laurel, see Appendix 1, line 31, and gloss notes 17 and 18.

4. Cox-Rearick, *Dynasty and Destiny*, 17–23.

5. On the development of chancery cursive, James Wardrop, *The Script of Humanism: Some Aspects of Humanistic Script 1460–1560* (Oxford, 1963).

6. As noted in Chapter 6, p. 154 and notes 48–50.

7. Morello, *Raffaello e la Roma dei Papi*, cat. 84.

8. Ibid. cat. 85; and Alfred Fairbank, "Another Arrighi Manuscript Discovered," *Book Collector* 20 (1971): 332–4.

9. Sheryl E. Reiss, "Cardinal Giulio de' Medici's 1520 Berlin Missal and Other Works by Matteo da Milano," *Jahrbuch der Berliner Museen* 33 (1991): 107–28; and Jonathan J. G. Alexander, ed., *The Painted Page: Italian Renaissance Book Illumination 1450–1550*, Exh. Cat. (Munich, 1994), cat. 128.

10. As suggested by Jonathan J. G. Alexander (email correspondence).

11. Another close comparison may be made to the illuminated dedication page of an edition of Plotinus (BNCF 86) painted by Attavante and dedicated to Leo *in minoribus*, although the shape of the shield is slightly different; illustrated in Nicoletta Baldini and Monica Bietti, *Nello splendore mediceo: Papa Leone X e Firenze* (Florence, 2013), cat. 15, 378–9.

12. On Giulio's cardinalate seals in this period, Reiss, "Cardinal Giulio de' Medici as a Patron of Art," 414–19; and Hegener, *DIVI IACOBI EQVES*, 89–90 and fig. 35.

13. I am grateful to Katja Brandt for this observation.

14. Sherman, "'Nota Bembe': How Bembo the Elder Read his Pliny the Younger."

15. Ginevra was the Platonic love interest of the elder Bembo, who evidently commissioned the portrait with his device on the verso, which was later overpainted with hers. Bernardo Bembo, humanist and Venetian ambassador, was well connected in Laurentian Florence, where he took part in the chivalric tradition of celebrating a Platonic lover with Petrarchan imagery, and the culture of villa life. For literature on his device, Leonardo's painting, and the conservation treatment that revealed the change to the inscription, see Caroline Elam, "Bernardo Bembo and Leonardo's *Ginevra de' Benci*: A Further Suggestion," in *Pietro Bembo e le arti* (Venice, 2013), 407–20; Lina Bolzoni, "I ritratti e la comunità degli amici fra Venezia, Firenze e Roma," in *Pietro Bembo e l'invenzione del Rinascimento*, 210–18; Bolzoni, *Cuore di cristallo*, 345–50; and David Alan Brown, ed., *Virtue and Beauty: Leonardo's Ginevra de' Benci*

and Renaissance Portraits of Women (Princeton, 2001), 142–6, with earlier bibliography, notably Jennifer Fletcher, "Bernardo Bembo and Leonardo's Portrait of Ginevra de' Benci," *Burlington Magazine* 131 (1989): 811–16. Although Leonardo himself was in France by the time of Sperulo's poem, the artist's residence in the Vatican until a few years before may have made this conceit well known. (The whereabouts of the Ginevra portrait in 1519 remain unknown, although presumably it was in Florence.)

16. This combination was also familiar from *deschi da parto* and Netherlandish paintings, as noted by Brown, *Virtue and Beauty*, 146 n. 8. Specifically, a mid-quattrocento pair of Medici portraits (perhaps Piero and Giovanni?) variously attributed to Andrea del Castagno or Domenico Veneziano, also paired likenesses on the rectos with wreaths containing *palle* on the versos. But the style is totally different; in the verso of these paired portraits, the wreaths are round and a very different foliate design from the paired sprigs of Bembo's device, Leonardo's Ginevra verso, or Sperulo's manuscript – and the *palle* are flattened circles. The paired portraits are now in the Gottfried Keller Stiftung, Zurich. Illustrated and discussed in Baldini and Biette, *Nello splendore mediceo*, 358–61 (catalogue entry by Miklós Boskovits), with earlier bibliography, to which should be added Brown, *Virtue and Beauty*, 146 n. 8.

17. We may see the same pairing of sprigs framing Leo's papal arms, in this case palm with laurel or myrtle, but differently shaped and not forming a wreath, in Egidio da Viterbo's *Libellus de litteris hebraicis* of 1517; BAV, Vat. Lat. 5808, Morello cat. 84, illuminated by Matteo da Milano.

18. Luke Syson, catalogue entry 33 and 33a, in *The Currency of Fame: Portrait Medals of the Renaissance*, ed. Stephen K. Scher (New York, 1994), 114–15. Among other medals commemorating recent building initiatives were one depicting Bramante's Vatican logge overlooking the Cortile di San Damaso, and another with a bird's-eye view of the Cortile del Belvedere; illustrated in Millon and Lampugnani, *The Renaissance from Brunelleschi to Michelangelo*, cats. 127 and 128.

19. As noted in Chapter 3, p. 64. See also Appendix 1 dedicatory letter §1 for Sperulo's emphasis on Giulio's great expense in building the villa,

surely a reflection of Medici strategy to keep it in the family beyond Leo's pontificate.

20. See Conclusion, p. 177. For the topos about the relative longevity of words and monuments, see Chapter 2, p. 55 and notes 55–6.

21. For Arrighi in Rome and his ties to the circle of Cardinal Giulio and Raphael: A. S. Osley, *Scribes and Sources: Handbook of the Chancery Hand in the Sixteenth Century* (Boston, 1980), ch. 5; Cecil H. Clough, "Ludovico degli Arrighi's Contact with Raphael and with Machiavelli," *Bibliofilia* 75 (1973): 294–306; Clough, "Ludovico degli Arrighi and Raphael," *Journal of the Society for Italic Handwriting* 79 (1974): 13–16; Clough, "A Manuscript of Paolo Giovio's *Historiae sui Temporis Liber VII*. More Light on Ludovico degli Arrighi," *Book Collector* 38 (1989): 27–59, especially at 44–7; A. Pratesi, "Ludovico Arrighi, detto il Vicentino," in *Dizionario biografico degli Italiani* (1962), vol. 4, 310–13; Stefano Pagliaroli, "Ludovico degli Arrighi," in *Studi medievali umanistici* (Messina and Rome, 2005), vol. 3, 47–79.

22. The hand is a close, but not exact, match with that of Genesius de la Barrera, a Spaniard who worked as a copyist in the Chancery with Arrighi between 1519 and 1523; for which, José Ruysschaert, "Le copiste Genesius de la Barrera et le manuscrit Barberini d'*Il Principe* de Machiavelli," in *Studies on Machiavelli*, ed. Myron P. Gilmore (Florence, 1972), 348–59. Neither is it an exact match with the hand of Evangelista Maddaleni, known as Fausto Capodiferro (see Wardrop, *The Script of Humanism*, 43–4 and pl. 46); or with the poet and scriptor Giovanni Francesco Vitali, one of the Coryciana scribes. Vitali did a manuscript of the Coryciana poetry with Caius Silvanus. His hand had the same sloping quality as the Sperulo manuscript, although the tails of the p's are very different. For Vitali, José Ruysschaert, "Les péripéties inconnues de l'édition des 'Coryciana' de 1524," in *Atti del convegno di studi su Angelo Colocci* (Jesi, 1972), 50–1 and *passim*.

23. For the signature of Genesius, see Ruysschaert, "Le copiste Genesius de la Barrera," fig. 9; for that of Vitali, Ruysschaert, "Les péripéties inconnues de l'édition des 'Coryciana'," fig. 4.

24. Although various signatures, or closing marks, appear in this volume; sometimes an S is crowned with dots instead of x's (as in his

poem about the *Laocoön*, fol. 150v); or else a stylized S and two dots appear at the end of a line. Sperulo's elegy on Leo's clemency (fol. 102v–103r) is the only work that closes with the S and three x's at the center bottom like his villa poem, perhaps because it marks the end of his third book of elegies in this volume.

25. Tamburini, *Santi e peccatori*, 209.

26. See now Gwynne, *Patterns of Patronage*, vol. 2, xxiii, noting that Sperulo's Vatican manuscripts appear to be autograph.

27. Richardson, *Manuscript Culture in Renaissance Italy*, 79–81.

28. *Ibid.* 81, and *passim*.

29. For an instance of close collaboration between painter and scribe in the making of maps in luxurious late quattrocento manuscripts, F. W. Kent† and Caroline Elam, "Piero del Massaio: Painter, Mapmaker and Military Surveyor," *Mitteilungen des Kunsthistorischen Institutes in Florenz* 67 (2015): 65–89.

BIBLIOGRAPHY

PRIMARY SOURCES

AA.VV. *Coryciana*. Rome, 1524.

Alberti, Leon Battista. *On the Art of Building in Ten Books*, trans. Joseph Rykwert, Neil Leach, and Robert Tavernor. Cambridge, MA, 1988.

Albertini, Francesco. "Opusculum de mirabilibus novae & veteris urbis Romae (Rome, 1510)." In *Five Early Guides to Rome and Florence*, ed. Peter Murray. Farnborough, 1972.

Apuleius. *Metamorphoses (The Golden Ass)*, vol. 1, ed. and trans. J. Arthur Hanson. Cambridge, MA, 1996.

Ariosto, Ludovico. *Orlando furioso secondo la princeps del 1516*, ed. Marco Dorigatti and Gerarda Stimato. Florence, 2006.

Aristotle. *Nichomachean Ethics*, trans. H. Rackham. London, 1926.

Ash, Harrison Boyd, ed. *Marcus Porcius Cato: On Agriculture. Marcus Terentius Varro. On Agriculture*, trans. William Davis Hooper. Cambridge, MA, 1993.

Barocchi, Paola, ed. *Scritti d'arte del cinquecento*. 3 vols. Milan and Naples, 1973.

Basile, Tania, and Jean-Jacques Marchand, eds. *Antonio Tebaldeo: Rime*. Ferrara, 1989.

Caro, Annibale. *Lettere*. Florence, 1957–61.

Castiglione, Baldassare. *The Book of the Courtier*, trans. Charles S. Singleton. New York, 1959.

 "Il Libro del Cortegiano." In *Opere di Baldassare Castiglione, Giovanni della Casa e Benvenuto Cellini*, ed. Carlo Cordie. Milan and Naples, 1960.

 Le Lettere, ed. Guido La Rocca. Milan, 1978.

Cavalli, Gigi, ed. *Lorenzo de' Medici: tutte le opere*. 2 vols. Milan, 1958.

Cicero. *Letters to Atticus, Vol. I*, ed. and trans. D. R. Shackleton Bailey. Cambridge, MA, 1999.

 Letters to Quintus and Brutus. Letter Fragments. Letter to Octavian. Invectives. Handbook of Electioneering, ed. and trans. D. R. Shackleton Bailey. Cambridge, MA, 2002.

 Orations. Pro Milone. In Pisonem. Pro Scauro. Pro Fonteio. Pro Rabirio Postumo. Pro Marcello. Pro Ligario. Pro Rege Deiotaro. Trans. N. H. Watts. Cambridge, MA, 1931.

 De oratore: with an introduction by H. Rackham, trans. E. W. Sutton. Cambridge, MA, 1976.

 De senectute, De amicitia, De divinatione, trans. William Armistead Falconer. London, 1923.

Columella, Lucius Junius Moderatus. *On Agriculture*, trans. Harrison Boyd Ash, 3 vols. Cambridge, MA, 1941–55.

Dio Cassius, *Roman History*, trans. Earnest Cary, 9 vols. Cambridge, MA, 1914–27.

Dionysius of Halicarnassus. *Roman Antiquities*, trans. Earnest Cary, vol. 2, books 3–4. Cambridge, MA, 1939.

 Elegy and Iambus with the Anacreontea, trans. J. M. Edmonds, vol. 2. Cambridge, 1954.

Ficino, Marsilio, and Paul Oskar Kristeller. *Opera omnia*. Turin, 1962.

Fiera, Baptista. *De iusticia pingenda: A Dialogue between Mantegna and Momus*, ed. James Wardop. London, 1957.

Filarete. *Filarete's Treatise on Architecture, Being the Treatise by Antonio di Piero Averlino, Known as Filarete*, trans. John R. Spencer. New Haven, 1968.

Fulvio, Andrea. *Opera di Andrea Fulvio delle antichità della città di Roma*, trans. Paolo dal Rosso. Venice, 1543.

 Antiquaria urbis. Rome, 1513.

 Antiquitates urbis. Rome, 1527.

Gellius, Aulus. *Attic Nights*, vol. 1, trans. J. C. Rolfe. Cambridge, MA, 1978.

Giovio, Paolo. *De vita Leonis Decimi Pont. Max.* Florence, 1551.

Dialogo dell'imprese militari et amorose. Rome, 1555.

Giraldi, Lilio Gregorio. *Modern Poets*, trans. John N. Grant. Cambridge, MA, 2011.

Opera omnia. Leyden, 1696.

Homer. *The Odyssey*, trans. Richmond Lattimore. New York, 1967.

Horace. *Odes and Epodes*, ed. and trans. Niall Rudd. Cambridge, MA, 2004.

Satire, Epistles and Ars poetica, trans. H. Rushton Fairclough. Cambridge, MA, 1955.

Juvenal. *Juvenal and Persius*, trans. Susanna Morton Braund. Cambridge, MA, 2004.

Juvencus. *Evangeliorum libri IV*. Mediolani, 1569.

Lampridius, Benedictus. *Carmina*. Venice, 1550.

Livy. *History of Rome, Vol. VI*, trans. Frank Gardner Moore. London, 1940.

Lucretius Carus, Titus. *De rerum natura*, trans. W. H. D. Rouse. Cambridge, MA, 1943.

Machiavelli, Niccolò. *Florentine Histories*, trans. Laura Banfield and Harvey Mansfield Jr. Princeton, 1988.

Il principe, ed. Carmine Donzelli and Gabriele Pedullà. Rome, 2013.

Martial. *Epigrams*, trans. D. R. Shackleton Bailey. Cambridge, MA, 1993.

Medici, Lorenzo de'. *Ambra (Descriptio Hiemis.)*, ed. Rossella Bessi. Florence, 1986.

Miller, Mary. "*The Elegiae in Maecenatem* with Introduction, Text, Translation, and Commentary." Ph.D. diss., University of Pennsylvania, 1942.

Ovid. *The Art of Love and Other Poems*, trans. J. H. Mozley, rev. G. P. Goold. Cambridge, MA, 1979.

Fasti, trans. James George Frazer, rev. G. P. Goold. Cambridge, MA, 1996.

Metamorphoses, trans. Frank Justus Miller, rev. G. P. Goold, 2 vols. Cambridge, MA, 1999.

Paulinus, Bishop of Aquileia. *L'œuvre poétique de Paulin d'Aquilée*, ed. Dag Norberg. Stockholm, 1979.

Philostratus. *Imagines*, trans. Arthur Fairbanks. Cambridge, MA, 2000.

Pindar. *Olympian Odes*, trans. William H. Race. Cambridge, MA, 1997.

Pliny the Elder. *Natural History*, II, books 3–7, trans. H. Rackham. Cambridge, MA, 1942.

Natural History, IV, books 12–16, trans. H. Rackham. Cambridge, MA, 1945.

Natural History, IX, Books 33–5, trans. H. Rackham. Cambridge, MA, 1999.

Natural History, X, books 36–7, trans. D. E. Eicholz. Cambridge, MA, 1962.

Pliny the Younger. *Letters*, trans. W. Melmoth, vol. 1. Cambridge, MA, 1961.

The Letters of the Younger Pliny, trans. Betty Radice. New York, 1986.

Poliziano, Angelo. *Silvae: English & Latin*, trans. Charles Fantazzi, ed. James Hankins. Cambridge, MA, 2004.

The Stanze of Angelo Poliziano, trans. David Quint. Amherst, 1979.

Polybius. *The Histories*, vol. 4, trans. W. R. Paton, rev. Frank W. Walbank and Christian Habicht. Cambridge, MA, 2011.

Pontano, Giovanni Gioviano. *Baiae*, trans. Rodney Dennis, ed. James Hankins. Cambridge, MA, 2006.

Propertius, Sextus. *Elegiae*, trans. H. E. Butler. Cambridge, MA, 1952.

Prudentii Clementis, Aurelii. *Carmina*, ed. Mauricii P. Cunningham. Corpus Christianorum, Series Latina, 126. Turnhout, 1966.

Quintilian. *Institutio oratoria*, trans. H. E. Butler. Cambridge, MA, 1996.

Sannazaro, Jacopo. *Arcadia and Piscatorial Eclogues*, trans. R. Nash. Detroit, 1966.

Poemata ex antiquis editionibus accuratissime descripta. Patavii, 1731.

Seneca, Lucius Annaeus. *Ad Lucilium epistulae morales*, trans. Richard M. Gummere, 3 vols. Cambridge, MA, 1917–25.

Moral Essays, vol. I, De providentia. De constantia. De ira. De clementia, trans. John W. Basore. Cambridge, MA, 1928.

Moral Essays, vol. III, De beneficiis, trans. John W. Basore. Cambridge, MA, 1935.

Serlio, Sebastiano. *Sebastiano Serlio on Architecture: Books I–V of "Tutte l'opere d'architettura et prospetiva',"* trans. Vaughn Hart and Peter Hicks. New Haven, 1996.

Sidonius. *Poems and Letters*, trans. W. B. Anderson. Cambridge, MA, 1963–5.

Silius Italicus, Tiberius Catius. *Punica*, trans. J. D. Duff. Cambridge, MA, 1936.

Statius. *Silvae*, trans. D. R. Shackleton Bailey. Cambridge, MA, 2003.

Strabo. *Geography*, trans. Horace Leonard Jones, 8 vols. London and New York, 1917–32.

Suetonius. *Lives of the Caesars; Lives of Illustrious Men: Grammarians and Rhetoricians. Poets*, ed. and trans. J. C. Rolfe. 2 vols. Cambridge, MA, 1997–8.

Tacitus. *Annals*, ed. and trans. Alfred John Church and William Jackson Brodribb. London, c. 1876.

Valeriano, Pierio. "Dialogo della volgar lingua." In *Discussioni linguistiche del cinquecento*, ed. Mario Pozzi, 37–93. Turin, 1988.

Hieroglyphica. Lyons, 1602. Reprint New York, 1976.

Vasari, Giorgio. *Le vite de più eccellenti pittori scultori ed architetti*, 9 vols., ed. Gaetano Milanesi. Florence, 1878–85.

Le vite de' più eccellenti pittori scultori e architettori: nelle redazioni del 1550 e 1568, 6 vols., ed. Rosanna Bettarini and Paola Barocchi. Florence, 1966–.

Verino, Ugolino. *Epigrammi*, ed. Francesco Bausi. Messina, 1998.

Vidae, M. Hieronymi. *Opera omnia*. Patavii, 1731.

Virgil. *Eclogues. Georgics. Aeneid I–VI*, trans. H. Rushton Fairclough. Cambridge, 1999.

Aeneid VII–XII. Appendix Vergiliana, trans. H. Rushton Fairclough. Cambridge, MA, 2000.

Aeneidos Liber Sextus, ed. R. G. Austin. Oxford, 1977.

Vitruvius. *On Architecture*, books I–V, ed. and trans. Frank Granger. Cambridge, MA, 1998.

On Architecture, books VI–X, ed. and trans. Frank Granger. Cambridge, MA, 1999.

Voragine, Jacobus de. *The Golden Legend*, trans. William Granger Ryan. Princeton, 1995.

SECONDARY SOURCES

Abramson, Daniel M. "Stakes of the Unbuilt." *The Aggregate website* transparent peer reviewed (2014): http://we-aggregate.org/piece/stakes-of-the-unbuilt.

Ackerman, James. "Architectural Practice in the Italian Renaissance." *Journal of the Society of Architectural Historians* 13 (1954): 3–11.

The Cortile del Belvedere. Città del Vaticano, 1954.

The Villa: Form and Ideology of Country Houses. Princeton, 1990.

"The Geopolitics of Venetan Architecture in the time of Titian." In *Distance Points: Essays in Theory and Renaissance Art and Architecture*, 453–94. Cambridge, MA, 1991.

"Transactions in Architectural Design." In *Distance Points: Essays in Theory and Renaissance Art and Architecture*, 23–36. Cambridge, MA, 1991.

"Imitation." In *Antiquity and its Interpreters*, ed. Alina Payne, Ann Kuttner, and Rebekah Smick, 9–16. Cambridge, 2000.

Agosti, Barbara. *Paolo Giovio: uno storico lombardo nella cultura artistica del cinquecento*. Florence, 2008.

Ait, Ivana, and Manuel Vaquero Piñeiro. *Dai casali alla fabbrica di San Pietro. I Leni: uomini d'affari del Rinascimento*. Rome, 2000.

Aksamija, Nadja. "Landscape and Sacredness in Late Renaissance 'Villeggiatura'." In *Delizie in Villa: il giardino rinascimentale e i suoi committenti*, ed. Gianni Venturi and Francesco Ceccarelli, 33–63. Florence, 2008.

"Architecture and Poetry in the Making of a Christian Cicero: Giovanni Battista Campeggi's Tuscolano and the Literary Culture of the Villa in Counter-Reformation Bologna." *I Tatti Studies: Essays in the Renaissance* 13 (2011): 127–91.

Alazard, Jean. "Sur les hommes illustres." In *Il mondo antico nel Rinascimento: Atti del V convegno internazionale di studi sul Rinascimento, Firenze-Palazzo Strozzi, 2–6 settembre 1956*, 275–7. Florence, 1958.

Alcina, Juan F. "Notas sobre la silva neolatina." In *La silva: i encuentro internacional sobre poesia del siglo de oro, Sevilla–Córdoba, 1990*, ed.

Begona López Bueno, 129–55. Seville and Cordoba, 1991.

Aleci, L. Klinger. "Images of Identity. Italian Portrait Collections of the Fifteenth and Sixteenth Centuries." In *The Image of the Individual: Portraits in the Renaissance*, ed. Nicholas Mann and Luke Syson, 67–79, 204–13. London, 1998.

Alexander, Jonathan J. G., ed. *The Painted Page: Italian Renaissance Book Illumination 1450–1550*, Exh. Cat. Munich, 1994.

Amati, G. "Notizia di manoscritti dell'Archivio Segreto Vaticano." *Archivio storico italiano* Ser. 3, III, parte I (1866).

Andreae, Bernard. *Praetorium speluncae: l'antro di Tiberio a Sperlonga ed Ovidio*, trans. Katrin Schlaefke and Felice Constabile. Soveria Mannelli (Catanzaro), 1995.

 "I gruppi di Polifemo e di Scilla a Villa Adriana." In *Ulisse: il mito e la memoria*, ed. Bernard Andreae and Claudio Parisi Presicce, 342–4. Rome, 1996.

Andreae, Bernard and Claudio Parisi Presicce. *Ulisse: il mito e la memoria*. Rome, 1996.

Andreina, Rita. "Per la storia della Vaticana nel primo Rinascimento." In *Le origini della Biblioteca Vaticana tra umanesimo e Rinascimento (1447–1534)*, vol. 1, ed. Antonio Manfredi, 237–307. Città del Vaticano, 2010.

Antonetti, Martin. "New Clues to the Early Life of Arrighi. Ludovico degli Arrighi's 'Bellissimo canzoniere' for Bartolomeo della Valle, 1508." *Book Collector* 61 (2012): 159–80.

Ariani, Marco. "*Descriptio in somniis*: racconto e *ekphrasis* nella *Hypnerotomachia Poliphili*." In *Storia della lingua e storia dell'arte in Italia: dissimmetrie e intersezioni*, ed. Vittorio Casale and Paolo d'Achille, 153–60. Florence, 2004.

Armellini, Mariano. *Le chiese di Roma dal secolo IV al XIX*, second edition. Rome, 1891.

Armstrong, Adrian. *The Virtuoso Circle: Competition, Collaboration, and Complexity in Late Medieval French Poetry*. Tempe, AZ, 2012.

Ashby, Thomas, ed. *La campagna romana al tempo di Paolo III: mappa della campagna romana del 1547 di Eufrosino della Volpaia*. Rome, 1914.

Aurenhammer, Hans H. "*Multa aedium exempla variarum imaginum atque operum*. Das Problem der *imitatio* in der italienischen Architektur des frühen 16. Jahrhunderts." In *Intertextualität in der Frühen Neuzeit: Studien zu ihren theoretischen und praktischen Perspektiven*, 533–605. Frankfurt, 1994.

Baldini, Nicoletta, and Monica Bietti, eds. *Nello splendore mediceo: Papa Leone X e Firenze*, Exh. Cat. Florence, 2013.

Bambach, Carmen C. *Leonardo da Vinci Master Draftsman*, Exh. Cat. New York, 2003.

Bandyopadhyay, Soumyen, Jane Lomholt, Nicholas Temple, and Renée Tobe, eds., *The Humanities in Architectural Design: A Contemporary and Historical Perspective*. London, 2010.

Bardeschi, Marco Dezzi. "L'opera di Giuliano da Sangallo e di Donato Bramante nella fabbrica della villa papale della Magliana," *L'arte* 4 (1971): 111–73.

Barkan, Leonard. *Unearthing the Past: Archeology and Aesthetics in the Making of Renaissance Culture*. London and New Haven, 1999.

 "The Heritage of Zeuxis. Painting, Rhetoric, and History." In *Antiquity and its Interpreters*, ed. Alina Payne, Ann Kuttner, and Rebekah Smick, 99–109. Cambridge, 2000.

Battisti, Eugenio. "Il concetto di imitazione nel cinquecento italiano." In *Rinascimento e Barocco*, 175–215. Turin, 1960.

Batistini, Giovanni. "Raphael's Portrait of Fedra Inghirami." *Burlington Magazine* 138 (1996): 541–5.

Bausi, Francesco. "Il broncone e la fenice." *Archivio storico italiano* 150.552 (1992): 437–54.

Baxandall, Michael. *Giotto and the Orators*. Oxford, 1971.

Beltramini, Guido. "Pietro Bembo e l'architettura." In *Pietro Bembo e l'invenzione del Rinascimento*, ed. Guido Beltramini, Davide Gasparotto, and Adolfo Tura, 12–31. Venice, 2013.

Beltramini, Guido, and Howard Burns, eds. *Andrea Palladio e la villa veneta da Petrarca a Carlo Scarpa*. Venice, 2005.

Beltramini, Guido, Davide Gasparotto, and Adolfo Tura, eds. *Pietro Bembo e l'invenzione del Rinascimento*. Venice, 2013.

Benzi, Fabio. "Percorso reale in sogno di Polifilo, dal tempio della Fortuna di Palestrina a Palazzo Colonna in Roma." *Storia dell'arte italiana* 93–4 (1998): 198–206.

Bergmann, Bettina. "Painted Perspectives of a Villa Visit: Landscape as Status and Metaphor." In *Roman Art in the Private Sphere*, ed. E. K. Gazda, 49–70. Ann Arbor, 1991.

Bertelli, Carlo. "Architecto doctissimo." In *Bramante e la sua cerchia a Milano e in Lombardia 1480–1500*, ed. Luciano Patetta, 67–75. Milan, 2001.

Biermann, Hartmut. "Lo sviluppo della villa toscana sotto l'influenza umanistica della corte di Lorenzo il Magnifico." *Bollettino del Centro internazionale di studio Andrea Palladio* 11 (1969): 36–46.

"Der runde Hof Betrachtungen zur Villa Madama." *Mitteilungen des Kunsthistorischen Institutes in Florenz* 30 (1986): 493–536.

"Palast und Villa: Theorie und Praxis in Giuliano da Sangallos Codex Barberini und im Taccuino Senese." In *Les traités d'architecture de la Renaissance*, ed. Jean Guillaume, 135–50. Paris, 1988.

Bisaha, Nancy. *Creating East and West: Renaissance Humanists and the Ottoman Turks*. University Park, PA, 2004.

Blanco, Antonio, and Manuel Lorente. *Catalogo de la Escultura Museo del Prado*, second edition. Madrid, 1969.

Bober, Phyllis Pray. "The 'Coryciana' and the Nymph Corycia." *Journal of the Warburg and Courtauld Institutes* 40 (1977): 223–39.

"Appropriation Contexts: *Decor, Furor Bacchicus, Convivium*." In *Antiquity and its Interpreters*, ed. Alina Payne, Ann Kuttner, and Rebekah Smick, 229–43. Cambridge, 2000.

Bober, Phyllis Pray, and Ruth Rubinstein. *Renaissance Artists and Antique Sculpture*. Cambridge, 1986.

Bodel, John. "Monumental Villas and Villa Monuments." *Journal of Roman Archeology* 10 (1997): 5–35.

"Villaculture." In *Roman Republican Villas. Architecture, Context, and Ideology*, ed. Jeffrey A. Becker and Nicola Terrenato, 45–60. Ann Arbor, 2012.

Bolzoni, Lina. *The Gallery of Memory: Literary and Iconographic Models in the Age of the Printing Press*, trans. Jeremy Parzen. Toronto, 2001.

Il cuore di cristallo: ragionamenti d'amore, poesia e ritratto nel Rinascimento. Turin, 2010.

"I ritratti e la comunità degli amici fra Venezia, Firenze e Roma." In *Pietro Bembo e l'invenzione del Rinascimento*, ed. Guido Beltramini, Davide Gasparotto, and Adolfo Tura, 210–18. Venice, 2013.

Bonito, Virginia. "The Saint Anne Altar in Sant'Agostino in Rome: A New Discovery." *Burlington Magazine* 122 (1980): 805–12.

"The Saint Anne Altar in Sant'Agostino, Rome." Ph.D. diss., Institute of Fine Arts, New York University, 1983.

Borghini, Gabriele. *Marmi antichi*. Rome, 2001.

Bouscharain, Anne. "L'éloge de la villa humaniste dans une silve de Battista Spagnoli, le Mantouan: la *Villa Refrigerii* (*c.* 1478)." In *La villa et l'univers familial dans l'Antiquité et à la Renaissance*, ed. Perrine Galand-Hallyn and Carlos Lévy, 93–116. Paris, 2008.

Braund, Susanna Morton. "Praise and Protreptic in Early Imperial Panegyric: Cicero, Seneca, Pliny." In *The Propaganda of Power: The Role of Panegyric in Late Antiquity*, ed. Mary Whitby, 53–76. Leiden, 1998.

Broise, Henri, and Vincent Jolivet. "A proposito di Andrea Moneti e la villa degli horti Luculliani, con una replica dell'autore." *Palladio* 20 (July–Dec. 1997): 119–25.

Brothers, Cammy. "The Renaissance Reception of the Alhambra: The Letters of Andrea Navagero and the Palace of Charles V." *Muqarnas* 11 (1994): 79–102.

"Architecture, History, Archeology: Drawing Ancient Rome in the Letter to Leo X and in Sixteenth-century Practice." In *Coming About: A Festschrift for John Shearman*, ed. Lars Jones and Luisa Matthew, 135–40. Cambridge, MA, 2002.

Brown, Alison. "The Humanist Portrait of Cosimo de' Medici, *Pater Patriae*." *Journal*

of the Warburg and Courtauld Institutes 24 (1961): 186–221.

Brown, David Alan, ed. *Virtue and Beauty: Leonardo's* Ginevra de' Benci *and Renaissance Portraits of Women*. Princeton, 2001.

Brummer, Hans Henrik. *The Statue Court in the Vatican Belvedere*. Stockholm, 1970.

The Muse Gallery of Gustavus III, Antikvariskt Arkiv 43. Stockholm, 1972.

Brummer, Hans Henrik, and Tore Janson. "Art, Literature and Politics: An Episode in the Roman Renaissance." *Konsthistorisk tidskrift* 45 (1976): 79–93.

Bruschi, Arnaldo, and Cristiano Tessari. *San Pietro che non c'è: da Bramante a Sangallo il Giovane*. Milan, 1996.

Buddensieg, Tilmann. "Die Konstantinsbasilika in einer Zeichnung Francescos di Giorgio und der Marmorkoloss Konstantins des Grossen." *Münchner Jahrbuch der bildenden Kunst* 13 (1962): 37–48.

Bullard, Melissa Meriam. "Heroes and their Workshops: Medici Patronage and the Problem of Shared Agency." *Journal of Medieval and Renaissance Studies* 24 (1994): 179–98.

Burioni, Matteo. "Die Immunität Raffaels. Lehre, Nachahmung und Wettstreit in der Begegnung mit Pietro Perugino." In *Perugino Raffaels Meister*, Exh. Cat, ed. Andreas Schumacher, 129–51. Ostfildern, 2011.

Burns, Howard. "Raffaello e 'quell'antiqua architectura'." In *Raffaello architetto*, ed. Christoph Luitpold Frommel, Stefano Ray, and Manfredo Tafuri, 381–404. Milan, 1984.

"Building against Time: Renaissance Strategies to secure Large Churches against Changes to their Design." In *L'église dans l'architecture de la Renaissance: Actes du colloque de Tours, 1990*, ed. Jean Guillaume, 107–32. Paris, 1995.

"Painter-Architects in Italy during the Quatrocento and Cinquecento." In *The Notion of the Painter-Architect in Italy and the Southern Low Countries*, ed. Piet Lombaerde, 1–8. Turnhout, 2014.

Burns, Howard, and Arnold Nesselrath. "Raffaello e l'antico." In *Raffaello architetto*, ed. Christoph Luitpold Frommel, Stefano Ray, and Manfredo Tafuri, 379–450. Milan, 1984.

Butler, Kim E. "'Reddita lux est': Raphael and the Pursuit of Sacred Eloquence in Leonine Rome." In *Artists at Court: Image-making and Identity, 1300–1550*, ed. Stephen J. Campbell, 138–48. Chicago, 2004.

"Giovanni Santi, Raphael, and Quattrocento Sculpture." *Artibus et historiae* 30 (2009): 15–39.

"La Cronaca rimata di Giovanni Santi e Raffaello." In *Raffaello e Urbino: la formazione giovanile e i rapporti con la città natale*, Exh. Cat, ed. Lorenza Mochi Onori, 38–43. Milan, 2009.

Butters, Humfrey. "Lorenzo and Naples." In *Lorenzo il Magnifico e il suo mondo*, ed. Gian Carlo Garfagnini, 143–51. Florence, 1994.

Butters, Suzanne B. *The Triumph of Vulcan: Sculptor's Tools, Porphyry and the Prince in Ducal Florence*. Florence, 1996.

"Figments and Fragments: Julius II's Rome." In *Rethinking the High Renaissance: The Culture of the Visual Arts in Early Sixteenth-century Rome*, ed. Jill Burke, 57–93. Farnham, 2012.

Butzek, Monika. *Die kommunalen Repräsentationsstatuen der Päpste des 16. Jahrhunderts in Bologna, Perugia und Rom*. Bad Honnef, 1978.

Caglioti, Francesco. *Donatello e i Medici: storia del David e della Giuditta*. Florence, 2000.

CALMA. Compendium auctorum latinorum medii aevi, 500–1500 (Florence, 2011), III.

Calvesi, Maurizio. *Il Sogno di Polifilo*. Rome, 1983.

Camerlenghi, Nicola. "The Longue Durée and the Life of Buildings." In *New Approaches to Medieval Architecture*, ed. Robert Bork, William Clark, and Abby McGehee, 11–20. Farnam, 2011.

Camesasca, Ettore, and Giovanni M. Piazza. *Raffaello: gli scritti*. Milan, 1993.

Cancik, Hubert. *Untersuchungen zur lyrischen Kunst des P. Papinius Statius*. Hildesheim, 1965.

Canfora, Davide. "'Carmine studioso, tamen veridico': encomio, poesia e storiografia nell'epica di Francesco Sperulo." In *Il*

Principe e la storia: Atti del convegno Scandiano 18–20 settembre 2003, ed. Tina Matarrese and Cristina Montagnani, 291–9. Novara, 2005.

Cappelletti, Giuseppe. *Le chiese d'Italia: dalla loro origine sino ai nostri giorni*. Venice, 1870, vol. 21.

Carey, Sorcha. *Pliny's Catalogue of Culture: Art and Empire in the* Natural History. Oxford, 2003.

Carmichael, Ann G. "The Health Status of Florentines in the Fifteenth Century." In *Life and Death in Fifteenth-century Florence*, ed. Marcel Tetel, Ronald G. Witt, and Rona Goffen, 28–45. Durham, NC, 1989.

Carpo, Mario. *Alberti, Raffaello, Serlio e Camillo*. Geneva, 1993.

Carruthers, Mary. "The Poet as Master Builder: Composition and Locational Memory in the Middle Ages." *New Literary History* 24 (1993): 881–904.

——— "Collective Memory and *Memoria rerum*. An Architecture for Thinking." In *The Craft of Thought: Meditation, Rhetoric, and the Making of Images, 400–1200*, ed. Mary Carruthers, 7–21. Cambridge, 1998.

——— *The Craft of Thought: Meditation, Rhetoric, and the Making of Images, 400–1200*. Cambridge, 1998.

——— *The Book of Memory: A Study of Memory in Medieval Culture*. Cambridge, 2008.

——— "The Concept of 'Ductus'. Or Journeying through a Work of Art." In *Rhetoric beyond Words: Delight and Persuasion in the Arts of the Middle Ages*, ed. Mary Carruthers, 190–213. Cambridge, 2010.

Caruso, Carlo. "Poesia umanistica di villa." In *"Feconde venner le carte": studi in onore di Ottavio Besomi*, ed. Tatiana Crivelli, vol. 2, 272–94. Bellinzona, 1997.

Cassieri, Nicoletta. *La Grotta di Tiberio e il Museo archeologico nazionale, Sperlonga*. Rome, 2000.

Cast, David. *The Delight of Art: Giorgio Vasari and the Traditions of Humanist Discourse*. University Park, PA, 2009.

——— "On the Unity/Disunity of the Arts: Vasari (and Others) on Architecture." In *Rethinking the High Renaissance: The Culture of the Visual Arts in Early Sixteenth-Century Rome*, ed. Jill Burke, 129–43. Farnham, 2012.

Castagnoli, F. "Raffaello e le antichità di Roma." In *Raffaello: l'opera, le fonti, la fortuna*, ed. Mario Salmi, vol. 2, 571–86. Novara, 1968.

Cavallaro, Anna. *La villa dei papi alla Magliana*. Rome, 2005.

——— "'… quella casa è del papa …': la villa della Magliana e la contesa per il suo possesso alla morte di Leone X." In *Congiure e conflitti: L'affermazione della signoria pontificia su Roma nel Rinascimento: politica, economia e cultura*, ed. M. Chiabò et al., 17–432. Rome, 2013.

Cavicchi, Filippo. "Una vendetta dell'Equicola." *Giornale storico della letteratura italiana* 37 (1901): 94–8.

Celenza, Christopher S. *Renaissance Humanism and the Papal Curia: Lapo da Castiglionchio the Younger's* De curiae commodis. Ann Arbor, 1999.

Cellauro, Louis. "The Casino of Pius IV in the Vatican." *Papers of the British School at Rome* 63 (1995): 183–214.

——— "Iconographical Aspects of the Renaissance Villa and Garden: Mount Parnassus, Pegasus and the Muses." *Studies in the History of Gardens and Designed Landscapes* 23 (2003): 42–56.

Cesarini Martinelli, Lucia, ed. *Commento inedito alle* Selve *di Stazio di Poliziano*, vol. 5, Studi e testi (Istituto nazionale di studi sul Rinascimento). Florence, 1978.

——— "Un ritrovamento Polizianesco: il fascicolo perduto del commento alle *Selve* di Stazio." *Rinascimento* 22 (1982): 183–212.

——— "Poliziano e Stazio: un commento umanistico." In *Il Poliziano Latino: Atti del convegno, Lecce, 1994*, ed. Paolo Viti, 59–102. Galatina, 1996.

Charbonnier, Sarah. "Poétique de l'ekphrasis et rhétorique de l'image dans la Rome de Léon X." *Camenae* 6 (2009): 1–22.

Chastel, André. *Art et humanisme à Florence au temps de Laurent le Magnifique*. Paris, 1959.

——— *The Sack of Rome*. Princeton, 1983.

Christian, Kathleen Wren. "From Ancestral Cults to Art: The Santacroce Collection of Antiquities." *Annali della Scuola normale superiore di Pisa. Classe di lettere e filosofia* Series IV, 14 (2002): 255–72.

Empire without End: Antiquities Collections in Renaissance Rome, c. 1350–1527. London, 2010.

"The Multiplicity of the Muses: The Reception of Antique Images of the Muses in Italy, 1400–1600." In *The Muses and their Afterlife in Post-Classical Europe,* ed. Claudia Wedepohl, Kathleen W. Christian, and Clare E. L. Guest, 103–53. London and Turin, 2014.

Cieri Via, Claudia. "Villa Madama: una residenza 'solare' per i Medici a Roma." In *Roma nella svolta tra quattro e cinquecento,* ed. Stefano Colonna, 349–74. Rome, 2004.

Cipriani, Giovanni. *Il mito etrusco nel Rinascimento fiorentino.* Florence, 1980.

Ciseri, Ilaria. *L'ingresso trionfale di Leone X in Firenze nel 1515.* Florence, 1990.

Clarke, Georgia. *Roman House – Renaissance Palaces: Inventing Antiquity in Fifteenth-Century Italy.* Cambridge, 2003.

Clarke, Georgia, and Paul Crossley, eds. *Architecture and Language: Constructing Identity in European Architecture, c. 1000–1650.* Cambridge, 2000.

Clough, Cecil H. "Ludovico degli Arrighi's contact with Raphael and with Machiavelli." *Bibliofilia* 75 (1973): 294–306.

"Ludovico degli Arrighi and Raphael." *Journal of the Society for Italic Handwriting* 79 (1974): 13–16.

"A Manuscript of Paolo Giovio's *Historiae sui Temporis* Liber VII. More Light on Ludovico degli Arrighi." *Book Collector* 38 (1989): 27–59.

Clüver, Claus, Matthijs Engelberts, and Véronique Plesch, eds. *The Imaginary: Word and Image/L'imaginaire: text et image.* Leiden, 2015.

Coffin, David. *The Villa d'Este at Tivoli.* Princeton, 1960.

"The Plans of the Villa Madama." *Art Bulletin* 49 (1967): 111–22.

The Villa in the Life of Renaissance Rome. Princeton, 1979.

Gardens and Gardening in Papal Rome. Princeton, 1991.

Coleman, Kathleen M. *Statius: Silvae IV.* Oxford, 1988.

"Mythological Figures as Spokespersons in Statius' *Silvae.*" In *Im Spiegel des Mythos: Bilderwelt und Lebenswelt/Lo specchio del mito: immaginario e realtà,* 67–80. Wiesbaden, 1999.

Colomina, Beatriz. "Collaborations: The Private Life of Modern Architecture." *Journal of the Society of Architectural Historians* 58 (1999): 462–71.

Cordellier, Dominique, and Bernadette Py. *Raphael: son atelier, ses copistes;* vol. 5, *Inventaire général des dessins italiens.* Paris, 1992.

Cornini, Guido, ed. *Raphael in the Apartments of Julius II and Leo X.* Milan, 1993.

Cosenza, Mario Emilio. *Biographical and Bibliographical Dictionary of the Italian Humanists and of the World of Classical Scholarship in Italy, 1300–1800.* Boston, MA, 1962.

Cox-Rearick, Janet. *Dynasty and Destiny in Medici Art: Pontormo, Leo X, and the Two Cosimos.* Princeton, 1984.

Cropper, Elizabeth. "On Beautiful Women. Parmigianino, Petrarchism, and the Vernacular Style." *Art Bulletin* 58 (1976): 374–94.

Cruciani, Fabrizio. *Il Teatro del Campidoglio e le feste romane del 1513.* Milan, 1969.

Cummings. Anthony M. *The Politicized Muse: Music for Medici Festivals, 1512–1537.* Princeton, 1992.

The Lion's Ear: Pope Leo X, the Renaissance Papacy, and Music. Ann Arbor, 2012.

Curran, Brian A. *The Egyptian Renaissance: The Afterlife of Ancient Egypt in Early Modern Italy.* Chicago, 2007.

Curtius, Ernst Robert. *European Literature and the Latin Middle Ages,* trans. Willard R. Trask. New York, 1953.

D'Amico, John. *Renaissance Humanism in Papal Rome: Humanists and Churchmen on the Eve of Reformation.* Baltimore, 1983.

Dacos, Nicole. *Le Logge di Raffaello.* Rome, 1986.

Daly Davis, Margaret. "'Opus Isodomum' at the Palazzo della Cancelleria. Vitruvian Studies and Archaeological and Antiquarian Interests at the Court of Raffaele Riario." In *Roma, centro ideale della cultura dell'antico nei secoli XV e XVI*, ed. Silvia Danesi Squarzina, 442–57. Milan, 1989.

"I geroglifici in marmo di Pierio Valeriano." *Labyrinthos* 17/18 (1990): 47–77.

Danesi Squarzina, Silvia, ed. *Roma, centro ideale della cultura dell'antico nei secoli XV e XVI*. Milan, 1989.

Davies, Paul, and David Hemsoll. "Sanmicheli's Architecture and Literary Theory." In *Architecture and Language: Constructing Identity in European Architecture, c. 1000–c.1650*, ed. Georgia Clarke and Paul Crossley, 102–17. Cambridge, 2000.

De Beer, Susanna. *The Poetics of Patronage: Poetry as Self-Advancement in Giannantonio Campano*. Turnhout, 2013.

De Caprio, Vincenzo. "Intellettuali e mercato del lavoro nella Roma medicea." *Studi romani* 29.1 (1981): 29–46.

"L'area umanistica romana (1513–1527)." *Studi romani* 29.3/4 (1981): 321–35.

"I cenacoli umanistici." In *Letteratura italiana: iIl letterato e le istituzioni*, ed. Alberto Asor Rosa, 799–822. Turin, 1982.

De Divitiis, Bianca. "Giovanni Pontano and his Idea of Patronage." In *Some Degree of Happiness: studi di storia dell'architettura in onore di Howard Burns*, ed. Maria Beltramini and Caroline Elam, 107–31. Pisa, 2010.

"PONTANVS FECIT: Inscriptions and Artistic Authorship in the Pontano Chapel." *California Italian Studies* 3 (2012): 1–36.

"Giuliano da Sangallo in the Kingdom of Naples: Architecture and Cultural Exchange." *Journal of the Society of Architectural Historians* 74 (2015): 152–78.

De Grazia, Diane. *Bertoia, Mirola, and the Farnese Court*. Bologna, 1991.

De Jong, Jan. *The Power and the Glorification: Papal Pretensions and the Art of Propaganda in the Fifteenth and Sixteenth Centuries*. University Park, PA, 2013.

De Neef, A. Leigh. "Epideictic Rhetoric and the Renaissance Lyric." *Journal of Medieval and Renaissance Studies* 3 (1973): 203–31.

De Vivo, Filippo, and Brian Richardson, Preface to special edition of *Italian Studies* 66 (2011): 157–60.

Del Lungo, Isidoro, ed. *Prose volgari inedite e poesie latine e greche edite e inedite di Angelo Ambrogini Poliziano*. Florence, 1867.

ed. *Angelo Poliziano: le selve e la strega: prolusioni nello studio fiorentino (1482–1492)*. Florence, 1925.

Delaborde, Henri. *Marc-Antoine Raimondi: étude historique et critique suivie d'un catalogue raisonné des œuvres du maître*. Paris, 1888.

Della Torre, S. "L'inedita opera prima di Paolo Giovio ed il museo: l'interesse di un umanista per il tema della villa." In *Atti del convegno Paolo Giovio: il Rinascimento e la memoria, Como, 1983*, 283–301. Como, 1985.

Dempsey, Charles. *The Portrayal of Love: Botticelli's Primavera and Humanist Culture at the Time of Lorenzo the Magnificent*. Princeton, 1992.

Denhaene, Godelieve. *Lambert Lombard: Renaissance et humanisme à Liège*. Anvers, 1990.

ed. *Lambert Lombard: peintre de la Renaissance, Liège 1505/06–1566*, Exh. Cat. Brussels, 2006.

Dewar, Michael. "Blosio Palladio and the *Silvae* of Statius." *Studi umanistici piceni* 10 (1990): 59–64.

"Encomium of Agostino Chigi and Pope Julius II in the *Suburbanum Augustini Chisii* of Blosio Palladio." *Res publica litterarum* 14 (1991): 61–8.

Dewez, Guy. "La Villa Madama: peut-on imaginer l'œuvre de Raphael?" In *Archives et histoire de l'architecture. Actes du colloque, Paris, 1988*, ed. Pierre Joly, 304–23. Paris, 1990.

Villa Madama: A Memoir Relating to Raphael's Project. London, 1993.

Di Cesare, Mario A. *Vida's* Christiad *and Vergilian Epic*. New York, 1964.

Di Teodoro, Francesco Paolo. *Ritratto di Leone X di Raffaello Sanzio*. Milan, 1998.

Raffaello, Baldassar Castiglione e la lettera a Leone X: "con lo aiuto tuo mi sforcero vendicare dalla

morte quel poco che resta … ". San Giorgio di Piano (Bologna), 2003.

Dinkler, Erich. *Der Einzug in Jerusalem: ikonographische Untersuchungen im Anschluss an ein bisher unbekanntes Sarkophagfragment.* Opladen, 1970.

Dionisotti, Carlo. "Calderini, Poliziano e altri." *Italia medioevale e umanistica* 11 (1968): 151–86.

Döring, Marina. "La nascita della rovina artificiale nel Rinascimento italiano, ovvero il 'Tempio in rovina' di Bramante a Genazzano." In *Donato Bramante: ricerche, proposte, riletture*, ed. Francesco Paolo Di Teodoro, 343–406. Urbino, 2001.

Donato, M. "Gli eroi romani tra storia ed 'exemplum'. I primi cicli umanistici di Uomini Famosi." In *Memoria dell'antico nell'arte italiana*, ed. Salvatore Settis, 97–152. Turin, 1985.

D'Onofrio, Cesare. *Visitiamo Roma nel quattrocento: la città degli umanisti.* Rome, 1989.

D'Ossat, Guglielmo de Angelis. "Giuliano da Sangallo e Villa Madama." *Bollettino del Centro internazionale di studi di architettura Andrea Palladio* 15 (1973): 89–106.

DuBois, Page. *History, Rhetorical Description and the Epic from Homer to Spenser.* Cambridge, 1982.

Du Prey, Pierre de la Ruffinière. *The Villas of Pliny from Antiquity to Posterity.* Chicago, 1994.

Duchesne, Louis. "Notes sur la topographie de Rome au moyen-âge, I: Templum Romae, Templum Romuli." In *Scripta minora: études de topographies romaine et de géographie ecclésiastique*, 3–15. Rome, 1973.

Dunbabin, Katherine M. D. "Convivial Spaces: Dining and Entertainment in the Roman Villa." *Journal of Roman Archaeology* 9 (1996): 66–80.

Dunston, John. "Studies in Domizio Calderini." *Italia medioevale e umanistica* 11 (1968): 71–150.

Dyer, Joseph. "Roman Processions of the Major Litany (*litaniae maiores*) from the Sixth to the Twelfth Century." In *Roma Felix: Formation and Reflections of Medieval Rome*, ed. Éamonn Ó Carragáin and Carol Neuman de Vegvar, 112–37. Aldershot, 2007.

Dykmans, Marc, S.J. "Du Monte Mario à l'escalier de Saint-Pierre de Rome." *Mélanges d'archéologie et d'histoire* 80 (1968): 547–94.

Ebert-Schifferer, Sybille. "Ripandas Kapitolinischer Freskenzyklus und die Selbstdarstellung der Konservatoren um 1500," *Römisches Jahrbuch für Kunstgeschichte (Jahrbuch der Bibliotheca Hertziana)* 23/24 (1988): 76–218.

Edwards, Catharine. *Writing Rome: Textual Approaches to the City.* Cambridge, 1996.

Eiche, Sabine. "A New Look at Three Drawings for Villa Madama and Some Related Images." *Mitteilungen des Kunsthistorischen Institutes in Florenz* 36.3 (1992): 275–86.

Eisenstein, Sergei. *Film Sense.* New York, 1942.

Elam, Caroline. "The Raphael Conference in Rome." *Burlington Magazine* 125 (1983): 437–9.

 "Art and diplomacy in Renaissance Florence." *Journal of the Royal Society of Arts* 136 (1988): 813–26.

 "Drawings as Documents: The Problem of the San Lorenzo Façade." *Studies in the History of Art* 33 (1992): 98–114.

 "Michelangelo and the Clementine Architectural Style." In *The Pontificate of Clement VII: History, Politics, Culture*, ed. Kenneth Gouwens and Sheryl E. Reiss, 199–226. Aldershot, 2005.

 "'Tuscan Dispositions': Michelangelo's Florentine Architectural Vocabulary and its Reception." *Renaissance Studies* 19.1 (2005): 46–82.

 "Bernardo Bembo and Leonardo's *Ginevra de' Benci*: A Further Suggestion." In *Pietro Bembo e le arti*, ed. Guido Beltramini, Howard Burns, and Davide Gasparotto, 407–20. Venice, 2013.

Elet, Yvonne. "Papal *villeggiatura* in Early Modern Rome: Poetry, Spoils, and Stucco at Raphael's Villa Madama." Ph.D. diss., New York University, 2007.

 "Raphael and the Roads to Rome. Designing for Diplomatic Encounters at Villa Madama." *I Tatti Studies in the Italian Renaissance* 19 (2016): 143–75.

 "Writing the Renaissance Villa." In *WritingPlace: Investigations in Architecture and*

Literature, ed. Klaske Havik, Susana Oliveira, and Mark Proosten, 74–86. Rotterdam, 2016.

Ellis, Simon P. "Power, Architecture, and Decor: How the Late Roman Aristocrat Appeared to his Guests." In *Roman Art in the Private Sphere: New Perspectives on the Architecture and Decor of the Domus, Villa, and Insula*, ed. Elaine K. Gazda, 117–34. Ann Arbor, 1991.

Emison, Patricia. *Creating the "Divine" Artist, from Dante to Michelangelo*. Leiden and Boston, 2004.

Eörsi, Anna K. "Lo studiolo di Leonello d'Este e il programma di Guarino da Verona." *Acta historiae artium Academiae scientiarum hungaricae* 21 (1976): 15–52.

Eriksen, Roy. *The Building in the Text: From Alberti to Shakespeare and Milton*. University Park, PA, 2001.

Eubel, Conrad. *Hierarchia catholica medii et recentioris aevi*, 4 vols. Regensberg, 1923.

Evans, Mark, Clare Browne, and Arnold Nesselrath, eds. *Raphael: Cartoons and Tapestries for the Sistine Chapel*. London, 2010.

Fabiani Giannetto, Raffaella. *Medici Gardens: From Making to Design*. Philadelphia, 2008.

Fabricius Hansen, Maria. "Out of Time: Ruins as Places of Remembering in Italian Painting ca. 1500." In *Memory and Oblivion: Proceedings of the XXIXth International Congress of the History of Art held in Amsterdam, 1996*, 795–802. Dordrecht, 1999.

Fagiolo dell'Arco, Maurizio. "La Basilica Vaticana come tempio-mausoleo 'Inter duas metas'. Le idee e i progetti di Alberti, Filarete, Bramante, Peruzzi, Sangallo e Michelangelo." In *Antonio da Sangallo il Giovane: la vita e l'opera. Atti del XXII Congresso di storia dell'architettura; Roma, 19–21 febbraio 1986*, ed. Gianfranco Spagnesi, 187–210. Rome, 1986.

Fairbank, Alfred. "Another Arrighi Manuscript Discovered." *Book Collector* 20 (1971): 332–4.

Falk, Tilman. "Studien zür Topographie und Geschichte der Villa Giulia in Röm." *Römisches Jahrbuch für Kunstgeschichte* 13 (1971): 101–78.

Fanelli, Vittorio. "Il ginnasio greco di Leone X a Roma." *Studi romani* 9 (1961): 379–93.

Farago, Claire. "The Classification of the Visual Arts in the Renaissance." In *The Shapes of Knowledge from the Renaissance to the Enlightenment*, ed. Donald R. Kelley and Richard H. Popkin, 23–48. Dordrecht, 1991.

Favro, Diane. "The Roman Forum and Roman Memory." *Places* 5 (1988): 17–24.

——. *The Urban Image of Augustan Rome*. Cambridge, 1996.

Fehl, Philipp P. "Raphael as a Historian: Poetry and Historical Accuracy in the Sala di Costantino." *Artibus et historiae* 14 (1993): 9–76.

Ferrajoli, Alessandro. *La congiura dei cardinali contro Leone X*, Miscellanea della R. società romana di storia di patria 7. Rome, 1919–20.

——. *Il ruolo della corte di Leone X (1514–16)*, ed. Vincenzo De Caprio. Rome, 1984.

Findlen, Paula. "The Museum: Its Classical Etymology and Renaissance Geneaology." *Journal of the History of Collections* 1 (1989): 59–78.

Fleming, Juliet. *Graffiti and the Writing Arts of Early Modern England*. London, 2001.

Fletcher, Jennifer. "Bernardo Bembo and Leonardo's portrait of Ginevra de' Benci." *Burlington Magazine* 131 (1989): 811–16.

Floriani, Pietro. *Bembo e Castiglione: studi sul classicismo del cinquecento*. Rome, 1976.

Floriani Squarciapino, M. *I pannelli decorativi del tempio di Venere Genitrice*. Ser. 8, vol. 2, fasc. 2, Atti dell'Accademia nazionale dei Lincei: memorie, classe di scienze morali, storiche e filologiche. Rome, 1948–50.

Folena, Daniela Goldin. "Lessico melodrammatico verdiano." In *Le parole della musica*, ed. Maria Teresa Muraro, 227–53. Florence, 1995.

Foster, Philip E. "Raphael on the Villa Madama: the text of a lost letter." *Römisches Jahrbuch für Kunstgeschichte* 11 (1967–8): 308–12.

——. *A Study of Lorenzo de' Medici's Villa at Poggio a Caiano*. New York, 1978.

Fowler, Alastair. "Georgic and Pastoral: Laws of Genre in the Seventeenth Century." In *Culture and Cultivation in Early Modern England: Writing and the Land*, ed. Michael

Leslie and Timothy Raylor, 81–8. Leicester, 1992.

Francini, Carlo. "L'udienza della Sala Grande di Palazzo Vecchio." In *Baccio Bandinelli: scultore e maestro (1493–1560)*, Exh. Cat., ed. Detlef Heikamp and Beatrice Paolozzi Strozzi, 202–11. Florence, 2014.

Frapiselli, Luciana. *Presenze di grandi a Monte Mario: all'ombra di un antico pino*. Rome, 1979.

Monte Mario: finestra su Roma. Rome, 1998.

La via francigena nel Medioevo da Monte Mario a San Pietro. Rome, 2003.

Frascari, Marco, Jonathan Hale, and Bradley Starkey, eds. *From Models to Drawings: Imagination and Representation in Architecture*. London, 2007.

Freedman, Luba. *The Classical Pastoral in the Visual Arts*. New York, 1989.

Friedländer, Paul, ed. *Johannes von Gaza, Paulus Silentiarius und Prokopios von Gaza: Kunstbeschreibungen justinianischer Zeit*. Hildesheim, 1969.

Frommel, Christoph Luitpold. *Die Farnesina und Peruzzis architektonisches Frühwerk*. Berlin, 1961.

"Bramantes 'Ninfeo' in Genazzano." *Römisches Jahrbuch für Kunstgeschichte* 12 (1969): 137–60.

"La Villa Madama e la tipologia della villa romana nel cinquecento." *Bollettino del Centro internazionale di studi di architettura Andrea Palladio* 11 (1969): 47–64

Der römische Palastbau der Hochrenaissance. Berlin, 1973.

"Raffaello e il teatro alla corte di Leone X." *Bollettino del Centro internazionale di studi di architettura Andrea Palladio* 16 (1974): 173–87.

"Die architektonische Planung der Villa Madama." *Römisches Jahrbuch für Kunstgeschichte* 15 (1975): 59–87.

"Die Peterskirche unter Papst Julius II im Licht neuer Dokumente." *Römisches Jahrbuch für Kunstgeschichte* 16 (1976): 241–309.

"Villa Madama." In *Raffaello architetto*, ed. Christoph Luitpold Frommel, Stefano Ray, and Manfredo Tafuri, 311–22. Milan, 1984.

"Raffael und Antonio da Sangallo der Jungere." In *Raffaello a Roma: Atti del convegno, 1983*, 261–304. Rome, 1986.

"Le opere romane di Giulio." In *Giulio Romano*, 97–133. Milan, 1989.

"La restitution des edifices de la Renaissance: problèmes de crédibilité." In *Archives et histoire de l'architecture. Actes du colloque, Paris, 1988*, ed. Pierre Joly, 285–304. Paris, 1990.

"Il cantiere di S. Pietro prima di Michelangelo." In *Les chantiers de la Renaissance*, ed. Jean Guillaume, 175–90. Tours, 1991.

"Raffaello e gli ordini architettonici." In *L'emploi des ordres à la Renaissance: Actes du colloque de Tours, 1986*, ed. Jean Guillaume, 119–36. Paris, 1992.

"St. Peter's: The Early History." In *Renaissance Architecture from Brunelleschi to Michelangelo: The Representation of Architecture*, ed. Henry A. Millon and Vittorio Magnago Lampugnani, 399–423. Milan, 1994.

"The Endless Construction of St. Peter's: Bramante and Raphael." In *Renaissance Architecture from Brunelleschi to Michelangelo: The Representation of Architecture*, ed. Henry A. Millon and Vittorio Magnago Lampugnani, 598–631. Milan, 1994.

"Introduction. Antonio da Sangallo the Younger and the Practice of Architecture in the Renaissance." In *The Architectural Drawings of Antonio da Sangallo the Younger and his Circle*, vol. 2, *Churches, Villas, the Pantheon, Tombs, and Ancient Inscriptions*, ed. Christoph Luitpold Frommel and Nicholas Adams, 1–21. New York and Cambridge, MA, 1994.

"Raffaele Riario committente della Cancelleria." In *Arte, committenza ed economia a Roma e nelle corti del Rinascimento*, ed. Christoph Luitpold Frommel and Arnold Esch, 197–211. Turin, 1995.

"Raffaello e Antonio da Sangallo il Giovane." In *Architettura del Rinascimento alla corte papale*, ed. Christoph Luitpold Frommel, 280–97. Milan, 2003.

Frommel, Christoph Luitpold, and Nicholas Adams, eds. *The Architectural Drawings of Antonio da Sangallo the Younger and his Circle*, vol. 2, *Churches, Villas, the Pantheon, Tombs,*

and Ancient Inscriptions. New York and Cambridge, MA, 1994.

Frommel, Christoph Luitpold, Stefano Ray, and Manfredo Tafuri, eds. *Raffaello architetto*, Exh. Cat. Milan, 1984.

Fusco, Annarosa Cerutti. "Teatro all'antica e teatro Vitruviano nell'interpretazione di Antonio da Sangallo il Giovane." In *Antonio da Sangallo il Giovane: la vita e l'opera*, ed. Gianfranco Spagnesi, 455–69. Rome, 1986.

Fusco, Laurie, and Gino Corti. "Giovanni Ciampolini (d. 1505), a Renaissance Dealer in Rome and his Collection of Antiquities." *Xenia* 21 (1991): 1–46.

Gaisser, Julia Haig. "The Rise and Fall of Goritz's Feasts." *Renaissance Quarterly* 48 (1995): 41–57.

Pierio Valeriano on the Ill Fortune of Learned Men: A Renaissance Humanist and his World. Ann Arbor, 1999.

"Seeking Patronage under the Medici Popes: A Tale of Two Humanists." In *The Pontificate of Clement VII: History, Politics, Culture*, ed. Kenneth Gouwens and Sheryl E. Reiss, 293–309. Aldershot, 2005.

"The Mirror of Humanism: Self-reflection in the Roman Academy." In *On Renaissance Academies: Proceedings of the International Conference "From the Roman Academy to the Danish Academy in Rome,"* ed. Marianne Pade, 122–32. Rome, 2011.

Galand-Hallyn, Perrine. *Le reflet des fleurs: description et métalangage poétique d'Homère à la Renaissance.* Geneva, 1994.

Les yeux de l'éloquence: poétiques humanistes de l'évidence. Orléans, 1995.

"Quelques coincidences (paradoxales?) entre *L'Épître aux Pisons* d'Horace et la poétique de la *silve* (au début du XVIe siècle en France)." *Bibliothèque d'humanisme et Renaissance* 60 (1998): 609–39.

"Aspects du discours humaniste sur la villa au XVIe siècle." In *La villa et l'univers familial de l'Antiquité à la Renaissance*, ed. Perrine Galand-Hallyn and Carlos Lévy, 117–43. Paris, 2008.

Galand-Hallyn, Perrine, and Carlos Lévy, eds. *La villa et l'univers familial dans l'Antiquité et à la Renaissance.* Paris, 2008.

Galinsky, Karl. *Memoria Romana* project: www .utexas.edu/research/memoria/.

Garnett, R. "A Laureate of Caesar Borgia." *English Historical Review* 17 (1902): 15–19.

Gattoni da Camogli, Maurizio. *Leone X e la geopolitica dello Stato Pontificio, 1513–1521.* Città del Vaticano, 2000.

Geronimus, Dennis V. *Setting Sail for the Vulcan Isle: Piero di Cosimo's Jason and Queen Hypsipyle with the Women of Lemnos and its Companion Scenes.* New York, 2005.

Geymüller, Heinrich von. *Raffaello studiato come architetto.* Milan, Naples and Pisa, 1884.

Geyssen, John W. *Imperial Panegyric in Statius: A Literary Commentary on* Silvae *1.1.* Frankfurt, 1996.

Ghatan, Maia Wellington. "Michelangelo and the Tomb of Time: The Intellectual Context of the Medici Chapel." In *Studi di storia dell'arte*, 59–124. Todi, 2002.

Gilbert, Creighton. *Italian Art 1400–1500: Sources and Documents.* Evanston, IL, 1980.

Gilbert, Felix. "Bernardo Rucellai and the Orti Oricellari: A Study on the Origin of Modern Political Thought." *Journal of the Warburg and Courtauld Institutes* 12 (1949): 101–31.

Glodzik, Jeffrey. "Vergilianism in Early Cinquecento Rome: Egidio Gallo and the Vision of Roman Destiny." *Sixteenth Century Journal* 45 (2014): 73–98.

Gnoli, Domenico. "Orti letterari nella Roma di Leone X." *Nuova Antologia* 65 (1930): 3–19, 137–48.

La Roma di Leon X. Milan, 1938.

Godman, P. *From Poliziano to Machiavelli: Florentine Humanism in the High Renaissance.* Princeton, 1998.

Goethert, Friedrich Wilhelm. "Trajanische Friese." *Jahrbuch des Deutschen Archäologischen Instituts* 51 (1936): 72–81.

Goffi, Federica. *Time Matter(s): Invention and Re-imagination in Built Conservation. The Unfinished Drawing and Building of St. Peter's, The Vatican.* Farnham, 2013.

Gombrich, Ernst H. "The Early Medici as Patrons of Art: A Survey of Primary Sources." In *Italian Renaissance Studies*, ed. E. F. Jacob, 279–311. London, 1960.

"Renaissance and Golden Age." *Journal of the Warburg and Courtauld Institutes* 24 (1961): 306–9.

"Alberto Avogadro's Descriptions of the Badia of Fiesole and of the Villa of Careggi." *Italia medioevale e umanistica* 5 (1962): 217–29.

Gouwens, Kenneth. "Perceiving the Past: Renaissance Humanism after the 'Cognitive Turn'." *American Historical Review* 103 (1998): 55–82.

Remembering the Renaissance: Humanist Narratives of the Sack of Rome. Leiden, 1998.

"L'umanesimo al tempo di Pierio Valeriano: la cultura locale, la fama, e la *Respublica litterarum* nella prima metà del cinquecento." In *Bellunesi e Feltrini tra umanesimo e Rinascimento: filologia, erudizione e biblioteche,* ed. Paolo Pellegrini, 3–10. Rome, 2006.

Grafton, Anthony. *Leon Battista Alberti: Master Builder of the Italian Renaissance.* New York, 2000.

Worlds Made by Words: Scholarship and Community in the Modern West. Cambridge, MA, 2009.

Gravelle, Sarah Stever. "Humanist Attitudes to Convention and Innovation in the Fifteenth Century." *Journal of Medieval and Renaissance Studies* 11 (1981): 193–209.

Greene, Thomas M. "The Double Task of the Humanist Imagination." In *Rome in the Renaissance: The City and the Myth*, ed. P. A. Ramsey, 41–54. Binghamton, 1982.

Guasti, Cesare. *I Manoscritti Torrigiani donati al R. Archivio di Stato di Firenze.* Florence, 1878.

Günther, Hubertus. "Raffaels Romplan." *Sitzungsberichte der Kunstgeschichtlichen Gesellschaft zu Berlin* 31 (1982/83): 12–15.

"Die Straßenplanung unter den Medici-Päpsten in Rom (1513–1534)." *Jahrbuch des Zentralinstituts für Kunstgeschichte* (1985): 237–93.

Guerrini, Lucia. *Marmi antichi nei disegni di Pier Leone Ghezzi.* Città del Vaticano, 1971.

Guest, Clare E. L. "*Varietas, poikilia* and the *silva* in Poliziano." *Hermathena* 183 (2007): 9–48.

Gundersheimer, Werner L. *Art and Life at the Court of Ercole I d'Este: The* De triumphis religionis *of Giovanni Sabadino degli Arienti.* Geneva, 1972.

Gwynne, Paul. *Patterns of Patronage in Renaissance Rome. Francesco Sperulo: Poet, Prelate, Soldier, Spy.* 2 vols. Bern, 2015.

Haar, James. *Essays on Italian Poetry and Music in the Renaissance, 1350–1600.* Berkeley, 1986.

Habel, Dorothy Metzger. *When all of Rome was under Construction: The Building Process in Baroque Rome.* University Park, PA, 2013.

Hankins, James. "Humanist Crusade Literature in the Age of Mehmed II." *Dumbarton Oaks Papers* 49 (1995): 111–207.

Humanism and Platonism in the Italian Renaissance. Rome, 2003.

"Exclusivist Republicanism and the Non-monarchical Republic." *Political Theory* 38 (2010): 452–82.

Hanning, Robert W. "Castiglione's Verbal Portrait: Structures and Strategies." In *Castiglione: The Ideal and the Real in Renaissance Culture*, ed. Robert W. Hanning and David Rosand, 131–41. New Haven, 1983.

Hardie, Alex. *Statius and the Silvae: Poets, Patrons and Epideixis in the Graeco-Roman World.* Liverpool, 1983.

Hardison, O. B. *The Enduring Monument: A Study of the Idea of Praise in Renaissance Literary Theory and Practice.* Chapel Hill, 1962.

Haskell, Francis, and Nicholas Penny. *Taste and the Antique: The Lure of Classical Sculpture 1500–1900.* New Haven, 1982.

Hatfield, Rab. "Some Unknown Descriptions of the Medici Palace in 1459." *Art Bulletin* 52 (1970): 232–49.

Havik, Klaske. *Urban Literacy: Reading and Writing Architecture.* Rotterdam, 2014.

Heffernan, James A. W. *Museum of Words: The Poetics of Ekphrasis from Homer to Ashbery.* Chicago, 1993.

Hegener, Nicole. "Clemens curavit, Bandinellus restauravit. Der Flußgott Arno im Statuenhof des vatikanischen Belvedere." In *Zentren*

und Wirkungsräume der Antikerezeption: zur Bedeutung von Raum und Kommunikation für die neuzeitliche Transformation der griechisch-römischen Antike, ed. Kathrin Schade and Detlef Rößler, 177–99. Münster, 2007.

DIVI IACOBI EQVES: Selbstdarstellung im Werk des florentiner Bildhauers Baccio Bandinelli. Munich and Berlin, 2008.

Hemsoll, David. "A Question of Language. Raphael, Michelangelo and the Art of Architectural Imitation." In *Raising the Eyebrow: John Onians and World Art Studies: An Album Amicorum in his Honour*, ed. Lauren Golden and Martin Kemp, 123–31. Oxford, 2001.

"Raphael's New Architectural Agenda." In *Imitation, Representation and Printing in the Italian Renaissance*, ed. Roy Eriksen and Magne Malmanger, 209–31. Pisa and Rome, 2009.

Henry, Tom, and Paul Joannides. "Raphael and his Workshop between 1513 and 1525: 'per la mano di maestro Rafaello e Joanne Francesco e Giulio sui discepoli." In *Late Raphael*, Exh. Cat. ed. Tom Henry and Paul Joannides, 17–85. Madrid, 2012.

eds. *Late Raphael*, Exh. Cat. Madrid, 2012.

Henry, Tom, and Carol Plazzota. "Raphael: From Urbino to Rome." In *Raphael from Urbino to Rome*, Exh. Cat, ed. Hugo Chapman, Tom Henry, and Carol Plazzotta, 15–65. London, 2004.

Herbert, Gilbert, and Mark Donchin, eds. *The Collaborators: Interactions in the Architectural Design Process*. Farnham, 2013.

Hersey, George. "Water-Works and Water-Play in Renaissance Naples." In *Fons Sapientiae: Renaissance Garden Fountains*, ed. E. MacDougall, 61–83. Washington, DC, 1978.

Higginbotham, James. *Piscinae: Artificial Fishponds in Roman Italy*. Chapel Hill, 1997.

Hochmann, Michel. "L'*ekphrasis* efficace. L'influence des programmes iconographiques sur les peintures et le décors italiens au XVIᵉ siècle." In *Peinture et rhétorique. Actes du colloque de l'Académie de France à Rome*, ed. Olivier Bonfait, 43–76. Paris, 1994.

Hochmann, Michel, Julian Kliemann, Philippe Morel, and Jérémie Koering, eds. *Programme et invention dans l'art de la Renaissance*. Paris, 2008.

Hoffmann, W. von. *Forschungen zur Geschichte der kurialen Behörden vom Schisma bis zur Reformation*. 2 vols. Rome, 1914.

Hofmann, Theobald. *Raffael in seiner Bedeutung als Architekt*, vol. 1, *Villa Madama zu Rom*. Zittau, 1900.

Hollander, John. "The Poetics of Ekphrasis." *Word and Image* 4 (1988): 209–19.

The Gazer's Spirit: Poems Speaking to Silent Works of Art. Chicago, 1995.

Hope, Charles. "Artists, Patrons, and Advisers in the Italian Renaissance." In *Patronage in the Renaissance*, ed. Guy Fitch Lytle and Stephen Orgel, 293–343. Princeton, 1981.

Horn, Heinz Günter. "Die antiken Steinbrüche von Chemtou Simitthus." In *Die Numider: Reiter und Könige nördlich der Sahara*, 173–80. Bonn, 1979.

Hornblower, Simon, and Antony Spawforth, eds. *The Oxford Classical Dictionary*. Oxford, 1996.

Howard, Deborah. "Seasonal Apartments in Renaissance Italy." *Artibus et historiae* 22.43 (2001): 127–35.

Hunt, John Dixon. "Garden and Theatre." In *Garden and Grove: The Italian Renaissance Garden in the English Imagination*, 59–72. Philadelphia, 1986.

Huppert, Ann C. "Envisioning New St. Peter's. Perspectival Drawings and the Process of Design." *Journal of the Society of Architectural Historians* 68 (2009): 158–77.

Ijsewijn, Jozef. "Poetry in a Roman Garden: The Coryciana." In *Latin Poetry and the Classical Tradition: Essays in Medieval and Renaissance Literature*, ed. Peter Godman and Oswyn Murray. Oxford, 1990.

ed. *Coryciana / critice edidit, carminibus extravagantibus auxit, praefatione et annotationibus instruxit, Iosephus Ijsewijn*. Rome: Herder, 1997.

"Italian Voices. Oral Culture, Manuscript and Print in Early Modern Italy, 1450–1700." http://arts.leeds.ac.uk/italianvoices/.

Jacks, Philip. "The *Simulachrum* of Fabio Calvo: A View of Roman Architecture *all'antica* in 1527." *Art Bulletin* 72 (1990): 453–81.

The Antiquarian and the Myth of Antiquity: The Origins of Rome in Renaissance Thought. Cambridge, 1993.

Jacoff, Michael. *The Horses of San Marco and the Quadriga of the Lord.* Princeton, 1993.

Janitschek, Hubert. "Ein Hofpoet Leo's X über Künstler und Kunstwerke." *Repertorium für Kunstwissenschaft* 3 (1880): 52–60.

Janson, H. W. "The 'Image Made by Chance' in Renaissance Thought." In *Sixteen Studies*, 53–74. New York, 1973.

Jeanneret, Michel. *Perpetual Motion: Transforming Shapes in the Renaissance from da Vinci to Montaigne*, trans. Nidra Poller. Baltimore, 2001.

Jimborean, Ioana. "La Loggia delle Benedizioni at St. Peter's in the Quattrocento and the Visualization of Power." In *Perspectives on Public Space in Rome, from Antiquity to the Present Day*, ed. Gregory Smith and Jan Gadeyne, 109–30. Farnham, 2013.

Jones, H. Stuart. *A Catalogue of the Ancient Sculptures Preserved in the Municipal Collections of Rome*, vol. 2, *The Sculptures of the Palazzo dei Conservatori.* Oxford, 1926.

Jones, Prudence J. *Reading Rivers in Roman Literature and Culture.* Lanham, MD, 2005.

Joost-Gaugier, Christiane. "Earliest Beginnings of the Notion of *Uomini Famosi* and the *De viris illustribus* in Greco-Roman Literary Tradition." *Artibus et historiae* 3 (1982): 97–115.

"Some Considerations on the Geography of the Stanza della Segnatura." *Gazette des Beaux-Arts* 124 (1994): 223–32.

Raphael's Stanza della Segnatura: Meaning and Invention. Cambridge, 2002.

Kahane, Ahuvia. "Introduction: Antiquity and the Ruin." *European Review of History / Revue européenne d'histoire* 18 (2011): 631–44.

"Image, Word and the Antiquity of Ruins." *European Review of History / Revue européenne d'histoire* 18 (2011): 829–50.

Kallendorf, Craig. *In Praise of Aeneas: Virgil and Epideictic Rhetoric in the Early Italian Renaissance.* Hanover and London, 1989.

Kallendorf, Hilaire, and Craig Kallendorf. "Introduction. 'Conversations with the Dead': Quevedo's Annotation and Imitation of Statius." In *Francisco de Quevedo*, Silvas, ed. Hilaire Kallendorf, 23–86. Lima, 2011.

Karmon, David. *The Ruin of the Eternal City: Antiquity and Preservation in Renaissance Rome.* Oxford, 2011.

Kemp, Martin. "Leonardo's Early Skull Studies." *Journal of the Warburg and Courtauld Institutes* 34 (1971): 115–34.

"Dissection and Divinity in Leonardo's Late Anatomies." *Journal of the Warburg and Courtauld Institutes* 35 (1972): 221–2.

"From 'Mimesis' to 'Fantasia': The Quattrocento Vocabulary of Creation, Inspiration and Genius in the Visual Arts." *Viator* 8 (1977): 347–98.

ed. *Leonardo on Painting.* New Haven, 1989.

Kempers, Bram. "Words, Images and All the Pope's Men. Raphael's Stanza della Segnatura and the Synthesis of Divine Wisdom." In *History of Concepts: Comparative Perspectives*, ed. Iain Hampsher-Monk, Karin Tilmans, and Frank van Vree, 131–65 and 264–9. Amsterdam, 1998.

"Epilogue. A Hybrid History: The Antique Basilica with a Modern Dome." In *Old Saint Peter's, Rome*, ed. Rosamond McKitterick, John Osborne, Carol M. Richardson, and Joanna Story, 386–403. Cambridge, 2013.

Kent, Dale. *Cosimo de' Medici and the Florentine Renaissance: The Patron's Oeuvre.* New Haven, 2000.

Kent, F. W. *Lorenzo de' Medici and the Art of Magnificence.* Baltimore, 2004.

Kent†, F. W., and Caroline Elam, "Piero del Massaio: Painter, Mapmaker and Military Surveyor." *Mitteilungen des Kunsthistorischen Institutes in Florenz* 67 (2015): 65–89.

Kidwell, Carol. *Pontano: Poet and Prime Minister.* London, 1991.

Kleinbub, Christian. *Vision and the Visionary in Raphael.* University Park, PA, 2011.

"Raphael's *Quos Ego*: Forgotten Document of the Renaissance Paragone." *Word and Image* 28 (2012): 287–301.

Kliemann, Julian. "*Politische und humanistiche Ideen der Medici in der Villa Poggio a Caiano.*" Ph.D. diss., Heidelberg University, 1976.

"Il pensiero di Paolo Giovio nelle pitture eseguite sulle sue 'invenzioni'." In *Paolo Giovio: il Rinascimento e la memoria*, 197–223. Como, 1985.

"Programme, Inschriften und Texte zu Bildern. Einige Bemerkungen zur Praxis in der profanen Wandmalerei des Cinquecento." In *Text und Bild, Bild und Text* (Germanistische Symposien Berichtsbände 11), 79–95. Stuttgart, 1990.

Gesta dipinte: la grande decorazione nelle dimore italiane dal quattrocento al seicento. Milan, 1993.

"Dall'invenzione al programma." In *Programme et invention dans l'art de la Renaissance*, ed. Michel Hochmann, Julian Kliemann, Philippe Morel, and Jérémie Koering, 17–26. Paris, 2008.

Koering, Jérémie. "'Intrecciamento' – Benedetto Lampridio, Giulio Romano et la poétique de la salle de Troie." *Zeitschrift für Kunstgeschichte* 75 (2012): 335–50.

Koliji, Hooman. *In-Between: Architectural Drawing and Imaginative Knowledge in Islamic and Western Traditions.* Farnham, 2015.

Kolsky, Stephen. *Mario Equicola: The Real Courtier.* Geneva, 1991.

Krautheimer, Richard. "The Panels in Urbino, Baltimore, and Berlin Reconsidered." In *The Renaissance from Brunelleschi to Michelangelo: The Representation of Architecture*, ed. Henry Millon and Vittorio Lampugnani, 233–57. Milan, 1994.

Krautheimer, Richard, and Trude Krautheimer Hess. *Lorenzo Ghiberti.* Princeton, 1982.

Kris, Ernst, and Otto Kurz. *Legend, Myth and Magic in the Image of the Artist.* New Haven, 1979.

Kristeller, Paul O. *Iter Italicum.* London and Leiden, 1963.

Künzle, P. "Raffaels Denkmal für Fedro Inghirami auf dem letzten Arazzo." In *Mélanges Eugène Tisserant*, 499–548. Rome, 1964.

Kuttner, Ann. "Prospects of Patronage: Realism and *Romanitas* in the Architectural Vistas of the 2nd Style." In *The Roman Villa: Villa Urbana. First Williams Symposium on Classical Architecture Held at the University of Pennsylvania, 1990*, ed. Alfred Frazer, 93–107. Philadelphia, 1998.

"Delight and Danger in the Roman Water Garden: Sperlonga and Tivoli." In *Landscape Design and the Experience of Motion*, ed. Michel Conan, 103–56. Washington, DC, 2003.

Laird, Andrew. "Vt figura poesis: Writing Art and the Art of Writing." In *Art and Text in Roman Culture*, ed. Jaś Elsner, 75–102. Cambridge, 1996.

Lancellotti, G. F. *Ludovici Lazzarelli septempedani Poetæ Laureati Bombyx Accesserunt ipsius aliorumque poetarum carmina.* Aesii, 1765.

Lanciani, Rodolfo. "Raccolta antiquaria di Giovanni Ciampolini." *Bullettino della Commissione archeologica comunale di Roma* 27 (1899): 101–15.

Storia degli scavi e notizie intorno alle collezioni romane di antichita. Rome, 1902–12.

Lattès, S. "Recherches sur la bibliothèque d'Angelo Colocci." *Mélanges d'archéologie et d'histoire* 48 (1931): 308–44.

Lausberg, Heinrich. *Handbook of Literary Rhetoric*, trans. Matthew T. Bliss, Annemiek Jansen, and David E. Orton. Leiden, 1998.

Lazzaro, Claudia. *The Italian Renaissance Garden: From the Conventions of Planting, Design, and Ornament to the Grand Gardens of Sixteenth-Century Central Italy.* New Haven, 1990.

"River Gods: Personifying Nature in Sixteenth-Century Italy." *Renaissance Studies* 25 (2011): 70–94.

Leach, Eleanor Winsor. *The Rhetoric of Space: Literary and Artistic Representations of Landscape in Republican and Augustan Rome.* Princeton, 1988.

Leander Touati, Anne-Marie. *Ancient Sculptures in the Royal Museum*. Stockholm, 1998.

Leatherbarrow, David, and Mohsen Mostafavi. *Surface Architecture*. Cambridge, MA, 2002.

Lee, Renssalaer W. *Ut pictura poesis: The Humanistic Theory of Painting*. New York, 1967.

Lefevre, Renato. "La 'Vigna del Cardinale de' Medici' e il vescovo d'Aquino." *Strenna dei Romanisti* 22 (1961): 171–7.

"Un prelato del '500, Mario Maffei e la costruzione di Villa Madama." *L'Urbe* 32.3 (1969): 1–11.

Villa Madama. Rome, 1973.

"Interrogativi sulla 'vigna del Papa' a Monte Mario." *Accademie e biblioteche d'Italia* 51.4–5 (1983): 259–82.

Villa Madama. Rome, 1984.

Levi D'Ancona, Mirella. *Botticelli's Primavera: A Botanical Interpretation Including Astrology, Alchemy and the Medici*. Florence, 1983.

Lillie, Amanda. "Francesco Sassetti and his Villa at La Pietra." In *Oxford, China and Italy: Writings in Honour of Sir Harold Acton on his Eightieth Birthday*, ed. Edward Chaney and Neil Ritchie, 83–93. London, 1984.

"Giovanni di Cosimo and the Villa Medici at Fiesole." In *Piero de' Medici, "il Gottoso," 1415–1469: Art in the Service of the Medici*, ed. Andreas Beyer and Bruce Boucher, 189–205. Berlin, 1993.

"The Humanist Villa Revisited." In *Language and Images of Renaissance Italy*, ed. Alison Brown, 193–215. Oxford, 1995.

"The Patronage of Villa Chapels and Oratories near Florence: A Typology of Private Religion." In *With or Without the Medici: Studies in Tuscan Art and Patronage 1434–1530*, ed. Eckhart Marchand and Alison Wright, 23–4. Aldershot, 1998.

"Cappelle e chiese delle ville Medicee ai tempi di Michelozzo." In *Michelozzo: scultore e architetto (1396–1472)*, ed. Gabriele Morolli, 89–97. Florence, 1998.

"Memory of Place: Luogo and Lineage in the Countryside." In *Art, Memory, and Family in Renaissance Florence*, ed. Giovanni Ciappelli and Patricia Rubin, 195–214. Cambridge, 2000.

"Villa Medici a Fiesole." In *Andrea Palladio e la villa veneta da Petrarca a Carlo Scarpa*, ed. Guido Beltramini and Howard Burns, 219–20. Venice, 2005.

"Fiesole: Locus amoenus or Penitential Landscape?" *I Tatti Studies: Essays in the Renaissance* 11 (2007): 11–55.

Lipstadt, Hélène. "'Exoticising the Domestic': On New Collaborative Paradigms and Advanced Design Practices." In *Architecture and Authorship*, ed. Tim Anstey, Katja Grillner, and Rolf Hughes, 164–73 and 90–1. London, 2007.

Littlewood, A. R. "Ancient Literary Evidence for the Pleasure Gardens of Roman Country Villas." In *Ancient Roman Villa Gardens: The Tenth Dumbarton Oaks Colloquium on the History of Landscape Architecture, 1987*, ed. Elisabeth Blair MacDougall, 7–30. Washington, DC, 1987.

Lord, Carla. "Raphael, Marcantonio Raimondi and Virgil." *Source* 3 (1984): 23–33.

Loskoutoff, Yvan. "Le symbolisme des *palle* Médicéennes à la Villa Madama." *Journal des Savants* (2001): 351–91.

Lowe, Kate. "An Alternative Account of the Alleged Cardinals' Conspiracy of 1517 against Pope Leo X," *Roma moderna e contemporanea* 11 (2003): 53–78.

Lugli, Giuseppe. "Nymphaea sive musaea." In *Atti del IV congresso nazionale di studi romani*, 155–68. Rome, 1938.

Roma antica: il centro monumentale. Rome, 1946.

Lytle, Guy Fitch, and Stephen Orgel, eds. *Patronage in the Renaissance*. Princeton, 1981.

MacCarthy, Ita. "Grace and the 'Reach of Art' in Castiglione and Raphael." *Word and Image* 25 (2009): 33–45.

MacDonald, William, and John Pinto. *Hadrian's Villa and its Legacy*. New Haven, 1995.

Maddison, Carol. *Apollo and the Nine: A History of the Ode*. Baltimore, 1960.

Maffei, Sonia, ed. *Paolo Giovio. Scritti d'arte: lessico ed ecfrasi*, Centro di ricerche informatiche per i beni culturali, Accademia della Crusca, Strumenti e testi 5. Pisa, 1999.

Malmanger, Magne. "Rise and Fall of the Designer." In *Imitation, Representation and Printing in the Italian Renaissance*, ed. Roy Eriksen and Magne Malmanger, 233–46. Pisa and Rome, 2009.

Mangiafesta, Maria. "Fortuna del mito di Polifemo nelle collezioni di antichità tra XV e XVII secolo." *Bollettino d'arte* 82 (1997): 13–60.

Mansfield, Elizabeth C. *Too Beautiful to Picture: Zeuxis, Myth, and Mimesis*. Minneapolis, 2007.

Manzoli, Donatella. "Ville e palazzi di Roma nelle descrizioni latine tra Rinascimento e Barocco." *Studi romani* 16 (2008): 109–66.

Marcelli, Nicoletta. *Gentile Becchi: il poeta, il vescovo, l'uomo*. Florence, 2015.

Marchini, Giuseppe. "Leonardo e le scale." *Antichità viva* 24 (1985): 180–5, 214.

Marconi, Nicoletta. *Edificando Roma Barocca: macchine, apparati, maestranze e cantieri tra XVI e XVIII secolo*. Città di Castello, 2004.

Marshall, Adam R. "Statius and the *Veteres*: *Silvae* 1.3 and the Homeric House of Alcinous." *Scholia: Natal Studies in Classical Antiquity* 18 (2009): 78–88.

"*Spectandi Voluptas*: Ecphrasis and Poetic Immortality in Statius' *Silvae* 1.1." *Classical Journal* 106.3 (2011): 321–47.

Martines, Lauro. *Society and History in English Renaissance Verse*. Oxford, 1985.

Maugan-Chemin, Valérie. "Les couleurs du marbre chez Pline l'Ancien, Martial et Stace." In *Couleurs et matières dans l'Antiquité*, ed. Agnès Rouveret, Sandrine Dubel, and Valérie Naas, 103–26. Paris, 2006.

McBride, Kari Boyd. *Country House Discourse in Early Modern England*. Burlington, VT, 2001.

McKillop, Susan Regan. *Franciabigio*. Berkeley, 1974.

McManamon, John M., S.J. "Marketing a Medici Regime: The Funeral Oration of Marcello Virgilio Adriani for Giuliano de' Medici (1516)." *Renaissance Quarterly* 44 (1991): 1–41.

Métraux, Guy P. R. "Some Other Literary Villas of Roman Antiquity besides Pliny's." In *Tributes to Pierre du Prey: Architecture and the Classical Tradition, from Pliny to Posterity*, ed. Matthew M. Reeve, 27–40. New York and Turnhout, 2014.

Meyer zur Capellen, Jürg. *Raphael: A Critical Catalogue of his Paintings, vol. 3, The Roman Portraits, ca. 1508–1520*. Landshut, 2008.

"Baldassare Castiglione and Antonio Tebaldeo – Raphael Portrays Two of his Friends." In *The Portrait of Baldassare Castiglione & the Madonna dell'Impannata Northwick: Two Studies on Raphael*, 9–32. Frankfurt, 2011.

Meyers, Gretchen E. "The Divine River: Ancient Roman Identity and the Image of Tiberinus." In *The Nature and Function of Water, Baths, Bathing, and Hygiene from Antiquity through the Renaissance*, ed. Cynthia Kosso and Anne Scott, 233–247. Leiden, 2009.

Millon, Henry A., and Vittorio Magnago Lampugnani, eds. *The Renaissance from Brunelleschi to Michelangelo: The Representation of Architecture*. Milan, 1994.

Minnich, Nelson H. "Raphael's *Portrait of Leo X with Cardinals Giulio de' Medici and Luigi de' Rossi*: A Religious Interpretation." *Renaissance Quarterly* 56 (2003): 1005–52.

Minnis, Alastair J. *The Medieval Theory of Authorship: Scholastic and Literary Attitudes in the Later Middle Ages*. Philadelphia, 2012.

Mitchell, Bonner. *Rome in the High Renaissance: The Age of Leo X*. Norman, 1973.

Mitchell, W. J. T. *Iconology: Image, Text, Ideology*. Chicago, 1987.

"Word and Image." In *Critical Terms for Art History*, ed. Robert S. Nelson and Richard Shiff, 51–61. Chicago, 1996.

Mitrović, Branko. *Serene Greed of the Eye: Leon Battista Alberti and the Philosophical Foundations of Renaissance Architectural Theory*. Berlin, 2005.

Modesti, Paola. *Le delizie ritrovate: Poggioreale e la villa del Rinascimento nella Napoli aragonese*. Florence, 2014.

Molho, Anthony. "Cosimo de' Medici: *Pater Patriae* or *Padrino*?" *Stanford Italian Review* 1 (1979): 5–33.

Moneti, Andrea. "Forma e posizione della villa degli horti Luculliani secondo i rilievi

rinascimentali: la loro influenza sui pro-getti del Belvedere e delle Ville Madama, Barbaro e Aldobrandini [part 1]." *Palladio* 12 (1993): 5–24.

Monfasani, John. "The Byzantine Rhetorical Tradition and the Renaissance." In *Renaissance Eloquence*, ed. J. J. Murphy, 174–87. Berkeley, 1983.

Montenovesi, Ottorino. "Documenti perga-menacei di Romagna nell'Archivio di Stato di Roma." In *Atti e memorie della Regia Deputazione di storia patria per le provincie di Romagna* ser. IV, XVI (1926): 71–106.

Morello, Giovanni, ed. *Raffaello e la Roma dei Papi*, Exh. Cat. Rome, 1986.

Morolli, Gabriele. *'Le belle forme degli edifici antichi': Raffaello e il progetto del primo trat-tato rinascimentale sulle antichità di Roma.* Florence, 1984.

——— "Lorenzo, Leonardo e Giuliano: da San Lorenzo al Duomo a Poggio a Caiano." *Quaderni di storia dell'architettura e restauro* 3 (1990): 5–14.

Müntz, Eugène. "Le Musée du Capitole et les autres collections romaines à la fin du XVe siècle et au commencement du XVIe siè-cle avec un choix de documents inédits." *Revue archéologique* 43 (1882): 24–37.

Müntz, M. "Les collections d'antiques formées par les Médicis au XVI siècle." *Mémoires de l'Académie des Inscriptions et Belles Lettres* 35.2 (1896): 85–168.

Myssok, Johannes. "L'udienza di Palazzo Vecchio nel contesto internazionale." In *Baccio Bandinelli: scultore e maestro (1493–1560)*, Exh. Cat, ed. Detlef Heikamp and Beatrice Paolozzi Strozzi, 212–29. Florence, 2014.

Nagel, Alexander. *The Controversy of Renaissance Art*. Chicago, 2011.

Nagel, Alexander, and Christopher S. Wood. *Anachronic Renaissance*. New York, 2010.

Napoleone, Caterina, ed., *Raphael's Dream*, trans. Simon Turner. Turin, 2007.

Nauta, Ruurd R. "Statius in the *Silvae*." In *The Poetry of Statius*, ed. Johannes J. L. Smolenaars, Harm-Jan Van Dam, and Ruurd R. Nauta, 143–74. Leiden and Boston, 2008.

Nesselrath, Arnold. "Raphael's Archeological Method." In *Raffaello a Roma: Atti del con-vegno a Roma, 1983*, 357–71. Rome, 1986.

——— "The Imagery of the Belvedere Statue Court under Julius II and Leo X." In *High Renaissance in the Vatican: The Age of Julius II and Leo X*, Exh. Cat, ed. Michiaki Koshikawa and Martha McClintock. Tokyo, 1993.

——— "L'antico vissuto. La stufetta del cardinal Bibbiena." In *Pietro Bembo e l'invenzione del Rinascimento*, ed. Guido Beltramini, Davide Gasparotto, and Adolfo Tura, 284–91. Venice, 2013.

Neudecker, Richard. *Die Skulpturen-Ausstattung römischer Villen in Italien*. Mainz am Rhein, 1988.

Newlands, Carole Elizabeth. "The Transformation of the 'Locus Amoenus' in Roman Poetry." Ph.D. diss., University of California, Berkeley, 1984.

——— *Statius'* Silvae *and the Poetics of Empire*. Cambridge, 2002.

Newmyer, Stephen Thomas. *The* Silvae *of Statius: Structure and Theme*. Leiden, 1979.

Oberhuber, Konrad. "Raffaello." In *La bottega dell'artista tra Medioevo e Rinascimento*, ed. Roberto Cassanelli, 257–74. Milan, 1998.

Oger, Cécile. "Les pratiques de copies au sein de l'atelier de Lombard." In *Lambert Lombard: peintre de la Renaissance Liège 1505/06–1566*, Exh. Cat, ed. Godelieve Denhaene, 107–12. Brussels, 2006.

O'Malley, John W. "The Vatican Library and the School of Athens: A Text of Battista Casali, 1508." *Journal of Medieval and Renaissance Studies* 7 (1977): 271–87.

——— *Praise and Blame in Renaissance Rome: Rhetoric, Doctrine and Reform in the Sacred Orators of the Papal Court, c. 1450–1521*. Durham, NC, 1979.

O'Sullivan, Timothy M. *Walking in Roman Culture*. Cambridge, 2011.

Osley, A. S. *Scribes and Sources: Handbook of the Chancery Hand in the Sixteenth Century*. Boston, MA, 1980.

Pacciani, Riccardo. "New Information on Raphael and Giuliano Leno in the

Diplomatic Correspondence of Alfonso I d'Este." *Art Bulletin* 67 (1985): 137–45.

Pagliaroli, Stefano. "Ludovico degli Arrighi." In *Studi medievali umanistici*, vol. 3, 47–79. Messina and Rome, 2005.

Pallottino, Luigi, ed. *Monte Mario tra cronica e storia: mostra di dipinti, disegni, stampe e fotographie.* Rome, 1991.

Panofsky, Erwin. *Renaissance and Renascences in Western Art.* New York, 1969.

—— "The Early History of Man in Two Cycles of Paintings by Piero di Cosimo." In *Studies in Iconology: Humanistic Themes in the Art of the Renaissance*, 33–67. New York, 1972 (originally 1939).

Panza, Pierluigi. "Quando l'architetto fa il poeta. Il Paradiso nelle liriche milanesi del Bramante, tra Alberti, Bellincioni e Leonardo." Forthcoming in the Acts of the conference *Bramante e l'architettura lombarda dell'quattrocento*, held in Milan 28–29 October 2014.

Paoletti, John T. "Fraternal Piety and Family Power: The Artistic Patronage of Cosimo and Lorenzo de' Medici." In *Cosimo "il Vecchio" de' Medici, 1389–1464*, ed. Francis Ames-Lewis, 195–219. Oxford, 1992.

Papapetros, Spyros, and Julian Rose, eds. *Retracing the Expanded Field: Encounters between Art and Architecture.* Cambridge, MA, 2014.

Partner, Peter. *The Pope's Men: Papal Civil Service in the Renaissance.* Oxford, 1990.

Partridge, Loren. "The Sala d'Ercole in the Villa Farnese at Caprarola, Part I." *Art Bulletin* 53 (1971): 467–86.

—— "The Sala d'Ercole in the Villa Farnese at Caprarola, Part II." *Art Bulletin* 54 (1972): 50–62.

—— "The Farnese Circular Courtyard at Caprarola. God, Geopolitics, Geneaology and Gender." *Art Bulletin* 83 (2001): 259–93.

Pastor, Ludwig von. *Geschichte der Päpste.* Berlin, 1907.

Pastore, Christopher. "Expanding Antiquity: Andrea Navagero and Villa Culture in the Cinquecento Veneto." Ph.D. diss., University of Pennsylvania, 2003.

Patetta, Luciano, ed. *Bramante e la sua cerchia a Milano e in Lombardia 1480–1500.* Milan, 2001.

Patterson, Annabel. *Pastoral and Ideology: From Virgil to Valéry.* Berkeley and Los Angeles, 1987.

Payne, Alina. "Architectural History and the History of Art. A Suspended Dialogue." *Journal of the Society of Architectural Historians* 58 (1999): 292–9.

—— *The Architectural Treatise in the Italian Renaissance: Architectural Invention, Ornament and Literary Culture.* Cambridge, MA, 1999.

—— "*Ut poesis architectura*: Tectonics and Poetics in Architectural Criticism circa 1570." In *Antiquity and its Interpreters*, ed. Alina Payne, Ann Kuttner, and Rebekah Smick, 145–58. Cambridge, 2000.

Payne, Alina, Ann Kuttner, and Rebekah Smick, eds. *Antiquity and its Interpreters.* Cambridge, 2000.

Pellegrini, Marco. "Leone X." In *Enciclopedia dei Papi*, vol. 2. Rome, 2000.

Percier, Charles, and P. F. L. Fontaine. *Choix des plus célèbres maisons de plaisance de Rome et de ses environs, mesurées et dessinées.* Paris, 1809.

Pérez-Gómez, Alberto. *Architecture and the Crisis of Modern Science.* Cambridge, MA, 1983.

—— *Built upon Love: Architectural Longing after Ethics and Aesthetics.* Cambridge, MA, 2006.

—— "Questions of Representation: The Poetic Origin of Architecture." In *From Models to Drawings: Imagination and Representation in Architecture*, ed. Marco Frascari, Jonathan Hale, and Bradley Starkey, 11–22. London and New York, 2007.

—— www.polyphilo.com/introduction.swf.

Perini, Giovanna. "Carmi inediti su Raffaello e sull'arte della prima metà del cinquecento a Roma e Ferrara e il mondo dei *Coryciana.*" *Römisches Jahrbuch der Bibliotheca Hertziana* 32 (1997–8): 369–407.

Perosa, Alessandro, ed. *Alexandri Braccii Carmina.* Florence, 1943.

—— *Giovanni Rucellai ed il suo zibaldone*, vol. 1, *"Il zibaldone quaresimale."* London, 1960.

Pescetti, Luigi. "Mario Maffei (1463–1537)." *Rassegna volterrana* 6 (1932): 66–91.

Petrucci, Armando. *La descrizione del manoscritto: storia, problemi, modelli.* Rome, 2001.

Pettinelli, Rosenna Alhaique. "Punti di vista sull'arte nei poeti dei Coryciana." *Rassegna della letteratura italiana* 90 (1986): 41–54.

Picotti, G. B. "La congiura dei cardinali contro Leone X." *Rivista storica italiana*, new series 1 (1923): 249–67.

——— *La giovinezza di Leone X.* Milan, 1927.

Pieraccini, Gaetano. *La stirpe de' Medici di Cafaggiolo: saggio di ricerche sulla trasmissione ereditaria dei caratteri biologici*, vol. 1. Florence, 1924.

Pinelli, Antonio. "Intenzione, invenzione, artifizio. Spunti per una teoria della ricezione dei cicli figurativi di età rinascimentale." In *Programme et invention dans l'art de la Renaissance*, ed. Michel Hochmann, Julian Kliemann, Philippe Morel, and Jérémie Koering, 27–79. Paris, 2008.

Plesch, Véronique, Catriona MacLeod, and Jans Baetens, eds. *Efficacité/Efficacy: How To Do Things with Words and Images?* Amsterdam and New York, 2011.

Pozzi, Mario, ed. *Discussioni linguistiche del cinquecento.* Turin, 1988.

Pratesi, A. "Ludovico Arrighi, detto il Vicentino." *Dizionario biografico degli Italiani* 4 (1962): 310–13.

Preimesberger, Rudolf. "Tragische Motive in Raffaels 'Transfiguration'." *Zeitschrift für Kunstgeschichte* 50 (1987): 89–115.

Prosperi, Adriano. "Clemente VII." In *Enciclopedia dei Papi.* Treccani, 2000.

Quednau, Rolf. *Die Sala di Costantino im Vatikanischen Palast: Zur Dekoration der beiden Medici-Päpste Leo X und Clemens VII.* Hildesheim and New York, 1979.

——— "Aspects of Raphael's 'Ultima Maniera' in the Light of the Sala di Costantino." In *Raffaello a Roma*, 245–55. Rome, 1986.

Quinlan-McGrath, Mary. "The Villa of Agostino Chigi: The Poems and Paintings." Ph.D. diss., University of Chicago, 1983.

——— "Aegidius Gallus, *De Viridario Augustini Chigii Vera Libellus.* Introduction, Latin Text and English Translation." *Humanistica Lovaniensia* 38 (1989): 1–99.

——— "Blosius Palladius, *Suburbanum Augustini Chisii.* Introduction, Latin Text and English Translation." *Humanistica Lovaniensia* 39 (1990): 93–156.

Quinterio, Francesco. "Il rapporto con le corti italiane e europee." In *L'architettura di Lorenzo il Magnifico*, ed. Gabriele Morolli, Cristina Acidini Luchinat, and Luciano Marchetti, 181–5. Milan, 1992.

Radcliffe, David Hill. "Sylvan States: Social and Literary Formations in Sylvae by Jonson and Cowley." *Journal of English Literary History* 55 (1988): 797–809.

Raeder, J. *Die statuarische Ausstattung der Villa Hadriana bei Tivoli.* Frankfurt-am-Main and Bern, 1983.

Rausa, Federico. "I marmi antichi di Villa Madama. Storia e fortuna." *Xenia Antiqua* 10 (2001): 155–206.

——— "Un gruppo statuario dimenticato: il ciclo delle Muse c.d. Thespiades da Villa Adriana." In *Villa Adriana: paesaggio antico e ambiente moderno: elementi di novità e ricerche in corso. Atti del Convegno, Rome, 2000*, ed. Anna Maria Reggiani, 43–51. Milan, 2002.

Ray, Stefano. "Villa Madama a Roma." *L'architettura* 14 (1969): 822–9.

——— *Raffaello architetto: linguaggio artistico e ideologia nel Rinascimento romano.* Rome, 1974.

——— "Il volo di Icaro. Raffaello architettura e cultura." In *Raffaello architetto*, ed. Christoph Luitpold Frommel, Stefano Ray, and Manfredo Tafuri, 47–58. Milan, 1984.

——— "Antonio da Sangallo il Giovane e Raffaello. I connotati di un confronto." In *Antonio da Sangallo il Giovane: la vita e l'opera. Atti del XXII Congresso di storia dell'architettura, Rome, 1986*, ed. Gianfranco Spagnesi, 43–62. Rome, 1986.

——— "Palazzo e villa: Roma, 1510–1550." In *Il palazzo dal Rinascimento a oggi: Atti del convegno, 1988*, ed. Simonetta Valtieri, 93–100. Rome, 1988.

"Raffaello architetto, la costruzione dello spazio." In *Raffaello e l'Europa*, ed. Marcello Fagiolo and Maria Luisa Madonna, 131–52. Rome, 1990.

Lo specchio del Cosmo: da Brunelleschi a Palladio: itinerario nell'architettura del Rinascimento. Rome, 1991.

Redig de Campos, Deoclecio. "Dei ritratti di Antonio Tebaldeo e di alcuni altri nel 'Parnaso' di Raffaello." *Archivio della Società romana di storia patria* 75 (1952): 1–4.

The "Stanze" of Raphael. Rome, 1968.

Reeve, M. D. "Statius' *Silvae* in the Fifteenth Century." *Classical Quarterly* n.s. 27 (1977): 202–25.

Reilly, Patricia. "Raphael's *Fire in the Borgo* and the Italian Pictorial Vernacular." *Art Bulletin* 92 (2010): 308–25.

Reiss, Sheryl E. "Cardinal Giulio de' Medici's 1520 Berlin Missal and Other Works by Matteo da Milano." *Jahrbuch der Berliner Museen* 33 (1991): 107–28.

"Cardinal Giulio de' Medici as a Patron of Art, 1513–1523." Ph.D. diss., Princeton, 1992.

"'Villa Falcona': The Name Intended for the Villa Madama in Rome." *Burlington Magazine* 137 (1995): 740–2.

"Clemens VII." In *Hoch Renaissance im Vatikan: Kunst und Kultur im Rom der Päpste, 1503–1534*, 55–69. Ostfildern, 1999.

"Giulio de' Medici and Mario Maffei: A Renaissance Friendship and the Villa Madama." In *Coming About: A Festschrift for John Shearman*, ed. Louisa Matthew and Lars Jones, 281–8. Cambridge, MA, 2001.

"Widow, Mother, Patron of Art: Alfonsina Orsini de' Medici." In *Beyond Isabella: Secular Women Patrons of Art in Renaissance Italy*, ed. Sheryl E. Reiss and David L. Wilkins, 125–58. Kirksville, MO, 2001.

"Raphael and his Patrons: From the Court of Urbino to the Curia and Rome." In *The Cambridge Companion to Raphael*, ed. Marcia Hall, 36–55. Cambridge, 2005.

"Adrian VI, Clement VII, and Art." In *The Pontificate of Clement VII: History, Politics, Culture*, ed. Sheryl E. Reiss and Kenneth Gouwens, 339–62. Aldershot, 2005.

"'Per havere tutte le opere … Da Monsignor Reverendissimo': Artists Seeking the Favor of Cardinal Giulio de' Medici." In *The Possessions of a Cardinal: Politics, Piety, and Art, 1450–1700*, ed. Mary Hollingsworth and Carol Richardson, 113–31. University Park, PA, 2010.

"Raphael, Pope Leo X, and Cardinal Giulio de' Medici." In *Late Raphael*, ed. Miguel Falomir, 14–25. Madrid, 2013.

"A Taxonomy of Art Patronage in Renaissance Italy." In *A Companion to Renaissance and Baroque Art*, ed. Babette Bohn and James M. Saslow, 23–43. New York, 2013.

"The Patronage of the Medici Popes at San Lorenzo in the Historiographic Tradition." In *San Lorenzo: A Florentine Church*, ed. Robert Gaston and Louis A. Waldman. Florence, forthcoming.

Reiss, Sheryl E., and Kenneth Gouwens, eds. *The Pontificate of Clement VII: History, Politics, Culture.* Aldershot, 2005.

Reist, Inge Jackson. "Raphael and the Humanist Villa." *Source: Notes in the History of Art* 3 (1984): 13–28.

Revard, Stella P. "Lampridio and the Poetic Sodalities in Rome in the 1510s and 1520s." In *Acta Conventus Neo-Latini Bariensis: Proceedings of the Ninth International Congress of Neo-Latin Studies*, ed. Rhoda Schnur, 499–507. Tempe, AZ, 1998.

Reynolds, Anne. *Renaissance Humanism at the Court of Clement VII: Francesco Berni's Dialogue against Poets in Context.* New York, 1997.

Ribouillault, Denis. "Landscape '*All'antica*' and Topographical Anachronism in Roman Fresco Painting of the Sixteenth Century." *Journal of the Warburg and Courtauld Institutes* 71 (2008): 211–37.

"Toward an Archaeology of the Gaze: The Perception and Function of Garden Views in Italian Renaissance Villas." In *Clio in the Italian Garden: Twenty-First-Century Studies in Historical Methods and Theoretical Perspectives*, ed. Mirka Beneš and Michael G. Lee, 203–32. Washington, DC, 2011.

Rome en ses jardins: paysage et pouvoir au XVIe siècle. Paris, 2013.

Rice, Louise. "Bernini and the Pantheon Bronze." In *Sonderdruck aus Sankt Peter in Rom 1506–2006*, ed. Georg Satzinger and Sebastian Schütze, 337–52. Munich, 2008.

Richardson, Brian. "From Scribal Publication to Print Publication: Pietro Bembo's 'Rime' 1529–1535." *Modern Language Review* 95 (2000): 684–95.

———. "'Recitato et cantato': The Oral Diffusion of Lyric Poetry in Sixteenth-Century Italy." In *Theatre, Opera and Performance in Italy from the Fifteenth Century to the Present: Essays in Honour of Richard Andrews*, ed. Brian Richardson, Simon Gilson, and Catherine Keen, 67–82. Leeds, 2004.

———. "The Diffusion of Literature in Renaissance Italy. The Case of Pietro Bembo." In *Literary Cultures and the Material Book*, ed. Simon Eliot, Andrew Nash, and Ian Willison, 175–89. London, 2007.

———. *Manuscript Culture in Renaissance Italy.* Cambridge, 2009.

———. "Oral Culture in Early Modern Italy: Performance, Language, Religion." *Italianist* 34 (2014): 313–17.

Ricoeur, Paul. "The Function of Fiction in Shaping Reality." *Man and World: An International Philosophical Review* 12 (1979): 123–41.

Rijser, David. *Raphael's Poetics: Art and Poetry in High Renaissance Rome.* Amsterdam, 2012.

Robertson, Clare. "Annibal Caro as Iconographer. Sources and Method." *Journal of the Warburg and Courtauld Institutes* 45 (1982): 160–81.

———. "Paolo Giovio and the 'invenzioni' for the Sala dei Cento Giorni." In *Paolo Giovio: il Rinascimento e la memoria*, 225–53. Como, 1985.

Rogers Mariotti, Josephine. "Selections from a Ledger of Cardinal Giovanni de' Medici, 1512–1513." *Nuovi studi* 9 (2001–2): 103–46.

Romani, Vittoria. "Raffaello e Pietro Bembo negli anni di Giulio II." In *Pietro Bembo e le arti*, ed. Guido Beltramini, Howard Burns, and Davide Gasparotto, 339–56. Venice, 2013.

Romeo, Ilaria. "Raffaello, l'antico e le bordure degli arazzi vaticane." *Xenia* 19 (1990): 41–86.

Roscoe, William. *The Life and Pontificate of Leo the Tenth*, trans. and rev. Thomas Roscoe, sixth edition, 2 vols. London, 1853.

Rossi Pinelli, Orietta. "Chirurgia della memoria: scultura antica e restauri storici." In *Memoria dell'antico nell'arte italiana*, ed. Salvatore Settis, 181–250. Turin, 1986.

Rossi, Giuseppe Aldo. *Monte Mario: profilo storico, artistico e ambientale del colle più alto di Roma.* Rome, 1996.

Rossi, V. *Dal Rinascimento al Risorgimento (Scritti di critica letteraria III).* Florence, 1930.

Rousseau, Claudia. "Cosimo I de' Medici and Astrology: The Symbolism of Prophecy." Ph.D. diss., Columbia University, 1983.

———. "The Yoke *Impresa* of Leo X." *Mitteilungen des Kunsthistorischen Institutes in Florenz* 33 (1989): 113–26.

Roux, D. "Le Val des Muses et les Musées chez les auteurs anciens." *Bulletin de correspondence hellénique* 78 (1954): 22–48.

Rowland, Ingrid D. "Some Panegyrics to Agostino Chigi." *Journal of the Warburg and Courtauld Institutes* 47 (1984): 194–9.

———. "Render unto Caesar the Things Which Are Caesar's: Humanism and the Arts in the Patronage of Agostino Chigi." *Renaissance Quarterly* 39 (1986): 673–730.

———. "Angelo Colocci ed i suoi rapporti con Raffaello." *Res publica litterarum* 14 (1991): 217–28.

———. "Raphael, Angelo Colocci, and the Genesis of the Architectural Orders." *Art Bulletin* 76 (1994): 81–104.

———. "The Intellectual Background of the School of Athens." In *Raphael's School of Athens*, ed. Marcia Hall, 131–70. Cambridge, 1997.

———. *The Culture of the High Renaissance: Ancients and Moderns in Sixteenth-Century Rome.* Cambridge, 1998.

———. "Il giardino trans Tiberim di Agostino Chigi." In *I giardini Chigi tra Siena e Roma: dal cinquecento agli inizi dell'ottocento*, ed. C. Benocci, 57–72. Siena, 2005.

"Raphael and the Roman Academy." In *On Renaissance Academies: Proceedings of the International Conference "From the Roman Academy to the Danish Academy in Rome,"* ed. Marianne Pade, 133–46. Rome, 2011.

Rubin, Patricia Lee. *Giorgio Vasari: Art and History.* New Haven, 1995.

Rubinstein, Ruth Olitsky. "The Renaissance discovery of antique river-god personifications." In *Scritti di storia dell'arte in onore di Roberto Salvini,* 257–63. Florence, 1984.

"The Statue of the River God Tigris or Arno." In *Il cortile delle statue: der Statuenhof des Belvedere im Vatikan,* 275–85. Mainz, 1998.

Ruggles, D. Fairchild. *Gardens, Landscape, and Vision in the Palaces of Islamic Spain.* University Park, PA, 2000.

Rupprecht, Bernhard. *Villa: zur Geschichte eines Ideals.* Berlin, 1966.

Ruysschaert, José. "Les Péripétiès inconnues de l'édition de 'Coryciana' de 1524." In *Atti del convegno di studi su Angelo Colocci (Jesi, 1969),* 45–60. Jesi, 1972.

"Le copiste Genesius de la Barrera et le manuscrit Barberini d'*Il principe* de Machiavelli." In *Studies on Machiavelli,* ed. Myron P. Gilmore, 348–59. Florence, 1972.

Rykwert, Joseph. *The Judicious Eye: Architecture against the Other Arts.* Chicago, 2008.

Sambin de Norcen, Maria Teresa. "I miti di Belriguardo." In *Nuovi antichi: committenti, cantieri, architetti 1400–1600,* ed. Richard Schofield, 16–65. Milan, 2004.

"'Ut apud Plinium': giardino e paesaggio a Belriguardo nel quattrocento." In *Delizie in villa: il giardino rinascimentale e i suoi committenti,* ed. Gianni Venturi and Francesco Ceccarelli, 65–90. Florence, 2008.

Il cortigiano architetto: edilizia, politica, umanesimo nel quattrocento ferrarese. Venice, 2012.

Le ville di Leonello d'Este: Ferrara e le sue campagne agli albori dell'età moderna. Venice, 2012.

Santolini, Sandro. "Due esempi di residenze suburbane sul Monte Mario a Roma: la Villa Mellini e i Casali Strozzi." In *Delizie in villa: il giardino rinascimentale e i suoi committenti,* ed.

Gianni Venturi and Francesco Ceccarelli, 229–68. Florence, 2008.

Sapori, Giovanna. "Dal programma al dipinto: Annibal Caro, Taddeo Zuccari, Giorgio Vasari." In *Storia della lingua e storia dell'arte in Italia: dissimmetrie e intersezioni. Atti del III convegno Associazione per la storia della lingua italiana,* ed. Vittorio Casale and Paolo d'Achille, 199–220. Florence, 2004.

Saxl, F. *Lectures.* London, 1957.

Scher, Stephen K., ed. *The Currency of Fame: Portrait Medals of the Renaissance.* New York, 1994.

Schilling, Robert. *La religion romaine de Vénus.* Paris, 1982.

"L'évolution du culte de Vénus sous l'Empire romain." In *Dans le sillage de Rome: religion, poésie, humanisme,* ed. Robert Schilling, 152–257. Paris, 1988.

Schröter, Elisabeth. *Die Ikonographie des Themas Parnass vor Raffael: die Schrift- und Bildtraditionen von der Spätantike bis zum 15. Jahrhundert.* Hildesheim, 1977.

"Der Vatikan als Hügel Apollons und der Musen. Kunst und Panegyrik von Nikolaus V. bis Julius II." *Römische Quartalschrift für christliche Altertumskunde und Kirchengeschichte* 75 (1980): 208–40.

Schwartz, Martin. "Ut pictura poesis." Chicago School of Media Theory blog https://lucian.uchicago.edu/blogs/mediatheory/keywords/ut-pictura-poesis/.

Scorza, R. A.. "Vincenzo Borghini and Invenzione: The Florentine Apparato of 1565." *Journal of the Warburg and Courtauld Institutes* 44 (1981): 47–75.

Scullard, H. H. *Festivals and Ceremonies of the Roman Republic.* London, 1981.

Séris, Emilie. *Les étoiles de Némésis: la rhétorique de la mémoire dans la poésie d'Ange Politien (1454–1494).* Geneva, 2002.

Settis, Salvatore. "Artisti e committente fra quattro e cinquecento." In *Storia d'Italia. Annali 4. Intellettuali e potere,* ed. Corrado Vivanti, 701–61. Turin, 1981.

Laocoonte: fama e stile. Rome, 1999.

Setton, Kenneth M. "Leo X and the Turkish Peril." In *Europe and the Levant in the Middle*

Ages and Renaissance, 367–424. London, 1974.

The Papacy and the Levant (1204–1571), vol. 3. Philadelphia, 1984.

Sheard, Wendy Stedman, and John T. Paoletti. *Collaboration in Italian Renaissance Art*. New Haven, 1978.

Shearman, John. "Die Loggia der Psyche in der Villa Farnesina und die Probleme der Letzen Phase von Raffaels graphischem Stil." *Jahrbuch der Kunsthistorischen Sammlungen in Wien* 60 (1964): 59–100.

"Raphael's Unexecuted Projects for the Stanze." In *Walter Friedlaender zum 90 Geburtstag: eine Festgabe seiner europäischen Schüler, Freunde, und Verehrer*, 158–80. Berlin, 1965.

"Raphael … 'fa il Bramante'." In *Studies in Renaissance and Baroque Art Presented to Anthony Blunt on his 60th Birthday*, 12–17. London, 1967.

"Raphael as Architect." *Journal of the Royal Society of Arts* 116 (1968): 388–409.

Raphael's Cartoons in the Collection of Her Majesty the Queen and the Tapestries for the Sistine Chapel. London, 1972.

"Raphael, Rome, and the Codex Escurialensis." *Master Drawings* 15.2 (1977): 107–46.

"A Functional Interpretation of Villa Madama." *Römisches Jahrbuch für Kunstgeschichte* 20 (1983): 313–27.

"The Organization of Raphael's Workshop." *Art Institute of Chicago Centennial Lectures, Museum Studies* 10 (1983): 41–57.

"Raffaello e la bottega." In *Raffaello in Vaticano*, 258–63. Milan, 1984.

"The Born Architect?" *Studies in the History of Art* 17 (1986): 203–10.

"A Note on the Chronology of Villa Madama." *Burlington Magazine* 129 (1987): 179–81.

Only Connect: Art and the Spectator in the Italian Renaissance. Princeton, 1992.

"Castiglione's Portrait of Raphael." *Mitteilungen der Kunsthistorischen Institut in Florenz* 38 (1994): 69–97.

Raphael in Early Modern Sources, 2 vols. New Haven, 2003.

Sherman, William H.. "'Nota Bembe': How Bembo the Elder read his Pliny the Younger." In *Pietro Bembo e le arti*, ed. Guido Beltramini, Howard Burns, and Davide Gasparotto, 119–33. Venice, 2013.

Simonetta, Marcello. *Volpi e leoni: i Medici, Machiavelli e la rovina d'Italia*. Milan, 2014.

Smith, Christine. "Christian Rhetoric in Eusebius' Panegyric at Tyre." *Vigiliae Christianae* 43 (1989): 226–47.

Architecture in the Culture of Early Humanism: Ethics, Aesthetics, and Eloquence 1400–1470. Oxford, 1992.

Smith, Christine, and Joseph O'Connor. *Building the Kingdom: Giannozzo Manetti on the Material and Spiritual Edifice*. Tempe, AZ, 2006.

Sorbelli, Albano, and Giuseppe Mazzatinti. *Inventari dei manoscritti delle biblioteche d'Italia / Pesaro*, vol. 33. Florence, 1925.

Spotti, Alda. "Mario Maffei e Martino Virgoletta: note a un carteggio della Biblioteca Nazionale di Roma." In *Roma nella svolta tra quattro e cinquecento*, ed. Stefano Colonna, 151–8. Rome, 2004.

Squire, Michael. "Dining with Polyphemus at Sperlonga and Baiae." *Apollo* 158 (2003): 29–37.

Stewart, A. F. "To Entertain an Emperor: Sperlonga, Laokoon and Tiberius at the Dinner Table." *Journal of Roman Studies* 67 (1977): 76–90.

Stillinger, Jack. *Multiple Authorship and the Myth of the Author in Criticism and Textual Theory*. New York, 1991.

Stinger, Charles L. *The Renaissance in Rome*. Bloomington, IN 1985.

Storey, H. Wayne. "Dirty Manuscripts and Textual Cultures. Introduction to *Textual Cultures* 1.1." *Textural Cultures: Texts, Contexts, Interpretation* 1.1 (2006): 1–4.

Strunck, Christina. "Pontormo und Pontano. Zu Paolo Giovios Programm für die beiden Lünettenfresken in Poggio a Caiano." *Marburger Jahrbuch für Kunstwissenschaft* 26 (1999): 117–37.

Tafuri, Manfredo. "'Roma instaurata'. Strategie urbane e politiche pontificie nella Roma del primo '500." In *Raffaello architetto*, ed. C. Frommel, S. Ray, and M. Tafuri, 59–106. Milan, 1984.

Interpreting the Renaissance: Princes, Cities, Architects, trans. Daniel Sherer. New Haven, 2006.

Talvacchia, Bette. "Raphael's Workshop and the Development of a Managerial Style." In *The Cambridge Companion to Raphael*, ed. Marcia Hall, 167–85. Cambridge, 2005.

Tamburini, Filippo. *Santi e peccatori: confessioni e suppliche dai Registri della Penitenzieria dell'Archivio Segreto Vaticano 1451–1586*. Milan, 1995.

Tamm, Birgitta. *Auditorium and Palatium: A Study on Assembly-rooms in Roman Palaces during the 1st Century B.C. and the 1st Century A.D.*, Acta Universitatis Stockholmiensis/Stockholm Studies in Classical Archaeology. Stockholm, 1963.

Tanner, Marie. *Jerusalem on the Hill: Rome and the Vision of St. Peter's in the Renaissance*. Turnhout, 2010.

Tanselle, G. Thomas. "The Editorial Problem of Final Authorial Intention." *Studies in Bibliography* 29 (1976): 167–211.

Taylor, F. L. *The Art of War in Italy 1494–1529*. Cambridge, 1921.

Taylor, Paul. "Julius II and the Stanza della Segnatura." *Journal of the Warburg and Courtauld Institutes* 72 (2009): 103–41.

Temple, Nicholas. *Renovatio urbis: Architecture, Urbanism and Ceremony in the Rome of Julius II*. London, 2011.

Temple, Nicholas, and Soumyen Bandyopadhyay. "Contemplating the Unfinished." In *From Models to Drawings: Imagination and Representation in Architecture*, ed. Marco Frascari, Jonathan Hale, and Bradley Starkey, 109–19. London, 2007.

Terzoglu, Nikolaos-Ion. "The Human Mind and Design Creativity. Leon Battista Alberti and *lineamenta*." In *Humanities in Architectural Design*, ed. Soumyen Bandyopadhyay, Jane Lomholt, Nicholas Temple, and Renée Tobe, 136–59. London, 2010.

Testa, Fausto. "'ut ad veterum illa admiranda aedificia accedere videatur'. Il Cortile del Belvedere e la retorica politica del potere pontificio sotto Giulio II." In *Donato Bramante: ricerche, proposte, riletture*, ed. Francesco Paolo Di Teodoro, 229–66. Urbino, 2001.

Testa, Simone. "Studi recenti sulla cultura manoscritta." *Italian Studies* 66 (2011): 277–85.

Thoenes, Christof. "La 'Lettera' a Leone X." In *Raffaello a Roma: il convegno del 1983*, 373–81. Rome, 1986.

"St. Peter als Ruine. Zu einigen Veduten Heemskercks." *Zeitschrift für Kunstgeschichte* 49 (1986): 481–501.

"'Il carico imposto dall'economia'. Appunti su committenza ed economia dai trattati di architettura del Rinascimento." In *Sostegno e adornamento: saggi sull'architettura del Rinascimento*, 177–85. Milan, 1998.

"Neue Beobachtungen an Bramantes St.-Peter-Entwürfen." In *Opus incertum: italienische Studien aus drei Jahrzehnten*, 381–417. Munich and Berlin, 2002.

Tigerstedt, E. N. "The Poet as Creator: Origins of a Metaphor." *Comparative Literature Studies* 5 (1968): 455–88.

Tiraboschi, Girolamo. *Storia della letteratura italiana*. Milan, 1822–6.

Tomassetti, Giuseppe. *La campagna romana: antica, medioevale e moderna*, vol. 3, *Via Cassia e Clodia, Flaminia e Tiberina, Labicana e Prenestina*. Rome, 1976.

Trachtenberg, Marvin. "Building Outside Time in Alberti's *De re aedificatoria*." *Res* 48 (2005): 123–34.

Building-in-Time from Giotto to Alberti and Modern Oblivion. New Haven, 2010.

"Ayn Rand, Alberti and the Authorial Figure of the Architect." *California Italian Studies* 2 (2011).

Tuttle, Richard. "Vignola e Villa Giulio: il disegno White." *Casabella* 61 (1997): 50–69.

Ubaldini, Federigo. *Vita di Mons. Angelo Colocci: edizione del testo originale italiano (Barb. Lat. 4882)*, ed. Vittorio Fanelli (Città del Vaticano, 1969).

Ulrich, Roger Bradley. "The Temple of Venus Genetrix in the Forum of Caesar in Rome: The Topography, History, Architecture, and Sculptural Program of the Monument." Ph.D. diss., Yale University, 1984.

Unglaub, Jonathan. "Bernardo Accolti, Raphael's *Parnassus* and a New Portrait by Andrea del Sarto." *Burlington Magazine* 149 (2007): 14–22.

Valtieri, Simonetta, and Enzo Bentivoglio. "Sanzio sovrintendente. Una lettera inedita di Raffaello." *Architettura: cronache e storia* 17 (1971): 476–84.

Van Eck, Caroline. *Classical Rhetoric and the Visual Arts in Early Modern Europe*. Cambridge, 2007.

Van Grieken, Joris, Ger Luijten, and Jan van der Stock, eds. *Hieronymous Cock: The Renaissance in Print*, Exh. Cat. New Haven, 2013.

Vasaly, Ann. *Representations: Images of the World in Ciceronian Oratory*. Berkeley, 1993.

Verde, Armando F. *Lo studio fiorentino 1473–1503: ricerche e documenti*. Pistoia, 1977.

Vickers, Nancy. "The Body Re-membered: Petrarchan Lyric and the Strategies of Description." In *Mimesis: From Mirror to Method, Augustine to Descartes*, ed. John D. Lyons and Stephen G. Nichols, Jr., 101–9. Hanover, 1982.

Viljoen, Madeleine. "Prints and False Antiquities in the Age of Raphael." *Print Quarterly* 21 (2004): 235–47.

Viscogliosi, Alessandro. "Antra cyclopis: osservazioni su una tipologia di coenatio." In *Ulisse: il mito e la memoria*, ed. Bernard Andreae and Claudio Parisi Presicce, 252–69. Rome, 1996.

Wallace, William E. "Clement VII and Michelangelo: An Anatomy of Patronage." In *The Pontificate of Clement VII: History, Politics, Culture*, ed. Kenneth Gouwens and Sheryl E. Reiss, 189–98. Aldershot, 2005.

Ward-Perkins, J. B. "Tripolitania and the Marble Trade." *Journal of Roman Studies* 41 (1951): 89–104.

Wardrop, James. *The Script of Humanism: Some Aspects of Humanistic Script 1460–1560*. Oxford, 1963.

Wasserstein, A. "The Manuscript Tradition of Statius' *Silvae*." *Classical Quarterly* n.s., 3.1/2 (1953): 69–78.

Webb, Ruth. *Ekphrasis, Imagination and Persuasion in Ancient Rhetorical Theory and Practice* Farnham, 2009.

Weil-Garris, Kathleen. "On Pedestals: Michelangelo's *David*, Bandinelli's *Hercules and Cacus* and the Sculpture of the Piazza della Signoria." *Römisches Jahrbuch für Kunstgeschichte* 20 (1983): 377–415.

——. "La morte di Raffaello e la 'Trasfigurazione'." In *Raffaello e L'Europa: Atti del IV corso internazionale di alta cultura*, ed. Marcello Fagiolo and Maria Luisa Madonna, 177–90. Rome, 1990.

Weil-Garris Brandt, Kathleen. "Raffaello e la scultura del cinquecento." In *Raffaello in Vaticano*, 221–31. Milan, 1984.

——. "Michelangelo's Early Projects for the Sistine Ceiling: Their Practical and Artistic Consequences." In *Michelangelo Drawings*, ed. Craig Hugh Smyth, 56–87. Washington, DC, 1992.

——. "'The nurse of Settignano': Michelangelo's Beginnings as a Sculptor." In *Genius of the Sculptor in Michelangelo's Work*, 21–43. Montreal, 1992.

——. "The Relation of Sculpture and Architecture in the Renaissance." In *The Renaissance from Brunelleschi to Michelangelo: The Representation of Architecture*, ed. Henry A. Millon and Vittorio Magnago Lampugnani, 74–99. Milan, 1994.

Weil-Garris Posner, Kathleen. "Comments on the Medici Chapel and Pontormo's Lunette at Poggio a Caiano." *Burlington Magazine* 115 (1973): 640–9.

——. *Leonardo and Central Italian Art, 1515–1550*. New York, 1974.

Weil-Garris, Kathleen, and John d'Amico, eds. *The Renaissance Cardinal's Ideal Palace: A Chapter from Cortesi's* De Cardinalatu. Rome, 1980.

Weinstock, Stefan. *Divus Julius.* Oxford, 1971.

Weiss, Roberto. "Andrea Fulvio antiquario romano (c. 1470–1527)." *Annali della Scuola normale superiore di Pisa* ser. 2, 28 (1959): 1–44.

——— *The Renaissance Discovery of Classical Antiquity.* Oxford, 1988.

Wilkinson, Catherine. "The New Professionalism in the Renaissance." In *The Architect: Chapters in the History of the Profession*, ed. Spiro Kostof, 124–60. New York, 1977.

Williams, Robert. *Art, Theory, and Culture in Sixteenth-Century Italy.* Cambridge, 1997.

Willis, Daniel. *The Emerald City and Other Essays on the Architectural Imagination.* New York, 1999.

Winner, M., B. Andreae, and C. Pietrangeli, eds. *Il cortile delle statue: der Statuenhof des Belvedere im Vatikan. Akten des internationalen Kongresses zu Ehren Richard Krautheimers, Rome, 1992.* Mainz, 1998.

Winspeare, Fabrizio. *La conjiura dei cardinali contro Leone X.* Florence, 1957.

"Wissensgeschichte der Architektur/Epistemic History of Architecture," http://wissensgeschichte.biblhertz.it/WdA/WdA/WdA_coll/description/#Deutsch.

Wolk-Simon, Linda. "Competition, Collaboration, and Specialization in the Roman Art World, 1520–27." In *The Pontificate of Clement VII: History, Politics, Culture*, ed. Kenneth Gouwens and Sheryl E. Reiss, 253–76. Aldershot, 2005.

Woods-Marsden, Joanna. "One Artist, Two Sitters, One Role: Raphael's Papal Portraits." In *The Cambridge Companion to Raphael*, ed. Marcia Hall, 120–40. Cambridge, 2005.

Woodward, W. W. *Cesare Borgia: A Biography.* London, 1913.

Wray, David. "Wood: Statius's *Silvae* and the Poetics of Genius." *Arethusa* 40 (2007): 127–43.

Wrede, Henning. "Römische Antikenprogramme des 16. Jahrhunderts." In *il cortile delle statue: der Statuenhof des Belvedere im Vatikan*, ed. M. Winner, B. Andreae, and C. Pietrangeli, 83–115. Mainz, 1992.

——— "Antikenstudium und Antikenaufstellung in der Renaissance." *Kölner Jahrbuch* 26 (1993): 11–25.

Yates, Frances. *The Art of Memory.* London, 1966.

Zanker, Paul. *The Power of Images in the Age of Augustus*, trans. Alan Shapiro. Ann Arbor, 1988.

Zeiner, Noelle K. *Nothing Ordinary Here: Statius as Creator of Distinction in the* Silvae. New York, 2005.

Zimmermann, T. C. Price. "Renaissance Symposia." In *Essays Presented to Myron P. Gilmore*, vol. 1, 363–74. Florence, 1978.

——— *Paolo Giovio: The Historian and the Crisis of Sixteenth-Century Italy.* Princeton, 1995.

Zimmermann, T. C. Price, and Saul Levin. "Fabio Vigile's 'Poem of the Pheasant': Humanist Conviviality in Renaissance Rome." In *Rome in the Renaissance: The City and the Myth*, ed. P. A. Ramsey, 265–78. Binghamton, 1982.

INDEX